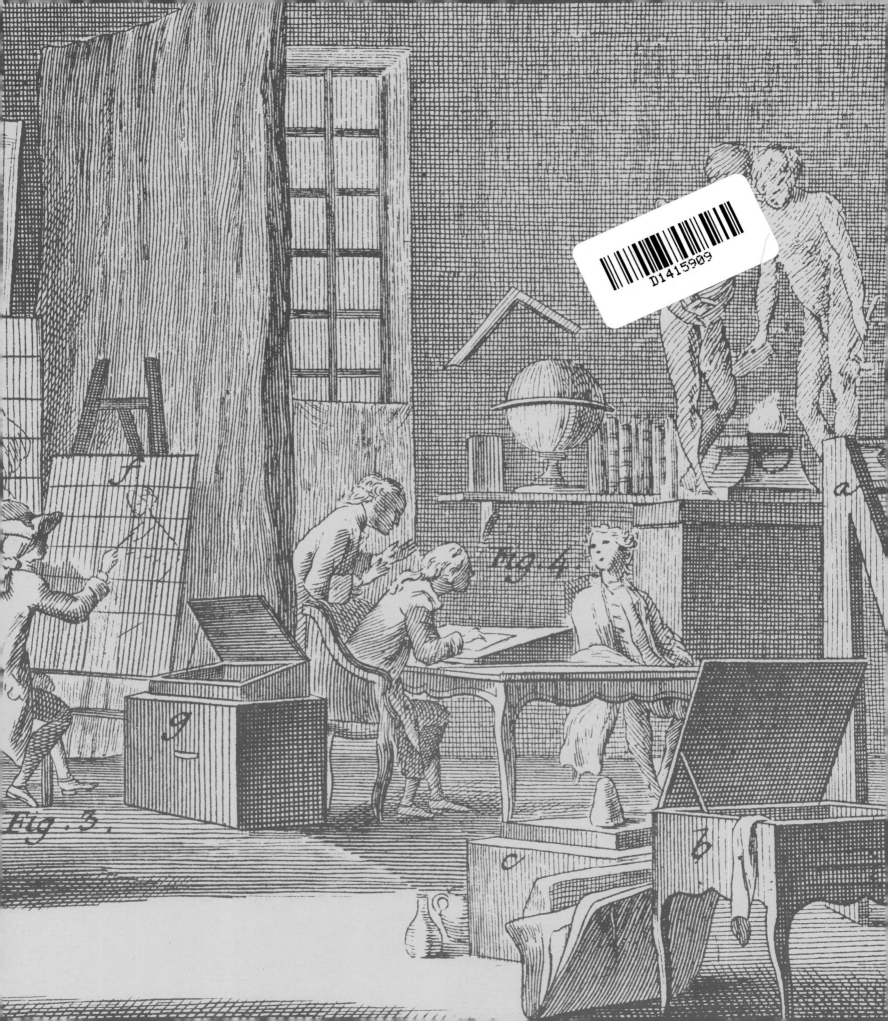

THE WRIGHTSMAN COLLECTION

VOLUME V

Paintings, Drawings, Sculpture

THE WRIGHTSMAN COLLECTION

VOLUME V

Paintings, Drawings

by EVERETT FAHY

Curator in Charge of European Paintings, The Metropolitan Museum of Art

Sculpture

by SIR FRANCIS WATSON

Director of the Wallace Collection, Advisor for Her Majesty's Works of Art

Introductions by

JOHN WALKER, Director Emeritus of the National Gallery of Art

SIR JOHN POPE-HENNESSY, Director of the Victoria and Albert Museum

THE METROPOLITAN MUSEUM OF ART

Distributed by New York Graphic Society, Greenwich, Connecticut

LIBRARY OF CONGRESS CATALOGING IN PUBLICATION DATA

Wrightsman, Charles
 The Wrightsman Collection.

 "Catalogue of the collection of Mr. and Mrs. Charles
Wrightsman."
 Includes bibliographical references.

 CONTENTS: v. 1. Furniture.—v. 2. Furniture. Gilt
bronze and mounted porcelain. Carpets.—v. 3. Furniture,
gold boxes, by F. J. B. Watson. Porcelain boxes, silver,
by C. C. Dauterman.—v. 4. Porcelain, by C. C. Dauter-
man.—v. 5. Paintings, drawings, by E. Fahy. Sculpture,
by F. J. B. Watson.

 1. Art—Private collections. 2. Art, French—Catalogs.
I. Wrightsman, Jayne. II. Watson, Francis John Bagott,
1907– III. Dauterman, Carl Christian, 1908–
IV. Fahy, Everett, 1941– V. Title.

N5220.W88 708.1471 66-10181
ISBN 0-87099-012-8

PREFACES

THE FORMAT of the entries for the paintings and drawings catalogued in this volume differs from that used for the previously published furniture and works of art in the Wrightsman Collection. The comparatively small number of pictures and the vast literature on some of them demanded a variation on the system employed in the earlier volumes. Here, a biography of the artist is followed by a description of the picture, its provenance, a general discussion of the picture's significance and style, a list of exhibitions, and an annotated bibliography. Each entry concludes with technical notes on the dimensions, medium, support, and condition of the painting. The entries are arranged alphabetically by artist.

Although all the paintings are illustrated with color plates and a number of black and white details, each picture is carefully described in words. This may strike some readers as an old-fashioned convention, but the descriptions serve to introduce terminology for objects and costumes that appear in the pictures. They also encourage one to look attentively at the paintings. As Bernard Berenson observed in 1956, in the third edition of his monograph on Lorenzo Lotto, "Some readers may ask: why this attempt to describe a picture, now that good illustrations reproduce it so well? No doubt, but the reader is too apt to take in a reproduction at a glance, to extract from it a minimum of its quality—and that confined to the treatment of the subject only—and to pass on to the next. A description may serve to make the reader look in more detail, now that photographic reproduction permits it. I only wish I had the leisure and allowed myself the space to describe more minutely."

By its very nature a catalogue is a collaborative undertaking: it incorporates the results of specialized studies, and it reflects the knowledge and opinions of experts in many fields. To demonstrate this debt the bibliographies appended to the individual entries for the paintings aim to be comprehensive, even the briefest references in the literature being noted. The drawings, however, have been treated in a less exhaustive manner. Owing to considerations of time and space, it was impossible to go into great detail about the three volumes illustrated with drawings by Gabriel de Saint-Aubin.

There was considerable collaboration in the actual writing of the entries. Work on the paintings, for example, was begun over a decade ago by Theodore Rousseau, Curator in Chief and Vice-Director of the Metropolitan Museum. He prepared draft entries for the El Greco, Guercino, Largillierre, Pissarro, Rubens, Tiepolo (the sketch for the Würzburg ceiling), Georges de La Tour, and Vermeer. Much of what he wrote is incorporated in the present entries for these pictures. During the period he worked on the catalogue, he was assisted by Claire Wever Bracaglia and Anne Poulet. Claus Virch, Philippe de

Montebello, and Margaretta Salinger, then members of the Department of European Paintings, contributed useful information to Mr. Rousseau's entries. In 1968 Sir Francis Watson furnished all the entries for the paintings by Canaletto and the single work by Francesco Guardi. For help in compiling these entries, Sir Francis wishes to acknowledge his debt to Mr. J. G. Links, who placed his knowledge of the topography of eighteenth-century Venice at his disposal and read through the entries in manuscript. They have subsequently been recast to conform to the format for the other paintings entries.

Because of the pressure of administrative duties, Mr. Rousseau asked me to help him, and in the summer of 1969 I was invited to assume full responsibility for the paintings entries. The burden of my work was immeasurably lightened by Anne Poulet who assisted me for two years, preparing detailed dossiers on each painting. She also composed first drafts of many of the biographies, provenances, and descriptions. The informative discussions of some of the pictures, particularly the Largillierre, the de Troys, and the Vestier, are largely her work. Without her dedicated help, my job would certainly have been far more time-consuming. On both a professional and personal level, our work together was most gratifying.

The members of the European Paintings Department also assisted me. Elizabeth E. Gardner, John Walsh, Katharine Baetjer, and Elizabeth Hammond shared their knowledge and solved many problems for me. Two student assistants in the Department, James Thompson and Olivier Aaron, also helped. Mr. Thompson made an illuminating study of the Seurat, and M. Aaron assisted me for over a year, gathering information about the Delacroix, the impressionist pictures, and all of the drawings. Other colleagues at the Museum also deserve my thanks. Helmut Nickel, Curator of Arms and Armor, identified weapons in the Wrightsman paintings; Olga Raggio, Chairman of the Western European Arts Department, translated a Barberini document; and Yvonne Hackenbroch, Curator of Western European Arts, shared her knowledge of jewelry. Adolph S. Cavallo, former Chairman of the Costume Institute, shed light on the dates and names of the garments worn in the paintings; Mark Lindley, formerly a Fellow in the Department of Musical Instruments, kindly gave useful information.

Most of the paintings in the Wrightsman Collection have benefited from the sensitive eye and hand of Hubert von Sonnenburg, Conservator of Paintings at the Metropolitan Museum. His intimate experience of them is reflected not only in their beautiful appearance but also in the notes printed in the individual entries on their physical condition. John M. Brealey, who cleaned several of the paintings in London, was likewise most generous with his time and observations. Mario Modestini, who cleaned the El Greco and one of the Tiepolo sketches, also kindly gave me useful information.

The drawings were removed from their frames by Merritt Safford, Conservator, Paper Conservation Laboratory of the Metropolitan Museum. Jacob Bean, Curator of Drawings, and Linda Boyer Gillies, Assistant Curator, helped to identify collectors' marks and inscriptions on the old mounts.

Most of the research on the paintings was conducted in the Thomas J. Watson Library of the Metropolitan Museum. The task was made easier by the sympathetic help of Elizabeth R. Usher, Chief

Librarian, and the untiring efforts of her cooperative staff. Thanks are also due Mildred Steinbach, Librarian of the Frick Art Reference Library. The facilities of the New York Public Library and the New York Society Library were also frequently employed. John N. Sunderland, Witt Librarian of the Courtauld Institute of Art in London, gave me free access to his resources; and M. Roy Fisher, Librarian for Wildenstein & Co., Inc., New York, and Clovis Whitfield, Librarian for Thos. Agnew & Sons, Ltd, London, solved many a bibliographical problem.

For opinions and answers to specific questions I am indebted to the following colleagues in American museums and universities: Charles E. Buckley, Director of the City Art Museum of St. Louis; Anthony M. Clark, former Director of the Minneapolis Institute of Arts; Charles Cunningham, former Director of the Art Institute of Chicago; Mary M. Davis, Executive Vice-President, Samuel H. Kress Foundation, New York; Colin Eisler, professor at the Institute of Fine Arts, New York University; Julius S. Held, former professor at Barnard College, Columbia University; Robert L. Herbert, professor at Yale University; Darryl E. Isley, Curator of the Norton Simon, Inc., Museum of Art, Los Angeles; Rensselaer W. Lee, professor emeritus at Princeton University; John Maxon, Vice President for Collections and Exhibitions of the Art Institute of Chicago; Edgar Munhall, Curator of the Frick Collection, New York; Phoebe Peebles, Curator of Archives of the Fogg Art Museum, Cambridge; D. Stephen Pepper, professor at Johns Hopkins University, Baltimore; Pinkney Near, Curator of the Virginia Museum of Fine Arts, Richmond; John Rewald, professor at City University of New York; David E. Rust, Curator, National Gallery of Art, Washington, D.C.; Fern Rusk Shapley, Curator of Research, Samuel H. Kress Foundation, National Gallery of Art; Richard E. Spear, professor at Oberlin College, Oberlin, Ohio; Charles Sterling, professor at the Institute of Fine Arts, New York University; Barbara Sweeny, former Curator of the John G. Johnson Collection, Philadelphia; John Walker, Director Emeritus of the National Gallery of Art; George L. Watson, Curator of the Hill-Stead Museum, Farmington, Connecticut; Otto Wittmann, Director of the Toledo Museum of Art.

European officials who aided my research are Joël Audouy, Conservateur en Chef des Archives et Bibliothèques de la Marine, Paris; A. Janssens de Bisthoven, Conservateur van de Stedelijke Musea, Bruges; Helmut Börsch-Supan, Schloss Charlottenburg, Berlin; Hugh Brigstocke, Assistant Keeper of Paintings, National Gallery of Scotland, Edinburgh; Monsieur Brunon, Musée de l'Armée, Paris; Général d'Armée Cantarel and Général Fornier, Chef du Service Historique, Ministère d'État Chargé de la Défense Nationale, Vincennes; V. Chomel, Directeur des Archives Départementales de l'Isère et de l'ancienne Province de Dauphiné, Grenoble; Edgard Clerc, Société de l'Histoire de la Guadeloupe, Point-à-Pitre, Guadeloupe; Gerhard Ewald, Chief Curator, Staatsgalerie, Stuttgart; Terence W. I. Hodgkinson, Keeper, Department of Architecture and Sculpture of the Victoria and Albert Museum; Michael Jaffé, Director of the Fitzwilliam Museum, Cambridge; Robert Keyszelitz, Director of the Graf Harrach'sche Gemäldegalerie, Rohrau, Austria; Rüdiger Klessmann, Director of the Herzog Anton Ulrich-Museum, Brunswick, Germany; Michael Levey, Keeper, National Gallery, London; R. W.

Lightbown, Assistant Keeper, Department of Metalwork of the Victoria and Albert Museum; Anna-lise Mayer-Meintschel, Gemäldegalerie Alte Meister, Dresden; M. J. Marechal, Director of Archives de l'État, Bruges; Stella Mary Newton, Courtauld Institute of Art, London; A. V. B. Norman, Keeper of Arms and Armor, Wallace Collection, London; Pierre Rosenberg, Conservateur au Département des Peintures, Musée National du Louvre; Susan Urbach, Szepmüveszeti Mùzeum, Budapest; Jacques Vilain, Conservateur à l'Inspection des Musées de Province, Musée du Louvre; Ellis Waterhouse, former Director of the Barber Institute of Art, University of Birmingham; Gustav Wilhelm, Director of the Sammlungen des Regierenden Fürsten von Liechtenstein, Schloss Vaduz, Liechtenstein.

I am also indebted to the following individuals and private collectors for sharing their information with me: Vitale Bloch, The Hague; Douglas Cooper, Château de Castille, Argilliers; Gladys Cumber-lege-Ware, Coombe Lodge, Poole, Dorset; François Daulte, Lausanne; Pierre Dieterle, Paris; André Fabius, Paris; Rudolf J. Heinemann, Ph.D., New York; Lady Inchcape, Quendon Park, Saffron Walden, Essex; Marilyn Aronberg Lavin, Princeton, New Jersey; Denis Mahon, London; Henry P. McIlhenny, Philadelphia; Robert Montgomery Scott, Embassy of the United States of America, London; Philip Pouncey, London; Mrs. Michael Rinehart, Bennington, Vermont; Count Antoine Seilern, London; Baron Nikolaus von Stumm, Munich; Basil Taylor, London; Frances Vivian, London; J. Howard Whittemore, Naugatuck, Connecticut; Christopher Wright, London.

A number of dealers, including many who never handled any of the pictures in the collection, generously provided information about provenances and exhibitions, which is incorporated in the entries. Also, for help in tracing obscure references and for shedding light on the subject matter of certain pictures, I wish to thank the following: Julian Agnew, Thos. Agnew & Sons, Ltd, London; Kenneth L. Beech, French & Co., Inc., New York; Herbert N. Bier, London; Mr. and Mrs. Leopold Blumka, New York; Harry A. Brooks, Wildenstein & Co., Inc., New York; David Carritt, London; Andrew S. Ciechano-wiecki, Heim Gallery Ltd, London; Charles Durand-Ruel, Durand-Ruel & Cie, Paris; Gilbert Gruet, Bernheim-Jeune & Cie, Paris; François Heim, Paris; D. A. Hoogendijk, Amsterdam; Evelyn Joll, Thos. Agnew & Sons, Ltd, London; William Mostyn-Owen, Christie, Manson & Woods, Ltd, London; Alexandre Rosenberg, Paul Rosenberg & Co., Inc., New York; the late Saemy Rosenberg, Rosen-berg & Stiebel, New York; Germain Seligman, Jacques Seligmann & Co., Inc., New York; Michael Simpson, P. & D. Colnaghi & Co., Ltd, London; E. V. Thaw, New York; R. M. D. Thesiger, David Carritt Ltd, London; Daniel Wildenstein, Paris.

Modified versions of two of the catalogue entries, those on the Gerard David Madonna and the Tiepolo Meeting of Antony and Cleopatra, first appeared in *Apollo* and *The Burlington Magazine*. To the editors of these journals, Denys Sutton and Benedict Nicolson, I am grateful for permission to republish much the same material that they originally printed.

During the three years I spent compiling the painting and drawing entries, I enjoyed the constant support of Sir Francis Watson. As general editor of the Wrightsman catalogue, not only did he make

[viii]

valuable comments on the individual entries but also he shared with me his unrivaled knowledge of eighteenth-century French and Venetian art. My debt to him is very great. I also benefited from the encouragement of several personal friends, in particular Sir John Pope-Hennessy, Director of the Victoria and Albert Museum, and also C. Channing Blake, T. A. Lovejoy, Julia Keydel, and Gabrielle Kopelman. Their suggestions and criticisms stimulated and improved my work.

The task of editing the entries and preparing the illustrations was executed by Anne MacDougall Preuss. I am deeply grateful to her for the thoughtful and untiring attention she gave the manuscript. Joan Sumner Ohrstrom undertook the laborious chore of checking every reference and date. Thanks to her sharp eye many mistakes and typographical errors were caught.

My last—and probably greatest—debt of gratitude is to Mr. and Mrs. Wrightsman. Both of them had a keen interest in the catalogue and spurred me on at every phase of compiling it. They made every facility available to me and even took me to Europe and Russia on several occasions so that I could study works related to pictures in their collection. The enthusiasm with which they followed my work was a source of real encouragement, and I am deeply grateful to them.

EVERETT FAHY

THE FIFTH and final volume of the catalogue of the Wrightsman Collection brings the task I began as compiler and general editor in the spring of 1960 to a conclusion. It covers two independent subjects: paintings and a few drawings, and a small collection of sculpture.

The authorship, like that of volumes III and IV, is twofold. The greater part of the entries for the paintings and drawings have been compiled by Everett Fahy, Curator in Charge of European Paintings at the Metropolitan Museum. Mr. John Walker has kindly written an introduction on the formation of the Wrightsman Collection for this section of the catalogue.

I was responsible for the entries for the sculpture and for the original preparation of the entries for the paintings by Canaletto and Guardi. These latter have been recast to conform with the format of the other painting entries, which, as explained below, differs somewhat from that adopted for the rest of the catalogue. But they have not been otherwise altered.

In preparing the descriptions of the Venetian view paintings by Canaletto and Guardi, I benefited greatly from the unrivaled topographical knowledge of the city of Venice of Mr. J. G. Links, who also drew my attention to a number of important points about the provenance of the group of Canalettos. I also compiled the entries for each item of sculpture and here I should like to express my gratitude to Sir John Pope-Hennessy and Mr. Terence Hodgkinson of the Victoria and Albert Museum, London,

both of whom read my manuscript and made a number of helpful suggestions. Sir John Pope-Hennessy has also kindly written an introduction to the sculpture section of the catalogue.

As in the previous volumes of the catalogue the various items are numbered in sequence, and groups of matching objects (of which there are, naturally, fewer in these volumes than in any other) have been grouped together, the individual pieces within the groups being distinguished by letters e.g., No. 1 A,B. The scheme adopted for the entries for works of sculpture follows precisely that used for the other types of objects of art in earlier volumes, e.g., the physical description of each piece is followed by what is known of its history and that succeeded by discussion of comparative material and style. With the paintings and drawings, however, the nature of the material demanded a slight variation on this system as Mr. Fahy explains in his preface.

In each section, the terms *right* and *left* refer to the spectator's right and left as he looks at the piece from the front. Measurements are overall unless otherwise noted and are given in both inches and centimeters, e.g., 30 (76.2). Height precedes width.

The bibliographies appended to the individual entries for the paintings and drawings are completely comprehensive, even the briefest reference in the literature being noted. Those for the sculpture are deliberately somewhat more selective (e.g., Catalogue No. 50, where the total bibliography is immense). The nature of the material, however, clearly called for no general bibliography of either of the two main sections as was provided for the more specialized subject of French furniture in volumes I and II. As with any collection still in the course of formation certain items were inevitably acquired too late for inclusion in the appropriate sections of the catalogue. There are still a few items of furniture and Sèvres porcelain that remain uncatalogued, though insufficient to provide material for a further volume of the catalogue at the present time.

FRANCIS WATSON

CONTENTS

PAINTINGS

INTRODUCTION

COLLECTING IN the West extends as far back as the pharaohs and continues with increasing intensity through Hellenic, Hellenistic, and Roman times. With the breakup of the Roman Empire connoisseurship diminished, and the Church became a different kind of collector. In the Middle Ages the anatomical remains of saints, their clothing, and the instruments of their suffering enthralled the ecclesiastical hierarchy, while the more scholarly churchmen focused their efforts on assembling ancient manuscripts, which kept alive the flickering light of culture.

After the collapse of the Roman Empire, it was not until the end of the Middle Ages that the private collector in the modern sense entered the scene. He did so in the guise of such nobles as the Duc de Berry and Charles V of France, or in Italy of those Popes and despots who were in constant competition for works of art. Over the years his taste, his interests, and his desires have constantly changed. The mutability of fashion is reflected in these changes, not only in what collectors have assembled, but also in their motives and sources of supply. American collections typical of taste around the First World War are different from those of today, just as society itself is different. The earlier collectors greatly admired the way of life of the British aristocracy. They wished to reproduce in America the stately houses of England, both those in London and those in the country. This would lead one to expect that their collections would resemble the works of art to be found at Chatsworth, Bridgewater House, or Petworth. Not at all. The mixture assembled by Morgan, the Wideners, Frick, Altman, and other millionaires of their generation—a medley of enamels, rock crystals, jewels, ceramics, medals, small bronzes, tapestries, Renaissance and French eighteenth-century furniture—is much closer to the "Stile Rothschild," to Mentmore and the Faubourg St.-Honoré, than to the type of works of art brought back by English nobles from the Grand Tour. Possibly, these Rothschild houses were more accessible than ducal homes; certainly their effect on America has been greater. The "Stile Rothschild" was also the *beau idéal* of the dealers whose influence on American taste has been prodigious.

But the "Stile Rothschild" itself had its progenitor. If one collector can be singled out for this honor, it is Lord Hertford, an English peer so eccentric as to become a francophile. To rival the Wallace Collection, which, enormous as it is, contains less than a third of the works he assembled, became the goal of a generation of collectors on both sides of the Atlantic.

Those American connoisseurs who emulated Lord Hertford in the high standards of their acquisitions have provided the bone and marrow of our great museums. Their collections were formed when

American wealth seemed able to draw an unending stream of works of art across the Atlantic. Then the reservoirs of Europe were full, and through their sluices flowed a torrent of masterpieces. But, more recently, these reservoirs have become alarmingly low. More stringently enforced export restrictions have closed the floodgates. Great works of art such as now fill our museums have continued to come to America, but the rate has changed from a torrent to a trickle.

As a consequence in recent years fewer and fewer collectors have tried to buy old masters. Instead the staple of American collections has been impressionism and post-impressionism. But with American wealth concentrated on the purchase of French painting produced by a few artists during half a century, their major works have soon disappeared, mopped up by our ubiquitous affluence; and with these gone, the market has been flooded with their minor efforts. Gresham's law that bad money drives out good applies equally to art. Second-rate productions diminish the stature of superb achievements. Nevertheless, with demand growing, a price squeeze has given absurd values to mediocrity. One remembers the tulip madness of Holland, and one wonders whether this overswollen bubble of impressionism may not similarly burst.

Art collecting, however, is thought by many to be a prudent investment. There are even mutual funds for speculation in art. The shareholders point to the steady rise in prices during the last two decades, and they also buttress their position by showing how supply, in their opinion, must always be less than demand. Their conclusions are logical. For museums withdraw permanently from sale a percentage of art objects, while at the same time, museum curators spend millions of dollars each year in a constantly narrowing market. In seventeenth-century Holland one could have grown more tulips, but one cannot produce more El Grecos, Vermeers, Tiepolos, and Renoirs. The owners of mutual funds in art believe scarcity will always assure rising prices.

Under certain circumstances their reasoning is correct. Prices will continue to rise provided collectors continue to buy. But there is another possibility. A market limited in opportunities may chill the interest of buyers, which in turn may lead to a decline in values. This has not yet happened, and prices are still rising spectacularly. But I have begun to notice a slight apathy toward certain schools of the old masters. The market is sluggish in the field of early Italian painting, work of the thirteenth, fourteenth, and fifteenth centuries, a period of art, incidentally, not represented in the Wrightsman Collection. It is only when a picture of the importance of Leonardo's portrait of Ginevra de' Benci is available that a price commensurate with its rarity is reached. As collectors become indifferent, so does the public, for it is the predilections of collectors that determine popular taste. The early Italian rooms in the National Gallery of Art and the Metropolitan Museum are the least visited of all.

The possibility that collectors may lose interest in the old masters gives particular importance to the collection assembled by Charles and Jayne Wrightsman. For here is proof that a superb group of masterpieces can be brought together even now, given sufficient alertness, determination, and discrimination. We need more dedicated collectors like the Wrightsmans, collectors who are willing to devote time and money to a quest for that most elusive of quarries, the great work of art.

[4]

How much easier was such hunting in the past! Take, for example, Andrew Mellon, the last American collector with almost unlimited opportunities. Of the three qualities that I have mentioned, he needed only one, discrimination. His entire collection was bought from only two dealers, Knoedler & Co., and Duveen Brothers. They brought him the greatest masterpieces they could acquire, knowing that what he rejected others would buy. Museums like the Hermitage in Leningrad and the Kaiser Friedrich Museum in Berlin were parting with some of their treasures. Thus, his two agents could propose purchases not only from their own stock, but also from several of the world's greatest art galleries. Inheritance taxes had forced the British nobility to sacrifice many of their artistic possessions, and England still had no export restrictions. "The Golden Apples of the Hesperides" were lying everywhere, only waiting to be gathered by the dealers and offered to Andrew Mellon. The same situation had existed during the first quarter of the century. The Wideners, Henry Clay Frick, Benjamin Altman, J. P. Morgan, and others needed only wealth and good judgment to fill their houses with masterpieces.

Charles and Jayne Wrightsman, who became serious collectors as late as 1952, have faced different circumstances. Collecting today requires far more of those other two qualities: alertness and determination. The ranks of the dealers in old masters, for instance, have been decimated. Duveen Brothers has been liquidated, and though Knoedlers continues, it has left its large building on 57th Street for more modest quarters and a new ownership. Auction houses have become magnets attracting private collectors as never before. Once it was customary for American millionaires to buy their works of art from dealers, paying one hundred per cent or more than the dealer had recently paid at auction; now collectors have begun going directly to Sotheby's or Christie's to bid against the few professional traders who remain, an endeavor more difficult and uncertain than ordering pictures on approval, as did Mr. Mellon, for a leisurely inspection at home. Moreover, European governments have become purchasers instead of vendors, pouring millions of dollars into the market, often to replace treasures they once sold. Private collectors today are forced to search out private owners, hoping when possible to anticipate and to outbid the dealers and the museums. Considering these difficulties it is amazing that the Wrightsmans have been able to form their splendid collection.

With all these impediments, why do collectors continue to search out and acquire great and noble works of art? There are many inducements. There is the excitement of the chase; there is the prestige of ownership; there is the intrinsic joy of looking at beautiful objects; there is the desire to add to the cultural heritage of this country through the enrichment of our museums; and there is the security of investment in an inflationary period.

Where, among American private collections does the Wrightsman Collection rank? To consider only the Wrightsman paintings, if we exclude from comparison collections of a single school, such as the astounding and unparalleled assemblage of English pictures belonging to Mr. and Mrs. Paul Mellon, it is in my opinion the most important group of old masters in America still privately owned. The rival for this honor would be the far larger Norton Simon Collection, but these works of art belong in part to his Foundation. The pictures once in the possession of Robert Lehman are more impressive, but with

his recent death, they have become public property. Though the Wrightsman Collection is small it is without peer among American collections of old masters that can be considered entirely private.

IT WAS IN the summer of 1951 that I was first introduced to Charles and Jayne Wrightsman. They had arrived in Venice on their yacht, and together we watched the annual Venetian regatta from a balcony of the Palazzo Brandolini. When the festival was over we returned to the yacht for cocktails. There were a good many people, but I remember that I found myself alone with Jayne on the aft deck. She asked me astute questions and was a superb listener. We talked about my career—I was at the time the Chief Curator of the National Gallery of Art—and she drew me out about museum work and my training for it. I felt in her a responsiveness to everything I said, a passion for the world of art, which I thought extraordinary in one with so little knowledge or experience. Her eagerness, however, should have been a clue to the future. It did not matter that she was artistically unsophisticated. The spark was there, ready to burst into flame. I should have been able even then to predict her life as a collector and her remarkable involvement in museums and in art education.

There was even less in Charles's background to indicate a commitment to art. His connoisseurship before we met had been limited largely to a choice of polo ponies and to a discerning evaluation of polo players. He had brought together a team that had won the English Cup in 1938; but the next year, as Europe went to war, he sold his stables and disbanded his team.

Jayne's experience in artistic matters was somewhat less negligible. She had been involved in the redecoration of a beautiful house in Palm Beach, which Charles had bought a few years after their marriage in 1944. Its interior when they purchased it was the product of one of the most fashionable decorators of the time, who specialized in English eighteenth-century furniture, a style then *de rigueur* among the rich. The house was well known and much admired; and when the Wrightsmans introduced a French commode into the living room there was general surprise and little approval. But both Charles and Jayne felt drawn to the refinement of French taste, and they decided their French commode made the English furniture look coarse. Little by little Hepplewhite and Chippendale vanished to be replaced by Jacob and Vanrisamburgh. It was an unconventional change, for it took place before the vogue of Louis Quinze and Louis Seize had been revived. French furniture of quality was still startlingly cheap. However, no two people have contributed more to its rise in value than Charles and Jayne Wrightsman.

But decorating, as they were doing, is very different from collecting, as they were about to do. Charles had made tentative and unsuccessful starts as a collector. In the thirties he had purchased, as a gift for his mother, a Dutch portrait. It came from the leading New York dealer of the time, and it turned out to be valueless. He had also bought English porcelains for his Palm Beach house. They, too, had proved to be inferior. He realized that he needed guidance, help Jayne was still too inexperienced to offer.

One day the Wrightsmans went to the Metropolitan Museum to see an exhibition entitled *Masterpieces of European Porcelain*, to which Judge Irwin Untermyer, a Trustee of the Museum, was the principal

lender. Charles recognized a true connoisseur from the loans he saw, and he realized that what he himself had been buying was mediocre. As soon as he left the museum he called his lawyers on the theory that, as they were in the legal business, they must know local judges, and he explained that he wanted an introduction to Judge Untermyer immediately. His intuition about lawyers and judges was correct, and the meeting took place. Judge Untermyer soon became a close friend and for many years always took his neophytes to the antique dealers' fairs in London, where, to their delight, he arranged for them to be admitted before the show was open to the public. After meeting Judge Untermyer, Charles made very few mistakes in his selection of porcelain.

Pierre Verlet, the Conservateur of Decorative Arts at the Louvre, and Francis Watson, the Director of the Wallace Collection, were soon added to the Wrightsmans' circle of advisers and friends. They helped especially with the selection of decorative arts. I was able to assist in my own field of painting. That, however, was over twenty years ago, and since then Jayne has dedicated herself to the most intensive and successful self-education of any connoisseur I know. She has reached a point where she no longer needs our guidance.

I found in my files letters written by her in 1957 inquiring about a correspondence course in French eighteenth-century art, which was being offered by the University of Chicago. Was it worthwhile for her to take it? I replied, after investigating the course, that it was far too elementary. By that time, I felt, she knew as much as most curators. I sent her, instead, a very thorough and professional bibliography. I have no doubt that she procured and read nearly every article I suggested. Today she has become one of the best connoisseurs in America of the art of the *ancien régime*. The Wrightsman Collection itself is the proof. In recent years Jayne and I have reversed our roles, and I have often asked *her* opinion of paintings. I have found her judgment remarkable, perhaps because it has so often agreed with mine! This congruence of taste has had occasionally distressing consequences, as I shall explain later.

Francis Watson has told me of his own similar experience of Jayne as a connoisseur of French eighteenth-century furniture. He met her several years after I first got to know her and early in their acquaintance, in the spring of 1959, he and his wife stayed with Charles and Jayne in their house at Palm Beach. At that moment Francis was writing a book on Louis XVI furniture and had the proofs with him. One evening after dinner he brought out the pulls of the two hundred and forty illustrations and sat on a sofa beside Jayne idly turning them over. They were entirely uncaptioned. He was astonished to find that, in almost every instance, Jayne knew the name of the *ébéniste* responsible for making the pieces illustrated and often the name of their owners too. To many of them she could give an accurate date and often remembered the occasion when it had passed through the sale rooms. Such a prodigious feat of memory on a highly specialized subject impressed him enormously and was, he always claims, a potent factor in his deciding to accept their invitation to collaborate with them by undertaking the editorship of the catalogue of their collection.

But at the beginning of the Wrightsmans' career as collectors I can claim considerable influence.

I brought to their attention the first important picture they acquired. On one of my trips to New York, I went to see a small dealer, quite by chance. He showed me a charming Monet, so cheap in those days I could have bought it myself. However, I have never been a collector except for the National Gallery, which at the time had virtually no purchase funds, and so I mentioned the painting to Charles, who bought it at once. It hangs beside the bedroom my wife and I occupy when we stay with the Wrightsmans, and we always glance at this entrancing, sun-filled scene a little wistfully.

The purchase of this picture gave Charles the confidence he had lost when he naïvely bought the worthless Dutch portrait. A note from Jayne a few months later indicates that this confidence had grown. Charles, she said, had given her a "very stylish Pissarro for Christmas," and she hoped I would like it. It proved to be a painting of two figures in a landscape, unusually large for Pissarro, and in my opinion his most impressive work in this genre. When I came that winter to stay with the Wrightsmans in Palm Beach, I congratulated Charles on his purchase, and I could see that the virus of collecting had entered his blood. Having possessed two beautiful paintings, Charles was now himself possessed. He asked me to let him know if I came across other impressionist canvases he might buy.

Shortly thereafter I learned to my dismay that the beautiful Girl with a Cat by Renoir, which had been on loan to the Gallery for several years from the Whittemore Collection, had to be sold by the family, who had so generously given us other pictures, and from whom I had hoped the National Gallery would receive this additional gift. I tried to find a donor for the painting, but my luck failed me. My most hopeful prospect turned out to be a cat hater! Finally as the painting was about to leave the Gallery I called Charles and told him that I could not discover a benefactor; and since we had no purchase funds, I hoped the Renoir would be acquired by a friend. He knew it well from his visits to Washington and without hesitation said he would buy it.

After acquiring several impressionist paintings, Charles told me that he also wished to find outstanding works of other schools, especially eighteenth-century paintings, which would harmonize with his rapidly growing collection of French furniture and decorative arts. I had seen two superb pictures by de Troy on 57th Street, and again I had tried to interest a National Gallery benefactor, in this case the Samuel H. Kress Foundation, which was buying extensively and marvelously for the Gallery. But Mr. Kress had little sympathy for French art if he felt it suggested any possible impropriety. My two lovely canvases he thought a little too *dix-huitième* in subject matter. They were quickly rejected; I was equally dejected; but my dejection ultimately added two more enchanting pictures to the Wrightsman Collection.

Another painting I wanted for the Gallery, in this case infinitely more, was the Portrait of a Girl by Jan Vermeer. It had been sent to America by the Duc d'Arenberg. I had tried for months to get the Kress Foundation to add to their gifts to the Gallery this landmark in the work of Vermeer. For it is one of the pictures Thoré-Bürger illustrated in his famous article of 1866 in the *Gazette des Beaux-Arts*, in which he re-established the *œuvre* of that supreme master of Holland, who had been completely forgotten.

[8]

I remember lunching with Charles and Jayne, who, with their usual sensitivity to the moods of their guests, asked me why I seemed so depressed. I explained that one of the most important pictures to come to America was about to be returned to Europe for lack of a buyer. The price seemed high at the time, and I had been unable to persuade the Kress Foundation that no price was exorbitant, since the picture was priceless. Charles asked whether he could look at the painting. I said that I would see what I could do. I knew that the dealer, having abandoned hope of selling the Vermeer, had just sailed for Paris. Nevertheless, I rang up his gallery. There was only a secretary on duty, who said the canvas was in a vault and could not be seen. I lost my temper. I threatened never to buy another picture from the dealer unless the Vermeer was produced immediately. I was very unfair to the secretary. The National Gallery was an important customer, and she did not want to be responsible for losing its patronage. Yet she had instructions to show the painting to no one. In her dilemma she decided to take a chance. She said that if we came at once, she would violate her orders and that we could see the Vermeer.

Charles, Jayne, and I walked around the corner and found the ashen secretary in front of an easel with the painting on display. Charles looked at it coldly, and even Jayne did not express her usual warm enthusiasm when confronted by a masterpiece. We left, and I felt still sorrier for the secretary and more than ever a cad for having put her in this awkward position to no purpose.

The Wrightsmans departed shortly thereafter for their annual trip to Paris, and I put the rather unhappy incident out of my mind. Several weeks later I received a cable saying that after long and tiresome negotiations the Vermeer would remain in America, as I had wished, and would I like it on loan at the National Gallery with the compliments of Charles and Jayne Wrightsman? I have always hoped the secretary was given a bonus.

The Wrightsmans have had failures as well as successes in their collecting. The auction room has not always been the scene of triumphs. I sat between Charles and Jayne when the Portrait of the Duke of Wellington by Goya came up for sale at Sotheby's in June 1961. Jayne wanted the picture desperately. We realized that the competition would be stiff, and Charles had decided to bid up to a figure considerably above the highest price ever fetched by a Goya at auction. This sum was reached with alarming rapidity. Charles, rather breathlessly, whispered to me, "What shall I do?" Jayne whispered in my other ear, "Tell him to go on." I did. Decisions have to be made in seconds at an auction, and bravely up went Charles until at $392,000 the picture was knocked down to him.

Immediately after the sale all England was in an uproar. The newspapers screamed in chorus that the loss to the nation of the most famous portrait of the greatest of all British generals would be intolerable. Charles was at once cooperative. If the picture was so important to England, then the London National Gallery should have it, provided he was reimbursed for what he had paid. Eventually with blood, sweat, and tears, Sir Philip Hendy, the Director of the Gallery, managed to raise the money, and Charles relinquished the painting, only to have it stolen from the National Gallery almost on delivery (it was eventually recovered).

At another auction, this time in New York, Charles and I were opponents. The painting involved was La Liseuse by Fragonard. I had fallen in love with the subject of the painting in my college days, and I used to have tea with the picture's owner, Mrs. Ericson, largely to look out of the corner of my eye at Fragonard's enchanting ingenue. Again and again Jayne and I have wanted the same work of art, and our successes and failures have been about equal. This time with the help of the late Ailsa Mellon Bruce, who shared my passion for La Liseuse, I won; but not until Charles had forced us to $875,000, a price far beyond that ever fetched by any work by Fragonard. I remembered clearly when we made our last bid, and I waited for Charles to bid again. How I wished he had never become interested in paintings! How I wished Jayne's taste had never improved! The thirty seconds until the auctioneer's hammer fell seemed like the thirty years I had loved Fragonard's young girl. La Liseuse is a canvas that I am delighted to say is not in this catalogue!

On other occasions when Jayne and I have been rivals I have lost. Once after a cruise on the Wrightsman yacht we stopped in Venice and went to see the great exhibition being held that summer of the work of Francesco Guardi. We were both struck by a landscape of exceptional quality and best of all of an unhackneyed subject, the Villa Loredan in the Veneto. Looking in the catalogue we saw that it had been lent anonymously. Without telling Jayne I went to the director of the museum and found out that the anonymous lender was a dealer. A little ungraciously, considering that I had been the Wrightsmans' guest, I rushed to London to try to buy the painting for the Gallery. To my sorrow I found that the picture was in the dealer's private collection and not for sale. Somewhat crestfallen I gave up. Jayne did not resent my getting to the dealer first. She is the fairest of competitors. She simply discovered that there was a companion piece of still greater beauty and bought it.

Charles and Jayne have always made rapid decisions about works of art. Once Jayne and I were together at a dealer's, inevitably a danger given the similarity of our tastes. We were shown a transparency of a canvas by Gian Domenico Tiepolo, an entrancing scene of masked figures stepping into a gondola. Some years before we had seen the original in Venice. Jayne never forgets a painting, and before I could say, "Reserve it for the National Gallery of Art," she said, "I'll buy it." The dealer was overjoyed. Had I been a second quicker and spoken first, the painting would have remained in limbo until the next meeting of our Board of Trustees. Little wonder that private collectors are more popular with art dealers than museum directors, especially in a seller's market.

But though Charles and Jayne decide quickly what they want, before the purchase is consummated, except at auction where it is not possible, there is always a proviso that the picture be subject to a thorough physical examination. This is Charles's particular interest. If the picture cannot pass the tests of X-rays, ultraviolet, and infrared, back it goes to the dealer. The magic eyes of science have focused on every picture in the collection. Only those that have proved sound have remained.

The Wrightsmans are constantly distilling their collection. Two still life paintings attributed to Guardi were bought more or less on my recommendation. I looked upon them as of decorative interest,

brilliant and effective; but this was not enough. Quality and significance must be maintained at the highest level. My poor Guardis could not meet the competition, beautiful as I thought they were.

Charles has often credited me with making him a collector, but my inspiration, such as it is, has always seemed to me far less than that of the greatest critic and connoisseur of our time, Bernard Berenson. I introduced the Wrightsmans to him in 1954. Their friendship was an example of spontaneous combustion, especially in the case of Jayne. B.B., as he was known to his friends, guided her studies and found her in turn a correspondent after his own heart. Though they did not meet often, through their weekly letters a deep attachment sprang up between a very old man and a very young woman. In 1955 when B.B. was ninety years old, Jayne wrote me, "I hear all the time from B.B. One letter he sounds on the top of the world and the next not so well. He is a darling and loving friend that I worry about all the time. I do not know whether I am happy or sad that you brought him into my life, but I am deeply touched and grateful for his friendship."

One day I was telling Charles about my life in Florence as a student when I was working for B.B. I said one of my greatest disappointments was that he had not come to America since the National Gallery had been established and so had never seen the collection and its installation for which I had been in part responsible. The Wrightsmans had just returned from flying in their plane around the Far East where Jayne had taken remarkable stereo-photographs. Charles said at once, "Jayne must take stereo-photographs of every painting and piece of sculpture in the National Gallery and also show their settings. This will give B.B. some idea of what he would never see otherwise."

They both went to work, night after night, with cameras and flashlights. In all they took well over a thousand shots, Charles with our laborers carrying the cumbersome equipment, and Jayne running up and down ladders. The slides when they reached Florence gave B.B. the greatest delight, and he constantly showed them to his guests; but more important, Charles and Jayne looked very hard at a collection of great works of art. Their eyes were trained by this arduous photographic project. Poring over slides, indentifying and cataloguing them, Jayne learned to see quality, to discern, and to discriminate. Connoisseurship can be developed only in this way, by an intensive scrutiny of masterpieces.

Collecting, I have often thought, resembles big game hunting. It requires travel, and it requires marksmanship. It is in the museum that the collector finds his opportunities for target practice. Not until his eye is trained, his aim sure, is he ready to go on his art safaris.

Charles, Jayne, my wife, and I have made a number of such safaris. A private airplane was a great advantage. We flew to Holland to see the Van Beuningen Collection when we thought it might come on the market, to Aschbach to see the von Pölnitz Christ Calling Peter and Andrew by Peter Breughel the Elder (which the owner offered to sell at a price that staggered us then and was later to stagger the Canadian government), to Liechtenstein in pursuit of Ginevra de'Benci, which I eventually captured, and to many other collections.

Sometimes while the Wrightsmans were pursuing private collectors, the dealers were pursuing

them. Then the hunters were hunted, occasionally with amusing results. There was a jeweler in Milan who also sold pictures on the side. He had two pink diamonds of inestimable value and also four Canalettos of superb quality, which Charles knew about. Somehow the dealer thought Charles was a collector of jewels, not of paintings, and he begged the Wrightsmans to come and see his diamonds. After an ardent, one-way correspondence, Charles finally consented to look at the diamonds in Venice but suggested that he also be shown the four Canalettos, which he said he had been told the jeweler owned. A meeting at Cipriani's was arranged, and the dealer arrived with his precious jewels and with the Canalettos, which he stacked against the wall.

A long discussion followed about the pink diamonds, their rarity, their beauty, their value. Charles indicated he might buy them and the Canalettos too if prices were at all reasonable. The dealer offered the diamonds at an astronomical figure, and to make the package more attractive, the Canalettos at a decent price. To his horror Charles immediately bought the paintings and said he really was not interested in the jewels, rare and beautiful as they were. Disconsolate, the dealer returned to Milan with the diamonds in his pocket, and Charles was left with the Canalettos, which when cleaned proved to be among the finest early examples in existence.

These paintings were acquired after I had ceased to advise Charles. In 1956 he had become a trustee of the Metropolitan Museum. As a member of its Acquisitions and Executive Committees his responsibilities and mine were too directly competitive to continue our safaris together. Our friendship remained, but Charles tactfully turned elsewhere for advice. James Rorimer became influential in his collecting and inspired him to publish this catalogue. Theodore Rousseau, then Curator of European Paintings at the Metropolitan Museum, Everett Fahy, his successor, and above all Francis Watson, the editor of these catalogues, became his principal guides. Their search for works of art was extraordinarily rewarding. They brought home many trophies I would have loved to have had for the National Gallery: canvases and panels by Gerard David, El Greco, La Tour, Poussin, Rubens, Van Dyck, Gian Battista and Gian Domenico Tiepolo, and others. Jayne's sure marksmanship in the jungles of 57th Street, Bond Street, the Rue de la Boétie, and wherever works of art are to be found earned her the respect of all of us who are professionals. And Charles has always been at her side with the necessary ammunition and the necessary faith in the accuracy of her aim. This catalogue is a proud record of their success.

But both Charles and Jayne have felt that gathering together masterpieces is only part of the collector's task. Collections should be cherished and interpreted by highly qualified professionals. At present these are in short supply. To increase the number of historians of art and museum curators, Charles and Jayne have given both their time and their money to the Institute of Fine Arts of New York University. Again the influence of their trips to Florence is evident. As a trustee of New York University, Charles has helped to instill in its graduate school of the history of art the ideals of scholarship learned in Italy, listening to B.B.'s unforgettable conversations. I have often thought what pleasure it would have given Berenson to know that his words had been taken to heart by the Wrightsmans, to realize that they had

been influenced by the works of art he showed them at I Tatti and told them about elsewhere. For he deeply affected the lives of these two people, much more than he recognized in his own lifetime.

But all of us are molded by fortuitous meetings: in the case of the Wrightsmans it was Judge Untermyer at the Metropolitan Museum, myself on the yacht in Venice, B.B. at I Tatti, weaving his magic net of words. These chance encounters pointed out to Charles and Jayne a way of life, showed them the joys and delights of collecting, caused them ultimately to know the power and excitement of influencing the activities of a great museum. Yet, in the style of life they have so successfully chosen, I feel the most satisfactory and happiest experiences have come through their involvement with scholars, their companionship with those who have followed the same arduous and rewarding quest, the pursuit of the masterpiece and the search for its meaning. Several of these museum directors and art historians have contributed to the catalogues of the Wrightsman Collection. Their friendship and admiration are reflected in the pages of these publications.

JOHN WALKER
Director Emeritus of the National Gallery of Art, Washington, D.C.

PARIS BORDON (1500–1571) worked in the shadow of Titian (1487/90–1576) and Tintoretto (1518–1594), yet maintained an individual style of painting. Although a secondary figure, he contributed much to the history of sixteenth-century Venetian art. He is best known for his elaborate mythological compositions, which introduced into Venice a variation of Mannerism very likely inspired by the School of Fontainebleau.

The basic source of information about Bordon is the brief account of him written by Giorgio Vasari (1511–1574), who visited him in Venice in 1566. He was born at Treviso and at the age of eight moved to Venice with his mother, who was Venetian by birth. Despite the fact that he was trained by Titian and spent most of his career working in Venice, he preserved his ties with Treviso, occasionally filling a commission for one of his compatriots and frequently signing his paintings *Paris bordonus tarvisinus*.

His career is difficult to trace, for although he signed over fifty paintings, only a handful of them are dated. In the earliest datable works, the altarpieces from Crema, now in the Accademia Tadini, Lovere, and the Pinacoteca di Brera, Milan, he already shows a proclivity to make movement a key element in his compositions. As in almost all his paintings, the figures in these pictures move with deliberate grace, as though they were performing a very slow, stylized dance.

Like Lorenzo Lotto (about 1480–about 1556) and Giovanni Antonio Pordenone (about 1484–1539), Bordon often accepted commissions outside the city of Venice. According to Vasari, his travels took him as far as Fontainebleau, where he worked in 1538 for the court of François I, who reigned from 1515 until 1547. He may also have returned to France during the brief reign of François II (1559–1560) and come in contact with Antoine Caron (about 1515–1593), with whose paintings some of Bordon's late works have much in common. Vasari also says that he worked in Germany and painted some decorations for the Fugger residence at Augsburg. A Portrait of Jerome Crofft, now in the Louvre, is signed and dated Augsburg 1540. By April 1543, Bordon was back in Venice, but he seems to have departed almost immediately for Milan, where he worked for several important Milanese families. When Vasari visited Bordon six years before his death at the age of seventy-one, he was living in quiet retirement. He told Vasari that he painted only to please himself and that he avoided the jealousy and ambition of his colleagues.

Because of his travels Bordon had been exposed to Mannerist paintings in a way that local Venetian painters were not. The personal idiom that he evolved, combining artificially posed figures and architectural fantasies inspired by Sebastiano Serlio (1475–1554), was a precedent for the style developed slightly later by Tintoretto and El Greco (*q.v.*).

1 Portrait of a Man in Armor with Two Pages

IN THIS three-quarter-length portrait a military officer, with two pages, stands before an open landscape. The officer (Fig. 7) has short gray hair and a gray beard, and he wears a suit of very dark blue-gray armor. The edges of each piece of his armor are gilded, and there is a gilded cross on his breastplate. At his wrists are visible the ruffled cuffs of a white shirt. His pantaloons are burgundy, with dull orange stripes on the codpiece. The doublet of the page on the left (Fig. 2) is sumptuously colored with golden-rust and black stripes. The blackamoor on the right, holding an open helmet, or burgonet, with a gray plume, wears a glossy black doublet, with puffed sleeves of another material, decorated with deep red-violet and black squares. The officer and his pages all carry weapons; the officer rests his left hand on a rapier, and the pages have daggers at their waists.

The landscape immediately behind the figures is predominantly deep brown, whereas the sky and distant hills are painted in shades of bluish green. Three streams of dark gray smoke rise above the fortified tower on the left, and a large group of infantrymen marches along the horizon on the right (Fig. 8). These soldiers carry dozens of pikes and an unfurled banner of salmon-colored and black stripes.

In the grass between the officer and the blackamoor there is a gray ribbon inscribed: *OPVS PARIDIS BORDON* (Fig. 1).

1. *Detail: signature*

PROVENANCE: The picture may be identical with a portrait by Paris Bordon that belonged to Bernardo Trincavella, an art collector who was granted Venetian citizenship in 1629. Trincavella's painting was described in 1648 as a "Cavaliere, à cui un paghetto allaccia l'armatura," by Carlo Ridolfi (*Le maraviglie dell'arte*, Detlev von Hadeln, ed., Berlin, 1914, I, p. 234). Ridolfi does not mention the blackamoor, but then neither do several modern writers who have described the picture.

A blackamoor does figure in a military portrait by Bordon that belonged somewhat later to Paolo del Sera, a Florentine painter who resided in Venice from 1640 until his death in 1672. His picture gallery contained a portrait of a general armed by two pages, which Marco Boschini described in his long poem in Venetian dialect, *La carta del navegar pitoresco* (1660, pp. 366–367). His detailed account of the portrait deserves to be quoted:

> De più ghe vn generoso General,
> Fato dal nostro Paris Treuisan,
> Che vn Pagio industrioso con le man
> Ghè veste l'arme, lustre più che azzal.
> Ghè porzel' elmo, tuto gratia, vn Moro,
> Che vn viuo no' sà far ato sì belo
> Ben de Paris fù celebre el penelo!
> La xè vna zogia da ligarla in oro.
>
> (Boschini, 1660, pp. 366–367)

Moreover, there is a gallant General
Painted by our Paris of Treviso
And the hands of an industrious Page
Invest him with his armor, more lustrous than steel.

Gracefully, a Moor proffers his helmet,
A live person cannot act so beautifully.
Well was Paris' brush celebrated!
It is a jewel to be set in gold.

(translation quoted from Borenius, 1936, p. 8)

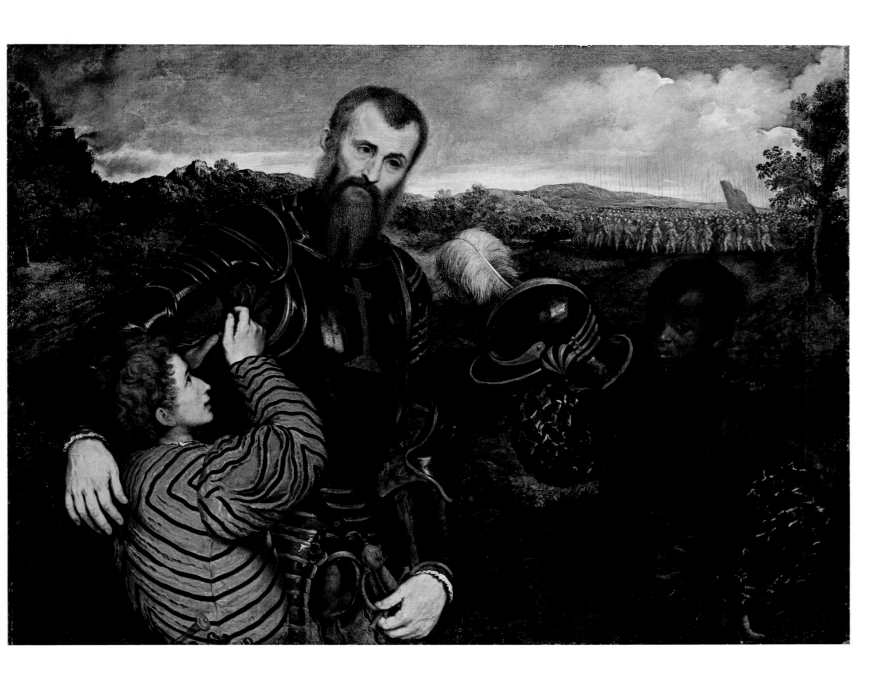

According to Boschini (1660, p. 361, marginal note), del Sera's collection was acquired en bloc by Cardinal Leopoldo de' Medici (1617–1675) in Florence. (On the relations between del Sera and Cardinal Leopoldo, see Michelangelo Muraro, "Studiosi, collezionisti e opere d'arte veneta dalle lettere al Cardinale Leopoldo de' Medici," in *Saggi e memorie di storia dell'arte*, IV, 1965, pp. 72–74, 79–81). During the period the portrait was in Florence, Francesco Scannelli (*Il microcosmo della pittura*, Cesena, 1657, p. 259) saw a portrait by Bordon in the grand-ducal collections, which he described as "di meza figura al naturale, la quale se bene sia sicura operatione di Paris Bordone vien communemente stimata di Titiano." The Medici owned other portraits by Bordon, but none so splendid as the one now in the Wrightsman Collection. Although Scannelli did not mention the two pages, it is possible that it is this picture to which he referred. How it subsequently made its way to England, where it was recorded in the nineteenth century, remains a mystery.

In modern times the painting was first recorded in the collection of Philip Reginald Cocks, fifth Baron Somers (1815–1899), Eastnor Castle, Herefordshire. It was in his possession by 1866, when he lent it to an exhibition at the British Institution, London. It was acquired from Somers's heirs by Henry Lascelles, sixth Earl of Harewood (1882–1947), Harewood House, Leeds, who owned it by 1936 when a catalogue of his collection was published. It passed by inheritance to his son, George Lascelles, seventh Earl of Harewood, and was sold at Christie's, July 2, 1965, lot 76, when Mr. and Mrs. Wrightsman acquired it.

THIS PAINTING belongs to the genre of the military portrait, which was popular in Europe from the time of the Roman Empire until the nineteenth century. From ninth-century portraits of Charlemagne to Sir Thomas Lawrence's Portrait of King George IV, in the Pinacoteca Vaticana, Rome, great rulers were often depicted as military heroes.

Following the example of the Roman emperors, they had themselves portrayed as soldiers mounted on horseback or standing in the guise of a military commander.

During the sixteenth century the leading artists of Venice invented formats for military portraits that were subsequently adapted by Rubens (*q.v.*), Van Dyck (*q.v.*), and many later artists (see, for instance, the portrait by Largillierre in the present catalogue, No. 14). Titian's portraits of Alfonso d'Avalos, in the Louvre and the Prado, and Veronese's Portrait of Agostino Barbarigo, in the Cleve-

2. Detail: page fastening armor

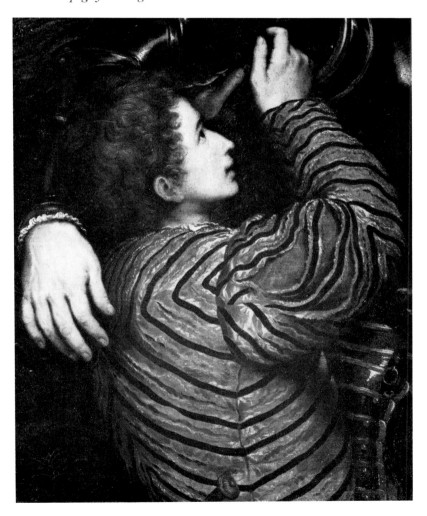

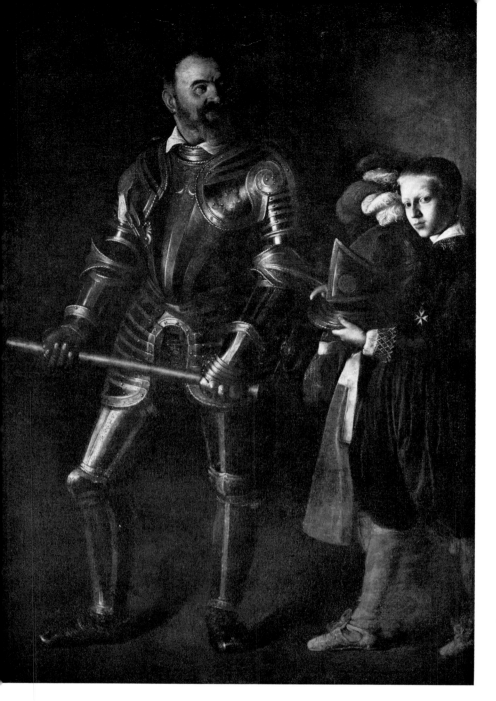

land Museum of Art, are representative of one of the most popular formats for the Venetian military portrait. They show the sitter wearing armor and standing in poses derived from Roman Imperial portraits. A less conventional format, showing the sitter preparing for battle, was also devel-

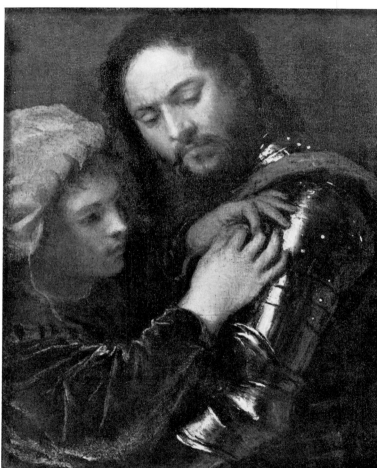

ABOVE:

3. *Caravaggio, Portrait of Alof de Wignacourt. Oil on canvas, 195.0 by 134.0 cm. Paris, Musée du Louvre. Photo: Alinari*

4. *Copy after Giorgione or Titian, Portrait of a Man in Armor with a Page. Oil on wood, 21.0 by 18.0 cm. Castle Howard, Yorkshire, collection of George Howard. Photo: Alinari*

[20]

oped in Venice during the sixteenth century, and it is with this type that the portrait by Paris Bordon in the Wrightsman Collection is most closely associated. It shows a high-ranking officer with two pages, one of whom holds his helmet, while the other fastens the armor on his right arm. The motif of the page fastening armor seems to go back to an early sixteenth-century Venetian prototype

5. *Paris Bordon, Portrait of a Young Man Armed by Bellona and Mercury. Oil on canvas, 104.0 by 154.5 cm. Birmingham (Alabama) Museum of Art, Kress Collection*

(*Viatico per cinque secoli di pittura veneziana*, Florence, 1946, p. 64) and others have suggested. Regardless of the authorship of the original picture, it is clear from the replicas that the composition was an imaginative invention, dominated by the style of Giorgione and the early Titian. The action

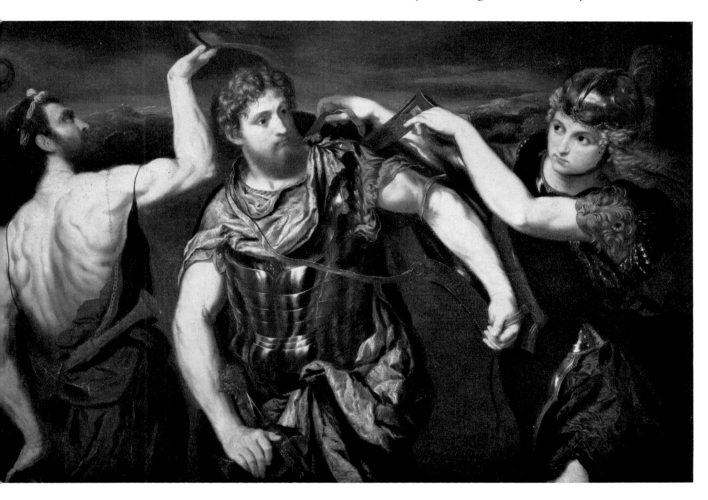

known only from numerous replicas (see Fig. 4), showing a man looking over his shoulder as a page adjusts his suit of armor. One of the replicas of this composition, formerly in the Orléans Collection, was catalogued in the eighteenth century as a Portrait of Gaston de Foix by Giorgione (about 1477–1510); however, the prototype may well have been an early work by Titian, as Roberto Longhi

of the page and the gaze of the man endow the portrait with an informality and psychological intimacy that rarely appear in conventional military portraits.

This Giorgionesque spirit is preserved in the present portrait. The withdrawn gaze of the man in armor and the wistful expressions of the two pages belong to Giorgione's poetic world. But

[21]

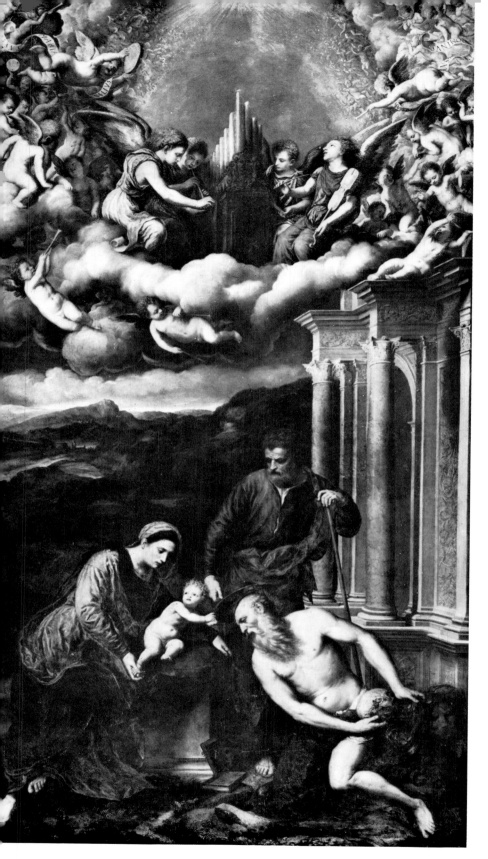

Bordon has enlarged the format of the original composition and made it more complex. He added the vast landscape background and introduced on the right the page holding the officer's helmet. This motif, which also appears in Titian's portraits of Alfonso d'Avalos, was later employed by Caravaggio in his full-length portrait of Alof de Wignacourt (Fig. 3).

The horizontal format of the painting is highly unusual for three-quarter-length portraits, which usually occupy upright canvases. It provided Bordon with a wider field in which to deploy his figures. He has arranged them in mobile poses, so that they fill the composition with a sense of rotating movement. Beginning on the left of the composition, the eye moves along the semicircular outlines of the arms, breastplate, and helmet. These semicircles form a cohesive curvilinear pattern that relates the officer and pages to one another. Moreover, the figures themselves even appear to move gently. The officer, with his head inclined to the right, seems to sway slightly toward the spectator, while the body of the page fastening his armor moves in the opposite direction. This movement, which seems almost to defy the laws of gravity, is characteristic of Bordon's personal style, and in later works, such as the Allegorical Portrait of a Young Man Armed by Bellona and Mercury (Fig. 5), in the Kress Collection of the Birmingham Museum of Art, it becomes so exaggerated that the figures appear to twist and float in mid-air. This is the style that Tintoretto later brought to perfection in his four mythological canvases of 1578 in the Sala dell'Anti-Collegio of the Palazzo Ducale in Venice.

The portrait can be dated rather securely, owing to its stylistic analogies with works Bordon painted in the early 1540s in Milan. It would be impossible to date it earlier, because the evidence of Bordon's

6. *Paris Bordon, Holy Family with Angels and St. Jerome. Oil on canvas, 351.0 by 191.0 cm. Milan, Santa Maria presso San Celso. Photo: Anderson*

documented portraits suggests that until the late 1530s he limited himself to busts or three-quarter-length views of single sitters isolated against neutral backgrounds. It was only in the Portrait of a Man, in the Palazzo Balbi at Piovera (near Genoa), which is dated 1537, that Bordon placed the sitter against an open landscape with rolling hills and a cloudy sky. In the Balbi portrait the sitter stands erect, without that suggestion of suspended movement which characterizes the figures in the Wrightsman portrait. This movement and also an

7. Detail: head of the officer

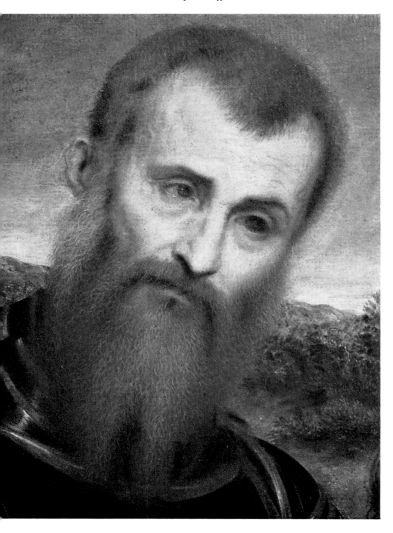

analogous treatment of landscape do appear in several paintings that Bordon executed in Milan for Carlo da Rho. These include an altarpiece of the Holy Family with St. Jerome (Fig. 6) in the church of Santa Maria presso San Celso, which was completed by 1542, and two large figure compositions, the Bath of Bathsheba, in the Wallraf-Richartz Museum, Cologne, and the Mars and Venus Overtaken by Vulcan, in the Treuhandverwaltung von Kulturgut, Munich, both of which appear to have been painted about the same time.

Vasari, who described these pictures in his account of Bordon's activity in Milan, adds that Bordon also painted a portrait of Carlo da Rho. Given the close stylistic affinity of the Wrightsman portrait with the paintings Bordon made for Carlo da Rho, it would not be surprising to find that the portrait represents him. No documented likenesses of him are known, so it is impossible to establish if the officer in the portrait actually resembles him. Carlo da Rho is known, however, to have been a military commander. He died, in fact, at Malta where he had gone to join Don Alvaro da Sande's expedition against the Turks. His death occurred several months after October 1559, when he left Milan for Malta.

Some writers have suggested that the portrait represents the Duke of Alba, but this may be discounted because the sitter bears no resemblance to the documented portraits of him by Titian and others. The features of the officer in the Wrightsman portrait (Fig. 7) are quite distinctive: a strong aquiline nose, a crossed eye, and hair that recedes deeply above his temples. The possibility that it represents Carlo da Rho is strengthened, moreover, by the colors worn by the two pages. During the sixteenth century the pages of high-ranking military officers were often dressed in heraldic colors, and this seems to be the case in the Wrightsman portrait, particularly since the banner carried by the troops in the background (Fig. 8) repeats the black and orange stripes of the doublet of the page on the left. Carlo da Rho's coat of arms showed an eagle on a yellow field and a black wheel on a red

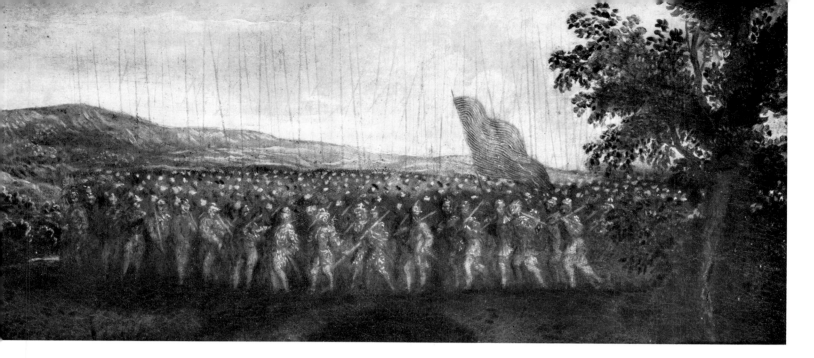

8. *Detail: infantrymen in the background*

background. The orange, red, and black clothing of the two pages may be related to this color scheme. Also, the armor worn by the officer in the portrait is the relatively light variety used by infantrymen. It is thus significant that the troops in the background are foot soldiers, which Carlo da Rho commanded, rather than cavalrymen.

EXHIBITED: British Institution, London, *Pictures by Italian, Spanish, Flemish, Dutch, French, and English Masters*, 1866, catalogue no. 32 (described as "A Knight and Attendant"); Royal Academy of Arts, London, *Exhibition of the Works of the Old Masters*, 1873, catalogue no. 227; Wildenstein & Co., New York, *The Italian Heritage*, 1967, catalogue no. 24 (illustrated); The Metropolitan Museum of Art, New York, on extended loan since 1965.

REFERENCES: Marco Boschini, *La carta del navegar pitoresco; dialogo tra un senator venetian deletante, e un professor de pitura*, Venice, 1660, pp. 366–367 (describes a painting by Bordon of a general being armed by two pages, which had passed from the collection of Paolo del Sera, Venice, to that of Leopoldo de' Medici, Florence) // Luigi Bailo and Gerolamo Biscaro, *Della vita e delle opere di Paris Bordon*, Treviso, 1900, p. 199 (list among the missing works of Paris Bordon the portrait in the Medici collections that Boschini had described) // Tancred Borenius, *Catalogue of the Pictures and Drawings at Harewood House and elsewhere in the Collection of the Earl of Harewood*, Oxford, 1936, pp. 7–8, catalogue no. 9, pl. VI (catalogues it as the portrait by Paris Bordon described in 1660 by Boschini and suggests that it was the picture in the collection of Leopoldo de' Medici; reports that A. Van de Put suggested that it might represent the Duke of Alba and that Charles R. Beard dated the suit of armor about 1510) // Bernard Berenson, *Italian Pictures of the Renaissance: a List of the Principal Artists and Their Works with an Index of Places*, Oxford, 1932, p. 431; and also in the Italian edition, *Pitture italiane del rinascimento: catalogo dei principali artisti e delle loro opere con un indice dei luoghi*, Milan, 1936, p. 370 (lists it as a work by Paris Bordon and describes it as a portrait of a knight with one page) // Rodolfo Pallucchini, *La giovinezza del Tintoretto*, Milan, 1950, pp. 26–27 (cites it as an example of Paris Bordon's work that is similar in style to Tintoretto's early paintings; says it is difficult to determine if in this portrait Bordon actually anticipated Tintoretto's style, or if he was already influenced by the early work of Tintoretto) // Giordana Canova, *Paris Bordon*, Venice, 1964, p. 79, pls. 116–117 (catalogues it among Paris Bordon's documented works and accepts the identification of the picture as the one described by Boschini; dates it about 1555–1560 and observes that it reflects Tintoretto's style) // Simona Savini-Branca, *Il collezionismo veneziano nel '600*, Padua, 1964, p. 277 (cites Boschini's description of the portrait in the collection of Leopoldo de' Medici, without connecting it with the present painting) // Henry A. La Farge, "Noble Metropolitan Visitors," in *Art News*, LXV, February 1967, pp. 28, 29–30, fig. 4 (tentatively accepts the identification of the man in the portrait as the Duke of Alba) // Denys Sutton, "Pleasure for the Aesthete," in *Apollo*, XC, September 1969, p. 232, fig. 2 (illustrates it as a work by Paris Bordon).

Oil on canvas, H. 46 (116.9); W. 62 (157.5).

The painting was cleaned during the spring of 1967 in The Metropolitan Museum of Art by Hubert von Sonnenburg.

CANALETTO (Antonio Canal, 1697–1768) was the most famous of all Venetian view painters. His father, Bernardo, was a theatrical designer, and it was in his father's studio that Canaletto received his training in *quadratura*, or strict architectural perspective. But he appears to have found this restricting and turned from painting theatrical scenery to view painting, probably under the influence of Roman/Dutch landscape artists. In 1720 Canaletto's name first appears in the Venetian *Fraglia* or list of painters. By 1722 he was being employed by Owen McSwiney, the Irish operatic impresario living in Venice, to collaborate with other artists on two canvases from a group of complex allegories, *Les Tombeaux des princes, grands capitaines, etc.*, in which the arts of the theatrical scene designer, the landscape artist, and the figure painter were combined.

About 1723 Canaletto painted his first views of Venice that can be dated on topographic grounds. Henceforth, such subjects were to constitute the principal theme of his paintings. His earliest documented views, commissioned by a Lucchese merchant, Stefano Conti, were executed in 1725–1726. At this date he was already commanding high prices from his clients. In the following four years or so Canaletto executed a series of large-scale views of the center of Venice (now in the English Royal Collection) for Joseph Smith, the future British Consul at Venice, as well as for a few other clients. Smith thereafter became the artist's chief patron and seemingly the leading entrepreneur between the artist and the traveling English who were to be his chief clients for the rest of his life.

All these early paintings are carried out in a broad, luminous, almost pre-impressionist manner based on a careful observation of nature. But Canaletto soon abandoned his early broad manner in favor of a more conventionalized, tighter, more linear, and more "realistic" style of painting. This change was probably intended to facilitate speed of execution (for he was notoriously avaricious) but also to provide a more accurate topography, better suited to the taste of his clients. At the same time he began to use mechanical devices like the camera obscura and to adopt increasingly conventionalized methods of representing figures and reflected light, also perhaps to simplify the work of assistants.

The outbreak of the War of the Austrian Succession in 1741 caused a decrease in the visits of his principal clients, the English, to Venice. At first he seems to have concentrated mainly on painting a series of views of Rome variously dated 1742 and 1743 and a group of Venetian *capricci*, both groups commissioned by Smith and now in the English Royal Collection. But when the loss of his most regular clients persisted, Canaletto determined to visit England and arrived in London in May 1746. He remained in England, apart from two short visits to Venice, until the latter part of 1755, when he returned finally to his native city where he spent the rest of his life. In England he painted not only numerous views of London and its immediate neighborhood but also scenes as far afield as Warwick, Cambridge, and Alnwick in Northumberland.

Canaletto's last years in Venice seem to have been beset by illness, and his production during these final years was comparatively scanty, the most important being a series of drawings of the *Feste Dogali* intended for engraving, for throughout his life he had always been a masterly draughtsman. He also

seems increasingly to have turned his attention to painting *capricci*, or artificially composed landscapes with architecture, real or imaginary, fancifully grouped. This flight from reality is reflected in the increasing mannerisms of his already mannered style, which eventually became exaggeratedly calligraphic, composed largely of dots, flourishes, and ruled lines. When the Venetian Academy was founded in 1756 Canaletto was not chosen for membership, and he failed to be elected in January 1763 when his name was put forward. The rejection was probably due to the low esteem in which his type of landscape painting was held, though jealousy of his financial success may have played some part also. The artist, was, however, finally elected in September 1763, five years before he died. His reception piece for the Academy was, characteristically, a capricious view of a courtyard now in the Accademia, Venice.

2 Venice: Grand Canal looking South from the Ca' da Mosto to the Rialto Bridge

THE VIEW shows the business and administrative center of old Venice. It focuses on the foot of the Rialto bridge on the east bank, which is visible just to the left of the center of the composition (Fig. 2). The top of the campanile of the church of San Bartolommeo just appears above the buildings beyond the bridge. The campanile is shown as it was before its rebuilding in 1747.

The palace at the extreme left is the Ca' da Mosto, a thirteenth-century Veneto-Byzantine building, considerably altered today by the addition of a top story. Immediately beyond is the fifteenth-century Casa del Dolfin, and the Palazzo Bollani-Erizzo. Then there is a low, two-story house, followed by the Pesaro and Sagredo (today Civran) palaces. Farther off, the large building adjacent to the foot of the Rialto bridge is the Fondaco dei Tedeschi.

At the right of the bridge is the elegant Renaissance building of the Palazzo dei Camerlenghi, built between 1525 and 1528 by the architect Guglielmo Bergamasco (died about 1530). Next to this at the right is the Naranzeria (literally, the "orange store"), still the main fruit and vegetable market today. Beside this can be seen the Fabbriche

vecchie di Rialto, whose open arcades now shelter part of the fish market.

At the center of the foreground are a sailing barge (Fig. 1) and a *sandaletto*, with gondolas and *sandaletti* dispersed about the canal. One in the left foreground is tied up beside the steps of the Ca' da Mosto.

PROVENANCE: This picture originally belonged to a set of twenty-one Venetian views by Canaletto, all of the same size and character, which were last in the collection of Sir Robert Grenville Harvey (1856–1931), Langley Park, Slough, Buckinghamshire. It is not clear how he acquired them. According to Constable (1962, II, pp. 262–263, catalogue no. 188), "these are said to have been bought in Venice by the last Duke of Buckingham and Chandos, whose daughter married a Morgan-Grenville; and descended to a member of that family, through Sir Robert Grenville Harvey." This provenance poses several problems. In the first place, as Links (1969, p. 229, note 1) observes, "it seems unlikely that the group would have been intact in Venice during the life-time of the last

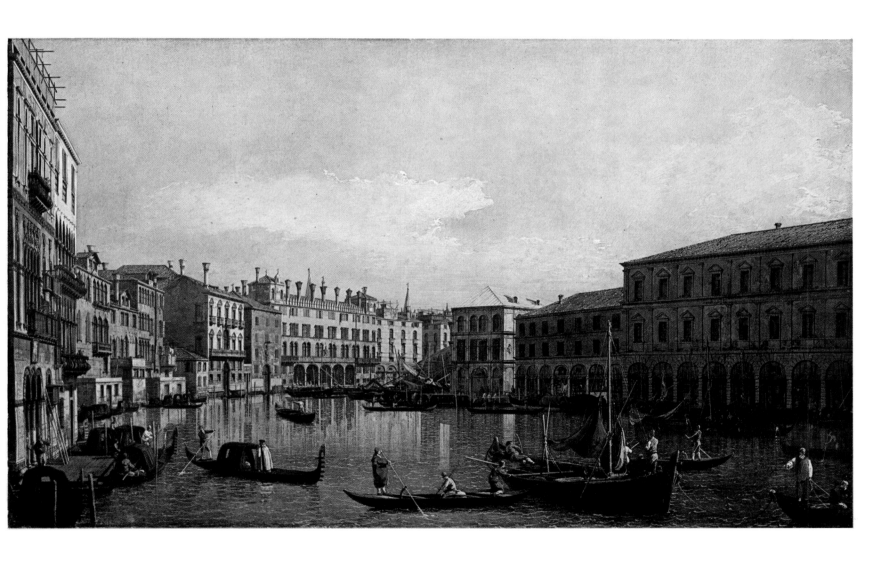

Duke, who was not born until 1823." Secondly, the last duke's first wife was Caroline Harvey of Langley Park. She died in 1874, leaving three daughters, the eldest of whom became the Baroness Kinloss and married Major Luis Ferdinand Morgan, afterward Edward Morgan-Grenville. Why the pictures would have passed from her to Sir Robert Grenville Harvey, her first cousin, is unexplained. The likelihood, moreover, that the last Duke of Buckingham and Chandos possessed a large series of Canalettos is slim, since the second Duke (1797–1861) was forced by the threat of financial ruin to sell at auction nearly one thousand paintings after he succeeded to the title in 1839 (Henry Rumsey Forster, *The Stowe Catalogue: Priced and Annotated*, London, 1848, p. 151).

In any case it is certain that the group belonged to Sir Robert Grenville Harvey when he died in 1931. They were not sold by the trustees of his estate until sometime about 1957. Mr. and Mrs. Wrightsman acquired the present member of the series in London in 1964.

DURING THE 1730s Canaletto received a number of commissions from Englishmen, some of them for large series of views of Venice. Thus the fourth Duke of Bedford ordered no less than twenty-four views, the fourth Earl of Carlisle, a series of seventeen. The five Canalettos in the Wrightsman Collection come from a similar group of twenty-one views, known as the Harvey series from the name of their last owner.

No less than six of the paintings in the Harvey series were engraved by Antonio Visentini (1688–1762) for an album of thirty-eight prints issued in three parts under the title *Prospectus Magni Canalis Venetiarum, addito Certamine Nautico et Nundinis Venetis: Omnia sunt Expressa ex Tabulis XIV. Pictis ab Antonio Canale, in Aedibus Josephi Smith Angli, Delineante atque Incidente, Antonio Visentini.* (The first part consists of fourteen engravings issued in 1735. To a reprint of this, two other parts, each consisting of twelve engravings, were subsequently added in 1742, each with the same title page with the addition of the words: *Elegantius recusi* and the new date.) All three parts were published by G. B. Pasquali, a well-known Venetian editor, printer, and publisher.

It seems likely that the Visentini engravings formed in some degree a repertory or catalogue from which visiting tourists could select the subjects they wished to have painted. The subjects appear over and over again with slight variations in Canaletto's work. They also were repeated by later imitators and copyists.

The first series of fourteen of the Visentini engravings issued in 1735 is taken from paintings—now in the English Royal Collection—acquired from Joseph Smith, British Consul in Venice from 1745 until 1760, by George III in 1762–1763. It is likely that the originals from which the additional twenty-four engravings in the 1742 edition of Visentini's album were made also belonged to Joseph Smith. Although Constable (1962, p. 262) writes of the series of Harvey paintings that "it cannot be assumed (as the catalogue of the R. A. exhibition *European Masters of the Eighteenth Century* tends to do) that they all belonged to Smith," Frances Vivian (1971, p. 32) has convincingly demonstrated that at least the engraved canvases from the Harvey series belonged to him. The engraved ones (Constable, nos. 241, 262, 281, 283, 313, and 314) must certainly have been his if the phrase *in Aedibus Josephi Smith Angli* (in the house of Joseph Smith, Englishman), which appears on the title page of all three series of Visentini engravings, is to be believed. In addition, one of the Wrightsman Canalettos originally prepared for an engraving that was never executed (Catalogue No. 5) seems likely to have been Smith's as does Catalogue No. 6, which can now be identified as the original for one of the Visentini engravings (see below).

Since the Harvey series was presumably acquired as a unit in Venice at some time after Smith's death in 1770, it seems reasonable to suppose that the paintings had remained together since they were executed. A unified group of this size is unlikely to have been assembled factitiously. It is true, however, that when the Visentini engravings

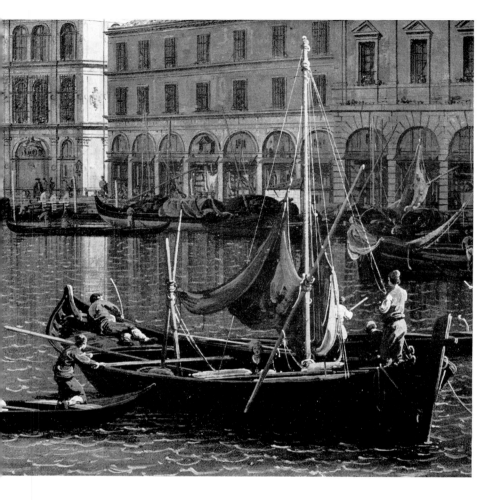

1. *Detail: sailing barge in the foreground*

were reissued in 1755 all indications of ownership were dropped from the title pages. Smith may perhaps have therefore disposed of them before that date, but it should be observed that, in spite of the omission of his name from the title, he owned the originals of the first fourteen until they were sold to George III in 1762–1763 (although negotiations for their purchase had already been opened). He may therefore have continued to own the twenty-four others also. They are not, however, identifiable in the inventory of the contents of Smith's Venetian palace, taken after his death on September 9, 1770 (it is printed by C. A. Levi, *Le*

collezioni Veneziane d'arte e d'antichità dal secolo XIV. ai nostri giorni, Venice, 1900, II, pp. 236–248), although this would not preclude their being in his country villa at Maggiano, the contents of which are unknown.

There are Harvey originals for engravings in both the second and third series of the *Prospectus Magni Canalis* (see Constable, 1962, pp. 606–608). They all presumably were completed before 1742, the date of the publication of the prints. How long before is uncertain. The rather stronger coloring and less blond tonality of the Harvey paintings as compared, for instance, with the two Tatton paintings (Constable, catalogue nos. 97 and 111), which are securely dated 1730, or with the originals of the first fourteen engravings (published in 1735) suggests a date a few years later than this, perhaps soon after 1735, though doubtless the execution of so large a series must have been spread over a certain period of time.

The topography of the present view provides one clue for dating the series a bit more precisely. On the left side of the Grand Canal is a small two-story brick house standing beside the Palazzo Civran. As Links observed (1967, p. 406, fig. 33), this house does not appear in a privately owned painting by Canaletto showing the Palazzo Civran. Instead, there is only an open quay, from which the artist sketched some of his earliest views of the Rialto bridge. Since the privately owned Caneletto was engraved before 1735, it establishes the approximate date after which the brick house was built, and accordingly the date after which the Wrightsman view must have been painted.

The history of some of the buildings in the present view is of some interest. For example, the Ca' da Mosto, the palace in the left foreground, is said to be the birthplace in 1432 of the famous explorer Alvise da Mosto. From the fifteenth to the end of the eighteenth century it became the Albergo del Leon Bianco, the most famous hotel in pre-nineteenth-century Venice, visited in January 1782 by the future Czar Paul I traveling incognito as the Comte du Nord with his wife Maria Teodorovna

(Bianca Tamassia Mazzarotto, *Le feste veneziane*, Florence, 1961, pp. 314, 315, 330, note 19). Boguslav von Lobkowitz, a member of the famous Bohemian family, mentions staying there as early as May 1483; the Emperor Joseph II was a guest there in the eighteenth century; and shortly before it closed in the early nineteenth century Châteaubriand stayed there (E. Zaniboni, *Alberghi italiani e viaggiatori stranieri*, Naples, 1921, pp. 60–64).

The Palazzo Bollani-Erizzo is remembered today as the former residence of Pietro Aretino, the notorious "Scourge of Princes" and blackmailer. He wrote that this was the finest position on the Grand Canal and that from it he could enjoy "the

2. Detail: center of the composition, showing the foot of the Rialto bridge

fairest highway and the most joyous view in the world." Beyond the Palazzo Bollani is the Fondaco dei Tedeschi, now the main Venice post office. It was a German trading post and famous from the time of its rebuilding in 1505 for the frescoed decorations of the façade by Giorgione and Titian. Only a shadowy figure stripped from the wall survives in the Accademia Gallery. Even in the eighteenth century the frescoes were evidently so badly damaged that they are not visible in the present view.

GENERAL REFERENCES TO THE ENTIRE HARVEY SERIES: K. T. Parker, *The Drawings of Antonio Canaletto in the Collection of His Majesty the King at Windsor Castle*, Oxford—London, 1948, pp. 31, 32, 36 (mentions the Harvey series "of twenty Venetian views" in connection with drawings directly related to three of them) // F. J. B. Watson, *Master Painters:*

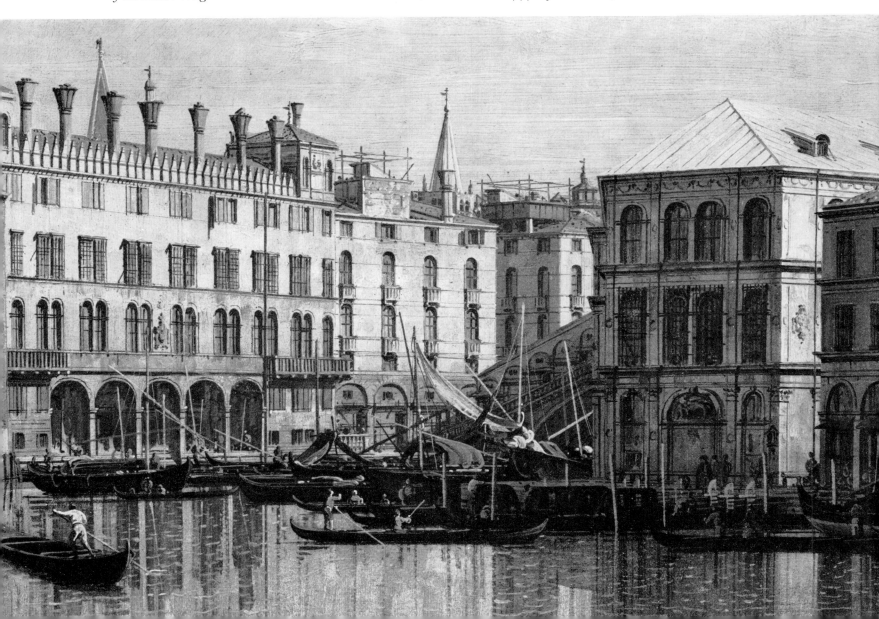

Canaletto, 2nd ed., London, 1954, p. 11 (observes that several of the views belonging to the Harvey estate served as the originals for engravings in the second edition of Visentini's album; dates the paintings in the mid-1730s) // Vittorio Moschini, *Canaletto*, Milan [1954], pp. 22, 30, 38 (maintains that within Canaletto's development the Harvey series begins to display a certain fanciful virtuosity; observes that they are related stylistically to a painting by Canaletto in the National Gallery of Canada [which can be firmly dated for topographical reasons about 1735]) // Terisio Pignatti, *Il quaderno di disegni del Canaletto alle gallerie di Venezia*, Milan, 1958, pp. 23, 41–43 (identifies pen and ink sketches for two of the Harvey pictures, Constable catalogue nos. 262, 267) // Decio Gioseffi, *Canaletto and His Contemporaries*, New York, 1960, p. 65 (assumes that all the views in the Harvey series that were engraved by Visentini were painted for Joseph Smith) // Cesare Brandi, *Canaletto*, Milan, 1960, p. 125 (illustrates ten views from the Harvey series, remarking that they betray Canaletto's use of the *camera ottica*; dates them about 1741) // W. G. Constable, *Canaletto: Giovanni Antonio Canal 1697–1768*, Oxford, 1962, 2 vols., *passim* (catalogues in great detail twenty of the Venetian views in the Harvey series, though he states repeatedly throughout his book that there were twenty-one views in the set; suggests they were "painted in two batches" (I, p. 112), the Grand Canal ones about 1731–1732 and the churches and the *campi* in which they stand about 1735; discusses the relation between the Harvey pictures and the Accademia sketchbook) // Francis Haskell, *Patrons and Painters*, New York, 1963, p. 305 (suggests that the first edition of Visentini's album may have been intended as an advertisement of Canaletto's talents; states that "it was during the last half of the 1730s that Canaletto painted . . . [a] series of twenty [views] for Sir Robert Hervey [*sic*]") // Anonymous, "Arricchimenti nelle collezioni private," in *Acropoli: Rivista d'Arte*, III, 1963, pp. 237–246 (illustrates and describes ten views belonging to the Alemagna Collection in Milan, which had been acquired from the Harvey estate) // W. G. Constable, *Canaletto*, exhibition catalogue, Toronto, 1964, p. 15 (writes that the views in the Harvey series "lack the dramatic, imaginative quality of [Canaletto's] earlier work") // J. G. Links, "A Missing Canaletto Found," in *The Burlington Magazine*, CIX, July 1967, p. 406, fig. 33 (states that the Harvey series "was among twenty-one paintings bought in Venice by the first Duke of Buckingham"; observes that while Constable dates the Harvey series 1731–1732, the only evidence for dating them is their style) // Pietro Zampetti, *I vedutisti veneziani del settecento*, exhibition catalogue, Venice, 1967, pp. 150, 154 (states that there were originally twenty-one views in the Harvey series, and that they were painted between 1730 and 1735) // Lionello Puppi, *The Complete Paintings of Canaletto*, New York, 1968, p. 101 (describes the Canalettos

in the Harvey Collection as a series of twenty-one views but does not enumerate them) // J. G. Links, "Secrets of Venetian Topography," in *Apollo*, XC, September 1969, pp. 222–229 (discusses the five paintings by Canaletto in the Wrightsman Collection, which he dates about 1735; raises some doubt about Constable's assertion that the Harvey series was bought in Venice by the last Duke of Buckingham and Chandos) // Frances Vivian, *Il console Smith: mercante e collezionista*, Vicenza, 1971, p. 32, fig. 33 (maintains that the Canaletto views engraved by Visentini for the 1742 edition of the *Prospectus Magni Canalis Venetiarum* passed through Consul Smith's hands; identifies one of the Harvey series, a View of the Campo Santa Margherita, as now in the Wrightsman Collection [a printer's error]) // J. G. Links, *Views of Venice by Canaletto: Engraved by Antonio Visentini*, New York, 1971, *passim* (mentions the Wrightsman Canalettos that served as the originals for Visentini's engravings and comments that the relationship between these engravings and Visentini's preparatory drawings for them "points strongly to the assumption that Joseph Smith once owned the so-called Buckingham, or Harvey, series").

VERSIONS (Catalogue No. 2): Constable (1962, catalogue no. 240) describes three versions of the present composition in the Accademia Carrara, Bergamo; Lord Wharton Collection; and the late Henry Oppenheimer Collection. Besides the Wrightsman canvas, only the version at Bergamo is considered to be by Canaletto himself.

EXHIBITED (together with Catalogue Nos. 3, 4, 5): Ashmolean Museum, Oxford, 1936–1938; City of Birmingham Museum and Art Gallery, *An Exhibition of Treasures from Midland Homes*, November 2—December 2, 1938 (twenty Venetian views were lent by the Executors of Sir Robert Grenville Harvey, catalogue nos. 151–155, 157–161, 164–168, 170–174); on extended loan to the City of Birmingham Museum and Art Gallery, 1938—about 1957; The Metropolitan Museum of Art, New York, March—October 1967.

REFERENCES: Constable, 1962, I, fig. 240; II, catalogue no. 240 (classifies this canvas as Canaletto's primary version of this composition; lists three versions of it) // Links, 1967, p. 406, fig. 33 (reproduces a detail of a small house built after 1735 and concludes that the painting must have been painted after this date) // Puppi, 1968, p. 101, catalogue no. 118 A (lists it as an autograph original, datable about 1731–1735) // Links, 1969, pp. 225–226, color pl. XVII (identifies the buildings in this view, and states that they were painted from drawings made at three different viewpoints on the bank of the canal).

Oil on canvas, H. 18⅜ (46.5); W. 30¼ (77.0).

The picture was cleaned during the autumn of 1972 by John M. Brealey in London.

3 Venice: Santa Maria Zobenigo

THE FAÇADE of the church of Santa Maria del Giglio, or Zobenigo, as it is popularly known in Venice, appears at the right (Fig. 1); the *campo* of the same name is at the left. A glimpse of the Grand Canal and the *traghetto* station is just visible in the distance at the extreme left of the composition. On the far side of the Grand Canal can be seen the small house that for many years stood on the site now occupied by the Salviati glass factory. Beyond the church, toward the center, is the brick campanile of the church with its tiled conical cap; and below it are two well heads, the right one partly cut off by the corner of the church. The campanile collapsed in 1774, but its base survives and is now used as a shop.

Various figures, including a senator at the center of the foreground, and animals are wandering about the *campo*.

PROVENANCE: From the collection of Sir Robert Grenville Harvey (for further details see under Catalogue No. 2). It was acquired along with Catalogue No. 2 by Mr. and Mrs. Wrightsman in London in 1964.

BOTH CHURCH and *campo* take their name from the Jubanicos, a family who died out in the twelfth century and who had founded the church as early as the ninth century. The building shown here, however, was erected between 1678 and 1683 by the architect Giuseppe Sardi (about 1620–1699) at the expense of the Barbaro family, whose arms (*argent, an eagle with two heads displayed sable, in the breast an oval escutcheon of the first charged with an annulet gules*) appear below the central pediment of the façade. The rich decoration of this baroque frontispiece is intended to glorify the military

1. *Detail: façade of the church*

prowess of Venice. In the central niche above the door is a statue of the *capitan del mar* Antonio Barbaro (died 1679) flanked by figures of Honor and Virtue in smaller niches. All three statues are by the Fleming Giusto Le Court (1627–1679). The

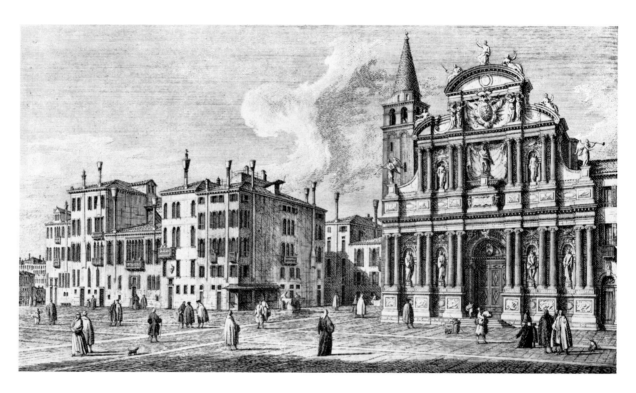

plinths below the columns flanking these statues are carved in relief with galleys and military trophies. Below, at street level, are four additional statues of members of the Barbaro family set between the coupled columns, also by Le Court. The podiums on which the columns rest are carved in relief with plans of cities and fortified places: Zara, Candia, Padua, Rome, Corfu, and Spalato (it is not clear why Rome appears in an otherwise all-Venetian scheme). The whole decorative design of the façade has a particular appropriateness here, since the palazzi at the left of the composition occupy the site of the original fortified wall of Venice built in the tenth century by Doge Pietro Tribuno (888–912).

The most unusual feature of the painting is the strange distortion Canaletto made of the space in front of the church. In reality the church stands in a narrow *calle*, which is (and always has been) only about thirty feet wide. It would be impossible to find a vantage point in the *calle* that would take in the whole façade as Canaletto has shown it, as well as the open *campo* extending all the way over to the Grand Canal on the extreme left. The wide angle of vision and the somewhat strained perspective might awaken suspicions that the view was produced with the aid of the camera obscura. But as Links (1969, p. 223) observed, such an instrument would have been of no help here, for "it would have had to be moved up, down and sideways, and all its angles would have been wrong. Only a series of drawings and much calculation in the studio could have produced the desired result" (see also under Catalogue No. 4).

[34]

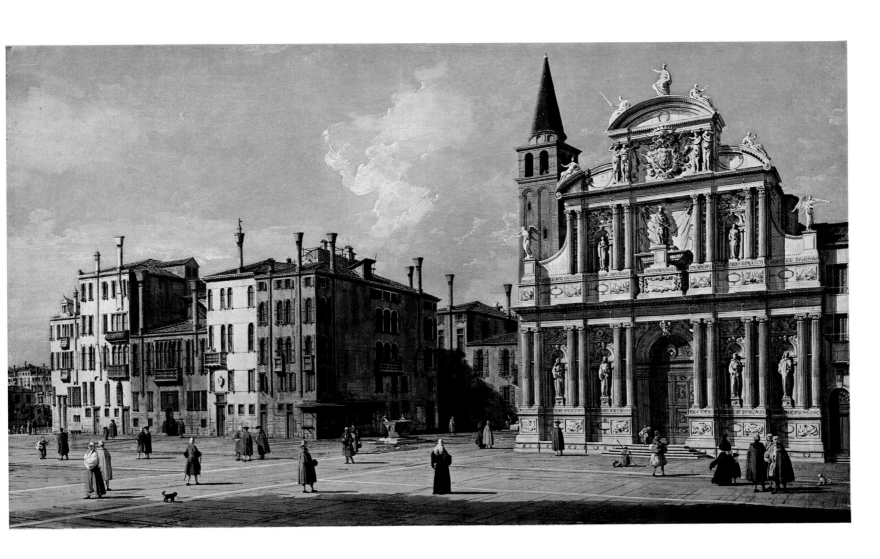

This view is one of the scenes from the Harvey series that was engraved by Visentini. No doubt the print (Fig. 2) served as a model for some of the repetitions of this subject by Canaletto's assistants. It was also used by Francesco Guardi (*q.v.*) for the design of one of his early paintings in the collection of Renato Bacchi, Milan (Morassi, 1963, figs. 1–4). Although Guardi skillfully copied most of the elements of Canaletto's composition, he did not reproduce the crystalline atmosphere and robust solidity of the original. As a copyist, Guardi revealed his own identity in the fantastic figures animating the *campo* and the soft, wavering light, which gives the whole scene an enchanting quality of unreality.

VERSIONS: In addition to the variant by Guardi mentioned above, there are three other versions listed by Constable (1962, catalogue no. 313). He claims that one, sold in the Jaffé sale (Berlin, Lepke's, April 14, 1931, lot 132), is by Canaletto, while the other two are school pieces.

For exhibitions and general references to the entire Harvey series, see under Catalogue No. 2.

REFERENCES: Moschini, 1954, p. 28, fig. 135 (cites this picture as an example of how Canaletto exaggerated linear perspective to emphasize the three-dimensional quality of the buildings) // Brandi, 1960, fig. 60 (illustrates it without mentioning it specifically) // Bedö Rudolf, *Canaletto*, Budapest, 1961, pl. 13 (illustrates it with a date about 1735) // Constable, 1962, I, fig. 313; II, catalogue no. 313 (describes it in detail, mentioning other versions) // Antonio Morassi, "Francesco Guardi as a Pupil of Canaletto," in *The Connoisseur*, CLII, March 1963, pp. 152, 154, fig. 6 (compares the picture with a copy of it by Guardi, which he dates between 1770 and 1780; tentatively dates the Wrightsman picture "several years before 1742" and asserts that Guardi based his painting on Visentini's engraving rather than Canaletto's original) // Puppi, 1968, p. 102, catalogue no. 130, illustrated // Links, 1969, p. 223, color pl. XIV (publishes a detail of a seventeenth-century view showing the campanile as Canaletto painted it; observed that the church stands in a narrow *calle*, "whereas a far more distant viewpoint would be needed to take in its whole façade and at the same time the view across the Grand Canal on the extreme left") // Links, 1971, p. 78 (refers to the painting in his discussion of the engraving Visentini based on it).

Oil on canvas, H. 18½ (47.0); W. 30⅝ (78.0).

The painting was cleaned in London during the fall of 1972 by John M. Brealey.

4 Venice: Grand Canal from the Campo della Carità to the Palazzo delle Torreselle

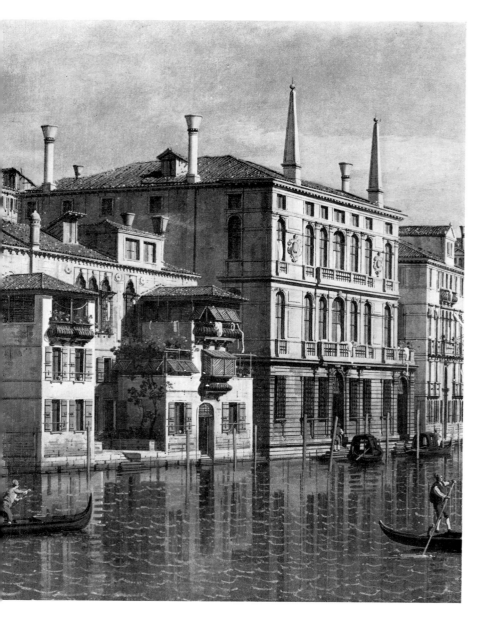

THE BUILDING just showing at the extreme left of the composition (Fig. 1) is the rusticated remains of the already ruined Ca' del Duca, started for the Corner family and continued by Francesco Sforza, Duke of Milan, but never occupied by him. Beside it, with two projecting loggias, is the Palazzetto Falier (today Bonara), a fifteenth-century Gothic building much restored and greatly altered (particularly by the addition of the loggias). Immediately beyond is the early seventeenth-century Palazzo Giustinian or Lolin (today Levi), an early work of Baldassare Longhena (1598–1682). Farther on, in profile at the turn of the canal, is the Palazzo Cavalli, later entirely reconstructed by Baron Franchetti after whom it is now named. Beyond is the Palazzo Barbaro-Curtis.

At the right (Fig. 2) is the foreshortened façade of the Palazzo Contarini dagli Scrigni, a classical building begun from designs by Vincenzo Scamozzi (1552–1616) in 1609. Beyond it the eighteenth-century Palazzo Querini, now the British Consulate, is to be seen. Farther on is the campanile (which collapsed in 1744) of the church of the monastery of Santa Maria della Carità. Beside it, in shadow, can be seen a glimpse of the *scuola* of the monastery, which now houses the picture galleries of the Accademia. Beyond is the Palazzo Brandolin, and, adjacent to it, the fifteenth-century Palazzo Contarini dal Zaffo, or Manzoni, as it appeared before extensive nineteenth-century restorations were carried out.

Farther on can be seen the break in the buildings

1. *Detail: left side, from the Palazzetto Falier to the Palazzo Giustinian*

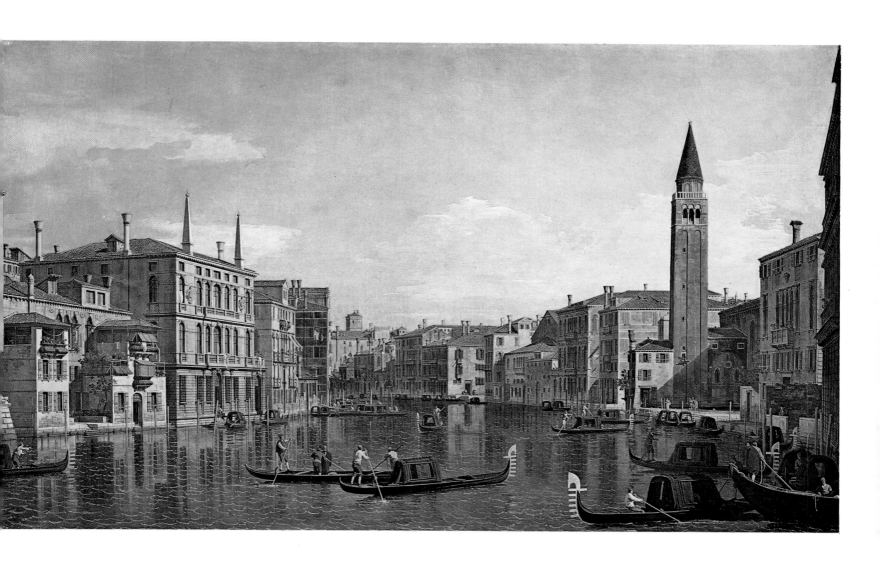

where the Campo San Vio then was, with the side of the Palazzo Barbarigo in full sunshine. A tower, tall and rectangular, appears above the building almost exactly at the center of the composition. This is no longer there but formed part of the Palazzo Venier delle Torreselle, which adjoined the Palazzo Venier dei Leoni and has almost totally disappeared today, though its name is recalled by the adjacent Rio delle Torreselle.

PROVENANCE: From the collection of Sir Robert Grenville Harvey (for further details, see under Catalogue No. 2). On the stretcher there is a Roman customs stamp dated March 29, 1957. It was acquired along with Catalogue No. 5 by Mr. and Mrs. Wrightsman in London in 1965.

THIS VIEW is apparently taken from the center of the canal, but is in fact based upon several drawings taken from the bank. Although the painting gives a unified impression, the left half is drawn from a house on the right bank, and the buildings on the right were drawn from at least two different vantages. The actual preparatory drawings do not survive, but it is known that Canaletto made numerous drawings, both finished ones for collectors and very sketchy outlines as studies for his paintings. Among the latter category are examples in a sketchbook, now in the Accademia, which Canaletto used for at least two paintings in the Harvey series (Constable, catalogue nos. 262, 267). It seems to have been Canaletto's practice to incorporate these studies into convincing compositions in his studio. From the rough studies he worked up more finished drawings, which then served as models for the paintings. In the collection of Canaletto drawings at Windsor Castle, K. T. Parker (1948, p. 35) found evidence of "a distinct series of views of Venetian churches . . . [which] make the definite impression of deriving from previously made studies, and not of having been drawn on the spot, that is from nature."

It has often been suggested (see References below) that this view of the Grand Canal gives the

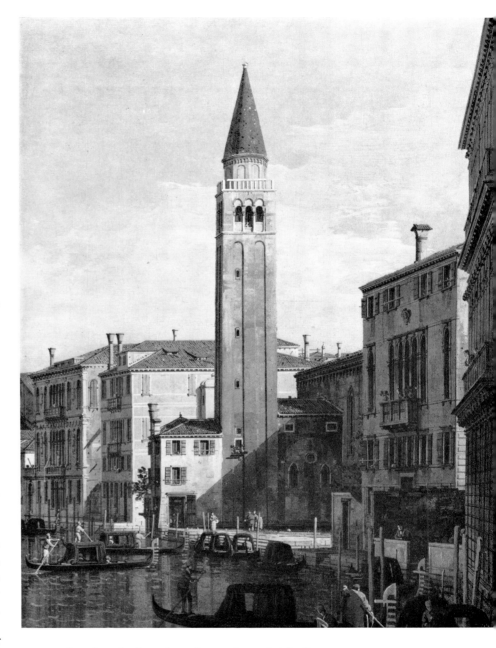

2. *Detail: right side, from the Palazzo Contarini dagli Scrigni to the Palazzo Contarini dal Zaffo*

impression of having been made with a camera obscura. Canaletto is recorded by his contemporaries to have used this instrument as an aid to the architectural accuracy of his cityscapes. But if he did (as many contemporary painters also did), he covered his tracks so carefully that it is impossible to point with certainty to any painting or even to any drawing that was evidently made with it. In designing the present painting it seems highly unlikely that he employed the camera obscura, because the optical distortions in it are quite arbitrary exaggerations of the heights of *some* buildings and towers. The effect is not of a broadened perspective, as it would be in a wide-angle picture.

The painting is the only known example of this view in Canaletto's œuvre. It is perhaps suggestive that, as it was not among the views Visentini engraved, there are no painted repetitions of it or workshop variants.

For exhibitions and general references to the entire Harvey series, see under Catalogue No. 2.

REFERENCES: Moschini, 1954, p. 30, fig. 139 (cites the present picture as particular evidence of Canaletto's use of the *camera ottica*) // Brandi, 1960, fig. 64 // Constable, 1962, I, p. 112, fig. 198; II, catalogue no. 198 (agreeing with Moschini, he says the distortions in the picture result from Canaletto's use of the camera obscura; remarks that it is "an unusual view of which no other versions are known") // Puppi, 1968, p. 101, catalogue no. 115, illustrated // Links, 1969, pp. 224–225, color pl. XVI (rejects the idea that an optical device was used, maintaining that the composition was constructed with more than one viewpoint; he observes that Canaletto exaggerated the height of the distant buildings, as he invariably does in his paintings of the campanile of St. Mark's).

Oil on canvas, H. 18½ (47.0); W. 35 (88.9).

5 Venice: Campo Sant'Angelo

AT THE CENTER, on the opposite side of the square, is to be seen the campanile and the church of Sant'Angelo Michele, totally destroyed in 1837. To the right of it (Fig. 3), is the Oratorio dell'Annunciata, founded in the tenth century and still frequently visited by pious Venetians today. Beyond and in between the two buildings can be seen the entrance to the cloister of the church of Santo Stefano, the buildings above which are now occupied by the Venetian tax offices.

The large fifteenth-century palace at the left (Fig. 1) is the former Palazzo Zeno, today known as the Palazzo Duodo. The top of the leaning campanile of Santo Stefano can be seen above the roofs at the left. The palace on the right side of the square, with a seventeenth-century frontispiece above and around the entrance, is the former Palazzo Trevisan, now the Palazzo Pisani.

Numerous groups are walking in the square, where two wellheads with wooden lids are to be seen. There are several carpenter's or cabinet maker's shops around the square, a prominent one at the left (Fig. 1) with planks of wood and a work bench on the pavement outside. A second, with a completed table and various articles of furniture outside, is to the right of the oratory. Paintings displayed for sale are hung on the wall at the foot of the campanile at the center (Fig. 3).

PROVENANCE: From the collection of Sir Robert Grenville Harvey (for further details, see under Catalogue No. 2). On the stretcher there is a Roman customs stamp dated March 29, 1957. It was acquired along with Catalogue No. 4 by Mr. and Mrs. Wrightsman in London in 1965.

IT APPEARS from a series of preparatory drawings

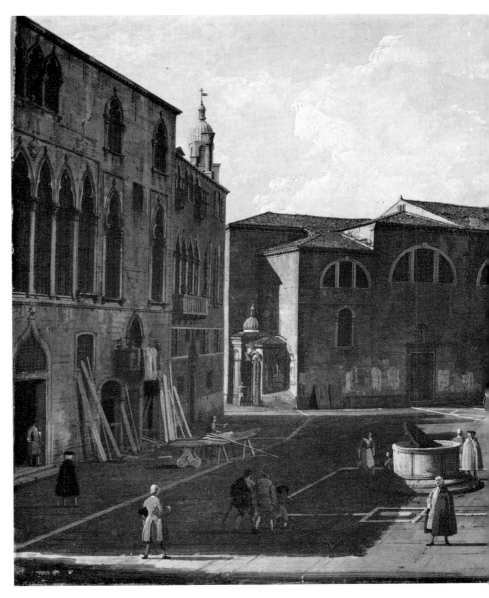

1. *Detail: left side, with the Palazzo Duodo and a wellhead*

[43]

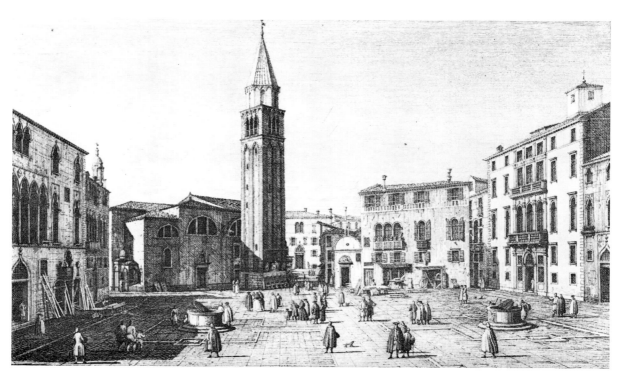

2. *Antonio Visentini, drawing of the painting. Ink on
paper, 25.4 by 43.2 cm. London, British Museum,
courtesy of the Trustees*

by Visentini that it was originally the intention to
reproduce the present painting in the *Prospectus
Magni Canalis*. Visentini made two sets of prepara-
tory drawings for the engraver: one in the Correr
Museum of forty-five outline drawings, and an-
other in the British Museum of forty-five highly
finished drawings. Although drawings were made
of the present picture (Fig. 2), an engraving of it
was not published in the album. Three other paint-
ings were similarly omitted (see F. J. B. Watson,
"Notes on Canaletto and His Engravers—II:
Canaletto and Visentini," in *The Burlington Maga-
zine*, XCII, December 1950, pp. 351–352).

Since Visentini made drawings of the painting
that were obviously intended for the engraver, it
can reasonably be assumed that this view origi-
nally belonged to Joseph Smith, especially as the
British Museum series is known to have belonged
to him.

Another painting from the Harvey series for
which there is a Visentini drawing has been mis-
takenly identified as being in the Wrightsman
Collection (see Vivian, 1971, fig. 33).

For exhibitions and general references to the entire Harvey
series, see under Catalogue No. 2.

EXHIBITED: Royal Academy of Arts, London, *European
Masters of the Eighteenth Century*, November 27, 1954—
February 27, 1955, catalogue no. 3.

REFERENCES: Moschini, 1954, fig. 131 (illustrates the picture
but does not discuss it) // Brandi, 1960, fig. 56 // Constable,

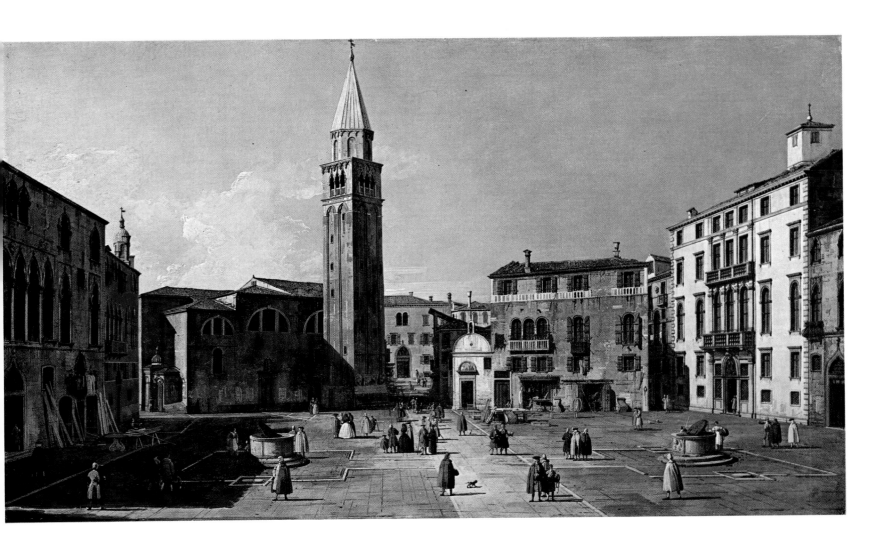

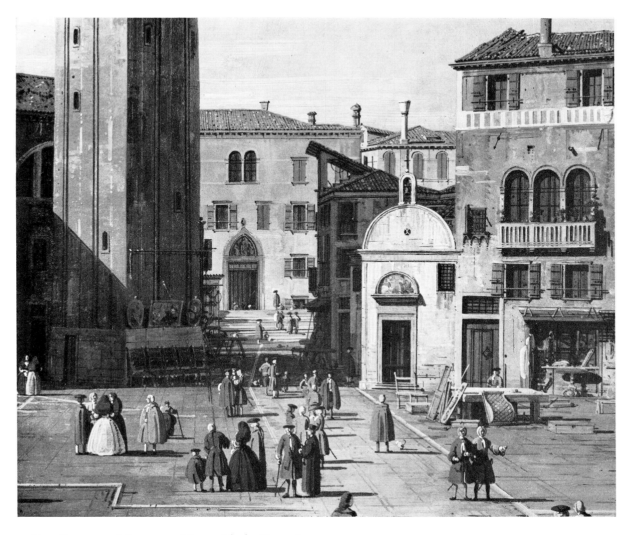

3. *Detail: center of the composition, with the Oratorio dell' Annunciata*

1962, I, fig. 274; II, catalogue no. 274 (describes it in detail, noting the Visentini drawings copied from it) // Puppi, 1968, p. 102, catalogue no. 122, illustrated (observes that "This is the only time Canaletto is known to have painted this subject") // Links, 1969, p. 224, color pl. xv.

Oil on canvas, H. 18⅜ (46.7); W. 30½ (77.5).

The painting was cleaned by John M. Brealey in London during the fall of 1972.

6 Venice: Grand Canal from the Palazzo Flangini to San Marcuola

AT THE LEFT is the seventeenth-century Palazzo Flangini, built after designs by Giuseppe Sardi (about 1620/30–1699), with the Scuola dei Morti (Fig. 1). This last was entirely rebuilt in a different form after the Austrian bombardment of 1849. Beyond the adjacent garden wall is the *canonica*, or priest house, of the church of San Geremia with a gable breaking the line of its roof, little changed in appearance today. Only the lantern surmounting the dome of the church is visible in the painting rising above the roof of the Scuola dei Morti. The wall of the little garden of the Palazzo Labia (itself on the Cannaregio and totally invisible in the

1. *Detail: left side, from the Scuola dei Morti to the entrance of the Cannaregio*

painting) is beyond. The entrance to the Cannaregio is immediately next to this with, on its other bank, the still unfinished Palazzo Querini, which was finally completed only in 1828.

To the right of the center of the painting, just before the canal turns, is the waterfront of the Campo San Marcuola in front of the (here invisible) church popularly known by that name (it is in fact dedicated to Santi Ermagora and Fortunato). Farther on, half cut off by the buildings on the right bank of the canal is a part of the façade of the eighteenth-century Palazzo Vendramin-Calergi.

Along the water's edge of the Grand Canal at the right is the Riva di Biasio. Along the Riva is to be seen the eighteenth-century Palazzo Zen (later Donà Balbi) crowned by a pair of obelisks. It was destroyed in 1849 by the Austrian bombardment, when the whole area suffered greatly. Nearer the spectator are to be seen the Palazzo Corner and the sixteenth-century Palazzi Gritti and Corner, both greatly altered today. The projecting side wall of the Palazzo Bembo (now demolished), seen in profile, cuts off the view on the right bank.

In the center of the foreground a man is being rowed across the canal in a *sandaletto*. Various gondolas and *sandaletti* are dispersed about the canal or moored to the water's edge.

PROVENANCE: As explained below, there is reason to believe that this picture was once part of the Harvey series. It was with Leggatt, the London art dealer, in 1925. It later belonged to Robert G. Stout of Ardmore, Pennsylvania. Mr. and Mrs. Wrightsman acquired it in New York in 1965.

THIS PAINTING corresponds exactly to Visentini's

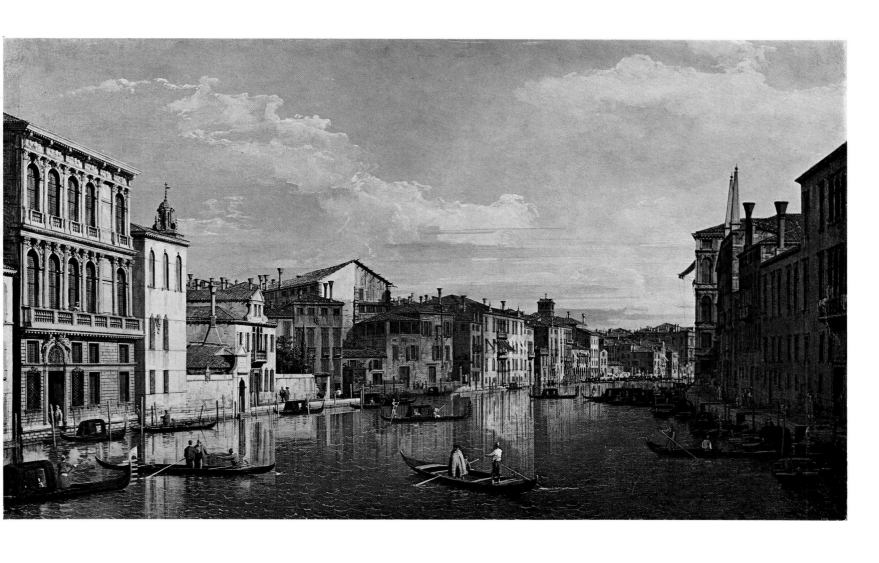

engraving (Fig. 2) of the 1742 edition of the *Prospectus Magni Canalis*, as well as with Visentini's preparatory drawing in the British Museum for the series of engravings. None of the other four versions of this view mentioned by Constable do so nearly so closely. The size of the canvas and the color, tonality, and general character of the picture agree with that of the other four paintings here described and indeed with all the rest of the Harvey series of views. It must clearly have been painted at about the same date.

There is a puzzle about the precise number of paintings in the Harvey series. Constable, who examined and made notes on the series in the 1920s before it was publicly exhibited at Oxford and Birmingham, states repeatedly throughout his book that there were twenty-one paintings in all, but in fact includes only twenty in his catalogue.

2. *Antonio Visentini, engraving of the painting. Ink on paper, 23.6 by 41.8 cm. London, British Museum, courtesy of the Trustees*

Only twenty were exhibited at the Oxford and Birmingham galleries in the years between 1936 and 1956. Constable (1962, I, p. 111) describes the series as consisting of eleven views of the Grand Canal and ten of churches and the *campi* in which they stand. In fact, he catalogues only ten views of the Canal. There is therefore some presumptive evidence that the missing painting represents a scene on the Grand Canal, as the present picture in fact does.

According to private information from the Harvey family, one painting from the series was found in an attic at some time between 1918 and 1936 and was sold separately at an unspecified date. This was the period when the present picture first appeared on the market. It is tempting to suggest that this picture is in fact the missing Harvey painting, for it agrees in size and general character with the rest of the series to a remarkable degree. Moreover, it was engraved for Smith as were a number of other Harvey paintings.

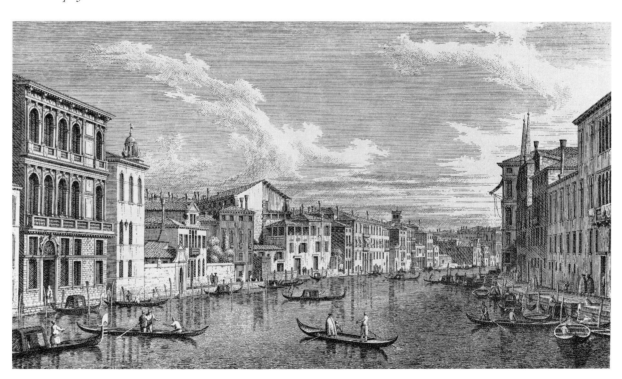

One topographical detail has some bearing on the dating of the present painting. On the left bank along the water's edge at the end of the *fondamenta* (by the entrance to the Cannaregio) a balustrade was to be built in 1742 ending in a pedestal surmounted by a figure of St. John Nepomuk by Giovanni Marchiori (1696–1778). The statue was signed and dated 1742, the year the second edition of the Visentini engravings was published. The absence of the statue in the painting suggests that the picture was executed before that year. It is curious, however, that the statue is shown in Visentini's engraving of the Entrance to the Cannaregio (Visentini, Part 1, pl. x). The Canaletto original for this engraving is now in the English Royal Collection, and as Michael Levey ("Canaletto's Fourteen Paintings and Visentini's *Prospectus Magni Canalis*," in *The Burlington Magazine*, CIV, August 1962, p. 338) discovered, the statue was also added to the painting, presumably by Canaletto at Joseph Smith's request, to bring the picture up to date topographically. This detail was overlooked in the present painting, which was engraved without the statue's being added.

VERSIONS: Constable lists four other versions of this composition:

 257. Wallace Collection, London
 257a. Miss Tessie Jones, Newburgh, New York
 257b. Private collection, England
 257c. Spiridon sale, Paris, May 27, 1911

He considers the Wallace Collection picture to be the primary version, but in the most recent edition of *Wallace Collection Catalogues: Pictures and Drawings*, 16th ed., London, 1968, p. 54, it is correctly described as coming "From the studio of Antonio Canale, and predominantly the work of studio assistants."

The Jones version has been bequeathed to the Minneapolis Institute of Arts. Constable (1962, II, p. 297, catalogue no. 257a) claims that "from a photograph, the painting is likely to be by Canaletto and the original of the engraving," but comparison with the Visentini print (Fig. 2) reveals innumerable discrepancies. The Wrightsman painting, like all the engraved views in the Harvey series, follows the print exactly. Moreover, the Wrightsman picture is exactly the same size as the other engraved originals, whereas the Minneapolis variant is considerably larger (61.5 by 92.5 cm.).

EXHIBITED: (together with Catalogue Nos. 2, 3, 4, 5): The Metropolitan Museum of Art, New York, March—October 1967.

REFERENCES: Constable, 1962, II, catalogue no. 257d (lists it as one of four versions of a picture in the Wallace Collection, London; describes it as having been with Leggatt, the London dealer, in 1925, and notes: "Very similar to the Visentini engraving. Possibly by Canaletto") // Links, 1969, pp. 226–227, color pl. XVIII (convincingly argues that it is the original engraved by Visentini and that it once belonged to the Harvey series) // Links, 1971, pp. 8, 48, fig. 10 (argues that the Minneapolis version of this view was not the original engraved by Visentini because it is larger than other canvases in the engraved series; accepts the Wrightsman painting as the original and writes "There can be little doubt that it is the missing member of the Harvey series and that it has fortuitously joined the four known members of the series in the same collection").

Oil on canvas, H. 18½ (47.0); W. 30⅝ (77.7).

GERARD DAVID (about 1460–1523) was born at Oudewater in southern Holland and spent most of his life working in Bruges. Although the date of his birth is unrecorded, he is generally assumed to have belonged to the same generation as the Dutch painter Geertgen tot Sint Jans (about 1455/65–about 1485/95). Nothing is known about David's early training, but for stylistic reasons it seems probable that, like Geertgen, he was a pupil of Albert van Oudewater, who was active in Haarlem during the third quarter of the fifteenth century.

The earliest reference to David dates from 1484, when he became a member of the painters' guild in Bruges. After the death of Hans Memling (about 1430–1494), David became the leading painter in Bruges and received the most important civic and religious commissions of the city. For the Judgment Room of the Town Hall in Bruges he painted two large pictures, the Verdict of Cambyses (dated 1498) and the Flaying of Sisamnes. During the first decade of the sixteenth century he traveled to Italy. For a church near Genoa he painted a large polyptych, dated 1506, parts of which are now divided between the museum of the Palazzo Bianco, Genoa, and The Metropolitan Museum of Art.

David's earliest works, the Triptych of Jan de Sedano, in the Louvre, and an Adoration of the Shepherds, in The Metropolitan Museum of Art, reflect the influence of the Haarlem school. The physical types in these pictures recall those of Geertgen tot Sint Jans, and the landscapes are filled with closely observed naturalistic detail in the Dutch manner. After settling in Bruges David quickly refashioned his style on the example of Hans Memling, who was then the leading master of the school of Bruges. By 1500 he had evolved a more personal style with large, statuesque figures. His paintings rarely show physical movement or strong emotions, but rather convey a feeling of calm and quiet reverie. His palette, particularly in the later works, tends toward a subdued blue monochrome.

During the fifteenth century Bruges attracted the talents of Jan van Eyck, Petrus Christus, Rogier van der Weyden, Hugo van der Goes, and Hans Memling. By the time Gerard David had settled there, the city was faced with economic decline, and the greatest era of Netherlandish painting was coming to an end. David's students, Ambrosius Benson and Adrien Isenbrandt, abandoned Bruges for the richer opportunities of Antwerp, the city that soon replaced Bruges as the cultural center of the Netherlands.

7 Virgin and Child with Four Angels

THE STANDING Virgin, clad in a bright scarlet robe over a dark blue dress lined with gray fur, holds the Christ Child, who wears a translucent tunic. The Virgin wears a black headband decorated with illegible Gothic characters, and around the Child she holds a white cloth with lettering along its border: IHESVS [RE]DEMPT[OR]. Over the Virgin's right shoulder the Child holds a rosary of red and dark blue beads. Above and to either side of the Virgin are four angels, all of them with mul-

ticolored wings and all of them wearing red head-
bands with gold crosses. The pair of angels hover-
ing above the Virgin's head hold a gold crown,
adorned with pearls, rubies, and dark blue gems.
Both of the airborne angels wear simple blue-gray
albs, or closed-sleeved vestments, the only differ-
ence between them being the addition of a long,
blue-violet belt to the angel on the left and a robe
of the same color to the one on the right. The
angels seated beside the Virgin wear more sump-
tuously colored garments, the one on the left, dark
green with yellow highlights, the one on the right,
pale blue with violet shadows (Fig. 1). These angels
play a harp with seventeen strings and a lute with
five strings.

The architectural setting appears to be part of
an ecclesiastical building: an open loggia, a porch,
or even possibly a portal of a large sanctuary. On
either side there are two porphyry columns sur-
mounted by elaborate capitals carved with acan-
thus leaves and children's heads. The seats on
which the angels sit and the step in the foreground
are cool gray, whereas the rest of the masonry is
reddish brown. The pavement consists of buff,
yellow, dark green, brown, and white tiles.

In the middle ground a tonsured monk clad in
a white robe reads a book by a wooden door in
the brick wall containing the garden, or court-
yard, behind the Virgin. The background affords
a detailed view of Bruges set against a mountain-
ous landscape (Fig. 2). The church on the left is
Saint-Donatien, destroyed in 1800; the tower on
the right belongs to Notre Dame, a familiar
Bruges landmark.

PROVENANCE: Acquired in 1962 from a private
collection in Paris.

THE PICTURE is filled with realistic details, most
of which have symbolic meaning. The flowers in
the courtyard, for example, are depicted so mi-

1. *Detail: angel strumming a lute*

2. *Detail: Virgin and Child with a view of Bruges*

nutely that they can be readily identified, and the ones in the foreground on either side of the Virgin are traditional symbols of the Seven Sorrows of the Virgin. The iris on the left illustrates the prophecy of Simeon, because its leaves resemble "the sword that shall pierce through" the Virgin's heart. Likewise, the columbine on the right is associated with the Virgin's sorrows, because its name (*ancolie*, in French) and its purple color are identified with melancholy. Moreover, the court-yard in the middle ground of the painting, while rendered as an actual scene, may be a symbol of the purity of the Virgin. It might possibly be an allusion to the *hortus conclusus* mentioned in the

Song of Solomon (4:12), which is a popular theme in early Netherlandish painting. The setting of the Virgin and Child in an ecclesiastical building may also have symbolic significance. In paintings by earlier Flemish artists, such as the Madonna in a Church by Jan van Eyck, in the Staatliche Museen, Berlin-Dahlem, or the Madonna Enthroned by Rogier van der Weyden, in the Thyssen Collec-tion, Lugano, the Virgin is equated with the Church, both the building and the institution. The setting of the present painting may very likely refer to the role of the Virgin Mary as an embodi-ment of the Church in the latter sense.

Not only these iconographic details but also the

[57]

3. *Jan Van Eyck, Madonna of the Fountain.* Oil on wood, *19.0 by 12.2 cm. Antwerp, Musée Royal des Beaux-Arts*

design and the compositional format of the picture belong to the tradition of early Netherlandish painting. The standing Virgin, for instance, is derived from Jan van Eyck's Madonna of the Fountain (signed and dated 1439), in the Musée Royal des Beaux-Arts in Antwerp (Fig. 3). The posture of the body, with the right knee drawn forward, the arrangement of the hands, the presence of the rosary, and even the folds of drapery are comparable. The most radical alteration David made from his model was to change the position of the Christ Child's head. Instead of pressing next to the Virgin's cheek, the Child turns his head back over his shoulder to gaze directly into the eyes of the viewer. David also made a significant change in the color of the Virgin's dress: with the exception of this Virgin, who wears a blue robe, all Van Eyck's Virgins wear red ones. The scarlet robe in the present painting repeats the design, but not the color, of the robe in the Antwerp painting.

Angels holding a crown above the Virgin appear in David's Madonna with Four Apostles, in the Norton Simon Foundation, Los Angeles. Like other motifs in David's work, they seem to be derived from Hans Memling (compare, for instance, Memling's altarpiece of the two St. Johns, in the Johannes Hospital, Bruges, where there is a pair of similar angels crowning the Virgin). Ultimately, the tradition of crown-bearing angels must go back to Van Eyck's Madonna of Chancellor Rolin, in the Louvre.

For the arrangement of the music-making angels beside the Virgin, David may have followed the example of Robert Campin (about 1378–1444). Campin painted a Madonna in an Apse, now lost, of which over a dozen copies exist (for these, see Martin Davies, *Les Primitifs flamands: The National Gallery, London*, Antwerp, 1953, I, pp. 60–65, pls. CXXXVI–CXLI). Although the angels in the Gerard David painting are sitting rather than standing on either side of the Virgin, they resemble the angels in the lost painting by Campin, because they play the same instruments and they flank a standing Madonna.

Thus in designing the picture Gerard David made conscious use of motifs in paintings by earlier artists. While this eclecticism bears the stamp of David's personality, it is also an important characteristic of other artists working in the Netherlands around the turn of the sixteenth century. Quentin Massys, Joos van Cleve, and Jan Gossaert, to mention but a few, seem to have all looked back with renewed interest to the work of the founders of the Flemish school of painting. They seem to have specialized in making copies of Van Eyck and Robert Campin. Earlier artists occasionally incorporated motifs from pictures by other artists (compare, for example, Rogier van der Weyden's Standing Madonna, in the Kunsthistorisches Museum, Vienna, which is adapted from Jan van Eyck's Madonna of the Fountain), but these borrowings are used in a creative way that does not have the look of a copy after an old master. The artists of David's generation had an unabashed antiquarian taste, and it is indicative that most of the copies after Campin's Madonna in an Apse are roughly contemporary with the present picture.

Since so few of Gerard David's paintings are firmly dated, it is impossible to establish a precise chronology for his works. The Wrightsman Madonna can be assigned an approximate date only on stylistic grounds. Clearly, it is a mature work executed with great authority and elegance. The stiff, wooden handling of David's Verdict of Cambyses (dated 1498) has given way here to a softer, more yielding manner, which is particularly evident in the atmospheric treatment of the faces and the fluent design of the drapery. On the other hand, the small scale of the work might account for the graceful character of the figures. The palette does not show the cool blue tonality that first appears about 1505 in David's works, particularly in the panels at Genoa and the large altarpiece at Rouen, completed in 1509. For these reasons, the Wrightsman picture should be placed about 1500.

The Carthusian monk standing in the courtyard

may throw some light on the identity of the patron who commissioned the picture. The religious figures in Gerard David's fully documented paintings are invariably connected with the names and the religious orders of the patrons who commissioned them. It would thus seem probable that the Wrightsman Madonna was commissioned for a Carthusian. The relatively modest dimensions of the panel indicate that it was designed not as an altarpiece but rather as a private devotional picture, such as the Madonna of Jan Voss attributed to Jan van Eyck and an assistant, in the Frick Collection, New York. By coincidence, the latter picture was commissioned for the charterhouse of Genadedal, the only known Carthusian monastery of the period near Bruges, and it is conceivable that the Wrightsman Madonna was painted for someone connected with the same religious house.

The view of Bruges in the background of the painting is rendered with remarkable accuracy, considering the distortions that usually occur in contemporary topographical views. The buildings are seen from the quarter of Saint-Jacques, a neighborhood in the southeast corner of the city. According to A. Janssens de Bisthoven (written communication, October 22, 1968), who kindly identified the church of Saint-Donatien in the painting, Gerard David worked in a house located in the Sint Jacobstraat in the quarter of Saint-Jacques. It is possible that the view was actually taken from there.

VERSION: A variant (Fig. 5) exists in the collection of Baron H. H. Thyssen-Bornemisza, Lugano. It was published as a work of the "Master of the André Madonna," an anonymous painter who worked at Bruges under the influence of Gerard David at the turn of the sixteenth century, by Max J. Friedländer (*Die altniederländische Malerei: Joos van Cleve, Jan Provost, Joachim Patenier*, Berlin, 1931, IX, pp. 95–96). Friedländer was unaware of the existence of the Wrightsman painting. Like the Wrightsman Madonna, the variant at Lugano is painted on panel, but it is slightly smaller, 62.0 by 32.0 cm. as compared with 63.2 by 38.7 cm. Of the numerous differences between the two pictures, one should note the radically dissimilar physical types and the change in the pose of the Christ Child. In the Thyssen picture the perspective of the tile pavement is rudimentary and the architectural setting is simplified. The landscape background is less detailed, and the foreground is extended with a bed of leafy plants. The two pictures are manifestly by two different artists.

REFERENCES: Rudolf Heinemann, ed., *The Thyssen-Bornemisza Collection* [Lugano], 1969, catalogue entry by Johann Conrad Ebbinge-Wübben, pp. 206–207 (and again in the German edition, *Sammlung Thyssen-Bornemisza* [Lugano], 1971, pp. 240–241) (ascribes both the Thyssen and the Wrightsman Madonnas to the "Master of the André Madonna," observing that the Wrightsman painting is "nearer in style to Gerard David, and for that reason in the Wrightsman Collection attributed to Gerard David himself") //

4. *Back of the panel*

Everett Fahy, "A Madonna by Gerard David," in *Apollo*, XC, September 1969, pp. 190–195 (publishes the Wrightsman Madonna as an autograph work of Gerard David and dates it about 1500–1505).

Oil on wood, H. 24⅞ (63.2); W. 15¼ (38.7).

Along the right- and left-hand sides of the panel, and also along the bottom, there are narrow margins of unpainted wood, which probably were originally covered by an engaged frame that no longer exists. The dimensions of the actual painted surface thus are H. 24⅝ (62.5); W. 14½ (37.0). There are four vertical cracks in the panel, which has been reinforced on the back with canvas strips (Fig. 4). Along the cracks there are negligible local losses in the paint surface; the painting is otherwise remarkably well preserved. It was cleaned shortly before it was acquired by the Wrightsmans. It was revarnished in London in January 1972 by John M. Brealey.

5. *Master of the André Madonna, Virgin and Child with Four Angels. Oil on wood, 62.0 by 32.0 cm. Lugano, Thyssen Collection*

EUGÈNE DELACROIX (1798–1863), the leader of French Romantic painting, was legally known as the son of an important government agent who died when Delacroix was quite young, but it is widely believed that he was the natural son of Charles Talleyrand, the French statesman. His maternal grandfather was Jean Henri Riesener (1734–1806), *ébéniste du Roi*, and his uncle was Henri François Riesener (1767–1828), the portraitist. He received a classical literary education at the Lycée, and from about 1815 until 1823 worked in the atelier of Pierre Guérin (1774–1833), one of David's academic followers. But the decisive influences on his style were Théodore Gericault (1791–1824), for whose masterpiece the Raft of the Medusa he posed in 1818, and Richard Parkes Bonington (1802–1828), the young English painter with whom Delacroix became acquainted in Paris. It was through Bonington that Delacroix developed an interest in Shakespeare, Byron, and Scott, authors who provided the Romantic themes of many of his pictures. He also admired Baron Gros and made copies after Rubens (*q.v.*), Veronese, and Velázquez.

At the age of twenty-four he scored a tremendous success with his first major work, Dante and Virgil Crossing the Styx. A powerful composition of Michelangelesque grandeur, it was highly praised at the Salon of 1822 and was purchased by the French government. At the Salon of 1824 he exhibited the Massacre at Chios, a monumental composition illustrating a recent event in the Greek Wars of Independence. Its raw coloring and dazzlingly free technique were inspired by Bonington and John Constable (1776–1837), who also exhibited at the same Salon. Despite hostile criticism, the picture was bought by the State, enabling Delacroix to visit England the following spring and summer. In London he saw Shakespeare acted for the first time and met Thomas Lawrence (1769–1830) and David Wilkie (1785–1841).

Returning to Paris he received his first official commission, the decoration of the Palais du Conseil d'État with a large picture, the Emperor Justinian Composing His Laws. To the Salon of 1827 he contributed the Death of Sardanapalus, a subject inspired by Byron, which he depicted with voluptuous abandon. A highly controversial work, it cost the artist several years of official patronage.

Delacroix came back into government favor with his allegory of the 1830 Revolution, Liberty Leading the People (Salon of 1831). Shortly thereafter he was sent by Louis Philippe to accompany a diplomatic mission to the Sultan of Morocco. He visited Spain, Morocco, and Algiers, filling sketchbooks with vivid records of the exotic sights and blazing colors of Islamic Africa. The impact the trip made on the artist's imagination can be seen in the Women of Algiers (Salon of 1834) and the Jewish Wedding in Morocco (Salon of 1841). Though related to his earlier Turkish scenes inspired by Byron, these pictures have greater authority, partly because they are not pure fantasies.

From the 1830s onward one important government commission followed another: the decorations of several rooms in the Palais Bourbon (1833–1847), the dome of the library of the Palais Luxembourg (1841–1846), the central panel of the Galerie d'Apollon in the Louvre (1849–1851), and finally, near the end of his life, the chapel of the Saints-Anges in Saint-Sulpice (1853–1861).

THE SITTER is represented half-length against a plain gray background, posed with her left shoulder closest to the picture plane and her head turned to the viewer. She has jet-black hair and light brown eyes, and wears a black dress with voluminous sleeves. Her white ruffled lace bonnet (Fig. 1) is tied beneath her chin with a collar at the back. Around her neck she wears a ruff (or *fraise tuyautée*) similar to the neckpieces worn in the early seventeenth century. Beneath the ruff is a foulard (Fig. 2) printed with brilliant scarlet, black, and yellow stripes. It is worn at the front like a cravat, tied at the neck and tucked under her belt at the waist. She wears no jewelry save a thin gold chain of the type used for pendent watches or eyeglasses. The chain falls from her shoulders and disappears behind her belt.

PROVENANCE: For over a century this portrait remained with the Riesener family. After the sitter's death in 1847 it belonged to her son, Léon (1808–1878). In 1885 his widow lent it to the Delacroix memorial exhibition. Later it belonged to their daughter, Louise Riesener, Mme Claude Léouzon-le-Duc (born 1860), who lent it to the 1930 Delacroix exhibition. By 1956, when it was shown at Venice, it belonged to Louis Salavin, Paris. Mr. and Mrs. Wrightsman acquired it in New York in 1971.

UNLIKE INGRES, who is remembered today for numerous portraits executed throughout his career, Delacroix painted comparatively few, and almost all of them are of intimate friends or members of his family. The portrait in the Wrightsman Collection is no exception. It depicts Mme Henri Riesener (1786–1847), Delacroix's aunt by marriage. His letters and *Journal* reveal that she occupied a special place in his heart. Years after she died he wrote, "Ma pensée se porte à mon réveil sur les

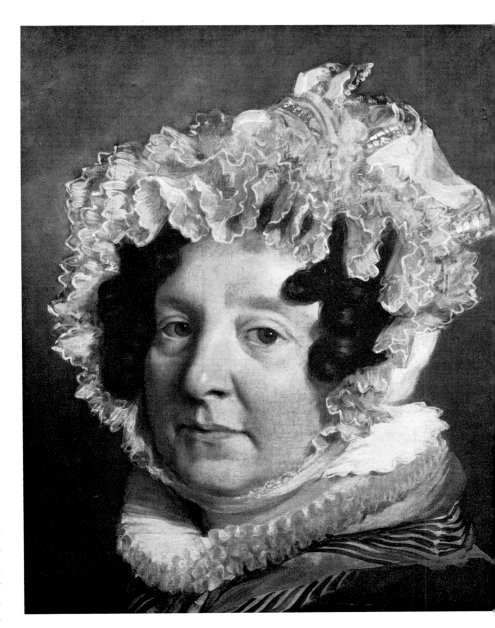

1. *Detail: head*

[63]

moments si agréables et si doux à ma mémoire et à mon coeur que j'ai passés près de ma bonne tante à la campagne" (entry for April 28, 1854, in Delacroix's *Journal*, 1893, II, p. 341). His portrait of her conveys this affectionate feeling. It is a remarkably tender and human record of someone Delacroix loved dearly. The sympathetic expression his brush captures in her eyes and the suggestion of a smile on her lips disclose a deeply personal bond between the artist and his aunt. Despite the busy frills of her lace bonnet or the coruscating color of her foulard, the portrait is serene and unspectacular in a way that few of Delacroix's works are. In spite of this, all the bold genius of Delacroix's painterly gifts are here—the exuberant handling of the black sleeves alone is a tour de force.

Delacroix was related to Mme Riesener through his mother, one of the daughters of Jean François Oeben, the master cabinet maker (see Volume II of this Catalogue, p. 555). Oeben died in 1763, leaving his widow (Delacroix's grandmother) with an unfinished piece of furniture, the celebrated desk of Louis XV now in the Louvre. The desk was eventually completed by Oeben's assistant, Jean Henri Riesener, who signed it in 1769 with his name alone. (There is a signed side table by Riesener in the Wrightsman Collection; see Volume I of this Catalogue, p. 236.) Before he completed the table Riesener married Oeben's widow and had a son, Henri François (1767–1828). It is the latter's wife who is portrayed in the Wrightsman painting.

Mme Riesener led a remarkable early life. She was born Félicité Longrois, and was the granddaughter of Pierre Longrois, who was in charge of the furniture at the Château de la Muette. Through one of her uncles she was introduced to the Imperial service, where she became a *dame d'annonce*. Napoleon took a fancy to her, and she became his mistress for a brief period during the winter of 1805–1806. During the following summer she was married off to Henri Riesener, the Empress Josephine signing the prenuptial con-

tract. Riesener was then almost forty years old, his attractive wife not yet twenty (Gavoty, 1963, pp. 252–254). Her appearance at this time is recorded in a large double portrait Riesener painted of his fiancée and her sister (Fig. 3). Mme Riesener, wearing the official red gown of Napoleon's *dames d'annonce*, is seated with a portable writing table on her lap, while her sister looks over her shoulder. Shown in a prominent position at the Salon of 1808, this canvas was highly acclaimed by the critics, and it was shown again at the Salon of 1814. Throughout Delacroix's life it remained in the possession of the Riesener family, and it is certain that he saw it many times. Only in 1886 was it presented to the museum at Orléans by Mme Riesener's daughter-in-law (Paul Vitry, *Le Musée d'Orléans*, Paris, 1922, pp. 12, 45, illustrated; mistakenly said to have been exhibited at the Salon of 1810).

The Rieseners settled near Rouen and seem to have led a happy life. After the deaths of Delacroix's father in 1805 and his mother in 1814, they were his closest relatives, and he often spent his holidays with them in the country at Frépillon near Montmorency. He grew devoted particularly to his aunt, and even as a mature man frequently stayed with her. In a letter written on August 7, 1832, immediately after he had returned from his trip to North Africa, he expressed how much she meant to him. Proposing to see her within the week, he wrote, "C'est assez vous dire, bonne tante, que j'ai bien souvent pensé à vous et au petit nombre de personnes dont la vie m'est chère" (*Correspondance générale d'Eugène Delacroix*, André Joubin, ed., Paris, 1938, V, pp. 159–160).

It was probably through Mme Riesener's husband that Delacroix took an interest in painting. Henri Riesener was a tolerably successful painter who specialized in neoclassical portraits. He had been a student of Antoine Vestier (*q.v.*), who in turn had painted a portrait of his father (see under Catalogue No. 33, Fig. 5). He is often credited with placing the young Delacroix in the studio of Pierre Guérin, but this is unlikely, since Riesener

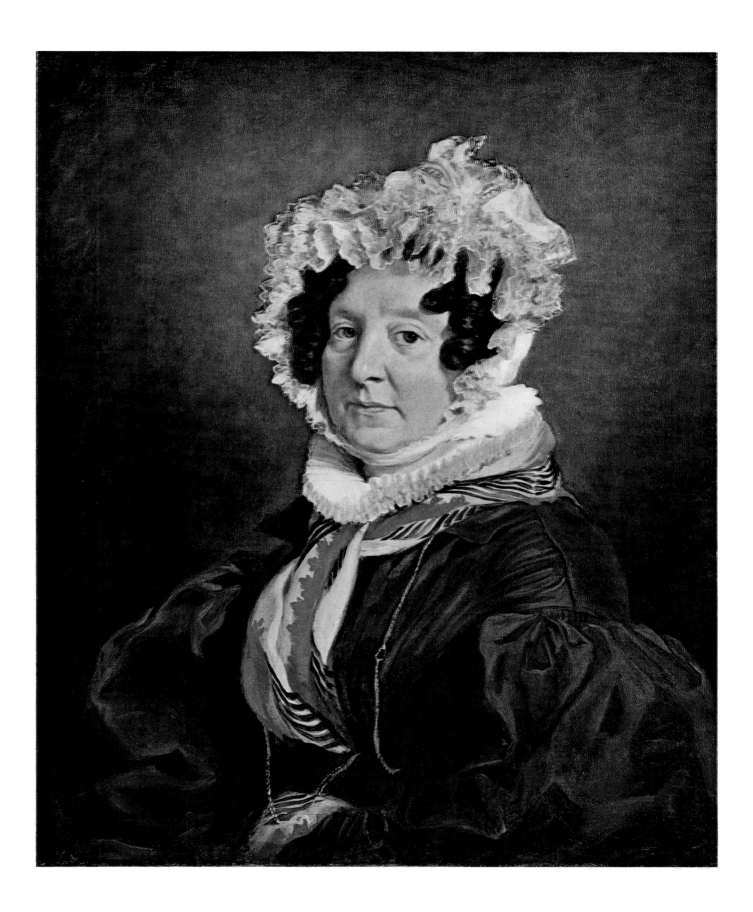

was in Russia when Delacroix began his formal training as an artist. He spent seven years there, from 1813 to 1820, painting an equestrian portrait of Czar Alexander I and many pictures for the Russian aristocracy. When he came back he urged Delacroix to study with David in Brussels. Delacroix reported this advice in a letter of July 8, 1820, to his sister, Henriette de Verninac:

M. Riesener est arrivé de Russie. Il paraît qu'il gagné beaucoup, outre des diamants, des cachemires et de belles fourrures qu'il rapporte à sa femme. Il se trouve avoir gagné à peu près cent dix mille roubles. Il voudrait pour mon intérêt que j'allasse étudier près de M. David à Bruxelles, j'y ai pensé bien souvent: mais il faut encore y réfléchir (*Correspondance*, 1938, V, p. 61).

2. *Detail: blouse and scarf*

M. Riesener has come back from Russia. Apparently he has made a great deal of money, as well as bringing back diamonds, cashmere shawls and fine furs for his wife. He had earned about 110,000 roubles. He thinks it would be to my advantage to go and study with M. David in Brussels; I have often considered this, but I must think it over still further (*Eugène Delacroix: Selected Letters 1813–1863*, selected and trans. by Jean Stewart, London, 1971, p. 73).

It is hard to imagine what course Delacroix's career would have taken had he followed his uncle's advice and studied with David.

The Rieseners had a son called Léon (1808–1878) who also became a painter and a close friend of Delacroix. They were often together at Frépillon, and, from Delacroix's correspondence, it transpires that he did much to further his younger cousin's career. Léon Riesener sat for Delacroix in

1834: the result is a strikingly vivid and handsome portrait (Fig. 4). It is not so large or so elaborate as the painting Delacroix did of Léon's mother, but it has the same immediacy and direct rapport between the artist and his subject. In contrast to Mme Riesener's peaceful gaze, the twenty-six-year-old Léon looks out at the world with a slightly melancholy, yet intense expression in his eyes.

Mme Riesener sat for her portrait shortly after Delacroix had painted her son. According to Moreau (1873, p. 236), it was painted at Frépillon in the summer of 1835. Although this is the only evidence for the date, there seems to be no reason to question or reject it. Moreau knew Delacroix personally, and there is every reason to believe he interviewed the Riesener family when he gathered the material for his monograph, the first book on Delacroix. Moreover, the style of the portrait, as much as one can deduce from comparisons with the documented works of 1835, seems plausible for that year, and the apparent age of the sitter also coincides with this period (in 1835 Mme Riesener would have been a widow about fifty years old). Some writers (see under References, below) claim that the portrait was done in February 1835, since that is the only time during the year when it is certain that Delacroix was at Frépillon (see the letter postmarked February 27, 1835, in *Correspondance*, 1935, I, p. 391). One need not be so precise, however, since Delacroix was a regular guest at Frépillon, and the fact that there is no documentary evidence proving he was there during the summer does not eliminate the possibility.

3. *Henri François Riesener, Portrait of Mme Henri François Riesener and Her Sister. Oil on canvas, 216.0 by 180.0 cm. Orléans, Musée. Photo: Giraudon*

OPPOSITE:
4. *Eugène Delacroix, Portrait of Léon Riesener. Oil on canvas, 54.0 by 44.0 cm. Paris, Musée du Louvre. Photo: Agraci*

Twelve years later Delacroix wrote to the novelist George Sand:

J'ai éprouvé un grand chagrin. J'ai perdu ma bonne tante que j'aimais comme une mère. C'était une femme d'un grand caractère et chez qui (chose rare) les qualités de l'âme avaient le pas sur tout: il aurait fallu l'admirer quand on ne l'eût pas aimée; vous jugez donc du vide que cela fera dans ma vie déjà bien seule. Vivez donc, chère amie, soignez cette étincelle précieuse qui vous fait non seulement vivre, mais aimer et être aimée. J'éprouve déjà bien qu'on vit véritablement dans les autres; chacun des êtres nécessaires à notre existence qui disparaît à son tour emporte avec lui un monde de sentiments qui ne peuvent revivre avec aucun autre: qu'est-ce que c'est donc qu'un vieillard et que regrettent-ils en quittant ce monde? (letter dated November 20, 1847, *Correspondance*, 1936, II, pp. 330–331).

I have had a sad bereavement. I have lost my good aunt whom I loved like a mother. She was a woman of noble character and one in whom spiritual qualities took precedence over everything, which is rare; one must needs have admired her, even if one had not loved her; you can imagine then what a gap this leaves in my already lonely life. Live, then, dear friend, cherish that precious spark which makes you not only live but love and be loved. I know now by experience that we really live through other people; when one of the beings who are necessary to our existence disappears he takes away with him a whole world of feelings which no other relationship can revive: what are old men, then, and what have they to regret when they leave this world? (*Selected Letters*, 1971, p. 278).

Two years later Delacroix wrote in his *Journal* about the portrait he had painted of his late aunt:

Je comparais ces jours-ci les peintures qui sont dans le salon du cousin. Je me suis rendu compte de ce qui sépare une peinture qui n'est que naïve, de celle qui a un caractère propre à la faire durer. En un mot, je me suis souvent pris à me damander pourquoi l'extrême facilité, la hardiesse de touche, ne me choquent pas dans Rubens, et qu'elles ne sont que que de la pratique haïssable dans les Vanloo . . . j'entends ceux de ce temps-ci comme ceux de l'autre. Au fond, je sens bien que cette facilité dans le grand maître n'est pas la qualité principale; qu'elle n'est

que le moyen et non le but, ce qui est le contraire dans les médiocres . . . J'ai été confirmé avec plaisir dans cette opinion, en comparant le portrait de ma vieille tante avec ceux de l'oncle Riesener. Il y a déjà, dans cet ouvrage d'un commençant, une sûreté et une intelligence de l'essentiel, même une touche pour rendre tout cela qui frappait Gaultron lui-même (entry for October 9, 1849 in Delacroix's *Journal*, 1893, I, pp. 391–392).

These last days, I have been comparing the paintings which are in my cousin's drawing room. I came to an idea of what separates a painting that is only naïve from one that has a character such as will make it endure. In a word, I have often been led to ask myself why extreme facility and boldness of touch do not shock me in Rubens, and why they are merely detestable facility in a man like Vanloo, I mean those of the present as well as those of the past. Fundamentally, my feeling is quite clear enough that facility in the great master is not his chief quality; that it is only the means and not the end, the reverse being the case with mediocre men. I had the pleasure of finding confirmation for this opinion on comparing the portrait I once painted of my old aunt with those by uncle Riesener. There is already, in that work by a beginner, a sureness and an intelligence as to essentials, and even a quality of touch in the rendering of the whole which struck Gaultron himself (*Journal*, 1961, p. 204).

One of the pictures by his uncle that Delacroix would have seen there at his cousin's was the double portrait illustrated in Fig. 3. Although Delacroix perhaps underestimates his own portrait of Mme Riesener when he refers to it as "that work by a beginner," his pleasure at seeing it, almost fifteen years after having painted it, was well deserved. It is a commanding work of art, tempered by "a sureness and an intelligence as to essentials," yet so freely painted as to be worthy of the great Rubens he so much admired.

EXHIBITED: École Nationale des Beaux-Arts, Paris, *Exposition Eugène Delacroix: au profit de la souscription destinée à élever à Paris un monument à sa mémoire*, March 6–April 15, 1885, catalogue no. 167; Palais du Louvre, Paris, *Exposition Eugène Delacroix*, June–September 1930, catalogue no. 73; Petit Palais, Paris, *Gros: ses amis et ses élèves*, May–July 1936,

no. 241; Wildenstein & Co., Ltd., London, *Eugène Delacroix 1798–1863*, June–July 1952, catalogue no. 18, illustrated; XXVIII Biennale Internazionale d'Arte, Venice, *Delacroix alla Biennale*, June 1956, catalogue no. 18; La Glyptothek ny Carlsberg, Copenhagen, *Exposition des portraits français de Largilliere à Manet*, October 15–November 15, 1960, catalogue no. 13; Musée du Louvre, Paris, *Centenaire d'Eugène Delacroix 1798–1863*, May–September 1963, catalogue no. 222; Kunstmuseum, Bern, *Eugène Delacroix*, November 16, 1963–January 19, 1964, catalogue no. 41, illustrated; Kunsthalle, Bremen, *Eugène Delacroix 1798–1863*, February 23–April 26, 1964, catalogue no. 36, illustrated; Arts Council, Royal Academy of Arts, London, *Delacroix*, October 1–November 8, 1964, catalogue no. 36; Municipal Museum, Kyoto, May 10–June 8, 1969, and National Museum, Tokyo, *Exposition Delacroix*, June 14–August 3, 1969, catalogue no. H-14, illustrated.

REFERENCES: Adolphe Moreau, *E. Delacroix et son oeuvre*, Paris, 1873, p. 236 (claims it was painted during the summer of 1835 at Mme Riesener's estate at Frépillon, where Delacroix was a frequent visitor; he calls it "cette belle toile, d'une exécution énergique et d'une couleur superbe") // Alfred Robaut, *L'Oeuvre complet de Eugène Delacroix: peintures, dessins, gravures, lithographies*, Paris, 1885, p. 161, catalogue no. 606, illustrated with a line engraving (associates the portrait with a letter Delacroix wrote [in 1835] recommending that Mme Riesener's son, Léon, be employed to help him complete the portrait of the Maréchal du Tourville, which the State had commissioned for Versailles) // Eugène Véron, *Eugène Delacroix*, Paris—London, 1887, p. 66 (mentions it as one of Delacroix's major works) // *Journal de Eugène Delacroix*, Paul Flat and René Piot, eds., Paris, 1893, I, pp. 391–392 (in the entry for October 9, 1849, refers with pride to the portrait; the passage is quoted above in the text) // Étienne Moreau-Nélaton, *Delacroix: raconté par*

lui-même, Paris, 1916, I, pp. 155–156, fig. 126 (observes that the lively brushwork "est fort anglais" and that it owes something to Bonington, who had died seven years earlier) // Raymond Escholier, *La Vie et l'art romantiques: Delacroix: peintre, graveur, écrivain*, Paris, 1927, II, pp. 214, 226, 230, illustrated opp. p. 220 (calls it a *chef d'oeuvre*, stating mistakenly that it is signed and dated; describes the palette as "très britannique" and contends that its classical harmony is comparable to that found in the most distinguished portraits by David and Ingres) // Louis Hourticq, *Delacroix: l'oeuvre du maître*, Paris, 1930, p. 60, illustrated // *The Journal of Eugene Delacroix*, Walter Pach, trans., New York, 1961, p. 204, note 41 (confuses the portrait with Delacroix's painting of Mme Bornot, Robaut no. 1460) // André Gavoty, "La 'Bonne Tante' de Delacroix," in *La Revue des Deux Mondes*, May 15, 1963, pp. 248–259 (describes it as one of Delacroix's masterpieces and gives a full account of Mme Riesener's life) // René Huyghe, *Delacroix*, New York, 1963, pp. 19, 32, 482, 527 note 41, 535, pl. 26 (does not analyze the portrait itself but refers to Delacroix's affection for his aunt) // Jean Cau et al., *Delacroix*, Paris, 1963, unpaginated, fig. 59 (states that the portrait was done in 1834, the same year that Delacroix painted Mme Riesener's son, Léon [fig. 60]) // Maurice Serullaz, *Mémorial de l'Exposition Eugène Delacroix*, Paris, 1963, p. 165, no. 219, illustrated (claims that it was done in February, rather than during the summer, of 1835) // Luigina Rossi Bortolatto, *L'opera pittorica completa di Delacroix*, Milan, 1972, pp. 102, 103, fig. 275 (states that it was probably executed in February 1835 and remarks upon its similarity to the style of portraits by David and Ingres).

Oil on canvas, H. 29⅛ (74.0); W. 24⅞ (63.0).

The painting, which has never been relined, is on its original stretcher. The paint surface is exceptionally well preserved.

DOMENICHINO (Domenico Zampieri, 1581–1641) was born at Bologna, and, like his slightly older compatriot Guido Reni (*q.v.*), began his training with Denis Calvaert (1540–1619). He moved on to the more progressive studio of Ludovico Carracci (1555–1619), and in 1602 went to Rome and joined the group of young Bolognese artists at work in the Palazzo Farnese with Ludovico's brother Annibale (1578–1609). Domenichino's earliest documented work, a small Vision of St. Jerome, mentioned in an inventory of 1603 and now in the National Gallery, London, is deeply influenced by Annibale's style. His earliest identifiable frescoes are three scenes from Ovid, painted on an exterior loggia of the Palazzo Farnese. Their tender feeling and the prominence of their poetic landscape backgrounds reveal the artist's individuality. Annibale's favorite assistant, Domenichino was entrusted with some of the frescoes on the side walls beneath Annibale's masterpiece, the ceiling of the Farnese Gallery.

About 1608 he began the decoration of the abbey church at Grottaferrata for Cardinal Odoardo Farnese. The work was interrupted, however, by a project in association with Guido Reni to fresco the oratory of Sant'Andrea attached to the church of San Gregorio Magno, Rome. Reni's influence on Domenichino can be felt in the more graceful and fluid compositions with which he eventually completed the Grottaferrata frescoes in 1610.

After Annibale's death and Reni's return to Bologna, Domenichino became the leading exponent of the classical style in Roman painting. His position was championed by Monsignor Giovanni Battista Agucchi (1570–1632), an important art theorist who upheld the principles of classicism as opposed to the naturalism of Caravaggio and his followers. Domenichino's major works of this period were the Last Communion of St. Jerome, a justly famous altarpiece completed in 1614 and now in the Pinacoteca Vaticana, and the frescoes of the life of St. Cecilia in San Luigi de' Francesi, Rome. Drawing upon Raphael's great narrative cycles and the antique, they had a lasting influence on painters in the classical tradition, particularly Poussin (*q.v.*).

In 1616 he designed and supervised the decoration of a garden pavilion of the Villa Aldobrandini at Frascati. This cycle of frescoes, most of which is now detached and in the National Gallery, London, was once regarded as the artist's early work; now in light of its actual date its uneven quality is attributed to workshop assistants. Domenichino's most famous oil, the Hunt of Diana, in the Borghese Gallery, Rome, was executed about 1617.

In mid-1617 Domenichino returned to his native city, then dominated by Reni, and executed two large altarpieces. In 1621 he went back to Rome as the papal architect to the new pope, Gregory XV. The following years were occupied by the important frescoes in the tribune of Sant'Andrea della Valle, completed in 1628. Challenged by the rivalry of Giovanni Lanfranco (1582–1647), who filled the dome of this church with a daringly illusionistic Assumption, Domenichino divided the apse of the church into rectangular compartments, which he treated as separate pictures, avoiding an overall baroque effect.

In 1628 he was elected president of the Accademia di San Luca, the artists' professional association. In 1631 he accepted a commission to decorate the chapel of San Gennaro in the Cathedral of Naples.

The jealousy of the local painters caused him to flee to Rome in 1634, but he returned the following year and worked on the chapel until his death.

9　Landscape with Moses and the Burning Bush

IN THE foreground of a deep river landscape (Fig. 1) Moses kneels before brilliant yellow and orange flames of a burning bush. Dressed as a shepherd, he wears a loose-fitting, brown fur tunic and has a scarlet cape thrown over his left shoulder. With his right hand he shields his head from the fire, and with his left he leans on a staff to support himself. The bush burns at the foot of a lofty tree, which reaches almost to the top of the picture (Fig. 2). It has a gnarled trunk and dark green and bronze-colored foliage. Immediately behind Moses (Fig. 1) grazes his flock of sheep, gathered in a fold constructed with thin posts and wattling.

Beyond the sheep, in the middle ground (Fig. 3), stands another tall tree, its golden foliage silhouetted against the sky. Farther back on the right several hills and a precipitous cliff, covered with dark green trees, tower over a fortified city. Its silvery strongholds and dark gray buildings overlook a bend in the river, which continues beyond to the horizon. Flecks of white paint in the river mark the sails of ships below the dark blue mountains in the distance. The river has a greenish blue cast, contrasting with the pure cerulean hue of the sky. There are wispy clouds high in the sky.

1. *Detail: Moses and his flock of sheep*

2. *Detail: trees in the foreground*

PROVENANCE: This picture was first recorded at the end of the seventeenth century (Rossini, 1693, p. 48). At that time it was hanging in a small room of the Palazzo Colonna, Rome, as the pendant to Domenichino's Landscape with Tobias Laying Hold of the Fish, now in the National Gallery, London (Fig. 4). Although these pictures were described then simply as a pair of landscapes, it is safe to assume that they are the Wrightsman and London paintings because the Colonna Collection did not have any other pairs of landscapes by Domenichino. Furthermore, in the 1783 catalogue of the Colonna Collection, their subjects and dimensions are given. The 1783 catalogue also specifies that they were executed on copper, a fact that distinguishes them from all the other landscapes with Moses and Tobias attributed to Domenichino, which are on canvas (see under Versions, below).

It is not known when the pictures were acquired by the Colonna family. However, as Levey (1971, p. 93) remarks, they probably were bought by Lorenzo Onofrio Colonna (1637–1689), a great patron of Claude Lorrain and a celebrated collector of landscape paintings (see Marcel Röthlisberger, *Claude Lorrain: The Paintings*, I, *Critical Catalogue*, New Haven, 1961, pp. 374–375).

At some unknown date both pictures were sold from the Palazzo Colonna and eventually made their way to England, where they were first documented in the possession of Arthur Harrington Champernowne (1769–1819). They were in the posthumous sale of his collection at Christie's, London, June 30, 1820, lots 84 (the Wrightsman picture, "a charming silvery specimen") and 85 (the National Gallery picture). They next belonged to Admiral Lord Radstock (William Waldegrave, 1753–1825) and were included in his sale at Christie's on May 12, 1826, as lots 58 and 59. The catalogue entry for the latter describes the painting now in the Wrightsman Collection: "A Landscape, companion to the preceeding [*sic*], in which is introduced Moses before the burning bush, in the same sweet tone, and of equally beau-

[74]

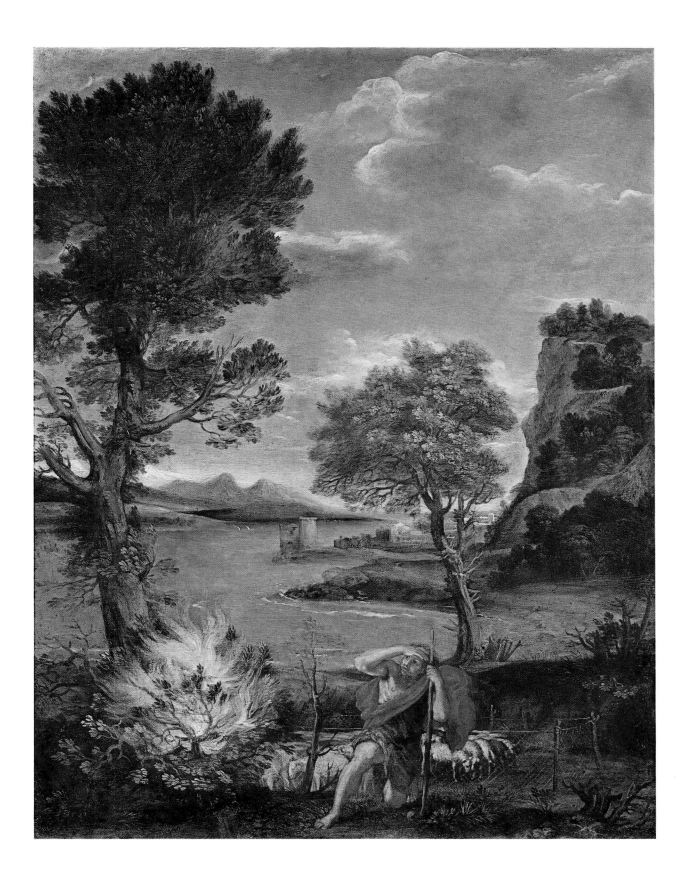

3. Detail: tree and city in the middle ground

tiful execution. . . . This and the preceding Picture are from the Colonna Palace." At the Radstock sale the pictures were sold separately: lot 58 was purchased for £430 by the Rev. W. Holwell Carr, who bequeathed it five years later to the National Gallery; lot 59 went for £270 to Alexander Baring (1774–1848), who became the first Lord Ashburton in 1835. Waagen (1854, p. 101) saw it in the London residence of his son, William Bingham Baring (1799–1864), second Lord Ashburton. It passed by descent to Alexander Francis St. Vincent Baring (born 1898), the sixth and present Lord Ashburton, who offered it for sale at Christie's on June 26, 1970, lot 73. Mr. and Mrs. Wrightsman acquired it at this auction.

THE NARRATIVE of this picture is taken from the Old Testament (Exodus, Chapter 3). It is one of three miracles—the burning bush, the serpent rod, and the leprous hand—that God showed Moses to confirm his divine mission to lead the people of Israel out of Egypt. As Moses was tending the sheep of his father-in-law Jethro, "the angel of the Lord appeared unto him in a flame of fire out of the midst of a bush: and he looked, and, behold, the bush burned with fire, and the bush was not

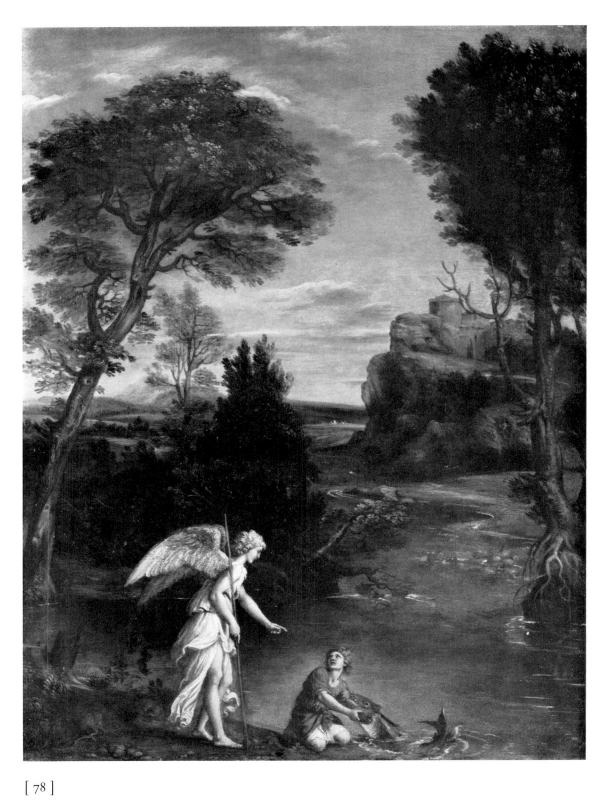

4. *Domenichino, Landscape with Tobias Laying Hold
of the Fish. Oil on copper, 45.1 by 33.9 cm. London,
National Gallery*

consumed." Moses stared at the bush and God called out to him, "Draw not nigh hither: put off thy shoes from off thy feet, for the place whereon thou standest is holy ground." Then, "Moses hid his face; for he was afraid to look upon God."

Domenichino portrayed the first part of this story, the instant Moses sees the bush and falls on one knee in a dramatic attitude of surprise and reverence. He depicted the Old Testament hero as a robust, manly figure, his face filled with awe. Behind Moses his flock grazes unperturbed, and the idyllic, sunny landscape contains no suggestion of the extraordinary event taking place in the foreground. If anything, the serenity of the setting makes the miracle seem all the more mysterious and supernatural.

When this picture was first recorded (see Provenance, above), it was the pendant to another landscape by Domenichino showing Tobias Laying Hold of the Fish (Fig. 4). They are related to one another in that both were painted on pieces of copper approximately the same size, the scale of the figures in relation to the backgrounds is about the same, and the handling of paint is almost identical. Furthermore, Tobias's red tunic is the same shade as the cape Moses wears. There does not, however, appear to be an obvious iconographic link between the two pictures, aside from the general one of having miraculous themes. Nevertheless, they appear to have been conceived as a pair. Perhaps their subjects appealed to the artist because they afforded the opportunity to paint sweeping landscapes.

In other paintings Domenichino illustrated different events from Moses' life, but none of them are directly related to the Wrightsman or London pictures. One is a Landscape with Moses Delivering the Daughters of Raguel from the Shepherds

(J. Byam Shaw, *Paintings by Old Masters at Christ Church Oxford*, London, 1967, pp. 106–107, catalogue no. 196, pl. 137). A second example is a Landscape with the Finding of Moses (Borea, 1965, p. 179, catalogue no. 72, pl. 72)—this picture may be by a follower rather than by the artist himself.

There also once existed another Landscape with Moses before the Burning Bush (Fig. 5), which

5. *H. Adam, Landscape with Moses and the Burning
Bush. Etching, 14.5 by 16.5 cm., from Muxel,
Gemälde Sammlung in München seiner Königl.
Hoheit des Dom Augusto Herzogs von Leuchtenberg
und Santa Cruz Fürsten von Eichstädt, Munich,
about 1835*

was attributed to Domenichino in the Leuchten-berg Collection, Munich (see J. N. Muxel, *Gemälde Sammlung in München seiner Königl. Hoheit des Dom Augusto Herzogs von Leuchtenberg und Santa Cruz Fürsten von Eichstädt*, Munich [1835?], p. 24, catalogue no. 75, illustrated in an etching). Its composition is quite unlike that of the Wrights-man picture. It is horizontal rather than vertical, and shows Moses covering his face with both hands, as a half-length figure of God emerges from the flames. A canvas of exactly the same design appeared in the auction of the Felix Ziethen Collection (Helbing's, Munich, September 22, 1934, lot 98, pl. XVIII, fig. 98). It probably was the Leuchtenberg picture.

The chronology of Domenichino's landscapes has not been firmly established. None of them can be dated with certainty, though comparisons can be made with the backgrounds of his documented works. His earliest landscapes appear to be pictures such as the Rest on the Flight into Egypt, in the Musée Mandet, Riom, and Peasants Crossing a Ford, in the Galleria Doria Pamphili, Rome, which are densely constructed in the manner of Annibale Carracci and filled with glimpses of genre scenes taken from everyday life. Domenichino's later landscapes are the large canvases in the Louvre, majesterial settings for the Labors of Hercules and Erminia Appearing to the Shepherds. The latter, incidentally, has a fold of sheep not unlike the one in the Wrightsman picture.

The landscapes with Moses and the Burning Bush and Tobias Laying Hold of the Fish would appear to be the work of the artist's early maturity. The closest analogy in his documented work to the composition of the Wrightsman painting can be seen in Domenichino's drawing for one of the Frascati frescoes showing Apollo pursuing Daphne (Fig. 6). The figures occupy the foreground, and a pair of tall trees tower over the vista of the valley in the background. It also has a lofty hill on the right, comparable to the cliff on the right of the Wrightsman picture. Since the Frascati frescoes were designed in 1616 (Levey, 1971, p. 101), it

6. *Domenichino, Landscape with Apollo and Daphne. Pen and brown ink on paper, 25.6 by 19.4 cm. Windsor, Royal Library*

would not be unreasonable to suppose that the Wrightsman and London landscapes date from about the same time. Richard E. Spear (letter, March 10, 1972) suggests dating them slightly earlier, about 1610–1612.

Both pictures are prime examples of Domenichino's contribution to the development of land-

scape painting. Although relatively small pictures, they are remarkable for their sense of vast spaciousness. At the beginning of the seventeenth century, Domenichino's master Annibale Carracci had invented a new type of landscape, the so-called heroic landscape, which consisted of carefully constructed panoramas dominated by relatively large figures. In Domenichino's work, the figures are smaller in scale, and nature becomes the dominant subject of the picture. Because of their truth to nature they are the direct antecedents of the celebrated landscapes of Claude Lorrain.

VERSIONS: There are at least two known copies of the Wrightsman picture, as well as others mentioned in literary sources. Since all of them were painted on canvas, they cannot be confused with the original, which was painted on copper.

The most widely known version belongs to the Boymans-van Beuningen Museum in Rotterdam (inventory no. 1189; oil on canvas, 43.5 by 34.5 cm.). It is generally accepted as an autograph work by Domenichino (see, for example, Evelina Borea, "Aspetti del Domenichino paesista," in *Paragone*, no. 123, March 1960, pp. 12, 13, pl. 15; Johann Conrad Ebbinge-Wübben, *Museum Boymans-van Beuningen: Catalogus schilderijen tot 1800*, Rotterdam, 1962, p. 45; catalogue for the 1962 exhibition at Bologna, pp. 79, 105–106, pl. 23; Borea, 1965, pp. 60, 173, pl. 54a). But compared to the Wrightsman picture, the flames in the Rotterdam version are lifeless, the folds of the garments inert, and the foliage tellingly weak. It is unconvincing as an original and appears to be no more than a contemporary copy. This view is shared by Denis Mahon (letter, September 21, 1970) and Richard E. Spear (letter, March 10, 1972).

The second extant copy belongs to the Earl of Lichfield, Shugborough, England (Courtauld Institute photograph, no. B54/937). Of very poor quality, it is coarsely painted on canvas and may be a seventeenth- or even an eighteenth-century copy. Borea (1965, p. 173) tentatively considers it an original, and adds that another possibly autograph version was included in the Ziethen sale in 1934 at Munich (but this is an entirely different composition, see Fig. 5).

A version of the Wrightsman picture belonged to Cardinal Jules Mazarin (1602–1661) and was recorded in an inventory made at his death (see Gabriel Jules Cosnac, *Les Richesses du Palais Mazarin*, 2nd ed., Paris, 1885, p. 295,

catalogue no. 946). Another is listed in the sale catalogue of the Earl Waldegrave Collection, Prestage's, London, November 19, 1763, lot 21 (19 by 15 inches). Neither of these pictures has been traced; it is conceivable that they could be identical to one or the other of the extant copies.

EXHIBITED: British Institution, London, *Italian, Spanish, Flemish and Dutch Masters*, 1828, catalogue no. 23.

REFERENCES: Pietro Rossini, *Il Mercurio errante delle grandezze di Roma, tanto antiche, che moderne*, Rome, 1693, Book I, p. 48 (among the small paintings in the Palazzo Colonna, he lists "due Paesi, del Domenichino") // Anonymous, *Catalogo dei quadri, e pitture esistenti nel Palazzo dell'eccellentissima Casa Colonna in Roma*, Rome, 1783, p. 69, catalogue no. 558 (lists it as one of a pair of paintings on copper by Domenichino, "di palmi 2. per alto," approximately 18 inches high) // Friedrich Wilhelm Basilius von Ramdohr, *Ueber Mahlerei und Bildhauerarbeit in Rome*, Leipzig, 1787, II, p. 109 (lists two small landscapes by Domenichino in the ninth room of the Palazzo Colonna) // Gustave Friedrich Waagen, *Treasures of Art in Great Britain*, London, 1854, II, pp. 98, 101 (describes it as "Remarkably powerful, and full and marrowy in the painting"; gives its location as Lord Ashburton's residence in Piccadilly, London, rather than his country seat, the Grange, Hampshire) // *L'Ideale classico del seicento in Italia e la pittura di paesaggio*, exhibition catalogue, Bologna, 1962, pp. 105–106, catalogue no. 23, entry by Gian Carlo Cavalli (confuses the picture now in the Wrightsman Collection with the Rotterdam version, proposing a date for it between 1612 and 1615) // Evelina Borea, *Domenichino*, Milan, 1965, p. 173, catalogue nos. 54a, 54b (observes that Domenichino's Landscape with Moses and the Burning Bush formerly in the Colonna Collection was recorded as painted on copper, and that it may be identical with the painting seen by Waagen in the Ashburton Collection) // Michael Levey, *National Gallery Catalogues: The Seventeenth and Eighteenth Century Italian Schools*, London, 1971, p. 92 (identifies it as the version paired in the Colonna Collection with Domenichino's Landscape with Tobias Laying Hold of the Fish, now in the National Gallery, London; states that they "need not have been painted as a pair, and show little sense of being composed as pendants, but obviously share a date of origin" around 1617–1618).

Oil on copper, H. 17¹¹⁄₁₆ (45.0); W. 13³⁄₈ (34.0).

The painting was cleaned at the Metropolitan Museum by Hubert von Sonnenburg in 1970.

LUCA GIORDANO (1634–1705), nicknamed *Luca fa presto* because of the speed with which he worked, produced a prodigious number of large oil paintings and enormous ceiling frescoes. Working out of Naples, his native city, he received commissions from all over Italy and even from the king of Spain, helping to establish Naples as an art center of international importance.

Giordano was capable of working in any style he chose. He astonished his contemporaries with convincing pastiches of Dürer, Lucas van Leyden, Rubens, Rembrandt, Veronese, Sebastiano del Piombo, Raphael, and Titian. At the beginning of his career Giordano's personal style was most indebted to Jusepe Ribera (1591–1652), the Spanish master who worked in Naples. Most of Giordano's youthful works were influenced by Ribera's choice of subject matter and style. Painted in dark, somber tones with almost no bright colors, they usually represent single half-length figures of hermit saints, philosophers, or astrologers.

Shortly after Ribera's death, Giordano traveled to Rome, where he studied the works of Raphael (1483–1520) and Pietro da Cortona (1596–1669). He then went to Venice and saw the works of Titian (1487/90–1576) and Veronese (1528–1588). The result of these trips can be seen in the Miracle of St. Nicholas, an altarpiece Giordano painted in 1654 when he returned to Naples. Although this altarpiece still reflects Ribera's influence, it reveals Giordano's personal genius in its daring synthesis of the formal language of Roman baroque art and the saturated colors of Venetian Renaissance painting.

Giordano's palette gradually became lighter and his brushwork more spontaneous. By the time he returned to Venice during the 1660s to paint three altarpieces in the church of the Salute his personal style was fully formed. The brilliantly colored Salute altarpieces, painted with incredible freedom and dynamic energy, were to have lasting influence on Venetian painters of the late seventeenth and early eighteenth centuries.

About 1681 Giordano was called to Florence by the Corsini family to paint the cupola of their family chapel. During this period in Florence he also executed one of his greatest masterpieces, the ceiling frescoes in the Palazzo Medici-Riccardi.

At the invitation of Charles II of Spain, Giordano left Naples in 1692 and traveled to Madrid. He painted several vast ceiling frescoes for the king in the Escorial, and he executed many easel pictures for the Spanish court and private patrons in Madrid. His works of this late period are comparable to those of Titian, in that they convey a pictorial vision through loosely painted forms that appear to dissolve in light and color. He tended at this time to use thinly applied paint and transparent glazes of color, a technique inspired perhaps by the pictures he saw in Spain by Velázquez (1599–1660).

In 1702 Giordano returned to Naples and during the three remaining years of his life completed some of his finest works, the altarpieces of Sts. Philip Neri and Charles Borromeo in the church of the Gerolomini and the frescoes in the charterhouse of San Martino.

Giordano is remembered today as an artist of extraordinary talent and untiring energy. He profoundly changed the character of Neapolitan painting during the seventeenth century, replacing the

dark tenebrism of Caravaggio's followers with brilliantly colored, luminous compositions painted in a grandiloquent manner that paved the way for the rococo painters of the next century.

10 The Annunciation

THE VIRGIN, kneeling on the right at a *prie-dieu*, turns and looks up at the Archangel Gabriel flying above her. Directly above Gabriel is a flying white dove from which radiates a hazy golden glow filling the upper third of the painting. The architectural background is of simple but imposing gray masonry walls with a doorway visible behind Gabriel's legs. In the upper right corner of the picture two putti pull back a dark green curtain. The putto closest to the foreground is naked, while the one behind him is partly covered by a billowing white sash.

The Virgin (Fig. 2) wears a loosely fitting red garment tied at the waist, with wide sleeves to the elbows. Her forearms are covered by the sleeves of a thin white blouse. A heavy blue mantle is wrapped around her legs and over her shoulders, with one end trailing over the top of the *prie-dieu*. A filmy golden veil falling from her head is held across her breast with her left hand.

The Archangel Gabriel (Fig. 3) floats suspended in a graceful contrapposto pose with his left leg projecting in front of his right. He carries a branch of lilies in his left hand and raises his right in a commanding gesture. In contrast to the Virgin's dark brown hair and eyes, he is very fair, with curly blond hair. He wears a filmy white garment, tied at the waist with a long yellow sash trailing behind him. His garment is pinned above his left knee with a golden brooch set with a red stone and a large pendant pearl. A plum-colored mantle swirls around his shoulders and waist. His sandals are tied with crisscrossed golden straps decorated with

pearls and red jewels. His widespread wings are of blue and white feathers.

In the left foreground is a gilded stool (Fig. 4) ornamented with a carved mask between its elaborately scrolled legs. On top of the stool is a green box with several pieces of material piled on it. On the floor in front of the stool are some white fringed material and a ball of white yarn. The floor has a geometric gray and beige pattern.

The *prie-dieu* is light brown with a partially opened door on the side. There is a lectern with an opened book on top of it. The painting is signed and dated on the base of the *prie-dieu* in dark brown paint: *L. Jordanus F. 1672* (Fig. 1).

1. *Detail: signature and date*

PROVENANCE: The picture was acquired in Paris in 1958.

THIS LARGE altarpiece is an outstanding example of Italian baroque painting at its best. It is painted in a bold, flowing manner; the effortless brush strokes fairly glide across the canvas. Beginning with a fundamentally balanced composition, Gior-

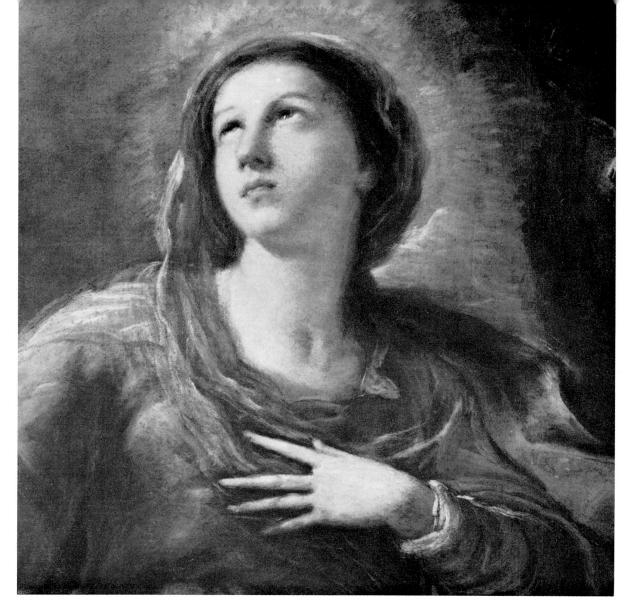

2. Detail: Virgin

dano charges the picture with emotional theatri-
cality. Everything seems to be set in motion, even
the color itself, which shimmers and dissolves in
light. Giordano shows the Virgin illuminated by a
miraculous radiance. Her face, full of devotion,
looks up at the Archangel hovering in mid-air. A
mass of swirling drapery and smoldering color,
he glances at her lovingly and announces that she
will give birth to the Son of God.

Giordano's Annunciation was painted at a cru-
cial point in his career. It is one of his few surviving
works dating from the decade when his style

changed from the essentially Venetian manner of
his early masterpieces to the high baroque style of
his full maturity. This decade begins with the
Assumption of the Virgin of 1667, in Santa Maria
della Salute, Venice, and ends with the magnificent
frescoes of 1678 in Santa Brigida, Naples. In his
earlier work the artist still leans heavily upon the
great Venetian masters of the sixteenth century,
particularly Tintoretto (1518–1594) and Titian
(1487/90–1576). But by the end of the decade, his
personal idiom was completely formed. The
Wrightsman Annunciation is inscribed 1672, plac-

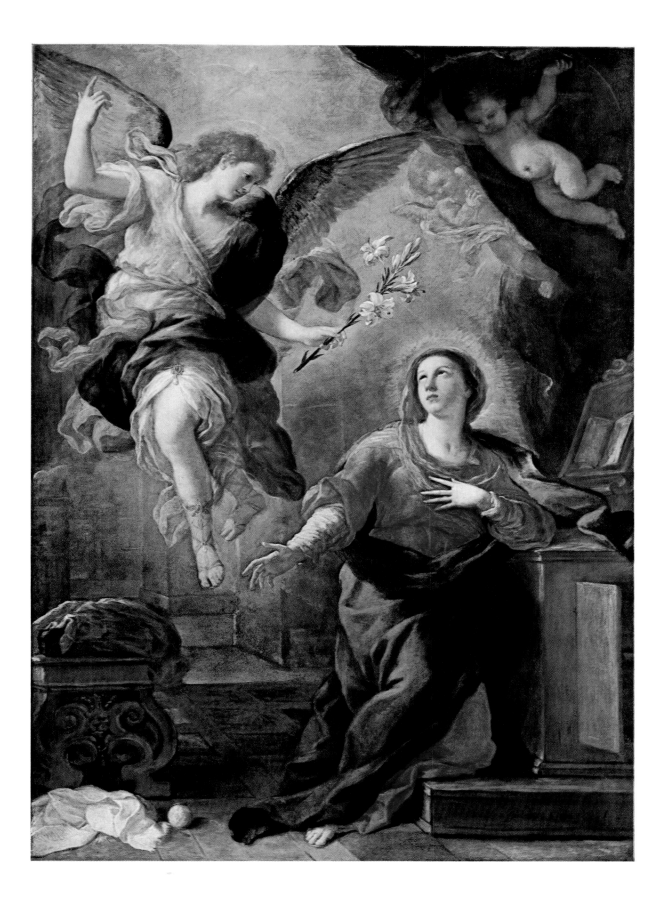

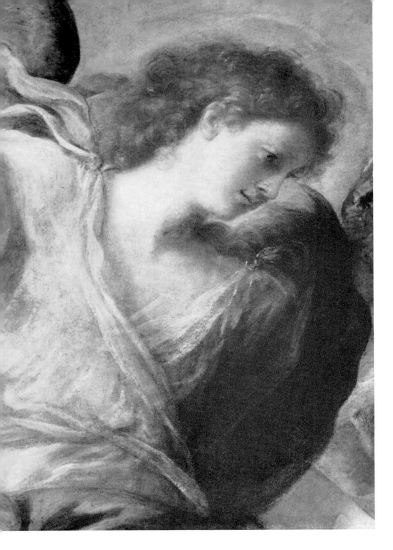

LEFT:
3. *Detail: Archangel Gabriel*

some biographers have maintained. Because the Wrightsman Annunciation bears the same date, there is a good likelihood that it was also painted in the south.

The early history of Giordano's Annunciation is unknown, but it is possible that it shared the same provenance as the Crispano altarpiece. The two pictures are so closely related that they may well have been painted as pendants for the same church. Besides having the same date, the Crispano and Wrightsman altarpieces are nearly the same size. Moreover they are intimately related in style and motifs; the gestures, for instance, of the Virgin's hands are repeated in reverse by the St.

4. *Detail: wooden stool and sewing box*

ing it midway between these two points. It is clearly a work of transition, reflecting the influences of Giordano's early period and anticipating the baroque exuberance of his developed style.

The date of Giordano's Annunciation suggests that it was painted in southern Italy, rather than in Venice (as stated by La Farge, 1967, p. 60). The only other dated work by Giordano surviving from this period is a large altarpiece of the Madonna of the Rosary (illustrated by Ferrari and Scavizzi, 1966, fig. 126). Dated the same year as the Wrightsman Annunciation, it is located in the parish church at Crispano, a village north of Naples on the road to Caserta. The location of the Crispano altarpiece proves that Giordano must have worked in and around Naples during the early 1670s and not have remained in Venice as

[87]

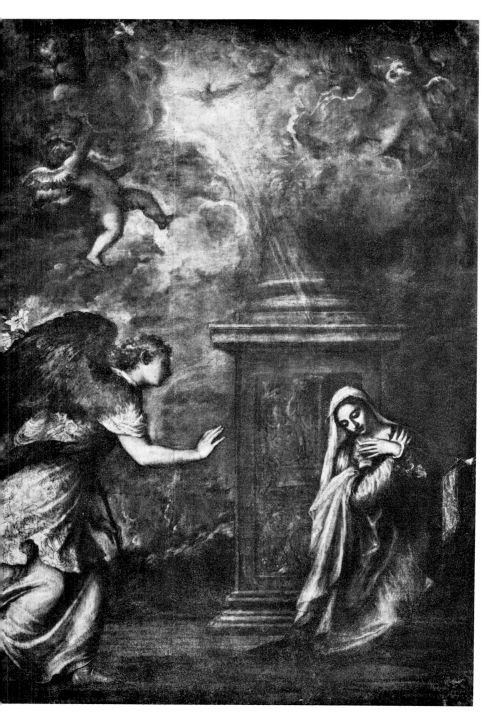

Catherine in the Crispano altarpiece. Because of the large size, splendid quality, and fact that the Madonna of the Rosary is a Dominican subject, it seems likely that it was commissioned for a wealthy Dominican church in Naples and then, at a subsequent unknown date, transferred to the country church at Crispano. Since there is virtually no mention of the Wrightsman altarpiece in any Italian guidebook or inventory, it is possible that it shared a similar fate.

The style of the painting is consistent with the influences Giordano could have experienced in his native city of Naples. Although he traveled extensively and was profoundly affected by what he saw, he had ample opportunity to familiarize himself with paintings in Naples by several leading masters. The great Feast of Herod by Rubens (*q.v.*), now in the National Gallery of Scotland, had been there from about 1640, in the collection of Gaspar de Roomer (died 1674). Its luscious handling of paint, rich coloring, and fluid composition had a profound effect upon Giordano. In the Wrightsman altarpiece Rubens's influence is particularly apparent in the billowing drapery and the filmy transitions of glowing color.

Even more influential for the development of Giordano's style was a large painting of the Annunciation (Fig. 5) by Titian. Painted about 1555–1556 and installed shortly thereafter in the church of San Domenico in Naples, it was one of the finest paintings the artist could have seen in his native city. As a young man Giordano paid Titian's painting the compliment of making a full-size copy of it. This copy, now in the church of San Ginés, Madrid, is so faithful to the original that some writers have actually believed it to be by Titian and the original to be by Giordano. Titian's Virgin, kneeling at a *prie-dieu* on the right with her arms folded over her breast, is comparable to the Virgin in the Wrightsman Annunciation. In

5. *Titian, Annunciation. Oil on canvas, 280.0 by 210.0 cm. Naples, San Domenico. Photo: Anderson*

painting her, Giordano seems particularly to have been inspired by Titian's luminous coloring and ease of execution.

Giordano's treatment of the Archangel Gabriel may owe something to another composition by Titian, a lost altarpiece of yet another Annunciation. Although Giordano could never have seen this painting, which was already missing in the sixteenth century, he could surely have seen the widely circulated engraving after it (Fig. 6) by Giovanni Jacopo Caraglio (about 1500–1570). In the engraving the Archangel has just alighted in the Virgin's chamber, his draperies billowing out around him. He carries a branch of lilies and raises his right hand with the index finger extended just as he does in the Wrightsman altarpiece.

Giordano's conception, however, is far more baroque than either of these Annunciations by Titian. For example, Giordano shows Gabriel flying, whereas Titian depicts him walking. By placing Gabriel in mid-air, Giordano gives his composition greater physical action and dramatic excitement. Compared with those in the two Annunciations by Titian, the figures in the Wrightsman Annunciation are larger in relation to the overall proportions of the altarpiece and add to the imposing theatrical character of the picture.

The impetus for this baroque style came from Pietro da Cortona, the great Roman painter and architect. Cortona, in a series of magnificent fresco decorations, epitomized the Roman baroque style. In Naples there is a large painting by him representing the Ecstasy of St. Alexis (Fig. 7). Executed about 1638 for the church of San Filippo Neri, Naples, its bold composition has the essential element of Giordano's Annunciation. It shows two principal figures, an angel hovering in mid-air above the supine figure of a saint, illuminated by a diagonal shaft of light. Everything in the composition is vested with a sense of motion and energy, even the drapery encircling the legs of the saint in ecstasy. As a young artist growing up in Naples, Giordano must have been impressed by this picture.

6. *Giovanni Jacopo Caraglio, copy after a lost Annunciation by Titian. Engraving, 45.5 by 31.7 cm. New York, The Metropolitan Museum of Art, Elisha Whittelsey Fund, 49.97.219*

Pietro da Cortona also painted a large altarpiece of the Annunciation (Fig. 8), comparable in spirit and design to the Wrightsman Annunciation. Executed about 1665, it is more nearly contemporary to the Wrightsman picture than is Cortona's altarpiece in Naples. Giordano conceivably could have seen it on one of his trips through Tuscany before he painted the Wrightsman Annunciation. He was, however, already well acquainted with Cor-

[89]

7. *Pietro da Cortona, Ecstasy of St. Alexis. Oil on canvas, 240.0 by 175.0 cm. Naples, San Filippo Neri. Photo: Gabinetto Fotografico Nazionale*

OPPOSITE:

8. *Pietro da Cortona, Annunciation. Oil on canvas, 400.0 by 280.0 cm. Cortona, San Francesco. Photo: Gabinetto Fotografico, Florence*

tona's style, and this specific picture need not have influenced him when he painted the Wrightsman altarpiece. As early as 1655 he had borrowed, if not plagiarized, motifs and complete groups of figures from Pietro da Cortona's frescoes in the Palazzo Barberini, Rome (Walter Vitzthum, review of Ferrari and Scavizzi, in *The Burlington Magazine*, CXII, April 1970, pp. 242, 244). By 1672, when Giordano painted the Annunciation in the Wrightsman Collection, his admiration for Cortona manifested itself not so much in quotations from his work as in a new feeling of expansiveness, prodigious energy, and a masterful control of light and movement. These are the qualities that distinguish the Wrightsman Annunciation, separating it from Giordano's previous work.

There is a drawing by Giordano of the Annunciation in the Museum of San Martino at Naples (illustrated by Giuseppe Scavizzi, "Disegni di Luca Giordano a Capodimonte e a San Martino," in *Napoli Nobilissima*, III, July–August 1963, fig. 8). Milkovich (1964, p. 33) has suggested that it might be a study for the Wrightsman altarpiece. It is not, however, very closely related in composition or style. In the drawing the figures of the Virgin and the Archangel Gabriel are reversed, and Gabriel flies in from the side, rather than appearing suspended in an upright position as he does in the Wrightsman painting. Moreover, the drawing has a balustrade running across the middle ground of the composition and a large bed on the left, neither of which appear in the altarpiece. For these reasons the drawing seems to be related to the Wrightsman altarpiece only by subject.

EXHIBITED: Brooks Memorial Art Gallery, Memphis, Tennessee, *Luca Giordano in America*, 1964, catalogue no. 7 (illustrated); The Metropolitan Museum of Art, New York, exhibited since 1959 except when lent to the Brooks Memorial Art Gallery; The Metropolitan Museum of Art, *Master-*

pieces of Fifty Centuries, November 1970—June 1971 (not included in the catalogue).

REFERENCES: Michael Milkovich, *Luca Giordano in America: Paintings, Drawings, Prints: A Loan Exhibition*, Memphis, Tennessee, 1964, p. 33, illustrated p. 9, catalogue no. 7 (catalogues the picture as an autograph work, calling it a "delicate and poetic composition"; suggests that a drawing of the Annunciation in the Museo di San Martino, Naples, might be a preparatory study by Giordano for the picture; states that the composition was "probably inspired" by another drawing of the Annunciation in the Louvre by Pietro da Cortona) / / Oreste Ferrari and Giuseppe Scavizzi, *Luca Giordano*, Naples, 1966, I, pp. 68–71, 234; II, pp. 76, 78–79; III, fig. 125 (regard the picture as an exquisite work, "raffinatissima," and observe that it is strongly influenced by Pietro da Cortona, not only in its general composition but also in its liquid pictorial treatment, the rhythmical arrangement of the figures, and the atmospheric space; the authors also note that the Wrightsman Annunciation and an altarpiece at Crispano, also dated 1672, are Giordano's only securely documented works surviving from the period between 1668 and 1675) / / Henry A. La Farge, "Noble Metropolitan Visitors," in *Art News*, LXV, February 1967, p. 60, fig. 6 (assigns it to Giordano's Venetian period) / / Ann Tzeutschler Lurie, "The Apparition of the Virgin to Saint Francis of Assisi," in *The Bulletin of the Cleveland Museum of Art*, LV, February 1968, pp. 51, 52 note 36 (compares the composition to that of Giordano's Allegory of Sacred and Profane Love in the Ringling Museum, Sarasota, Florida).

Oil on canvas, H. 93⅛ (236.5); W. 66⅞ (169.9).

There is no record that the painting has ever been cleaned. The varnish surface was refreshed in January 1960, September 1965, and again in January 1970. In 1965, several old discolored restorations were corrected by Hubert von Sonnenburg of The Metropolitan Museum of Art.

EL GRECO (Domenikos Theotopoulis, 1541–1614) was the outstanding painter in Spain during the last quarter of the sixteenth and the first part of the seventeenth century. He was born at Candia, a small town on the island of Crete, then part of the Venetian republic. The last record of his presence there is dated 1566. Throughout his life he was deeply interested in Greek literature and philosophy. He was an avid collector of Greek and Latin books, and his friends in Italy and Spain were learned humanists.

El Greco studied in Venice under Titian (about 1487/90–1576) for an unspecified length of time. During the decade of the 1560s, Titian painted several masterpieces that marked the beginning of his late style, notably the Annunciation and the Transfiguration, in San Salvatore, Venice, and the Martyrdom of St. Lawrence, now in the Escorial. The explosive handling of paint and the impassioned emotional force of these pictures made a profound impression on the young artist from Crete.

El Greco left Venice for Rome shortly before November 1570, when Giulio Clovio (1498–1578), the manuscript illuminator, recommended him to his patron, Cardinal Alessandro Farnese. El Greco appears to have been granted lodgings in the Palazzo Farnese, and several of his early works, among them the Miracle of Christ Healing the Blind, now in the Pinacoteca at Parma, once belonged to the Farnese Collections. In Rome, El Greco was also befriended by Fulvio Orsini, librarian to Cardinal Farnese. The inventories of Orsini's possessions show that he owned at least seven paintings by El Greco, including the Portrait of Giulio Clovio now in the Museo Nazionale di Capodimonte, Naples.

Sometime before the spring of 1577, El Greco moved to Spain. During the period that he worked in Italy, El Greco never received commissions for altarpieces or other large paintings, and it is possible that he left because of the promise of important commissions at Toledo or the Escorial. He received a commission from Philip II for a large painting of the Allegory of the Holy League, at the Escorial. The Allegory evidently did not win the king's favor, for El Greco was not invited to paint any further pictures for the Escorial.

He finally settled at Toledo and remained there for the rest of his life. His three altarpieces in the church of Santo Domingo el Antiguo, Toledo, and his Espolio, in Toledo Cathedral, all completed by 1579, were received favorably. Their success marked the first appearance of El Greco as a truly major artist. He developed quickly, and the high point of his career was reached with the Burial of the Conde de Orgaz (1586) in Santo Tomé, Toledo. With its intensely expressive, elongated figures placed in an unrealistic setting, it is a masterly example of El Greco's highly personal idiom. The stylized character of El Greco's work recalls the contemporary painting of the Italian Mannerists, but the highly charged, mystical force of his paintings is the product of his own reaction to the Counter Reformation and the religious beliefs of his time.

Throughout his career, El Greco often painted more than one version of his compositions. As his popularity grew, the number of these versions increased so greatly that it is not unusual to find as many as ten or twelve of a single composition. He was aided by a team of assistants, who were so skillful that it is often difficult to determine which versions the master actually painted himself.

11 The Miracle of Christ Healing the Blind

THE MIRACLE takes place in a vast architectural setting. A line of gray, arcaded buildings runs diagonally from the left-hand side of the picture toward the horizon near the center of the composition. Behind the figures and the architecture there are patches of lapis-lazuli blue sky and rolling white clouds. In the foreground there are two large groups of figures.

The one on the left consists of eleven figures, including Christ, his right hand on the eyes of a blind man kneeling before him, and a partially clad youth, his arm raised, his back to the spectator. The colors of Christ's red-violet tunic and lapis-lazuli robe are repeated in the youth's red-violet cloak, which is lined with the same shade of blue. The body of the kneeling man is partially covered with a golden brown cloth. Most of the men in the crowd behind the three principal figures are dressed in pale blue and gray, except for one who wears a white turban and a bright green cloak.

The group of seven standing figures on the right balances the one on the left. The figure closest to the edge of the pavement is seen from behind, like the gesticulating youth on the left. He wears a golden robe lined with blue over a red-violet tunic. The bald, bearded man standing with both arms outstretched wears a blue-violet tunic and a green mantle with a golden brown lining. The figure on the far right, with downcast eyes, wears a white mantle with gold and gray stripes.

In the foreground there is a curious opening in the pavement, where a man and woman stand and stare with amazement at the miracle. The dark-skinned man wears a simple green garment, and the woman wears a filmy white blouse and a blue and red robe. In the middle ground two men, clad in diaphanous pink, blue, and gold robes, sit on a step in the pavement (Fig. 1). In the background several figures run before a carriage drawn by a pair of white horses (Fig. 2).

PROVENANCE: The picture once belonged to Martin H. Colnaghi (died 1908), the nephew of Paul and Dominic Colnaghi, the famous English art dealers. The back of the canvas formerly bore one of his labels, which was lost when the painting was relined in 1958. It was stamped 2424 R, and gave the address of Martin Colnaghi's firm, the Guardi Gallery, at 11 Haymarket. He moved to this address in 1876.

There was also once a note pasted to the back of the canvas. Now preserved in The Metropolitan Museum of Art, it states that the painting was "Brought from Mr. Rennie, 6 Gt. Cumberland Place, Hyde Park, July 8th, 1877." This establishes that the painting entered the collection of William Rennie (died 1888) shortly after it belonged to Martin Colnaghi. It is not clear why the picture was "brought from" Mr. Rennie's residence on July 8, which was a Sunday in 1877. It is possible, however, that it was being delivered to a restorer or framemaker.

The painting remained in William Rennie's

1. Detail: two men sitting on the pavement

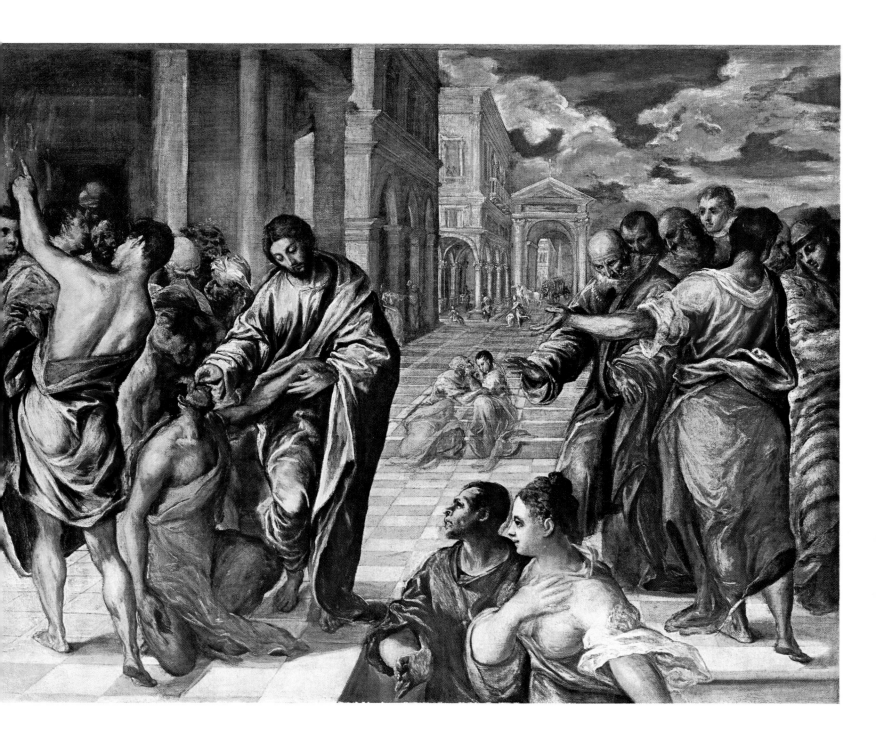

possession until his death, when it was sold along with the rest of his collection at Christie's on April 23, 1888 (lot 88, as by Tintoretto, for 17 gns.). The purchaser's name at this sale was Eyles, about whom nothing is known. The painting subsequently passed to the Smith-Bosanquet family. It was sold by George Smith-Bosanquet of Hengrave, Bury St. Edmunds, Suffolk, at Christie's on May 9, 1958 (lot 14, as by Veronese, for 36,000 gns.). It was acquired by Mr. and Mrs. Wrightsman in 1960.

2. *Detail: city gate with a carriage drawn by two white horses*

THE MIRACLE of Christ Healing the Blind, a subject typical of El Greco's Italian period, is described in the Gospels of Sts. Mark (8:22–25), John (9:1–11), and Matthew (9:27–31). The three accounts differ slightly. According to Mark, Christ healed a single blind man at Bethsaida by spitting on his eyes and placing his hands on him. According to John, Christ gave sight to a blind man by anointing his eyes with clay and sending him to bathe in the pool of Siloam. Matthew speaks of two blind men, and it is probably his version of the story that El Greco followed when he designed his painting.

Some observers have maintained that the picture

[97]

illustrates the version of the story with one blind man, as related in the Gospels of Sts. Mark and John. According to this interpretation, the blind man is depicted three times in the painting: kneeling before Christ who anoints his eyes, standing on the left and pointing upward in wonder at the light which he sees for the first time, and finally seated in the middle ground where his eyes are examined by one of the Jews who "did not believe that he had been blind and had received his sight." The man and woman in the foreground would be the blind man's parents, who were called and questioned about their son.

The notion of composing a picture with different events of the narrative shown happening simultaneously was not uncommon during the Renaissance, and it was particularly characteristic of the Byzantine school of painting, with which El Greco was familiar from childhood. But the three figures in the painting supposed to be the blind man are so dissimilar that it is unlikely that the painter intended them to be the same person. They wear different-colored clothing, and the kneeling man has a much darker complexion than either the youth seen from behind or the figure seated on the step in the middle ground. The probability is that El Greco has followed the Gospel of St. Matthew and shown two blind men, one who is being anointed by Christ and one who has already been cured and exclaims to the crowd behind him.

If El Greco used Matthew as his source, he may also have included in his painting other incidents that are described only in this Gospel. Matthew's account of the Miracle of the Blind is immediately preceded by an account of Christ raising from the dead the daughter of Jairus, and it is followed by the story of Christ healing a dumb man "possessed with a devil." It is inferred by A. G. Xydis (1963, pp. 27–36) that El Greco also incorporated these miracles in the Wrightsman painting and that the mysterious figure with downcast eyes on the far right is the daughter of Jairus. The shroud-like costume of this figure lends color to this hypothesis. By the same token, the emotion-filled man

with the woman in the immediate foreground might be the mute whom Christ cured. But there is no convincing internal evidence for identifying any of the figures, except Christ and the blind men. The others simply represent the multitude of Pharisees and the Apostles who witnessed the miracle.

Of the three accounts of the miracle, Matthew's is the most dramatic and the one most likely to have appealed to the imagination of the young painter. The only calm element in his painting is the figure of Christ, whose gentle gesture of healing contrasts with everything around him. He stands in a statuesque pose, with one foot placed in front of the other, his right knee bent. The turbulent crowd behind him, the gesticulating Pharisees, the intense and eager curiosity of the man who watches the miracle from below, the little figures running in the distance, and even the agitated patterns of the clouds are full of excitement and movement. All this is emphasized by the play of bright colors, intense blue, green, and red-violet, and by the free, almost impetuous quality of the brushwork.

Although the color and the mode of painting the draperies were inspired by El Greco's master, Titian, the dramatic perspective of the space behind the figures is reminiscent of Tintoretto. The young El Greco must have felt an innate sympathy with Tintoretto's treatment of supernatural lighting effects and of wild, rushing movement. These Venetian elements in the picture were recognized in the past, for it was catalogued in the nineteenth century as a Tintoretto and only recently as a Veronese.

According to Wethey (1962, p. 41), Christ Healing the Blind was a subject inspired by the Counter Reformation. When it was painted, the picture would have been read by El Greco's contemporaries as an allegory of the Church of Rome as an embodiment of true faith and religion. Similarly, El Greco's paintings of the Purification of the Temple were symbolic of the reform of the Church during the mid-sixteenth century. These subjects had rarely been depicted in art before the

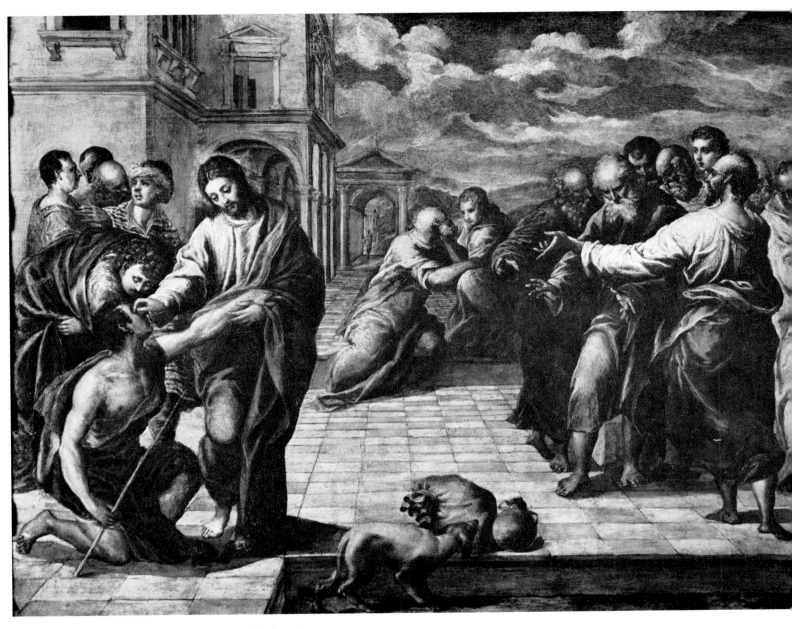

3. El Greco, *Miracle of Christ Healing the Blind.* Oil on wood, 66.0 by 84.0 cm. Dresden, Staatliche Gemälde-Galerie. Photo: Deutsche Fotothek

time of the Counter Reformation. The sudden rise in popularity of these themes is documented by the numerous occasions on which El Greco and his followers painted them. At least five autograph versions of the Purification of the Temple are known to exist.

In addition to the painting now in the Wrightsman Collection, there are two other paintings of Christ Healing the Blind by El Greco, one in the Staatliche Gemälde-Galerie, Dresden, and another in the Galleria Nazionale, Parma. Although both are much more highly finished, the compositions are intimately related to that of the Wrightsman painting. The one at Dresden (Fig. 3), about one half the size of the Wrightsman painting, is painted on a wooden panel. The main elements are the same, but the two half-length figures in the foreground of the Wrightsman painting are missing, as is the second blind man who raises his arm and turns his back to the spectator. One detail of the Dresden picture that does not appear in the Wrightsman painting is the dog sniffing the sack and gourd in the center foreground. Also there are changes in emphasis: for example, the less elaborate architectural background and the less pronounced sense of recession in depth, in addition to the changed scale of the pair of figures in the middle ground, who are much larger than their counterparts in the Wrightsman painting. The version now at Parma (Fig. 4) more closely resembles the Wrightsman painting. Its architectural background is more like that of the Wrightsman painting than that of the version at Dresden, and it includes the second blind man. It is, however, considerably smaller (less than one half the size), and the figures are bigger in scale.

Together, all three variants form a remarkable record of El Greco's early development as an artist. Although some writers have dated them over a span of as many as ten or twelve years, they may well have been painted during a much shorter interval of time. The handling of color and the brushwork of the version at Dresden have a strong Venetian cast, and the picture accordingly is dated by most writers shortly before El Greco left Venice, but it could have been done in Rome, before he came under the influence of the Roman school. The version now at Parma was certainly done after he arrived in Rome in 1570. It once belonged to the Farnese family, who patronized El Greco in Rome during the early 1570s. Moreover, some details in the painting seem to have been inspired by Roman monuments. The ruins standing at the end of the perspective of the pavement were inspired by the Baths of Diocletian, and the nude with a black beard on the left is reminiscent of the Hellenistic Hercules, which then belonged to the Farnese family. But the differences between the Dresden and Parma versions are more than archaeological details. By simultaneously enlarging the scale of the figures in the foreground of the version at Parma and by reducing the size of the figures in the middle ground, El Greco gave the composition a monumental character that captures the grandiose spirit of Roman art. Rather than standing in an orderly fashion on a neatly drawn pavement, as the figures do in the Dresden version, the figures in the foreground tower over their setting with mighty gestures. The irrational separation of the figures from their spatial environment in the version at Parma is prophetic of the direction El Greco's style would take in his subsequent works. By the time of his first altarpieces in Spain, he did away with realistic architectural backgrounds and placed his figures in abstract, visionary settings, without perspective and illusionistic three-dimensional space.

The version of Christ Healing the Blind in the Wrightsman Collection may have been painted shortly after El Greco reached Spain in 1577, but it is still the product of his experiences in Italy. It repeats certain details from the version at Dresden, such as the city gate in the background. Like the general style of the Dresden version, this particular detail is highly Venetian in character, having been inspired by a design for a stage setting by Sebastiano Serlio (1475–1554; illustrated by Wethey, 1962, fig. 7). Serlio's design has a similar gate with a

4. *El Greco, Miracle of Christ Healing the Blind. Oil on canvas, 50.0 by 61.0 cm. Parma, Galleria Nazionale. Photo: Alinari*

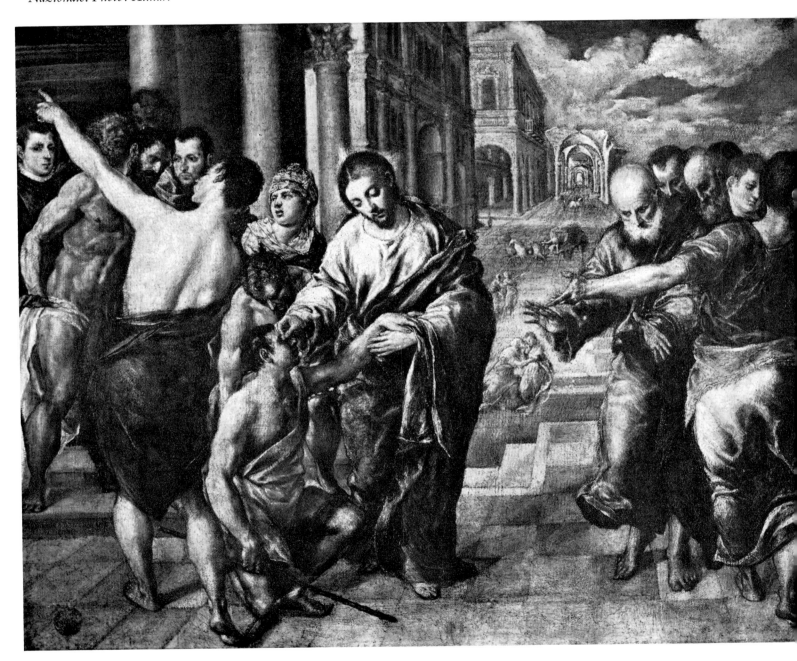

5. *Francesco Salviati, Visitation. Fresco. Rome, San Giovanni Decollato. Photo: Gabinetto Fotografico Nazionale*

statue standing at the apex of the pediment (the statue is painted rather sketchily over the pediment in the Wrightsman painting). Moreover, the Dresden version also shows, on the far right, a bearded man dressed in a yellow cloak who resembles the figure that has been identified as the daughter of Jairus in the Wrightsman painting.

Fundamentally, the Wrightsman painting is more closely connected with the version at Parma and, like it, owes some of its style to contemporary Roman art. The two figures in the foreground of the painting, for instance, recall an unusual illusionistic device employed by Francesco Salviati (1510–1563) and Pirro Ligorio (about 1510–1583) in their frescoes for the oratory of San Giovanni Decollato, Rome. These frescoes (Fig. 5) show members of the confraternity of San Giovanni Decollato portrayed as spectators standing in an area cut out of the immediate foreground of the platform on which the religious scenes take place. During the years El Greco was in Rome this device was also used by Federico Zuccaro (about 1540–1609) in his frescoes in the Oratorio del Gonfalone, Rome (dated 1573). El Greco repeated this arrangement for the portraits in another work of his Roman period, the Purification of the Temple, now in the Minneapolis Institute of Arts.

There are two copies of the Wrightsman painting in Spain. The picture may have been there before it was taken to England, where it was first documented in Colnaghi's possession. It probably was not brought out of Spain until the late nineteenth century, as there is no record of any picture of Christ Healing the Blind in English exhibitions or sales before then.

Although the painting is typical of El Greco's development in the years immediately before he left Italy for Spain, it possesses at the same time elements of his fully developed style. The coloring is particularly close to that of the Assumption of the Virgin (dated 1577) now in the Art Institute of Chicago, which was the first altarpiece El Greco

painted on his arrival at Toledo. The Wrightsman painting is clearly a transitional work. El Greco may actually have taken it with him from Italy and worked on it after his arrival in Spain. By comparison with the architecture in the version at Parma, the buildings on the left-hand side appear to be only roughly sketched on the canvas. The unfinished columns and capitals may indicate that El Greco never completed the painting.

Although unfinished, the Wrightsman painting did not remain in El Greco's possession, since it is not listed in the inventory of his studio drawn up at the time of his death by his son Jorge Manuel. This fact and the existence of the copies in Spain suggest that it was either sold or given by El Greco to a church or collection where people saw it. Perhaps future research in Spanish inventories will disclose where this was.

VERSIONS: The variants of this composition at Dresden and Parma are given a full discussion by Wethey (1962, I, pp. 22–24; II, pp. 41–44). The one at Dresden is painted on a wooden panel, 66.0 by 84.0 cm.; the one at Parma is on canvas, 50.0 by 61.0 cm., which has been cut along the right-hand side (thus eliminating the figure corresponding to the one presumed to be the daughter of Jairus in the Wrightsman painting).

The two copies in Spain of the Wrightsman composition are in the collections of José Eduardo del Valle, Madrid, and Estanislao Herrán Rucabado, Madrid. The bibliography on these pictures is summarized by Wethey (1962, p. 175). The del Valle picture (illustrated by José Camón Aznar, *Dominico Greco*, Madrid, 1950, I, p. 237, fig. 137) does not show the last figure on the left. There are no clouds in the sky, and the blind man turning his back wears a shirt. Remains of old repaint on the Wrightsman painting show that the corresponding figure was once clothed with a shirt, too. This, as well as the repetition of other details such as the unfinished columns of the building on the left, suggests that the del Valle picture is a copy. It probably dates from sometime after the seventeenth century. The Rucabado picture (illustrated by Halldor Soehner, "Greco in Spanien. Teil II: Atelier und Nachfolge Grecos," in *Münchner Jahrbuch der bildenden Kunst*, IX-X, 1958–1959, p. 227, catalogue no. 241, fig. 51) is known only from a photograph. It was quite evidently copied from the Wrightsman painting, probably during the eighteenth or even early nineteenth century. On the basis of this copy, A. G. Xydis (1963, pp. 27–36) sug-

gested that the Wrightsman painting has been cut down slightly on all four sides.

EXHIBITED: The Metropolitan Museum of Art, New York, June-September 1960, June-August 1961, May-October 1967, and December 1972-April 1973.

REFERENCES: A. G. Xydis, Letter to the Editor, *The Times*, London, May 17, 1958, p. 7, col. 5 (discusses El Greco's paintings of the Miracle of Christ Healing the Blind and proposes that the version now in the Wrightsman Collection dates from about 1576–1577) // Stuart Preston, "Current and Forthcoming Exhibitions," in *The Burlington Magazine*, CII, July 1960, p. 334, fig. 44 (reports that the picture was then on loan to the Metropolitan Museum) // Alfred Frankfurter, "El Greco: An Autobiography in Paint," in *Art News*, LIX, Summer 1960, pp. 36–37, 73–74, fig. on p. 36, color pl. opp. p. 36 (identifies the man and woman standing in the immediate foreground as a "blind petitioner and his guardian" and suggests on the basis of the pentimenti around the man's head that El Greco began the painting in Venice and "then worked on it again after an interval of at least ten years") // Fritz Neugass, "Sommerlicher Ausklang in New York," in *Die Weltkunst*, XXX, August 15, 1960, p. 6, illustrated p. 6 (reports Frankfurter's dating of the picture and suggests that the man in the immediate foreground may be a portrait of someone who had been blind once himself and who commissioned the painting to commemorate his regained sight) // Pál Kelemen, *El Greco Revisited: Candia, Venice, Toledo*, New York, 1961, pp. 125–126 (observes that in the Dresden, Parma, and Wrightsman versions of the Healing of the Blind "the general arrangement is the same and the figure of Christ remains unchanged, suggesting that the paintings do not fall far from one another in time") // Anonymous, "Aportaciones recientes a la historia del arte español," in *Archivo Español de Arte*, no. 134, April–June 1961, p. 187, catalogue no. 178 (mentions the Wrightsman painting in connection with its having been exhibited at the Metropolitan Museum during the summer of 1960 and states that it is the third and latest version of the subject that El Greco painted) // Harold E. Wethey, *El Greco and His School*, Princeton, 1962, I, p. 38, fig. 12; II, pp. 42–43, 44, 175 (gives a detailed account of the painting and convincingly refutes Frankfurter's theory that the man and woman in the foreground were an afterthought added by the artist over a decade after he began the painting) // Roberto Longhi, "Una monografia su El Greco e due suoi inediti," in *Paragone*, no. 159, March 1963, p. 53 (mentions the Wrightsman painting in passing as an example of one of the paintings inspired by the Gospels that El Greco painted after his arrival in Rome) // Earl Rosenthal, review of Wethey's *El Greco and His School*, in *The Art Bulletin*, XLV, December 1963, p. 385 (remarks that Wethey rejected the

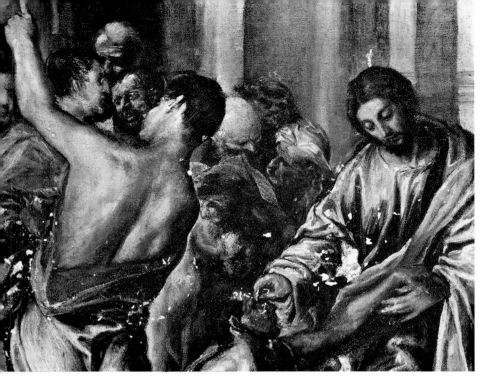

6. *Detail: Christ and the two blind men (areas of restoration). Photo: Bullaty-Lomeo*

evidence of the X-ray examination of the Wrightsman painting, which suggested to Frankfurter that the half-length figures in the foreground were later additions by El Greco to the picture) // A. G. Xydis, "New Light on the Sources and Compositional Methods of El Greco" [in Greek], in *Krētika Chronika*, XVII, 1963, pp. 27–36, pl. 1 (devotes an entire article to the painting, which he dates on the basis of style at the beginning of El Greco's Spanish period, slightly earlier than the Assumption of the Virgin in the Art Institute of Chicago, which is dated 1577; because of the more complete composition of the copy now in the Estanislao Herrán Rucabado Collection, he states that the Wrightsman painting has been cut down on all four sides; he proposes that the picture represents not only the miracle of Christ healing the blind, but also the raising of the daughter of Jairus and the healing of the dumb man, as related in the ninth chapter of the Gospel of St. Matthew) // A.G. Xydis, "El Greco's 'Healing of the Blind,' Sources and Stylistic Connections," in *Gazette des Beaux-Arts*, LXIV, November 1964, pp. 301–306, fig. 1 (suggests that certain figures in El Greco's paintings of Christ Healing the Blind were inspired by Titian's painting of the Glory of the Holy Trinity, which is now in the Prado, Madrid, and which El Greco may have known in Italy through an engraving or a copy) // Geoffrey Agnew, *Agnew's: 1817–1967*, London, 1967, unnumbered plate (illustrates it along with other pictures formerly owned by Thos. Agnew & Sons, Ltd.) // Philip Troutman, *El Greco*, rev. ed., London, 1967, pp. 25–26 (states that it is the largest and latest treatment of the subject by El Greco; dates it during El Greco's Roman period, after 1570, and suggests parenthetically that it might be identical to the painting formerly in the del Valle Collection [which is listed above as a copy]) // Denys Sutton, "Pleasure for the Aesthete," in *Apollo*, XC, September 1969, p. 231, color pl. xx.

Oil on canvas, H. 47 (119.5); W. 57½ (146.0).

The painting was cleaned and relined in 1958 by Mrs. Gertrude Blumel. It was treated again two years later by Mario Modestini. There are some losses, particularly in the drapery of Christ's outstretched arm (Fig. 6) and the throat of the woman (Fig. 7) in the immediate foreground.

7. *Detail: man and woman (areas of restoration). Photo: Bullaty-Lomeo*

FRANCESCO GUARDI (1712–1793), Venetian figure and landscape painter, is renowned chiefly for his views of Venice. But, in fact, he was a mature artist before he began to paint these *vedute*. He came of a family of painters from the Trentino and received his training at Venice in the studio of his elder brother Gianantonio (1699–1760). Gianantonio was a figure painter of no great fame among his contemporaries: his commissions consisted chiefly in providing altarpieces for unimportant churches and small cult paintings for private individuals.

It was in this studio that Francesco's early life was spent as an anonymous assistant to his elder brother. The degree to which they actually collaborated on the same paintings is not easily determined. Francesco's earliest signed work, A Saint in Ecstasy, in the museum at Trent, is a fairly conventional picture based, apparently, on an engraving after Piazzetta, and probably dating from soon after 1740. One of the two panels of Hope and Faith, in the Ringling Museum, Sarasota, Florida, was formerly signed and dated 1747, but this has been removed by cleaning. As late as 1763 Guardi was still producing baroque altarpieces of the same type as his brother's, for in that year he painted A Miracle of St. Dominic, now in the Kunsthistorisches Museum, Vienna. But already, around 1750, he seems to have begun a more individualistic career by painting landscapes either copied from or in the manner of Marco Ricci (1676–1729), as well as interiors and genre scenes somewhat in the style popularized by Pietro Longhi (1702–1785).

A number of Guardi's earliest views of Venice are copied from Canaletto's works or based on engravings after them. There seems, however, to be little basis for the contemporary assertion of Pietro Gradenigo that Guardi was a "buon scolare di Canaletto" except in this sense. These early *vedute* are frequently signed or initialed as though to draw public attention to his name as an independent artist, a habit that he seems slowly to have more or less abandoned as he established himself.

In spite of these attempts to emulate Canaletto, Guardi never obtained the success of his predecessor with his contemporaries, nor was he able to command anything like such large prices for his work. Although he enjoyed some success among the English in the second half of the eighteenth century, the rise of neoclassicism turned their attention increasingly toward antiquity. Rome rather than Venice became the focal point of the Grand Tour. In any case, Guardi's painting was of a far more rococo character than Canaletto's and therefore less calculated to appeal to the nascent neoclassic taste, though today he is the more popular of the two artists precisely on this account.

His early views were generally painted on a dark reddish bole ground and tend to be somewhat dark and heavy. With the passage of time he adopted a lighter palette, as may be seen in the series of paintings (in the Louvre and other French museums) taken from Brustoloni's engravings of the *Feste Dogale* issued in 1766 (though Guardi's "copies" were probably painted over a period of several years after this). The changed style is very evident in the views commissioned by the City of Venice recording the visit of the Pope in 1782. Guardi rarely dated his paintings, but a sufficient number, such as these,

are datable on historic, topographic, or other external grounds, so that it is possible to establish a reasonably coherent chronology of his stylistic development.

Guardi was a prolific and attractive draughtsman. He seems to have had no assistant apart from his nephew Giacomo (1764–1835), who appears to have inserted the figures in a number of his uncle's later works, as well as to have completed paintings and drawings left unfinished in the studio at his death.

12 View of the Villa Loredan near Paese

THE BACK OF the villa, a three-storied block in the Palladian style, with a central triangular pediment, is seen across a broad lawn. It is flanked at the right (Fig. 1) by an arcaded *barchessa*, or outbuilding, within a curved wall pierced by a gate. Farther to the right are two smaller villas. On the left there is a low building beyond the garden wall, at the end of which is an aviary in which a golden pheasant can be recognized. A fourth, larger villa with a curved pediment is visible, slightly lower down, beyond the trees at the left. The season is early autumn, for the leaves are just turning brown, and the bluish foothills of the Alps in the distance are touched with the first snow.

In the foreground at the left (Fig. 2) an artist, presumably Francesco Guardi himself, wearing a red cloak, kneels before a garden seat on which he is sketching the scene. Standing, watching him, are two men, one with his back to the spectator dressed in brown, the other in profile to the right, in pale yellow. In the middle distance (Fig. 1) two men and a woman, wearing a pale blue cloak over a pink skirt and with feathers in her headdress, are playing with three dogs, one of which sits upright on its hind legs and begs. Farther off are other figures, one of them leading a horse.

PROVENANCE: This picture and the three others mentioned below were probably painted for John Strange (1732–1799), British Resident in Venice between 1773 and 1790. Three of the four views seem to correspond to the following items in the catalogue (not recorded by Lugt) of the sale by private treaty of a number of Strange's paintings, which took place at the European Museum in London on May 27, 1799, some two months after the owner's death:

Lot 49 A superb chateau in the environs of Padua, Guardi

Lot 187 A view near Padua Mr. Strange's country seat, Guardi

Lot 200 A view near Padua, Mr. Strange's country house

They evidently were unsold, for on March 15 of the following year they appeared in the sale at Christie's of paintings from the collection "formed by the late John Strange, Esq." By this time they had been linked up with a fourth painting:

Lot 97 Guardi A pair of views near Padua, Mr. Strange's country house

Lot 99 Guardi Two, a superb chateau and companion, in the environs of Padua

The confusion of the name of a small and unfamiliar village in the Veneto, Paese, with the widely known city of Padua by the auctioneer preparing the catalogue of the earlier sale is readily understandable. The paintings next make their appearance in the collection of Colonel Milligan of Caldwell Hall, Burton-on-Trent, Nottinghamshire. They are listed in the catalogue of the sale of his

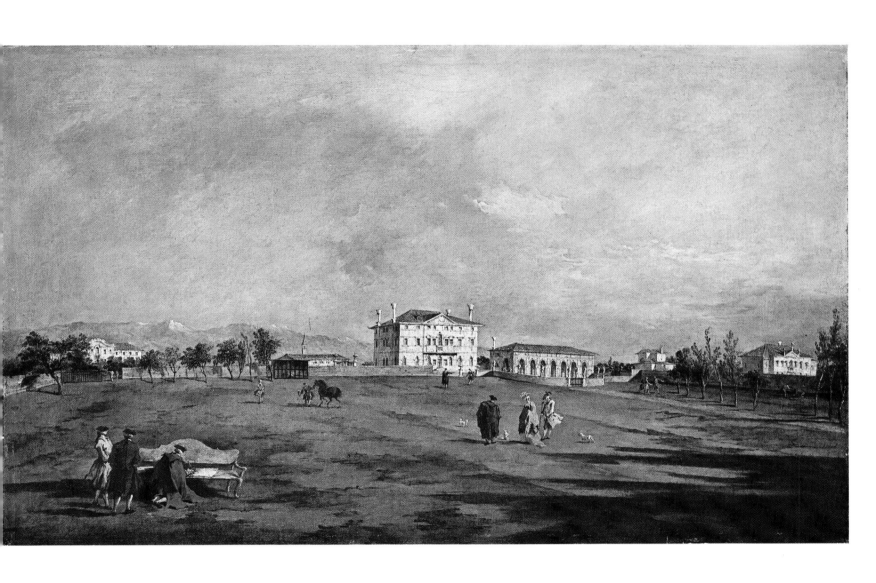

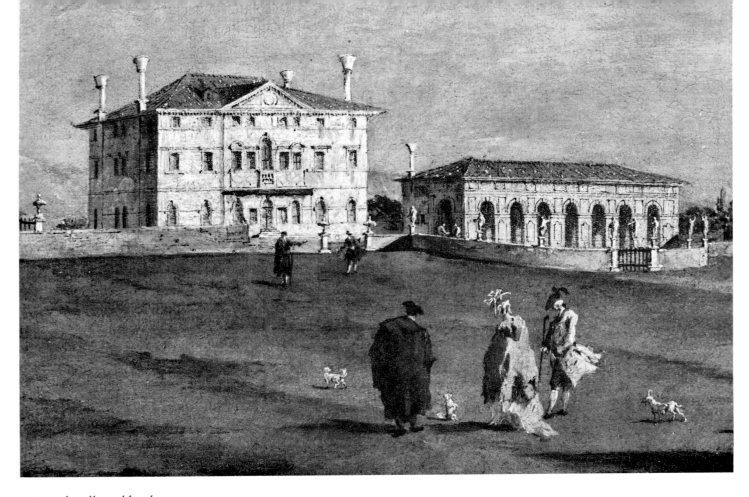

1. *Detail: villa and barchessa*

2. *Detail: artist sketching*

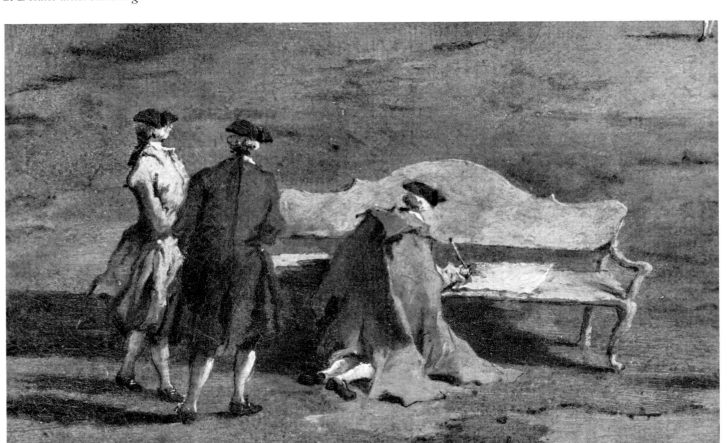

[109]

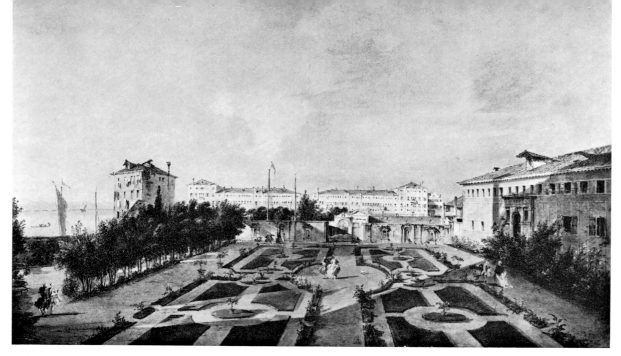

ABOVE:

3. *Francesco Guardi, View of the Courtyard of the Palazzo Contarini dal Zaffo, Venice. Oil on canvas, 49.0 by 79.0 cm. Present whereabouts unknown. Photo: Frederick Mont*

4. *Francesco Guardi, View of the Front of the Villa Loredan. Oil on canvas, 49.0 by 79.0 cm. London, private collection. Photo: National Gallery*

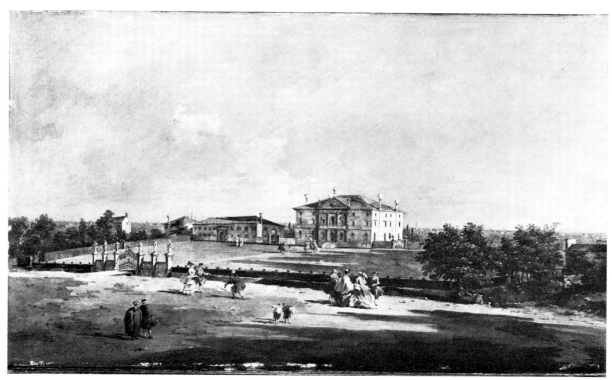

pictures at Christie's on March 13, 1883, as:

Lot 358 A Pair of Views of Country seats near Venice
with figures 20 × 24
Lot 359 A Pair of Ditto

All four were purchased by the well-known dealer Charles Davies for 700 guineas. It is not known on whose behalf he was buying them, but in these years he was buying extensively for various members of the Rothschild family. They next appear during the 1920s in the collection of Harold Sidney Harmsworth, first Viscount Rothermere (1868–1940). According to Ames (1963, p. 37), Rothermere acquired them from Colnaghi's. They are not listed in Paul G. Konody's catalogue, *Works of Art in the Collection of Viscount Rothermere* (London, 1932), nor were they included in the post-humous sale of part of the Rothermere Collection at Christie's on December 19, 1941, although there were no less than fifteen paintings by Guardi in the sale. They appear to have been sold privately before this date. In 1955, when the painting was exhibited at Zurich, it was in a private collection in London. Mr. and Mrs. Wrightsman acquired it in London in 1968.

THIS PAINTING is one of a group of four views (see Provenance, above) by Guardi, three of them representing villas (they are the only painted views of this type by Guardi known) and a fourth, the courtyard of the Palazzo Contarini dal Zaffo at Venice (Fig. 3). One of these shows the front of the same villa that forms the principal subject of the Wrightsman painting (Fig. 4). A drawing (Fig. 5) by Guardi in the Ashmolean Museum, Oxford, corresponds closely to this painting and bears an inscription said to be in John Strange's hand: "View of the Seat of S. E. Loredano at Paese near Treviso at present in the possession of John

5. *Francesco Guardi, View of the Front of the Villa Loredan. Pen and ink on paper, 40.0 by 75.5 cm. Oxford, Ashmolean Museum*

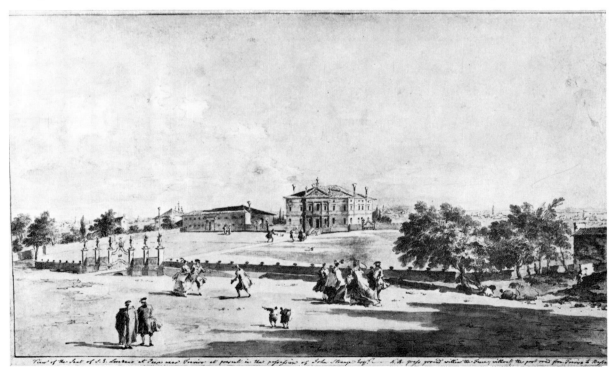

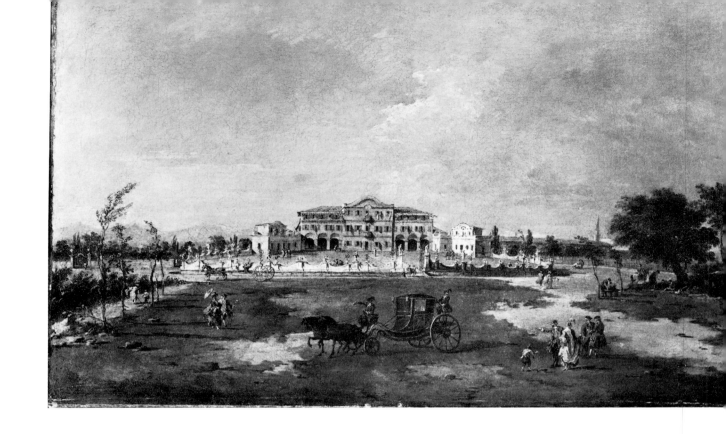

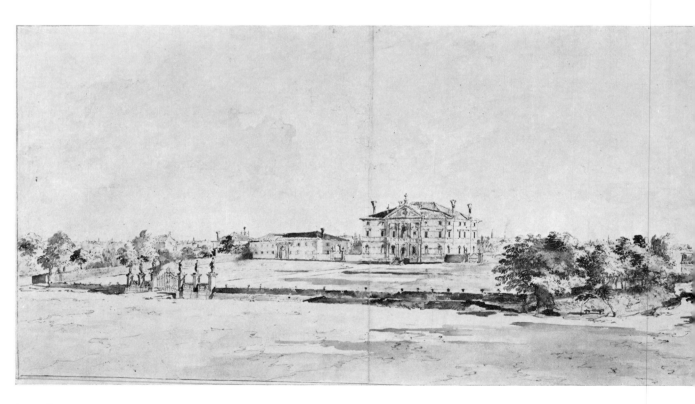

Strange, Esq. N. B. grass ground within the Fence; without the post road from Treviso to Bassan." This establishes the locality of the scene. Another of these four paintings (Fig. 6) shows the villa with a curved pediment (Villa del Timpano Arcuato) seen at the left of the Wrightsman painting.

In the autumn of 1778 Guardi (who was evidently on good terms with Strange; see below) visited the Val di Sole where his family owned property (see Fernanda de Maffei, *Gian Antonio Guardi: pittore di figura*, Verona, 1951, pp. 42–43). He also seems to have visited the same neighborhood in 1782 (see George Simonson, *Francesco Guardi: 1712–1793*, London, 1904, p. 52). On both his journeys he would have passed not far from Paese, and it seems likely that he made drawings of the villas on one of these occasions, as he is doing in the foreground of the Wrightsman painting.

A number of drawings of the immediate vicinity of Strange's villa are known, five of them relating directly to the Villa Loredan:

1. A view of the front of the villa (Fig. 7), in the Metropolitan Museum.

2. A second, smaller version of this, in the Museum of the Rhode Island School of Design, Providence (Zampetti, 1965, p. 321, catalogue no. 59, fig. 59).

3. The inscribed drawing (Fig. 5) in the Ashmolean Museum, Oxford, mentioned above.

4. A view from one of the back windows of the Villa Loredan, also in the Ashmolean Museum, Oxford.

5. A view from the front of the Villa Loredan showing the entrance gate and the plain of the Veneto beyond, in the Fodor Museum, Amsterdam.

In addition, a signed drawing by Guardi for the front of the adjacent Villa del Timpano Arcuato is in the Musée Wicar at Lille (illustrated by Ames, 1963, pl. 21). Small, somewhat faint sketches of both villas are found again on the reverse of the drawing in Providence already referred to (illustrated by Ames, 1963, p. 39, fig. 2). There may have been at one time a drawing of the back of the Villa Loredan corresponding more or less with the Wrightsman painting. But if so, its present whereabouts is unknown. None of these drawings is specifically listed among the sixty or seventy drawings by Guardi included in the sale of Strange's prints and drawings at Christie's, March 19–24, 1800.

The architect who built the villa for the Loredan family at Paese in the mid-seventeenth century is unknown. Sometime before 1779 Count Gerolamo Antonio Loredan sold the villa, with all its contents and splendid furnishings, to the Marquis Giuseppe de Canonicis (Giuseppe Mazzotti, *Le ville venete*, Treviso, 1952, p. 435), and it may have been from this family that Strange rented the villa as a summer retreat during his official appointment at Venice. According to Morassi (1950, p. 56), neither the Villa Loredan nor the neighboring villas exist today. Only the large *barchessa* seen in the painting survives next to the municipal offices of the village, which was formerly known as "Villa di Villa" on account of the importance of these neo-Palladian houses.

John Strange, diplomat, author, antiquarian, naturalist, and art collector, was British Resident at Venice in 1773 until 1790, though in fact he did not function after April 1786, being absent until May 1790 when his appointment was terminated. Strange arrived in Venice to take up his appointment on August 28, 1774. He was a collector of old masters, as well as modern paintings and drawings, and a patron of Guardi, some fifteen of whose paintings were in his collection when he died. Like most English diplomatists of his day

living in Italy, he dabbled in art dealing and, for instance, supplied six paintings by Guardi to Thomas Martyn, a Fellow of Sidney Sussex College, Cambridge, known as a connoisseur and collector (on Strange as a patron, see Francis Haskell, "Francesco Guardi as *Vedutista* and Some of His Patrons," in *Journal of the Warburg and Courtauld Institutes*, XXIII, 1960, pp. 268–270; also Francis Haskell, *Patrons and Painters*, London, 1963, pp. 373–375). It has been suggested, plausibly enough, that one of the figures in the foreground watching Guardi may be Strange, but the circumstances concerning the commission of the painting are not known, so one cannot be sure. Moreover, it is not clear why the group of view paintings in Strange's possession included one of the courtyard of the Palazzo Contarini dal Zaffo in Venice (Fig. 3), a fifteenth-century palace that was acquired in 1783 by the Manzoni, a family of rich silk merchants.

The dating in the late 1770s suggested in part by John Strange's possible ownership of the painting and also by the date of Guardi's visits to the neighborhood of the Villa Loredan is supported by the style of the costumes in the painting. As Watson (1967, p. 98) has observed, the lady in the Wrightsman painting (Fig. 1) wears the feathered headdress that became fashionable in 1775 in Paris and somewhat later in other European centers.

The style of the painting also coincides with this period in Guardi's career. Painted with daring freedom, it heralds the beginning of the master's late style. The dark shadows cast across the lawn in the foreground and the light glistening on the façades of the buildings are impressionistic effects that do not appear in earlier works. Likewise, the use of small globules of paint resembling shining pinheads of light on the surface of the canvas points to a date in the late 1770s. Unlike most of Guardi's earlier works, which were painted on rather dark reddish grounds, the View of the Villa Loredan was prepared with a lighter ground color with the result that the finished painting possesses a silvery gray and blue tonality, characteristic of Guardi's finest pictures.

EXHIBITED: Royal Academy of Arts, London, *European Masters of the Eighteenth Century*, 1954–1955, catalogue no. 89; Kunsthaus, Zurich, *Schönheit des 18. Jahrhunderts*, 1955, catalogue no. 134.

REFERENCES: Antonio Morassi, "Settecento inedito (II): VIII. Quattro 'Ville' del Guardi," in *Arte Veneta*, IV, 1950, pp. 50–56, figs. 51, 53 (publishes for the first time the painting and three others from the same series, which he dates about 1780; reproduces some of Guardi's drawings of the front of the villa) // J. Byam Shaw, *The Drawings of Francesco Guardi*, London, 1951, p. 65, catalogue no. 30, pl. 30 (describes it in a list of the paintings and drawings related to a drawing of the Villa Loredan in the Metropolitan Museum) // Anonymous, *European Masters of the Eighteenth Century*, exhibition catalogue, London, Royal Academy of Arts, 1954–1955, p. 40, catalogue no. 89 (calls it one of two views of the Villa Loredan, in a set of four paintings that were probably commissioned by John Strange) // J. Byam Shaw, "Guardi at the Royal Academy," in *The Burlington Magazine*, XCVII, January 1955, p. 16; reprinted in *J.B.S. Selected Writings*, London, 1968, pp. 117–118 (mentions it and the view of the Villa del Timpano Arcuato from the same series as "in perfect condition and, to my taste, among the most exquisite of Guardi's works") // K. T. Parker, *Catalogue of the Collection of Drawings in the Ashmolean Museum*, Oxford, 1956, II, pp. 501–511, catalogue no. 1015 (mentions the set of four villa views to which the Wrightsman painting once belonged and discusses Guardi's drawings of the front of the Villa Loredan) // Rodolfo Pallucchini, *La pittura veneziana del settecento*, Venice, 1960, p. 248 (dates the set of four villa views, of which the Wrightsman painting is one, during the last decade of Guardi's life) // Winslow Ames, "The 'Villa dal Timpano Arcuato' by Francesco Guardi," in *Master Drawings*, I, Autumn 1963, p. 37 (mentions the four views, which he reports passed from Colnaghi's to Lord Rothermere) // Jacob Bean, *100 European Drawings in The Metropolitan Museum of Art*, New York, 1964, notes to pl. 46 (lists it in a discussion of a drawing [Fig. 7] by Guardi of the Villa Loredan in the Metropolitan Museum) // Pietro Zampetti, *Mostra dei Guardi*, exhibition catalogue, Venice, 1965, p. 268, catalogue no. 139 (mentions the group of four views that belonged to John Strange in the catalogue entry for the View of the Villa del Timpano Arcuato, which was included in the exhibition) // Francis J. B. Watson, "Guardi and England," in *Problemi guardeschi: Atti del convegno di studi promosso dalla mostra dei Guardi*, Venice, 1967, p. 210 (refers to "the splendid group of four views of the country villa Strange rented at Paese" [in point of fact only two of the series depict this villa]) // F. J. B. Watson, "The Gulbenkian Guardis," in *The Burlington Magazine*, CIX, February 1967, p. 98 (observes that Guardi's "well-known views of Strange's villa at

Paese . . . cannot have been painted before mid-1774 and probably date from a good deal later"; he also notes that the women in these paintings wear a feathered headdress first made fashionable in Paris in 1775) // J. C. Links, "Secrets of Venetian Topography," in *Apollo*, XC, September 1969, pp. 227–229, color pl. XIX (discusses the painting in detail and states that the "Palladian style villa [was] built for the Loredan family in the middle of the seventeenth century, but sold by them some hundred years later and rented by Strange as his summer residence during his appointment at Venice") // Denys Sutton, *Italian Drawings from the Ashmolean Museum, Oxford*, exhibition catalogue, London, 1970, catalogue no. 70 (says that a drawing in the Ashmolean Museum of the front of the Villa Loredan "is related to a painting of the same subject now in the collection of Mr. and Mrs. Charles Wrightsman which is dated by F. J. B. Watson 1728 [*sic*], but may be a copy from it rather than a study for it" [this is incorrect on two counts: Watson associates the views of the Villa Loredan with a trip that Guardi made to the Val di Sole in 1778; secondly, the Ashmolean drawing is connected with a painting formerly in the Rothermere Collection of the front of the Villa Loredan; the Ashmolean drawing may be either a study for this painting or a copy after it, but in no case is the drawing related to the Wrightsman painting]) // Antonio Morassi, in the preface to Mercedes Precerutti-Garberi, *Frescoes from Venetian Villas*, New York, 1971, p. 1 (refers to the Wrightsman painting as one of "four splendid canvases" by Guardi that were discovered in London during the Second World War; states that the Villa Loredan had already disappeared in the nineteenth century) // Jacob Bean and Felice Stampfle, *Drawings from New York Collections III: The Eighteenth Century in Italy*, exhibition catalogue, New York, 1971, p. 87, catalogue no. 207 (mention the Wrightsman canvas in connection with Guardi's drawings of the Villa Loredan).

Oil on canvas, H. 17⅞ (45.6); W. 30 ¹³⁄₁₆ (78.0).

The Wrightsman painting and the other views from the same set were cleaned in London about 1941 or 1942 by Norman Hulme. There is no record of the Wrightsman painting's having been cleaned since that time.

GUERCINO (Giovanni Francesco Barbieri, 1591–1666) reflects in his work two trends in seventeenth-century Italian painting, the painterly style of baroque artists such as Caravaggio (1573–1610) and Pietro da Cortona (1596–1669) and the restrained manner of classical painters such as Poussin (*q.v.*) and Domenichino (*q.v.*). Guercino began with fluidly painted compositions, filled with glowing colors, but gradually evolved a subdued, undramatic style.

Born at Cento, a village near Bologna, Guercino was trained by an insignificant painter, Benedetto Gennari the elder (active 1585–1610). However, his style was far more influenced by Ludovico Carracci (1555–1619), by Scarsellino (1551–1620), by Guido Reni (*q.v.*), and by Rubens (*q.v.*). His first important work, the Madonna in Glory with Four Saints, painted in 1616, now in the Musée d'Art Ancien, Brussels, displays a precocious understanding of contemporary Venetian and Ferrarese painting.

A year later he was called to Bologna by Archbishop Ludovisi who, as Gregory XV, was to play an important role in Guercino's career. At Bologna the young artist painted several altarpieces that rank with the greatest masterpieces of seventeenth-century Italian painting. Among them are the Investiture of St. William, in the Pinacoteca at Bologna, and St. Francis in Ecstasy with St. Benedict, in the Louvre. Painted in 1620, they both show a distinctive, fully mature style.

When Ludovisi was elected Gregory XV in 1621, Guercino went to Rome and painted the large fresco of Aurora on the ceiling of the Casino of the Villa Ludovisi, which belonged to the Pope's nephew. Its bold foreshortening and illusionistic architectural setting mark the climax of his early development and an important stage in the evolution of the baroque style.

Between 1621 and 1623 Guercino worked on a huge altarpiece of the Burial and Reception into Heaven of St. Petronilla, commissioned for St. Peter's and now in the Pinacoteca Capitolina, Rome. According to some critics, this was the turning point in Guercino's career. Its unusually clearly organized composition, made up of compact forms seen in an evenly distributed light, shows a new classical approach. This change may have been prompted by Giovanni Battista Agucchi (1570–1632), an art theorist who championed the classical style of the Carracci and Domenichino.

Following Gregory's death in 1623, Guercino returned to Cento where he worked for the next twenty years. Content in the provincial setting of his native town, he declined invitations to work in London for King Charles I in 1625, or to work in Paris for Queen Marie de Médicis in 1629 and 1639. In 1629 Velázquez (1599–1660) paid a visit to the painter at Cento. Guercino remained there until 1642, when, shortly after Guido Reni's death, he transferred his studio to Bologna, where he took on religious commissions of the kind Reni had monopolized.

Guercino's style became increasingly classical, with a much lighter palette, reminiscent of Reni's late works. But it is interesting that even as late as 1660, when Don Antonio Ruffo of Messina commissioned him to paint a companion piece to his painting by Rembrandt (1606–1669) of Aristotle with a Bust of Homer, now in The Metropolitan Museum of Art, Guercino agreed to paint it in his "early manner" so that it would harmonize with the rich chiaroscuro of Rembrandt's painting.

13 The Vocation of San Luigi Gonzaga

SAN LUIGI GONZAGA stands gazing at a crucifix held on an altar by a life-size angel. The youthful saint has close-cropped hair and wears a white surplice over a black cassock (Fig. 1). At his feet are a branch of white lilies and a gold coronet with pearls and red and blue gems.

The angel (Fig. 2), standing on a step before the altar, has long blond hair and widespread white wings. His white blouse falls from his right shoulder to his waist, exposing his arm and part of his chest. Covering most of his body is a blue-violet robe, which has a bright blue lining, visible in the sleeve covering his right arm and around his left leg. The long sash tied around his waist and trailing over his hip is brownish orange. In his right hand he holds a crucifix and with his left he points at it. The crucifix has a naturalistically colored corpus and a base of four brown heraldic *monti*. Covering the front of the altar is a dark green antependium decorated with vertical gold stripes, five above and three below a horizontal band of tassels. The white cloth on top of the altar hangs down, covering the side closest to the picture plane.

Above their heads are two nude putti. The one in the center is about to place a wreath of small green leaves and white flowers on San Luigi's head. The other, to the left, holds up a red curtain over the altar.

All these figures are in front of an open monumental archway. This is a nondescript architectural setting, rather than the door to a specific ecclesiastical building. The colossal column on the right and the masonry of the floor and walls are painted in closely related shades of reddish and grayish brown. In the immediate foreground, running along the bottom of the canvas, there is a dark gray band, roughly seven centimeters high.

Framed by the archway and seated on a bank of clouds outside the building are four music-making angels. The one farthest to the left wears a simple

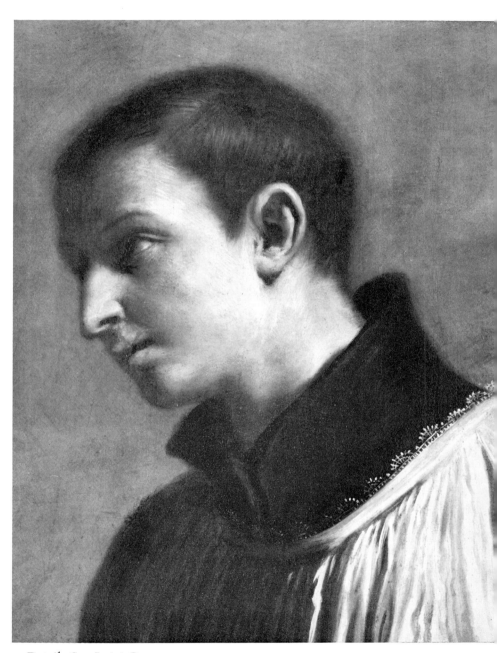

1. *Detail: San Luigi Gonzaga*

pale yellow garment and holds a sheet of music. The angel next to him wears a blue garment. The angel in the center, playing a viola da gamba, wears a dark green tunic with red-violet highlights. The angel on the right, playing a violin, is nude, save for the dull rose cloth draped over his waist. Below the angels the sky is deep blue with gray clouds; above them it takes on a warm pinkish orange hue. Through the arch two small figures can be seen standing in front of a clump of loosely painted trees (Fig. 3). Beyond the trees there are some fortified buildings, perhaps part of the town of Guastalla, visible against the low horizon.

PROVENANCE: The picture was commissioned for the church of the Theatines at Guastalla, a small town not far from Cento on the road between Mantua and Parma. It remained there until 1805, when Médéric Louis Elie Moreau de Saint-Méry (1750–1819), the French general administrator of the duchies of Parma, Piacenza, and Guastalla, appropriated it for himself (Campori, 1855, p. 49). The following year Napoleon called Moreau back to Paris in disgrace because he failed to quell a riot. The altarpiece then fell into the hands of Andache Junot, Duc d'Abrantes (1771–1813), Napoleon's powerful aide-de-camp who was ordered to replace Moreau in July 1806. Junot remained in Italy only long enough to stop the insurrection, before moving on to the Iberian peninsula where he continued to serve from 1807 to 1811. Evidently, he had the altarpiece shipped to Paris in 1806. It was included among the pictures in Junot's collection that were put up for auction at Christie's in London on June 7, 1817, lot 35 (unsold at 350 guineas). It was auctioned again at Christie's on May 4, 1818. In the sale catalogue the picture is described as:

> Guercino . . . 58 The Conversion of St. Louis de
> Gonzaga by an Angel exhibiting to him a crucifix,
> a choir of Angels above—a noble gallery picture,
> in his clear and elegant manner, 11 ft. by 6½ wide

There is a difference here in the dimensions of the picture: according to these measurements Junot's painting was about nine inches shorter and twenty-eight inches narrower than the Wrightsman altarpiece. Discrepancies of inches, however, are quite common in sale catalogues (several inches on each side can be concealed by a frame). The rather large difference in the width may be accounted for by a misprint of 6 [feet] for 8 [feet].

At the Junot sale in London the altarpiece was purchased by Samuel Woodburn (1786–1853), the famous collector and art dealer. He bought it for 190 guineas, by far the highest price paid for any of Junot's pictures. He seems to have bid on it for a young Scotsman, John Grant, 3rd, of Kilgraston (1798–1873). According to a booklet published by the latter's son (Grant, 1882, p. 8), he was afraid that his father would be angry with him for having bought the picture. The elder Grant, indeed, disclaimed the purchase sometime before his death (July 26, 1818), as his son was not yet of age. Woodburn subsequently disposed of the picture, and it next turned up with Carlo Sanquirico, a dealer in Milan.

Once John Grant came of age he tracked the picture down in Italy. According to a manuscript contract, dated Milan, August 24, 1821, and now on deposit in The Metropolitan Museum of Art, New York, the dealer Sanquirico asked more for the picture than Grant could afford to pay. Sanquirico finally consented to accept as part payment three of Grant's horses with their saddles and harnesses. The picture was then shipped to Grant's house in Scotland at Kilgraston, Perthshire.

The altarpiece thus traveled to Paris in 1806, to London by 1817, to Milan in 1818 or shortly thereafter, and to Kilgraston in 1821. It seems extraordinary that such an enormous picture should have been moved about so much, but in the early nineteenth century it was customary to treat paintings in this way. They usually were rolled on drums, saving them from injury.

Eventually the painting passed by inheritance to Grant's son, Charles Thomas Constantine Grant (1831–1891), who put it in a sale (T. Chapman & Son, Edinburgh, April 15, 1882, lot 87) but bought

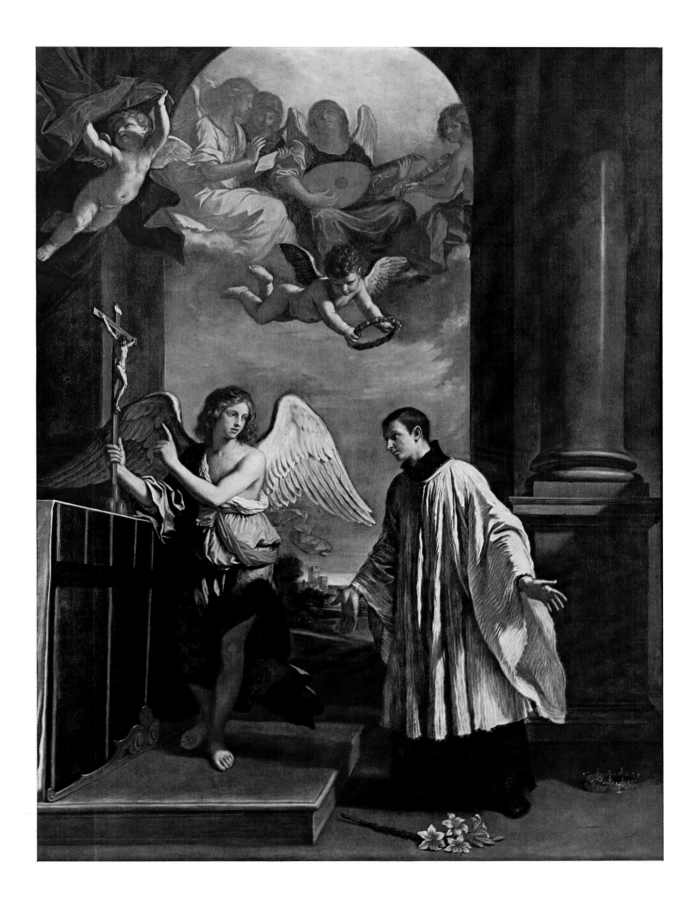

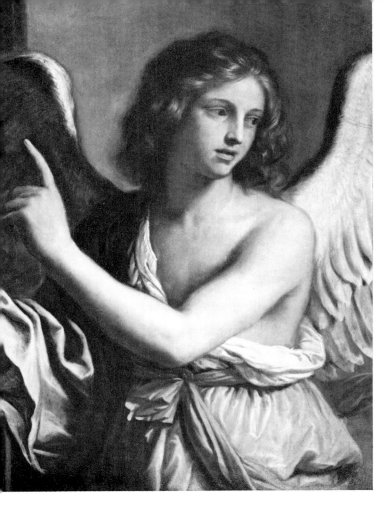

2. *Detail: angel*

3. *Detail: landscape background*

it in for £100. His son, Lieutenant Colonel John Patrick Nisbet Hamilton Grant (1872–1950) of Biel Dunbar, moved the picture from Kilgraston to Biel about 1919. The Lieutenant Colonel's cousin and heir of entail, Vice-Admiral Basil Charles Barrington Brooke (born 1895), was the last owner of the picture before it was acquired by Mr. and Mrs. Wrightsman in London in 1957.

GUERCINO's WORK is better documented than that of any other major seventeenth-century Italian painter. For thirty-five years he kept a careful record of all his work in a *libro dei conti* or account book. On March 29, 1650, he noted an advance payment for the painting now in the Wrightsman Collection, the "Blessed Luigi Gonzaga with a glory of angels above." It was commissioned by a certain Signor Quaranta Sampieri on behalf of the Duke of Guastalla.

The following year, Guercino received two further payments for the altarpiece from the duke himself. The duke, Don Ferrante III Gonzaga (died 1670), a member of a cadet branch of Luigi Gonzaga's family, may have ordered the painting to promote the canonization of the saint. In 1621 Luigi Gonzaga had been beatified by Gregory XV, Guercino's patron, but it took over a century before Benedict XIII canonized him as San Luigi, or, as he is called in English, St. Aloysius.

Luigi Gonzaga (1568–1591) was the eldest son of Ferdinando Gonzaga, Marquis of Castiglione, kinsman to the Duke of Mantua. Born in the castle of Castiglione near Brescia, as a young boy he showed concern for the poor and extraordinary piety, and, despite his family's opposition, he resolved to enter the Church. In 1585 he ceded his marquisate to his younger brother and entered his novitiate at the Jesuit church of Sant'Andrea in Rome, giving up a position of wealth and power to join one of the strictest arms of the Counter Reformation. However, he served for only six years, dying in an epidemic at the age of twenty-three. His pious and chaste character, often used as a model for Italian children, is also the source of the caustic Italian dismissal of a too pure young man as a "regular San Luigi."

Guercino's painting of San Luigi does not illustrate a specific event in the saint's life; instead it telescopes different moments into a single image of the saint's dedication. For example, according to San Luigi's biographers, his vocation became apparent when he was seven years old, considerably earlier than in Guercino's painting, and he relinquished his marquisate when he was seventeen, several months before he would have adopted the Jesuit habit he wears in the painting.

The altarpiece depicts in allegorical terms the saint's abdication of a temporal for a spiritual vocation. His family's coronet lies on the floor behind him, while a putto brings him a flowered wreath symbolizing his heavenly reward. The branch of lilies at his feet alludes to chastity, his most famous virtue. This iconography for San

4. *Jerome Wierix, Vocation of San Luigi Gonzaga. Engraving, 10.7 by 6.8 cm. New York, The Metropolitan Museum of Art, Elisha Whittelsey Fund, 51.501.6197*

Luigi was firmly established shortly after the saint's death. The coronet, flowered wreath, and lilies all appear in a pair of engravings of San Luigi (Figs. 4, 5), made about 1607 by Anton Wierix (about 1552–1624) and Jerome Wierix (about 1553–1619). It is quite possible Guercino referred to these or similar engravings when he designed his altarpiece a half century later.

Guercino's painting of San Luigi has an air of dignity and monumentality. The great arch in the background provides a grandiose setting. The broad shaft of light, originating within the arbi-

5. *Anton Wierix, Vocation of San Luigi Gonzaga. Engraving, 11.0 by 6.9 cm. New York, The Metropolitan Museum of Art, Elisha Whittelsey Fund, 51.501.6389*

Vnde flores casti odoris,
Christus, cum beatis choris
Cingunt Aloysium?

Quamuis terris habitabat,
Mente tamen euolabat
Campum ad Elysium.

Anton. Wierx fecit et excud.

trary setting, is steady and even, undramatically illuminating the folds of San Luigi's surplice, the head and upper body of the angel holding the crucifix, and the bodies of the flying putti. The physical types of the saint and standing angel, with their quiet, reserved expressions and gestures, add to the remote quality of the altarpiece. The cool, harmonious colors and the even and controlled handling of the paint also help to communicate the calm, thoughtful, and detached feeling of the picture.

The Wrightsman altarpiece is a good example

of Guercino's style during the last period of his life. Less than ten years earlier, he was still working in a dramatic, more painterly manner exemplified by the altarpiece of the Guardian Angel (Fig. 6), executed in 1642, in the Museo Civico Malatestiano at Fano. The angel in this work is comparable to the one in the Wrightsman altarpiece. The clothing and general posture are similar, yet the angel in the earlier picture is more robust, and the folds of his drapery are more broadly painted, the folds loosely flowing around his legs, while the angel in the Wrightsman painting is more delicately rendered. There is also a difference in the scale of the figures in relation to the overall surface of the canvas, the figures in the Wrightsman altarpiece being smaller and more refined. They are framed, moreover, in an imposing architectural setting, characteristic of the classical spirit of Guercino's late works.

VERSIONS: In 1662 Guercino painted another altarpiece of San Luigi Gonzaga. It was ordered by the Prince of Massa for the city of Palermo (Calvi, 1808, p. 155) and appears to have been a smaller picture, judging from the price. For the altarpiece of San Luigi in the Wrightsman Collection, Guercino received the equivalent of 500 scudi, while the painting for Palermo cost only 375 scudi. The painting has disappeared, and no copies survive, so it is impossible to tell how its composition compared with that of the Wrightsman painting.

EXHIBITED: British Institution, London, *Pictures by Italian, Spanish, Flemish, Dutch, French, and English Masters*, 1857, catalogue no. 4; Royal Academy of Arts, London, *Works of the Old Masters*, 1873, catalogue no. 225; The Metropolitan Museum of Art, New York, on extended loan since 1957.

REFERENCES: Carlo Cesare Malvasia, *Felsina pittrice: vite de pittori bolognesi*, Bologna, 1678, II, p. 378 (lists it as a work Guercino executed in 1650) // Ireneo Affò, *Istoria della città e ducato di Guastalla*, Guastalla, 1787, III, p. 162 (reports that in 1654 the Duke of Guastalla buried one of his daughters in the church of the Theatines, "avanti l'Altare di San Luigi Gonzaga, dov' è un bel Quadro dipinto dal rinomato Guercino") // Jacopo Alessandro Calvi, *Notizie della vita, e delle opere del cavaliere Gioan Francesco Barbieri detto il Guercino da Cento celebre pittore*, Bologna, 1808, pp. 124, 128 (also reprinted as an addendum to Giampietro Zanotti's edition of Malvasia's *Felsina pittrice*, Bologna, 1841, II, pp. 330, 332) (publishes transcriptions of Guercino's *libro dei conti* record-

ing payments for the Wrightsman altarpiece on March 29, 1650, and April 24 and 27, 1651) / / Giuseppe Campori, *Gli artisti italiani e stranieri negli stati estensi: catalogo storico corredato di documenti inediti*, Modena, 1855, p. 49 (reprints Calvi's transcriptions for April 24 and 27 from Guercino's *libro dei conti* for the altarpiece now in the Wrightsman Collection and adds that it was in the church of the Theatines at Guastalla in 1805, when it was confiscated by Moreau de Saint-Méry and believed to have been carried off to France) / / Gaetano Atti, *Intorno alla vita e alle opere di Gianfrancesco Barbieri detto il Guercino da Cento*, Rome, 1861, p. 117 (includes the altarpiece in a list of Guercino's works arranged alphabetically by subject) / / Charles Thomas Constantine Grant, *San Luigi di Gonzaga and Guercino* [privately printed], Bruges, 1882, pp. 3–7, 8 (gives information about San Luigi Gonzaga's life; states that John Grant bought the altarpiece in Milan about 1818 and saved it from a fire in 1872) / / Henry A. La Farge, "Noble Metropolitan Visitors," in *Art News*, LXV, February 1967, pp. 29, 60, fig. 5 (describes the subject of the altarpiece and its provenance and suggests that it "may in fact have promoted the subsequent canonization" of San Luigi Gonzaga [which seems unlikely since he was not canonized until 1726]; states that it had been recently cleaned) / / Denis Mahon, ed., *Il Guercino (Giovanni Francesco Barbieri, 1591–1666): Catalogo critico dei disegni*, Bologna, 1969, p. 225, catalogue no. 256, pl. 256a (illustrates the page

from Guercino's *libro dei conti*, included in the Guercino exhibition, recording the payments for the altarpiece on April 24 and 27, 1651) / / Denys Sutton, "Pleasure for the Aesthete," in *Apollo*, XC, September 1969, p. 233, fig. 3 (reports the provenance of the painting and gives a brief account of San Luigi Gonzaga's biography).

Oil on canvas, H. 140 (355.6); W. 106 (269.3).

The painting is basically in sound condition. Minor losses of paint have been retouched in the past, and several vertical tears in the canvas (in the masonry background on the right) have been repaired. The changes Guercino made while painting are visible, particularly in the fingers of San Luigi's right hand and in the capital of the archway, which overlaps the drapery of the angel playing the violin on the far right.

Charles Grant (1882, p. 8), records that "During the burning of Kilgraston in 1872, the picture was cut out of its frame by the late John Grant, Esquire, with the aid of two servants, ands [*sic*] was carried out of the house before the roof fell in." There is no evidence that the canvas was actually cut down at this time, but it does appear to have been reduced in size some time in the past, particularly at the top where the archway is incomplete.

It was described by La Farge (1967, p. 60) as having been cleaned recently, presumably before it entered the Wrightsman Collection, because it has not been cleaned since then.

OPPOSITE:
6. *Guercino, Guardian Angel. Oil on canvas, 292.0 by 178.0 cm. Fano, Museo Civico Malatestiano. Photo: Villani & Figli*

NICOLAS de LARGILLIERRE (1656–1746) was one of the most successful portrait artists in France during the reigns of Louis XIV and Louis XV. Following the Flemish tradition of Rubens (*q.v.*) and Van Dyck (*q.v.*), he specialized in sumptuous portraits, which were sought by members of the court and the bourgeoisie alike. He painted their elaborate costumes and trappings with a sureness and brio matched only by his friend and contemporary, Hyacinthe Rigaud (1659–1743).

Largillierre was born in Paris, but at the age of three moved with his family to Antwerp, where he eventually was apprenticed for about six years to Anthony Goubaud (1616–1698), a minor Flemish artist. He then moved to England in 1674 and spent four years working in the studio of Sir Peter Lely (1618–1680), a prolific and popular portrait painter trained under Van Dyck. Because of the persecution of Catholics in England, Largillierre fled to Paris, where he enjoyed the favor and protection of two influential artists, Adam François van der Meulen (1623–1690) and Charles Le Brun (1619–1690).

Quickly establishing himself as a major talent, Largillierre became a member of the French Academy in 1686, with a portrait of Le Brun as his reception piece. He held the titles of *peintre d'histoire* and *peintre de portraits*, and was given several important commissions by the City of Paris. The only one to survive is the Échevins of the City of Paris before Sainte-Geneviève, which was painted in 1696 and now hangs in the church of Saint-Étienne-du-Mont, Paris.

Largillierre had primarily bourgeois clients, while Rigaud received most of his commissions from members of the court and nobility. He confided to his biographer, Dézallier d'Argenville (*Abrégé de la vie des plus fameux peintres*, Paris, 1762, IV, p. 298), that he preferred working for them, because "les soins en étoient moins grands, & le payement plus prompt." He worked with such speed and ease that Pierre Jean Mariette (*Abécédario . . . et autres notes inédites de cet amateur sur les arts et les artistes* [Paris, 1753]; edition by Ph. de Chennevières and A. de Montaiglon, Paris, 1854–1856, III, p. 61) wrote that there were more than 1200 portraits by his hand in Paris alone.

The eclecticism of Largillierre's portraits was a result of his training in several different countries. Throughout his career he remained indebted to Rubens, inspired by his rich textures and brilliant palette. On the other hand, Largillierre's paintings owe their formats and general designs to Van Dyck's and Lely's allegorical portraits. The special combination Largillierre made of these styles became the foundation of French portraiture of his time. A precursor of the French eighteenth century, he introduced a highly polished and derivative style of portraiture to France at a moment when it best embodied the spirit of Versailles and Louis XIV.

IN THIS three-quarter-length portrait a man is shown standing with his left hand on his hip and his right hand on a helmet, which rests on an embankment in the immediate foreground. He wears a wig tied at the nape of his neck with a gray bow (Fig. 1). The white hair of the wig provides a foil for his youthful features: full black eyebrows, brown eyes, and bright red lips. He wears a white shirt with lace cuffs, a ruff, and a tight-fitting stock that completely covers his neck; a deep burgundy velvet greatcoat with wide, buttoned cuffs and gold embroidery over a gold-embroidered waistcoat; and a blue mantle lined with fur. His silvered breastplate (Fig. 3) is ornamented with incised gold borders, and the handle of his sword is shaped like a parrot's head. His helmet, which is incised in a design that matches that of his breastplate, has a steel blue plume. Behind him

1. Detail: head and shoulders

on the left is the side of a tent; in the distant background on the right a battle takes place before some burning fortifications (Fig. 4).

PROVENANCE: The portrait remained in the hands of d'Herculais's descendants at least until June 1928, when it was lent by M. Amaury Aloys (*sic*) d'Herculais to the *Exposition N. de Largillierre* at the Petit Palais, Paris. It was sold anonymously at the Palais Galliera, Paris, March 30, 1963, lot 27, pl. XII (as a portrait of André François Alloys de Theys d'Herculais au Siège de Fontarabie) and purchased by Germain Seligman, New York. It was acquired by Mr. and Mrs. Wrightsman in 1964.

THIS PAINTING was in the possession of the d'Herculais family for generations. It had always been thought to be a portrait of André François Alloys de Theys d'Herculais (1692–1779), which appears to be true. In 1727, when Largillierre signed and dated the back of the picture (Fig. 2), d'Herculais would have been about thirty-five years old. His handsome face appears somewhat younger than this in the painting, but as eighteenth-century French portraits tend to flatter the sitter, there is no reason to doubt the traditional identification of the portrait.

André François d'Herculais came from a rich and powerful bourgeois family from the region of Grenoble. His father, Claude Alloys (died 1698), held several important posts in the service of Louis XIV. His mother was Marie de Theys de Tournet d'Herculais (Camille Blanchard, "Notes brèves sur la famille dauphinoise 'Les Alloys d'Herculais' originaires des vallées cédées par le traité d'Utrecht en 1713," in *Les Procès-Verbaux de l'Académie Delphinale*, 7th series, I, II, 1956–1957, pp. XLIV–XLVII). In November 1736 he married Claire Charlotte de Vaulserre, whose father was also a prominent bourgeois in the service of the king. In the birth certificates of their children, d'Herculais is mentioned as a powerful and important man ("Haut et puissant seigneur") and the owner of several estates.

Like the sons of many rich, landed, bourgeois families, d'Herculais chose a military career. In 1725 he held the rank of captain of the cavalry regiment of Clermont-Condé. According to an old family tradition, he is supposed to have participated in the Battle of Fontarabia. This battle took place in June 1719, when French forces successfully besieged and captured this small northern Spanish town, thus helping to protect the throne of France from Philip V's claim to succession. It may be this battle that is represented in the background of the portrait (Fig. 4).

The painting belongs to the genre of military portraits, of which the picture by Paris Bordon in this collection (Catalogue No. 1) is an earlier example. In portraying d'Herculais, Largillierre has taken recourse to a type of military portrait that first appeared in Italy during the mid-sixteenth century (for instance, the portrait in the Uffizi, by Federico Barocci, of Francesco Maria II della Rovere, datable about 1572) and that was fre-

2. *Inscription on the back of the canvas*

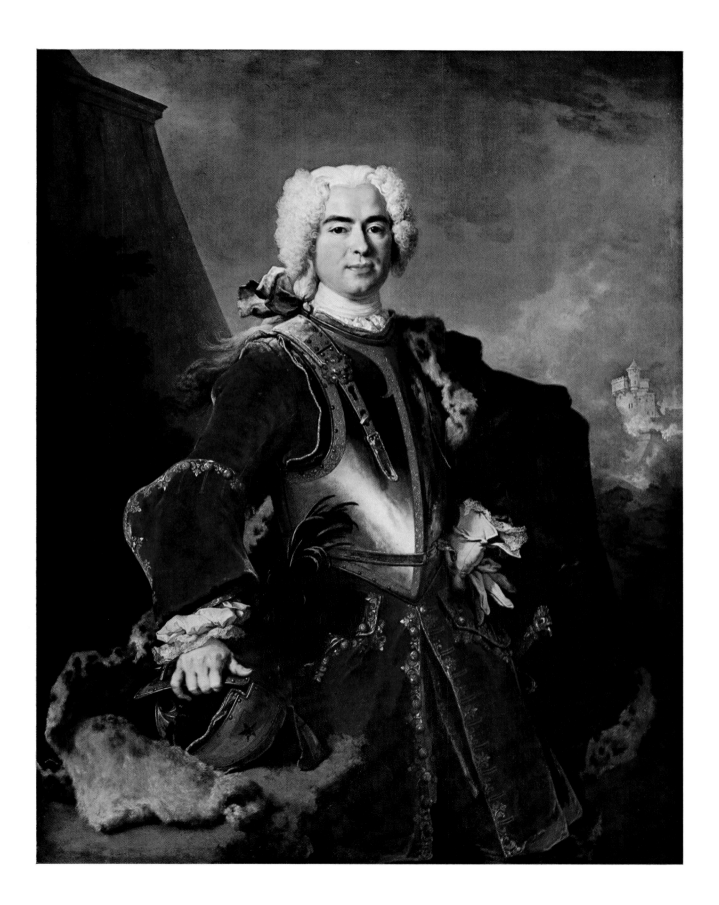

quently employed in the seventeenth century by Rubens and Van Dyck. For example, Rubens's portraits of Charles the Bold and the Emperor Maximilian I, in the Kunsthistorisches Museum, Vienna, and Van Dyck's portrait of Charles I, in the collection of the Duke of Norfolk, Arundel Castle, show the same general arrangement of a three-quarter-length figure in armor with one arm akimbo. But what for Rubens and Van Dyck had been strictly reserved for monarchs and great military rulers was appropriated by Largillierre for his bourgeois clients. He adopted a standard model, showing a three-quarter-length view of his sitter, wearing a breastplate and resting one hand on a helmet. He applied this formula without variation in the Portrait of André François d'Herculais, as well in the portraits of James Francis Edmond Stuart, formerly in the Sedelmeyer Gallery, Paris; August III, King of Poland, in the National Gallery of Victoria, Melbourne, Australia; Louis Joseph de Vendôme, Duc de Mercoeur, in a private collection; Comte de Bérulle, formerly in the collection of Vicomte G. Chabert, Paris; and Jacques François Lénor Grimaldi, mentioned below.

The costume d'Herculais wears is not one he would have worn in combat. His sword is ceremonial, and his freshly powdered wig, which sprinkles white dust on his shoulders (Fig. 1), is obviously inappropriate for battle. D'Herculais's wig and greatcoat are actually part of the *grand habit*, or formal attire, worn in the early eighteenth century. His helmet and highly ornate breastplate (Fig. 3) are merely allegorical attributes, worn perhaps to make the portrait more imposing. The helmet is a *bourguignotte* of the first half of the seventeenth century and was no longer in use by 1700. The breastplate is of a type worn in the first half of the eighteenth century. It may be questioned whether d'Herculais actually owned the armor he wears in the portrait, because identical breastplates and helmets reappear in three nearly contemporary portraits by Largillierre: Jacques François Lénor Grimaldi, Duc de Valentinois, in the Palais de Monaco at Monaco; Sir Robert

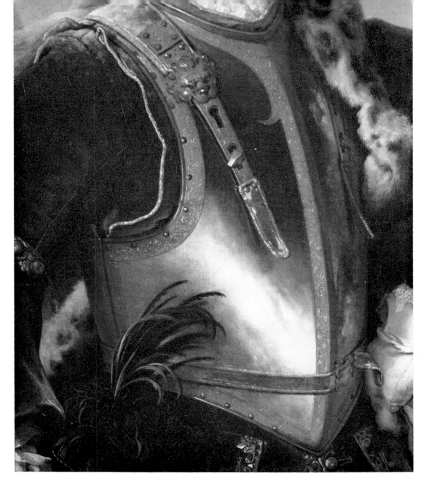

3. *Detail: breastplate*

4. *Detail: fortifications in the background*

[131]

Throckmorton (Fig. 5), which is signed and dated 1729; and Louis de Lamorelie, formerly with Trotti in Paris. The breastplates in these pictures have exactly the same gold design down the center and along the edges and the same straps with lion's-head buckles over the shoulders. Largillierre may well have owned the armor himself and kept it on hand in his studio for clients who wished to be portrayed in this manner.

D'Herculais sat for Largillierre when the artist was seventy-one years old and at the peak of his popularity. His talents were not diminished by age. Although the portrait dates from late in his career, it is painted with extraordinary vitality and flair. Largillierre is remarkable in that he successfully spanned the close of Louis XIV's reign and the blossoming of the rococo era under Louis XV in the eighteenth century. The portrait of d'Herculais illustrates the brilliant transition he made from the taste of one century to the other. While using the format typical of the Grand Siècle, he caught the spirit of the new century in the opulent colors of his sitter's costume and the rich impasto of the paint surface. It is a handsome portrait, ranking with Largillierre's finest works.

EXHIBITED: Petit Palais, Paris, *Exposition N. de Largillierre*, 1928, catalogue no. 62; The Metropolitan Museum of Art, New York, on extended loan since July 1968.

REFERENCES: Camille Gronkowski, "L'Exposition N. de Largillierre au Petit Palais," in *Gazette des Beaux-Arts*, XVII, June 1928, p. 322 (mentions the portrait along with several others that still belonged to the families for which they were originally painted)//Helmut Nickel, *Warriors and Worthies: Arms and Armor through the Ages*, New York, 1969, p. 103 (illustrates it in color as an example of an eighteenth-century French cavalry officer's attire).

Oil on canvas, H. 54¼ (137.8); W. 41½ (105.5).
The canvas had been cleaned and relined shortly before it entered the collection. The back of the original canvas, no longer visible, is inscribed: *peint par N. de Largillierre/1727* (Fig. 2).

OPPOSITE:
5. *Nicolas de Largillierre, Portrait of Sir Robert Throckmorton. Oil on canvas, 135.3 by 104.8 cm. H. M. Treasury and the National Trust, Coughton Court, near Alcester, Worcestershire. Photo: Courtauld Institute of Art*

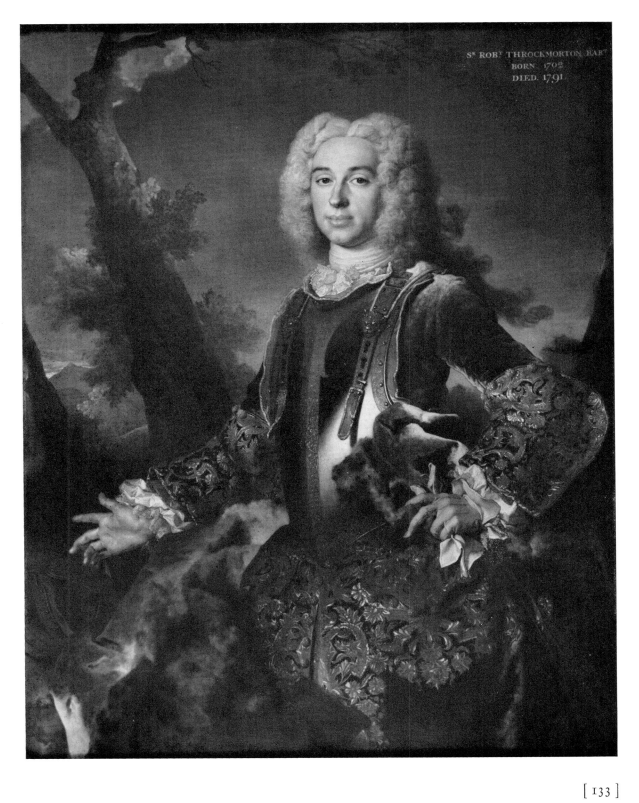

Sᴿ ROBᵀ THROCKMORTON BARᵗ
BORN. 1702
DIED. 1791

[133]

GEORGES de LA TOUR (1593–1652) holds a unique place in the history of seventeenth-century painting. Unlike his French contemporaries who were drawn to Paris or to Rome, he remained in the provinces and developed an isolated and highly enigmatic style. The subject matter of his paintings was restricted to the traditional Caravaggesque repertory of cardsharps, fortune tellers, beggars, and austere religious scenes, such as the penitence or death of single saints. He was not a portraitist, and he did not attempt history or landscape painting. The essence of his art was its utter simplicity: he concentrated upon the human figure, showing it in quiet and undramatic situations and reducing it to generalized forms that have an almost abstract clarity. His works, which have often been confused with those of Zurbarán and Velázquez, possess a deeply spiritual character and a monumental grandeur.

He was born at Vic-sur-Seille in the duchy of Lorraine. Nothing is known about his artistic education. He is mentioned for the first time as a painter in his marriage contract in 1616. Four years later he settled at Lunéville and established an atelier with apprentices. He spent the rest of his life there, and from the start he appears to have enjoyed a high reputation. In the early 1620s Duke Henri of Lorraine bought two of his pictures for remarkably high prices. In 1633 the duchy fell to the French, and six years later his name is listed at Lunéville with the title *peintre du Roi*. There is no record of his ever working in Paris, but Louis XIII is known to have kept a St. Sebastian by him in his bedroom. For Henri, Duc de La Ferté Senneterre, the French governor of Lorraine, he painted several expensive canvases paid for by public taxes: a Nativity (1645), a St. Alexis (1649), a St. Sebastian (1650), and a Denial of St. Peter (1652). Although the subjects of these documented canvases correspond with some of the known works by La Tour, there is no way to prove that any of the surviving pictures are the ones mentioned in the documents.

The chronology of La Tour's work is largely conjectural. Only two of his compositions are dated, and both of them are late: the Repentant St. Peter of 1645, in the Cleveland Museum of Art, and the Denial of St. Peter of 1650, in the Musée des Beaux-Arts, Nantes. Modern scholarship assigns La Tour's daylight scenes to his early period. These would include the Card Players, now in the Louvre, Paris, the Fortune Teller, in The Metropolitan Museum of Art, and the St. Jerome Doing Penitence, in the National Museum, Stockholm. They differ from the dated late compositions in being far less geometric. The flesh is minutely described in the naturalistic manner of the Dutch followers of Caravaggio. The mature works, on the other hand, show a generalized treatment and far less realistic detail. The masterpieces of this phase are the Christ with St. Joseph in the Carpenter's Shop, in the Louvre, and Le Nouveauné, in the Musée des Beaux-Arts, Rennes. These are night scenes in which a candle flame is the sole source of illumination. The light serves to model the figures as well as to endow the scenes with a haunting, spiritual quality, the hallmark of La Tour's style.

THE MAGDALEN is depicted as a full-length seated by a table. She turns her face away from the viewer in a *profil perdu* position (Fig. 4). Her long dark brown hair is pulled back over her shoulders, and strands of it are visible quite far down her back. Her hands are folded on top of a skull nestled in her lap (Fig. 1). Her blouse, cream-colored with full, three-quarter-length sleeves, is unbuttoned at the neck and opened almost down to the waist. Her scarlet skirt is trimmed with parallel silver stripes, four of them running down the front and two bordering the hem at the bottom. Her square-toed shoes are just visible beneath the skirt.

The table is covered with a dark brown cloth. On top of it there is a mirror (Fig. 3) with an elaborate gilt frame propped up against a brown wicker basket. The mirror reflects the short candle and its long, tapering flame. On the table there also are a large pearl drop earring and a string of pearls.

The shadow immediately to the left of the Magdalen reveals the proximity of the dark, reddish brown background. The shadow of the mirror

1. Detail: hands and skull

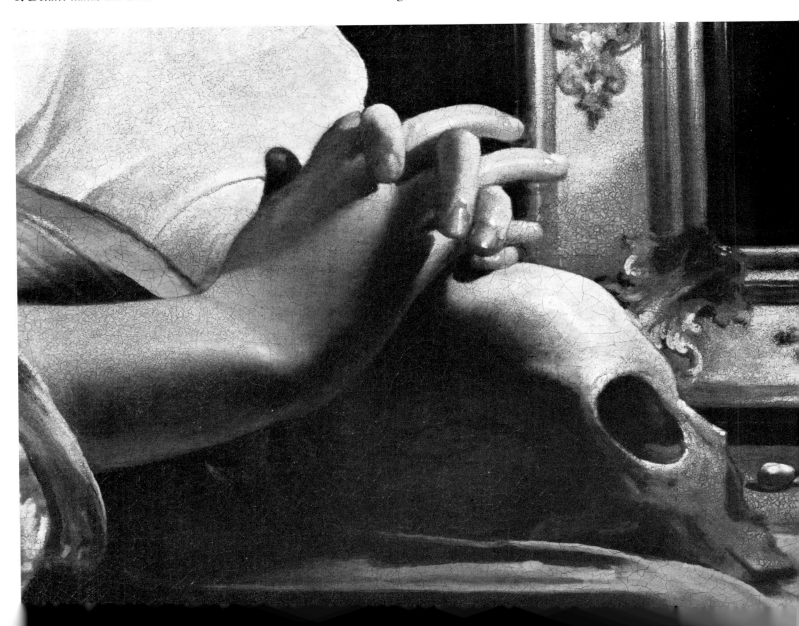

cast against this background slopes at an angle behind the Magdalen's profile and stops within inches of the top of the canvas.

On the dark, reddish brown floor at the Magdalen's feet (Fig. 2) are two gold bracelets and the mate of the earring on the table.

PROVENANCE: According to Pariset (1961, p. 39), the picture belonged to an old French family of the Lorraine region who had owned it since at least 1890. A twenty-five-year-old member of this family, who got possession of the picture after World War I, moved it to a different part of France in 1920. It still belonged to this person in 1961, when Pariset first saw it. Mr. and Mrs. Wrightsman acquired the painting in Paris in 1963.

THIS PICTURE illustrates the moment when the Magdalen decides to renounce her life as a prostitute. Realizing the vanity of her past, she has stripped off her jewelry, throwing some of it on the ground. Surrounded by evidence of the luxury she sinfully enjoyed, she stares at the candle, an image of the frailty of human life, and rests her exquisite fingers on the skull, a symbol of death. Her conversion is conveyed with great force in the unforgettable pose of her head. We see only her profile, and this turning aside is the outward, physical manifestation of her inward, spiritual conversion.

More than any other element of the composition, the candle is the key to the spiritual meaning of the picture, which is devoid of religious symbols such as a halo or crucifix. A symbol of the Magdalen's wasted life, it burns brightly but ultimately will be consumed. It radiates a supernatural glow that gives form to the Magdalen's face and bust, her hands, and the skull, while everything in shadow is insubstantial or invisible. Its long, straight flame tells us that not a breath of air is stirring. The faint, flickering movement at the very top of the flame emphasizes the immobility of the scene, which is utterly still and silent.

The artist executed the painting with great economy of means. He used few colors. They range from shades of the palest yellow in the flame to the warm golden tone of the skull and the dark browns and blacks of the deep shadows. The rich red skirt is the only strong color. The artist designed the composition with the same simplicity. Each form is carefully worked out in a strong rectilinear pattern made up of the verticals and horizontals of the mirror, the table, and the saint's lap, and the diagonals of her sloping arms and skirt. Against these straight lines, the curve of her sleek hair and turned head is all the more expressive. The "lost profile" in which the eyelash, tip of the nose, and parted lips are just visible beyond the lovely curved outlining of the cheek, subtly conveys the saint's innermost thoughts and emotion. The edge of the shadow cast on the wall runs just behind her profile, giving life to the turn of her head. The small shadow to the left is another example of the calculated use of an extremely simple detail: it makes us aware of the darkly enclosed space in which she sits. The handling of paint is correspondingly quiet and methodical, and avoids any trick or seeking after effect. It is applied very thinly in the shadows, becoming richer and more solid in passages like the skull, the folds of the sleeve, and the highlights of the frame.

The theme of penitence was a popular subject for religious paintings in the seventeenth century. Innumerable canvases of the period show saints such as the Magdalen or Jerome and Francis in homely settings, contemplating their sins or praying for atonement. In France there was a special predilection for the Magdalen (see Françoise Bardon, "Le thème de la Madeleine pénitente au XVIIeme siècle en France," in *Journal of the Warburg and Courtauld Institutes*, XXXI, 1968, pp. 274–306). Her penitence inspired many religious writers as well as poets and painters such as Simon Vouet (1590–1649). Vouet's paintings of the Magdalen are typical in that they express the erotic overtones that came to be associated with the subject. His Magdalens equivocate between sincere religious meditation and voluptuousness for its

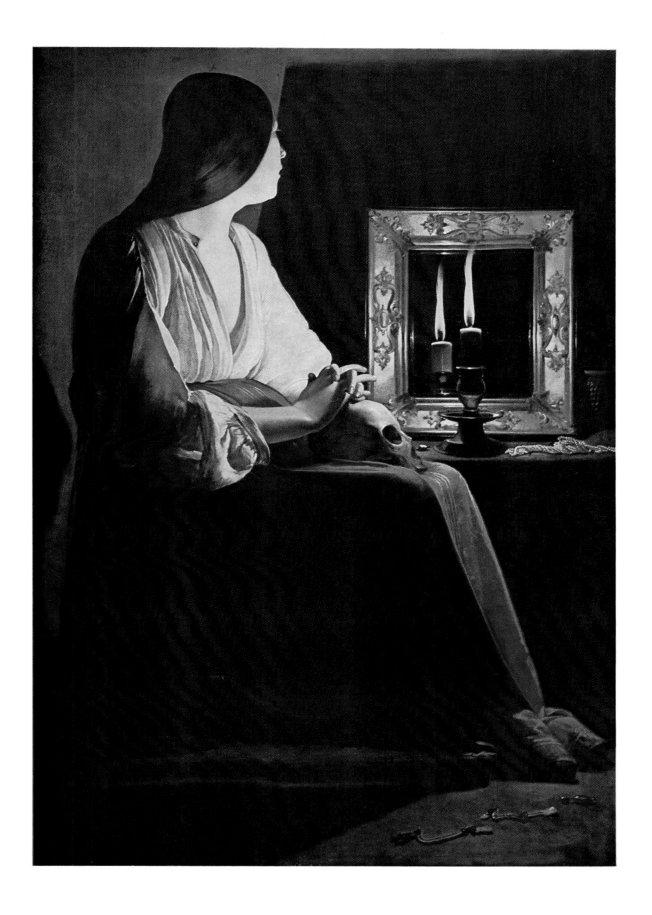

2. *Detail: jewels on the floor*

3. *Detail: mirror and candle*

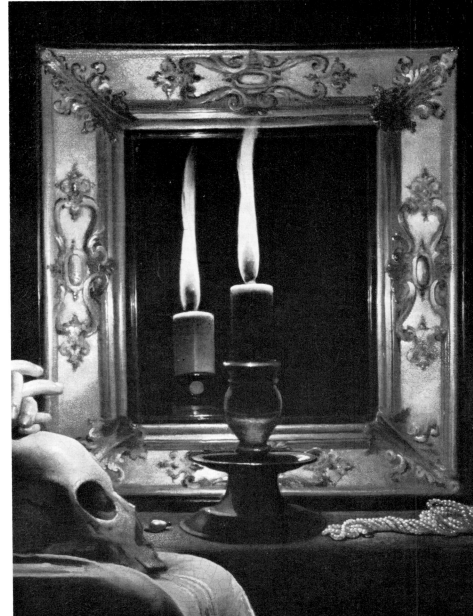

own sake. In this context it is remarkable how profoundly chaste and spiritual La Tour's Magdalen is.

La Tour painted three different interpretations of the Magdalen's penitence. All three are approximately the same size. They are similar upright compositions and represent the Magdalen as a seated, full-length figure. They are also relatively modern discoveries. The first to come to light (Fig. 6) is now in the Fabius Collection, Paris. It was found in 1936. The second (Fig. 5), now in the Louvre, was recognized a year later. The Wrightsman version has been known only since 1961. While there are partial replicas of the Louvre and Fabius canvases, no copies or repetitions of the Wrightsman picture are recorded.

It was characteristic of La Tour's creative process to concentrate upon a theme such as the Magdalen's penitence and paint different renderings of it. He often portrayed the same subject over again with significant alterations in design and mood. For example, two different compositions of St. Jerome Flagellating Himself are known to survive (in Stockholm and Grenoble), and it is stated in

[139]

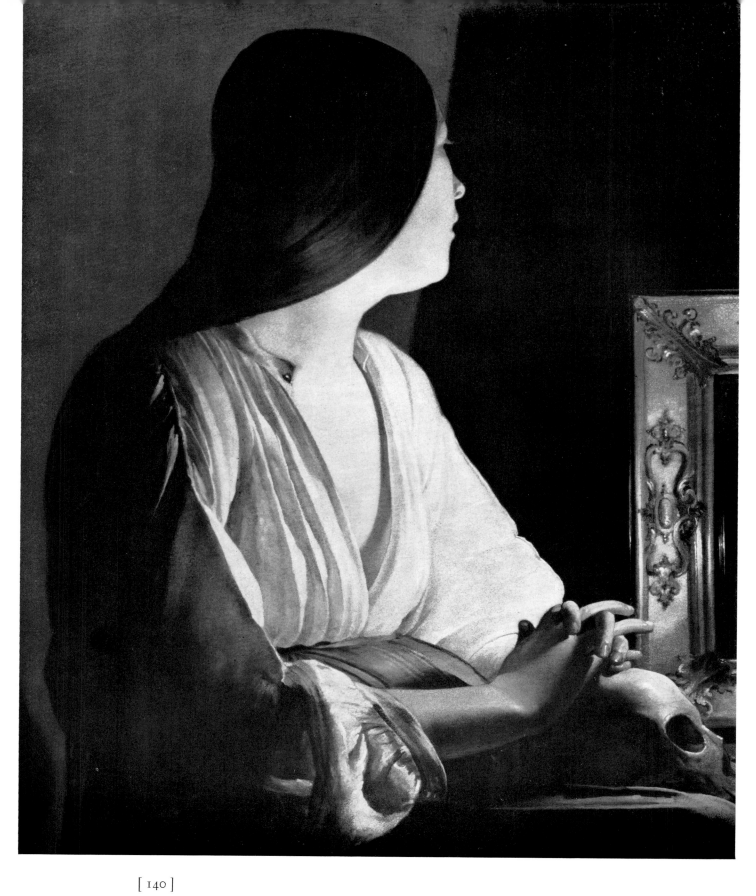

seventeenth-century documents that he painted at least three different versions of St. Sebastian.

In the three versions of the Magdalen the artist dwelled upon different aspects of her reformed life. The earliest, in terms of her conversion, is the one in the Wrightsman Collection, showing her

OPPOSITE: 4. *Detail: half-length view*

5. *Georges de La Tour, Penitent Magdalen. Oil on canvas, 128.0 by 94.0 cm. Paris, Musée du Louvre. Photo: Bulloz*

renunciation of the worldly life. The next, in the Louvre (Fig. 5), depicts her in simple clothes, with bare legs and feet, her face expressing contrition and remorse. As in the Wrightsman canvas there are a death's head in the saint's lap and a single source of light, the flame of an open oil lamp. In contrast to the luxurious golden mirror and jewels in the Wrightsman painting, the Louvre picture shows two large books, a simple wooden cross, and a

6. *Georges de La Tour, Penitent Magdalen. Oil on canvas, 113.0 by 93.0 cm. Paris, André Fabius Collection*

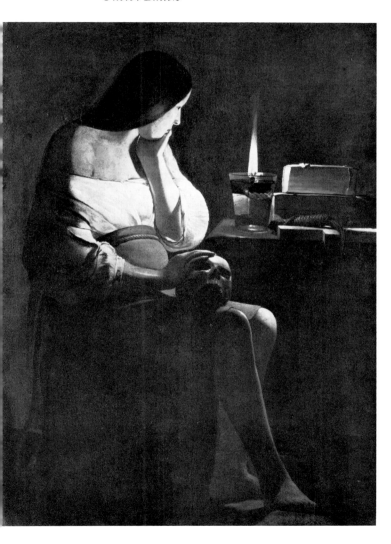

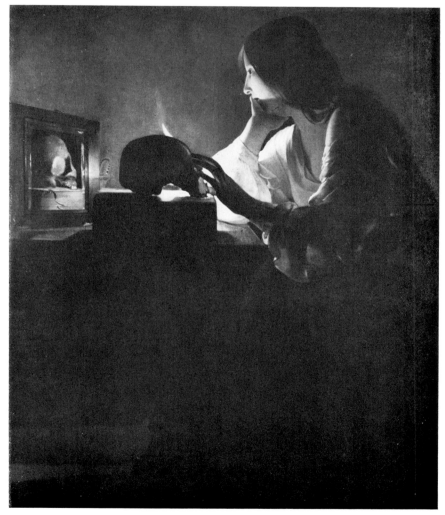

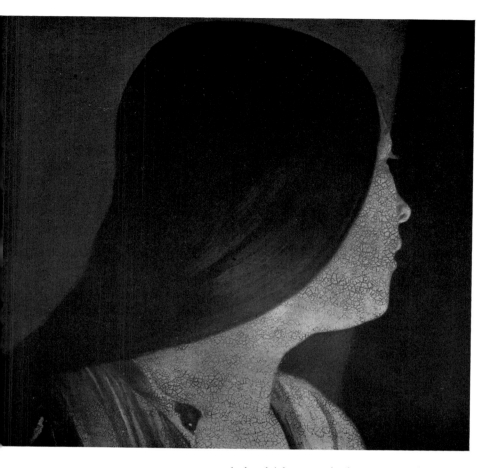

7. *Detail: head (showing the heavy craquelure before restoration)*

scourge for flagellating the saint's exposed back. The last version (Fig. 6), in the Fabius Collection, depicts the saint as a hermit. The skull lies before her on a Bible. Her fingertips rest lightly on its face, and she gazes at its reflection in a small mirror with a plain wooden frame. She is lost in the deepest meditation. Of all the versions, the one in the Wrightsman Collection is perhaps the most elegant, largely because of its comparatively sumptuous setting, but it is no less convincing than the others as a depiction of spiritual atonement.

Given the paucity of dated works by La Tour, it would be pointless to attempt to date the Wrightsman picture too precisely. It is clear,

though, that it is not contemporary with his late work, the dated compositions of 1645 and 1650. Nor does it display the meticulous handling of paint found in the daylight scenes that generally are regarded as the artist's earliest efforts. There is a tendency toward geometrical forms in the arms and skirt, which suggests that the picture belongs to the artist's middle period, the decade of the 1630s. Until more is known about the artist's development, it would be idle to speculate about the chronological relation of the picture to La Tour's other versions of the Magdalen. The style of all three seems to be sufficiently related to suggest that they were executed more or less about the same time.

None of the details within the picture help to date it. The candlestick reappears in La Tour's Joseph with the Angel, at Nantes, but this picture is not dated. At first glance the mirror frame might appear to provide some internal evidence for dating the picture (see Pariset, 1962, p. 165), but its design was a common one. As Benedict Nicolson has observed (verbal communication, October 1971), an early example of this type of mirror frame can be seen in the Portrait of Anna Eleonora Sanvitale by Girolamo Mazzola Bedoli (about 1500–1569) in the Galleria Nazionale, Parma. Dated 1562, this picture shows a large mirror in the background with a flat, ornamented frame comparable to the one in the Wrightsman picture (see Armando Ottaviano Quintavalle, *Mostra parmense di dipinti noti ed ignoti dal XIV al XVIII secolo*, Parma, 1948, pl. xxx).

EXHIBITED: The Metropolitan Museum of Art, New York, March—October 1967; The Metropolitan Museum of Art, *The Painter's Light*, October 5—November 10, 1971, catalogue no. 7 (illustrated); Musée du Louvre, Orangerie, Paris, *Georges de La Tour*, May 10—September 25, 1972, catalogue no. 19 (illustrated).

REFERENCES: François Georges Pariset, "La Madeleine aux deux flammes: un nouveau Georges de La Tour?," in *Bulletin de la Société de l'Histoire de l'Art Français*, 1961, pp. 39–44, illustrated (proposes that it is by Georges de La Tour; compares it to La Tour's other versions of this subject; on the

basis of his analysis of the date of the mirror frame, suggests that the picture was painted between 1630 and 1640) // François Georges Pariset, "La Madeleine aux deux flammes," in *Le Pays Lorrain*, IV, 1962, pp. 162–166, illustrated (reports that cleaning confirms the attribution; repeats the observations made in his previous article and reproduces a photograph of La Tour's Flea Picker, in the Musée Lorrain at Nancy, which he compares with the Wrightsman picture) // Vitale Bloch, "Erinnerungen (Persönliches und Kunsthistorisches)," in *Hommage à Hermann Voss*, Strasbourg, 1966, opp. p. 49, illustrated (the caption states that it was first discovered in 1912 by Herman Voss [a printer's error]) // Denys Sutton, "Pleasure for the Aesthete," in *Apollo*, XC, September 1969, p. 232, no. 4, illustrated (states that it was probably executed during the 1630s) // Hidemichi Tanaka, *L'Oeuvre de Georges de La Tour* (doctoral dissertation presented to the University of Strasbourg), 1969, pp. 73–75, 123, 165 (dates it 1625 to 1628 and interprets the jewels on the floor as a symbol of the Magdalen's rejection of "la vie mondaine") // Agnès Szigethi, *Georges de La Tour*, Budapest, 1971, fig. 12 (analyzes the geometrical structure of the picture, comparing it with the design of La Tour's Flea Picker at Nancy) // Pierre Rosenberg and Jacques Thuillier, *Georges de La Tour*, exhibition catalogue, Paris, 1972, p. 177, catalogue no. 19, illustrated p. 176, frontispiece, and color pl. p. 46 (date it about 1639–1643) // François Georges Pariset, "Consécration d'un grand peintre: Georges de La Tour," in *Plaisir de France*, no. 399, May 1972, p. 9, color pl. 11 (states that it once belonged to the Galerie Heim, Paris) // Robert Hughes, "An Analytical Stillness," in *Time*, July 3, 1972, p. 53 (observes that in this picture the artist successfully rendered "the exact difference in the highlights that a tallow flame creates on the bone of a skull and on the grayed sea luster of a pearl")

// Jacques Thuillier, "La Tour: Between Yesterday and Tomorrow," in *Art News*, LXXI, Summer 1972, p. 26 (mentions it as one of the La Tours acquired for an American private collection) // Ulysse Moussalli, *À la Recherche de Georges de La Tour*, Paris, 1972, pp. 63–65 (alludes to the symbolism of the skull and jewels and states that the picture was directly inspired by Caravaggio's painting of the Penitent Magdalen in the Doria Pamphili Gallery, Rome) // François Georges Pariset, "L'Exposition de Georges de La Tour à l'Orangerie, Paris," in *Gazette des Beaux-Arts*, LXXX, October 1972, p. 209 (points out that restoration has minimized the effect of the craquelure and that fresh varnish has given more life to the painting) // Hélène Adhémar, "La Tour et les Couvents Lorrains," in *Gazette des Beaux-Arts*, LXXX, October 1972, pp. 219–220, fig. 1 (proposes that the picture may portray Marie Elisabeth de Ranfaing, 1592–1649, or possibly some other nun at Notre-Dame du Refuge; in 1624 Ranfaing founded this convent at Nancy for *filles débauchées*, who were urged to venerate the Magdalen).

Oil on canvas, H. 52½ (133.3); W. 40¼ (102.9).

The paint, particularly in the Magdalen's face and blouse, is covered with a network of deep cracks (Fig. 7). The effect of this craquelure has been diminished by retouching.

When Pariset (1961, pp. 39–40) first published the picture, it was covered with a heavy coat of discolored varnish. Pariset (1962, p. 162) subsequently reported that it had been cleaned in 1962 and found to be in generally good condition. It was treated again in 1970 in the conservation studio of the Metropolitan Museum by Hubert von Sonnenburg, who removed some of the restoration in the areas of strong craquelure, exposing the clear tonality of the original paint.

CLAUDE MONET (1840–1926) was born at Paris but spent his childhood by the sea at Le Havre on the Normandy coast. In 1858 he met Eugène Boudin (1824–1898), the painter of beach scenes and marine views, who encouraged him to paint out-of-doors *sur le motif*. The following year Monet went to Paris, and, against his family's wishes, studied painting at the Académie Suisse, where he met Pissarro (*q.v.*). His studies were interrupted between 1860 and 1862 when he was sent to Algeria as a military conscript. Returning to Paris in November 1862, he came into close association with Renoir (*q.v.*) and Frédéric Bazille (1841–1871). They often met in the forest of Fontainebleau and painted landscapes in the open air, free of academic restrictions. Their works of this period are indebted to Corot and the landscape painters of the preceding generation. Monet's full-length portraits and figure paintings dating from this early period were not enthusiastically received, and because of his strained financial situation, he was forced to return to Le Havre in 1866 and live with his family. It was at this time that he produced one of his first masterpieces, the Terrace at Sainte-Adresse, now in the Metropolitan Museum. With its fresh coloring and brilliantly clear atmosphere, it foreshadows the artist's purely impressionist works of the following decade.

Following the outbreak of the Franco-Prussian war in 1870, Monet went to London where he joined Pissarro and Charles François Daubigny (1817–1878). They introduced him to Paul Durand-Ruel, the dealer who was to play an important role in his career. The following year he left England and, after a short but productive stay in Holland, returned to Paris. In the winter of 1871 he settled at Argenteuil, where he lived for the next six years. In 1874 he participated in an exhibition held by a group of "independent" artists in the Paris studio of the photographer Nadar. The title of one of Monet's pictures, Impression—Sunrise, was applied derisively to the entire group of artists in the show. Monet's picture, which now belongs to the Musée Marmottan, Paris, is a sketchy view of the harbor at Le Havre done two years before the exhibition. In 1878 he moved farther away from Paris to Vétheuil, where he produced some of his most impressionist works, remarkable for their evanescent atmosphere and luminosity. In 1883 he settled at Giverny, where he was to spend the remaining years of his life. Near his house he built an elaborate water garden, which was to become the subject of most of his late works.

Over the years the founders of impressionism gradually drifted apart. Renoir sought to achieve more firmly drawn compositions, Pissarro experimented with the divisionist technique practiced by Seurat (*q.v.*), and Gauguin and Van Gogh appeared on the scene. Monet's canvases of the 1880s reveal that he also experimented to a degree—he tended to employ rather violent colors and to devise compositions with emphatic patterns—but his art remained firmly based upon visual experience. In 1884 he started his famous series of Haystacks, which were followed in the 1890s by the series of Poplars and Rouen Cathedral. The aim of these series was to capture the instantaneous appearance of changing visual phenomena.

During his last years he suffered from severe eye trouble, but, like Renoir, he triumphed over his physical afflictions, developing an incredibly dynamic method of painting enormous and highly abstract compositions of waterlilies and other plants in his garden at Giverny.

16 The Garden of Monet's House, Argenteuil

A PALE PINK house with a gabled roof stands in
the center of the composition. There are beds of
red and pink flowers growing around it, and a
path on the right leads to the door. In the fore-
ground a man and woman lounge on the lawn in
the shade of two tall saplings. The man wears a
white shirt and dark cravat, a dark blue jacket and
gray trousers; the woman wears a pale rose-violet
dress. The foliage of the trees occupies much of
the upper half of the picture.

The canvas is signed in reddish brown paint in
the lower right-hand corner: *Claude Monet* (Fig. 1).

PROVENANCE: The earliest certain record of this
picture dates from August 25, 1891, when it was
listed in the stock books of Durand-Ruel & Cie,
Paris. It was photographed then (Durand-Ruel
negative 1773) and assigned the inventory number
1363 (which corresponds to the handwritten label
[Fig. 2] affixed to the back of the stretcher:
Monet 1363 | Jardin ensoleillé | 1880 | . . . ibdc). But
it may have belonged to Durand-Ruel before this
time. On May 10, 1882, the firm purchased a can-
vas by Monet described as "Le repos, effet de
soleil." This title was used for the Wrightsman
painting when it was exhibited in 1899 (see under
Exhibitions, below). The 1882 inventory, how-
ever, does not give the dimensions of the picture,
so it is impossible to be sure that it was the same
picture.

On August 8, 1911, it was purchased by Baron
Maurice de Herzog, Paris (according to Charles
Durand-Ruel, letter, May 5, 1972). It subse-
quently belonged to Guy Lemm (according to
Daniel Wildenstein, letter, February 2, 1972). In
the early 1950s it was acquired by the firm of
A. & R. Ball, New York. Mr. and Mrs. Wrights-
man purchased it in New York in 1952.

1. *Detail: figures and signature*

2. *Label on the back of the stretcher*

THIS IS A little-known work by Monet of a rather unusual subject. Unlike his familiar views of the open countryside, the Seine, or the sea, this is a confined scene of a couple in a secluded garden. The trees in the foreground and the building in the middle form narrow boundaries within which the artist focuses his attention more on the play of light than on the solid structure of the forms he portrays. The mass of foliage in the upper half of the picture shimmers with radiant light, and the façade of the building seems almost to dissolve in the glare of the sun. Light streams through the leaves of the trees and forms pools of glowing color on the lawn where the figures sit. The figures themselves are so freely painted that at first glance they appear to be reflections of the dappled sunlight.

As Daniel Wildenstein (letter, February 2, 1972) pointed out, the building in the middle of the picture is a house Monet rented at Argenteuil. The artist first settled in this small town on the Seine north of Paris in 1871. Three years later, because of financial difficulties, he gave up the lease on the house he originally rented there and moved to the one seen in the Wrightsman picture. This house still exists. It stands at 5, boulevard Saint-Denis (now 21, boulevard Karl-Marx). A photograph of it, made in 1964, was published by Rodolphe Walter ("Les Maisons de Claude Monet à Argenteuil," in *Gazette des Beaux-Arts,* LXVIII, Decem-

ber 1966, p. 338, fig. 4). It is a modest two-story building with a rose-colored façade and green window shutters.

This house also appears in the background of paintings belonging to Walter H. Annenberg, the American Ambassador to London (Fig. 3), and the Countess of Inchcape, Quendon Park, Saffron Walden, Essex (reproduced in the exhibition catalogue *Claude Monet: The Early Years,* Lefevre Gallery, London, 1969, catalogue no. 15). Like the Wrightsman painting, these are upright rectangular compositions, the Annenberg view being almost exactly the same size, the Inchcape one slightly smaller (62.8 by 52.0 cm.). In all three pictures the foliage of young trees partially obscures the upper part of the pink façade and the steeply pitched gabled roof of the house. The Annenberg painting also depicts the thin trunks of the trees growing in the foreground of the Wrightsman picture. It also shows a walking figure, tentatively identified as the artist's wife, Camille.

Although neither the Annenberg nor the Inchcape canvases are dated, they have been traditionally assigned to the summer of 1876. The Wrightsman picture very likely belongs to the same period, notwithstanding the later dates suggested for it by the Durand-Ruel label and the exhibition catalogues (see below). The date of 1876 is supported by the artist's technique, which closely resembles his manner of painting documented canvases such as the View of the Parc Monceau, Paris, which is signed and dated 1876 and now belongs to The Metropolitan Museum of Art (acc. no. 59.206). All of these canvases are executed in short, choppy brush strokes, with the paint applied without much oil used as a vehicle for the pigment. This differs from Monet's customary practice of applying a more liquid medium, which penetrates the interstices of the canvas. Each spot of paint has a dry appearance, allowing the rough texture of the canvas to show through. The technique of these pictures is also notable for the way the blue of the sky was dabbled on at the last moment, on top of the arkd

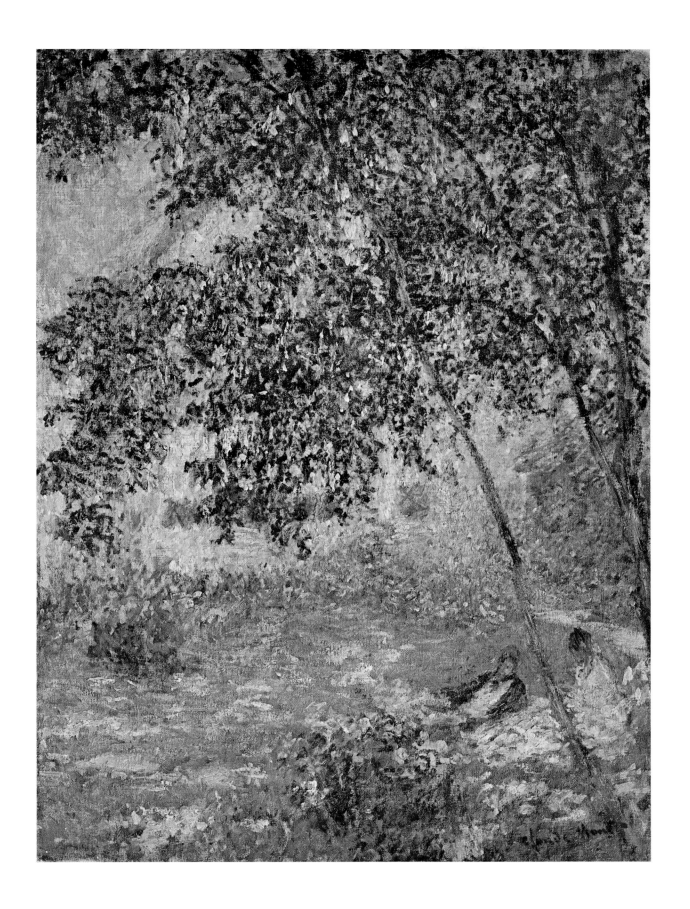

green of the foliage. This unusual technique breaks up masses of solid color and emphasizes the play and variety of atmospheric light. It is particularly effective in the Wrightsman picture where all the strokes and dabs of the brush melt together to form a glowing impression of the heat and intense light of a summer afternoon.

EXHIBITED: Galeries Durand-Ruel, Paris, *Exposition de tableaux de Monet, Pissarro, Renoir, Sisley*, April 1899, catalogue no. 12 (as "Le Repos. 1881"); Grossherzogliches Museum, Weimar, *Exposition Monet*, April—May 1905, catalogue no. 10 (as "Garten 1880"; lent by Durand-Ruel); The Metropolitan Museum of Art, New York, *Paintings from Private Collections: Summer Loan Exhibition*, July 6—September 4, 1960, catalogue no. 79.

REFERENCES: Unpublished.

Oil on canvas, H. 31⅞ (81.0); W. 23⅝ (60.0).

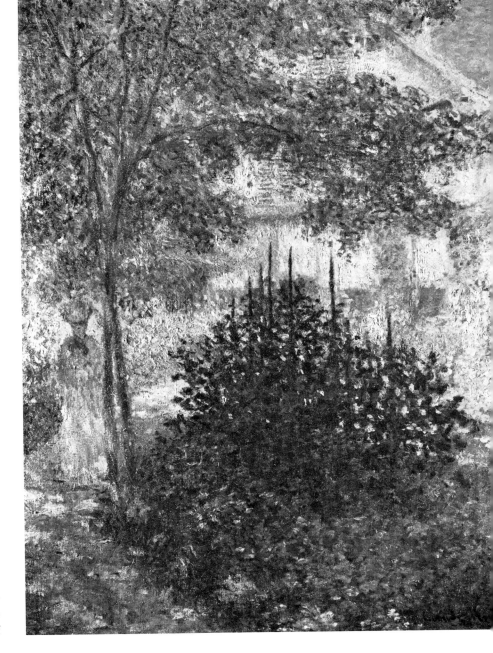

3. *Claude Monet, Camille Monet in the Garden, Argenteuil. Oil on canvas, 82.5 by 62.5 cm. London, collection of U.S. Ambassador Walter H. Annenberg*

JACOB CAMILLE PISSARRO (1830–1903), the impressionist best known for his paintings of the French countryside, was born on the island of St. Thomas in the Danish West Indies. He was educated in Paris, and in 1852 traveled to Caracas, Venezuela, with Fritz Melbye (1826–1898), the Danish sea and landscape painter. Pissarro's earliest known watercolors and drawings date from this trip, and they reflect Melbye's detailed topographical style. In 1855 he returned to France and saw the great international art show at the Exposition Universelle in Paris. At this exhibition he was particularly impressed by the paintings by Jean-Baptiste Corot (1796–1875), Jean François Millet (1814–1875), and Gustave Courbet (1819–1877). He admired Corot's works so much that as late as 1865 he designated himself his pupil, though he never actually studied with him. Pissarro's landscapes of this period, such as Jallais Hill, Pontoise, dated 1867, in The Metropolitan Museum of Art, reflect Corot's early Roman style in their use of strong color, solid brush strokes, and cubic forms.

During his first ten years in Paris, Pissarro made friends with the young Renoir (*q.v.*), Monet (*q.v.*), and Alfred Sisley (1839–1899). Like them, he formed the habit of painting out-of-doors rather than from sketches in the studio. But he also worked occasionally at the Académie Suisse, where he befriended Armand Guillaumin (1841–1927) and Paul Cézanne (1839–1906).

In 1870, to escape the Franco-Prussian War, Pissarro went to London where he was influenced by the landscapes of John Constable (1776–1837) and William Turner (1775–1851). Monet was also in London at this time, and the two artists worked closely together. Returning to Paris in 1871, Pissarro lightened his palette, and, like Monet, made numerous studies of the countryside around Paris at different times of day and in different seasons. In 1874 he helped organize what is now known as the first impressionist exhibition; he was the only artist to participate in all eight of them.

In 1885 he met Seurat (*q.v.*) and Paul Signac (1863–1935) and adopted their color theory of divisionism, or pointillism. In such a picture as the Île Lacroix, Rouen: Effect of Fog, dated 1888, in the Johnson Collection, Philadelphia, Pissarro followed Seurat's technique of painting an entire picture with small dots of color. After about five years of slow and painstaking work in this rigid manner, he decided that the pointillist technique hampered his personal expression and so returned to the looser brush strokes of the pure impressionism of his earlier work.

Because of an eye ailment that began in 1889, Pissarro was eventually unable to paint out-of-doors. During the last ten years of his life, he confined himself to painting cityscapes from windows. In a wonderfully free and sure technique, he painted views of the boulevards and squares of Paris and Rouen.

17 Two Young Peasant Women

TWO YOUNG peasant women are depicted in the foreground of a large, open field. The one on the left is seated with her head resting on her right hand and her left hand drawn across her waist. Her blonde hair is parted at the crown and tightly drawn back to a bun with bangs at her forehead. She wears a simple, long-sleeved, blue-striped blouse and a dark blue skirt. Her head is in profile, and her expression is one of quiet contemplation. Her companion, standing on the right, leans on the long wooden handle of a farm implement and rests her right hand on her knee. Tied over her dark brown hair is a red-flowered kerchief. She wears a collar-less, long-sleeved, light blue shirt and a long, dark blue skirt with a small bustle in the back. She faces the seated girl but seems to be absorbed in her own thoughts.

In the left background a row of four fruit trees recedes sharply into the distance. Between the two figures appears a large expanse of open field, with a patch of yellow grass in the middle ground and green grass in the background that is visible up to the very high horizon. There is an isolated tree in the middle of the field with a row of taller trees dotting the distant horizon to the left. Behind the standing peasant girl appears a cultivated garden with rows of stakes and vines. A very narrow strip of blue sky with a few puffy white clouds can be seen above the horizon.

The painting is signed and dated in red in the lower right-hand corner: *C. Pissarro.1892* (Fig. 1).

1. *Detail: signature and date*

PROVENANCE: The picture originally belonged to the artist's wife. Following an exhibition of his work at Durand-Ruel, Pissarro wrote to Mirbeau on February 26, 1892, "Durand-Ruel a fini par prendre ce qui me restait de tableaux à vendre, excepté . . . et ceux appartenant à Mme Pissarro," indicating that the painting was among those returned to her (see letter quoted in Kunstler, 1930, pp. 224, 226). After her death, it was sold at auction at the Galerie Georges Petit, Paris, December 3, 1928, lot 25 (bought by Paul Rosenberg for 173,000 francs). Some time before December 1933 it entered the collection of Baron Maurice de Rothschild (1881–1957), Paris (he lent it to an exhibition held that month; see below, under Exhibitions). It remained in the Rothschild Collection until 1952. Mr. and Mrs. Wrightsman acquired the painting in New York in 1952.

THOUGH THIS painting depicts a seemingly simple, straightforward, bucolic subject, it bears political and social overtones. As early as 1883 Pissarro had become involved in the anarchist movement in France. While his paintings were never openly propagandistic, they reflected the artist's anti-industrial, anti-capitalist convictions in his choice of subject matter: peasants in the open countryside, the agrarian way of life in the rural areas outside of Paris. Pissarro objected to the emerging industrial-urban society of late nineteenth-century France. By 1890 he had become a member of the Club de l'Art Social and a contributor to the anarchist publication *La Révolte*, later *Les Temps Nouveaux* (see Robert L. and Eugenia W. Herbert, "Artists and Anarchism: Unpublished Letters of Pissarro, Signac, and Others—I," in *The Burlington Magazine*, CII, November 1960, pp. 473–482). In July 1891, the month in which Pissarro was probably painting the present picture, he sent his son Lucien a letter, addressing him as "anarchist and lover of

nature" (John Rewald, ed., *Camille Pissarro: Letters to His Son Lucien*, New York, 1943, p. 179). In April 1892, only three months after the painting had been finished, he wrote that Kropotkin (1842–1921), one of the leaders of French Anarchist-Communism,

> croit qu'il faut vivre en paysan pour bien les comprendre. Il me semble qu'il faut être emballé par son sujet pour le bien rendre; mais est-il nécessaire d'être paysan? Soyons d'abord artiste et nous aurons la faculté de tout sentir, même un paysage sans être paysan (Kunstler, 1930, p. 228).

> believes that one must live like a peasant in order to understand them. It seems to me that one must be sympathetic to a subject in order to paint it well, but is it necessary to be a peasant? Let us first be artists and we will have the power to understand anything, even a landscape without being a peasant.

The present painting reveals Pissarro's love of nature and his affection for peasants and their way of life. In a quiet, meditative way, the picture champions simple, unmechanized country living.

Two Young Peasant Women is among the largest and most ambitious works Pissarro ever did. In February 1892 Joseph Durand-Ruel held a major retrospective exhibition of Pissarro's work, including paintings and gouaches executed between 1870 and 1892. Of the fifty paintings in the show, the artist considered Two Young Peasant Women to be one of the three most important. He singled it out on January 13, 1892, when he wrote Durand-Ruel concerning the exhibition that "nous pourrions faire faire 3 cadres mats pour les 3 principaux tableaux tels que le no. 9 T. 25—le no. 10 T. 20—le no. 11 T. 50," the latter being the Wrightsman painting (Venturi, 1939, II, p. 32). In the same letter he mentions that he has not yet finished the picture, referring to it as "ma grande toile," but will have it ready in time for the exhibition. It was completed the following week and shipped to Paris on January 19, 1892 (Venturi, 1939, II, pp. 33, 34). Pissarro was particularly proud of the painting, and made a gift of it to his wife, who kept it for the rest of her life.

Although the picture was finished in January 1892, it is most likely that Pissarro began to paint it in the summer of 1891. Although Pissarro painted directly from nature throughout his life, after contracting an eye infection in 1889 he often did a preliminary sketch out-of-doors, which he then completed in his studio. The trees in Two Young Peasant Women are in full leaf, indicating that it was begun during the summer. It may have been started in mid-July of 1891, since Pissarro wrote to his son Lucien from Éragny on July 14, 1891, "Just when I least expected it, just when I was fully at work, this cursed eye trouble came back. I was working in our field in superb weather, there came a sudden wind—or maybe it was a puff of dust—and in two days an abscess had formed and broken" (Rewald, 1943, p. 180). This eye trouble may account for the long time it took the artist to complete the picture.

The picture's setting is a field near the Pissarro house at Éragny, very likely the field mentioned in the letter quoted above. This field frequently appears in the background of the artist's compositions. Two canvases dating from the mid-1880s (Pissarro and Venturi, 1939, catalogue nos. 590, 1377, both illustrated) show it seen from exactly the same angle as in the Wrightsman picture.

From the standpoint of style and technique the painting is similar to Haymakers Resting (Fig. 2), a picture Pissarro signed and dated 1891. Like the Wrightsman picture it shows peasants depicted as large figures resting in the foreground, while the background is a vast expanse of open field leading to a high horizon with very little sky visible. Moreover, the two paintings are similar in the way they are executed, with small, comma-shaped brush strokes. This technique of painting is due in part to Pissarro's association with Seurat.

In a letter of February 10, 1891, describing a painting he had recently finished, he wrote that "I divided the tones without waiting for the paint to dry and nevertheless it is quite luminous. It has much more suppleness than my previous paintings and has as much purity and light. So I feel that I

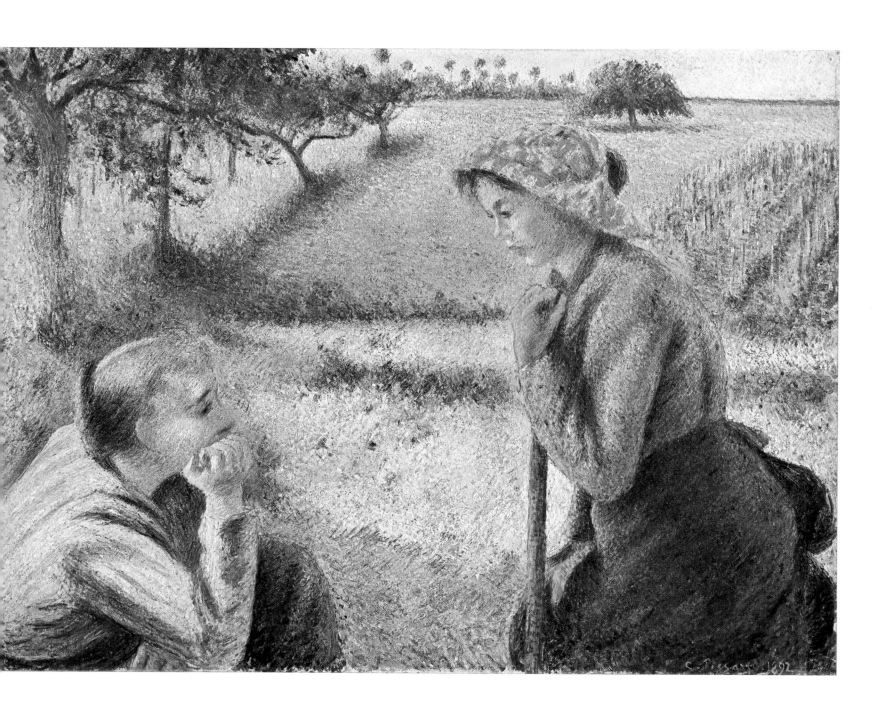

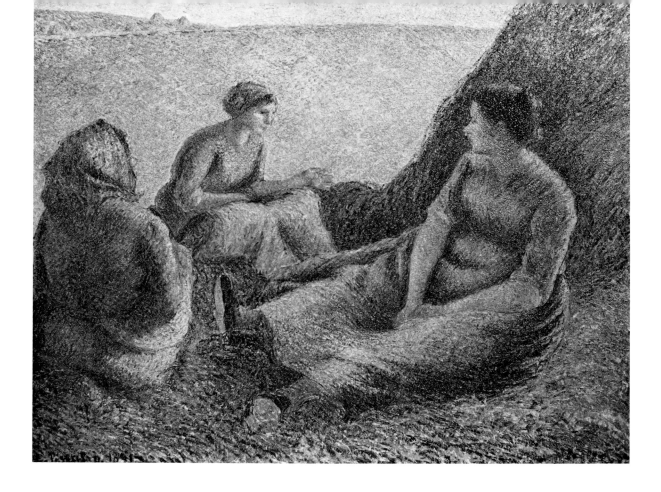

2. *Camille Pissarro, Haymakers Resting. Oil on canvas, 65.0 by 80.0 cm. San Antonio, Texas, McNay Art Institute*

am about to make rapid progress with this approach" (Rewald, 1943, p. 150). This is precisely the style Pissarro used in Two Young Peasant Women. While it still shows traces of his divisionist technique in the small dots of pure color, it is much freer and looser in execution.

Another characteristic of the style of the Wrightsman picture is the unusually large scale of the figures. In Pissarro's paintings before 1890 the figures were comparatively small in relation to the landscape. An explanation for the larger proportions of the figures in the Wrightsman painting may be the artist's growing interest in Japanese prints. As early as 1863 Pissarro is known to have made etchings, but it was not until the late 1870s, when he studied printmaking with Edgar Degas (1837–1917) and Mary Cassatt (1845–1926), that

he began to use larger foreground figures. In April 1891, shortly before beginning the Wrightsman picture, he wrote to Lucien, "Incidentally I have agreed to do a series [of etchings] with Miss Cassatt; I will do some Markets, Peasant Women in the Fields, and—this is really wonderful—I will be able to try to put to the proof some of the principles of neo-impressionism" (Rewald, 1943, p. 158). In this series, following the example of Japanese prints, he experimented with large, arbitrarily cut-off figures patterned against flat or tipped-up backgrounds, as in the Wrightsman painting.

Pissarro may also have been inspired by the work of Jean François Millet (1814–1875), his predecessor as a great champion of peasants and the agrarian way of life. Pissarro actually owned an impression of Millet's woodcut, the Seated Shepherdess (Fig. 4), which bears a remarkable resemblance in attitude and proportion to the seated peasant in Pissarro's painting. Pissarro also

3. *Jean François Millet, Man with a Shovel. Woodcut on paper, 18.8 by 13.2 cm. New York, The Metropolitan Museum of Art, gift of Van Horne Norrie, 17.34.15*

owned an impression of Millet's Man with a Shovel (Fig. 3). The pose of the man leaning on the shovel is a possible source for the pose of the standing peasant in the Wrightsman composition.

The painting has been given different titles in the past. When the artist first wrote about it to Durand-Ruel on January 19, 1892, he referred to it as "2 jeunes paysannes" (Venturi, 1939, II, p. 34); but by the time of the posthumous exhibition of his work in 1904, it was called La Causette, or the Chat. This title is somewhat inappropriate in that the figures rest in unanimated, introspective poses, seeming not to talk at all.

A drawing for the seated figure appeared in 1928 at the sale of Mme Pissarro's collection (Pissarro and Venturi, 1939, catalogue no. 1593, illustrated). Its present location is not recorded.

EXHIBITED: Galeries Durand-Ruel, Paris, *Exposition Camille Pissarro*, February 1892, catalogue no. 50, as "Deux Jeunes Paysannes"; Galeries Durand-Ruel, *Exposition de l'oeuvre de Camille Pissarro*, April 1904, catalogue no. 84, as "La Causette"; Galerie Nunes & Fiquet, Paris, *La Collection de Madame Veuve C. Pissarro*, May–June 1921, catalogue no. 29; Musée de l'Orangerie, Paris, *Centenaire de la naissance de Camille Pissarro*, February–March 1930, catalogue no. 81 (illustrated); Galeries Beaux-Arts, Paris, *Seurat et ses amis; la suite de l'impressionnisme*, December 1933–January 1934, catalogue no. 49; Wildenstein & Co., London, *Nineteenth Century Masterpieces*, May–June 1935, catalogue no. 29 (illustrated); Wildenstein & Co., London, *Seurat and His Contemporaries*, January–February 1937, catalogue no. 26 (illustrated); Stedelijk Museum, Amsterdam, *Honderd Jaar Fransche Kunst*, Summer 1938, catalogue no. 195; National Gallery of Art, Washington, D. C., February 1956—October 1957, April 1959; The Metropolitan Museum of Art, New York, *Paintings from Private Collections: Summer Loan Exhibition*, July—September 1961 (not listed in catalogue).

REFERENCES: Théodore Duret, *Histoire des peintres impressionnistes*, Paris, 1906, p. 65 (mentions it among Pissarro's paintings of peasants) / / Théodore Duret, *Manet and the Impressionists*, John Ernest Crawford Flitch, trans., London, 1910,

p. 132 (lists the composition as one of Pissarro's pictures of "Peasants, working at their various tasks") // Georges Lecomte, *Camille Pissarro*, Paris, 1922, illustrated opp. p. 46 // Théodore Duret, *Die Impressionisten*, Berlin, 1923, p. 86 (includes it in a list of paintings of peasants by Pissarro, incorrectly dating it 1882) // Emil Waldmann, *Die Kunst des Realismus und des Impressionismus im 19. Jahrhundert*, Berlin, 1927, p. 88, illustrated p. 468 (claims that Pissarro was a follower of Millet, and refers to this picture as an example of his influence) // Charles Kunstler, "La Collection Camille Pissarro," in *Le Figaro: Supplément Artistique*, Hebdomadaire, November 29, 1928, p. 103, illustrated (notes that in this picture Pissarro returned to comma-like brush strokes) // Anonymous, "Les Grandes Ventes prochaines: La Collection Camille Pissarro," in *Le Bulletin de l'Art Ancien et Moderne*, December 1928, p. 412, illustrated p. 410 (remarks that it illustrates Pissarro's evolution away from the influence of older artists) // Charles Kunstler, "Camille Pissarro (1830–1903)," in *La Renaissance de l'Art*, December 1928, p. 505 (considers it one of Pissarro's most appealing works and one that he would like to see acquired by the Louvre) // Charles Kuntsler, "Des Lettres inédites de Camille Pissarro à Octave Mirbeau (1891–1892) et à Lucien Pissarro (1898–1899)," in *La Revue de l'Art Ancien et Moderne*, LVII, March 1930, illustrated p. 189; April 1930, pp. 224, 226 (publishes Pissarro's letter of February 26, 1892, in which he says the pictures [including the Wrightsman painting] belonging to Mme Pissarro were among those not sold by Durand-Ruel) // Anonymous, "Nineteenth-Century Masterpieces," in *The Burlington Magazine*, LXVI, 1935, p. 297, illustrated opp. p. 293 (cites it as an "idyllic study . . . reminiscent of Millet") // Lionello Venturi, *Les Archives de l'impressionnisme*, Paris—New York, 1939, II, pp. 32, 34 (publishes Pissarro's letter of January 13, 1892, to Joseph Durand-Ruel in which the picture is cited as one of the three most important paintings to be shown in the 1892 exhibition; also publishes a letter of January 19, 1892, from Pissarro to Durand-Ruel in which the canvas is listed as one of the paintings being sent to the exhibition) // Ludovic Rodo Pissarro and Lionello Venturi, *Camille Pissarro: son art—son oeuvre*, Paris, 1939, I, p. 61, catalogue no. 792; II, pl. 163 (consider it to be one of Pissarro's most famous works; note that it is carefully composed, that it is not sentimental, and that it still reflects the style of neo-impressionism in color and formal organization) // John Rewald, *Pissarro*, Paris [about 1945], fig. 10.

Oil on canvas, H. 35¼ (89.5); W. 45⅞ (116.5).

4. *Jean François Millet, Seated Shepherdess. Woodcut on paper, 27.1 by 21.9 cm. New York, The Metropolitan Museum of Art, Rogers Fund, 19.34.1*

NICOLAS POUSSIN (1594–1665), the leading French painter of the seventeenth century, was born at Les Andeleys, Normandy, but spent most of his life working in Rome. A highly literate and intellectual artist, he was the exponent of classicism in the baroque era. His art is often concerned with philosophical ideas, poetically rendered in carefully deliberated compositions painted with great sensitivity.

He first studied in Paris under Ferdinand Elle (about 1585–1637) and Georges Lallemand (died 1636), mediocre painters of the Second School of Fontainebleau who practiced a retardatory mannerist style. It was not until he arrived in Rome at the age of thirty that he embarked upon his formative studies of the great Italian Renaissance masters and the antique. Inspired by Titian's Bacchanals, then in the Vigna Ludovisi in Rome, he gradually evolved a highly individualistic style, combining the classical design of Raphael's great frescoes and the sensuous coloring of Titian's masterpieces. He worked in the studio of Domenichino (q.v.), the most classically oriented contemporary Italian painter, and in 1627 produced his first major Roman picture, the Death of Germanicus, now in the Minneapolis Institute of Arts. His first public commission was the Martyrdom of St. Erasmus (1628–1629), a large altarpiece ordered for a prominent place in St. Peter's. It demonstrated his ability to work in the flamboyantly baroque style of his Italian contemporaries.

In 1630 he nearly died of a grave illness, and when he recovered his career took a new direction. He turned down large public commissions and devoted himself to smaller pictures for a cultivated group of patrons including Cassiano dal Pozzo, secretary to Cardinal Francesco Barberini, and a growing number of French collectors. He studied treatises on perspective, investigated theories of movement in his two versions of the Rape of the Sabine Women (in the Louvre and the Metropolitan Museum), and took an archaeological interest in ancient sculpture. The major works of the thirties include a set of Seven Sacraments for dal Pozzo and a pair of Bacchanals commissioned in 1636 by Cardinal Richelieu.

In 1640 he returned to Paris to work for Louis XIII, who gave him the title *premier peintre du Roi* and a handsome pension. In return he was required to execute large decorative schemes for which he was temperamentally unsuited: large altarpieces, designs for tapestries, as well as the decoration of the Orangerie in the Palais Luxembourg and the Grande Galerie in the Louvre. He also encountered the bitter jealousy of the painters who were already established in Paris, particularly Simon Vouet (1590–1649) and Jacques Fouquières (died 1659), who conspired against him. Incapable of coping with these uncongenial conditions, he returned to Rome after eighteen months of working for the king.

In Rome he was considered a great master. His reputation there was rivaled only by that of Pietro da Cortona (1596–1669) whose major works were large frescoes totally unlike the complex and carefully painted compositions Poussin executed. Toward the end of his life he worked in an increasingly austere and restrained style, an extension of the cerebral approach underlying all his work. The late pictures are also remarkable for their serenity and the poetic quality of their landscape backgrounds.

ON THE SHORE of an island two knights attack a dragon, which recoils on the right and opens its mouth menacingly. To the left, Fortuna, the woman in the boat moored to the island, stares at the confrontation (Fig. 2). She wears a *changeant* scarlet-violet dress and holds an oar over the side of the heavily carved bronze-colored boat. Both men carry shields and wear grayish green sandals and silver cuirasses with gold waistbands and gold shoulder guards. Ubaldo, who raises a golden wand above his head (Fig. 3), wears a silver helmet decorated with a dark blue plume and a silver griffin. The sleeves and skirt of his tunic are lustrous deep blue. The hilt of his falchion is shaped like an eagle's head; the scabbard is ornamented with a gold and silver pattern. Carlo, the knight holding the sword, wears an ornate golden helmet with a red plume; the sleeve of his shirt is modeled in red and orange; his tunic skirt is a rich yellow-ochre. The rocks and tree trunks of the background are painted warm brownish gray colors that are close in hue and value to the clouds in the sky.

On the back of the painting, there is a label attached to the stretcher (Fig. 1). It is inscribed in an eighteenth- or early nineteenth-century hand: *Carolus.Et.Hubertus.ut.Tassus. | Cecinit.Rinaldum. Liberaturi. | Poussinus.Pinx.*

1. *Label on the back of the stretcher*

2. *Detail: the goddess Fortuna*

PROVENANCE: Friedlaender (1933, p. 324) identified this picture as one of the Poussins recorded in the Palazzo dal Pozzo in Rome late in the seventeenth century. He connected it with the following passage in a memoir, believed to have been written shortly before 1689 by Robert de Cotte: "dans la 5me [chambre] une rebecca du poussin . . . et une autre representant les deux chevaliers qui vont délivrer Renaud des enchantements darmide" (Paris, Bibliothèque Nationale, Ms. fr. 9447, fol. 210).

The collection in the Palazzo dal Pozzo was formed by Cassiano dal Pozzo (1588–1657) and his younger brother Carlo Antonio (1606–1689). It is likely that the picture was commissioned by Cassiano, since he patronized Poussin and owned fifty paintings by him. The collection was dispersed early in the eighteenth century.

It should be noted that the label on the back of the picture (Fig. 1) is similar to inscriptions on the backs of other paintings known to have belonged to Cassiano dal Pozzo. It is in Latin, and it is punctuated with full stops between each word. Mrs. Michael Rinehart (letter, July 5, 1971) observed that the Poussins in the dal Pozzo Collection were inscribed on the back in Latin, boldly printed in Roman capitals with a punctuation dot between every word (for an illustration of one, see Denis Mahon, "The Dossier of a Picture: Nicolas Poussin's 'Rebecca al Pozzo,'" in *Apollo*, LXXXI, March 1965, p. 204, fig. 5). Because the label on the Wrightsman painting is in Latin and has the same punctuation between each word, it is fairly safe to assume that it was copied from an inscription on the back of the original canvas, now covered by a relining canvas.

The painting is next recorded in the collection of the Counts Harrach in Vienna. It probably was acquired in Italy by Count Aloys Thomas Raimund Harrach (1669–1742) while he served as viceroy of the Kingdom of Naples from 1728 until 1732. In 1745 it was listed in an inventory of the Harrach family's possessions in Vienna (Heinz, 1960, p. 9). It remained in the possession of the Harrach family until 1967, when it was sold by Countess Stéphanie Harrach. Mr. and Mrs. Wrightsman acquired it in New York in 1968.

THIS PICTURE illustrates an episode from Torquato Tasso's heroic poem *Jerusalem Delivered*. First published in 1580, the poem combines an account of the First Crusade with imaginary adventures and love stories. One of the heroes, Rinaldo, is abducted by the pagan sorceress Armida, who falls in love with him and carries him off to her palace on the island of Fortune. There she casts a spell on him, making him fall in love with her. Two Christian knights, Carlo and Ubaldo, come to exhort Rinaldo to leave his beloved and rejoin his fellow crusaders. Their way to Armida's palace is blocked by a dragon. It is this scene that is shown in the painting.

In other paintings Poussin depicted earlier events from Tasso's poem, such as Armida Discovering Rinaldo on the Battlefield (Dulwich College, London; Pushkin Museum, Moscow) and Armida Carrying the Wounded Rinaldo off to Her Palace (Staatliche Museen, Berlin). Since they differ from the present painting in terms of style and dimensions, it is unlikely that there was a unified series. Two drawings by Poussin in the Louvre show Carlo and Ubaldo Leading Rinaldo off the Island, a subject that conceivably could have formed a pendant to the Companions of Rinaldo; but as Friedlaender and Blunt (1949, pp. 21, 23) have observed, the drawings seem to have been made at least a decade later than the painting.

Tasso's poem enjoyed a great vogue among seventeenth-century painters, who often depicted the amorous side of Rinaldo's adventures, but the Companions of Rinaldo appears to be a unique example in painting of the Christian knights coming to Rinaldo's rescue. Certainly no well-known artist of the time ever dealt with the subject (see Anton Pigler, *Barockthemen*, Budapest, 1956, II, pp. 448–451). The fact that Poussin was drawn to paint this particular subject is indicative of his artistic personality. He found in the subject a power-

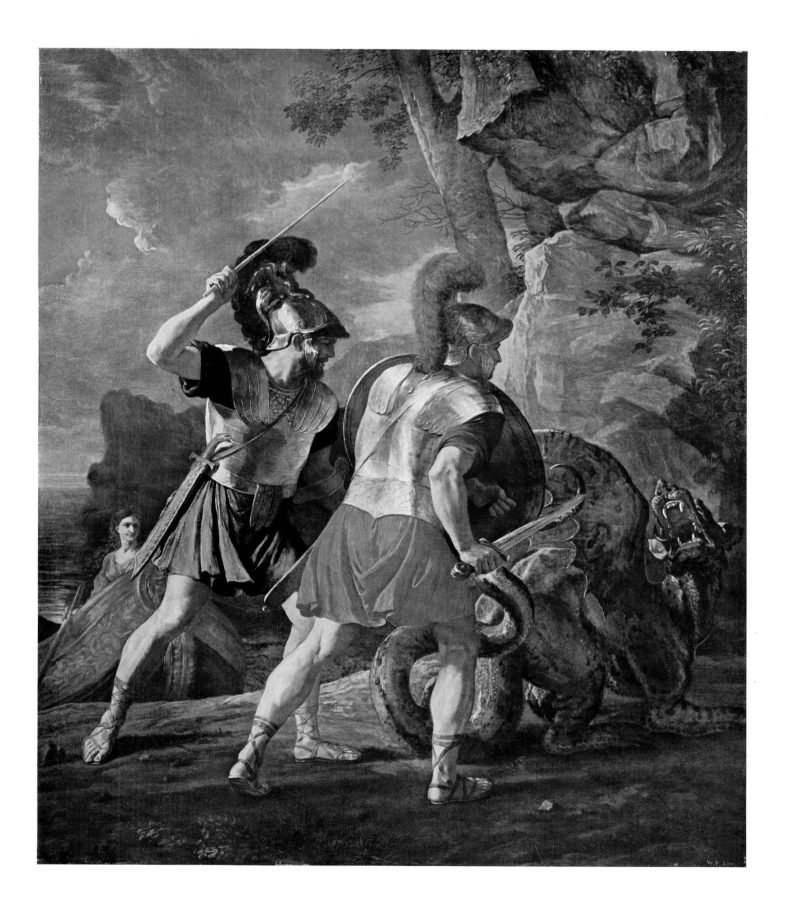

ful confrontation that could be illustrated in grand and exalted terms.

In the Wrightsman painting the artist follows the poet's words very closely:

I due Guerrieri in loco ermo, e selvaggio
. . . s'attraversa
Fiera serpendo orribile e diversa.
.

Già Carlo il ferro stringe, e'l serpe assale;
Ma l'altro grida a lui: che fai? che tente?
Per isforzo di man, con arme tale,
Vincer avvisi il difensor serpente?
Egli scote la verga aurea immortale,
Sì che la belva il sibilar ne sente;
E impaurita al suon, fuggendo ratta,
Lascia quel varco libero, e s'appiatta.

(Canto XV, verses 47, 49)

Within a thick, a dark, and shady plot,
. . [the two warriors encountered]
An ugly serpent which forestall'd their way;
.

Charles drew forth his brand to strike the snake:
Ubaldo cried—Stay, my companion dear,
Will you with sword or weapon battaile make
Against this monster that affronts us here?—
This said, he 'gan his charmed rod to shake,
So that the serpent durst not hiss for fear,
But fled, and dead for dread fell on the grass,
And so the passage plain, eath, open was.

(Edward Fairfax translation, 1600)
[reprinted New York, 1845]

This is precisely what is happening in the painting. Carlo has unsheathed his sword and holds it ready at his side, while Ubaldo raises a golden wand (Fig. 2). The hideous monster, writhing with terror, has already turned to flee. The other figure in the painting, the mysterious woman seated in the boat (Fig. 1), is also described in the poem. She is the goddess Fortuna, who led Carlo and Ubaldo to the island. The poet gives a long account of her strangely colored dress:

La sua gonna or azzurra, ed or vermiglia
Diresti, e si scolora in guise mille;

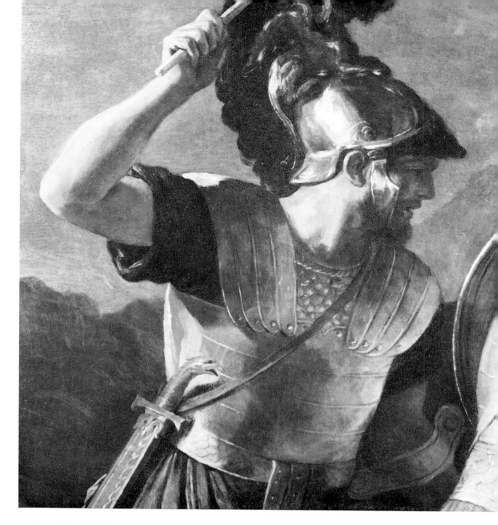

3. *Detail: Ubaldo*

Sì ch'uom sempre diversa a sè la vede,
Quantunque volta a riguardarla riede.
.

Or d'accesi rubin sembra un monile;
Or di verdi smeraldi il lume finge;
Or insieme gli mesce; e varia e vaga
In cento modi i riguardanti appaga.

(Canto XV, verses 4–5)

Her robe seem'd sometimes red and sometimes blue,
And changed still as she did stir or move;
That look how oft man's eye beheld the same,
So oft the colors changed, went and came:
.

And now of rubies bright a vermeil chain,
Now make a carknet rich of emeralds green;
Now mingle both, now alter, turn, and change
To thousand colors, rich, pure, fair, and strange.

(Edward Fairfax translation, 1600)

[163]

4. *Antonio Tempesta, Companions of Rinaldo. Engraving, 33.0 by 46.3 cm., from Tasso, Gerusalemme Liberata, Rome, before 1630, pl.* xv, *New York, The Metropolitan Museum of Art, Elisha Whittelsey Fund, 51.501.4052*

Poussin was surely inspired by this description, for he colored the goddess's dress in the most extraordinary *changeant* hues, ranging from pale violet and scarlet and gold to a shimmering blue.

In addition to the printed word Poussin may have been influenced to some extent by engravings illustrating the poem. One of the editions of *Jerusalem Delivered* published before the picture was painted contains, for example, a print by Antonio Tempesta (1555–1630) that shows Carlo and Ubaldo overcoming the dragon, as well as other obstacles that Armida placed in their path (Fig. 4). But Tempesta's engraving is a cluttered resumé of all the highlights of the fifteenth canto of the poem. By contrast, Poussin's painting focuses on one dramatic event. Nevertheless, it is tempting to think that he saw this particular edition of Tasso and was inspired by the coiled dragon and the classical costumes in Tempesta's engraving.

Like many other works by Poussin, the Wrights-

man painting shows the artist's preoccupation with classical antiquity. Although the story of the painting is set in the Middle Ages, it looks as if it took place in ancient times. This is typical of the creative process by which Poussin's imagination transformed subjects, elevating them to a lofty plane of noble thought and emotion. The adventures of medieval knights serve him as a pretext to illustrate, with archaeological precision, his idea of classical heroism.

There are certain details in the picture suggesting that the artist copied specific classical antiques

5. *Nicolas Poussin, copies of reliefs on the Column of Trajan. Ink on paper, 32.0 by 21.0 cm. Valenciennes, Musée des Beaux-Arts. Photo: Giraudon*

and then incorporated them in his picture. The helmets, for instance, resemble those on a sheet of drawings (Fig. 5) he made after the bas-reliefs on the Column of Trajan. Also, the design of Carlo's and Ubaldo's armor is closely similar to that of some figures which Poussin copied from the same reliefs (Fig. 6). The simple tunic skirts, the shoulder guards, and the strips extending down from the waistbands appear again and again in Poussin's drawings from the reliefs on the Column of Trajan. Even closer parallels for the poses and the costumes of the two warriors in the painting may be found in certain reliefs of which no drawings survive (see Salomon Reinach, *Répertoire de reliefs grecs et romains*, Paris, 1909, I, p. 314, no. 34, p. 358, no. 84; Karl Lehmann-Hartleben, *Die Trajanssäule: ein römisches Kunstwerk zu Beginn der Spätantike*, Berlin, 1926, pls. XL, CVI). It is curious that these details borrowed from the Column of Trajan appear only in this painting by Poussin.

For the design of the boat Poussin seems to have copied a well-known classical relief. Kauffmann (1961, pp. 113–114) has pointed out that it corresponds with the boats on a relief (Fig. 7) formerly in Rome and now in the Museo Archeologico, Venice (Carl Robert, *Die antiken Sarkophag-*

6. *Nicolas Poussin, copies of reliefs on the Column of Trajan. Ink on paper, 26.2 by 19.0 cm. Oxford, Ashmolean Museum*

7. *Greco-Roman, I century* B.C., *relief with boats. Marble, 80.0 by 80.0 cm. Venice, Museo Archeologico*

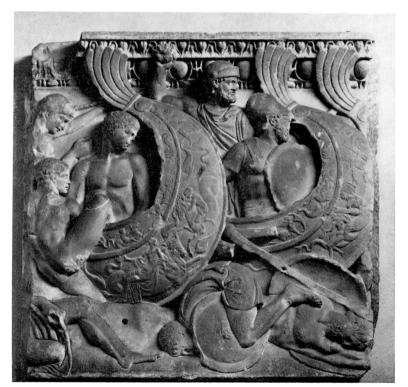

[165]

Reliefs, Berlin, 1904, III, Part 2, p. 366, no. 11, supp. pl. B, fig. 11). Poussin may have seen the relief itself or a drawing or an engraving made after it.

All of these classical motifs probably appealed to Cassiano dal Pozzo, the man for whom the picture was painted. An avid student of Roman art, he formed a collection of almost 1,500 drawings after the antique, which fill over twelve rebound volumes now divided between the British Museum and the Royal Library at Windsor. He even had plaster casts made from the reliefs on the Column of Trajan so that artists like Poussin could copy scenes that are too high above the street to be seen clearly. Although Poussin certainly shared his patron's enthusiasm for classical antiquity, the fact that he painted this picture for dal Pozzo may well account for the strongly archaeological character of the two medieval Christian knights seen as a pair of Roman soldiers.

The dating of the picture has given rise to some speculation. Grautoff's original suggestion that it belongs to the years 1630–1635 has been qualified by Blunt and Mahon. They agree that it belongs to this period, but they differ about precisely when. In the catalogue for the Poussin exhibition at the Louvre (1960, p. 69) Blunt dated it 1630–1633. In a more recent publication (1966, pp. 141, 142) he proposed dating it about 1633–1635. On the other hand, Mahon (1962, p. 53) has argued persuasively that it was done shortly before 1633. The year 1633 is crucial because, while there are few securely dated works from this period in Poussin's career, he did sign and date that year a large painting of the Adoration of the Magi, now at Dresden. The Dresden picture is important, moreover, because it marks a stage in Poussin's stylistic development in the direction of greater spatial clarity and the use of firmly modeled figures seen in full daylight. This style is different from that of the Wrightsman painting, where the figures are bathed in a warm, romantic twilight characteristic of his work before 1633. The vertical composition and the dimensions of the Wrightsman picture are also linked to Poussin's work be-

fore 1633. Poussin seldom used this vertical format for his paintings, but it does occur in a few early works such as the Arcadian Shepherds, at Chatsworth, and the Inspiration of the Lyric Poet, at Hanover. After the early 1630s there are no further examples in this format.

EXHIBITED: Kunsthistorisches Museum, Vienna, *Poussin*, 1935, catalogue no. 2; Kunstmuseum, Bern, *Europäische Barockmalerei aus Wiener Privatgalerien: Czernin, Harrach, Schwarzenberg*, December 21, 1947—March 31, 1948, catalogue no. 37; Musée du Louvre, Paris, *Exposition Nicolas Poussin*, May—July 1960, catalogue no. 32 (illustrated).

REFERENCES: Charles Philippe de Chennevières-Pointel, *Recherches sur la vie et les ouvrages de quelques peintres provinciaux de l'ancienne France*, Paris, 1854, III, pp. 152–154 (publishes Robert de Cotte's description of the dal Pozzo Collection, which included Poussin's Companions of Rinaldo) // Anton Gruss, *Verzeichniss der Gräflich Harrach'schen Gemälde-Galerie zu Wien*, Vienna, 1856, p. 41, catalogue no. 200 (erroneously catalogues the painting as by Le Sueur) // *Catalog der erlaucht Gräflich Harrach'schen Bildergallerie*, Ed. Gerisch and K. Špaček, Vienna, 1897, p. 74, no. 199 (repeat the Le Sueur attribution) // Walter Friedlaender, *Nicolas Poussin: die Entwicklung seiner Kunst*, Munich, 1914, p. 128 (unaware of the Wrightsman picture, then in the Harrach Collection, he lists a lost painting by Poussin of the Companions of Rinaldo as recorded by de Cotte in the dal Pozzo Collection) // Otto Grautoff, *Nicolas Poussin: Sein Werk und sein Leben*, Munich, 1914, I, pp. 110; II, pp. 66–67 (publishes the Harrach painting for the first time as a Poussin and dates it 1630–1635) // Hermann Ritschl, *Katalog der erlaucht Gräflich Harrach'schen Gemälde-Galerie in Wien*, Vienna, 1926, p. 67, catalogue no. 199 (catalogues it as by Poussin and mistakenly identifies the woman in the boat as Armida) // Walter Friedlaender, "Nicolas Poussin," in *Allgemeines Lexikon der bildenden Künstler* (Thieme—Becker), Leipzig, 1933, XXVII, p. 324 (connects the Harrach canvas for the first time with the picture formerly in the dal Pozzo Collection [but mistakenly cites Jonathan Richardson's *Traité de la peinture*, Amsterdam, 1728, as the source for this information]) // Wolfgang Born, "A Poussin Exhibition at Vienna," in *The Burlington Magazine*, LXVIII, February 1936, p. 101 (mentions it as a loan from Count Harrach and dates it about 1630–1635 along with the Louvre Bacchanalian Scene) // Louis Hourticq, *La Jeunesse de Poussin*, Paris, 1937, p. 97 (observes how closely Poussin followed Tasso's text in the painting) // Louis Massignon, "L'Amour courtois de l'Islam dans la *Gerusalemme liberata* du Tasse: à propos d'un tableau de Poussin," in *Bulletin de la Société Poussin*, I,

June 1947, p. 35 (cites it as one of eight paintings by Poussin inspired by Tasso's *Jerusalem Delivered*) // Thérèse Bertin-Mourot, "Notes et documents," in *Bulletin de la Société Poussin*, I, June 1947, p. 73 (discusses Robert de Cotte's account of the dal Pozzo Collection; concludes that it was surely written by de Cotte and dates from before 1689 at the latest; concurs with Friedlaender that the Harrach painting is the same as that mentioned by de Cotte) // Monique Lavallée, "Poussin et Vouet," in *Bulletin de la Société Poussin*, II, December 1948, p. 91 (refers to Grautoff's dating of the painting about 1630–1635) // Walter Friedlaender and Anthony Blunt, *The Drawings of Nicolas Poussin*, London, 1949, Part II, pp. 21, 23 (note that it is one of the five paintings by or after Poussin illustrating the story of Rinaldo and Armida; date it in the early 1630s and mention that no preparatory drawings for it are known to exist, although two drawings in the Louvre represent a moment in the narrative close to that of the Harrach painting) // D. Wild, "Nicolas Poussin: von den Schlachtenbildern zum sterbenden Germanikus," in *Actes du XIXe Congrès International d'Histoire de l'Art*, Paris, 1959, p. 452 (calls it an early Roman work and suggests that Poussin may have been inspired to paint scenes from Tasso through reading the poem with his friend, the Italian poet Giovanni Battista Marino) // Sheila Somers Rinehart, "Poussin et la famille dal Pozzo," in *Nicolas Poussin* (Colloques internationaux, Paris, September 19–21, 1958), Paris, 1960, I, p. 29 (in a list of paintings by Poussin in the dal Pozzo Collection, she includes the Harrach picture, which she dates 1628, and incorrectly entitles Renaud et Armide) // Francis Haskell and Sheila Rinehart, "The Dal Pozzo Collection, Some New Evidence," in *The Burlington Magazine*, CII, July 1960, p. 324 (republish de Cotte's list of the pictures in the dal Pozzo Collection, including Poussin's Companions of Rinaldo) // Jacques Thuillier, "Pour un 'Corpus Pussinianum,'" in *Nicolas Poussin* (Colloques internationaux, Paris, September 19–21, 1958), Paris, 1960, II, pp. 202–203 (concurs with Bertin-Mourot that the description of the dal Pozzo Collection is by Robert de Cotte and dates from before 1689; reproduces the complete document) // Heinz Althöfer, "Reopening of the Harrach Gallery," in *The Burlington Magazine*, CII, June 1960, p. 263 (mentions that the collection includes works by Poussin) // Anthony Blunt, *Exposition Nicolas Poussin*, exhibition catalogue, Paris, 1960, p. 69, no. 32, illustrated (compares its size, format, and style with the Arcadian Shepherds at Chatsworth and the Inspiration of the Lyric Poet at Hanover; dates it tentatively 1630–1633) // Denis Mahon, "Poussin's Early Development: An Alternative Hypothesis," in *The Burlington Magazine*, CII, July 1960, p. 300 (dates it about 1633 and remarks that it had been recently cleaned) // Günther Heinz, *Katalog der Graf Harrach' schen Gemäldegalerie*, Vienna, 1960, pp. 9, 59 (mentions that inventories of the Harrach Collection were

compiled in 1738, when part of the collection left Naples for Vienna, and again in 1745 and 1749; reports that the Poussin appears as no. 74 in the Harrach inventories of 1745 and 1749, and repeats Friedlaender's error of citing the account of the dal Pozzo Collection as being by Richardson instead of de Cotte) // Georg Kauffmann, "Poussins letztes Werk," in *Zeitschrift für Kunstgeschichte*, XXIV, 1961, pp. 113–114 (proposes that the boat in the painting was based on a relief formerly in Rome and now in the Museo Archeologico, Venice) // Rensselaer W. Lee, "Armida's Abandonment: A Study in Tasso Iconography before 1700," in *De Artibus Opuscula XL: Essays in Honor of Erwin Panofsky*, New York, 1961, pp. 347–348 (discusses it in relation to three other paintings by Poussin with themes taken from Tasso) // Denis Mahon, "Poussiniana," in *Gazette des Beaux-Arts*, LX, July–August 1962, pp. 53–55 (discusses Poussin's chronology and dates the Harrach painting slightly before 1633) // Denis Mahon, *Poussiniana*, Paris—New York—London, 1962, p. XI (sees the Harrach picture as stylistically consistent with Poussin's work of the early 1630s) // Francis Haskell, *Patrons and Painters*, London, 1963, p. 105 (in a description of the dal Pozzo Collection, he states that it contained a Poussin depicting a scene from Tasso [which would be the Wrightsman painting]) // Anthony Blunt, "Poussin and His Roman Patrons," in *Walter Friedlaender zum 90. Geburtstag*, Berlin, 1965, p. 61 (repeats the identification of the Harrach painting with the one known to have been in the dal Pozzo Collection) // Anthony Blunt, *The Paintings of Nicolas Poussin: A Critical Catalogue*, London, 1966, pp. 141–142, catalogue no. 205, illustrated (lists the fundamental bibliographical references to the painting and dates it 1633–1635) // Walter

8. *Detail: scalloped edge of the canvas*

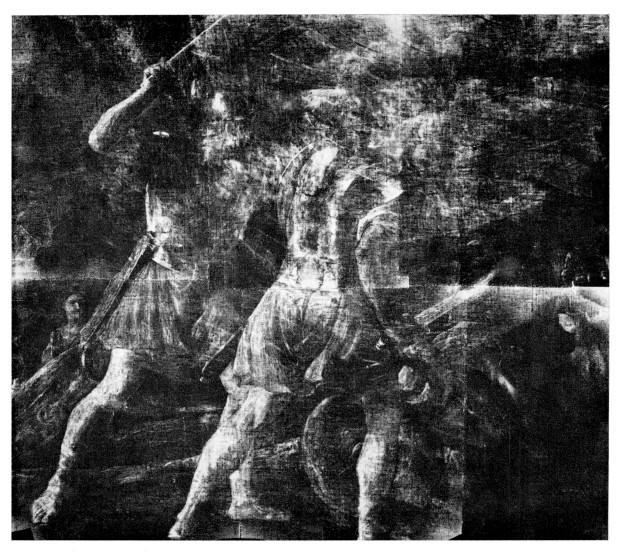

9. *X-ray of a section of the painting*

Friedlaender, *Nicolas Poussin: A New Approach*, New York [1966], pp. 49–50 (mentions it in passing) // Jacques Thuillier, "Poussin," in *Encyclopedia of World Art*, New York, 1966, XI, col. 559 (lists it in a catalogue of Poussin's works documented by seventeenth-century sources) // Anthony Blunt, *Nicolas Poussin*, New York, 1967, I, p. 148; II, pl. 86 (cites it in connection with Poussin's illustrations of Tasso).

Oil on canvas, H. 46⅜ (117.8); W. 40⅛ (101.9).

The picture was relined, probably for the first time, in the eighteenth century. The scalloped edges of the original canvas (Fig. 8) indicate that it has not been cut down to any considerable extent, since the scalloped pattern was formed when the canvas was nailed to the original stretcher.

According to Dr. Robert Keyszelitz, Gemälderestaurator of the Harrach Gallery (letter, November 30, 1968), the picture was restored at the beginning of the twentieth century. It was also cleaned shortly before the 1960 Poussin exhibition (Mahon, 1960, p. 300).

X-rays (Fig. 9) made of the picture in 1968 by the Metropolitan Museum confirm that the paint is solidly preserved. The most conspicuous pentimento revealed by the radiographs is the changed position of Carlo's sword, which was first painted in a lower position.

GUIDO RENI (1575–1642), one of the greatest Italian painters of the seventeenth century, was born at Bologna where he spent most of his life. At the age of nine he was apprenticed for ten years to Denis Calvaert (1540–1619), a painter from Antwerp who operated an influential workshop in which Domenichino (q.v.) and Francesco Albani (1578–1660) were also trained. About 1594 Reni joined the Accademia degli Incamminati, a school of painting run by Annibale Carracci (1560–1609) and his brothers. Reni's first public work, the Coronation of the Virgin with Four Saints, a large altarpiece now in the Pinacoteca at Bologna, seems to have been painted about this time. While it betrays the influence of his training, combining the ethereal linear grace of Calvaert's Mannerism with the bold naturalism of Annibale's style, it also testifies to Reni's interest in Raphael's St. Cecilia altarpiece at Bologna, which seems to have made a lasting impression on him.

Though never happy far from Bologna, Reni made several trips to Rome. During the first, about 1600, he studied classical antiquity and the works of the High Renaissance masters, and came under the influence of Caravaggio (1573–1610). The latter's uncompromising realism and powerful tenebrism left its mark on such masterpieces as Reni's Crucifixion of St. Peter, in the Pinacoteca Vaticana, Rome, painted about 1603–1604. He was in Rome again between 1609 and 1612. It was during this period that he painted the fresco of St. Andrew Led to His Martyrdom, which Cardinal Scipione Borghese commissioned for the Oratory of St. Andrew attached to the church of San Gregorio Magno, Rome. Another trip brought him back during the years 1613–1614, when he completed the fresco of Aurora in the casino of the Palazzo Rospigliosi Pallavicini. An incontestable masterpiece of Reni's personal blend of refined coloring and linear elegance, this fresco set the seal on Reni's fame.

Despite his success in Rome Reni returned to Bologna and remained there for the rest of his life. Isolated from the high baroque paintings that younger artists such as Pietro da Cortona (1596–1669), Andrea Sacchi (1599–1661), and Nicolas Poussin (q.v.) were creating in Rome, his style became more refined and individual. This can be seen in the delicate colors, soft modeling, and gentle emotional character of the Assumption of the Virgin, painted at Bologna in 1617 for the church of Sant'Ambrogio at Genoa. An even clearer example is the highly individual palette of pale silvery hues Reni used for the Palione della Peste, in the Pinacoteca Nazionale at Bologna. His mature compositions took on an almost iconic quality, and his brushwork became more and more spontaneous. In the latest works the handling is so delicate, so light and free, that the paint resembles diaphanous veils of muted color. It is largely on the basis of these late works that Reni is acclaimed today as one of the great painters of the century.

19 An Allegory of Charity

CHARITY, REPRESENTED as a young woman with three children, is shown as a three-quarter-length figure sitting on two roughhewn blocks of gray masonry. Behind her is a dark gray wall illuminated by a shaft of light, which falls diagonally from the upper left-hand corner of the picture. Charity wears a beige veil, which falls over her shoulders and across her breast. Her dress is a smoky rose color, and the sleeve of her blouse (Fig. 1), visible on her right arm, is pale gray. Of the three children, the one nursing at Charity's

1. Detail: drapery on Charity's right arm

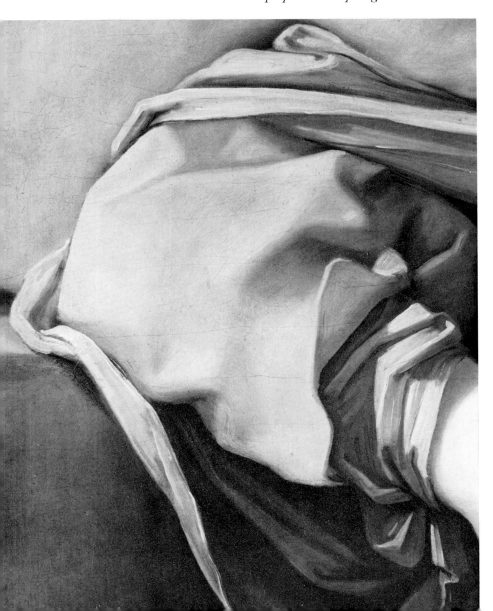

breast has pale white skin and rust-colored hair, the child asleep in the middle has a ruddier complexion and chestnut hair, and the child resting on Charity's right shoulder has an even darker complexion and golden-red hair.

PROVENANCE: The early history of Reni's Allegory of Charity is not altogether clear. The first record of the painting is in a catalogue of the Liechtenstein Collection, Vienna, published in 1767. It is not known when the painting entered the collection, but it is possible that, like some of the other seventeenth-century Italian paintings that once belonged to the Liechtenstein family, it was purchased in Italy around 1630 by Prince Karl Eusebius von Liechtenstein (1611–1684), who traveled extensively between 1629 and 1631, collecting many of the pictures that formed the nucleus of the Liechtenstein Collection. The painting remained in the Liechtenstein Collection until 1882, when it was sold (Hôtel Drouot, Paris, May 16, 1882, lot 21, for 820 francs) along with a number of other seventeenth-century Italian pictures from the collection. For the next half century it disappeared from sight, and when in the 1930s it reappeared in the collection of Mr. and Mrs. Jacob Reder, New York, it bore a misleading attribution to Simon Vouet (1590–1649). It was on the New York art market between 1964 and 1968, when it was acquired for the Wrightsman Collection.

To EARLY Christian theologians, Charity denoted two forms of love—*amor dei*, the love of God, and *amor proximi*, the love of one's neighbors. In the art of the Middle Ages, these two meanings of Charity were exemplified by a female figure carrying two attributes symbolizing heavenly and earthly charity: respectively, a flame or flaming heart, and a basket or cornucopia filled with fruit.

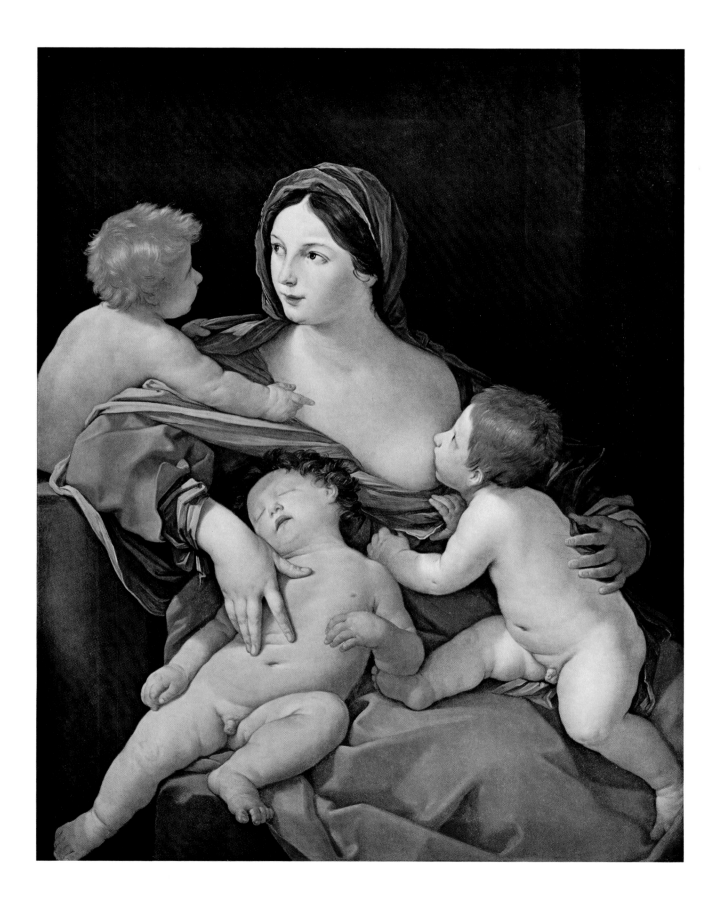

2. *Raphael, Allegory of Charity. Oil and tempera on wood, 16.0 by 24.0 cm. Rome, Pinacoteca Vaticana. Photo: Alinari*

By the time of Thomas Aquinas, who argued that the love of God enables men to be charitable on earth, theologians had begun to combine the two forms of Charity, and artists gradually dispensed with the traditional flames and cornucopias and replaced them with a young woman nursing several children. An example of this new iconography for Charity appears in a predella panel in the Vatican (Fig. 2), which Raphael painted about 1506–1507 for the Baglioni Deposition. While it still shows the traditional attributes of Charity, they are held by two putti. The Virtue herself is personified by a young woman with five children in her arms. Guido Reni's Allegory of Charity is part of this tradition. Charity is presented alone with three nude children and no identifying attributes.

According to one seventeenth-century source (Cesare Ripa, *Iconologia overo descrittione di diverse imagini* . . ., Rome, 1603, p. 63), painters depicted Charity wearing a blood-red dress as an allusion to the blood Christ shed on the cross. Reni was probably aware of this convention, though he actually painted her dress a smoky rose shade, rather than the deep red color of blood. On the other hand, it is unlikely that the different complexions of the three children in Reni's Allegory of Charity have symbolic meaning. Reni habitually varied the flesh colors in his paintings. The putti, for example, in his Assumption of the Virgin at Genoa and his Ecstasy of Sant'Andrea Corsini at Florence are just as diverse in coloring as those in the Wrightsman painting.

Reni's painting conforms with a local Bolognese convention for depicting Charity. During the sixteenth and seventeenth centuries, the local schools of Italian painting developed recognizable formats for this theme. Thus, at Genoa, Luca Cambiaso (1527–1585) and Bernardo Strozzi (1581–1644) depicted the Virtue as a variation of a Melancholia figure, showing a tired woman seated on the ground with her hand supporting her downcast face. In Florence and Rome a well-defined local tradition was established by Andrea del Sarto (1486–1531), Giuliano Bugiardini (1475–1554), and Francesco Salviati (1510–1563), who represented Charity as an elegant full-length figure. At Bologna, Guido Reni's compatriots tended to present a half-, or three-quarter-length view of Charity looking either to the right or left (as she does in the present painting). This Bolognese format occurs in a fresco by Ludovico Carracci (1555–1619) in the Museo di San Domenico at Bologna and in an engraving of 1626 by Guercino (*q.v.*). It also is the format of the only other

3. *Guido Reni, Allegory of Charity. Oil on canvas, 115.0 by 90.0 cm. Florence, Galleria Palatina. Photo: Alinari*

Allegory of Charity by Guido Reni, an upright oval composition in the Galleria Palatina at Florence (Fig. 3).

The version of Charity at Florence was painted early in Reni's career. It has traditionally been connected with a document of 1607, but it may date somewhat later (see D. Stephen Pepper, "Caravaggio and Guido Reni: Contrasts in Attitudes," in *The Art Quarterly*, XXXIV, Autumn 1971, p. 342, note 34). Like the Crucifixion of St. Peter, which Reni painted in 1604, it reflects the influence of Caravaggio. The colors are subdued,

and the strong contrasts of light and shadow, so typical of Caravaggio's style, play an important part in the picture. By the time of the Charity in the Wrightsman Collection, Reni preferred a palette of high-keyed colors with faint shadows rendered in breathtakingly light tonalities.

Despite the changes in Reni's style, the two versions of Charity have much in common. The women in both pictures might even be taken for sisters, and the placing of the hand on the middle child in each painting is similar. But fundamentally the pictures are different. Where the earlier painting is firmly modeled and tightly composed, the Wrightsman painting has the breadth and relaxed amplitude of Reni's mature masterpieces. In the earlier picture the figures resemble a compact sculptural group, tightly pulled together by an intricate pattern of curving shapes. In the Charity in the Wrightsman Collection the figures are much more expansive and painterly. Their proportions are more robust, and there is a much greater sense of the interval of space between each figure. The bodies of the two lateral children are placed so that they help to define a diagonal movement running through the composition from the upper left-hand corner down to the lower right-hand corner of the picture. Thus the extended arm of the child at Charity's shoulder and the silhouette of the child nursing at her breast complement the diagonal line established by the décolletage of her dress. This simple compositional device is played off against the sleeping child, whose body defines an emphatic diagonal in the opposite direction. The composition accordingly has a stability that sets Reni apart from his more flamboyant baroque contemporaries.

In the absence of documentary evidence, the Wrightsman painting must be dated by comparing it with other works by Reni. While it is much more broadly painted than any of his securely dated works of the late 1620s, it is not yet characterized by that complete freedom of handling which first appears in the Palione della Peste (Fig. 4), on which Reni was working in 1631. This is an

4. *Guido Reni, Pali-
one della Peste.
Oil on silk, 382.0
by 242.0 cm.
Bologna, Pinaco-
teca Nazionale.
Photo: Alinari*

enormous painting on silk of the Madonna and Child with the patron saints of Bologna, which was used as a processional banner and now is in the Pinacoteca at Bologna. Its light tonality, delicate brushwork, and soft contours herald the development of Reni's late impressionistic style. In the Wrightsman Charity the folds of the drapery still have some sharp outlines (Fig. 1), and most of the brightly lit forms are highly finished. But other passages, particularly those in shadow, such as the left sleeve of Charity's dress (Fig. 5), are loosely painted. The painting, consequently, should be dated around 1630, immediately before the Palione.

Guido Reni portrayed sleeping children like the one in the Allegory of Charity on more than one occasion during the late 1620s. A painting by Reni of the Virgin adoring the sleeping Christ Child is mentioned by Rinaldo Ariosto in a letter of January 1627 to the Duke of Modena, and it probably is related to Reni's famous oval composition of the same subject, of which over a dozen replicas exist (see Robert Enggass, "Variations on a Theme by Guido Reni," in *The Art Quarterly*, XXV, Summer 1962, pp. 113–121). The pose of the child in this composition is reminiscent of that of the sleeping child in the Wrightsman Charity. There are even closer parallels for the posture of the child in a fresco of a Sleeping Putto, which Reni made for Cardinal Francesco Barberini in January 1629. The occurrence of these motifs in Reni's paintings of the late 1620s tends to corroborate the dating suggested by the style of the painting.

Of all the paintings that Reni executed about this time, his Portrait of Cardinal Bernardino Spada (Fig. 6) provides the closest analogies for the style and dignified air of the Allegory of Charity. Granting the difference in their subject matter, the two paintings are intimately linked to one another, not only in their liberal display of smoky rose hues and shimmering highlights, but, more important, in the splendid nobility of the figures. The extraordinary similarity of the masterly brushwork and deft handling of paint places the

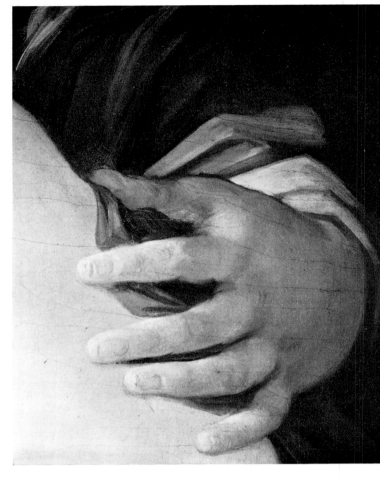

5. *Detail: drapery on Charity's left arm*

OPPOSITE:
6. *Guido Reni, Portrait of Cardinal Bernardino Spada. Oil on canvas, 222.0 by 147.0 cm. Rome, Galleria Spada. Photo: Alinari*

two pictures at the same moment in Reni's career. This occurred early during the period Cardinal Spada spent at Bologna as papal legate between 1629 and 1632.

Spada took a keen interest in Reni's work and no doubt was an admirer of the Charity when it was first unveiled. In 1629, when Marie de Médicis invited Reni to paint a continuation of Rubens's

Medici Cycle in the Palais Luxembourg, Paris, it was Cardinal Spada who declined the invitation on Reni's behalf. He wrote to the queen that Reni was unable to leave his native city because of "l'impegno di molti quadri, de quali hà ricevuto commissioni et gaggi da diversi Principi e personaggi" (Jules Guiffrey, "Lettre du cardinal Spada à Marie de Médicis au sujet de la galerie du Luxembourg [1629]," in *Nouvelles Archives de l'Art Français*, IV, 1876, pp. 252–254).

The queen's request gives some indication of the esteem Reni's contemporaries held for him. The Allegory of Charity, which Reni must have painted about the time of her request, is a superb example of his inimitable talents. Its large size, which alone indicates it was intended for no modest patron, suggests that it well may have been one of those pictures Reni created for the "diversi Principi e personaggi" mentioned by the cardinal. It might even have been painted for Prince Karl Eusebius von Liechtenstein, who traveled in Italy around 1630 (see Victor Fleischer, *Fürst Karl Eusebius von Liechtenstein als Bauherr und Kunstsammler [1611–1684]*, Vienna, 1910, p. 14). The prince's trip coincides not only with Cardinal Spada's letter but also with the probable date of the painting.

The painting seems to have been much admired by Reni's contemporaries. Other artists, who thought nothing of plagiarizing his work, lifted the motif of the sleeping child and incorporated it in their own compositions. The sleeping child, for example, in a Holy Family (Fig. 7) attributed to Francesco Polazzo (1683–1753), is clearly a copy of Reni's figure. Similarly, the Sleeping Cupid (Fig. 8), by the Bolognese engraver Francesco Curti (1603–1670), is no more than a reverse image of Reni's figure, embellished with wings, a bow, and a quiver of arrows.

VERSIONS: A replica of the composition formerly in the Feversham Collection, Duncombe Park, Yorkshire (illustrated in *Photographs of the "Gems of Art Treasures Exhibition," Manchester, 1857*, by Signori Caldesi and Montecchi, London, 1858, pl. 77) was sold at auction (Henry Spencer & Sons, Nottingham, April 7, 1959, lot 95). Its present whereabouts and its dimensions are unrecorded. A second replica, slightly larger than the original in the Wrightsman Collection, is in the gallery at Potsdam (illustrated in Götz Eckardt and Barbara Spindler, *Die Bildergalerie im Park von Sanssouci*, Potsdam, 1971, p. 17, catalogue no. 10). It measures 141.0 by 109.0 cm. and was first recorded in a late eighteenth-century catalogue of the collection (Matthias Oesterreich, *Déscription des tableaux de la galerie royale et du cabinet de Sans-Souci*, 2nd ed., Potsdam, 1771, catalogue no. 68). There also was a copy of the composition in a private Milanese collection, which was published as a work of Guido Reni by Alberto Riccoboni ("Inediti del Seicento bolognese," in *Emporium*,

7. *Attributed to Francesco Polazzo, Holy Family. Oil on canvas, 138.0 by 110.0 cm. Copenhagen, Statens Museums for Kunst*

CXXXIII, March 1961, p. 100). The corners of the canvas were cut, and it measured 128.0 by 105.0 cm. A poor copy in a private collection in Rome was offered for sale to the Metropolitan Museum in October 1972 by F. Echave.

Carlo Cesare Malvasia (*Felsina pittrice: vite de pittori bolognesi*, Bologna, 1678, II, p. 90) lists a painting of Charity by Guido Reni in the Palazzo Barberini, Rome. According to Malvasia, it originally belonged to the Bolognetti Collection in Bologna. This picture is described in seventeenth- and eighteenth-century inventories of the Barberini Collection; its present whereabouts is unknown. Its composition may have been related to that of the Wrightsman painting.

An engraving of Charity (Fig. 9) copied from a painting purportedly by Reni was made by Benedetto Fariat (1646–1720). The location of the painting is not recorded. Its composition differs from the Wrightsman painting, but it is somewhat similar in showing a three-quarter-length woman and three nude putti, with one reaching over her shoulder and another nursing at her breast.

EXHIBITED: The Metropolitan Museum of Art, New York, December 1968—May 1970.

REFERENCES: Vincenzio Fanti, *Descrizzione completa di tutto*

8. *Francesco Curti, Sleeping Cupid. Engraving, 17.8 by 13.0 cm. New York, The Metropolitan Museum of Art, Harris Brisbane Dick Fund, 17.3.1862*

9. *Benedetto Fariat, Allegory of Charity. Engraving. Rome, Calcografia Nazionale. Photo: Oscar Savio*

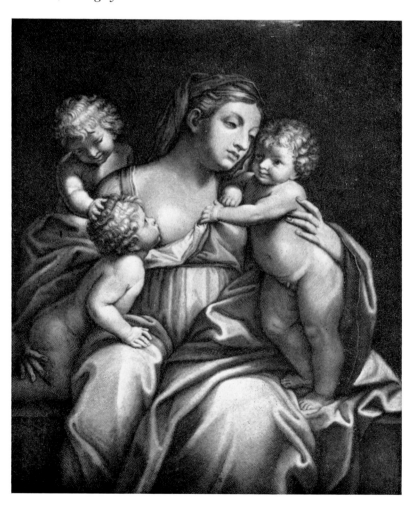

ciò che ritrovasi nella galleria di pittura e scultura di Sua Altezza Giuseppe Wenceslao del S.R.I. principe regnante della casa di Lichtenstein [sic], Vienna, 1767, p. 98, no. 498 (lists the Allegory of Charity as a work of Guido Reni) // Abbate Luccini, Déscription des tableaux et des pièces de sculpture que renferme la Gallerie de son altesse François Joseph . . . de Liechtenstein, Vienna, 1780, p. 175, no. 581 (catalogues the picture as a Guido Reni and observes that the coloring is "transparent et inimitable") // Gustav Parthey, Deutscher Bildersaal: Verzeichniss der in Deutschland vorhandenen Oelbilder verstorbener Maler aller Schulen, Berlin, 1864, II, p. 350 (lists it as a work by Guido Reni) // Jacob Falke, Katalog der Fürstlich Liechtensteinischen Bildergallerie, Vienna, 1873, p. 9, catalogue no. 62 (lists it as by Guido Reni) // Sale catalogue, Catalogue de tableaux anciens des écoles italienne, flamande, hollandaise et française, Hôtel Drouot, Paris, May 16, 1882, no. 21 (describes it as a "beau tableau du maître, d'une parfaite conservation") // Elisabeth Henschel-Simon, Die Gemälde und Skulpturen in der Bildergalerie von Sanssouci, Berlin, 1930, p. 25, catalogue no. 78 (cites it in connection with another version of the same composition at Potsdam, which she dates 1620–1630) // Ann Sutherland Harris, "Florentine Sunset,"

in Art News, LXVIII, May 1969, p. 61 (mentions it in passing) // D. Stephen Pepper, "A Rediscovered Painting by Guido Reni," in Apollo, XC, September 1969, pp. 208–213, figs. 1, 2, 5, color pl. XIII (analyzes the style of the painting and concludes that it probably was painted about 1628–1630; compares the sleeping child with a fresco of the same subject in the Barberini Collection) // Ann Tzeutschler Lurie, "An Important Addition to Solimena's Oeuvre," in The Bulletin of The Cleveland Museum of Art, LIX, October 1972, p. 225, fig. 14 (illustrates it as an example of Guido Reni's work that influenced Solimena's style).

Oil on canvas, H. 54 (137.1); W. 41¾ (106.0).

The painting was cleaned and the canvas relined sometime between 1964 and 1967. There are numerous, but not major, pentimenti throughout the composition, the most conspicuous one appearing in the veil above Charity's forehead. The picture has a rather pronounced pattern of craquelure, which was already clearly visible before 1880, when the earliest known photograph of the painting was made. The negative for this photograph is in the possession of the Fürst Liechtensteinische Gemäldegalerie, Vaduz.

PIERRE AUGUSTE RENOIR (1841–1919) was born at Limoges but was raised and spent most of his life in Paris. At the age of thirteen he was apprenticed in a porcelain factory in order to learn to decorate china plates. In 1862 he enrolled in the teaching studio of Marc Gabriel Gleyre (1808–1874) at the École des Beaux-Arts. There he met Pissarro (*q.v.*), Monet (*q.v.*), Alfred Sisley (1839–1899), and Frédéric Bazille (1841–1871), all of whom were to contribute to the impressionist movement. From the start Renoir was precocious: one of his earliest paintings, the charming portrait of the youthful Mlle Romaine Lacaux (dated 1864) in the Cleveland Museum, is a work of consummate beauty and technical skill.

After Gleyre closed his studio in 1864, Renoir and his companions settled at Chailly-en-Bière near Barbizon in the forest of Fontainebleau. They began to paint from nature, inspired by Jean-Baptiste Corot (1796–1875) and the landscape painters of the Barbizon school. At the Salon of 1865 Renoir designated himself the student of Gustave Courbet (1819–1877), and his influence is apparent in Renoir's large Diana, in the National Gallery of Art, Washington, D.C., which belongs to the tradition of Courbet's solidly modeled female nudes. In Paris he shared a studio with Bazille and painted out-of-door scenes on the banks of the Seine, such as the View of the Pont-des-Arts (1868) belonging to the Norton Simon Foundation, Los Angeles. He also worked at Bougival with Monet, the two artists often depicting simultaneously the same subject, such as La Grenouillère (1869). They also did out-of-door scenes at Argenteuil (1872, 1873). Influenced by one another, they transformed their style of painting: their handling gradually became looser, their colors brighter, and the general tonality of their canvases much higher in key. The result was impressionism, the technique of painting patches of glowing color without firm contours to define three-dimensional form.

Renoir exhibited seven canvases at the first impressionist exhibition (1874), including the Loge, now in the Courtauld Institute Art Gallery, London, which shows his fully developed personal idiom. Unlike the other impressionist artists, who concentrated on landscapes and open-air scenes, Renoir explored a wide range of subjects, including portraits and bohemian gatherings in Montmartre. He was also more ambitious than the others in the scale of the pictures he undertook, exemplified by the unusually large dimensions of the masterpieces of this period, the Ball at the Moulin de la Galette (1876), in the Louvre, the Portrait of Madame Charpentier and Her Children (1878), in The Metropolitan Museum of Art, and the Luncheon of the Boating Party (1881), in the Phillips Memorial Art Gallery, Washington, D.C.

Soon after completing the Boating Party, Renoir abandoned his studio in Montmartre and gradually began to separate himself from the impressionist movement. He made extended trips in 1881 and 1882 to Algeria, the South of France, and Italy, where he was particularly impressed by the works of Raphael and the High Renaissance masters. Attempting to give his own paintings the classical structure he admired in Italian art, he stressed the contours of his figures and applied his paint in a tight, dry manner. This tendency culminated in the Grand Bathers (1884–1887), in the Carroll Tyson Collection at the Phila-

delphia Museum of Art, where the figures are sharply delineated with none of the soft, atmospheric handling of his earlier work. He soon relinquished this style, however, and adopted a more supple and fluid way of painting.

During the last twenty years of his life he was afflicted by arthritis, but he continued to produce a prodigious number of pictures up to the end of his life. The late works, predominantly female nudes and portraits of his wife and children, are characterized by a red-brick tonality and a sense of large, expanding forms.

20 A Young Woman with a Cat

A GIRL WITH bushy auburn hair is seated at a table looking up at a cat standing on its hind legs and climbing on a cachepot. Shown three-quarter-length in profile to the right (Fig. 3), she wears a tiny black and yellow earring and a simple, low-cut white dress with a wide blue belt at the waist. Her hands are folded on the table, which is covered with a red cloth, colored dark blue and green in the shadows. The cat (Fig. 2) has tortoise-shell brown and yellow fur on its head, back, and tail, and white fur on its throat, belly, and legs. The dark bluish green cachepot holds a plant with two kinds of blossoms, some pink and some pale cream-colored.

Behind the girl is a dark brown piano with sheet music piled on top of it. Attached to the upright front of the piano is a brass sconce with a white candle. In the upper left-hand corner there is another plant with pink and white flowers.

The picture is signed in the lower right-hand corner: *Renoir*. (Fig. 1).

PROVENANCE: The earliest record of this picture dates from May 17, 1892, when it was purchased from the framemaker Dubourg by Boussod, Valadon & Cie, Paris. According to Pierre Dieterle (letter, May 2, 1972), it was registered that day in volume 14 of the firm's stock books and assigned the number 22.315. On September 30 of the same year it was sold to Potter Palmer (1826–1902) of Chicago. Two months later, on December 13, 1892, Palmer sold it back to the company. It was assigned a new number, 22.690, and on the very same day it was sold to Alfred Atmore Pope (1842–1913) of Farmington, Connecticut.

A different account of the early history of the picture was published by Julius Meier-Graefe, who knew Renoir personally. Meier-Graefe (1931, pp. 42–43) claims to have seen the picture in Paris in 1900. On his advice it was purchased by a Venetian interpreter named Giovanelli. When the latter attempted to sell it to Durand-Ruel & Cie, its authenticity was questioned, since the canvas was unsigned. Two years later Meier-Graefe confronted Renoir with the picture. The artist said it had been stolen from him by Desbourg (*sic*), "a frame-maker on Montmartre . . . with red hair

1. *Detail: signature*

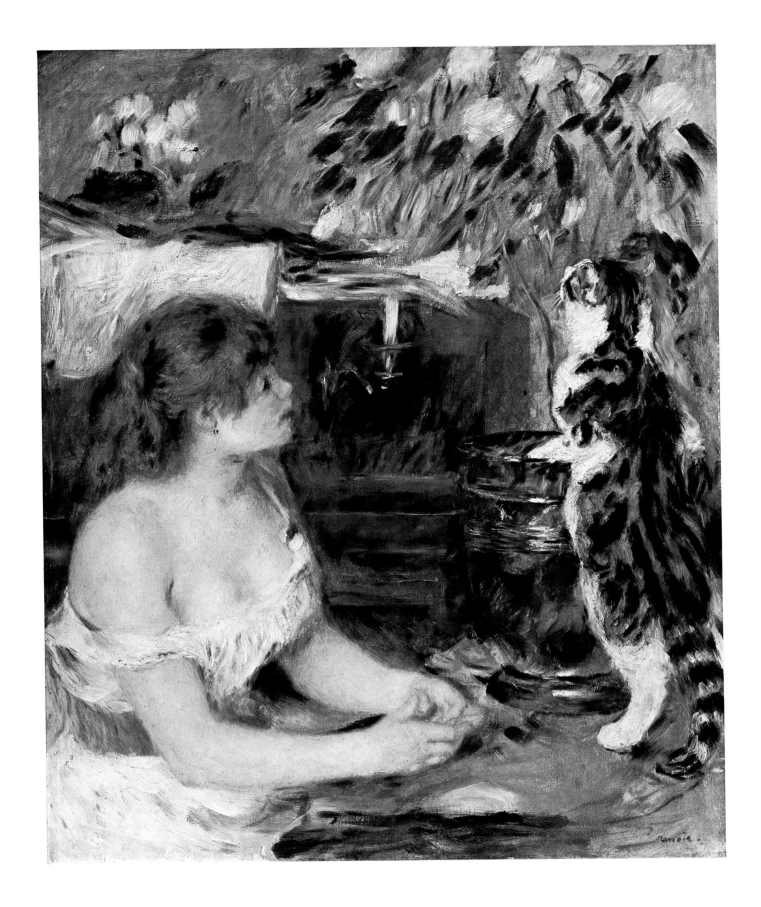

and a blind eye." (Meier-Graefe's spelling of his name is a mistake—the framemaker Dubourg, in the rue Saint-Roch, Montmartre, is mentioned in many letters published by Lionello Venturi, *Les Archives de l'impressionnisme*, Paris—New York, 1939, 2 vols., *passim*). According to Meier-Graefe, Renoir then signed the picture, it was returned to Giovanelli, and by the spring of 1903 he had sold it to Durand-Ruel.

Meier-Graefe's story obviously does not tally with all the known facts. In the first place, he does not mention Boussod, Valadon & Cie, Palmer, or Pope, and in his monograph of 1929 he mistakenly refers to the picture as *not* having a piano in the background. Furthermore, he is certainly incorrect in stating that Durand-Ruel owned the picture. There is no record of it with their Paris firm. Their New York office, however, did handle it in 1901. According to information kindly supplied by Charles Durand-Ruel (letter of January 5, 1968), Pope placed it on deposit with them in April of that year when it was photographed and assigned the number A 1059. The picture was returned to Pope the following month. A print of the Durand-Ruel photograph, deposited with the Department of European Paintings of the Metropolitan Museum, reveals that the painting was not signed at that time. This suggests that there is some truth to Meier-Graefe's story. It is not known when the canvas was signed.

An exhaustive description of the picture was published during Renoir's lifetime by La Farge and Jaccaci (1907, *Bibliography*, p. 28). Their account of its early history agrees essentially with the Boussod, Valadon & Cie records. They report, for example, that the canvas first belonged to Dubourg, who sold it to Eugène Glaenzer, an agent for Boussod, Valadon & Cie. It is significant that they also state that "M. Dubourg is unable to say just when and how it came into his hands."

The subsequent history of the picture is easier to reconstruct. When Pope died in 1913, he be-

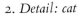

2. *Detail: cat*

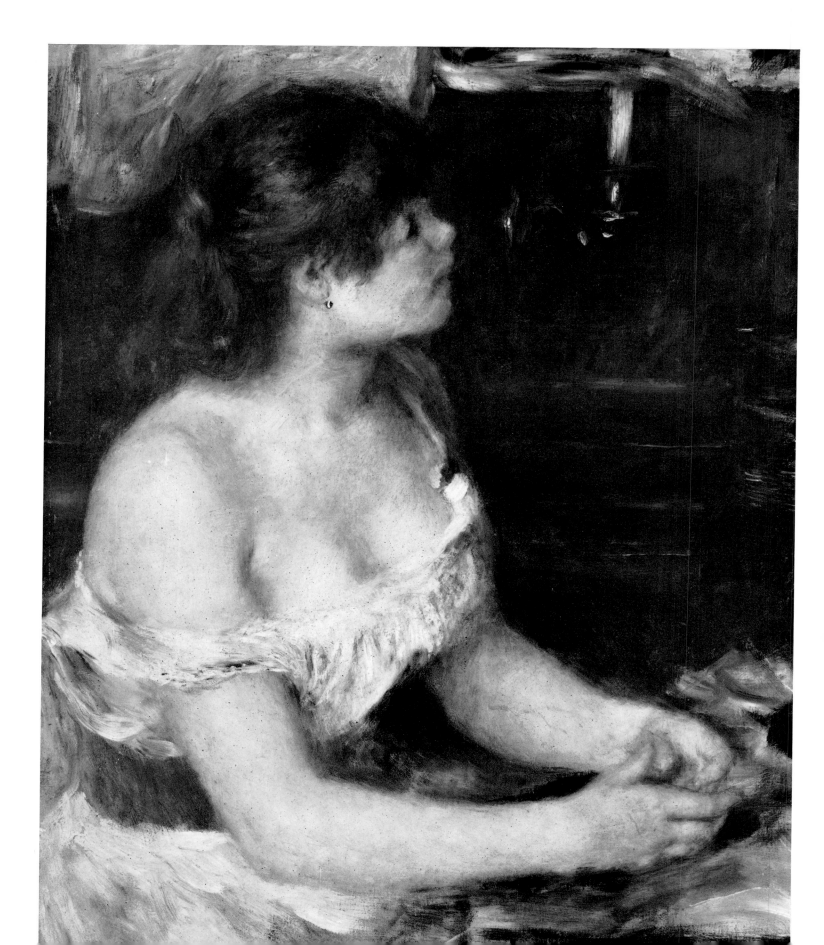

queathed it to his good friend and business partner, Harris Whittemore (1864–1927) of Naugatuck, Connecticut. Whittemore was an interesting figure who befriended Mary Cassatt (1844–1926) in Paris and encouraged Pope to buy impressionist pictures, many of which are now in the Hill-Stead Museum, Farmington, Connecticut. The two men also exchanged famous pictures, such as Le Viol by Degas (1834–1917), now in the Henry McIlhenny Collection, Philadelphia.

After Pope's death, the picture appears to have remained with his widow, for in 1919, when it was first exhibited at the Fogg Art Museum, it was lent jointly by Harris Whittemore and Mrs. Alfred Atmore Pope. A year before Whittemore's death, he transferred the ownership of the painting to the J. H. Whittemore Company, in a deed dated November 20, 1926. The company deposited it with the National Gallery of Art, Washington, D.C., from 1941 until 1954, the year Mr. and Mrs. Wrightsman acquired it.

Degas is supposed to have observed once in front of a painting he admired by Renoir, "It looks as if it had been painted by a cat!" Arsène Alexandre, to whom we owe this remark (La Farge and Jaccaci, 1907, p. 349), said Degas gave an imitation of an imaginary cat-painter: "Can you not see him seize his palette, dip his claws in the paint, nervously scratch or gently caress the canvas; at difficult points growing nervous and pretending to leave his work; then springing at it once more, and as though it were a skein of wool, getting deliciously tangled in its complexity. . . ." Although these remarks were not made apropos of the present picture, they suit the incredibly rich and playful way it was painted: it is a marvel of Renoir's supple brushwork and iridescent color. Ranging from the smoothly modeled and sensuous skin of the girl to the brilliant shower of bold strokes representing the flowers and leaves of the plant, the picture displays the surprisingly different

ways the artist varied his technique on a single canvas. In some places the paint is so thin that the canvas shows through; in others, such as the cat's fur, the artist mashed the bristles of his brush to build up a glistening impasto. Every inch of the picture is a delight to behold.

The motif of the cat is one that runs through Renoir's work. It first appears with the early painting of A Nude Boy with a Cat, in the collection of Eduard Arnold, Berlin, and recurs in such famous pictures as A Woman with a Cat (Fig. 4), probably executed about 1876 and now in the National Gallery of Art, Washington, D.C.; Sleeping Girl with a Cat (Fig. 5), dated 1880 and now in the Sterling and Francine Clark Art Institute, Williamstown, Massachusetts; and Geraniums and Cats, dated 1881 and now in the collection of Mrs. Albert Lasker, New York.

Though Renoir's pictures of women with cats are quite different from one another in design and narrative content, Renoir never differentiated between them, referring to them all simply as La Femme au Chat. This has caused a certain amount of confusion, because it is often difficult to tell which picture is meant. The artist refers to one of them, for example, in a letter of January 3, 1886 (Venturi, 1939, II, p. 227), and it is impossible to identify the picture. The same problem exists with the listings of Renoir's canvases in early exhibition catalogues, for they rarely give the dimensions or the owners of the pictures.

The Wrightsman composition appears to be later than any of the others. Renoir has been quoted (La Farge and Jaccaci, 1907, *Bibliography*, p. 28) as saying that, while he could not remember the exact date of the picture, he was certain he did it between 1880 and 1882. This places it about the time of one of his undisputed masterpieces, the Luncheon of the Boating Party, which was begun in 1880 and completed in 1881. Most writers on Renoir, however, date the Wrightsman picture 1882, but there is insufficient evidence for being so precise. Renoir was a notoriously inconstant artist, capable of changing his style at will, prac-

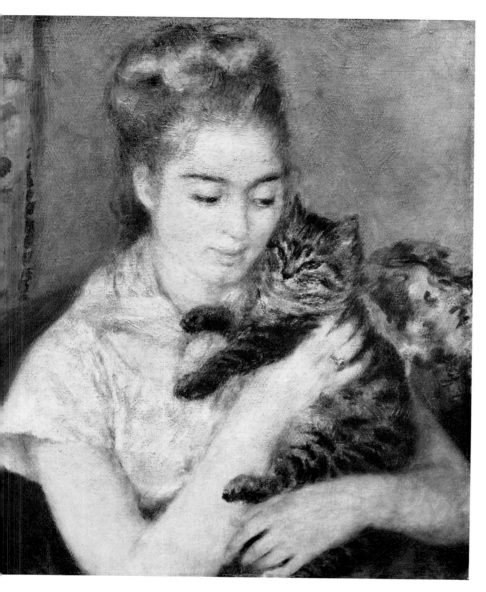

Mme Renoir is reputed to have made when she saw the picture in 1902. According to Meier-Graefe (1931, p. 43), she claimed that the green cachepot was a gift she received the day her first child was christened. This would place the picture in 1885 or later, but such a date is unacceptably late on grounds of style. Even Meier-Graefe, in the same article, declared that the picture "dated from the period of the Déjeuner des Canotiers and had much of the same charm." There is, moreover, some external evidence to discredit Mme Renoir's statement. In the Ryerson Collection of the Art Institute of Chicago there is a lovely painting by Renoir of A Woman Playing the Piano, which was included in the second impressionist exhibition of 1876. Painted in the artist's studio in the rue Saint-Georges, it shows a large cachepot and also an upright piano with sconces on the front like the one in the Wrightsman painting. Even if it is true that Mme Renoir received a similar jardinière in 1885, Renoir already had at least one in his studio a good four or five years before the probable date of the picture.

Mme Renoir, who was born Aline Charigot (1859–1915), was the model for the picture. According to Jean Renoir (*Renoir, My Father*, Rudolph and Dorothy Weaver, trans., Boston—Toronto, 1958, p. 214), she lived with her mother in the rue Saint-Georges near Renoir's studio in the same street. They both were seamstresses, and although the young Aline had been acquainted with the artist for some time she posed for him only occasionally, usually during her holidays. Although Renoir was fond of her, it was not until

ticing simultaneously more than one manner of painting. What is clear about the date of the Wrightsman canvas is that it antedates his *manière aigre*, as Renoir himself called the hard linear style that commences in his work about 1883 and culminates in the Grand Bathers of 1887 in the Philadelphia Museum of Art.

One argument that has been given against dating the picture about 1880–1882 is a statement

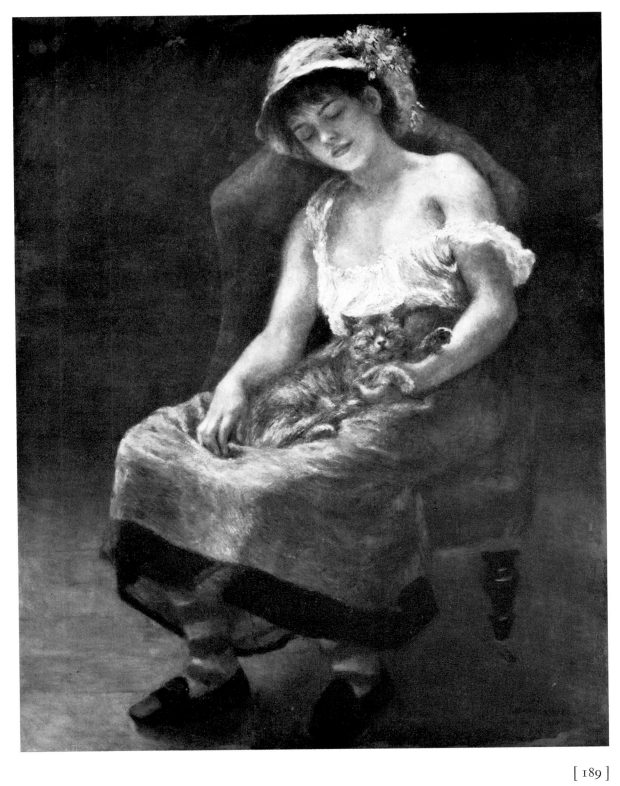

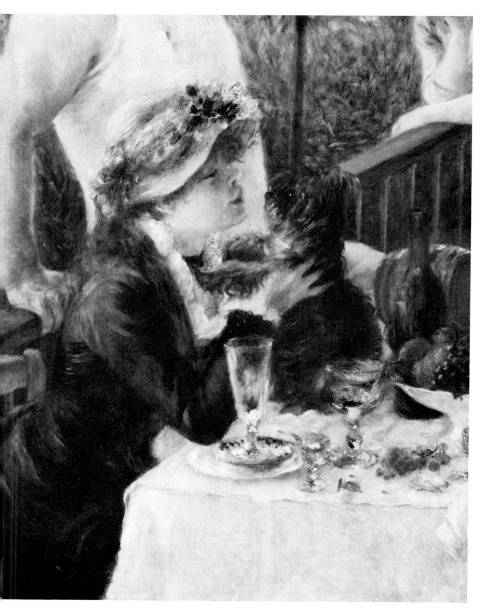

6. *Detail: Pierre Auguste Renoir, Luncheon of the Boating Party. Oil on canvas, overall 128.0 by 173.0 cm. Washington, D. C., Phillips Collection*

the summer of 1882 that he settled down and began to live with her and her mother. Their first child, Pierre, was born on March 21, 1885, and they finally were married in a civil service on April 14, 1890.

The earliest picture in which Aline appears is the Oarsmen at Chatou (1879), formerly in the Lewisohn Collection and now in the National Gallery of Art, Washington, D.C. It shows her standing beside the painter Gustave Caillebotte (1848–1894) on the bank of the Seine. She is more conspicuous in the Luncheon of the Boating Party (Fig. 6) where she sits in the foreground on the left, holding a small dog on the table. At the time the picture was finished, she was twenty-two years old, the artist forty and still unmarried.

In the Luncheon of the Boating Party one sees other models to whom Renoir was attracted, notably Jeanne Samary (1857–1894), the actress, and Angèle, the model who posed for the Williamstown Girl with a Cat (Fig. 5). Some writers have claimed that Angèle was the model for the Wrightsman canvas, but this is clearly not so. She was a dark brunette who sold flowers on Montmartre and "posed like a goddess" (according to Jean Renoir, 1958, p. 198). The Luncheon of the Boating Party is the last picture in which she appears. While it was being painted, she married a well-to-do young man who disapproved of her modeling. It is curious that in the Williamstown picture of her Renoir painted the blouse falling off her shoulder the same way it does in the Wrightsman picture.

For a long time Renoir was reluctant to take on the responsibilities of a family, and it was a combination of different factors that finally decided him. Just about the time of the Luncheon of the Boating Party he began to enjoy a certain amount of success. His works were favorably received at the official Salons: in 1879 his large Portrait of Mme Charpentier and Her Children was enthusiastically reviewed; in 1880 two works, including the Williamstown Girl with a Cat (Fig. 5), were accepted by the jury; and in 1881 he was repre-

sented with an oil and a pastel of Jeanne Samary. It also was about this time that he started to gain a measure of financial security. His portraits sold well, and in November 1880 Paul Durand-Ruel began to buy his pictures and keep him on a retainer. Yet he was dissatisfied with himself and with impressionism in general. In October 1881 he embarked upon a long Italian journey, which ended in January 1882 when he came down with pneumonia and was forced to remain at Marseille. After his recovery he convalesced for several months in Algeria. It was not until May 1882, seven months later, that he returned to Paris and decided to settle down with Aline Charigot.

Renoir's long absence from Paris fortified his desire to abandon pure impressionism and make his pictures more substantial in the tradition of the Italian Renaissance masters. All the pictures he painted after his return, such as the three paintings of dancing couples, begun in the fall of 1882, or the portrait of a young girl called By the Seashore, dated 1883, in the Havemeyer Collection of the Metropolitan Museum, show a much tighter handling of paint than he had used previously. For this reason alone it seems probable that the Wrightsman painting was done before Renoir left for Italy in the fall of 1881. The fact that he was absent for so long might also account for the mystery surrounding the early provenance of the picture. Possibly Renoir left it with Dubourg, the framemaker, before his trip and then forgot it during his long journey and illness.

Renoir is supposed to have repainted the picture to please one of its owners. According to La Farge and Jaccaci (1907, *Bibliography*, p. 28), the picture was returned to him "with the suggestion that the background did not quite 'go' with the figure, [so] Renoir amused himself by changing it and it was then that the plant and the cat were added." Appealing as this story is, it is rather difficult to accept, because the canvas discloses no evidence whatsoever of any extensive changes. There are minor pentimenti, such as in the cat's tail (which was originally an inch or two longer), but no trace of any radical changes. It is, furthermore, difficult to imagine the composition without the cat and plant. The woman, squarely placed on the left side of the picture, would only gaze out into a void. It is conceivable that the piano was a second thought, since most of Renoir's figure paintings have plain backgrounds. If it was in fact added later, then the original composition would have agreed with Meier-Graefe's description of it.

VERSIONS: The Toledo Museum possesses a variant of this composition without the cat (Fig. 7). Called the Green Jardinière, it is smaller in size (92.7 by 68.6 cm.) than the Wrightsman canvas and is signed but not dated. Meier-Graefe (1929, p. 182) assigns it to the year 1882, stating, however, that it was completed later. In exhibition catalogues it is frequently said to have been finished in 1912. According to Otto Wittmann (letter, December 28, 1967), this date was advanced by Paul Rosenberg who recalled being "with Renoir in his studio in 1912 while the picture was being finished." It probably was completed the year before, however, because it is documented that Rosenberg sold it to Durand-Ruel on December 8, 1911 (Daulte, 1971, catalogue no. 412).

The quality of the Toledo variant is markedly inferior to that of the Wrightsman picture. Because it lacks the cat, there is a vapid quality in the way the model stares off into space. Moreover, the handling is rather clumsy, the paint having been applied in heavy strokes quite unlike the delicate touch displayed throughout the Wrightsman canvas. The colors in the Toledo picture are garish by comparison (the cachepot is an intense green, and the tablecloth has a brownish cast), and the flesh and hair lack the sensuous quality they have in the version with the cat. Altogether, it looks like a repetition, executed no doubt by Renoir himself, but without the creative involvement he had with his initial conception of the subject.

Because Meier-Graefe described the Wrightsman picture as not having a piano in the background, it has been assumed (for instance, in the catalogue of the 1939 exhibition at Boston, pp. 70-71) that three versions of the composition exist: the Toledo and Wrightsman versions as well as one "ohne Piano mit einer Katze." This does not seem to be the case (only the Toledo and Wrightsman versions are listed in Daulte's exhaustive catalogue raisonné).

A partial copy of the Wrightsman picture, showing only the head and bust of the girl seen against the piano and measuring 58.5 by 44.5 cm., was once in the possession of Marguerite Namara and Guy Bolton (they offered it for sale at the American Art Galleries, New York, March 31, 1926, lot 153; it was resold at the same auction house on May 5, 1927,

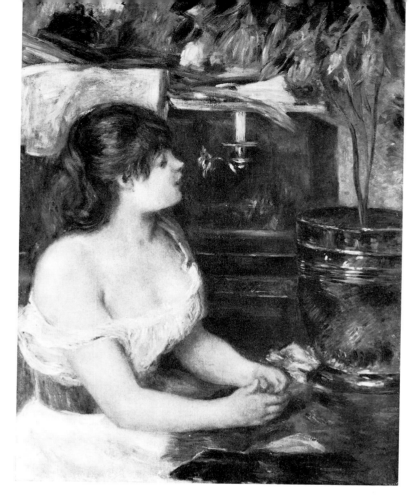

7. *Pierre Auguste Renoir, Green Jardinière. Oil on canvas, 92.7 by 68.6 cm. Toledo (Ohio) Museum of Art, gift of Edward Drummond Libbey*

lot 85). Judging from a photograph of it belonging to the Metropolitan Museum, it appears to be a weak copy, probably not by Renoir (it is not mentioned in Daulte's catalogue).

EXHIBITED: Fogg Art Museum, Cambridge, Massachusetts, *Retrospective Loan Exhibition of French Art*, April 9–23, 1919; Fogg Art Museum, *French Painting of the Nineteenth and Twentieth Centuries*, March—April 1929, catalogue no. 78, pl. XXXI; The Metropolitan Museum of Art, New York, *Renoir: A Special Exhibition of His Paintings*, May—September 1937, catalogue no. 38 (illustrated); Tuttle House, Naugatuck, Connecticut, April 1938, no. 28; Museum of Fine Arts, Boston, *Art in New England: Paintings, Drawings, Prints from Private Collections in New England*, June—September 1939, catalogue no. 103, pl. LII; Mattatuck Historical Society, Waterbury, Connecticut, January 1941; National Gallery of Art, Washington, D.C., on extended loan July 1941—September 1954, with the following two exceptions: Wildenstein & Co., New York, *A Loan Exhibition of Renoir for the*

Benefit of the New York Infirmary, March—April 1950, catalogue no. 36, pl. 22; Virginia Museum of Fine Arts, Richmond, *Paintings by the Impressionists*, October—November 1950; The Metropolitan Museum of Art, *Paintings from Private Collections: Summer Loan Exhibition*, July 6—September 4, 1960, catalogue no. 105; The Metropolitan Museum of Art, *Summer Loan Exhibition: Paintings, Drawings, and Sculpture from Private Collections*, June—September 1966, catalogue no. 157.

REFERENCES: John La Farge and August F. Jaccaci, eds., *Noteworthy Paintings in American Private Collections*, New York, 1907, II, illustrated opp. p. 302 (state that it belonged to the Potter Palmer Collection, Chicago, before Alfred Atmore Pope acquired it through Boussod, Valadon & Cie, Paris); Kenyon Cox, "The Collection of Mr. Alfred Atmore Pope," pp. 282–283 (describes it as one of Renoir's finest works); "The Critical Essays" by Arsène Alexandre, Roger Marx, Camille Mauclair, Léonce Bénédite, and Robert de la Sizeranne, pp. 349–354 (brief commentaries in the belles-lettres tradition: Marx states that "it was painted in 1882, shortly after the celebrated 'Canotiers'"; Bénédite concludes that it was done around 1880; none of them identifies the model) // John La Farge and August F. Jaccaci, eds., *Bibliography for "Noteworthy Paintings in American Private Collections": Being a Variorum Collection of Historical Data and Criticisms of the Paintings*, New York, 1907, p. 28 (report that Renoir did not remember the exact date of the picture but that he "places it surely about 1880–1882"; Renoir claims the picture had a different background originally and that he added the plant and cat sometime later at the suggestion of the then owner; outline the provenance as M. Dubourg, a framemaker, Eugène Glaenzer, an agent for Messrs Boussod, Valadon & Cie, sold by them to Potter Palmer of Chicago, back again with Boussod, Valadon & Cie, who sold it to Mr. Pope) // Emil Waldmann, "Französische Bilder in amerikanischem Privatbesitz," in *Kunst und Künstler*, IX, 1911, p. 145, illustrated p. 143 (calls it a highly important work of the mid-1870s) // Anonymous, "Exhibition at the Fogg Art Museum," in *Harvard Alumni Bulletin*, April 17, 1919, illustrated // Julius Meier-Graefe, *Renoir*, Leipzig, 1929, p. 182 (under a reproduction of the Toledo version, which he dates 1882 but says was completed later, he mentions "ein ähnliches Bild ohne Piano mit einer Katze," by which he is referring to the Wrightsman picture, although it does have a piano in the background) // Julius Meier-Graefe, "The Painter and the 'False' Renoir," in *International Studio*, XCVIII, March 1931, pp. 42–43, illustrated (recalls how in 1900 a Venetian friend of his named Giovanelli showed him this picture, then without Renoir's signature, which he immediately recognized as an authentic work dating "from the period of the *Déjeuner des Canotiers*," but that

Durand-Ruel and Renoir called it a forgery; two years later Meier-Graefe showed it again to the artist who stubbornly condemned it as a fake because it had been stolen thirteen or fourteen years earlier by Desbourg [*sic*], a Montmartre framemaker; however, Mme Renoir and her cousin Gabrielle recognized the cat, and Mme Renoir identified herself as the model and recalled that she received the green cachepot as a gift when her first child [born March 21, 1885] was christened; whereupon Renoir signed the canvas) // Anonymous, "A Renoir Recently Acquired," in *Museum News: The Toledo Museum of Art*, no. 71, June 1935, unpaginated (repeats Meier-Graefe's account of its theft) // Walter Heil, *Masterworks of Five Centuries: Golden Gate International Exposition*, San Francisco, 1939, no. 158 (mentions the Wrightsman painting in a catalogue entry on the Toledo version) // Alfred M. Frankfurter, "Now the Great French 19th Century in the National Gallery," in *Art News*, XL, December 15, 1941, p. 18 (illustrated as a work of 1882) // Anonymous, *Centennial Loan Exhibition 1841–1941: Renoir*, New York, 1941, catalogue no. 46 (mentions the Wrightsman picture in connection with the Toledo version, which is stated to have been "commenced in 1882 but completed in 1912") // Royal Cortissoz, "An Anniversary in Washington," in *The New York Herald Tribune*, March 29, 1942, sec. VI, p. 8, illus-trated (mentions it as a loan from the Whittemore Collection to the National Gallery) // Rosamund Frost, *Pierre Auguste Renoir*, New York, 1944, p. 23 (illustrated in color and dated about 1885) // Edward Alden Jewell, *French Impressionists and Their Contemporaries Represented in American Collections*, New York, 1944, color pl. 86 (dated about 1885) // Margaret Breuning, "Renoir's Special Spell of Enchantment in a Large Loan Exhibition," in *The Art Digest*, XXIV, April 1, 1950, p. 7, illustrated on cover (singles it out for its "authoritative design") // Anonymous review of Wildenstein exhibition, in *Time*, April 3, 1950, p. 76 (illustrated but not discussed) // Jean Alazard, *Auguste Renoir*, Milan—Florence, 1953, color pl. VII (dated about 1903) // Denys Sutton, "Pleasure for the Aesthete," in *Apollo*, XC, September 1969, p. 238, color pl. XXV (retells Meier-Graefe's story of how it was stolen and dates it in the early 1880s) // François Daulte, *Auguste Renoir: Catalogue raisonné de l'oeuvre peint*, I, *Figures 1860–1890*, Lausanne, 1971, catalogue no. 413, illustrated (states the picture was done in 1882 and gives an incomplete listing of its provenance, exhibitions, and bibliography).

Oil on canvas, H. 38¾ (98.4); W. 32¼ (81.9).

There is no record that the picture has ever been cleaned or restored.

PETER PAUL RUBENS (1577–1640) was born at Siegen in west Germany and spent most of his life in Antwerp, his family's native city. He received a classical education at the Latin school of Rombaut Verdonck, and was trained as a painter by Tobias Verhaecht, Adam van Noort, and Otto van Veen. He became a master in the painters' guild of Antwerp in 1598, and two years later departed for Italy.

For the next eight years he was employed by Vincenzo Gonzaga, Duke of Mantua. As court painter he made official portraits of the Gonzaga family, painted copies of Italian Renaissance pictures, and acted as the curator of the duke's collection, persuading him in 1606 to buy the famous painting now in the Louvre of the Death of the Virgin by Caravaggio (1573–1610). He performed diplomatic services for the duke such as traveling in 1603 from Mantua to Madrid with presents for the Spanish court. While in Italy he also received commissions for important altarpieces in Genoa, Fermo, and Rome. In 1608, just as he was completing the high altarpiece of the Chiesa Nuova in Rome, he was called back to Antwerp because of his mother's death.

He decided to settle in Antwerp and in 1609 married Isabella Brandt (1591–1626). He was appointed court painter to Archduke Albert and Archduchess Isabella, the Spanish governors of the Netherlands, and quickly established himself as the leading painter in his country, producing a magnificent series of altarpieces for churches in Antwerp and Ghent.

A great impresario, Rubens worked with a number of assistants whom he supervised carefully. His studio included Van Dyck (q.v.), Jacob Jordaens (1593–1678), and Frans Snyders (1579–1657), as well as a number of less famous men who carried out the master's designs, faithfully imitating his personal style. In 1620 Rubens began his first vast decorative project, the decoration of the Jesuit Church at Antwerp with thirty-nine ceiling paintings and three altarpieces. This was followed in 1622 with a commission from Louis XIII of France to design twelve tapestries depicting the Life of Constantine. Between 1622 and 1625 he produced twenty-one enormous canvases, now in the Louvre, for the gallery of Marie de Médicis in the Palais Luxembourg.

During the period from 1628 to 1630 he was involved in diplomatic activities attempting to bring peace to the Netherlands during the Thirty Years' War (1618–1648). He spent nine months as a secret envoy in Madrid, and in 1629 he visited England, where he was knighted by Charles I for devising a plan to exchange ambassadors between England and Spain. As a result of his contact with the English king, he was asked to decorate the Banqueting House in Whitehall, London. In 1635 the nine large canvases he produced were installed in the ceiling of this building. In 1635 he supervised the temporary decorations prepared for the state entry into Antwerp of Cardinal Infante Ferdinand, the brother of Philip IV and the successor to the archduchess as governor of the Netherlands.

Rubens's first wife died in 1626, leaving him a widower with three children. Four years later he married Helena Fourment (1614–1673), who was then only sixteen years old. She bore him five more children and was the inspiration for many of his late paintings. For her he purchased Het Steen, the

château of Elewijt, the setting of some of his most romantic landscape paintings, including the Landscape with a Rainbow, in the Wallace Collection, London. During the last eighteen months of his life he suffered from gout and painted only intermittently.

Throughout his career Rubens worked with unbelievable drive and creativity, and the sheer magnitude of his output is overwhelming. His enormous compositions epitomize the baroque spirit with their exuberant energy and color and their wealth of pictorial invention.

21 Portrait of a Woman, probably Susanna Fourment

THE SITTER is represented half-length against a plain, dark gray background. She is seen almost full-face (Fig. 3) with her right hand resting on her shoulder (Fig. 1) and her left hand held at her waist (Fig. 2). She has curly blonde hair and large, dark gray eyes, which are wide-set. Her black dress has a low-cut bodice trimmed with thin white material and long sleeves with white lace cuffs. She also wears a black veil with a gold fringe, which falls from her head in ample folds to her waist. She wears no jewelry except a pearl necklace.

PROVENANCE: The earliest record of the portrait dates back to the eighteenth century, when it was listed in the catalogue of an auction at Antwerp of books and paintings from the estate of Joanna Ludovica Josepha du Bois (*Catalogue van Historische, Rechtsgeleerde en andere Boeken mitsgaeders Schilderyen van de eerste Meesters, De welke zullen verkogt worden in Wiffelgelt op Maendag 7 Julii 1777 ten Sterf-huyze van Jonkvrouw Joanna Ludovica Josepha du Bois in haer leven Vrouw van Vroylande, Roofenbergh Etc. In de Lange-nieuw-straet binnen Antwerpen*, p. 27, lot 1). The catalogue describes it as "Eene fraeye en jonge Vrouwe" (a pretty and young woman) by P. P. Rubbens (*sic*).

According to Rooses (1890, IV, pp. 162–163), it belonged in 1831 to Countess d'Oultremont,

and, after her death and the subsequent division of her property, it became the property of Countess du Bois d'Edeghem. She belonged to a different branch of the same family that had possessed it during the preceding century. Rooses also states that between 1865 and 1870 it was sold in Paris to Baron Gaston (*sic*) de Rothschild. There was no Baron Gaston; Oldenbourg (1921, pl. 58) correctly identifies the Rothschild owner as Baron Gustav. The latter gave it to his daughter, Berthe Juliette (died 1896), who was married to a Baron Leonino. It eventually passed to their daughter, Baronne Antoinette Leonino, who sold it in 1959 to D. A. Hoogendijk in Amsterdam. Mr. and Mrs. Wrightsman acquired it in The Hague in 1966.

THERE IS AN air of mystery about this portrait. The sitter is unknown: she is not identified by any inscriptions or marks that might give some clue to her name. Her costume, moreover, is unusually somber for so young a woman. All that one can deduce is what one sees in terms of style and physiognomy. About one point, however, there is no question: that Rubens painted her. The portrait is an unquestionable example of his work, and its authenticity has never been doubted.

The informal pose of the sitter, the seductive look in her eyes, and the graceful gesture of her hand at her shoulder set this picture apart from the

formal portraits Rubens made for his wealthy patrons. It has an intimate quality unparalleled in his officially commissioned works. There is a beguiling character to her expression, so hesitant and charmingly feminine, and there is also something casual, yet thoughtful, in the way she draws aside her veil to reveal her face, neck, and bosom. One feels Rubens must have known her well.

When the portrait was first published, the sitter was not unreasonably called Rubens's second wife, Helena Fourment. Scholars have subsequently rejected this identification, but there still is something to be said for the striking resemblance between the sitter and Helena, whose features are immortalized in some of Rubens's most glorious works, such as the portrait of her in a fur cloak now at Vienna. Although the shapes of their mouths are different, their beautifully proportioned faces bear a family resemblance. Helena had six sisters, and it would not be unreasonable to suppose that the present painting might depict one of them.

Helena was the youngest child of Daniel Fourment (about 1565–1643), an Antwerp textile merchant, and Clara Stapperts. They married in 1590 and had eleven children, Helena being born on April 1, 1614. The other daughters were Clara (born 1593), Joanna (born 1596), Susanna (1599–1643), Maria (born 1601), Catherina (born 1603), and Elizabeth (born 1609). It is recorded that Rubens painted a portrait of Clara and as many as seven of Susanna (four of them are listed in the inventory of the artist's possessions at the time of his death; see J. Denucé, *The Antwerp Art-Galleries: Inventories of the Art-Collections in Antwerp in the 16th and 17th Centuries*, Antwerp, 1932, p. 78, nos. LXIII [LXIV], LXIX, LXX). No portrait of Clara has ever been indentified, and there is no documented portrait of Susanna. However Gustav Glück (*Rubens, Van Dyck, und ihr Kreis*, Vienna, 1933, pp. 118–148) advanced the hypothesis that her features can be recognized in several paintings and drawings. Among the generally accepted portraits of Susanna are the ravishingly beautiful full-length formerly in the Hermitage and now in the Gulbenkian Collection, Lisbon, two half-lengths in the Louvre, and a drawing in the Albertina in Vienna. Susanna also was the model for Rubens's superb masterpiece in the National Gallery, London, the Chapeau de Paille (Fig. 4).

As Gregory Martin (*National Gallery Catalogues: The Flemish School, circa 1600—circa 1900*, London, 1970, pp. 175–176) has shown, the style of the Chapeau de Paille belongs to the first half of the 1620s. This dating is supported, moreover, by two biographical facts. First, as Susanna was born in 1599, she would then have been in her early twenties. It is admittedly difficult to judge precisely the age of people in seventeenth-century portraits, but the model for the Chapeau de Paille appears certainly to be in her early twenties. Secondly, Susanna Fourment was married in 1622 to her second husband, Arnold Lunden, and in the painting her wedding ring is prominently displayed and could well refer to this event.

It was not until much later that Rubens married Susanna's youngest sister. He was, however, already related to her through his first marriage. His first wife's sister, Clara Brandt, had married Daniel Fourment, Susanna's and Helena's elder brother. And long before Rubens married Helena, he was on particularly close terms with their family. There is even evidence (Rooses, 1904, I, p. 303) that Rubens had done seven portraits of Susanna before his first wife died in June 1626.

The Wrightsman portrait probably shows Susanna, but shortly before she sat for the Chapeau de Paille. This identification has been endorsed by Julius S. Held (letter, November 1967) and Michael Jaffé (conversation, September 1970). If one compares the detailed photographs of the two faces (Figs. 1, 4), there is a resemblance in their physiognomies, the only real difference being that the face is slightly plumper in the Wrightsman picture. The differences in their costumes, on the other hand, are quite extraordinary. In the Chapeau de Paille, Susanna wears a brilliantly colored and extravagantly fanciful outfit, making a complete

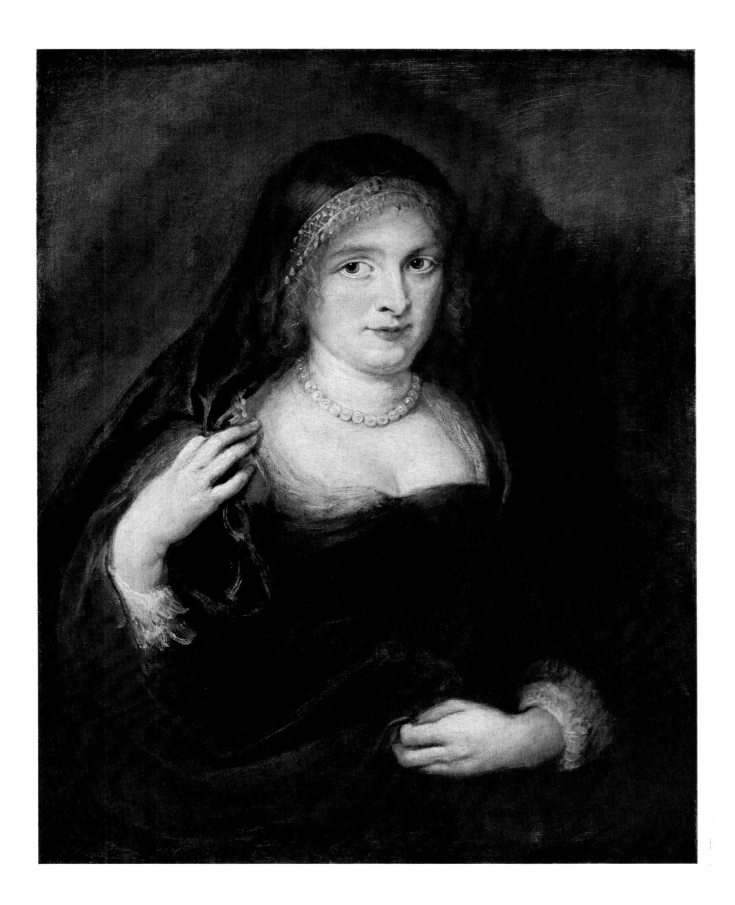

contrast with the somber black dress and veil worn in the Wrightsman picture. Rooses, who believed the Wrightsman portrait to represent Helena Fourment, said she was wearing a Spanish mantilla, and Stella Newton Pierce (in letters of April and June 1968) tentatively proposed her veil to be Hindu. Whatever the origin of the black veil, it suggests mourning, as Burckhardt (1938, p. 167) assumed when he described the copy in Dresden of the Wrightsman portrait as a charming widow wearing a pearl necklace. Susanna's first husband, Raymond del Monte, died in 1621, and her somber costume may well be due to his death.

Although the Wrightsman portrait has been dated as early as 1612 (Oldenbourg, 1921, pl. 58) and as late as 1635 (Rooses, 1890, IV, p. 162), its style falls between these two extremes. It is painted in the solid, unbroken manner characteristic of the beginning of Rubens's middle period, roughly about 1620, the time of his altarpieces for the Jesuit Church in Antwerp. The modeling of the flesh and the fluid treatment of the black veil sug-

1. *Detail: right hand*

2. *Detail: left hand*

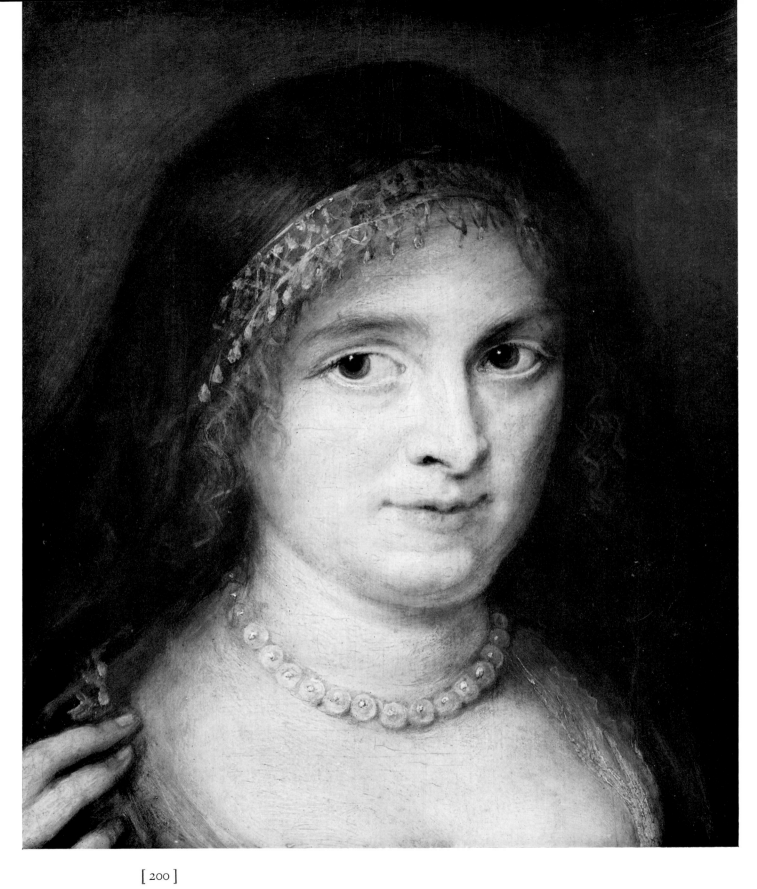

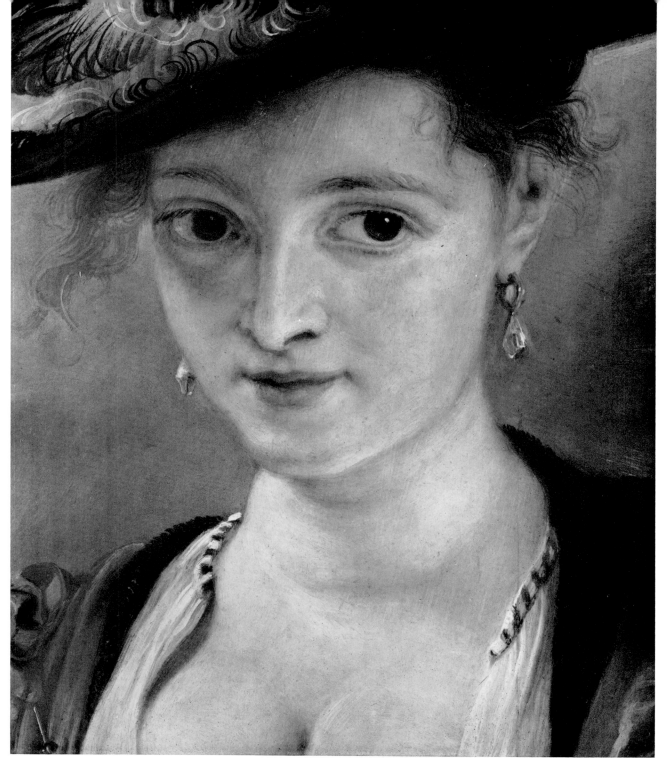

4. *Detail: Peter Paul Rubens, Chapeau de Paille. Oil on wood, overall 79.0 by 54.5 cm. London, National Gallery*

OPPOSITE: 3. *Detail: face*

gest that the picture was done about this time. The handling of paint is altogether looser and more spontaneous than in Rubens's Portrait of Emperor Augustus, formerly in the Bildergalerie at Sanssouci, Potsdam. As this picture is signed and dated 1619, the Wrightsman portrait may be dated a year or two later. The style of the picture thus coincides with the interval between the death of Susanna's first husband and her second marriage, in June 1622, to Arnold Lunden. These observations, of course, are hypothetical, and, while they do not prove a thing, taken together they make it seem likely that it is Susanna who is portrayed.

Some technical evidence of a more concrete nature, which strengthens this likelihood, has recently come to light. An X-ray of the Wrightsman picture (Fig. 5) shows that the picture originally had quite a different appearance. Initially, Rubens did not intend to show his sitter wearing a veil at all. Instead, he began by painting her hair combed back behind the ear in the Antwerp fashion of the early 1620s. Not only is the ear completely visible in the X-ray, but also a pearl earring can be seen. It is the same kind of pendant earring that Susanna wears in the universally accepted drawing of her (Fig. 6). In the drawing the head is seen from almost exactly the same angle as it is in the painting, making the resemblances between the drawing and the image revealed by the X-ray even more suggestive. One is almost tempted to regard the drawing as a preliminary study for the portrait, which Rubens then changed when he added the veil and painted the lovely hand holding it back.

VERSIONS: There is a copy, in reverse, of the Wrightsman portrait in the Gemäldegalerie at Dresden. It is painted on canvas, attached to panel, measuring 76.5 by 60.0 cm. (almost exactly the same size as the Wrightsman picture). Although some early writers regarded it as an original by Rubens or Van Dyck, it was convincingly dismissed as a poor seventeenth-century copy by Seidlitz (1893, p. 375).

Rooses (1890, IV, p. 163) recorded another copy, formerly in the collection of Mme Moons-Van Straelen at Antwerp. He did not give the dimensions or the support of this copy.

Another copy, which might be the Van Straelen one, was

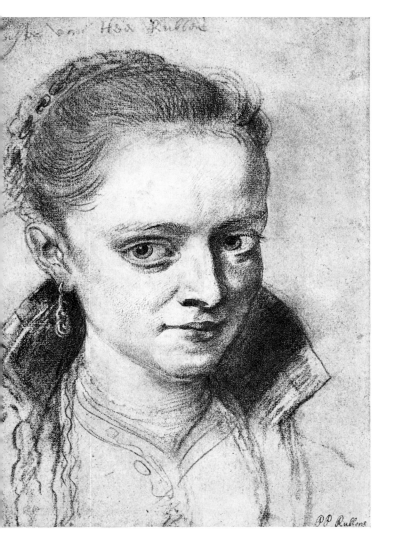

6. *Peter Paul Rubens, Portrait of Susanna Fourment. Colored chalks on paper, 35.0 by 26.0 cm. Vienna, Albertina*

published by Mayer (1935, pp. 224–225). When it was offered for sale at Sotheby's (July 10, 1968, lot 89; as Rubens's Portrait of Helena Fourment), it was generally agreed to be a copy of mediocre quality of the Wrightsman picture. It is painted on panel, 71.1 by 54.6 cm.

EXHIBITED: The Metropolitan Museum of Art, New York, March–October 1967.

REFERENCES: Karl Woermann, *Katalog der königlichen Gemäldegalerie zu Dresden*, Dresden, 1887, pp. 316–317, catalogue no. 971 (cites the Wrightsman painting as a better example of a replica of the portrait at Dresden; says both may be the work of Rubens) // Max Rooses, *L'Oeuvre de P. P. Rubens: histoire et description de ses tableaux et dessins*, Antwerp, 1890, IV, pp. 162–163, catalogue no. 938 (entitles it "Hélène Fourment è la Mantille" and describes it as an entirely autograph work done about 1635, "un des plus beaux portraits du maître, peint d'une manière grasse"; traces the provenance back to 1777, when it was included in the du Bois sale; lists its current location as Paris, Galerie du baron Gaston [sic] de Rothschild; notes a "répétition" of the portrait at Dresden and a copy that once belonged to Mme Moons-Van Straelen in Antwerp) // Karl Woermann, *Katalog der königlichen Gemäldegalerie zu Dresden*, 2nd ed., Dresden, 1892, p. 319, catalogue no. 971 (reports that Bode believes the Dresden variant of the Wrightsman portrait to be an early work by Van Dyck) // Wilhelm von Seidlitz, review of Woermann's catalogue in *Repertorium für Kunstwissenschaft*, XVI, 1893, p. 375 (asserts that it is incorrectly identified as Helena Fourment and declares that the Dresden variant is a poor copy by a follower of Rubens, and certainly not by Van Dyck) // Karl Woermann, *Katalog der königlichen Gemäldegalerie zu Dresden*, 3rd ed., Dresden, 1896, p. 326, catalogue no. 986 A (accepts Seidlitz's view that the Dresden variant is a copy after the Wrightsman portrait, which he states is an autograph work) // Max Rooses, *Rubens: sa vie et ses oeuvres*, Paris [1900–1903], p. 606 (describes it as Helena Fourment and states that her veil is a Spanish mantilla) // Max Rooses, *Rubens*, Harold Child, trans., London, 1904, II, p. 606 (believes it depicts Helena Fourment and that it was painted near the end of Rubens's life; compares it to a portrait in the Mauritshuis, The Hague, which he believes also represents Helena) // Edward Dillon, *Rubens*, London, 1909, pl. CCXCIV (dates it 1620–1630 and makes no attempt to identify the sitter) // Emil Schaeffer, ed., *Van Dyck: des Meisters Gemälde*, Stuttgart—Leipzig, 1909, p. 518 (mentions the Wrightsman portrait as a completely autograph Rubens in connection with the Dresden variant, which he lists as an authentic work by Van Dyck) // Adolf Rosenberg, ed., *P. P. Rubens: des Meisters Gemälde*, Stuttgart—Leipzig, 1911, p. 484, pl. 331 (correctly identifies

[203]

the owner as Baron Gustav von Rothschild, and rejects Rooses's identification of the sitter as Helena Fourment, preferring instead to call it an anonymous portrait done by Rubens about 1630–1635) // Anonymous, *Peter Paul Rubens: l'oeuvre du maître*, Paris, 1912, p. 484, illustrated p. 331 (accepts it as a Rubens of about 1630–1635, but sees no resemblance in it to Helena Fourment) // Rudolf Oldenbourg, ed., *P. P. Rubens: des Meisters Gemälde*, introduction by Adolf Rosenberg, Stuttgart—Berlin, 1921, pl. 58 (revises Rosenberg's late dating of 1630–1635 to about 1612, which would preclude identifying it as Helena Fourment) // Rudolf Oldenbourg, *Peter Paul Rubens*, Wilhelm von Bode, ed., Munich—Berlin, 1922, pp. 142–143 (rejects Rooses's identification of the sitter as Rubens's second wife and disagrees with his late dating of the painting, preferring a date of about 1614) // Anonymous, *Die staatliche Gemäldegalerie zu Dresden: Katalog der alten Meister: kleine Ausgabe*, 12th ed., Dresden—Berlin, 1930, p. 180, catalogue no. 986 A (refers to the Wrightsman portrait as the original after which the Dresden variant was copied) // August L. Mayer, "The Portrait of Helene Fourment in a Black Mantilla by Rubens,"

in *The Burlington Magazine*, LXVII, November 1935, pp. 224–225 (publishes a replica, which he claims "betrays in every way its superiority to" the Wrightsman portrait) // Jacob Burckhardt, *Erinnerungen aus Rubens*, Vienna, 1938, pp. 201 note 90, 436, illustrated p. 174 (the anonymous annotators of this edition of Burckhardt's essay, originally published in 1898, observe that the Wrightsman portrait is Rubens's original, correcting Burckhardt, who regarded the Dresden variant as an autograph painting by Rubens) // Denys Sutton, "Pleasure for the Aesthete," in *Apollo*, XC, September 1969, p. 232, illustrated p. 233 (identifies the picture as possibly a portrait of Susanna Fourment on the basis of a suggestion made by Julius Held, who "proposed that the veil was added by Rubens as a sign of mourning when Susanna's first husband, Raymond del Monte, died in 1621").

Oil on wood, H. 30¼ (77.0); W. 23⅝ (60.0).

The panel, 0.5 cm. thick, is cradled. The condition is excellent. An X-ray of the face (Fig. 5) was made when the picture was on loan at the Metropolitan Museum in 1967.

GEORGES PIERRE SEURAT (1859–1891), one of the major postimpression-ists, was born in Paris and died there prematurely at the age of thirty-one. He began to study art in 1875, attending drawing classes at a small municipal school. In 1878 and 1879 he studied at the École des Beaux-Arts under Henri Lehmann (1814–1882), a pupil of Ingres who stressed the importance of draftsmanship. His training was interrupted by a year of military service at Brest. Returning to Paris in November 1880 he studied the scientific theories of color published by the chemist Chevreul and others, and he scrutinized the paintings and writings of Delacroix (q.v.) for evidence of color theories he was beginning to formulate for himself. By 1882 he had perfected a method of drawing with conté crayons on heavily textured paper that was extremely effective. His first publicly exhibited work was one of these drawings, a Portrait of Edmond François Aman-Jean, which was shown at the official Salon of 1883 and now belongs to The Metropolitan Museum of Art.

His development as a painter was not so rapid. At first he experimented with a number of small, sketch-like pictures. His earliest major canvas, Bathing at Asnières, was shown in the spring of 1884 with the Groupe des Artistes Indépendants, and now belongs to the National Gallery, London. An ambitious composition on which the artist imposed a carefully calculated structure, its static and monumental design is at variance with the transitory effects of impressionism. His tendency to reduce his subjects to rigid geometric forms is even more apparent in his next major work, Sunday Afternoon on the Island of La Grande Jatte, exhibited at the eighth and final impressionist show and now in the Art Institute of Chicago. It is a classic example of the divisionist, or pointillist, technique for which he is famous. It is painted with regular dot-like strokes of different colors, which are separate on the canvas. According to his theory, the dots when seen from a certain distance form a *mélange optique*, or merge in the eye of the spectator.

He pursued his theories of color and rigid design in a large number of works executed during the remaining years of his short life. He spent his summers on the coast of the English Channel, painting a consistent series of harbor views and seascapes. During the winters he returned to his studio and worked on exceptionally large, mural-like compositions, such as the Models (1887–1888) in the Barnes Founda-tion, Merion, Pennsylvania, the Invitation to the Side Show (1888) in the Metropolitan Museum, Le Chahut (1890) in the Kröller Müller Museum at Otterlo, and the Circus (1891) in the Louvre.

His works reveal a systematic, classically oriented mind. Although his technique was unconven-tional, the formal structure and the restrained emotional content of his art belong to the tradition of Poussin (q.v.) and the great French classicists. The methodical way he applied his theories of light and color served only to discipline and never to detract from his poetic inspiration.

A MAN, SEEN from behind, is leaning with his elbows on the wall of the quay overlooking the Invalides. He wears a dark brownish black coat, which hangs to his knees, and he appears to have on a kepi, the flat-topped French military cap. His dark blue trousers disappear in the shadows.

On the left is silhouetted a tree that spreads its dark bluish green foliage across the upper edge of the panel and casts similarly colored shadows across the bottom of the picture. The tree trunk is the same color as the man's coat. The area in the foreground between the shadows and the wall is cream-colored. The wall itself is a warm brownish gray, with a bright yellowish ledge at the top. Beyond the wall is a pale blue horizontal building with a domed tower slightly to the right of center and directly above the head of the man. The dome

is highlighted with white and yellow paint. The sky is a mixture of cream-color and pale blue.

Traces of vertical squaring lines can be seen on the panel; three of them are particularly evident across the top of the parapet; a fourth parallels the lower half of the left side of the tree trunk.

The back of the panel (Fig. 1) is completely covered with paint, some of it rather heavily daubed on. The random appearance of the brush strokes and the haphazard distribution of the colors suggest that the artist may have used the panel as a makeshift palette.

PROVENANCE: According to de Hauke (1961, I, no. 12), this picture was listed as no. 1 in the posthumous inventory of the artist's studio. All the paintings and drawings were distributed by Seurat's mother, Ernestine Faivre (about 1820–1898). She presumably gave it to her son-in-law, Léon Appert (1837–1925), whose name is inscribed in ink on the back of the panel (Fig. 1). By 1908 it had passed from him to Alexandre Natanson (1867–1936), who sold it on January 13, 1914, to Bernheim Jeune & Cie, Paris. Two weeks later this firm sold it to Alphonse Kann, Paris. According to Dorra and Rewald (1959, p. 9), it then passed through the hands of Jacques Rodrigues-Henriques (died 1967), apparently acting as a selling agent. It had become the property of Albert Roothbert (1874–1965), New York, by 1924, when he lent it to the Seurat exhibition at the Brummer Galleries. He left it to his widow, Toni A. Roothbert (died 1970), Topstone Farm, Ridgefield, Connecticut, who in turn bequeathed it to the Topstone Fund. It was acquired in New York from the Topstone Fund by Mr. and Mrs. Wrightsman in 1971.

1. *Back of the panel*

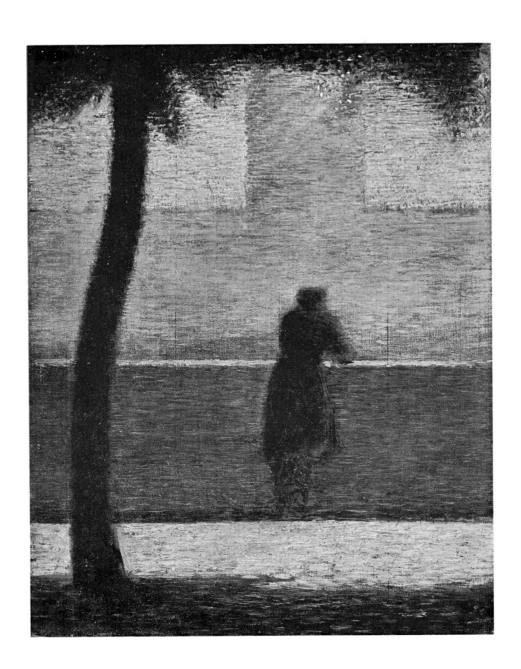

ALTHOUGH Seurat painted approximately 160 tiny wood panels, few of them can compare in delicacy of execution and poetry of mood with the present example. Unlike almost all the others, this one is manifestly a finished work of art, carefully prepared, minutely executed, and complete unto itself. The others are quick exercises, often done out-of-doors, and intended as studies for larger compositions. They were done on cigar box tops—the artist called them *croquetons*. Their small, stiff surfaces fitted conveniently inside his paint box, which he carried whenever he left his studio to sketch. The Wrightsman picture, though painted on a *croqueton*, is by no means a sketch. It was painstakingly executed in the studio. This is evident in the meticulous way the paint was laid on the panel. Every short, overlapping stroke of the brush has an extraordinarily thoughtful quality about it, as if the artist deliberated each one in relation to the hue and tonality of the adjacent pigment.

There is, moreover, nothing sketch-like about the design of the composition. Its emphatic horizontals are balanced by the vertical format of the panel itself and the upright forms of the man, tree, and tower. Each of these elements is sensitively placed, giving the overall design a wonderful sense of interval and spacing. The rectilinear elements never overpower the composition, but are relieved and ingeniously bound together by the repeated curving shapes of the gently bent tree trunk and the sloping posture of the man leaning on the parapet.

To achieve such a beautifully composed design the artist made a series of preliminary studies. In several graphite pencil sketches he explored the motif of a standing figure seen from behind and leaning on a wall or parapet (de Hauke, II, catalogue nos. 400, 407, 416). He also made a pair of highly finished drawings for the painting. One of them is a pastel in a private collection (de Hauke, II, catalogue no. 459). It is eight cm. higher than the panel and two cm. wider, and, according to Robert L. Herbert (letter September 7, 1971), it has the same subdued coloring as the Wrightsman

painting. Its composition is essentially the same as that of the panel, except for the position of the man at the parapet, who leans on his right elbow and gazes off to the left rather than straight ahead. The other finished study (Fig. 2) is a conté crayon drawing (de Hauke, II, catalogue no. 460) formerly in the collection of Jacques Rodrigues-Henriques, Paris. It more closely resembles the panel in that the pose of the leaning man is the same as that of the man in the painting. It differs slightly, however, in that the dome of the Invalides is more legible, and the wall of the quay appears to be slightly lower (in the painting the wall comes up to the man's waist). Moreover, the size and proportions of this study are not the same as those of the panel. Like the pastel, the conté crayon drawing is higher (6.7 cm.) and slightly wider (2.3 cm.) than the panel. The drawing and the panel are reproduced here (see Figs. 2, 3) at the same height, showing that the conté crayon is proportionately narrower than the painted panel. In the completed painting the artist added more space between the tree and the left edge of the panel.

Both the pastel and the conté crayon studies are "squared," which is to say Seurat marked them with a grid of vertical and horizontal lines. Traditionally, artists squared their drawings when they wanted to transfer a design to a larger surface. (And indeed there are lines inscribed on the Wrightsman panel that are clearly visible to the naked eye; see above.) But in this instance, the finished work is smaller than the preparatory drawings. The squaring may nevertheless have been employed for moving the composition to the panel or for aiding the artist in planning the intervals between each element of the picture.

In addition to these drawings there are two further conté crayon drawings connected with the Wrightsman panel: A View of the Invalides Seen from a Parapet on the Seine (de Hauke, II, catalogue no. 461), and A Woman Leaning on a Parapet Overlooking the Seine (de Hauke, II, catalogue no. 462). They probably were done about

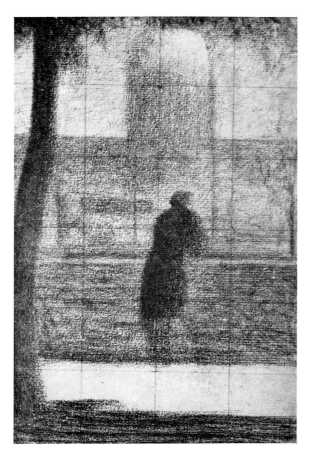

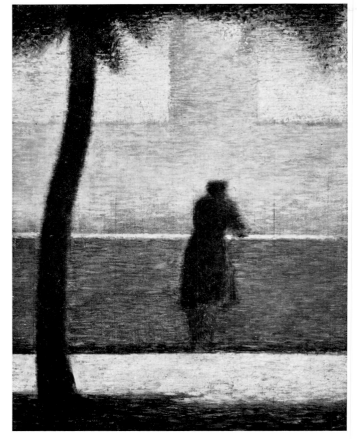

2. *Georges Seurat,* Man Leaning on a Parapet. *Conté crayon on paper, 23.5 by 15.0 cm. Paris, private collection*

3. *Georges Seurat,* Man Leaning on a Parapet. *Wrightsman Collection. Figures 2 and 3 are scaled to the same height in order to show their different proportions*

the same time as the conté crayon drawing illustrated here. Neither of them, however, is directly related to the painting, though they both reproduce its style, subject, and mood.

Although the painting usually is dated about 1881, Robert L. Herbert (letters of August 9 and September 7, 1971) has made the convincing suggestion that it dates from about 1878–1879 and as such is the very earliest surviving painting known by Seurat. Herbert's observations are based upon a pair of unpublished notebooks by Seurat currently on deposit at Yale University. The earliest

of them includes drawings the artist made on a trip to the Netherlands and down the Rhine, perhaps as early as 1876 and certainly no later than 1877–1878. Stylistically, these drawings are not as mature as the painting (or the pastel and conté crayon drawings related to it). The other notebook contains a set of drawings the artist did when he was stationed at Brest with the military. Like the published drawings of the Brest period, the ones in this notebook display more skill in depicting the human figure than the artist possessed when he painted the Man Leaning on a Parapet.

Moreover, some of the drawings in the second notebook are done in pastel, and the color is more pronounced than the subdued coloring of the Wrightsman painting or the pastel connected with it. In the colored drawings of the Brest period the artist started to employ separate strokes of pure color, as he was to do in his subsequent paintings. For these reasons the panel should be dated before November 1879, when the artist left Paris to serve in the army.

One of the most remarkable aspects of the Wrightsman painting is the way the artist rendered the light. With scrupulously consistent and regular touches of yellow and white paint, he depicted the glare of the sun on the domed tower of the Invalides and the light reflected from the top of the parapet and the pavement in the foreground. He thus was able to create a *contre-jour* effect, whereby the man and the tree are thrown into shadow, silhouetted against the vaporous atmosphere filling the picture. In this way Seurat intensified the sense of isolation and thoughtfulness that pervades the composition.

The luminous atmosphere is somewhat reminiscent of the misty *sfumato* found in the works of Henri Fantin-Latour (1836–1904) and Honoré Daumier (1808–1879), who are recognized as having influenced Seurat's art. There is a particularly striking relationship between the Wrightsman painting and a small panel by Daumier, Les Noctambules: Effet de claire de lune, now in the National Museum of Wales, Cardiff (K. E. Maison, *Honoré Daumier: Catalogue raisonné of the Paintings, Watercolours, and Drawings*, New York, 1968, I, pl. 51). Depicting two men walking along the quay of the Seine, it bears a haunting resemblance to the Wrightsman picture, particularly in the way the glowing atmosphere silhouettes the figures against the horizontal parapet of the quay.

Perhaps because topographical details are unclear in the painting, various titles have been assigned to it. In the catalogue for the 1900 exhibition the picture was described as Petit Homme au parapet. (One handwritten label on the back of the panel actually calls the soldier a woman.) In the 1908–1909 exhibition it was listed as L'invalide; in the 1924 exhibition, L'homme sur le pont. Finally, in the 1934–1935 and the 1936 exhibitions it was simply called the Quay. In the preparatory drawings for the painting, the dome of the building seen across the quay is fairly recognizable as that of the Invalides. Nevertheless, de Hauke (II, catalogue no. 12) flatly denies this identification. On the whole, the title first advanced in the 1908–1909 exhibition seems to be the most accurate description of the subject of the painting.

4. *Honoré Daumier, Invalid. Lithograph on paper, 25.6 by 21.9 cm. New York, The Metropolitan Museum of Art, bequest of Edwin De T. Bechtel, 57.650.255*

One of Daumier's lithographs, the Invalid (Fig. 4), is related to the subject of Seurat's painting. It shows an old soldier with a peg leg standing beside a cannon, against the background of the Invalides. Published in *Le Charivari* (September 5, 1870, p. 195), the lithograph was intended as a biting satire of the war of 1870. While Seurat's painting has no such topical or anecdotal overtones, its narrative content parallels the Daumier, because it illustrates a dialogue between a soldier looking back across the Seine to the Invalides, the hospital for the wounded and the retreat for invalided French veterans. Other instances of Daumier's influence on Seurat's work have been observed by Robert L. Herbert (in the exhibition catalogue *Seurat: Paintings and Drawings*, Chicago, 1958, pp. 24, 25; also in the monograph *Seurat's Drawings*, New York, 1962, pp. 65–71).

EXHIBITED: La Revue Blanche, Paris, *Georges Seurat (1860–1891): Oeuvres peintes et dessinées*, March—April 1900, catalogue no. 2; Galerie Bernheim Jeune, Paris, *Exposition Georges Seurat (1859–1891)*, December 1908—January 1909, catalogue no. 3; Joseph Brummer Galleries, New York, *Paintings and Drawings by Georges Seurat*, December 1924, catalogue no. 20; Museum of Modern Art, New York, *Modern Works of Art*, November 1934—January 1935, catalogue no. 25 (illustrated); Renaissance Society of the University of Chicago, *Studies for "La Grande Jatte" and Other Pictures*, February 1935, catalogue no. 19; Museum of Modern Art, *Cubism and Abstract Art*, March—April 1936, catalogue no. 258, fig. 5.

REFERENCES: Lucie Cousturier, "Georges Seurat," in *L'Art Décoratif*, XXVII, June 1912, p. 364 (illustrates it but does not mention it in her text; the caption entitles it L'Invalide and mistakenly states that it is a drawing) // André Fontainas and Louis Vauxcelles, *Histoire générale de l'art français de la Révolution à nos jours*, Paris, 1922, I, p. 240 (illustrate but do not discuss it and mistakenly call it a drawing in the caption) // Elie Faure, *History of Art: Modern Art*, Walter Pach, trans., New York—London, 1924, IV, p. 460 (again the painting is reproduced but not discussed) // Jacques de Laprade, *Georges Seurat*, Monaco, 1945, p. 95, illustrated (dates it about 1881 and mistakenly says it is painted on canvas) // Henri Dorra and John Rewald, *Seurat: L'Oeuvre peint, biographie et catalogue critique*, Paris, 1959, p. 9, illustrated (date it about 1881 and list its provenance, exhibitions, and bibliography) // C. M. de Hauke, *Seurat et son oeuvre*, Paris, 1961, I, catalogue no. 12, illustrated (outlines the picture's provenance, exhibitions, and bibliography, giving incorrect dimensions for the panel) // Anthony Blunt, *Seurat*, London, 1965, p. 77, catalogue no. 1, pl. 1 (says that it is usually dated 1881 but that it may have been done a year or two later and analyzes how its style differs from impressionism) // Pierre Courthion, *Georges Seurat*, New York [1968], p. 44, illustrated (observes that although this is one of Seurat's earliest works it already shows his mature style).

Oil on wood, H. 6⅝ (16.8); W. 5 (12.7).

The picture was cleaned and varnished by Hubert von Sonnenburg of the Metropolitan Museum in February 1971.

GEORGE STUBBS (1724–1806) was born in Liverpool and appears to have taught himself to paint. Throughout his life he was keenly interested in anatomy, and his approach to the art of painting was that of a natural scientist. He began his career as a portraitist in the North of England, but at the age of twenty-six he was already giving private lessons in human anatomy to medical students in York. His earliest surviving works are etchings of the human fetus, published as illustrations for John Burton's *Essay towards a Complete New System of Midwifry* (1751). He traveled to Rome in 1754, reputedly not so much to study the art of the past as to prove to himself that "nature is superior to art." Upon his return he settled again in Liverpool and by 1758 began research for his pioneering book, *The Anatomy of the Horse*, published in 1766. The preliminary work for this book involved dissecting and making anatomical drawings of a number of carcasses, a strenuous task that he undertook entirely on his own. His engravings of the drawings served as the illustrations for the book.

About 1759 Stubbs moved to London and started to exhibit paintings with the Society of Artists, and the following decade witnessed his greatest artistic success. Specializing in pictures of horses, he also did conversation pieces and paintings of wild animals. His expert knowledge of the horse, however, set new standards for realism in English "sporting pictures," a genre to which he contributed masterpieces such as the Grosvenor Hunt, dated 1762. His understanding of the dynamic structure of the animal was so deep and sympathetic that his best horse compositions possess an almost Oriental sense of graceful movement. This is most evident in his frieze-like compositions of Mares and Foals, most of which were painted during the 1760s.

Because he practiced the lowly genre of animal painting, Stubbs seems to have been excluded from the Royal Academy, which was founded by the leading history and portrait painters in 1769. It was not until 1780 that he was elected an associate of the Academy. He never became a full member, however, because he refused to submit a diploma work.

During the latter part of his life his interest turned to unusual techniques of painting. He made pictures with enamel on copper. He also experimented with paintings on porcelain plaques, manufactured expressly for him by Josiah Wedgwood. Shortly before his death he embarked upon another anatomical work, a comparison of the human body with that of a tiger and a bird.

23 A Brown Horse and a Spaniel

THE HORSE, a dark brown, mottled cob with a short thick neck and a bangtail, stands facing to the right. His head is inclined toward a brown and white King Charles spaniel, which looks up at him. The setting is the grassy bank of a lake, with three slender trees in the right foreground filling

the upper right-hand corner of the picture with foliage. Smaller trees are seen in the distance. The sky is blue with some clouds.

Signed and dated at the bottom, to the left of the dog: *Geo. Stubbs pinxit | 1789* (Fig. 1).

1. *Detail: signature and date*

PROVENANCE: The picture was first recorded in "A List of the Known Works by George Stubbs, May, 1896," published in 1898 as an appendix to the Stubbs monograph by Sir Walter Gilbey (1831–1914). At that time it belonged to the author, who lived at Elsenham Hall, Essex. It passed by inheritance to Mrs. Katherine T. Gilbey, Sheering Hall, Harlow, Essex, who lent it in 1960 to an exhibition in Richmond, Virginia. Mr. and Mrs. Wrightsman acquired the painting in London in 1963.

THIS PICTURE is basically a portrait of a horse. It neither tells a story nor depicts an allegory the way many paintings of animals do. It is a straightforward record of the appearance of an individual horse, and it is typical of a kind of painting that George Stubbs was often called upon to provide for eighteenth-century English horse fanciers. Shortly after he settled in London he began to produce pictures of this type. One of the earliest examples is his portrait of the filly Molly Long Legs, now in the Walker Art Gallery, Liverpool, which was exhibited in London in 1762 (Basil Taylor, *Stubbs*, London, 1971, pl. 17). Like the Wrightsman picture, it shows a solitary horse facing to the right and standing in an open landscape. For over thirty years Stubbs painted similar

portraits of famous racers. The formula was only occasionally varied by the addition of a groom, a trainer, a stable boy, or a dog.

Stubbs's portraits of individual horses are remarkable for their simplicity. Earlier horse painters embellished their pictures with a profusion of decorative elements such as marble urns, peacocks, and imposing classical architectural backgrounds. Stubbs concentrated on making anatomically exact and life-like portrayals of his subjects, placed in simple landscape settings. The backgrounds of his horse portraits are almost always generalized and seldom refer specifically to the horse's natural setting, the paddock or the race track.

The format of the Wrightsman painting is shared by other pictures by Stubbs. It is the same, for example, as the format of Pumpkin with a Stable Boy (Fig. 2), which is dated 1774. Both pictures show a single horse standing near a body of water with trees lining its grassy banks. Moreover, to the right there are taller trees with gently arching trunks. Essentially the same composition is repeated in Orinoco with a Dog (Fig. 3), dated 1780. The latter shows the horse quietly gazing at a spaniel, the same motif shown in the Wrightsman picture.

When Gilbey published the Wrightsman picture, he called it the Prince of Wales's Park Hack. There is no evidence, however, to verify this title. Stubbs was patronized by the Prince of Wales, later King George IV (1762–1830), and the Royal Collection contains a total of eighteen pictures by him (Oliver Millar, *The Later Georgian Pictures in the Collection of Her Majesty the Queen*, London, 1969, III, pp.XXIX, 122–126, catalogue nos. 1109–1126). Five of them are unrelated works dating from different periods of the artist's life. The remaining thirteen form a unified series, commissioned by the prince between 1790 and 1793. They all portray subjects directly related to the prince, and they are uniform in size, painted on canvases roughly forty by fifty inches, whereas the Wrightsman picture is on a wood panel about half that size. Perhaps because the Wrightsman picture is

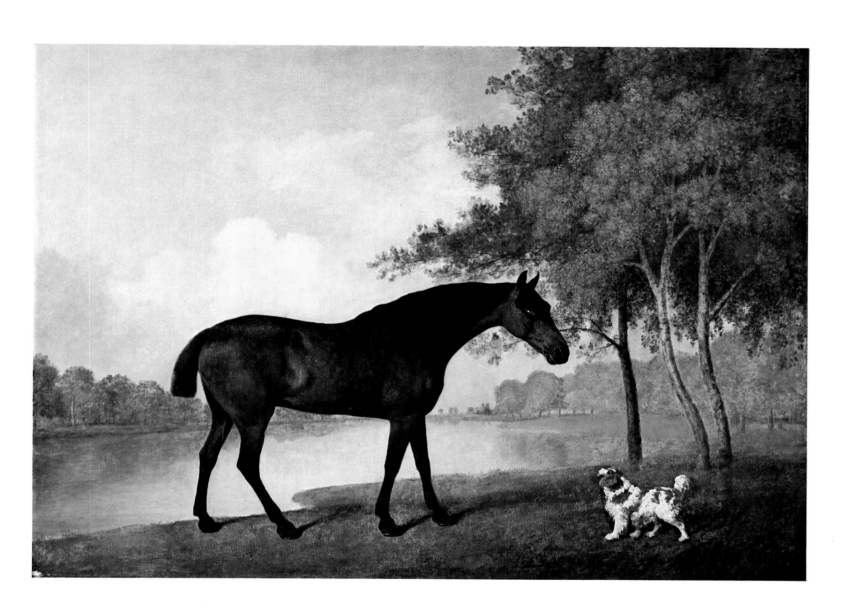

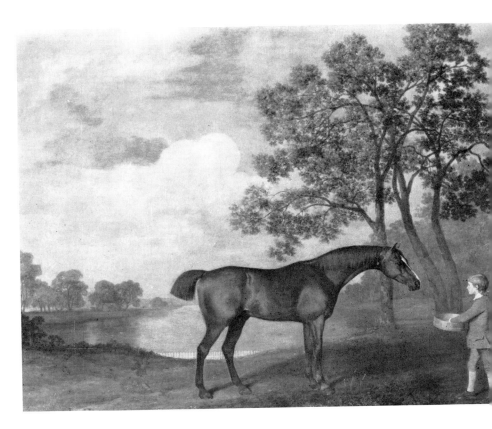

2. *George Stubbs,* Pumpkin with a Stable Boy. *Oil on wood, 83.3 by 99.5 cm. Upperville, Virginia, collection of Mr. and Mrs. Paul Mellon*

dated one year before the Prince of Wales series was begun, Gilbey associated it with him.

Gilbey identified the setting of the picture as the Serpentine in Hyde Park, and this does appear to be correct. The shape of the body of water in the background is similar to that seen in the background of one of the pictures in the Royal Collection, which has been convincingly identified as the Serpentine because of the distant view of Westminster Abbey (Millar, 1969, III, pl. 139).

EXHIBITED: Virginia Museum of Fine Arts, Richmond, Virginia, *Sport and the Horse*, April—May 1960, catalogue no. 24 (illustrated).

REFERENCES: Sir Walter Gilbey, *Life of George Stubbs R.A.* [*sic*], London, 1898, p. 165, catalogue no. 31 (included in a list of thirty-four works by Stubbs owned by the author, who describes the subject as the "Prince of Wales' Park Hack on the Banks of the Serpentine in Hyde Park, 1789") // Anonymous, *Sport and the Horse: Catalogue of the Exhibition of Paintings Assembled at the Museum in Richmond*, Richmond, Virginia, 1960, p. 33, catalogue no. 24, illustrated (entitles the picture "Brown Horse and a Spaniel," noting that Gilbey had previously called it the Prince of Wales's Park Hack).

Oil on wood, H. 22½ (57.2); W. 32 (81.3).
 The painting was cleaned in April 1972 by John Brealey in London. He observed that the picture had originally been painted on wood but later was transferred to canvas and then remounted on a new wood panel.

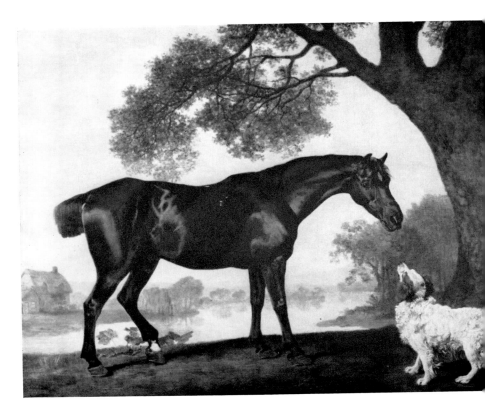

3. *George Stubbs,* Orinoco with a Dog. *Oil on wood, 55.9 by 71.0 cm. England, private collection. Photo: Courtauld Institute of Art*

GIOVANNI BATTISTA TIEPOLO (1696–1770) was the last great Venetian painter and the greatest Italian painter of the eighteenth century. Although he is usually classified as a rococo artist, his enormous fresco decorations were painted in the Grand Manner, following the tradition of Paolo Veronese (about 1528–1588), Pietro da Cortona (1596–1669), and Luca Giordano (*q.v.*).

When he was very young Tiepolo entered the studio of Gregorio Lazzarini (1655–1730). At eighteen he was an independent artist, and a year later he received his first recorded commission, a lunette of the Sacrifice of Abraham in the church of the Ospedaletto, Venice. Painted on a dark ground with dramatic contrasts of light and shade, this work shows the influence of Gian Battista Piazzetta (1683–1754).

Tiepolo's earliest frescoes, the Glory of St. Theresa in the vault of a side chapel of the church of the Scalzi, Venice, were painted shortly after 1720. They were painted in collaboration with Gerolamo Mengozzi-Colonna (1688–1772), who designed the ornamental parts of the decoration. Mengozzi-Colonna, a specialist in *quadratura* painting, was responsible for the foreshortening and the painted architecture in most of Tiepolo's subsequent works. Without his technical skill, the daring illusionism of Tiepolo's mature works would have been far less effective.

Between 1726 and 1728 Tiepolo executed a number of frescoes in the cathedral and archbishop's palace at Udine, in which his personal idiom of light-filled, airy compositions gradually emerged. During the 1730s and 1740s Tiepolo perfected his style in a prodigious series of frescoes for palaces, villas, and churches in Milan, Bergamo, and the Veneto. The masterpiece of this period is the fresco decoration of the main hall of the Palazzo Labia, Venice (see under Catalogue No. 24). In 1750 he was called to execute the greatest undertaking of his career, the frescoes in the archbishop's palace at Würzburg (see under Catalogue No. 25). When he returned to Venice in the autumn of 1753, Tiepolo received commissions to decorate several villas in the Veneto and to paint altarpieces for a number of churches, the most impressive being the great altarpiece of St. Thecla (1759) in the cathedral at Este. The Apotheosis of the Pisani Family, which he frescoed on the ceiling of the sumptuous villa at Strà in 1761–1762, announces the opening of his final period.

In 1762 Tiepolo was invited by Charles III of Spain to decorate the royal palace in Madrid. He frescoed the ceilings of three large rooms (see under Catalogue No. 26) and painted seven altarpieces (completed in 1769) for the church of San Pascual at Aranjuez, the sketches for which reveal the extraordinary depth of his religious feeling.

Tiepolo's last years were disturbed by the antagonism of Anton Raffael Mengs (1728–1779), the celebrated exponent of neoclassicism, and his Spanish supporters, who attacked Tiepolo's works for their frivolity and decorative character. When Tiepolo died in Madrid at the age of seventy-four, the altarpieces at Aranjuez were removed to make way for mediocre pictures by Mengs and his neoclassical followers.

This abrupt change of taste is indicative of the age in which Tiepolo lived. His flamboyant, high-spirited decorations were not in keeping with the sober moral attitudes of the neoclassical age. During

his life, Tiepolo's works were sought outside northeast Italy only by the courts of Spain and Russia and the German principalities. His sphere of activity never extended to the intellectual centers of Paris, London, and Rome, the strongholds of neoclassicism.

Tiepolo married Cecilia, the sister of the painters Francesco (*q.v.*) and Giantonio Guardi (1698–1760). They had nine children, two of whom, Domenico (*q.v.*) and Lorenzo (1736–1776), became painters. As soon as they were old enough to work, they assisted their father and very likely helped to complete many of his late works.

24 The Meeting of Antony and Cleopatra

ON THE BANK of a large body of water, in the middle of a crowd of attendants, Cleopatra receives Antony (Fig. 1) who has just disembarked from a large galleon, the masts and stern of which are visible behind them. Cleopatra wears a light yellow gown with a tall white collar. A pair of blackamoor pages, dressed in blue tunics and white leggings, hold up the train of her dress. Antony bows and kisses Cleopatra's outstretched hand. He wears a brown military uniform with a light crimson cape and a helmet with a white and gray plume. The color of Antony's cape echoes that of the flag of his galleon, unfurled above Cleopatra's head. An antique setting is suggested by the ruins of an obelisk on the right and the intertwined cypress and palm trees.

Freely sketched in around Antony and Cleopatra are other men in military attire and a prominently placed Oriental wearing a turban and a sumptuous white and beige costume. This figure may be intended to be Plancus, who was joint-consul with Antony. He looks down to the left at

1. *Detail: Antony and Cleopatra*

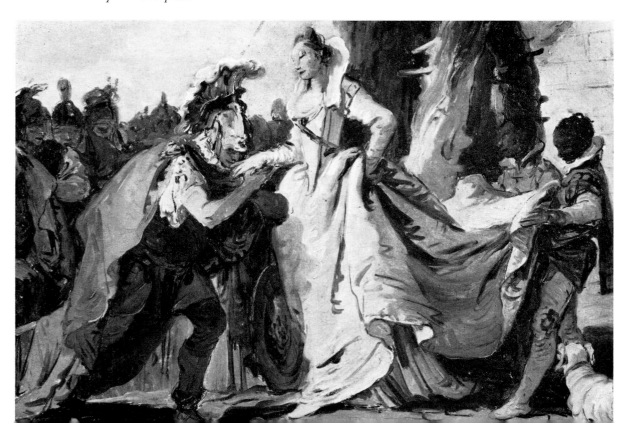

a man crouching in the foreground (Fig. 2), who wears a dark blue cloth around his waist and holds in his arms a large urn and some silver plate. Behind him a pair of servants carry a dark red litter bearing gold and silver treasures (Fig. 2). Behind them, several figures (Fig. 11) are silhouetted against the sea.

In the right-hand corner there is a Negro dwarf, clad in a red jacket and cap. Immediately in front of him, a man seen from behind and wearing the same colors as the blackamoors holding Cleopatra's dress is kneeling on one knee. A dark red banner rests in shadow on the ground beside them, and a white greyhound looks up at Cleopatra.

2. Detail: servants and the stern of the galleon

PROVENANCE: During the eighteenth century the painting may have belonged to the dei Vecchia family of Vicenza. They possessed several paintings by Tiepolo (Charles Nicolas Cochin, *Voyage pittoresque d'Italie*, Paris, 1756, II, pp. 473–474). One of their Tiepolos, a Meeting of Antony and Cleopatra, was carefully copied in 1760 by Jean Honoré Fragonard (1732–1806) in a red chalk drawing (Fig. 3) belonging to the Norton Simon Foundation, Los Angeles. It is possible that the composition Fragonard copied was a large painting, but it is more likely that it was a small oil sketch (since Cochin states that there were Tiepolo sketches in the dei Vecchia Palace), and that Fragonard's drawing of the Meeting of Antony and Cleopatra is a copy of the painting now in the Wrightsman Collection.

According to an old tradition, the Wrightsman painting belonged to the French academic painter Hugues Fourau (1803–1873). He possessed a number of old master paintings, among them a pair by Tiepolo that are listed as "Cléopâtre à la perle" and "Le débarquement de Cléopâtre" in the catalogue of his sale (Hôtel Drouot, Paris, March 1–2, 1869, lots 90, 91). According to the sale catalogue, the dimensions of Le Débarquement were 67 cm. high by 42 cm. wide, the measurements of an upright rectangle. These dimensions do not correspond with those of the Wrightsman sketch, which is a horizontal rectangle, 45 cm. high by 65.5 cm. wide. It is possible, however, that the dimensions in the catalogue were mistakenly reversed, in which case there would be little question about the traditional provenance.

It is certain that the Wrightsman sketch belonged to the Rt. Hon. George Augustus Frederick Cavendish Bentinck (1821–1891) of London and Brownsea Island. He possessed two Tiepolo sketches, listed as Cleopatra Receiving Antony and Cleopatra Dropping the Pearl in the sale of his collection (Christie's, London, July 8–14, 1891, lots 600, 601). Although Cavendish Bentinck is known to have bought many paintings in Venice, it is possible that his pair of Tiepolo sketches are the same as those which belonged to Fourau.

[220]

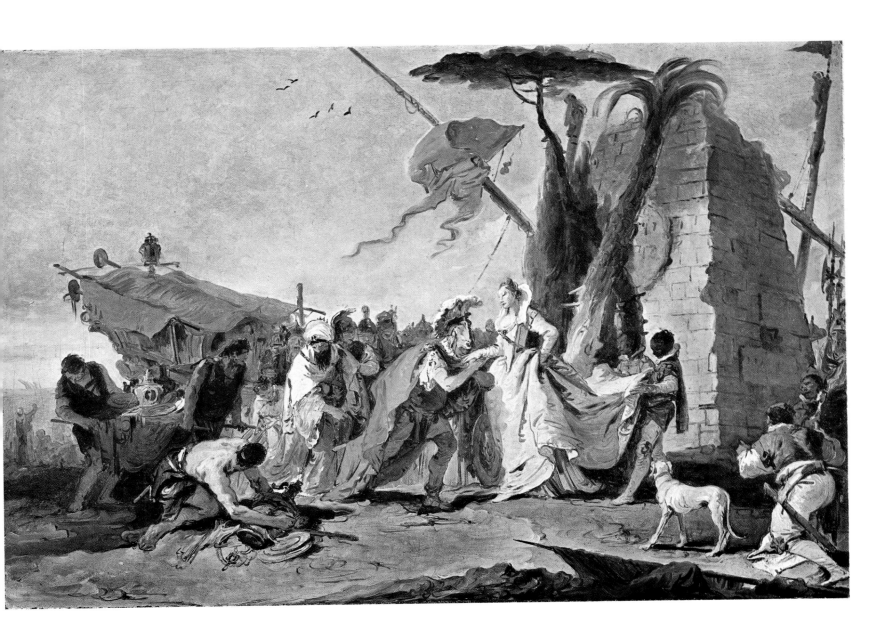

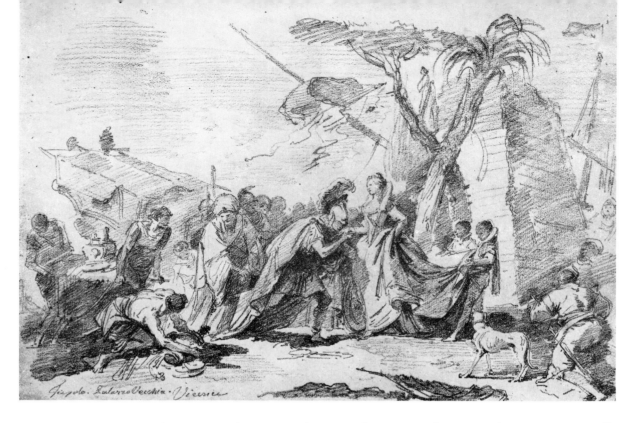

3. *Jean Honoré Fragonard, Meeting of Antony and Cleopatra. Red chalk on paper, 20.3 by 29.2 cm. Los Angeles, Norton Simon Foundation*

At the Cavendish Bentinck sale the pair of Tiepolo sketches were sold to P. & D. Colnaghi & Co. Ltd of London. The one entitled Cleopatra Dropping the Pearl was subsequently acquired by William Cleverly Alexander, London (died 1916). It passed to his daughters, who gave it to the National Gallery, London. All that is known about its companion, the painting now in the Wrightsman Collection, is that by 1909 it belonged to Baron Henri James de Rothschild (1872–1946) and that it passed by inheritance to his son Baron Philippe de Rothschild (born 1902). It was acquired in New York by Mr. and Mrs. Wrightsman in 1968.

Tiepolo's painting illustrates a famous episode in ancient history, the celebrated alliance of Antony and Cleopatra. The basic source for their story is Plutarch, yet so many other writers have retold and elaborated the tale that it would be difficult to identify the source, or sources, Tiepolo followed when he painted the sketch in the

Wrightsman Collection. The story essentially concerns Cleopatra VII (68–30 B.C.), the last of the Ptolemaic dynasty to rule Egypt. She used her beauty and charm to obtain military alliances, first with Julius Caesar (102–44 B.C.), by whom she had a son, Caesarion, and then with Mark Antony (about 82–30 B.C.), by whom she had three more children. Antony was ruler of the eastern half of the Roman Empire, and, during the more than ten years he spent with Cleopatra, he was at war with Octavian, the ruler of the western half of the empire. Antony was finally defeated, and took his own life. Cleopatra then sought to charm Octavian, but was rejected, and committed suicide rather than endure the humiliation of being the prize of his triumphal entrance into Rome.

The actual encounter depicted in the Wrightsman painting is probably the first meeting of Antony and Cleopatra when Antony visited Cilicia, a province in Asia Minor, in 41 B.C. In some of the French exhibition catalogues listed below, the painting is called "Les Adieux d'Antoine à Cléopâtre," but this title is clearly incorrect because the servants bearing the gold and silver treasure are arriving, not packing up to go away.

Tiepolo does not follow the story literally, but

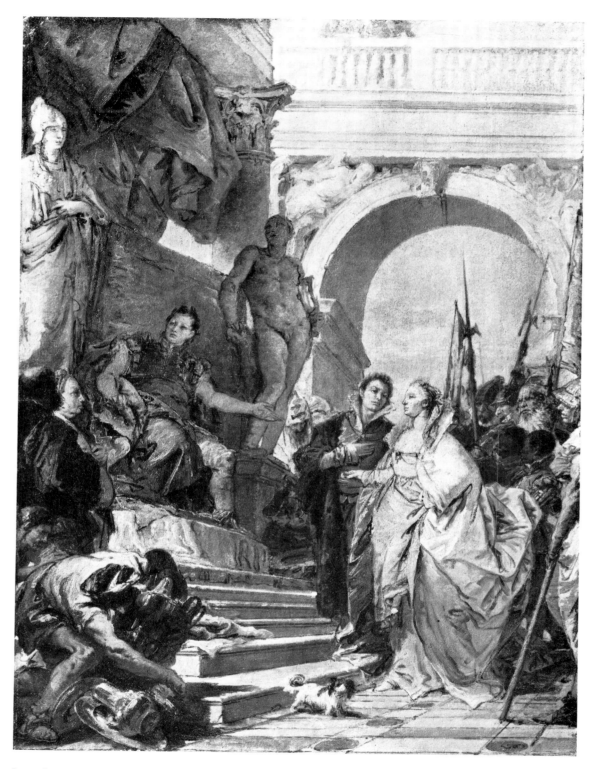

4. *Giambattista Tiepolo, Continence of Scipio. Oil on canvas, 60.4 by 44.0 cm. Stockholm, Nationalmuseum*

rather embroiders it into a highly personal fabric of eighteenth-century fantasy. The figures move across the canvas like actors in an operatic pageant, clad in sumptuous garments that sparkle with brilliant colors. There are no specific references to ancient Egypt in the painting, aside from the ruins of the obelisk on the right. The costumes and the physical types recall the High Renaissance paintings of an artist like Paolo Veronese (about 1528–1588). They are neither ancient nor contemporary, an anachronism that an artist with rigorous archaeological interests, such as Poussin (*q.v.*), would not have permitted.

Tiepolo thus transformed the cold facts of Roman imperalism and Egyptian intrigue into a love story, filled with all the color and glamorous pomp characteristic of eighteenth-century Venetian painting. He gives no hint of the tragic fate Antony and Cleopatra shared; for him, they were two people rapturously drawn together, extravagantly in love, and he revels in the exotic setting and splendid trappings surrounding them.

The Wrightsman sketch was probably painted in the early 1740s. In style and motif it is closely linked to Tiepolo's works of that period. A good example of this is a small oil sketch (Fig. 4) in the Nationalmuseum, Stockholm, representing the Continence of Scipio. This is accepted as a preparatory study for the large fresco of the same subject in the Villa Cordellina at Montecchio Maggiore (Vicenza), executed in 1743. Both the Stockholm

5. *Giambattista Tiepolo, Venetian General Receiving the Keys of a Turkish City. Brown ink on paper, 28.5 by 42.0 cm. Florence, Horne Museum. Photo: Gabinetto Fotografico, Florence*

6. *Giambattista Tiepolo, Meeting of Antony and Cleopatra. Brown ink and black chalk on paper, 40.8 by 29.2 cm. New York, The Metropolitan Museum of Art, Rogers Fund, 37.165.10*

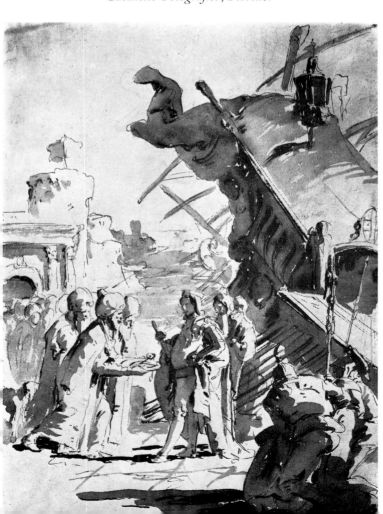

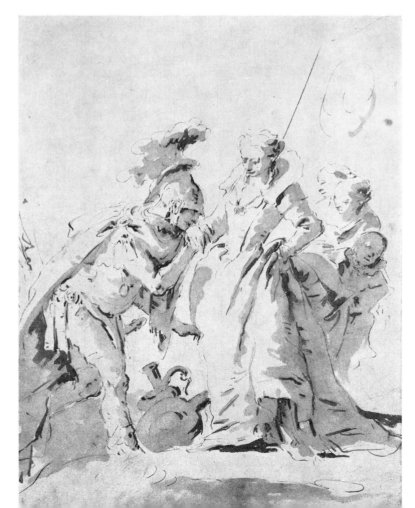

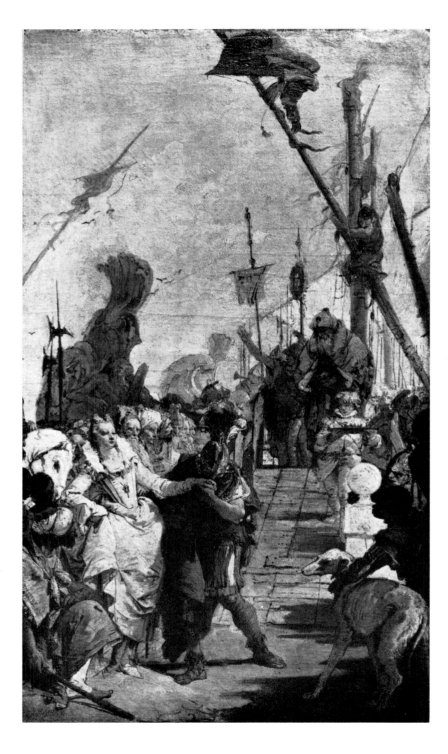

7. *Giambattista Tiepolo, Meeting of Antony and Cleopatra. Oil on canvas, 67.3 by 38.1 cm. Edinburgh, National Gallery of Scotland. Photo: Annan*

and the Wrightsman sketches show a woman in a full gown with a high collar, attended by a pair of blackamoor pages. In the foreground of both pictures, a partially clad man crouches and holds a silver urn in his arms.

Another work probably dating from the early 1740s is a beautiful drawing of a Venetian general receiving the keys of a Turkish city (Fig. 5), in the Horne Museum, Florence. It displays another motif found in the Wrightsman painting, the stern of a galleon covered with an awning and surmounted by a lantern, a detail that does not appear in any of Tiepolo's other known works.

Still another drawing, certainly connected with the Wrightsman painting, is a large pen and ink sketch on white paper showing Antony bowing to kiss Cleopatra's hand (Fig. 6). Although the position of Antony's legs was altered in the Wrightsman sketch, the rough indications of an obelisk with an oval cartouche behind the figures links the drawing to the sketch.

The theme of Antony and Cleopatra haunted Tiepolo's imagination during the 1740s, and the Wrightsman sketch is just one of a group of small sketches, large oil paintings, and frescoes done on the subject during this period. These include a pair of small paintings divided between the National Gallery of Scotland, Edinburgh (Fig. 7), and the University Museum, Stockholm; the large oil painting completed during the winter months of 1742–1743 of the Banquet of Cleopatra, now in the National Gallery of Victoria, Melbourne, Australia; the frescoes executed around 1745 of the Banquet of Cleopatra and the Meeting of Antony and Cleopatra (Fig. 8), in the great hall of the Palazzo Labia, Venice; and the enormous canvases, dated 1747, of the Banquet and the Meeting of Antony and Cleopatra (Fig. 9), at Arkhangelskoye, near Moscow.

These paintings, with the exception of the Mel-

8. *Giambattista Tiepolo, Meeting of Antony and Cleopatra. Fresco, 6.5 by 3.0 meters. Venice, Palazzo Labia. Photo: Alinari*

bourne Banquet, were all conceived as pairs. In the Palazzo Labia, the Meeting of Antony and Cleopatra faces the Banquet of Cleopatra, and the paintings at Arkhangelskoye were designed as a similar pair. Originally, the Wrightsman sketch also had a pendant, the Banquet of Cleopatra (Fig. 10) recently given by Miss Jean Alexander to the National Gallery, London. The Alexander picture has nearly the same dimensions as the Wrightsman sketch and is executed with the same swift touch.

Some writers have called the Wrightsman painting a preparatory study for the Arkhangelskoye Meeting. This idea was developed on the basis of Igor Grabar's thesis ("Paintings by Tiepolo in Arkhangelskoye and the Self-Portrait of the Master," in *Iskusstvo* [in Russian], X, March–April, 1947, pp. 63–81) that the pendant to the Wrightsman sketch, the Alexander Banquet (Fig. 10), was made as a study for the Arkhangelskoye Banquet. Since the Wrightsman and Arkhangelskoye Meetings (Fig. 9) are horizontal, their compositions appear to have much in common. But in fact the resemblances are not as strong as those between the Wrightsman and Edinburgh paintings (Fig. 7). In the Arkhangelskoye painting. Antony stands beside Cleopatra in a wooden posture that lacks all the poetry with which the Wrightsman and Edinburgh paintings are imbued.

Levey (1965, unpaginated), however, suggested tentatively that the Alexander–Wrightsman sketches were painted for the Labia frescoes. The other pair of small paintings by Tiepolo at Edinburgh (Fig. 7) and Stockholm are generally considered as the preparatory sketches for the Labia frescoes. They are of the same subjects and are approximately the same sizes as the Wrightsman–Alexander sketches, but they have upright rectangular formats, making them more like the Labia Tiepolos. But Levey convincingly observed that both the Edinburgh–Stockholm and Wrights-

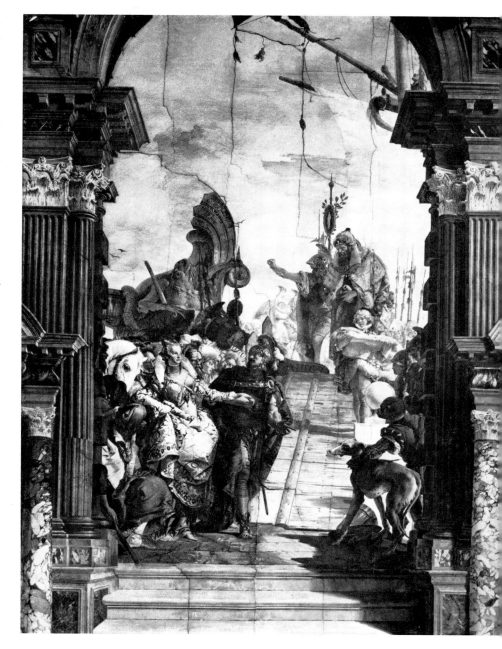

man–Alexander sketches are related to the Labia frescoes.

The Wrightsman and Edinburgh sketches have a number of motifs in common—the pair of black-amoor pages holding the train of Cleopatra's

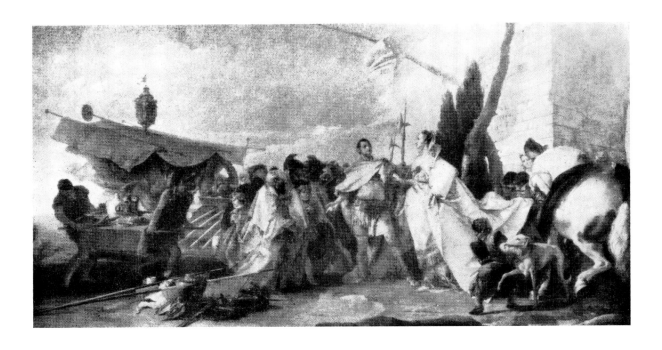

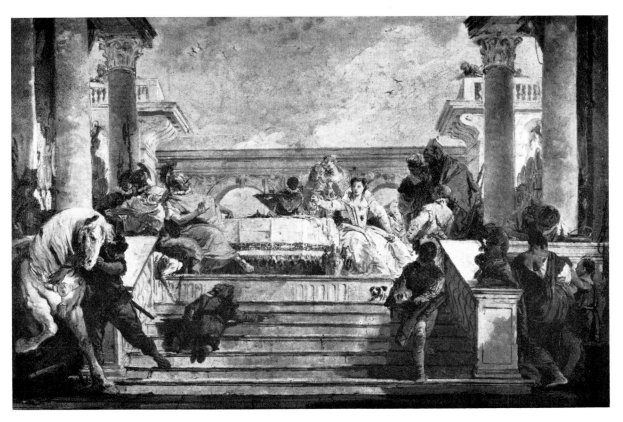

gown, the greyhounds in the foreground, and the smoky rose flags waving in the breeze above. They differ in that the Wrightsman painting gives the impression of having been quickly rendered, almost as if it were a spontaneously executed drawing or watercolor. Some figures are merely roughed in—the ghostly figures climbing up the shore on the far left (Fig. 11) and the observers in the background. Even the faces of Antony and Cleopatra read as swift notations of the brush, rather than as detailed character studies. The Edinburgh picture is more detailed. The costumes, particularly, are minutely described—Cleopatra's puffed sleeves, the zigzag silhouette of her collar, and the double necklaces with the suspended brooch, and Antony's pleated tunic skirt. But these differences—the tentative, truly sketchy technique of the Wrightsman painting and the fully cogitated, thoughtful treatment of the Edinburgh painting—would suggest that the former is an earlier preliminary sketch for the same fresco.

To say that the Wrightsman sketch was a preliminary study for the Arkhangelskoye Meeting is to overlook the similarities between the Wrightsman and Edinburgh sketches. The sketches are even more like one another than either of them is like the Labia fresco or the Arkhangelskoye canvas. In both sketches, the unfurled banner is more prominent than in the fresco. More significantly, the motif of Antony bowing to kiss Cleopatra's hand, found in both sketches, has been changed in

the fresco (Fig. 8), where Antony takes Cleopatra's arm, as if to lead her into the great hall of the Palazzo Labia itself. (This illusionistic aspect of the fresco is particularly evident in the panoramic photographs illustrated in *Palazzo Labia, Oggi,* Bruno Molajoli, ed., Turin, 1970, pp. 20, 21.) His movement from her right to her left side as he kisses her hand can be seen as part of the progression from the free sketch to the finished fresco. The most logical way to view all these works is to see the Wrightsman and Edinburgh sketches as preparatory studies for the Labia fresco, and the Arkhangelskoye canvas as a derivation from all

11. *Detail: men climbing up the shore*

three. This is suggested by the way Antony leads Cleopatra by the arm in the Arkhangelskoye Meeting as he does in the Labia fresco.

The chronology of the Labia and Arkhangelskoye Meetings has never been satisfactorily established. We know that the Labia frescoes were completed before the winter of 1746–1747 (Levey, 1965) and that one of the Russian paintings is dated 1747. However, it is impossible to be more precise than that, although some recent writers (such as George Knox and Christel Thiem, in the exhibition catalogue *Tiepolo: Zeichnungen von Giambattista, Domenico und Lorenzo Tiepolo*, Stuttgart, 1970, pp. 13, 152) maintain that the frescoes were executed during the summer of 1744. It is likely that Tiepolo worked out two parallel solutions, one for Venice and the other for the Arkhangelskoye canvases, and, being more committed to the Labia frescoes, one of the most important commissions of his career, hardly touched the Arkhangelskoye canvases. The actual execution of them is so mediocre that it is likely that Tiepolo's workshop assistants handled the commission, following his design. Several chalk drawings by Giambattista have recently been published as preparatory studies for these canvases (Knox and Thiem, 1970, p. 170, catalogue no. 182; catalogue no. 183 is identified as a drawing copied by Domenico after the Arkhangelskoye Meeting).

EXHIBITED: Petit Palais, Paris, *Exposition de l'art italien*, 1935, catalogue no. 445; Palazzo Giardini, Venice, *Mostra del Tiepolo*, 1951, catalogue no. 66 (illustrated); Galerie Cailleux, Paris, *Tiepolo et Guardi: Exposition de peintures et dessins provenant de collections françaises publiques et privées*, 1952, no. 30; Galerie des Beaux-Arts, Bordeaux, *De Tiepolo à Goya*, 1956, catalogue no. 54 (illustrated); L'Oeil Galerie d'Art, Paris, *Eighteenth Century Venetian Paintings and Drawings*, 1967, catalogue no. 21 (illustrated in color); The Metropolitan Museum of Art, New York, *Oil Sketches by 18th Century Italian Artists from New York Collections*, January 30–March 21, 1971, catalogue no. 32.

REFERENCES: Pompeo Molmenti, *G. B. Tiepolo: La sua vita e le sue opere*, Milan, 1909, p. 75; illustrated p. 72; and again in the French edition, *Tiepolo: La Vie et l'oeuvre du peintre*, Paris, 1911, p. 66, pl. 58 (associates the painting with the frescoes in the Palazzo Labia and calls it "un . . . bozzetto molto curioso," a very curious sketch) // Eduard Sack, *Giambattista und Domenico Tiepolo: Ihr Leben und ihre Werke*, Hamburg, 1910, p. 127 (mentions a painting by Tiepolo of the Meeting of Antony and Cleopatra in the collection of the Rothschilds in Paris, but does not include it in his catalogue raisonné) // L. E. Rowe, "A Ceiling by Tiepolo," in the *Bulletin of the Rhode Island School of Design*, XXI, October 1933, p. 58 (states that in the Rothschild Collection in Paris there are examples of Tiepolo's work from the Palazzo Labia, which presumably refers to the painting now in the Wrightsman Collection) // Antonio Morassi, *Tiepolo*, Bergamo, 1943, p. 34 (dates the painting about the time of Tiepolo's frescoes in the Villa Valmarana [which would be about 1757]) // Roberto Longhi, *Viatico per cinque secoli di pittura veneziana*, Florence, 1946, p. 41 (refers to Tiepolo's sketch for the fresco of the Meeting of Antony and Cleopatra in the Palazzo Labia, by which he could mean either the Edinburgh or Wrightsman painting; he singles out the motif of Antony kissing Cleopatra's hand as an example of a highly theatrical gesture, which fortunately does not appear in the fresco) // Terisio Pignatti, *Tiepolo*, Milan, 1951, p. 80, pl. 64 (illustrates a detail of the figures of Antony and Cleopatra and mentions the painting; the caption for the illustration dates the Wrightsman painting 1747) // Giulio Lorenzetti, *Mostra del Tiepolo*, 2nd ed., exhibition catalogue, Venice, 1951, pp. 89–91, no. 66, fig. 66 (describes how it differs from the Arkhangelskoye canvas and remarks that it is one of the "più squisiti ed avvicenti 'pezzi' di pittura tiepolesca") // F. J. B. Watson, "Reflections on the Tiepolo Exhibition," in *The Burlington Magazine*, XCIV, February 1952, p. 44, note 8, fig. 7 (observes that the "small scenes from the life of Cleopatra . . . formed the most scintillating group of paintings in the exhibition. Their subjects are free variations on the themes of the Labia frescoes; rather than being *modelli* for the decoration of the palace they were probably painted as *recordi* for admirers of the frescoes.") // François Fosca (pseudonym of Georges de Traz), *The Eighteenth Century*, Stuart Gilbert, trans., Geneva, 1952, p. 81 (illustrates the painting in color, dating it in the caption before 1747) // Anonymous, *Tiepolo et Guardi: Exposition de peintures et dessins provenant de collections françaises publiques et privées*, exhibition catalogue, Paris, 1952, p. 46, no. 30 (points out the resemblance of the partially clad man kneeling on the right to a figure in Tiepolo's frescoes in the Villa Cordelina) // Antonio Morassi, *G. B. Tiepolo: His Life and Work*, London, 1955, p. 24, fig. 30 (places it about the time of the Palazzo Labia frescoes, which he dates 1745–1750, and erroneously states in the caption of the illustration that the painting belonged to Baron Edmond de Rothschild) // *Art Treasures Centenary: European Old Masters*, exhibition catalogue, Manchester, 1957, p. 46, catalogue no. 163 (in the

catalogue entry for the painting the Banquet of Cleopatra, formerly in the Alexander Collection, the Wrightsman painting is mentioned as a pendant) // F. J. B. Watson in *Italian Art and Britain*, exhibition catalogue, London, 1960, p. 172 (mentions the Wrightsman painting as the pendant to the Alexander sketch; states that both were painted "as preparatory sketches" for the large canvases at Arkhangelskoye; implies that the Labia frescoes were painted later than the Arkhangelskoye pictures) // Decio Gioseffi, *Canaletto and His Contemporaries*, New York, 1960, pp. 35–36, color pl. 16 (mentions it as one of the finest "sketches, rough copies, and smaller variations" of the frescoes in the Palazzo Labia) // Antonio Morassi, *A Complete Catalogue of the Paintings of G. B. Tiepolo*, London, 1962, pp. 2, 43 (states that it is a sketch for the picture in Archangel [*sic*], and calls it "one of the best *modelli* of this period [about 1747], fresh in handling and splendid in colour") // Rodolfo Pallucchini, "Un nuovo 'banchetto di Cleopatra' di Giambattista Tiepolo," in *Acropoli, Rivista d'Arte*, II, 1961–1962, p. 110 (regards the Wrightsman and the Alexander paintings as Tiepolo's first ideas for the large canvases in the Yusupov Collection) // Jacob Bean, *100 European Drawings in The Metropolitan Museum of Art*, New York, 1964, pl. 43 (publishes a drawing by Tiepolo of the Meeting of Antony and Cleopatra, which he dates about the time of the frescoes in the Palazzo Labia; observes that the figures in the drawing are grouped the way they appear in the Wrightsman painting, which he states is a study for the canvas at Arkhangelskoye) // Egidio Martini, *La pittura veneziana del settecento*, Venice, 1964, p. 69, pl. 136 (illustrates a detail showing Antony kissing Cleopatra's hand; calls the painting one of Tiepolo's most spontaneous sketches; compares it with the paintings by Gian Antonio Guardi on the organ in the Chiesa dell'Angelo Raffaele, Venice) // Michael Levey, *Tiepolo: Banquet of Cleopatra* (Charlton Lectures on art delivered at the University of Newcastle in 1963), Newcastle upon Tyne, 1965, unpaginated (proposes that the Wrightsman and Alexander sketches were made around 1740–1743 in connection with the frescoes in the Palazzo Labia; suggests that the horizontal format of the sketches is not at variance with the vertical composition of the frescoes, since the architecture in the frescoes could have been designed after these sketches were made; observes that Fragonard made drawings that follow the compositions of the Wrightsman and Alexander sketches and may be copies either of them or "a pair of large-scale pictures based on them") // Anonymous, "Quelques Tableaux et dessins vénitiens du XVIIIe siècle," in *L'Oeil*, March 1967, p. 9, illustrated in color, fig. 3 (dates the sketch about

1747 and associates it with the Palazzo Labia and Yusupov compositions) // Anna Pallucchini, *L'opera completa di Giambattista Tiepolo*, Milan, 1968, p. 112, catalogue no. 176, fig. 176-A (mentions the Wrightsman painting as a *modelletto* for the Meeting of Antony and Cleopatra at Arkhangelskoye) // Claus Virch, "Dreams of Heaven and Earth: Giambattista and Domenico Tiepolo in the Wrightsman Collection," in *Apollo*, XC, September 1969, pp. 173–176, 178, fig. 1, and on the front cover in color (dates the Wrightsman painting before the Yusupov Meeting of Antony and Cleopatra, which is inscribed 1747; disputes the traditional provenance of the painting from the Fourau Collection and observes that the Wrightsman painting is probably the picture described in the Cavendish Bentinck sale catalogue) // Colin Thompson and Hugh Brigstocke, *National Gallery of Scotland: Shorter Catalogue*, Edinburgh, 1970, pp. 94–95 (suggest the Wrightsman picture was made in preparation for the Arkhangelskoye Meeting and that it may pre-date the sketch of the same subject at Edinburgh) // Jacob Bean, "A Selection from the Exhibition *The Eighteenth Century in Italy: Drawings from New York Collections, III*," in *The Metropolitan Museum of Art Bulletin*, XXIX, January 1971, p. 248 (lists the Wrightsman sketch as one of three paintings by Giambattista of the Meeting of Antony and Cleopatra; remarks that the pose of the figures in the drawing of the same subject in the Metropolitan Museum is closest to the Wrightsman painting) // Jacob Bean and Felice Stampfle, *Drawings from New York Collections III: The Eighteenth Century in Italy*, New York, 1971, p. 54 (state that the Wrightsman oil sketch "is a study for a large canvas by Giambattista, dated 1747, at Arkhangelskoye") // Everett Fahy, "Tiepolo's Meeting of Antony and Cleopatra," in *The Burlington Magazine*, CXIII, December 1971, pp. 735–740, fig. 45 (publishes the drawing Fragonard made of the Wrightsman sketch and proposes that the latter was a preliminary study by Giambattista for the Labia fresco, which his assistants utilized when they executed the Arkhangelskoye canvas) // Alistair Smith, "Presented by the Misses Rachel F. and Jean I. Alexander: Seventeen Paintings for the National Gallery," in *The Burlington Magazine*, CXIV, September 1972, p. 634 (mentions it as "a companion sketch" to the Banquet of Cleopatra from the Alexander Collection).

Oil on canvas, H. 17¾ (45.0); W. 25¾ (65.5).

A coating of discolored varnish was removed in 1968 by Mario Modestini. The original paint surface was found to be in a perfect state of preservation.

25 Allegory of the Planets and Continents

THE RECTANGULAR composition consists of five principal groups of figures: the classical deities in the sky and four crowds of allegorical figures on the cornice at the four sides of the painting. The allegorical figures are identified by inscriptions on the molding of the cornice: EVROPA, AFRICAE, AMERICA, and ASIA. At the four corners there are pairs of male nudes seated on either side of large upturned shells, classical masks, and heavy garlands of fruit, all painted in beige monochrome.

The deities in the sky are somewhat smaller in scale than the allegorical figures resting on the cornice. They are painted in much lighter hues to suggest their higher altitude. In the center (Fig. 1) Apollo stands with his legs clasped by two lightly indicated female figures. He is represented as a youthful athlete, nude except for a white chlamys thrown over his shoulders. There is a quiver of arrows on his back, and he carries in his upraised left hand an unidentifiable object (in the fresco it is a statuette). Around his head there is a halo-like radiance, and behind him there are vague indications of the columns of a circular building. To the right of Apollo (Fig. 2) four horses of his quadriga prance on the clouds. The most prominent one, a dark gray stallion, is led by a woman with large gray wings and beige draperies. The other three horses are also attended by female figures and flying putti. Mars and Venus (Fig. 3) recline below Apollo on a turquoise-blue and yellow cloth spread on a dark gray cloud. Venus is entirely nude, while Mars wears a silver helmet, a dull red jacket, and white britches. He holds a shield that blocks out of view the forequarters and head of a lion. A putto plays with Mars's sword, and two putti above Venus's head push a chariot partially concealed by a cloud. The three winged figures

on the right (Fig. 5) are the Fates—Clotho, Lachesis, and Atropos. They wear light scarlet, pale gray, and salmon-colored robes, and hold the thread of life in their hands. Below them, painted almost in monochrome, are four female figures who seem to struggle to support a cloud. They are the Keres, or Furies, who execute the will of the three Fates. In the uppermost part of the sky (Fig. 4), Mercury flies in mid-air. His youthful body is largely exposed, his beige chlamys having fallen off his shoulders. He wears a petasus, or round, winged hat, and there are wings on his heels. He carries a caduceus, the staff around which serpents are entwined. Below Mercury there is a goddess seen from behind, sitting on a pale yellow cloth. She wears a bright blue ribbon in her hair and some white drapery over her thighs. Suspended above her head, a small crescent identifies her as Diana, or Luna, as she is sometimes called. Her head is turned toward Jupiter who sits beside an eagle on a cloud. Below his upraised arm stands Hebe, a nude young maiden holding a patera, a shallow vessel for serving ambrosia to the gods. Directly below Jupiter are represented Saturn and Vulcan. Saturn is an old gray-haired man with large gray wings, recumbent upon a pale blue cloth. He holds a scythe and an hourglass in his hands. Vulcan, seated in profile to the right of Saturn, has a black beard and rests his hand on a staff.

Each of the Four Continents is personified by a female figure surrounded by appropriate attendants. Europa (Fig. 6), for example, is shown as a mature woman seated on a block of masonry beside a model of a classical temple. She wears a scarlet cape over a dress of *changeant* blue and beige shades. She holds a scepter in her right hand, above the head of a bull, her traditional attribute. Be-

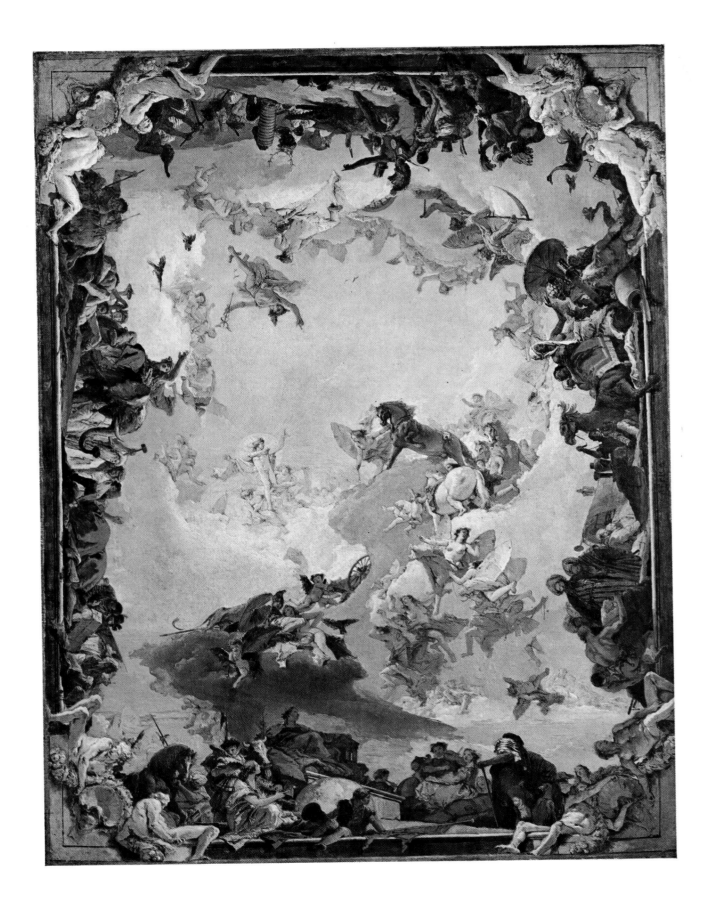

cause of the dark cloud above, on which Mars and Venus recline, Europa is cast in shadow, while the figures standing before her are lit by bright sunlight. There is a page in a pale lilac tunic, carrying a crown on a salver. In front of him a crouching woman, dressed in a gray gown, looks up to Europa and points to the large globe at the foot of her throne. In front of the globe a young boy in a blue jacket sits on the cornice. He rests his right hand on the barrel of a cannon and his left on a red banner. He looks back to the right where a group of young boys and girls play musical instruments.

The continent of Africa (Fig. 7) is personified by a Negress wearing a red and white turban and a beige cloth around her legs. She sits on a dark brown camel, which is resting on the ground. To the right a Negro page holds a parasol and an incense burner. He wears a light green doublet and carries a red quiver full of arrows over his shoulder. On the cornice in front of him a bearded river god reclines on an oar and an overturned water jug. A Negro page holds the camel's lead, and to the left

RIGHT: 1. *Detail: Apollo*

2. *Detail: horses of Apollo's quadriga*

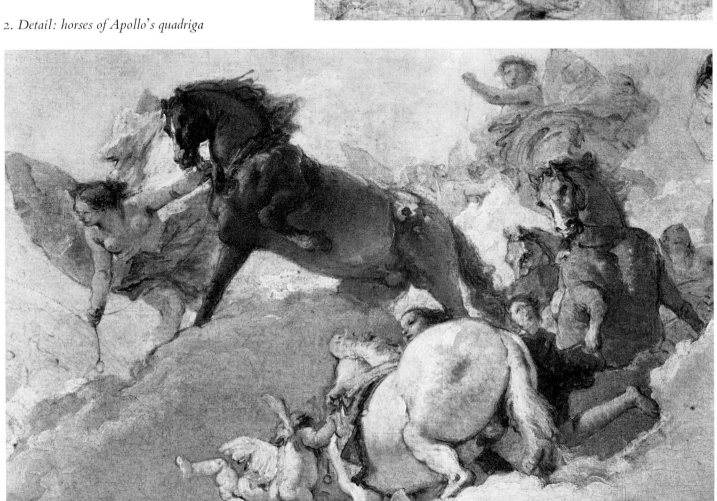

3. *Detail: Mars and Venus*

OPPOSITE:

5. *Detail: the three Fates and the Furies*

4. *Detail: Jupiter, Saturn, Vulcan, Diana, and Mercury*

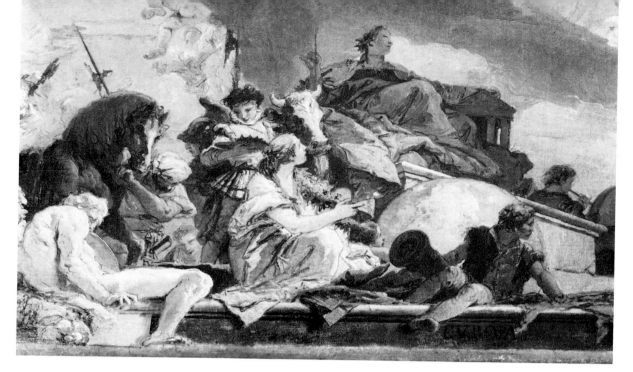

6. *Detail: Europa*

OPPOSITE, ABOVE: 8. *Detail: America*

7. *Detail: Africa*

OPPOSITE, BELOW: 9. *Detail: Asia*

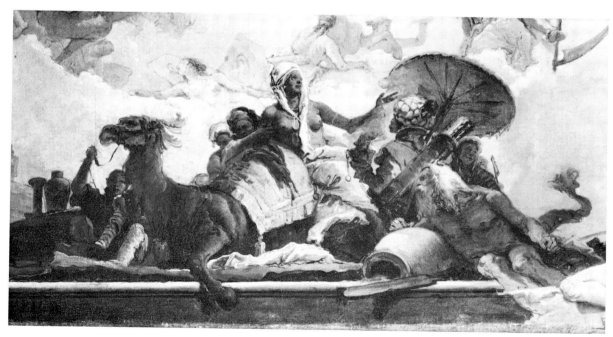

of the page there are two blue and gray vases resting on a block of masonry. Further to the left several bearded men, wearing turbans and striped Oriental costumes, watch two stevedores struggling with a heavy bundle.

America (Fig. 8) is a dark-skinned female Indian riding a crocodile. She wears a feather headdress, a necklace with large gold medallions, and a bright scarlet cloth over her thighs. On her back she carries a bow and a red quiver of arrows. On the left a man, wearing a white turban, lifts a cornucopia. Several dark-skinned Indians, wearing elaborate headdresses, bear gifts in their arms. On the right an antlered stag stands behind a pair of Negroes, one of whom holds a large cylindrical object. Far-

ther to the right a group of figures roast meat over an open fire.

Asia (Fig. 9) rides a gray elephant with bells dangling from its ears. She wears a blue and light ochre dress, and raises her left arm above her head. In the foreground on the right there are two men, kneeling in supplication, wearing bright scarlet and dull grayish red costumes. Behind them a procession of colorfully dressed figures moves to the right. On the far left two men with staves guard a tiger. The nude slaves in the foreground are bound and appear to be dragged alongside the elephant.

PROVENANCE: The picture was discovered in 1954 by the architect J. B. Gold in the ceiling of a corri-

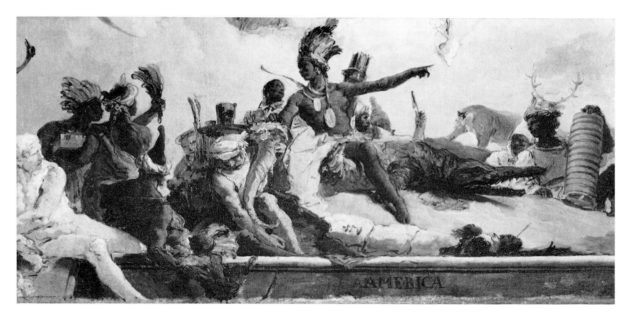

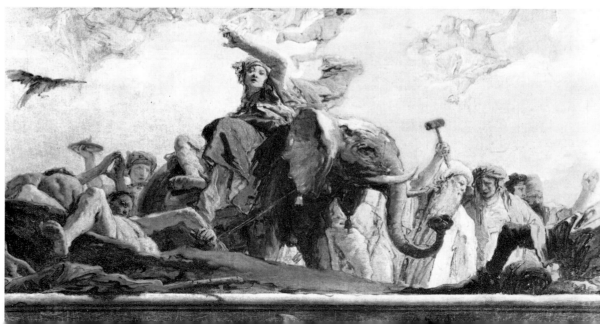

dor in the Hendon Hall Hotel, Hendon, London. Hendon Hall once belonged to David Garrick (1716–1790), the celebrated actor. It has been suggested (Evans, 1890, pp. 239–240) that Garrick himself installed the Wrightsman painting there. He bought Hendon Hall in 1756–1757, five years after the picture was presumably painted. Garrick is known to have collected works of art during his extensive travels on the Continent and even to have purchased paintings in Venice (Carola Oman, *David Garrick*, London, 1958, p. 244). There is also reason to believe that he may have been specifically interested in Tiepolo's work, since he was a friend of Francesco Algarotti (1712–1764), Tiepolo's patron. Yet it is impossible to prove that Garrick ever owned the painting. Furthermore, he never lived in Hendon Hall (Margaret Barton, *Garrick*, London, 1948, p. 284, note 1), so it is unlikely that he took the trouble to install a ceiling sketch in a house he did not intend to use. There is, moreover, some evidence that the collection formerly at Hendon Hall was made by one of its subsequent owners, C. N. Cumberlege-Ware, a keen art collector. His heirs reputedly possess a catalogue with watercolors illustrating many items he owned. The painting now in the Wrightsman Collection is not illustrated, but it is mentioned in the text, without any record of how it was acquired, as being attached to a ceiling in Hendon Hall. When Cumberlege-Ware sold his estate at Hendon, he removed most of the paintings, but the ceiling sketch remained behind. Mr. and Mrs. Wrightsman acquired it in 1956 in New York.

TIEPOLO'S FRESCOES at Würzburg mark the crowning achievement of his brilliant career. They were commissioned by Carl Philipp von Greiffenklau, who reigned as prince-bishop of Würzburg from 1749 to 1754. Early in the summer of 1750 Greiffenklau invited Tiepolo to provide the decorations for the new Residenz, the archbishop's palace, which had recently been built by the Bohemian architect Johann Balthasar Neumann (1687–1753). On October 12, 1750, a contract was drawn up in Venice, and two months later Tiepolo and his sons Domenico (*q.v.*) and Lorenzo (1736–1776) departed for Franconia. They worked there without interruption for more than three years.

Their first project at Würzburg was to decorate the Kaisersaal, or emperor's hall, of the Residenz. A masterpiece of rococo architecture, it is completely covered with gilt relief work, stucco figures, mirrors, and frescoes by Tiepolo portraying events from the life of the Holy Roman Emperor Frederick Barbarossa (1152–1190). On the ceiling Barbarossa is shown being led to his bride, Beatrice of Burgundy, by Apollo. On the walls there are large scenes of the Wedding of Barbarossa and Barbarossa's Investiture of the Prince-Bishop Harold von Hochheim with the Duchy of Franconia.

Although the frescoes in the Kaisersaal were not completed until July 4, 1752, during the winter months of 1751–1752 Tiepolo turned his attention to the design of the ceiling over the staircase (see partial view in Fig. 10). According to a document preserved in the Staatsarchiv at Würzburg (Histor. Verein, *Tagebücher des Hoffouriers*, Ms. q.176; quoted by Freeden and Lamb, 1956, p. 29), the prince-bishop and his sister, Baroness Sickingen, visited Tiepolo's atelier on April 20. There they inspected Tiepolo's plans for the ceiling, "das Project von der Hauptstiege, so der Maler Tiepolo entworfen." The project they saw is possibly identical to the sketch of the staircase ceiling now in the Wrightsman Collection. The actual contract for the ceiling was not drawn up until July 29, 1752. The delay may be explained by the alterations that were made on Tiepolo's original scheme.

The Wrightsman sketch simply depicts Apollo

OPPOSITE:

10. *Giambattista Tiepolo and assistants, partial view of the ceiling of the grand staircase. Fresco, 19.0 by 32.5 meters. Würzburg, Residenz. From Freeden and Lamb, Das Meisterwerk des Giovanni Battista Tiepolo: Die Fresken der Würzburger Residenz, Munich, 1956, pl. 83. Photo: Hirmer Verlag München*

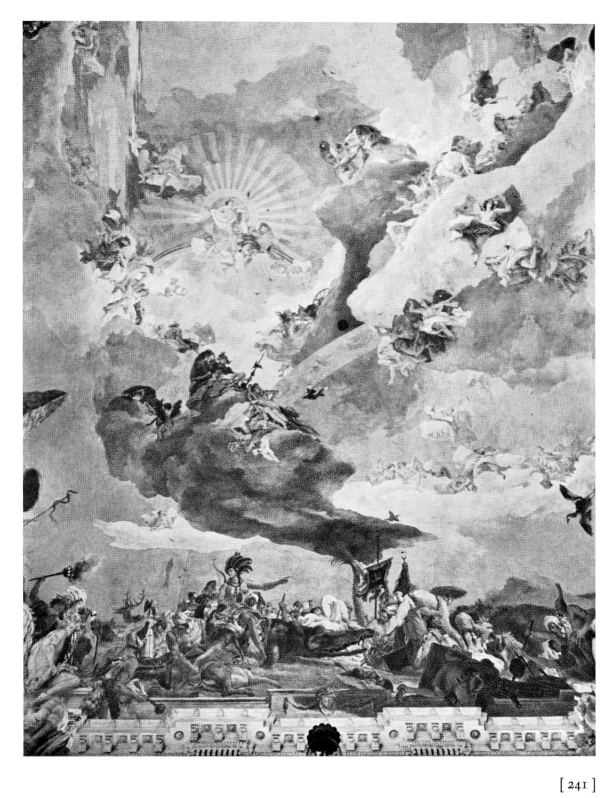

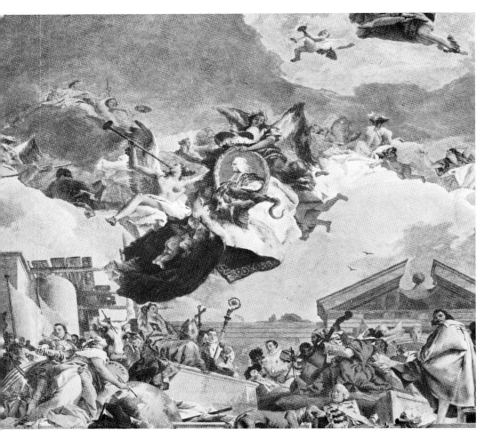

about to embark on his daily course across the sky. The winged female figures opposite him are preparing to harness the four horses of his quadriga, which is being pushed into place by two putti. The deities surrounding Apollo symbolize the planets, and the allegorical figures on the cornice represent the Four Continents of the earth. This iconographical program was not unusual during the seventeenth and eighteenth centuries. Less than two decades earlier Tiepolo himself had used a similar scheme for the ceiling of the Palazzo Clerici, Milan, which is decorated with the Course of the Sun on Olympus (see Paolo d'Ancona, *Tiepolo in Milan: The Palazzo Clerici Frescoes*, Milan, 1956).

In designing the composition, Tiepolo may have been influenced by the large fresco over the Treppenhaus of the Schönborn Castle at Pommersfelden. Between 1717 and 1718 the Schön-

born ceiling had been decorated with a fresco of Apollo and the planet divinities by Johann Rudolf Byss (1660–1738). The Schönborns were closely associated with Würzburg, several of them actually having served there as prince-bishops, and as Pommersfelden is located only a few miles away from Würzburg it is possible that Tiepolo had the opportunity to study these decorations. If for no other reason, he may have visited Pommersfelden to see the fine Venetian paintings that the Schönborn family had collected early in the eighteenth century.

Although the fresco by Byss is artistically mediocre, it is of interest because Byss published an explication of it (*Fürtrefflicher Gemähld-und Bilder-Schatz, so in denen Gallerie und Zimmern des Churfürstl. Pommersfeldtischen . . . Privat-Schloss zu finden ist*, Bamberg, 1719), which could also be applied to Tiepolo's decorations for the Treppenhaus in the Würzburg Residenz. According to Byss, the pagan divinities in his fresco stand for the planets of the solar constellation. As the sun illuminates the universe, so Apollo, the most prominent figure in the fresco, casts light on the deities about him. Apollo lights the planet deities—Mercury, Mars, Venus, Jupiter, Saturn, and Diana (goddess of the moon)—who revolve around him in a constellation-like pattern. Apollo is also surrounded by minor Olympian figures, such as Hebe, the Fates, the Furies, and a number of smaller unidentifiable ones. Finally, at the four sides of the composition, Apollo sheds light on the Four Continents of the earth.

There are many minor differences between the Wrightsman painting and the finished fresco at Würzburg. These differences show the normal revisions that occur when any composition is magnified from the modest dimensions of a canvas

sketch to the enormous expanse of a ceiling fresco. But there is one significant change. The sketch does not show the prince-bishop or his retinue, whereas in the fresco, Greiffenklau's portrait is conspicuously displayed in a medallion held by Fame and other allegorical figures (Fig. 11). Greiffenklau's contemporaries and even Tiepolo, his two sons, and Balthasar Neumann, are portrayed in the allegorical group of Europe. In the sketch Europe occupies what would be the northern end of the staircase. But in the final arrangement, which the prince-bishop approved, the groups of Europe and America were reversed, and the contemporary portraits were introduced.

When Tiepolo painted the sketch in the Wrightsman Collection, it may have been planned to place the portraits of the prince-bishop and his retinue on the walls below the ceiling. A drawing formerly in the Mainfränkisches Museum, Würzburg (illustrated by Freeden and Lamb, 1956, pl. 3) shows them standing on a fictive balcony painted between the doors leading to the Weisser Saal, the connecting room to the Kaisersaal. This plan, however, probably was discarded in favor of portraying them in the ceiling fresco.

By introducing the prince-bishop's portrait, the iconography of the ceiling fresco becomes "a kind of pagan and Catholic cosmorama" glorifying the prince-bishop (Morassi, *G.B. Tiepolo*, 1955, p. 27). The classical deities and the four corners of the earth pay homage to the relatively unimportant Greiffenklau. The ceiling is thus a startling flattery to a man who, had he not been Tiepolo's munificent patron, would be almost forgotten today.

It has been suggested that the Wrightsman painting is not the work of Tiepolo, but of his son Domenico (*q.v.*). Born in 1727, Domenico would have been about twenty-five years old when the Würzburg project was presented to the prince-bishop. During the first year at Würzburg he executed four overdoors in the Kaisersaal, one of which bears his signature and the date 1751. In these he reveals himself a devoted imitator of his father's style. At least one writer (Knox, 1957, p. 129), who

accepted the Wrightsman painting as *das Project* for the staircase ceiling, regarded it as a possible work by Domenico. It would seem altogether improbable, however, that Tiepolo would have entrusted his son with the composition of the most important commission of his entire career.

The relation between the present sketch and the documented works on a similar scale by Domenico Tiepolo is not close. One of Domenico's few nearly contemporary works on a similar scale is the sketch (Fig. 12) in the Brera Gallery, Milan, for the frescoes of 1754 in the church of Sts. Faustinus and Jovita at Brescia. The figures overlap one another in a confusing manner, lacking the sculpturesque clarity of the Wrightsman sketch. Instead of being solidly modeled in the round, Domenico's figures are built up with many nervous linear strokes of the brush, reminiscent of the busy calligraphy of his well-documented drawing style. As Virch (1969, p. 178) observed, the Wrightsman sketch "must ultimately be judged for its superb quality, its liquid and lively brushwork, its fine delectable ridges of paint, its masterful suggestion of forms and the rhythm pulsating throughout and uniting the manifold elements."

According to Watson (1955, p. 215; 1963, pp. 247–248), the Wrightsman painting is a *modelletto*, or pastiche after the finished fresco. Although he first observed that even "if it is a *modelletto* after the ceiling it cannot for that reason alone be rejected as a work of the master's own hand," he subsequently suggested that it was painted by Domenico from some red chalk drawings he made after the frescoes were completed. (Most of these drawings are now accepted as Giambattista's original studies for the ceiling, rather than as copies made after it by his son; see George Knox and Christel Thiem, *Tiepolo: Zeichnungen von Giambattista, Domenico and Lorenzo Tiepolo*, exhibition catalogue, Stuttgart, 1970, catalogue nos. 72, 84–98.) According to Watson's hypothesis, the red bole ground of the Wrightsman sketch is more typical of the son than the father. Upon close examination, however, the color appears to be midway between the

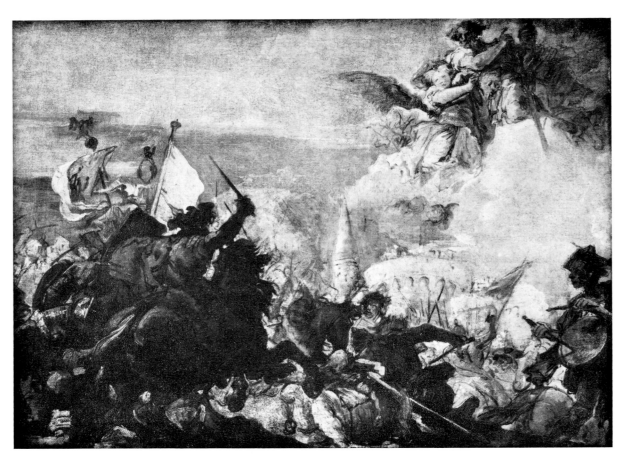

12. *Domenico Tiepolo, Battle of Sts. Faustinus and Jovita. Oil on canvas, 52.0 by 70.0 cm. Milan, Pinacoteca di Brera. Photo: Alinari*

reddish grounds of Tiepolo's early Piazzettesque works and the biscuit shade characteristic of his Spanish period. Such a transitional color is in keeping with the date of the Würzburg frescoes, midway in Tiepolo's career. Another argument Watson raised was the size of the canvas and the scale of the figures in relation to it. He observed that "the existing composition of the ceiling, with its vast open central area of sky, should consist of a thin trickle of figures around the border of the canvas"; instead, the figures in the Wrightsman painting are given more prominence. But surely if Domenico had copied the finished ceiling, he

would have recorded it faithfully, first in scale, second in the reversal of America and Europe, and third in the introduction of Greiffenklau and his contemporaries. Watson also pointed out that the dimensions of the Wrightsman painting do not conform with any of the standard sizes of Tiepolo's sketches, which are generally much smaller. If one considers, however, the extraordinary size of the Würzburg ceiling—19 by 32.5 meters— it is not surprising to find Tiepolo using an unusually large format. A decade later, when he made the prepara-

OPPOSITE:

13. *Giambattista Tiepolo, World Pays Homage to Spain. Oil on canvas, 182.0 by 105.0 cm. Washington, D. C., National Gallery of Art, Samuel H. Kress Collection*

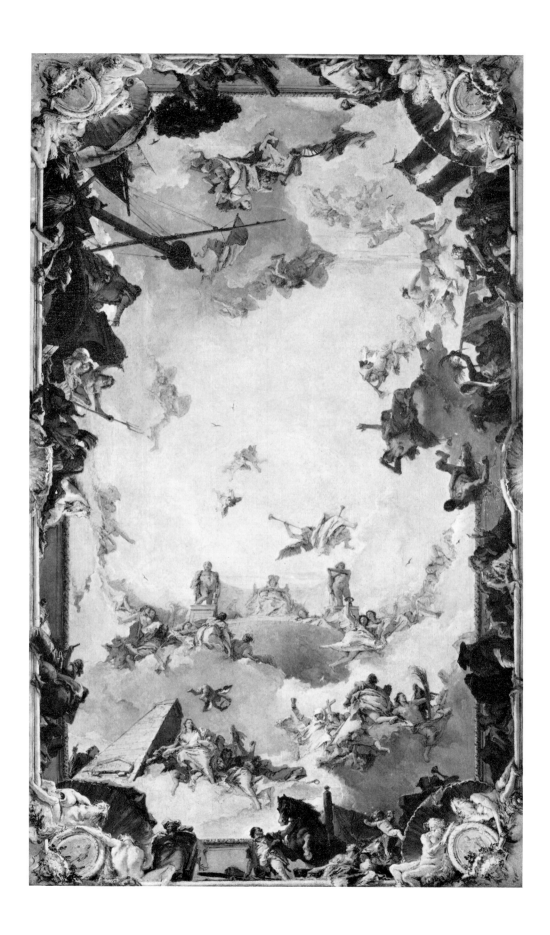

tory sketch for the fresco decorations on the ceiling of the throne room in the royal palace in Madrid, he used a canvas (Fig. 13) almost as large.

EXHIBITED: National Gallery of Art, Washington, D.C., June 1956–September 1957; The Metropolitan Museum of Art, New York, *Paintings from Private Collections: Summer Loan Exhibition*, July—September 1960, catalogue no. 118; The Metropolitan Museum of Art, March—August 1969; The Metropolitan Museum of Art, *Oil Sketches by 18th Century Italian Artists from New York Collections*, January 30—March 21, 1971, catalogue no. 27.

REFERENCES: Edward T. Evans, *The History and Topography of the Parish of Henden, Middlesex*, London, 1890, pp. 239–240 (describes the sketch among the contents of Hendon Hall: "There is another painted ceiling in a lobby off the hall with a number of small figures, representing, we are informed, the four quarters of the globe; this is very finely executed. . . . All the paintings are, we should say, of the same period as the house itself, and are said to have been inserted by the direction of Garrick himself") // Anonymous, "Tiepolo Discovery: Painting on Hotel Ceiling," in *The Times*, London, March 31, 1954, p. 5, col. 4 (reports that the sketch was accidentally discovered in Hendon Hotel by J. B. Gold, who recognized that it was a sketch by Tiepolo for the Würzburg fresco; according to Gold, the sketch "was acquired and put up by a certain Brian Scotney, who bought the house after Mrs. Garrick's death in 1822 and added to the building many architectural fragments from Wanstead House, which was demolished in 1823. The contents of the house, together with many Garrick relics, were sold in 1897, but the large pictures were left behind.") // Anonymous, *The Illustrated London News*, April 10, 1954, p. 559 (illustrated and described as a new discovery) // Antonio Morassi, *G. B. Tiepolo: His Life and Work*, London, 1955, p. 25, fig. 35 (mentions it parenthetically as a newly discovered "large *modello* for the staircase") // Antonio Morassi, "Some 'modelli' and Other Unpublished Works by Tiepolo," in *The Burlington Magazine*, XCVII, January 1955, p. 4, note 1 (observes that, of all the surviving sketches by Tiepolo, the one in the National Gallery of Art, Washington, for the ceiling of the throne room in the royal palace, Madrid, the Wrightsman painting, and a few others are exceptional for their large dimensions) // F. J. B. Watson, "Giovanni Battista Tiepolo: A Masterpiece and a Book," in *The Connoisseur*, CXXXVI, December 1955, p. 215 (suggests the possibility that the painting may be a *modelletto*, or record of the Würzburg ceiling, and observes that "if it is a *modelletto* after the ceiling it cannot for that reason alone be rejected as a work of the master's own hand") // Max H. von Freeden and Carl Lamb, *Das Meisterwerk des Giovanni Battista Tiepolo: Die Fresken der Würzburger*

Residenz, Munich, 1956, pp. 29, 53–61, 77, 80, 84, 87, 88, 91, 93, 102, pls. 35–40 (regard it as the preparatory sketch that Tiepolo presented to the prince-bishop on April 20, 1752; discuss in detail the differences between the painting and the final fresco) // Cyril Connolly, "Style Rococo," in *Art News Annual*, XXVI, 1957, p. 124 (illustrates the painting in color and calls it Tiepolo's "brilliant project in oil" for the frescoes on the ceiling of the staircase in the Würzburg residence) // George Knox, review of Freeden and Lamb's book, in *The Burlington Magazine*, XCIX, April 1957, p. 129 (rejects Giambattista Tiepolo's authorship of the Wrightsman painting on the grounds that it is not of the same proportions as the Würzburg ceiling, that the Europe and America groups are reversed, and that it is "too 'artistic,' too finished and detailed"; he accepts, however, the thesis that the painting is identical with the one that Tiepolo presented to the prince-bishop on April 20, 1752, but claims that "the chore of preparing such a work may well have been entrusted to Domenico") // Fritz Neugass, "Sommerlicher Ausklang in New York," in *Die Weltkunst*, XXX, August 15, 1960, p. 6 (states that it is a preparatory study [*Vorstudien*] by Giambattista Tiepolo for the Würzburg ceiling) // Antonio Morassi, *A Complete Catalogue of the Paintings of G. B. Tiepolo*, London, 1962, pp. 37, 68 (catalogues it as Tiepolo's preparatory sketch for the Würzburg ceiling; suggests it was painted in 1751; terms it "one of the most splendid large *modelli* by Tiepolo") // Anonymous review of J. Byam Shaw's *Drawings of Domenico Tiepolo*, in *The Times Literary Supplement*, August 31, 1962, p. 652 (attributes the painting to Domenico Tiepolo and calls it a "pastiche skillfully constructed from selected portions" of the Würzburg ceiling) // Gerhard Bott, *Giovanni Battista Tiepolo: Das Fresko im Treppenhaus der Würzburger Residenz* (Werkmonographien zur bildenden Kunst in Reclams Universal-Bibliothek, XCII), Stuttgart, 1963, pp. 8–10, figs. 12–13 (describes the individual parts of the sketch in exhaustive detail and regards it as *Das Project* that was probably presented to the prince-bishop [in April 1752]) // Francis Watson, "G. B. Tiepolo: Pioneer of Modernism," in *Apollo*, LXXVII, March 1963, pp. 247–248 (argues that the painting was made as a record of the Würzburg ceiling by Domenico Tiepolo, because it is painted on a red bole ground and because the proportions of the figures in relation to the overall dimensions of the composition differ from those of the ceiling fresco; suggests tentatively that a series of Domenico's red chalk drawings after the frescoes were "actually produced with the idea of such a *modelletto* in mind") // Gerhard Bott, "Zur Ikonographie des Treppenfreskos von Giovanni Battista Tiepolo in der Würzburger Residenz," in *Anzeiger des Germanischen Nationalmuseums*, Nuremberg, 1965, pp. 140–164, fig. 2 (considers the painting an autograph work by Giovanni Battista Tiepolo, and states that it is very likely the sketch that was presented to

the prince-bishop on April 20, 1752) // Anna Pallucchini, *L'opera completa di Giambattista Tiepolo*, Milan, 1968, p. 116, catalogue no. 199, figs. 199–D–H (accepts the painting as the sketch that Tiepolo presented to the prince-bishop in 1752) // Claus Virch, "Dreams of Heaven and Earth: Giambattista and Domenico Tiepolo in the Wrightsman Collection," in *Apollo*, XC, September 1969, pp. 176–178, fig. 3 (rejects the notion that the painting could have been made by Domenico Tiepolo on the grounds of its superb quality) // Aldo Rizzi, *Mostra del Tiepolo: dipinti*, exhibition catalogue, Venice, 1971, p. 108, fig. 58 (reproduces the canvas as Giambattista's "modelletto" for the Würzburg ceiling) // Erika Simon, "Sol, Virtus und Veritas im Würzburger Treppenhausfresko des Giovanni Battista Tiepolo," in *Pantheon*, XXIX, November–December 1971, pp. 484–486, 494, fig. 2 (accepts the sketch as Giambattista's preliminary study for the Würzburg fresco, which she interprets as an allegory of divine truth encompassing the universe; maintains that the statuette held by Apollo symbolizes Veritas, rather than the Arts or Victory, as some previous writers had suggested) // Peter Nathan, Fritz Nathan, and Hans Curjel, *Dr. Fritz Nathan und Dr. Peter Nathan 1922–1972*, Zurich, 1972, pl. 19 (illustrated as an example of one of the pictures sold by the Nathan firm; accepted as Giambattista's original sketch for the Würzburg ceiling).

Oil on canvas, H. 72⅞ (185.2); W. 54⅞ (139.4).

There are minor pentimenti visible in most of the figures. The inscription below the continent America was originally placed about a centimeter farther to the left. Around all four sides of the picture there is painted a black outline. The canvas was prepared beyond this line, but there is no painting in this area.

It was cleaned in 1972 by John M. Brealey, who found it to be in excellent condition.

26 Apotheosis of the Spanish Monarchy

THIS IS AN upright oval composition painted on a rectangular piece of canvas. The corners and edges on all four sides are covered with the same biscuit-colored preparation as that forming the ground of the painting itself. The figures are basically in three groups: those strung along the lower perimeter of the picture, between the two columns; those in the center, organized around the female figure seated on the cloud; and, finally, those nearer the top of the picture, clustered at the feet of Jupiter.

Along the bottom of the picture, starting on the left side, the man erecting a column is Hercules, the mythological protector of Spain. His column represents Gibraltar, the "pillars of Hercules," the separation of Europe from Africa. At the base of the column there is a crouching figure, seen from behind, clad in a blue robe. To the right, moving along the bottom of the picture, are three female figures symbolizing three of the Four Continents.

America is personified by an Indian wearing a headdress of blue feathers. Immediately to the right of America is the head of Europa, identified by the white pediment of a small classical building below her head. Africa is the dark-skinned woman with a green sash over her shoulder, a dull purple robe around her legs, and an elephant trunk on her head. The crouching leopard to her right may also allude to Africa. Still farther to the right is a dark-skinned woman seen from behind. She wears a bright turquoise-blue dress with white sleeves and sits on a scarlet cloth. The crenellated tower in the clouds near this figure identifies her as the personification of the Old Kingdom of Castile. Next to her, Mars sprawls on a block of masonry, his face in the shadow of his shield (Fig. 1). He wears a beige tunic skirt and a reddish breastplate. The nude woman reclining on a cloud slightly above

him is Venus. Her hand rests on the wheel of a chariot, and her attendant, Cupid, is at her shoulder. Emerging from the cloud above them, on the far right, are two female figures flanking a column, one of them symbolizing Fortitude. The putto in front of them dives down behind the cloud.

The group near the center of the picture is dominated by the seated female figure personifying Spanish Monarchy (Fig. 3). She wears a white dress with a high collar and sits on a pale yellow cloth spread on the cloud at her feet. On her left is a lion; on her right is Neptune. Neptune is represented as an old bearded man, his bare legs drawn up in front of him on the cloud. The woman seated slightly behind and to the right of Spanish Monarchy holds a serpent in her hand and symbolizes Prudence. Between Prudence and Spanish Monarchy, there is another face, partially concealed. Above them is a putto carrying a caduceus, that of Mercury who flies above Spanish Monarchy. Mercury, identified by his petasus, or winged hat, and by the wings at his heels, wears a pale blue chlamys and carries a crimson crown in his hands. Slightly higher and to the right of Mercury is the brightly lit figure of Apollo, an athletic youth, holding a scepter and lyre, wearing a laurel wreath and a beige chlamys draped over his left arm and around his hips.

Finally, above them all, is Jupiter (Fig. 2), who presides over the upper half of the composition, and, in fact, the whole scene. He holds a scepter in his right hand and gestures commandingly toward Apollo with his left arm. A beige robe is draped over his legs, and at his feet is a large eagle spreading its wings and clutching thunderbolts in its claws. Sketchily indicated female figures and putti surround Jupiter as well as figures blowing trum-

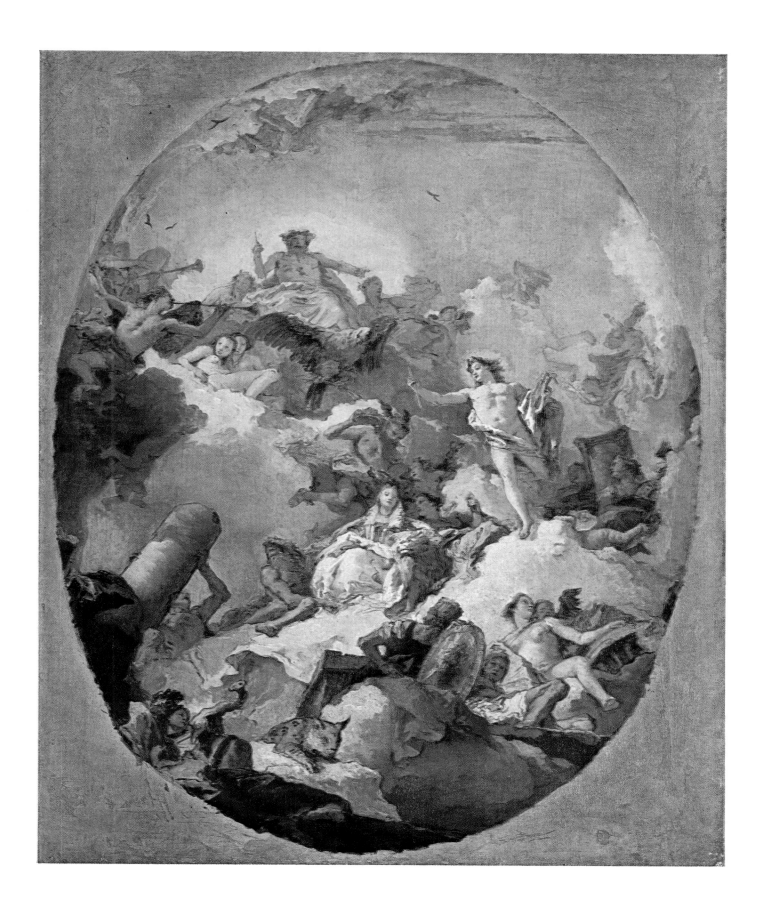

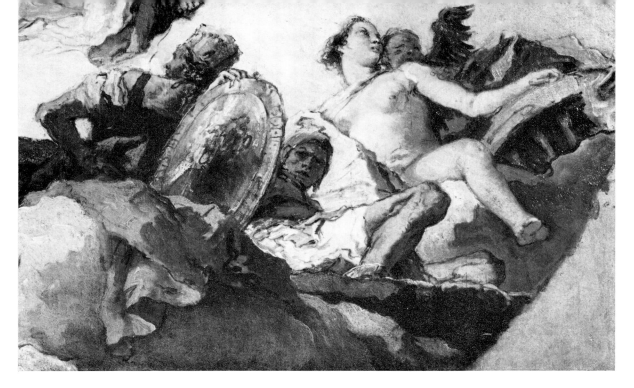

1. *Detail: Castile, Mars, and Venus*

2. *Detail: Jupiter*

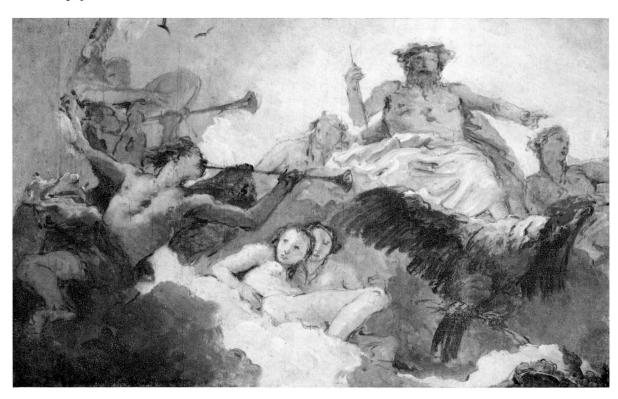

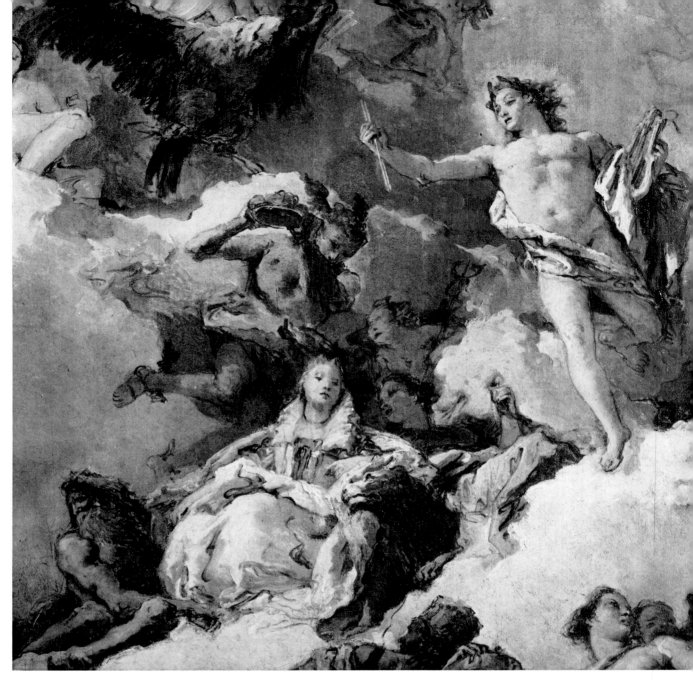

3. *Detail: Spanish Monarchy surrounded by Neptune,
Mercury, and Apollo*

pets and playing muscial instruments. Behind
Jupiter and the group that surrounds him is a large
aureole of pale yellow light, contrasting with the
pale blue of the sky. At the very top of the picture,
there are summary indications of a male nude

reclining on a cloud that partially conceals a fly-
ing putto.

PROVENANCE: This painting was first recorded in
the collection of Baron Ferdinand von Stumm-

Holzhausen (1843–1925). He served as German Ambassador at Madrid from 1887 until 1892, and he presumably acquired it then along with two other sketches by Tiepolo. These sketches, an Allegory of Venus and Apollo now in the collection of Dr. and Mrs. Rudolf Heinemann, New York, and a Triumph of Hercules, in the Currier Gallery of Art, Manchester, New Hampshire, have the same shape and almost the same dimensions as the present sketch. From the von Stumm Collection these sketches passed as a set to the Van Diemen Gallery, Berlin (before 1943, when they were published by Morassi). They subsequently belonged to Jakob Goldschmidt, who lived in Berlin and New York. They then passed into the collection of the Baroness Renée de Becker, New York. The three sketches were then separated, and Mr. and Mrs. Wrightsman acquired the present one in London in 1960.

In December, 1761, Charles III of Spain commissioned Tiepolo to decorate several rooms in the newly erected royal palace in Madrid. The major project was to be the ceiling of the throne room, but he was also to decorate two smaller rooms, the guard room and the Saleta. In the throne room Tiepolo painted a vast fresco, comparable to the ceiling over the grand staircase in the Residenz at Würzburg (see Catalogue No. 25). It represented the World Paying Homage to the Spanish Monarchy. The guard room was frescoed with Aeneas Conducted to the Temple of Venus, and the Saleta with the Apotheosis of the Spanish Monarchy (Fig. 4).

It is known that Tiepolo arrived in Madrid on June 4, 1762, and that all the frescoes in the royal palace were completed, at the latest, in 1766; thus Tiepolo spent a maximum of four years decorating the three rooms. The throne room ceiling, dated 1764, apparently occupied his first two years in Madrid. It is not known whether he worked on the ceilings of the guard room and Saleta during that time or later.

Traditionally, the subject matter and iconogra-

phy of such large frescoes would have been laid down in some detail by the patron, but, because of Tiepolo's reputation and prestige, it seems likely that Tiepolo was given considerable freedom in adapting the general subject of the glorification of Spain.

Sketches for all three frescoes survive. For the throne room, there is one large preliminary sketch, known to have been completed before he left Venice. This is probably the sketch in the National Gallery of Art in Washington, D. C. (Fig. 13 under Catalogue No. 25). For the two smaller rooms, he made pairs of sketches, all apparently painted in Madrid. The pair for the guard room now belong to the Museum of Fine Arts in Boston and the Fogg Art Museum in Cambridge, Massachusetts. The pair for the Saleta are both in New York, one at the Metropolitan Museum (Fig. 5) and the other in the collection of Mr. and Mrs. Wrightsman.

The fresco of the Apotheosis of the Spanish Monarchy in the Saleta (Fig. 4) depicts, like the other ceilings, a considerable number of mythological and allegorical figures. Many are easily identifiable; others are more obscure. A key to their identification is found in Antonio Ponz's description of the royal palace, written ten years after the completion of the frescoes (*Viage de España, en que se da noticia de las cosas mas apreciables, y dignas de saberse, que hay en ella*, Madrid, 1776, VI, pp. 19–20). Another, more detailed account of the iconography can be found in Francisco José Fabre's description (*Descripcion de las aleogorías pintadas en las bóvedas del Real palacio de Madrid*, published in 1829).

Once the figures have been identified, the general meaning or intent of the ceiling is basically clear. Tiepolo has depicted, in classical terms, the world-wide power Spain once possessed through her colonies. Jupiter, majestically presiding over the universe, commands Mercury, bearing a crown, and Apollo, bearing a scepter, to bestow on the personification of Spain and the monarchy power over her dominions in Europe, America,

[253]

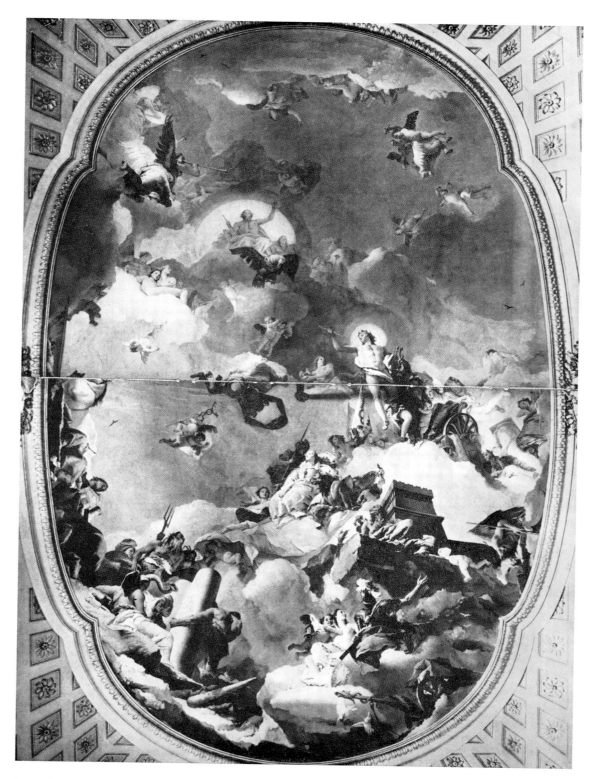

4. *Giambattista Tiepolo and assistants, Apotheosis of the Spanish Monarchy. Fresco, 15 by 9 meters. Madrid, Royal Palace, Saleta. From Morassi, G. B. Tiepolo: His Life and Work, London, 1955, fig. 59. Photo: Phaidon Press*

5. *Giambattista Tiepolo, Apotheosis of the Spanish Monarchy. Oil on canvas, 81.6 by 66.4 cm. New York, The Metropolitan Museum of Art, Rogers Fund, 37.165.3*

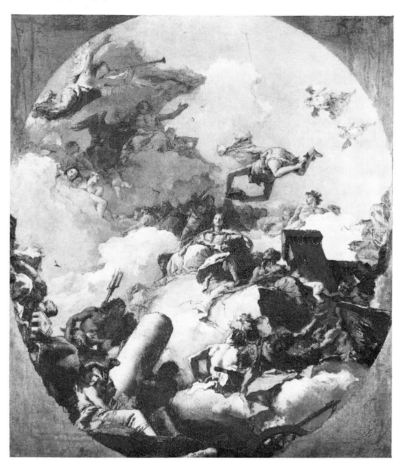

and Africa. In the Grand Manner, soon to be eclipsed by the rising popularity of the neoclassicists, Tiepolo set out to celebrate the mighty Spanish Empire, which, ironically, was already entering its final decline.

The two preparatory sketches for the Saleta fresco contain essentially the same figures, arranged to make essentially the same statement. They are so close, in fact, that it would be impossible to draw any sure conclusions about which of the sketches was painted first. Sanchez Canton (1953, p. 17) and Pallucchini (1968, p. 132) have suggested that the sketch in the Metropolitan (Fig. 5) is the earlier of the two, because the Wrightsman sketch seems to them to correspond more closely to the final work. Their argument rests on the fact that Apollo appears only in the Wrightsman sketch and the fresco. However, it is even easier to argue that the Wrightsman sketch is the earlier, since more of the details of the sketch in the Metropolitan appear in the Saleta fresco (Fig. 4). Found in both the Metropolitan sketch and the fresco are placement of the large tower, the pillars of Hercules, and Neptune; Saturn, Bacchus, Pan, Victory, Merit, and Minerva; the flight of Mercury down toward Spanish Monarchy in foreshortened *sotto in su* view. It is most likely that ideas from both sketches were utilized simultaneously in the ceiling fresco and that its composition is essentially an amalgam of the two sketches.

Because of failing health, Tiepolo seems to have relied on his sons for much of the execution of the fresco. It lacks the spontaneity and brilliance of his finest works. The preparatory sketches, on the other hand, reveal his full mastery. The Wrightsman sketch is characteristic of Tiepolo's final period. The light biscuit-colored ground on which it is painted gives the painting a luminous quality. In contrast to his earlier works, the colors here are pale, approaching, in many areas, a beige monochrome. The brushwork, while losing none of the exuberant brio of his earlier handling, is sparing, wavering, almost trembling, all of which enhances the ethereal character of the airborne figures. And finally, although the sketch deals exclusively with pagan and allegorical themes, it partakes of the depth of inner feeling of Tiepolo's last religious works, such as the altarpieces for the monastery at Aranjuez.

EXHIBITED: The Metropolitan Museum of Art, New York, *Paintings from Private Collections: Summer Loan Exhibition*, July—September, 1960, catalogue no. 119; The Metropolitan Museum of Art, *Oil Sketches by 18th Century Italian Artists from New York Collections*, January 30—March 21, 1971, catalogue no. 30.

REFERENCES: Antonio Morassi, *Tiepolo*, Bergamo, 1943, p. 48, pl. 125 (does not discuss the painting, but in the list of illustrations calls it a *bozzetto* by Tiepolo for the Saleta in the royal palace, Madrid; he dates it about 1764–1766 and states that it was formerly with the Van Dieman Gallery, Berlin) // F. J. Sanchez Canton, *J. B. Tiepolo en España*, Madrid, 1953, p. 17 (suggests that of the two surviving sketches by Tiepolo for the ceiling of the Saleta, the one now in the Wrightsman Collection was painted after the one in the Metropolitan Museum) // Antonio Morassi, *G. B. Tiepolo: His Life and Work*, London, 1955, pp. 149–150 (mentions it as one of a pair of sketches by Giambattista Tiepolo for the ceiling of the Saleta) // Fritz Neugass, "Sommerlicher Ausklang in New York," in *Die Weltkunst*, XXX, August 15, 1960, p. 6, illustrated on the cover (states that it is Tiepolo's preparatory study for one of the ceilings in the royal palace, Madrid) // Anonymous, "Aportaciones recientes a la historia del arte español," in *Archivo Español de Arte*, no. 134, April–June 1961, p. 187, catalogue no. 178, pl. III, opp. p. 165 (mentions the sketch as having been exhibited at the Metropolitan Museum during the summer of 1960) // Antonio Morassi, *A Complete Catalogue of the Paintings of G. B. Tiepolo*, London, 1962, pp. 21, 37, fig. 321 (catalogues it as the *modello* Tiepolo prepared about 1764 for the ceiling of the Saleta of the royal palace, Madrid) // *Goya and His Times*, exhibition catalogue, London, 1963–1964, catalogue no. 6 (mentions it as a sketch by Giambattista Tiepolo for the same ceiling as the sketch of the Apotheosis of the Spanish Monarchy in the Metropolitan Museum, which was lent to the exhibition) // Anna Pallucchini, *L'opera completa di Giambattista Tiepolo*, Milan, 1968, p. 132, catalogue no. 279, fig. 279–D (regards the sketch in the Metropolitan Museum as Tiepolo's first idea for the composition and calls the Wrightsman sketch "il modelletto vero e proprio," because its composition corresponds, in her opinion, more closely with that of the completed fresco) // Juan de Contreras, "Italian Decorators for the Bourbons," in *Apollo*, LXXXVII, May 1968, p. 329, fig. 7 (does not discuss the Wrightsman painting in the article, but illustrates it as a work of Tiepolo's dating from about 1764–1766; he entitles it the Power of the Spanish Monarchy) // Claus Virch, "Dreams of Heaven and Earth: Giambattista and Domenico Tiepolo in the Wrightsman Collection," in *Apollo*, XC, September 1969, p. 178, fig. 4 (states that it is more beautiful than the sketch of the same subject by Tiepolo in the Metropolitan Museum).

Oil on canvas, H. 33⅛ (84.0); W. 27⅛ (69.0).

GIOVANNI DOMENICO TIEPOLO (1727–1804) was the son of Giovanni Battista Tiepolo (*q.v.*) and Cecilia Guardi, the sister of the view painter Francesco Guardi (*q.v.*). The course of his career was determined largely by that of his father: he spent the better part of his life executing projects designed by his father, and he even traveled with him to Würzburg and Madrid to assist with the vast commissions there. After his father died in 1770, he appears gradually to have lost heart and painted less and less. He married only in 1776, six years after his father's death.

Trained in the family studio, Domenico did not develop an independent style of his own until he was about thirty years old. As a boy he was required to copy his father's work, such as the fresco ceiling of the Scalzi, Venice, after which he made a series of red chalk drawings in 1743. His earliest independent works include an altarpiece of 1748 in San Francesco di Paola, Venice, quite closely related in style to his father's religious paintings, and a series of fourteen oil paintings of the Stations of the Cross in San Polo, Venice, published by him as a set of etchings in 1749. At Würzburg Domenico assisted his father with frescoes executed between 1750 and 1753. He painted three large overdoors in the Kaisersaal of the Residenz, one of which is signed and dated 1751, and in addition he painted several easel paintings on religious subjects for private individuals. All of these works are barely distinguishable from those of his father.

Although Domenico could work in his father's characteristic mode if the commission called for allegorical or religious subjects in the Grand Manner, he was nevertheless fascinated by scenes of Venetian daily life and gradually evolved a distinctive style for portraying them. Within his father's oeuvre, the only painting recording contemporary life is the large canvas of Count Antonio Montegnasso before the Grand Council of the Order of Malta, painted about 1749–1750, and now in the museum at Udine. Since it differs so markedly from the Grand Manner of Giambattista Tiepolo's altarpieces and ceiling frescoes, some writers have suggested that even though he received the commission, it was actually executed by his son Domenico.

In 1757 Domenico helped his father with the decoration of the Villa Valmarana, near Vicenza, where his principal contributions are the scenes of Venetian daily life with which the Foresteria, or guest house, of the villa is decorated. Domenico also decorated certain rooms in the villa itself with chinoiserie scenes. All of these frescoes were painted in a realistic and rather informal style, quite different from his father's grandiloquent frescoes in the villa illustrating Tasso's *Jerusalem Delivered*.

Domenico spent eight years with his father in Madrid. He assisted with the ceiling frescoes in the royal palace and also worked independently on eight altarpieces of the Passion of Christ for the church of San Filippo Neri, Madrid. His later career is marked by a few undistinguished altarpieces and the ceilings of the church of San Lio, Venice, and the Doges' Palace, Genoa, of which only the *modello*, in the Metropolitan Museum, survives. His talents at this period are best displayed in the fanciful pen and ink drawings he made of satyrs, Commedia dell'Arte characters, and contemporary Venetian subjects. Among his last works were the frescoes of the life of Punchinello and other secular scenes, painted for

his own amusement in the Tiepolo family villa at Zianigo, near Murano. These charming scenes reveal Domenico's skill as an appealing and observant illustrator of everyday life.

27 A Dance in the Country

THE PICTURE represents a young couple (Fig. 1) dancing before a crowd of onlookers gathered beside a building on the Venetian terra firma. Pale blue mountains are visible above the red and brown carriage on the left. A pair of large trees silhouetted against the side of the building cast shade on some of the onlookers. Two smaller groups of spectators stand on the terrace above the wall on the left and at the window on the right (Fig. 2); those on the terrace play musical instruments and have a cup and chocolate pot resting beside them on the ledge.

The dancers and a number of the other figures belong to a troupe of actors of the Commedia dell'Arte, a popular Italian entertainment improvised by stock characters, who can be recognized in the painting by their clothing. The dancing young man, for example, wears the traditional costume of Mezzetino, a young singer and dancer who often played the role of a valet. He wears a red cap with black feathers, a reddish brown mask, a bright scarlet suit with matching shoes, and white gloves and stockings. The sleeve of his shirt is striped beige and black, and there is a ruffed collar at his neck. His dancing partner, very likely one of the actresses, wears a beige dress, which she lifts to expose her left foot. Above her ankle a gray underskirt is visible. Her wig, the tight-fitting bodice of her dress, and the high collar around her neck are all white.

On the extreme left-hand side of the composition a masked woman stands in profile facing to the right (Fig. 3). She wears a red and white *cuffia*,

or Venetian bonnet, and has a beige shawl over her shoulders. Standing immediately in front of her and seen from behind is a small girl wearing a pale lilac dress, her skirt caught up by a dark green ribbon attached to her shoulders. To the right, a pair of women (Fig. 4) chat with a young man holding a three-cornered hat under his arm. The two women have small bonnets, carry fans, and wear pale white and brown dresses of the Andrienne type (identifiable by their long-flowing skirts and their elbow-length sleeves terminating in several rows of lace, called *cascate*). The man wears a rust-colored *velada* over a dull yellow *camisiola*. In front of them is a black and white spaniel walking toward another young man, who wears a black bow below his chin, a young woman in a light yellow dress, and a young girl in a gray and white dress with an exceptionally high hemline. The unusual design of the latter's dress suggests that she belongs to the troupe of entertainers.

Immediately to the right of the dancing actor are the heads of several men (Fig. 1), two of whom wear the tall white hats of Punchinello, a popular character in the Commedia dell'Arte. The one closest to the foreground wears a white mask with a long nose, a white chiffon collar, and a loose white blouse. Next there is a woman wearing a large black mask. She wears a ribbon around her throat and a pale gray cape over her head and around her shoulders. To the right of the dancing woman is an actor wearing a large black hat. He is Pantalone, an old bearded character of the Commedia dell'Arte who traditionally is married

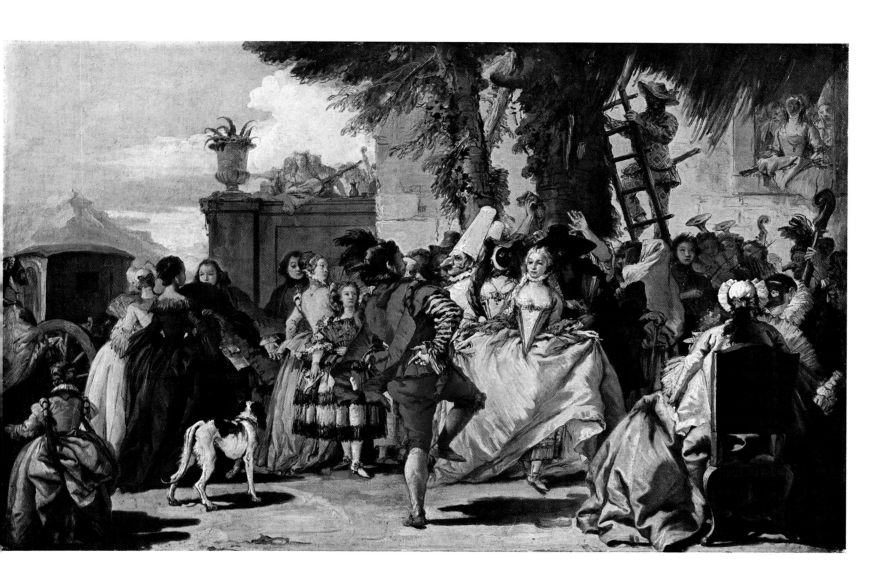

to a young woman who cuckolds him. Behind him is an upraised arm of an otherwise invisible figure and the profile of an old bearded man, who walks to the right leaning on a cane and carrying a brown hat.

Climbing on the ladder above this man is Arlecchino (Fig. 5), an acrobatic clown who wears a wide-brimmed hat, a black mask, and a checkered costume with a bat tied to his side. Below the ladder is a woman seen from behind, a pale pink shawl over her head. Farther to the right in the background are several men (Fig. 6) playing musical instruments: two violins, two horns, and a double bass. Seated on a red chair in the foreground, a woman holds a cup of chocolate and converses with an actor wearing a black mask and a high ruffed collar. The woman, seen from behind, wears a white bonnet with a gray bow holding her black hair, a white jacket, and a pale blue dress. The actor with whom she speaks may possibly be identified as the Dottore or Scaramuccia. Behind him a man wearing a mask with a long

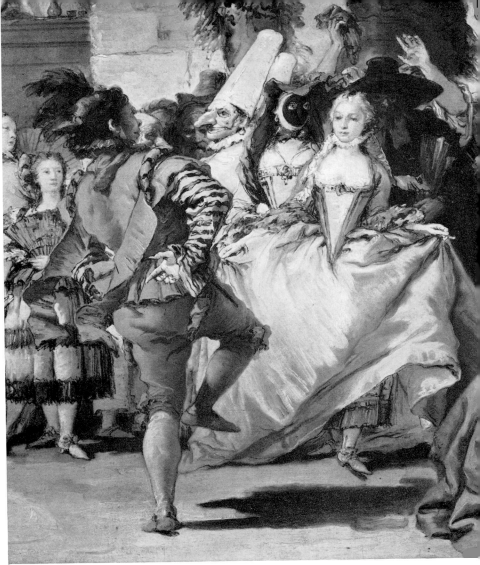

RIGHT: 1. *Detail: dancing couple*

2. *Detail: spectators at window*

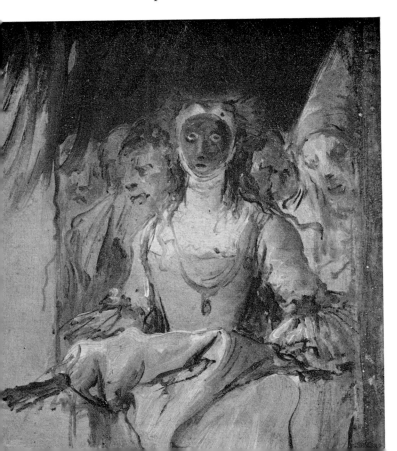

nose and a hat with black feathers plays a double bass.

PROVENANCE: The painting belonged to Johann Heinrich Merck (1741–1791), a *Kriegsrat*, or councillor of war, at Darmstadt. It remained with his family until 1963, when it was sold at auction by Frau Caroline Reinhold-Merck (Sotheby's, London, July 3, 1963, lot 75). Mr. and Mrs. Wrightsman acquired it at this sale.

DOMENICO TIEPOLO's Dance in the Country is an illustration of eighteenth-century Venetian life. During the hot summer months the Venetians customarily went into *villegiatura*, an extended coun-

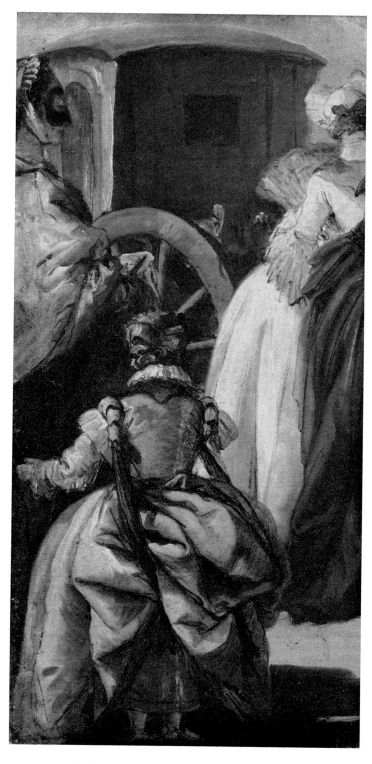

try holiday on the mainland where the air was more healthy than in the crowded city of Venice. There they enjoyed a leisurely way of life, occasionally enlivened by colorful traveling troupes of Commedia dell'Arte actors. Domenico's painting shows a party of elegant Venetians enjoying an entertainment provided by one of these troupes.

These entertainments occurred almost any time of day, whenever the actors could attract an audience. In Domenico's painting it appears to be late morning, the time when Venetians usually gathered outdoors to drink chocolate. Apparently they are watching the conclusion of one of these performances. Often the bawdy skits of the Commedia dell'Arte characters ended with a minuet. In Domenico's painting Mezzetino dances with one of the actresses, perhaps Columbina, while all the other performers and spectators look on.

The Dance in the Country is related to some other works by Domenico Tiepolo. One of them is a fresco in the Villa Valmarana in which Pantalone, an old bearded man clad in black, asks a lovely young actress to dance with him. Two others are oil paintings of about the same size as the Wrightsman painting. One (Fig. 7) is in the Cambo Collection of the Museo de Arte, Barce-

3. *Detail: masked woman and young girl*

4. *Detail: men and women with spaniel*

[262]

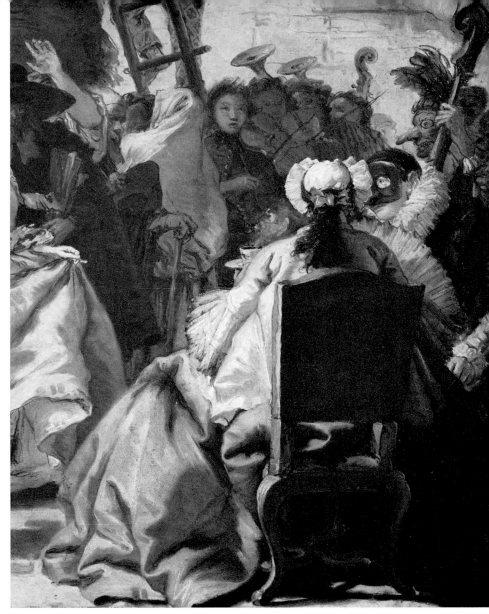

5. *Detail: Arlecchino climbing ladder*

6. *Detail: musicians and seated woman drinking chocolate*

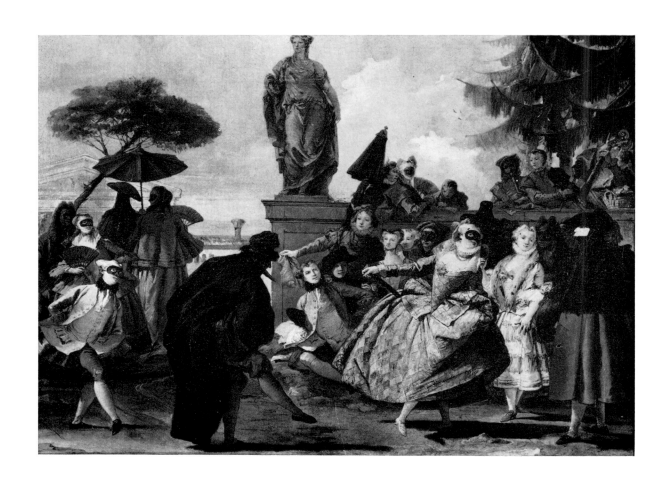

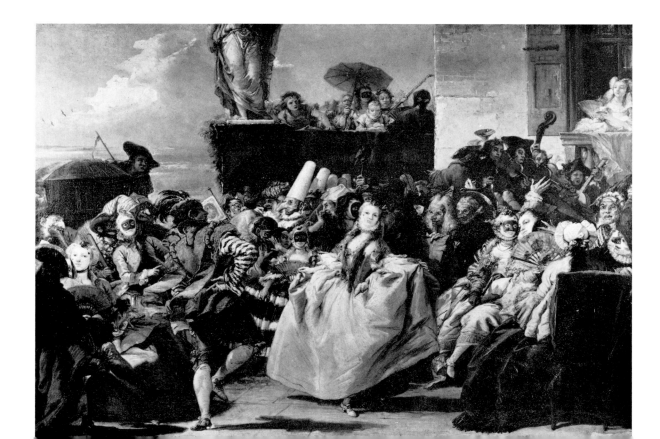

7. *Domenico Tiepolo, Dance in the Country. Oil on canvas, 75.5 by 110.0 cm. Barcelona, Museo de Arte, Cambo Collection. Photo: Mas, Art Reference Bureau*

8. *Domenico Tiepolo, Dance in the Country. Oil on canvas, 79.0 by 108.0 cm. Paris, Musée du Louvre. Photo: Alinari*

lona, and the other (Fig. 8) is in the Louvre. Each was designed as a pendant to paintings of a quack doctor advertising his wares in a Venetian piazza, another favorite scene with Domenico. If the Wrightsman picture was painted as a pendant to a similar scene, no record of it exists.

The painting at Barcelona (Fig. 7) shows Pantalone dancing with the actress of the Valmarana fresco. The Louvre painting (Fig. 8), much more closely related to the Wrightsman painting, shows Mezzetino dancing with one of the young actresses. It also shows the woman seated on the extreme right drinking chocolate, the young girl in the gray and white striped dress, the musicians, the building with its open window and raised terrace, and the carriage waiting on the extreme left.

Another character present in both the Wrightsman and Louvre paintings is Punchinello, one of the stock characters in the Commedia dell'Arte performances. Identifiable by his tall white hat, there are two Punchinellos in the Wrightsman painting and at least four in the Louvre painting. A rather unscrupulous figure, he was invented early in the seventeenth century by Silvio Fiorillo, a Neapolitan actor. By the middle of the eighteenth century he had become a familiar figure in Venetian carnival scenes. Punchinello seems to have held a special fascination for Domenico, who not only included him in almost all of his paintings on Commedia dell'Arte subjects, but also made drawings of 102 scenes from his life and decorated an entire room in the Tiepolo family villa at Zianigo with frescoes about him.

9. *Domenico Tiepolo, Ballroom Scene. Pen and ink on paper, 12.9 by 26.8 cm. London, collection of Count Antoine Seilern, no. 163. Photo: John R. Freeman*

10. *Domenico Tiepolo, Carriage. Black chalk, on the reverse of the sheet shown in Figure 9*

All of these paintings—the Barcelona, Valmarana, Louvre, and Wrightsman pictures—were executed before Domenico and his father left Venice for Madrid in 1762. The Barcelona painting is said to be dated 1756. The Valmarana fresco is signed and dated 1757. And, because the Louvre painting is known to have belonged to Francesco Algarotti, who died in 1764, it must have been completed before Domenico left Venice.

The dating of the Wrightsman painting is more difficult and subjective. There is no sure way to date it. Thematically, it could be dated contemporaneously with any one of these paintings, that is, roughly speaking, in the 1750s. A drawing (Fig. 9) in the collection of Count Antoine Seilern, London, may have some bearing on the date of the

Wrightsman painting. It is a brilliant pen and ink sketch on white paper, showing a couple dancing before a crowd of Venetian aristocrats. Despite the richly appointed interior setting and the three-cornered hats worn by both the men and the women, the drawing is like the Wrightsman painting in its depiction of a solitary dancing couple. Furthermore, on the reverse of the sheet there is a rough sketch in black chalk of the back of a carriage (Fig. 10), which is very much like the one in the Wrightsman painting. J. Byam Shaw (*The Drawings of Domenico Tiepolo*, Boston, 1962, p. 86) dated these drawings before 1760, because of the coiffure of the lady dancing in the foreground. It could be argued that if this sheet preserves one of the artist's first ideas for the Wrightsman painting, then the painting could date from the same period.

The Wrightsman painting, however, seems to be related stylistically to a small oil painting of Christ Healing the Blind (Fig. 11), in the Wadsworth Atheneum, Hartford, Connecticut. Although this is a religious picture, the paint has the same seductive quality as in the Wrightsman Dance in the Country; both are rich and creamy in consistency, the paint liberally applied in bold, fluid brush strokes. The Wadsworth Atheneum painting is signed and dated 1754, suggesting that the Wrightsman painting might be of the same period. This early dating might explain the German provenance of the painting, since it could conceivably have been executed while Domenico was at Würzburg (1750–1753). If painted in Germany, it would represent an astonishing evocation of the life and society Domenico had left behind in Venice. A masterpiece displaying Domenico's irresistible gift for describing the elegance and gaiety of his contemporaries, it is probably one of the earliest of his paintings of Venetian everyday life.

VERSIONS: For the bibliography of the variant of this composition in the Louvre, mentioned above, see Lorenzetti, 2nd ed., 1951, pp. 168–169. Although some writers have stated that it is signed and dated by Giambattista Tiepolo, it is catalogued as a Domenico Tiepolo by Morassi (1962, pp. 38–39), and Michael Levey ("The Eighteenth-Century Italian Painting Exhibition at Paris: Some Corrections and Suggestions," in *The Burlington Magazine*, CIII, April 1961, p. 140) reports that it is inscribed merely *Tiepolo/fecit*. It measures 79.0 by 108.0 cm., slightly smaller than the painting in the Wrightsman Collection. Rosenberg (1971, p. 176, catalogue no. 283) lists four copies of the Louvre variant; none are recorded of the Wrightsman painting. For the variant at Barcelona, see Morassi, 1962, p. 3. It is approximately the same size as the variant in the Louvre.

EXHIBITED: The Metropolitan Museum of Art, New York, March—October 1967.

REFERENCES: Pompeo Molmenti, *G. B. Tiepolo: La sua vita e le sue opere*, Milan, 1909, p. 206, illustrated p. 204 (regards the painting as an autograph work by Giovanni Battista Tiepolo, calling it a copy with variations of the Dancing Scene now in the Louvre); in the French edition, *Tiepolo: La Vie et l'oeuvre du peintre*, Paris, 1911, p. 162, pl. 165 (proposes that it is by Gian Domenico rather than by his father) / / Eduard Sack, *Giambattista und Domenico Tiepolo: Ihr Leben und ihre Werke*, Hamburg, 1910, pp. 120, 186, catalogue no. 311, pl. 111, opp. p. 120 (catalogues it as a free repetition by Giovanni Battista Tiepolo of the Dancing Scene now in the Louvre and dates it about 1760–1761) / / Anonymous, *Verzeichnis der National Wertvollen Kunstwerke*, Berlin, 1927, p. 10, no. 191 (lists it as a work by Giovanni Battista Tiepolo in the possession of Frau Dr. C. E. Merck, Darmstadt) / / Hans W. Hegemann, *Giovanni Battista Tiepolo*, Berlin, 1940, p. 141, fig. 88 (regards it as one of Giovanni Battista Tiepolo's variations on the carnival theme depicted in the frescoes in the guest house of the Villa Valmarana; the mountains in the distance behind the carriage on the left are not visible in the photograph that he reproduces) / / Antonio Morassi, "Domenico Tiepolo," in *Emporium*, XCIII, June 1941, pp. 271, 282, note 7 (classifies the painting with a group of carnival scenes, which he attributes to Domenico Tiepolo on the basis of the signed fresco in the Villa Valmarana) / / Antonio Morassi, *Tiepolo*, Bergamo, 1943, pp. 33, 48, pl. 102 (attributes the painting to both Domenico and Giovanni Battista Tiepolo, suggesting that they painted it in collaboration about 1756) / / Giulio Lorenzetti, *Mostra del Tiepolo*, exhibition catalogue, 2nd ed., Venice, 1951, p. 169 (mentions the picture as one of a number of genre scenes painted by Domenico Tiepolo) / / William E. Suida, *The Samuel H. Kress Collection in the Isaac Delgado Museum of Art*, New Orleans, 1953, p. 62 (describes the Wrightsman painting as a variant of Giandomenico's Minuet in the Louvre, observing that "the main figures in the foreground are very similar to those in the Louvre painting, while those in the background are completely different") / / Antonio Morassi, "Giambattista

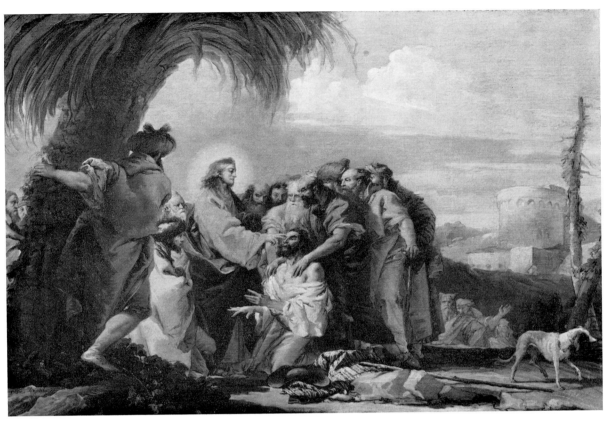

11. *Domenico Tiepolo, Christ Healing the Blind. Oil on canvas, 73.0 by 104.0 cm. Hartford, Connecticut, Wadsworth Atheneum, Ella Gallup Sumner and Mary Catlin Sumner Collection. Photo: Blomstrann*

Tiepolo's 'Girl with a Lute' and the Clarification of Some Points in the Work of Domenico Tiepolo," in *The Art Quarterly*, XXI, Summer 1958, p. 186, note 9 (mentions the painting as one of Domenico Tiepolo's best-known genre scenes) / / Mercedes Precerutti-Garberi, "Asterischi sull'attività di Domenico Tiepolo a Würzburg," in *Commentari*, XI, 1960, p. 277, fig. 13 (refers to it as a masterpiece and tentatively dates it shortly before 1754, toward the end of his sojourn in Germany) / / Anonymous, *La Peinture italienne au XVIIIe siècle*, exhibition catalogue, Paris, 1960–1961, p. 93, catalogue no. 440 (attributes the painting to Domenico rather than Giovanni Battista Tiepolo and states incorrectly that it belonged to the Darmstadt museum) / / Antonio Morassi, *A Complete Catalogue of the Paintings of G. B. Tiepolo*, London, 1962, p. 10 (states that although it has been

published as the work of Giovanni Battista Tiepolo, it should be considered "a masterpiece by Domenico") / / Anonymous, "Coup d'oeil sur les grandes ventes de la saison," in *L'Oeil*, July—August 1963, pp. 40–43, fig. 1 (states incorrectly that it comes from the collection of Lieutenant Colonel William Stirling of Keir; observes that it is in an excellent state of preservation) / / Mercedes Precerutti-Garberi, "Segnalazioni tiepolesche," in *Commentari*, XV, 1964, p. 253 (regards the painting as the work of Domenico Tiepolo and associates it with the four Carnival Scenes formerly in the collection of Maxwell Blake, Kansas City, Missouri, which are supposed to be dated 1765, and thus would belong to the period of Domenico's activity in Madrid) / / Claus Virch, "Dreams of Heaven and Earth: Giambattista and Domenico Tiepolo in the Wrightsman Collection," in *Apollo*, XC, September 1969, pp. 178–179, color pl. 1 (suggests that Domenico Tiepolo painted it before he left Venice for Madrid in 1762) / / Adriano Mariuz, *Giandomenico Tiepolo*, Venice, 1971, pp. 44, 48–49, 130, fig. 81, color pl. II (dates it in the mid-1750s and notes that it once belonged to Johann Heinrich Merck, a friend of Goethe) / / Pierre Rosenberg, *Venise au dix-huitième siècle: peintures, dessins et gravures des*

collections françaises, exhibition catalogue, Paris, 1971, p. 176, no. 283 (mentions the Wrightsman picture as a close variant of Giandomenico's painting of the same subject in the Louvre) / / Adriano Mariuz, "Giandomenico Tiepolo e la civilt a'veneta di villa," in *Atti del Congresso internazionale di studi sul Tiepolo con un'appendice sulla Mostra: celebrazione tiepolesche Udine 1970*, Venice [1972], p. 16 (cites the picture as one of Giandomenico's earliest genre scenes and remarks that this type of composition derives from the fêtes champêtres of Watteau, Pater, and Lancret).

Oil on canvas, H. 29¾ (75.5); W. 47¼ (120.0).

The painting was once somewhat larger than it is now. There are strips of fully painted canvas at the top, bottom, and left-hand side, which have been folded over the stretcher. Originally, the painting was at least about four cm. higher and perhaps two and a half cm. wider. It was cleaned by John M. Brealey in London in January 1972.

28 The Departure of the Gondola

A VENETIAN COUPLE, dressed in costumes typical of the carnival season, are about to step into a gondola by the side of a canal in front of the entrance to a walled garden (Fig. 1). They wear *tricorni*, black three-cornered hats used by both men and women in eighteenth-century Venice, and *baute*, characteristically Venetian garments of black cloth worn about the lower part of the face and over the shoulders and chest. The man wears a white *moreta*, a Venetian mask that covers only half of the face. The woman has one, too, propped on top of her *tricorno*. She wears a *tabarro*, or black cape, a pale pink dress with large cuffs of white lace at her elbows, and long white gloves. With her right hand she holds a fan and a white cloth; with her left she holds up her dress to enter the gondola. Behind her to the right a young man, wearing a bright scarlet jacket and a powdered wig, holds up her black cape; in front of her to the left a bareheaded *gondoliere* holds the boat steady and extends his arm to assist her.

There are two *gondolieri*, the second one standing on the platform at the stern of the gondola. Both of them hold long, pole-like oars and wear pearl earrings, white waist-length jackets with blue galloon trimming along the seams and around the neck and cuffs, golden sashes around their waists, richly textured knickers patterned with pale blue and white stripes, and white stockings and shoes trimmed in blue and gold. These uniforms repeat the colors of the four *palafitte*, the striped posts between which the gondola is moored. The gondola itself is painted black, except for the silver prow. It is equipped with a red, white, and blue floor covering and a *felze*, or enclosed cabin, with a grayish blue interior.

Along the *fondamenta*, or paved street running

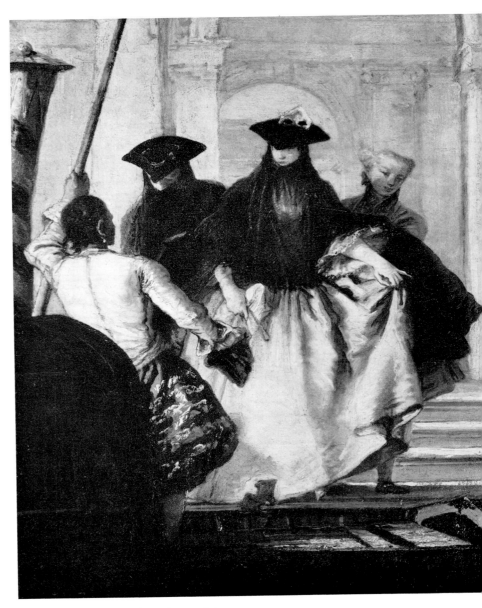

1. *Detail: couple boarding the gondola*

along the canal, there are several groups of on-lookers. Beginning on the extreme left, there is another couple (Fig. 3) clad similarly to the pair boarding the gondola. Their faces are completely covered by *moreta* masks and *bauta* veils. The man, whose arm rests on the wooden railing of the *fondamenta*, wears a long black *tabarro* over a lilac *velada*, or great coat, and raspberry *camisiola*, a Venetian waistcoat that hangs to the mid-thigh. The woman holds an open fan and wears a gold dress, barely visible behind the man's white stock-ings. Directly in front of this couple is a small boy, who looks wistfully over the railing. He wears a simple brown shirt and holds his hat in his left hand.

Immediately above the cabin of the gondola, three youths (Fig. 4) lean on the railing of the *fondamenta* and watch the couple boarding the gondola. The one on the right wears a light brown hat, shirt, and *bragoni*, or tight-fitting trousers that come just below the knee, and pale blue stockings. The bareheaded youth next to him wears a pale gray shirt and brown *bragoni* with gray stockings. Behind him stands a third youth, wearing a gray hat and leaning on his companion's shoulder. The

three youths partially block out of view a pair of women walking to the right. These women wear light pink and pale yellow shawls; one of them carries a basket.

The three men (Fig. 6) by the entrance to the garden wear pale blue, white, and gold outfits. Two of them, seen full-face, wear light blue and white *velade* over pale blue *camisiole*. They also wear powdered wigs tied back at the nape of the neck, white stockings, and pale blue *bragoni*. The third man in this group, who is seen in profile to the left, has golden stockings and a gold-colored *camisiola*.

To the right of these men there are several women spectators (Fig. 6). Most of them can be identified as middle-class women because of their black masks and the shawls they wear over their heads. The woman in the foreground wears upper-class apparel like that worn by the woman board-ing the gondola, the only difference being that her deep pink dress is trimmed with white lace. There are beauty patches on her left temple and cheek. Partially visible on the far right is another woman wearing a *tricorno*, a *bauta*, and a dusky pink dress.

Immediately behind the *fondamenta* is a white marble wall, pierced on the left by a grille through which a garden can be seen. Slightly to the right of center is a monumental gateway, surmounted by a broken pediment decorated with relief carvings in the spandrels. Through the archway another wall with an arched opening can be seen. Beyond the wall the tops of trees and several birds are visi-ble against the pale blue sky. On the far left there are two colossal columns rising from the *fonda-menta*, perhaps part of the portico of a building. The column closest to the edge of the picture bears a placard, which is inscribed: *DOM.o | TIEPOLO* (Fig. 2).

2. *Detail: placard with signature*

PROVENANCE: When the picture was first pub-lished (Sack, 1910, p. 120), it belonged to Andrés Antonio Salabert y Arteaga, eighth Marquis de la Torrecilla (1864–1925). It passed by inheritance to Luis Figueroa y Pérez de Guzmán el Bueno (born

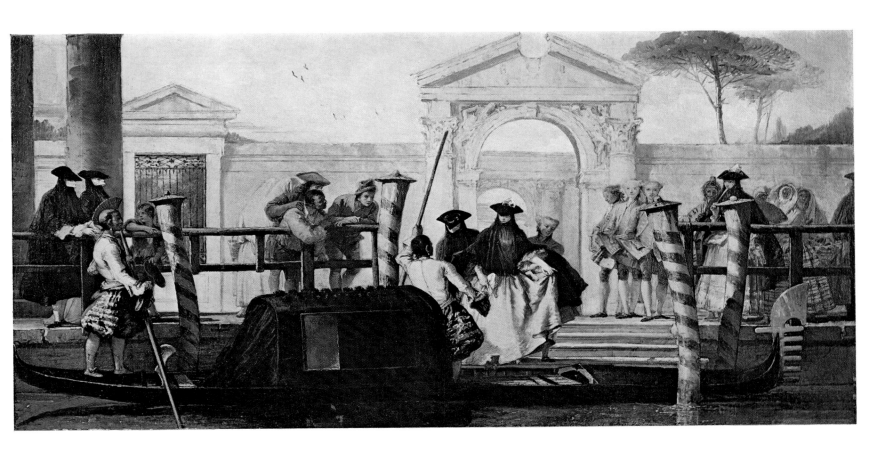

1918), 9th Count of Quintanilla, Madrid, a descendant of Torrecilla's sister. It was in Quintanilla's possession in 1950, when he lent it to the Tiepolo exhibition at Venice. Mr. and Mrs. Wrightsman acquired the painting in New York in 1959.

WITHIN DOMENICO Tiepolo's oeuvre the Departure of the Gondola is exceptional because of the extraordinary delicacy with which it is painted. It is an exquisite little picture of the greatest beauty, displaying an unusually sensitive mode of handling paint that differs remarkably from Domenico's characteristic manner. When seen with the other painting by Domenico in the Wrightsman Collection, the Dance in the Country (Catalogue No. 27), its highly detailed, almost miniature-like, treatment is apparent. The Dance in the Country, by contrast, is boldly rendered in large brush strokes and heavy impasto. Perhaps because of its refined quality, the Departure of the Gondola has been published several times as a work by Domenico's father, Giambattista. Yet it is clearly signed, and there can be little doubt that Domenico, and Domenico alone, was responsible for the design and execution of this enchanting masterpiece.

The picture is also exceptional in its subject matter. During the eighteenth century, paintings of everyday life were popular, and other Venetian artists—such as Pietro Longhi (1702–1785) and Francesco Guardi (*q.v.*) and his brother, Gian Antonio (1698–1760)—developed the genre of paintings of contemporary life. But the Departure of the Gondola stands apart from their portrayals of these subjects, because it is, curiously, much more realistic than any of the paintings by these artists. For example, in the glimpses of contemporary life provided by the Guardi brothers in their *ridotti*, or paintings of social gatherings, the figures are transformed into exotic creatures, who inhabit a fantasy world of flickering light and glittering color. Pietro Longhi's views of domestic interiors are more mundane, yet they are imbued with an innocent, child-like character that removes them

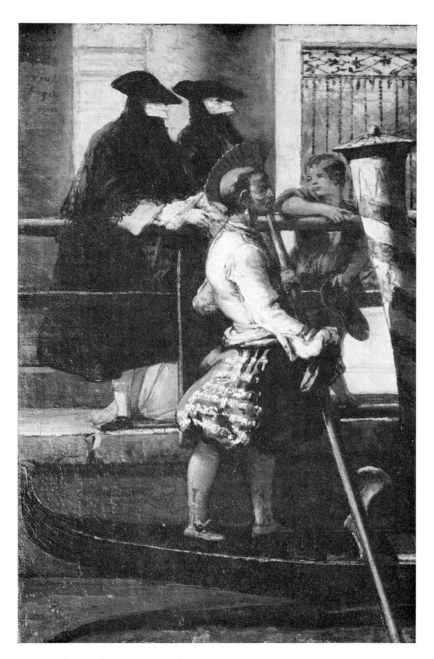

3. *Detail: people standing on the extreme left-hand side of the fondamenta*

from the real world. By contrast, Domenico Tiepolo's Departure of the Gondola records the actuality of a fleeting moment. Highly detailed and carefully composed, it captures the poetic essence of life in eighteenth-century Venice.

As a record of what eighteenth-century Venetians looked like, the painting is remarkable. Domenico has depicted the garments the Venetians wore so accurately that it is possible to identify most of them in the description above. Their colors and fantastic shapes naturally add to the allure of the painting. From an archaeological point of view, they also provide insight into some Venetian customs. The different classes of society, for example, are distinguished by their clothing: the middle-class women wear plain dresses and cover their heads with shawls, whereas the upper-class women wear capes and three-cornered hats. It is also curious that the upper-class women wear many of the same garments as their male counterparts. Writing on November 3, 1789, Arthur Young (1741–1820) observed that Venetian women generally wear "a

5. *Domenico Tiepolo, Young Woman in Domino and Tricorne. Oil on canvas, 61.9 by 49.2 cm. Washington, D. C., National Gallery of Art, Samuel H. Kress Collection*

4. *Detail: youths leaning on the railing of the fondamenta*

6. *Detail: people standing on the extreme right-hand
side of the fondamenta*

long cloth cloak, and a man's cocked hat. The
round hat in England is rendered feminine by
feathers and ribbons; but here when the petticoats
are concealed you look again at a figure before you
recognize the sex." (Arthur Young, *Travels during
the Years 1787, 1788, and 1789*, Bury St. Edmunds,
1792, p. 220). In addition to the hats, Young might
have mentioned fans. No Venetian woman of any
class appeared in public without a fan in her hand.
In Domenico's painting they are quite conspicuous.

The masks worn by the men and women are
another Venetian custom. They were worn for
about half the year during special periods that
were officially announced by the Venetian Re-
public. They were particularly popular during
carnival time, which in Venice started early, last-
ing from St. Stephen's Day, December 26, until
the beginning of Lent, in order to attract tourists.
Different masks were used, the most popular being
the *moreta*. It was made of canvas and almost al-
ways was painted white and coated with wax. In
Domenico's painting all the upper-class men and
women wear the *moreta* along with the *bauta*, a
black veil covering the lower portion of the face,
the shoulders, and upper part of the chest. The
baute seen in the Departure of the Gondola seem
to be made of lace, for they are translucent, allow-
ing the color of the garments underneath to show
through. Usually, *baute* were made of black silk or
taffeta; a typical example of one appears in Do-
menico's Portrait of a Young Woman (Fig. 5) in

[275]

the National Gallery of Art, Washington, D. C. By partially concealing the wearer, the *bauta* adds to the spirit of masquerade that so delighted the eighteenth-century Venetians.

The *gondolieri* of private Venetian families wore handsome costumes that usually repeated the principal colors of the families' coats of arms. In the Departure of the Gondola these colors are pale blue, gold, and white. The same livery colors decorate the four *palafitte* rising from the water, and they reappear in the attire of the three young men standing on the *fondamenta* by the archway. It has been suggested that these men are young aristocrats, but since their costumes repeat the colors of the household, it seems more likely that they are liveried servants.

It has been proposed by Morassi (1941, pp. 274–275) that the Departure of the Gondola was painted as a pendant to a painting (Fig. 7) of approximately the same dimensions in the Kunsthistorisches Museum, Vienna (inventory no. 6424), representing the Burchiello, a large omnibus boat that plied daily along the Brenta canal between Padua and Venice. The painting at Vienna is signed on a bale with the initials D. T. According to the published dimensions, it is about two cm. higher and about five cm. wider than the painting in the Wrightsman Collection, a negligible difference for paintings of this age. The probability that the two pictures were conceived as pendants is heightened by the presence in the Vienna painting of a gondola identical to the one in the Wrightsman painting.

There is no positive evidence for dating either of these pictures. Venetian fashions did not change markedly until the last quarter of the century, so the unusually detailed rendering of the costumes does not provide a clue for ascertaining the precise time or period when the pictures were painted. Because of the Spanish provenance of the Wrightsman painting, it has sometimes been suggested that it and its pendant were painted when Domenico Tiepolo was in Madrid. If this were true, the pictures would have to be interpreted as nostalgic memories of Venice that the artist painted while he was away from home. But there is no record of when the Wrightsman painting reached Spain (Sanchez Canton, 1953, p. 26), and it is not known if the Vienna painting ever was there. Considering the modest dimensions of the two pictures, it is conceivable that they were painted in Venice before 1762 and then carried to Spain by the artist.

The delicate handling of paint in the Departure of the Gondola, however, is not typical of the works Domenico painted before he departed for Madrid (compare, for example, his small signed and dated oil painting of Christ Healing the Blind in the Wadsworth Atheneum, Hartford—illustrated in the entry for Domenico's Dance in the Country, Catalogue No. 27, Fig. 11). In contrast to the fluidly painted, oleaginous character of these works, the Departure of the Gondola has a crumbly, almost powdery, consistency of paint, not unlike the parched, ascetic character of the sketches for the altarpieces for the church of Aranjuez that Domenico and his father painted during their last years in Madrid. Although Domenico's output in Madrid remains to be carefully analyzed, it would appear that he was susceptible to the changes that occurred in his father's last style. Domenico's Spanish works possess some of the silvery tonality of his father's Spanish works, and they are painted with the same dry, detailed treatment. The Departure of the Gondola possesses these characteristics; its style thus tends to support the view that it was painted during the 1760s in Madrid.

If the painting was in fact painted in Madrid, it would represent a remarkable evocation of not only the atmosphere but also the actual appearance of life in Domenico's native city. To paint it Domenico may have been aided by detailed drawings, such as the one in the Boymans Museum, Rotterdam, which served as a preparatory study for the painting of the Burchiello at Vienna. Unfortunately, no drawings have survived for the Departure of the Gondola, but, considering the balanced design of the figures and the subtle asymmetries of the overall composition, it would not be surprising

7. *Domenico Tiepolo, Burchiello. Oil on canvas, 38.0 by 78.3 cm. Vienna, Kunsthistorisches Museum. Photo: Alinari*

to find that an elaborate pen and ink drawing had been made for it, regardless of whether it was painted in Venice itself, or, as seems more likely, in Madrid.

VERSIONS: A poor copy of the Departure of the Gondola, measuring 42.3 by 71.0 cm., was once in the collection of Gustav M. Schneider, Frankfurt am Main. In 1925 he lent it to the exhibition *Meisterwerken alter Malerei aus Privatbesitz*, Staedel Institut, Frankfurt am Main, no. 225 (catalogued by Swarzenski, 1926, p. 78, pl. 89). It was recognized as a copy of the painting now in the Wrightsman Collection and ascribed to the eighteenth-century Venetian school. Judging from the reproduction of the painting in the exhibition catalogue, it could equally well have been painted by a Spaniard. Fiocco (1937, p. 333) mentioned a "miserevole ripetizione" of the painting now in the Wrightsman Collection. He attributed it to Lorenzo Tiepolo. As he did not indicate its whereabouts, it is possible that he was referring to the copy in the Schneider Collection.

EXHIBITED: Palazzo Giardini, Venice, *Mostra del Tiepolo*, 1951, catalogue no. 122 bis (illustrated); The Metropolitan Museum of Art, New York, *Paintings from Private Collections: Summer Loan Exhibition*, July—September 1960, catalogue no. 120.

REFERENCES: Eduard Sack, *Giambattista und Domenico Tiepolo: Ihr Leben und ihre Werke*, Hamburg, 1910, pp. 120, 210, catalogue no. 447, fig. 106a (catalogues it as an autograph work of Giambattista Tiepolo and extolls its delicacy and lively appeal) // Pompeo Molmenti, *Tiepolo: La Vie et l'oeuvre du peintre*, Paris, 1911, p. 162 (mentions the painting in passing as a work he knows only from a reproduction; he considers it to be an authentic work of Giambattista Tiepolo) // Gino Fogolari, "In tabarro e bauta," in *Settecento Veneziano*, color supplement to *Illustrazione Italiana*, no. 18, May 3, 1925, p. 1 (illustrates the painting, which he attributes to Giambattista Tiepolo, as a record of eighteenth-century Venetian dress; it is reproduced alongside a detail of an engraving by Michele Marieschi, 1710–1744, of a similar scene of a young woman boarding a gondola) // Georg Swarzenski, *Ausstellung von Meisterwerken alter Malerei aus Privatbesitz: Sommer MCMXXV*, exhibition catalogue, Frankfurt am Main, 1926, p. 78 (mentions it as an original work of Giambattista Tiepolo; catalogues a copy of it formerly in the collection of Gustav M. Schneider, which he illustrates on pl. 89) // Giuseppe Fiocco, "Giambattista Tiepolo in Spagna," in *Nuova Antologia*, XV, April 1937, p. 333 (regards it as a nostalgic masterpiece by Giambattista Tiepolo, painted while he was in Madrid; states that it represents the return, rather than the departure, of a gondola, and refers to a "miserevole ripetizione" by Gian Lorenzo Tiepolo, the

[277]

location of which he does not reveal) // Max Goering, "Giovanni Battista Tiepolo," in *Allgemeines Lexikon der bildenden Künstler* (Thieme–Becker), Leipzig, 1939, XXXIII, p. 151 (lists it as a work by Giovanni Battista Tiepolo) // Antonio Morassi, "Domenico Tiepolo," in *Emporium*, XCIII, June 1941, pp. 274–275 (argues that it was painted by Domenico rather than Giambattista Tiepolo and observes that it is similar to Domenico's signed painting of the Burchiello in the Kunsthistorisches Museum, Vienna) // Giuseppe Fiocco, "Tiepolo in Spagna," in *Le Arti*, V, October–November 1942, pp. 9, 10 (maintains that it was painted in Madrid by Giambattista and that it displays his nostalgia for Venice; entitles it the Return of the Gondola, rather than the Departure) // Terisio Pignatti, *Tiepolo*, Milan, 1951, pp. 128, 152, fig. 115 (accepts the attribution to Domenico Tiepolo, and dates it about 1770, which is to say about the time he returned to Venice from Madrid) // Giulio Lorenzetti, *Mostra del Tiepolo*, exhibition catalogue, Venice, 1951, 1st ed., p. 162 (mentions it as having been associated by Morassi with Domenico's painting of the Burchiello, in the Kunsthistorisches Museum, Vienna) // Giulio Lorenzetti, *Mostra del Tiepolo*, exhibition catalogue, Venice, 1951, 2nd ed., p. 172, catalogue no. 122 bis, illustrated (observes that it is signed *Dom.o Tiepolo* and calls it one of Domenico's most delicate paintings) // Luitpold Dussler, "Die Tiepolo-Ausstellung in Venedig," in *Kunstchronik*, V, January 1952, p. 9 (mentions the painting in passing as being in a private collection) // F. J. Sanchez Canton, *J. B. Tiepolo en España*, Madrid, 1953, p. 26 (states that the Marquis of Torrecilla owned for many years a painting by Tiepolo of a gondola with young people but that its previous provenance was unknown) // Antonio Morassi, "Giambattista Tiepolo's 'Girl with a Lute' and the Clarification of Some Points in the Work of Domenico Tiepolo," in *The Art Quarterly*, XXI, Summer 1958, pp. 180, 186, note 8 (observes the similarity between the face in Domenico's painting of a Young Woman in Domino and Tricorne, in the National Gallery of Art, Washington, D. C., and some of those in the Wrightsman painting; he states that the Wrightsman painting and "the

one entitled Burchiello in the Kunsthistorisches Museum of Vienna form a pair") // Rodolfo Pallucchini, *La pittura veneziana del settecento*, Venice, 1960, pp. 260–261, fig. 689 (dates it and the painting of the Burchiello during Domenico's Spanish period, slightly before the Carnival Scenes in the Maxwell Blake Collection, Kansas City, Missouri, which are inscribed 1765; he called it "un Giandomenico più raffinato e sensibilissimo agli effetti atmosferici") // Mercedes Precerutti-Garberi, "Asterischi sull'attività di Domenico Tiepolo a Würzburg," in *Commentari*, XI, January–December 1960, p. 278 (lists it along with a number of paintings by Giandomenico that had previously been mistaken for his father's work) // Decio Gioseffi, *Canaletto and His Contemporaries*, New York, 1960, p. 43, color pl. 22 (accepts it as a work by Domenico Tiepolo and cites it and the Burchiello as "exquisite evocations of Venetian life") // Antonio Morassi, *A Complete Catalogue of the Paintings of G. B. Tiepolo*, London, 1962, p. 37 (catalogues it as an "enchanting masterpiece by Domenico") // Mercedes Precerutti-Garberi, "Segnalazioni tiepolesche," in *Commentari*, XV, 1964, p. 253 (mentions it along with several other genre scenes by Domenico Tiepolo that were formerly regarded as the work of Giambattista) // Egidio Martini, *La pittura veneziana del settecento*, Venice, 1964, p. 299, note 299 (mentions it as a genre scene that is surely by Domenico, whereas he suspects that some of the other Tiepolo genre scenes may have been painted in collaboration with Giambattista) // John Masters, *Casanova*, New York, 1969, p. 61 (illustrated and entitled Young Women by a Gondola) // Claus Virch, "Dreams of Heaven and Earth: Giambattista and Domenico Tiepolo in the Wrightsman Collection," in *Apollo*, XC, September 1969, p. 179, color pl. II (suggests that it was painted in Spain and that it represents a woman leaving a villa on the Brenta) // Adriano Mariuz, *Giandomenico Tiepolo*, Venice, 1971, pp. 70, 71, 130, fig. 189, color pl. XII (calls it one of the high points of Domenico's painting and dates it during the first years he spent in Spain).

Oil on canvas, H. 14 (35.5); W. 28⁹⁄₁₆ (72.5).

JEAN FRANÇOIS de TROY (1679–1752), one of the most versatile French painters of the first half of the eighteenth century, never received the honors awarded his contemporary and arch rival, François Lemoine (1688–1737). De Troy's paintings, marked by great facility of execution, evince his ability to work in a variety of styles with equal ease.

He was born in Paris, the son of a popular portrait artist, François de Troy (1645–1730). Under his father's auspices he went to Rome in 1699 and was given a room at the French Academy. From Rome, where he must have seen the palace and church decorations of the great baroque painters, he went to northern Italy. In Venice he admired the sixteenth-century compositions of Paolo Veronese (about 1528–1588) and Jacopo Tintoretto (1518–1594) and the contemporary paintings of Sebastiano Ricci (1659–1734). De Troy was reluctant to return to Paris, and when his father stopped supporting him, he found a protector in Giovanni Grassulini, a wealthy Pisan who enabled him to remain in Italy for three more years. Finally returning to Paris shortly before 1706, he submitted to the Académie Royale a painting of Niobe and Her Children, now in the Musée Fabre, Montpellier. On the basis of this work he was accepted as a candidate and was elected a member of the Académie in July 1708.

During the decade after his return to Paris he painted a number of *tableaux de mode*, a type of genre painting he seems to have invented. These paintings represent elegantly dressed ladies and gentlemen in interior settings or formal parks where they court each other, play games, or read aloud to one another. While ultimately based on the *fêtes galantes* of Watteau (1684–1721) and Nicolas Lancret (1690–1743), and on seventeenth-century Dutch genre painting, de Troy's pictures of this sort differ from their prototypes. They are more realistic and record with extraordinary detail the clothing, furnishings, and social customs of contemporary Parisian society. They also are autobiographical in the sense that de Troy, reputedly a man of great charm, moved freely in the worldly circles depicted in these pictures.

In 1725 the Academy organized a Salon in which de Troy exhibited seven paintings, three of which were *tableaux de mode*. As a result of his success at the Salon he was given a commission for his first major history painting, the Plague of Marseille, dated 1726 and now in the Musée des Beaux-Arts, Marseille. Depending in part on the tradition of the great Venetians and on Rubens (*q.v.*), it demonstrates his mastery of large-scale, dramatic compositions.

In 1729 de Troy suffered a major disappointment when the commission for the ceiling of the Salon of Hercules at Versailles was awarded to Lemoine. Forced to turn from the large-scale paintings to which his talents were so well suited, he worked during the 1730s on paintings of relatively modest dimensions, many of which were incorporated as decorative panels in private interiors. It was not until 1734 that he was given a royal commission—several series of allegorical paintings for the royal apartments at Versailles and Fontainebleau.

When Lemoine was made *premier peintre du Roi* in 1736, de Troy turned to designing tapestries for the Gobelins factory. Illustrating the story of Esther, these designs finally won for de Troy widespread recognition. The sketches for the tapestries are masterpieces of decorative composition, rivaling the

color and virtuosity of Rubens. As a result of the success of these designs, he was appointed director of the French Academy in Rome. He worked there until his death, executing a number of religious and secular canvases, the most notable being another series of tapestry designs based on the theme of Jason and Medea.

29 The Garter

IN A RICHLY appointed interior a young woman (Fig. 1), seated in an armchair, pulls up her dress to reveal the lower part of her right leg and holds her unfastened garter in her right hand. A young man stands to her left, bending forward as though he had just left his chair to offer his aid in retying the garter. The woman holds out her left hand to prevent him from coming any closer. She wears a *sacque*, or morning dress, of gold, blue-green, and white stripes, which is loose-fitting and open to the waist. Under her *sacque* she wears a white, bow-trimmed corset, which has elbow length, lace-trimmed sleeves. Her garter is a dark green, embroidered ribbon, and her stockings are light gray with green trim. She wears green mules with pointed toes and curved high heels. Her powdered hair is studded with gold, pink, and blue flowers, and she wears a white lace cap and a drop earring. A cameo on a dark gray band encircles her left wrist.

The suitor wears a light bluish gray coat with large, open cuffs and pockets trimmed with small white buttons. His light gray hair is tied back with a dark gray ribbon. Another ribbon is tied around his neck to form a cravat over his white stock. Under his coat he wears a richly embroidered silver waistcoat and a pair of dark gray breeches finished with a band that fits smoothly over his white stockings. His black shoes have stylish red heels, a short tab, and small oval buckles. His black tricorne hat, trimmed with white feathers, has

fallen to the floor in his haste to aid the young woman. Tied at his waist is a sword with a gilt hilt and a dark green scabbard.

The young woman is seated in an armchair that has a gilded frame and is upholstered in a light blue and pink flowered fabric. The young man's chair appears to be of the same design, with matching upholstery. To the right of the young woman's chair is an open-front bookcase, surmounted by a clock of tulipwood mounted with gilt bronze (Fig. 5). The time marked by the hands on the enamel dial of the clock is 11:30. At the base of the clock reclines a winged and bearded figure of an old man who holds a balance in his outstretched right hand. Above the face of the clock is the small figure of an infant holding a scythe.

An exotic floral design in dark green and pink on a light pinkish gray ground covers the wall, while the floor is covered with geometrically arranged squares of greenish gray and white marble. To the right of the young woman is an ornately carved and gilded console table with a marble top (Fig. 6). Placed in the center of the table top is a bronze statuette of a seated female figure and, near the table's edge, a leatherbound book. Above and behind the console table is a tall mirror with a gilt frame. Reflected in the mirror is the light from a partially closed window and the outline of a paneled door, with a framed overdoor above it.

The painting is signed on the baseboard beneath the console table: *DETROY. 1724* (Fig. 6).

1. *Detail: man and woman*

30 The Declaration of Love

SEATED ON a brocaded sofa, a young woman leans on a pillow and looks at a young man, who is kneeling on one knee at her side with his left hand held across his breast and his right hand clasped in hers (Fig. 2). The woman wears a white *sacque* embroidered with blue sprays of plants and flowers. Unbuttoned to the waist, her dress has a frothy band of tiny curled blue ribbons around the collar. She wears a white bodice with a crisscross pattern of blue ribbons on it and lace ruffles at the elbows. Adorning her brown hair is a small white lace cap with scarlet ribbons and small flowers of the same color. Only the tips of the pointed toes of her red mules are visible beneath the skirt of her dress.

Wearing a greatcoat of rich crimson velvet with deep, open cuffs and pockets decorated with small gold buttons, her suitor leans forward to speak. His powdered hair is tied back with a black ribbon. He wears a white shirt with a lace ruff at the neck and lace at the cuffs. His stockings are dark blue, and he wears black shoes with short tabs, brass oval buckles, and red heels. The black scabbard of his sword is barely visible behind his bent right knee. A small black and white spaniel playfully jumps up on the folds of the woman's dress.

The sofa, covered in a light crimson brocade, has a gilded frame; the center of its high back is surmounted with an ornate shell motif. To the right of the sofa is a pedestal of green and light brown marble, on which stands a porphyry urn with gilt-bronze mounts. Both the sofa and the pedestal conform in shape to the gilded architectural molding on the wall behind them. A painting of two lovers embracing in a landscape (Fig. 8) is set in an elaborately carved frame on the green

marbleized wall behind the sofa. Its frame also conforms to the shape of the molding and the sofa beneath it.

A heavy crimson curtain falls in front of the wall painting and over the back and seat of the sofa to the floor. Resting on its folds behind the suitor is his tricorne hat, trimmed with gold thread and white feathers around the brim. The floor is of geometrically patterned parquet of the type known as *parquet de Versailles*, because it was used throughout the state rooms of the palace.

The young woman wears a small yellow wristband, which bears the inscription: *DETROY* (Fig. 2).

PROVENANCE: The Garter and the Declaration of Love were painted as pendants in 1724 and have remained together ever since. They were presumably still in the possession of the artist when they were exhibited in the Salon of 1725. According to Bode (1909, pp. 26–27), sometime in the mid-eighteenth century the pictures probably entered the collection of Frederick the Great of Prussia (1712–1786). During his lifetime he amassed a fine collection of contemporary French paintings and art objects. In 1738, two years before he was made King of Prussia, he wrote to his sister that he had already filled two rooms of his château at Rheinsberg with paintings, the majority by Watteau and Lancret. The Wrightsman de Troys may have numbered among these paintings. At the latest, they must have entered Frederick the Great's collection by 1754, for in that year he is said to have stopped collecting French paintings and to have begun instead to buy pictures by Italian and Flemish masters. In all, Frederick owned ten paintings by de Troy, most of them *tableaux de mode* (for

2. Detail: man, woman, and signature

which see *La Peinture française du XVIIIe siècle à la cour de Frédéric IIe*, Helmut Börsch-Supan, ed., exhibition catalogue, Paris, 1963, catalogue no. 5).

The Garter and the Declaration presumably remained in the German royal collection until the third quarter of the nineteenth century, when they were purchased from Kaiser Wilhelm I by Carl Ludwig Kuhtz (1809–1889). The paintings were

first recorded in the Kuhtz Collection in 1883, when he lent them to an exhibition in Berlin (Bode and Dohme, 1883, p. 254). They appeared in the sale of his collection at Lepke's, Berlin, on February 15, 1898, lots 37, 38 (illustrated in color in the catalogue; the Declaration sold for 17,625 francs, the Garter for 16,562 francs) and were acquired by Oscar Huldschinsky (1847–1931). They remained in Huldschinsky's possession until the sale of his collection at Cassirer and Helbing, Berlin, May 10, 1928, lots 64, 65 (illustrated in the catalogue, pls. LI, LII). At the Huldschinsky sale they were bought by Baron Thyssen-Bornemisza (1875–1947) and were housed first in his castle at Rohoncz, Hungary, and then after 1937 in his newly built gallery in the Villa Favorita, Lugano, Switzerland. They passed by inheritance to the present Baron H. H. Thyssen-Bornemisza (born 1921), who sold them in the early 1950s. They were acquired by Mr. and Mrs. Wrightsman in New York in 1955.

DE TROY's paintings of the Garter and the Declaration of Love should be considered together, for they were clearly conceived as a pair. Not only have the paintings been together ever since they were shown in the Salon of 1725, but their dimensions and subjects are uniform. They both depict young couples in richly decorated interiors. The scale of the figures and the line where the wall meets the floor is approximately the same in both paintings. Furthermore, the composition of one painting complements that of the other. In the Declaration the kneeling pose of the young man and the angle at which the young woman leans back on the pillow create a diagonal that runs from the lower left of the painting to the upper right. In the Garter an opposing diagonal is created from the lower right to the upper left by the slightly bent pose of the gentleman and the tilt of the lady's body to the left. Thus the diagonal in one painting counterbalances the diagonal in the other.

The Garter is a scene of a young lady receiving a gentleman in a salon or library in the morning. The exact hour of his visit, 11:30 A.M., is indicated by the clock on the bookcase and by the sunlight coming through the window that is reflected in the mirror. De Troy has painted the clothing and the room's furnishings in such detail that many of the original objects can be identified.

The lady is attired elegantly but informally. Her dress, or *sacque*, is a morning dress meant for receiving casually at home. The lace cap she wears in her hair is also an informal article of clothing. The striped silk of her dress can be considered extremely fashionable for 1724, for one usually associates this type of material with the fashions of the later eighteenth century. The lace on her cuffs and in her hair seems to be of very fine quality and beautifully styled. The underside of her cuffs is longer than the upper side, a very modish detail. Her costume is typical of the *haute bourgeoisie*, which was enjoying considerable influence in Paris at the time of the Regency.

The gentleman who has come to call is of the lady's rank and station. He is handsomely clad in a stylish greatcoat that is the latest word in men's fashions, with open, cut sleeves and smaller, more numerous buttons than were to be found on its predecessors. His cravat is also stylish, with a bow in the front made from the same ribbon as the bow in his hair. The fabric of his waistcoat is magnificently embroidered. His shoes have red lacquer heels, of the same type worn by the youthful Louis XV in de Troy's father's portrait of him (Fig. 3), painted in 1724 and now in the Palazzo Pitti, Florence.

De Troy reveals some aspects of the lady's character through her gestures and surroundings. Lovely and flirtatious, she is clearly in command of the situation. She is also a cultivated woman who enjoys reading, for she has just put aside a book that seems to have come from the top shelf of the bookcase behind her.

The interior of her home is furnished in a very modern and expensive taste. The wall covering has a chinoiserie design. It probably is an embroidered cloth, since its pattern "turns the corner" of

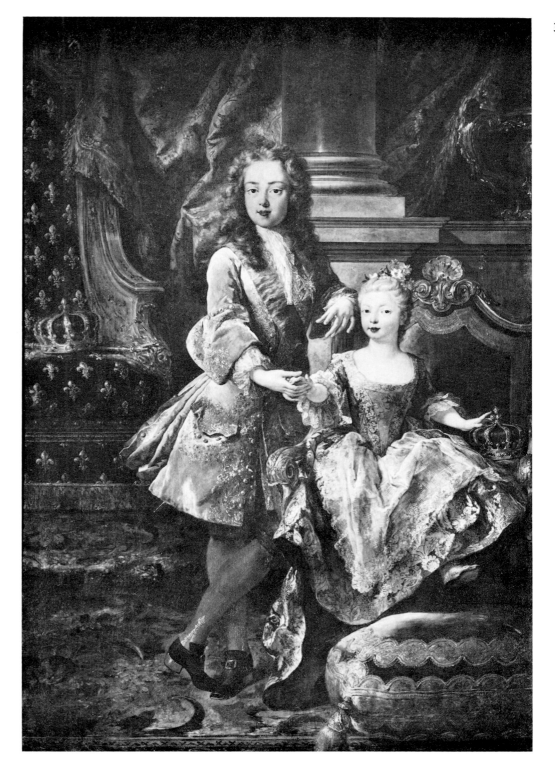

3. *François de Troy, Portrait of Louis XV and the Infanta of Spain. Oil on canvas, 240.0 by 160.0 cm. Florence, Palazzo Pitti. Photo: Alinari*

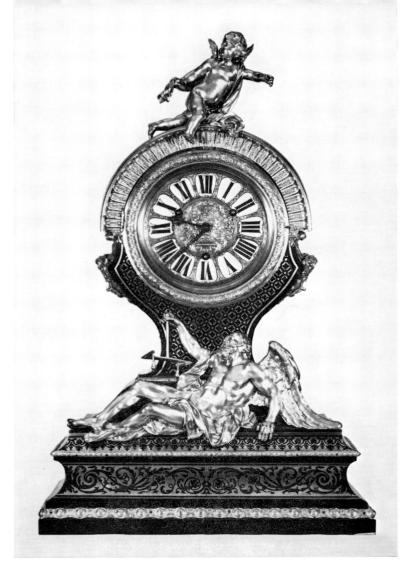

4. *Bracket clock. Oak and gilt bronze, 88.9 by 56.5 cm. London, Wallace Collection*

5. *Detail: clock*

the wall next to the mirror, something wallpaper rarely does. In 1724 a wall covering in the Chinese taste would have been rather modern. The pair of armchairs can be dated between 1715 and 1725 and seem to be elaborately carved from the glimpse of the arms we are given. They are upholstered in a fabric of floral design with a central medallion. The console table can be given approximately the same date as the armchairs. It is a Regency piece, with rather heavy proportions, which is worked in graceful curves and decorated with a carved shell motif. The mirror was made to go over the console table, being of the same width. The open-

front bookcase is of a simple but elegant design and is probably contemporary with the other pieces of furniture.

The clock on top of the bookcase (Fig. 5) is of gilt bronze and, according to Watson (1956, pp. 18–19), can be associated with a clock design attributed to André Charles Boulle (1642–1732). There are several examples of the clock known, one in the Wallace Collection (Fig. 4) being inscribed on the backplate *Martinot aux Galleries du Louvre 1726*. Evidently de Troy knew a slightly earlier version of the design, since the Garter is dated 1724. The clock also appears in his painting

7. *Atrributed to Adriaen de Vries, statuette of Architecture. Bronze, height 54.0 cm. New York, collection of Mr. and Mrs. Leopold Blumka. Photo: Thomas Feist*

LEFT:
6. *Detail: statuette, signature, and date*

of the Reading of Molière (Fig. 9), in the collection of the Marchioness of Cholmondeley, and in the Lady Attaching a Bow to a Gentleman's Sword, formerly in the collection of Baron Louis de Rothschild, Vienna.

On the console table is a statuette of a seated female figure (Fig. 6), which closely resembles a bronze statuette of Architecture (Fig. 7) in the collection of Mr. and Mrs. Leopold Blumka, New

York. It appears to be almost identical, except that the instruments in her hands are not visible in the painting. The statuette is based on a prototype by Giovanni Bologna (1529–1608). The pose of the legs, with the angle of the drawn-up leg placed behind the knee of the extended leg, follows almost exactly the position of the legs in his bronze statuette of Architecture. Hans R. Weihrauch (*Europäische Bronzestatuetten: 15.–18. Jahrhundert*, Berlin—Brunswick, 1967, p. 353, fig. 426) has published it as a work by Adriaen de Vries (about 1560–1626), a Dutch sculptor who was trained in Florence by Giovanni Bologna.

The Declaration of Love also shows a handsome young man in a salon with a young lady wearing a morning dress. The room is generally more formal and ponderous in tone than that in the Garter. The heavy damask curtain adds to the massive impression made by the furniture. While the fabric of the lady's dress is different from that of the lady in the Garter, it is cut in the same style. Extremely elegant, it has tiny buttons running up the front of the embroidered skirt to the open neck. Her elbow rests lightly on a superbly embroidered pillow. Her suitor wears a silk velvet greatcoat of much the same design as that of his counterpart in the Garter. He kneels on one knee and holds his hand over his heart, a pose de Troy often repeated in his *tableaux de mode*. The lady willingly gives her hand to the gentleman, yet draws back from too close contact. Compared to that depicted in the Garter, the salon in which the scene takes place is one with fewer but grander pieces of furniture. The sofa is deep and large and has been made to conform exactly to its architectural setting. Like the furniture in the Garter, it is in the full *Régence* style and may be dated between 1720 and 1725, the delicately curved lines of its back and the curvilinear shell motif hinting at the full rococo period to come. The marble pedestal next to the sofa is composed of two beautiful colors that perfectly complement the porphyry vase with gilt-bronze mounts resting on it. This vase reappears in the Portrait of Louix XV and

the Infanta of Spain (Fig. 3), mentioned above. The wall seems to be covered with marbleized green paint. To enrich the setting further, there is a large painting set into the wall, with a rococo frame. From the diminutive scale of the figures in relation to the landscape, the wall painting (Fig. 8) would appear to be a *fête galante* scene in the spirit of Watteau or Lancret. But according to Jacques Vilain (letter, September 1972), it is actually a lost mythological canvas by de Troy depicting Mars and Venus Embracing in a Landscape. The composition is recorded in an engraving by Caylus, preserved in the Bibliothéque Nationale, Paris.

While the costumes and furnishings in both of these pictures are painted with scrupulous accuracy, the ladies and gentlemen are anonymous. Charming and appealing as each one may be, they do not appear to be portraits of specific individuals, but rather examples of a certain aspect of contemporary Parisian society. Their thoughts and desires are reflected by their settings. Beneath the outward decorum, the furnishings of the rooms are alive with implied sensuousness. In the Garter, for instance, the statuette of the nude woman may give a hint of the young man's innermost thoughts. He probably would subscribe to the thesis of Love conquering Time, the theme symbolized by the gilt-bronze figures on the clock behind him (Fig. 5). The bearded man with wings represents Saturn, or, as he is popularly known, Father Time, the Grim Reaper. In his outstretched hand is a pair of scales to remind one that all things are measured in the balance of time. The cupid surmounting the clock stands for Love. Symbolizing Love's triumph over Time's final activity, Death, he holds in his left hand a scythe he has stolen from Saturn. In the Declaration the scantily clad lovers embracing in the landscape painting (Fig. 8) may express the thoughts of the gallantly posed and beautifully clad couple on the sofa beneath.

De Troy's *tableaux de mode*, of which the Wrightsman paintings are superb examples, are linked to the tradition of Watteau's *fêtes galantes*. But whereas Watteau created an ethereal, dream-

like world, lyrical and timeless in mood, de Troy portrayed contemporary society in a highly realistic manner. This realism may have been inspired by seventeenth-century Dutch genre painting, but where the Dutch masters concentrated on lower-class life and often depicted openly bawdy scenes, de Troy selected consistently urbane, elegant, and sophisticated subjects.

For de Troy's *tableaux de mode*, there are parallels in contemporary French theater, particularly in the social comedies of Pierre Marivaux (1688–1763). He wrote *comédies de moeurs*, centered on the themes of love and gallantry. Depending heavily on Molière (1622–1673), he was less openly satirical than the great seventeenth-century dramatist, and the situations he described in his plays resemble the scenes depicted in the Garter and the Declaration of Love. Despite the realism of costume and decor in these paintings, there is a pronounced theatrical air to the poses and gestures of the figures. Even the settings in which the lovers meet are staged with cleverly placed and revealing props, such as the book, clock, statue, and landscape painting. The tone of de Troy's painting is much like that found in Marivaux's plays, where the author does not mock his characters but gently satirizes them without letting them lose their charm or dignity.

Technically, de Troy's *tableaux de mode* are painted with bright colors in a rather even, highly finished manner. This is especially true of the pair of Wrightsman paintings. The brushwork in them is rather tight, particularly when compared with the handling in de Troy's mythological pictures, which are much more loosely painted. Perhaps the even consistency of the paint was necessary to reveal all the details of texture and color. An artist of extraordinary versatility, de Troy easily adapted his style to the subject matter at hand.

The chronology of de Troy's *tableaux de mode* is not clearly outlined. Although some of the small genre pictures are dated, the sequence in which they were produced has been confused by a misreading of the inscription on the Reading of Mo-

8. *Detail: Mars and Venus embracing in a landscape*

lière (Fig. 9). De Troy signed and dated this picture on the frame of the chair farthest to the left, but the numerals of the date are badly defaced. Some writers, nevertheless, have maintained that it can be read as 1710, a date entirely inconsistent with the fully developed style of the painting. It is much more plausibly dated about 1728 (as Cailleux, 1960, suggests). In 1710 de Troy had barely established himself as a painter in Paris, and his documented works of that year, a pair of large

[293]

altarpieces now in the museum at Rouen, are painted in a robust style directly inspired by Rubens and the great Italian baroque masters. The delicacy of the handling, in a word, the "Frenchness," of the Cholmondeley Reading of Molière is a characteristic that appeared in de Troy's work only at a later phase. In fact, the Wrightsman paintings of 1724 most certainly anticipate the style of the Cholmondeley picture. In terms of the scale of the figures in relation to the overall dimensions of the canvas and the evenness of the painted surface throughout, they represent a turning point

in de Troy's style. Only a year before they were painted, de Troy signed and dated the Alarm, in the Victoria and Albert Museum, London (Fig. 10). Sparkling with creamy impasto, it still has the large forms and the rich consistency of paint of the early works. In the pair of Wrightsman pictures, the paint surface is more minutely worked, and subtle differentiations of light and textures have replaced the exuberant brio of handling. The likelihood that the Wrightsman paintings are earlier than the Cholmondeley Reading of Molière is confirmed by the date of its pendant, the Declaration of Love, in the Schloss Charlottenburg, Berlin. Its date, 1731, can also be assigned to the Cholmondeley picture, since they were painted as a pair. Thus the Wrightsman Garter and Declaration of Love are relatively early examples within

9. *Jean François de Troy, Reading of Molière. Oil on canvas, 72.4 by 90.8 cm. Houghton Hall, Norfolk, collection of the Marchioness of Cholmondeley. Photo: Royal Academy of Arts*

de Troy's oeuvre of a genre of painting for which he was to earn his well-deserved reputation. In the Salon of 1725 they must have made a strikingly novel impression, displaying to full advantage de Troy's personal idiom.

VERSIONS: Replicas of the Wrightsman de Troys are in the collection of Harold D. Wimpfheimer, New York. Their dimensions, 65.0 by 54.3 cm., are almost identical to those of the Wrightsman paintings. They reproduce faithfully every detail of the originals, save the artist's signatures and the date. Compared to the Wrightsman paintings, they are inferior in quality, lacking the masterful brushwork and fresh coloring of the originals. Sterling (1937, p. 77) catalogued them as autograph replicas by de Troy, but they seem more likely to have been worked up in his atelier by an assistant. They are reputed to have been in the collection of Count Edmond Blanc, Paris, though they do not appear in the catalogue of his sale, which took place in Paris, December 2–3, 1850. They are said to have subsequently belonged to one Mme Evain of Paris. In 1925 they were sold by Wildenstein to Charles A. Wimpfheimer, father of the present owner.

EXHIBITED: Académie Royale de Peinture et de Sculpture, Paris, Louvre, Salon Carré, 1725; Kaiser Friedrich Museum, Berlin, *Die Ausstellung von Gemälden älterer Meister im Berliner Privätbesitz*, 1883; Kaiser Friedrich Museum, Berlin, *Ausstellung von Werken alter Kunst aus dem Privatbesitz der Mitglieder des Kaiser Friedrich-Museums-Vereins*, 1906, catalogue nos. 144, 145 (illustrated); Neue Pinakothek, Munich, *Sammlung Schloss Rohoncz: Gemälde*, 1930, catalogue nos. 329, 330, pls. 123, 124; Royal Academy of Arts, London, *France in the Eighteenth Century*, 1968, catalogue nos. 669, 670, pls. IV, XXVII (the Garter is erroneously reported to be dated 1752).

REFERENCES: Anonymous review in the *Mercure de France*, September 1725, reprinted in Georges Wildenstein, *Le Salon de 1725*, Paris, 1924, pp. 39–40 (states that de Troy exhibited seven paintings, including a pair that can be identified with the Wrightsman pictures; they are described as "petits Tableaux très-galands Au premier une declaration d'amour. Une jeune personne habillée de blanc, paroît assise sur un Sopha, appuyée sur un carreau de toile peinte; elle se tourne pour regarder un Cavalier en habit de velours qui lui parle. Il y a un petit chien sur le devant. Le fond est fort bien décoré. 2. Une Demoiselle un peu courbée, ayant une jambe découverte, tenant d'une main sa jarretiere, & de l'autre repoussant un jeune homme qui s'empresse à vouloir la lui renoüer.") // Wilhelm von Bode and Robert Dohme, "Die Ausstellung von Gemälden älterer Meister im Berliner

10. *Jean François de Troy, The Alarm. Oil on canvas, canvas, 70.5 by 57.8 cm. London, Victoria and Albert Museum, Jones bequest*

Privätbesitz," in *Jahrbuch der Königlich Preussischen Kunstsammlungen*, IV, 1883, p. 254 (mention the Declaration and the Garter as a pair of paintings lent by Carl Ludwig Kuhtz to an old master paintings exhibition) // Charles Ephrussi, "Exposition d'oeuvres de Maîtres anciens tirées des collections privées de Berlin en 1883," in *Gazette des Beaux-Arts*, XXX, 1884, p. 104 (observes that while the Declaration and the Garter reveal de Troy's great technical accomplishment, the style is too severe ["quelque chose de dur et de vitreux"] for the subjects depicted) // Wilhelm von Bode, ed., *Die Sammlung Oscar Huldschinsky*, Frankfurt am Main, 1909, pp. 26–27, pls. XXXVII, XXXVIII (describes the paintings as decorative in the best sense of the word and of high quality, with a close affinity to Watteau; mentions that several similar

[295]

genre paintings by de Troy are in other collections in Berlin and that they all probably were originally in the collection of Frederick the Great) // Hippolyte Mireur, *Dictionnaire des ventes d'art faites en France et à l'étranger pendant les XVIIIe & XIXe siècles*, Paris, 1912, VII, p. 216 (lists the Declaration and the Garter as having been sold by Kuhtz in Berlin in 1898) // Francis M. Kelly and Randolph Schwabe, *Historic Costume: A Chronicle of Fashion in Western Europe 1490–1790*, New York, 1925, pp. 199, 201, 203, 204, 206, 208, 209, 213, 214, 216, 227, 233; the Garter illustrated in line drawing, fig. 94 (refer to specific parts of male and female attire in the Garter as typical of French fashions around 1724) // Max J. Friedländer, "Die Sammlung Oscar Huldschinsky," in *Der Cicerone*, XX, January 1928, pp. 4, 8; the Declaration is illustrated on p. 8 (describes the paintings as pendants hung in the drawing room of Huldschinsky's house) // Gaston Brière, "Detroy," in *Les Peintres français du XVIIIe siècle*, ed., Louis Dimier, Paris, 1930, II, pp. 6, 40, catalogue nos. 84, 85; the Declaration illustrated pl. 7 (discusses the originality of de Troy's *tableaux de mode* and notes their detailed accuracy in recording the life of Parisian society; erroneously indicates in the caption for pl. 7 that the Wrightsman paintings once belonged to the "Musée de Berlin" [presumably the Kaiser Friedrich Museum]) // Eberhard Hanfstaengl, "Castle Rohoncz Collection Shown in Munich," in *Art News*, XXVIII, August 16, 1930, p. 19; the Garter is illustrated (mentions the Garter as being among Thyssen's eighteenth-century paintings) // Gaston Brière, "Jean-François de Troy peintre de la Société élégante," in *Bulletin de la Société de l'Histoire de l'Art Français*, 1931, p. 164 (lists the Declaration and the Garter as being among thirteen known *tableaux de mode* by de Troy) // Rudolf Heinemann, ed., *Stiftung Sammlung Schloss Rohoncz*, Lugano, 1937, I, p. 154, catalogue nos. 429, 430; II, pls. 259, 260 (catalogued as a pair, with the Huldschinsky Collection given as their provenance) // Charles Sterling, *Chefs d'oeuvre de l'art français*, exhibition catalogue, Paris, Palais des Arts, 1937, p. 77, catalogue nos. 148, 149 (in the catalogue entries for a pair of paintings in the Wimpfheimer Collection, he mentions the Wrightsman de Troys as the pictures exhibited in the Salon of 1725) // Hans Vollmer, "Jean François de Troy," in *Allgemeines Lexikon der bildenden Künstler* (Thieme–Becker), Leipzig, 1939, XXXIII, p. 442 (lists the pair of Wrightsman pictures among de Troy's paintings of genre scenes) // Millia Davenport, *The Book of Costume*, New York, 1948, II, p. 667; the Garter illustrated pl. 1788 (mistakenly gives the title of the Garter as the Declaration and the provenance as the Kaiser Friedrich Museum; describes the costumes of the man and woman in the painting as examples of French dress around 1724) // Rudolf Heinemann, ed., *Aus dem Besitz der Stiftung*

Sammlung Schloss Rohoncz, Lugano, 1949, pp. 74, 75, catalogue nos. 255 and 256 (repeats the text of his 1937 catalogue entries) // F. J. B. Watson, *Wallace Collection Catalogues: Furniture*, London, 1956, p. 19 (observes that a clock in the Wallace Collection is of the same type as the one in the Garter; attributes the design of the clock to André Charles Boulle, by whom there is a drawing of a similar clock in the Musée des Arts Décoratifs, Paris) // Cyril Connolly, "Style Rococo," in *Art News Annual*, XXVI, 1957, p. 111 (illustrates the Garter and calls it "A synthesis of the beginnings of Rococo style") // Emmanuel Bénézit, ed., *Dictionnaire critique et documentaire des peintres, sculpteurs, dessinateurs et graveurs*, Paris, 1959, VIII, p. 391 (mentions that the paintings were sold by Kuhtz in 1898 and gives their prices) // Jean Cailleux, "The 'Lecture de Molière' by Jean Francois de Troy and Its Date," in *The Burlington Magazine*, CII, February 1960, advertisement supplement published after p. 90 (refers to La Déclaration and La Jarretière, exhibited in the 1725 Salon, as typical of de Troy's *scènes galantes*) // Jacques Thuillier and Albert Châtelet, *French Painting from Le Nain to Fragonard*, James Emmons, trans., Geneva, 1964, p. 149 (mentions the Garter and the Declaration as having been among four genre paintings that de Troy exhibited in the Salon of 1725) // Marilyn Caldwell, "Amor Vincit Tempus," in the *North Carolina Museum of Art Bulletin*, VIII, September 1968, pp. 29, 34, note 3; the Garter illustrated fig. 4 (discusses the iconography of the type of clock depicted in the Garter and refers to the Wrightsman painting as an illustration of how the "Conceit of Love over Time was ideally suited to the taste of the age.") // Denys Sutton, "Le Dix-huitième Siècle Revived," in *Apollo*, LXXXVII, January 1968, pp. 1, 6; the Declaration illustrated in color on the cover (regards the Declaration and the Garter as part of a realistic current in French eighteenth-century art that has been neglected by scholars) // John Masters, *Casanova*, New York, 1969, the Garter illustrated in color opp. p. 179) // Denys Sutton, "Pleasure for the Aesthete," in *Apollo*, XC, September 1969, p. 230, color pls. XXIII, XXIV (calls them "ravishing of their type and [showing] what it was that English painters admired about their Parisian contemporaries, for they are exceedingly sophisticated and metropolitan works").

The Garter: Oil on canvas, H. 25¼ (64.2); W. 21⅟₁₆ (53.5). The Declaration of Love: Oil on canvas, H. 25½ (64.8); W. 21⅛ (53.7).

The Garter: There are clearly visible pentimenti in the tiles beneath the woman's shoes. Her right foot originally rested flat on the floor, and the left one was extended slightly forward.

ANTHONY van DYCK (1599–1641) was the most important seventeenth-century Flemish painter after Rubens (*q.v.*). He was born in Antwerp and began his training there at the age of ten with Hendrik van Balen (about 1575–1632). In 1618 he became a master in the Antwerp painters' guild, and two years later he was mentioned as one of Rubens's assistants in the contract for the ceiling paintings of the Jesuit church in Antwerp. His early paintings suggest that by this time he had already been closely associated with Rubens for several years, since his early figure compositions are demonstrably dependent upon Rubens. Yet his own artistic personality was quite unlike Rubens's robust and worldly character. Introspective and melancholic by temperament, he never rivaled Rubens's broad range of artistic expression. His forte was portraiture, and, perhaps because his personality was less overpowering than that of Rubens, he responded with greater sensitivity to his sitters.

In November 1620 he went to England to work for the court of James I, but left after a brief stay of four months and seems to have returned to Antwerp. By November 1621 he was in Italy where he was to spend the next four years. Working chiefly in Genoa, he also visited Venice, Bologna, Florence, and Rome. He visited Sicily in 1624 and painted an altarpiece of St. Rosalie Interceding for the Plague-stricken of Palermo, the *modello* for which is in the Metropolitan Museum. But with the sumptuous full-length portraits he created for the Genoese aristocracy the future of his career was determined. Although he was to paint an occasional religious or mythological subject, he gave most of his time and energy to portraiture, specializing in a highly elegant and psychologically acute style.

By 1628 he had re-established himself at Antwerp. The Archduchess Isabella gave him a gold chain for the portrait he executed of her, and by 1630 he was described as her court painter. During this period he completed the large altarpiece of the Ecstasy of St. Augustine, for a church in Antwerp, and the Madonna and Saints, now in the Kunsthistorisches Museum, Vienna.

He went to England in 1632 and became Principal Painter to Charles I, who knighted him on July 5 of that year. In return for a royal pension he painted portraits of the king's family and the court. He was in Brussels in 1634 to execute a portrait of the Cardinal Infante Ferdinand, the new governor-general of the Netherlands. By the summer of 1635 he had returned again to England. But, sensing the insecure position of Charles I, he sought employment on the Continent. He made an unsuccessful bid to assume the position left vacant by Rubens's death in 1640. He also went to Paris seeking the commission to decorate the Grande Galerie of the Louvre, but this job had already been assigned to Poussin (*q.v.*). Suffering from poor health, he returned to London and died there in December 1641.

THIS IS A three-quarter-length view, showing the queen standing beside a table before a plain, dark brown background. She is posed at an angle (Fig. 3), her left shoulder close to the picture plane, and her hands folded with the palms up, one on top of the other, below her waist. Her dark brown eyes gaze directly toward the viewer. Her golden brown hair, tied at the top with a small dark gray ribbon, is arranged in elaborate curls framing her face and gathered in a long lock resting on her right shoulder. Her saffron-yellow dress has full sleeves and broad white lace cuffs and collar. Her black sash is tied at the waist with two bows, one black and the other pale blue-violet.

Her jewelry consists of large pearl earrings, a string of pearls at the throat, and another long string across her shoulders, joining with a loop at the center of the corsage, where there is a black velvet bow and a large faceted jewel set in a gold octagonal mount (Fig. 1). A jeweled brooch fastens the top of the double lace collar.

The closed royal crown (Fig. 2) resting on the table is encrusted with pearls and cut stones and surmounted by a jeweled cross.

In the lower right-hand corner is the Barberini family inventory number: *F.14*.

PROVENANCE: The picture has an unbroken history going back to within a few years of when it was painted. It is first recorded in the collection of Cardinal Francesco Barberini (1597–1679) on August 26, 1639, when his brother, Cardinal Antonio Barberini, paid Giovanni Francesco Romanelli (about 1610–1662) for a copy of it (the receipt is in the Vatican Library, Archivio Barberini, Armadio 155, Cardinal Antonio, "Libro di Ricordi di quello che Entra & Esce della Guardarobba, 1636–44"; information communicated by Marilyn Aronberg Lavin, November 12, 1969). Perhaps Cardinal Antonio was having the copy made for his own collection or as a gift for someone else.

The portrait is next described in an inventory of Cardinal Francesco Barberini's possessions in the Cancelleria drawn up in 1649: "Un Quadro con cornice d'albuccio intagliata e tutta dorata mezza figura in tela la Regina d'Inghilterra alto palmi quattro e mezzo e largo p^{mi} quattro." At the time of his death in 1679, it was still hanging in the Cancelleria, Rome (information supplied by Frances Vivian, letter of November 11, 1968).

It figures as no. 933 in the 1730 inventory of the collection of Principessa Olimpia Giustiniani Barberini. In 1812, when the Barberini Collection was divided between the Barberini and the Colonna di Sciarra families, it appears as no. 135 in the "Seconda Classe" of paintings. In the 1817 Barberini inventory (Mariotti, 1892, p. 127), it is recorded as no. 14: "Ritratto della regina d'Inghilterra, di Vandyck." In the 1844 Barberini inventory it is described under no. 148 as "Regina d'Inghilterra, ossia la bella Hamilthon, Vandik, al. p. 4.5, lar. p. 3.7." The Hamilton reference is puzzling (perhaps it refers to the wife of Sir William Hamilton, who acted as an intermediary with Bernini for a proposed bust of Henrietta Maria).

In 1934 it was designated one of the pictures in the Barberini *fidecommesso* (trust) that the Italian government turned over to the Barberini heirs. By the terms of this settlement, it passed to Prince Tommaso Corsini (born 1905) of Florence. He sold it in 1968, and Mr. and Mrs. Wrightsman acquired it in London the following year.

HENRIETTA MARIA (1609–1669), the queen consort of Charles I of England, was born at the Louvre and was named after both her parents, Henry IV of France and Marie de Médicis. At the age of fifteen she was married to the king of England. Their first years together were unhappy,

1. *Detail: jewel tied to the string of pearls*

2. *Detail: crown*

because the Duke of Buckingham, a favorite of the king, did all within his power to generate distrust of the young and inexperienced queen, who was a practicing Roman Catholic and spoke little English. After the assassination of Buckingham in 1628, the king seems genuinely to have fallen in love with his young bride. She bore him nine children, some of whom were to be the subjects of Van Dyck's most beguiling group portraits.

In the Wrightsman portrait she is a woman of twenty-seven, expecting the birth of her sixth child, Princess Anne, who was to be born on March 17, 1637. There is a description of the queen at this time by George Conn (died 1640), a papal agent to the court of St. James's and her

personal confessor. Conn wrote to Cardinal Francesco Barberini in Rome that she was

> so full of incredible innocence that in the presence of strangers she is as modest as a girl. . . . When she confesses or communicates she is so absorbed as to astonish the confessor and everybody. In her bedroom no one may enter but women, with whom she sometimes retires and indulges in innocent amusements. She sometimes suffers from melancholy, and then she likes silence. When she is in trouble she turns with heart and soul to God. She has little care for the future, trusting altogether in the king. Consequently it is of more importance to gain the ministers of state, of whom she may be the patroness if she likes (transcripts of Barberini archives, London, Public Record Office, Add. Ms. 15389, fol. 196; quoted by S. R. G., in *Dictionary of National Biography*, London—New York, 1908, IX, p. 431).

As the Civil War approached Henrietta Maria threw herself into English politics, seeking foreign aid to overthrow the parliamentarians. In 1642 she sailed to Amsterdam and pawned a great part of the English crown jewels. Returning to England with munitions, she was nicknamed "La Generalissima" because of the military schemes she vigorously urged upon her mild-tempered husband. When the royalist position became hopeless, she fled to France. She was living in the Louvre when she received word that her husband had been beheaded at Whitehall on January 30, 1649.

A devout Catholic, she spent the remaining years of her life trying to convert her children to the Church of Rome and arranging advantageous marriages for them. After the Restoration in 1660 she returned to England for a brief period and then took up residence there in 1662. Three years later she left London for the last time and retired to her château at Colombes, near Paris.

Henrietta Maria was painted by Van Dyck many times. His first portrait of her is probably in the large family group of 1632, executed shortly after he settled in London. On May 7, 1633, the artist was paid for nine portraits of Charles I and his wife (Michael Jaffe, in *Encyclopedia of World Art*, New York, 1961, IV, col. 532). According to

Carola Oman (*Henrietta Maria*, New York, 1936, p. 81), the queen gave Van Dyck no less than twenty-five sittings, and his account of unpaid bills in 1638–1639 listed thirteen portraits of "la Reyne"—"dressed in blue, price thirty pounds"—"dressed in white, price fifty pounds"—"for presentation to her sister-in-law, the Queen of Bohemia"—"for presentation to the Ambassador Hopton. . . ."

All of these portraits do not represent fresh and original essays. Most of them were probably repetitions of one or another of the five or six basic formats the artist devised for the queen's portraits. These repetitions were done by the artist and his assistants to satisfy the large demand from family and friends for likenesses of her. The existing portraits of her thus can be classified according to their prototypes, the most important being the three-quarter-length in white (Fig. 4), painted for the King's Bedchamber at Whitehall and now at Windsor; the full-length in state robes in the Bildergalerie, Potsdam (Oliver Millar, *The Tudor, Stuart, and Early Georgian Pictures in the Collection of Her Majesty the Queen*, London, 1963, I, fig. 24); the full-length in red at the Hermitage, Leningrad (Gustav Glück, ed., *Van Dyck: Die Meisters Gemälde*, Stuttgart—Berlin, 1931, pl. 391); and the full-length with her dwarf, Sir Geoffrey Hudson (Fig. 5), in the National Gallery of Art, Washington, D.C.

The Wrightsman portrait was also a prototype for many repetitions and variants (see below, under Versions). Like the other prototypes, it is completely an autograph work of the master, displaying all the evidence of his own brushwork. The composition shows several conspicuous alterations that only he would have made, such as the large pentimento running down the side of the queen's left sleeve (originally the sleeve was about an inch wider). Similarly, the collar on her left shoulder seems to have been lowered, and there are slight changes visible in the outline of her right

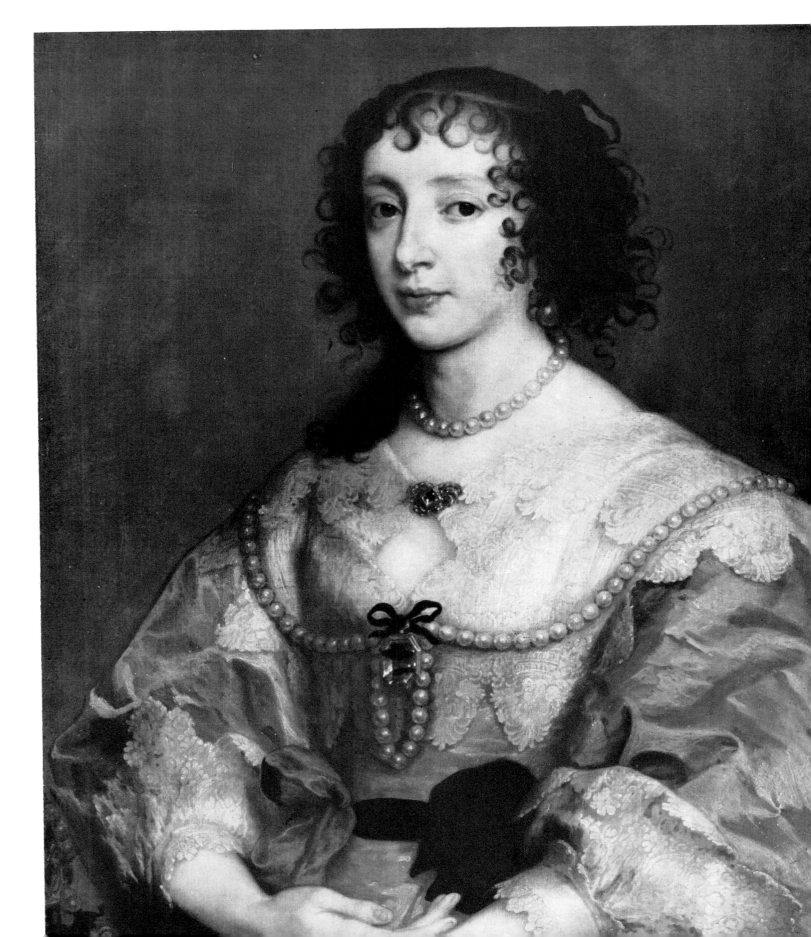

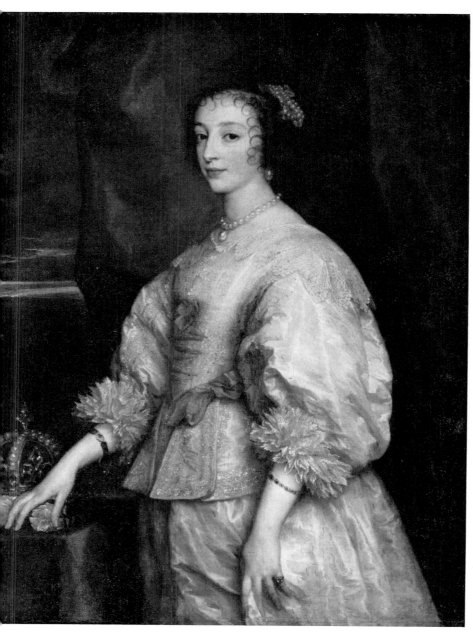

4. *Anthony van Dyck, Portrait of Henrietta Maria. Oil on canvas, 108.6 by 86.0 cm. Windsor Castle, Royal Collection*

sleeve. A copyist would not have reproduced these changes. Further evidence that this is the primary version of this particular format can be seen in the way the artist applied the background color. When the queen gave her first sitting, he merely laid in the color immediately around her head. Then at a later stage he filled in the rest of the background, but did not quite match the color, so that the first patch is somewhat darker, resembling an opaque halo around the head. Another feature indicating Van Dyck's own work is the incomplete preparation of the canvas: a margin roughly three inches wide on all four sides of the canvas is unprimed. An artist setting out to copy the composition would have prepared the entire canvas at once, whereas Van Dyck, being uncertain of the ultimate dimensions of the picture, filled in these margins after he had completed the figure.

It has been suggested that the Wrightsman portrait was executed in 1636 as a special gift for Francesco Barberini. As "Cardinal Protector of England" he sought to improve relations between Charles I and the Church of Rome. Knowing the king's interest in art, the cardinal dispatched a large group of Italian pictures as a gift for the queen. They reached England in 1636 and were highly appreciated by the royal family (Rudolf Wittkower, "Inigo Jones—'Puritanissimo Fiero,'" in *The Burlington Magazine*, XC, January 1948, pp. 50–51). In December of the same year George Conn reported to Cardinal Barberini:

> Non hà ancora voluto la Regina, che io li
> presenti la lettera di V. Em.ᶻᵃ, perche havendo
> saputo il contenuto di esso, e che io dovevo dimandar
> licenza a S. M.ᵗᵃ, si và trattendo fin che sia finito
> il suo ritratto (transcripts of the Barberini archives,
> London, Public Record Office, B. V. cod. Barb.
> Lat. 8637, fol. 340; quoted by Millar, 1969, p. 417).

> The Queen has not yet wanted me to present her the
> letter of Your Eminence, because having been
> apprised of its contents and knowing that I would
> ask Her Majesty for permission to take leave from
> her, she is delaying until her portrait is finished.

As Oliver Millar first observed, this probably refers to the present portrait. It may well have been intended as a token to the cardinal, whose generosity was warmly appreciated by the queen. The year after his pictures arrived in England, she prepared a display of them in her chapel at Somerset House (Albion, 1935, p. 396).

Cardinal Barberini also arranged to have Gianlorenzo Bernini (1598–1680) carve a bust of Charles I, which, unfortunately, was lost in the fire that destroyed Whitehall Palace in 1698 (Rudolf Wittkower, *Gian Lorenzo Bernini: the Sculptor of the Roman Baroque*, London, 1955, pp. 200–201). The artist carved it in Rome, using as his model a painting by Van Dyck of the king in three positions (Millar, 1963, I, pp. 96–97; II, pl. 70). This picture—now in the Royal Collection—belonged for several decades to Bernini and his heirs, and it seems very likely to have been the Van Dyck portrait displayed at the Pantheon on the famous occasion in 1650 when Velazquez's portrait of Juan de Pareja won great public acclaim.

According to Conn's correspondence with the Vatican authorities, Bernini's bust of the king "caused great interest in Rome, Cardinals, Ambassadors and all persons of quality flocking to see it before it was sent to England. There were a few stains in the marble on the forehead, but, as one wag suggested, these would quickly disappear once the King became a Catholic!" (Albion, 1935, p. 398). When the marble reached England in 1637, it excited the highest praise. The king liked it so much that he is reputed to have sent the sculptor a ring worth 6,000 crowns, and Henrietta Maria personally wrote the cardinal to express her appreciation of the masterpiece.

Two years later Henrietta Maria asked the cardinal if it would be possible for Bernini to carve one of her. She proposed to send the sculptor three portraits of herself in different positions. Probably the last portraits Van Dyck painted of the queen (one is illustrated in Fig. 6), they never were sent to Rome because of the outbreak of Civil War. Compared to the portrait in the Wrightsman

5. *Anthony van Dyck, Portrait of Henrietta Maria with Her Dwarf. Oil on canvas, 219.1 by 134.8 cm. Washington, D. C., National Gallery of Art, Samuel H. Kress Collection*

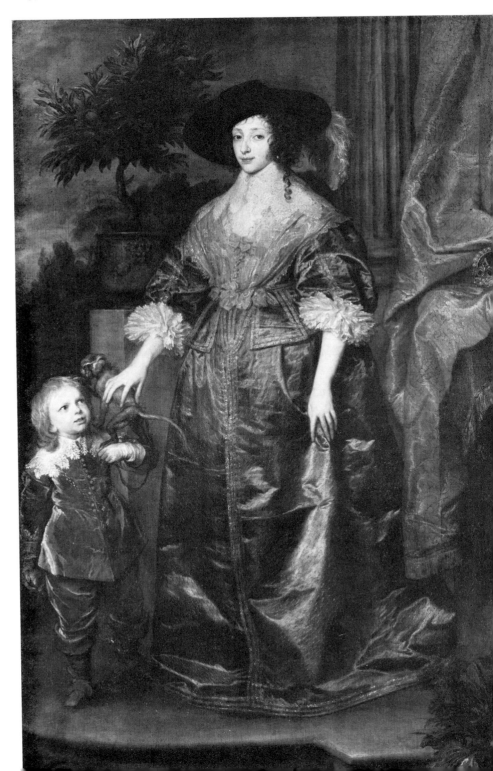

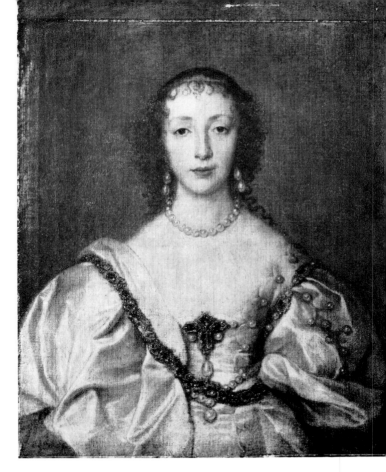

6. *Anthony van Dyck, Portrait of Henrietta Maria. Oil on canvas, 78.7 by 65.7 cm. Windsor Castle, Royal Collection*

Collection, they are surprisingly uninspired. The artist evidently was content simply to make straightforward records of her appearance. The execution of none of them measures up to the sensitivity and subtlety displayed in the Wrightsman canvas. This is difficult to reconcile with the intended destination of the three portraits, for when Van Dyck knew a picture was to be sent to Rome he customarily took pains to create a work of art that would meet the standards of the critical artists and patrons there. One of the distinguishing features of the Wrightsman portrait is that Van Dyck was fully aware that it would be judged as an example of his ability by the Barberini and their discriminating circle. As a result, the execution is flawless, and, as Oliver Millar observed (1969, p. 418), "There are, in short, few English royal portraits by Van Dyck which are more consistently finely painted and none in which his mature powers were more effectively concentrated."

7. *Detail: back of the canvas*

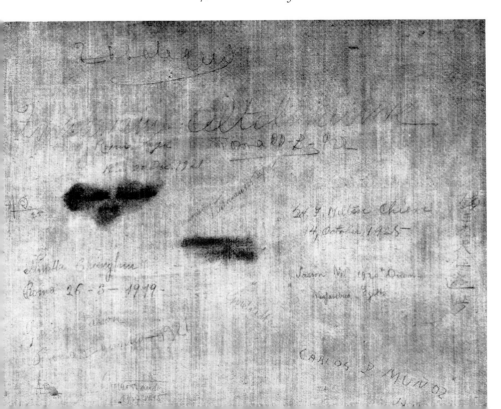

VERSIONS: Like all of Van Dyck's royal portraits, this picture was reproduced many times. Over a dozen copies or variants of it are recorded. Before the original was shipped to Rome, Van Dyck or an assistant must have made a replica that served as a prototype for the versions subsequently produced in England. It is curious that the earliest record of the picture is the payment for a copy by Romanelli (see above, under Provenance). The quality of a few of the versions is high enough to allow for Van Dyck's execution, or at least his supervision. The others are mediocre copies of no artistic merit. According to Millar (1969, p. 417, note 18) the best versions belong to the Earl of Warwick, Warwick Castle ("There are differences in the folds of drapery in the sleeves and the portrait has been regrettably enlarged into a full-length at a later date"; it measures 221.5 by 130 cm.) and to the Hon. Mrs. Hervey Bathurst, Eastnor Castle, Herefordshire.

Some of the better-known copies belong to the Earl of Pembroke, Wilton House, Salisbury (Emil Schaeffer, ed., *Van Dyck: Des Meisters Gemälde*, Stuttgart—Leipzig, 1909, pl. 373); the National Portrait Gallery, London (David Piper, *Catalogue of Seventeenth-Century Portraits in the National Portrait Gallery 1625–1714*, Cambridge, 1963, p. 161, no. 227; 59.2 by 78.3 cm.); the Earl of Ilchester, Melbury; Lieutenant Colonel Sir Howard and Lady Kerr, Melbourne, Derbyshire (86.5 by 70.0 cm.); Earl Poulett, Hinton St. George (sold before 1882); and the Earl of Buckinghamshire, Hampden House (a full-length illustrated by

8. *X-ray of the face*

John Skelton, *Charles I*, London, 1898, opp. p. 10). A faithful but mediocre copy on canvas (98.5 dy 81.5 cm.) was recently bequeathed to the country of Liechtenstein by Graf Maurice Bendern and is displayed in the museum at Vaduz. Other copies are recorded at Dunrobin Castle (59.0 by 77.0 cm.) and at St. John's College, Oxford. A free variant of the composition, with the queen wearing a black dress, is in the Radnor Collection, Longford Castle (Helen Matilda, Countess of Radnor, *Catalogue of the Pictures in the Collection of the Earl of Radnor*, London, 1909, I, no. 18, illustrated opp. p. 10; 106.7 by 81.3 cm.). Copies are also listed in the Pereire sale (Paris, March 6–9, 1872, p. 79, lot 119; 100.0 by 83.0 cm.; illustrated in catalogue with an engraving) and the Borchard sale (Parke-Bernet, New York, January 9, 1947, lot 42; 127.0 by 104.0 cm.; illustrated and said to have come from the collection of William K. Vanderbilt, Sr., Paris).

According to Michael Jaffé (verbal communication, November 1971), a copy by an Italian hand is in the collection of H. Lee Bimm, Rome (100.0 by 75.0 cm.).

REFERENCES: Filippo Mariotti, *La legislazione delle belle arti*, Rome, 1892, p. 127 (publishes an inventory of the Barberini Collection drawn up in 1817 in which the picture is listed under no. 14 as "Ritratto della regina d'Inghilterra, di Vandyck") // L. V. Bertarelli, *Guida d'Itália del Touring Club Italiano: Roma e dintorni*, 2nd ed., Milan, 1931, p. 257 (lists it as a work of the school of Van Dyck) // Anonymous, *Gazzetta ufficiale del regno d'Italia*, XII, no. 107, May 5, 1934, p. 2261, list B, no. 13 (includes it among the pictures in the Barberini trust that the family may export and sell without being taxed; identifies it as a female portrait, perhaps Henrietta Maria, and attributes it to the school of Van Dyck) // Gordon Albion, *Charles I and the Court of Rome: a Study in 17th Century Diplomacy*, Louvain, 1935, p. 399, note 5, illustrated opp. p. 151 (supposes that it was sent in 1647 to the Barberini so that Bernini could make a bust of the queen to match the one he had carved in 1636 of the king) // Leo van Puyvelde, *La Peinture flamande à Rome*, Brussels, 1950, p. 174, pl. 78 (claims that it is an original work by the master and describes it as hanging in the Palazzo Barberini, Rome) // Oliver Millar, "Notes on Three Pictures by Van Dyck," in *The Burlington Magazine*, CXI, July 1969, pp. 417–418, illustrated opp. p. 413 (calls it "a portrait of the highest quality"; claims that it is the first version of this particular design, of which he lists six variants; suggests that since the artist knew the portrait was being sent to Rome he sought to make it "worthy to stand in the eyes of the artists and *cognoscenti* in Rome as an example of his ability") // Denys Sutton, "Pleasure for the Aesthete," in *Apollo*, XC, September 1969, pp. 230, 235, color pl. XXII (states that it has an "eighteenth-century feeling and the Queen, one may well feel, would have proved an ornament to the court of Louis XV") // Gregory Martin, " 'The Age of Charles I' at the Tate," in *The Burlington Magazine*, CXV, January 1973, p. 59 (mentions it as an outstanding Van Dyck, "publicly exhibited here for the first time").

Oil on canvas, H. 41½ (105.5); W. 33⅛ (84.2).

The original canvas, which is folded over the stretcher on all four sides, is attached to a relining canvas. It is covered with signatures left by Italian and foreign visitors to the Palazzo Barberini (Fig. 7). Evidently the picture was displayed at an angle to the wall, enabling tourists to autograph it. The earliest signatures date from the second decade of the twentieth century, suggesting, perhaps, when the relining canvas was added.

A photograph documenting the appearance of the picture before it was removed from Rome was made by Alinari (negative no. 28609).

The picture was cleaned by John Brealey in London in October 1968. X-rays were made of it at the Metropolitan Museum in February 1969. They disclose no changes or alteration that are not clearly visible to the naked eye (Fig. 8).

JOHANNES VERMEER (1632–1675), a younger contemporary of Rembrandt (1606–1669) and Frans Hals (1581/85–1666), was born at Delft, where he lived in relative obscurity, working as an art dealer and innkeeper. He painted comparatively few pictures; only about thirty-five are regarded as authentic by modern scholars. Of these, only sixteen are signed, and two are dated.

Vermeer's short career can be broken roughly into three periods. During the first, from about 1655 to 1660, he painted relatively large canvases in an early baroque manner inspired by the Dutch followers of Caravaggio. In the second period, the decade of the sixties, he evolved his own personal style in a series of small, flawlessly composed pictures of genre subjects. In the final period, the early seventies, he emphasized the decorative elements of his style, producing a few pictures that, though lacking the naturalness of his earlier work, display a brilliant, artificial beauty. Because of illness he stopped painting in 1672, three years before he died.

The paintings of the first period of Vermeer's career show some affinity with the work of Carel Fabritius (1622–1654), the great Rembrandt student who settled at Delft about 1650. Fabritius may possibly have been Vermeer's master; although there is no documentary evidence to link the two artists, they shared the same interest in perspective and luminous effects. Vermeer's earliest dated picture, the Procuress of 1656, in the Gemäldegalerie, Dresden, recalls Fabritius in the play of daylight over the large-scale figures. They are painted with a surprisingly rich palette of warm browns, bright yellows, and reds. The execution of the picture is also extraordinary, displaying a broad painterly treatment reminiscent of Fabritius. Two other pictures datable to this early period because of their rich painterly style are Christ in the House of Martha and Mary, in the National Gallery of Scotland, Edinburgh, and A Girl Asleep at a Table, in The Metropolitan Museum of Art, New York.

To the decade of the sixties belong Vermeer's undisputed masterpieces. Their perfection is unrivaled by any Dutch contemporary. Usually they show one or two figures isolated in an interior softly lit by an open window. The figures stand in calm, quiet poses, often with withdrawn, enigmatic expressions. Frequently the objects in the foreground are deliberately distorted to enhance the illusion of space. While Vermeer painted the same type of genre pictures as Pieter de Hooch (1629–1681), Gerard ter Borch (1617–1681), Gabriel Metsu (1629–1667), and Nicolas Maes (1632–1693), he ennobled the subject matter of their cluttered scenes, giving a sense of dignity and elevation to the most trivial of daily activities.

To render the glittering highlights in his pictures Vermeer employed a kind of *pointillé* technique, applying thick points of bright color over darker areas. These points give the impression of brightly lit objects without changing their basic color values or dissolving them in light. The technique may have been inspired by Vermeer's experiments with the camera obscura. In the paintings of the early sixties, such as the Maid Servant Pouring Milk, in the Rijksmuseum, the points are rendered in thick impasto. They stand out from the surface of the canvas, giving the picture a rich painterly appearance. During

the last period of his career, Vermeer applied them as flat discs of light, giving the late paintings a strange schematic quality.

Vermeer's paintings of the seventies lack the sensuous painterly qualities of his earlier work. The forms in them are rendered with hard edges, and the textures and colors are given a brilliant enamel-like consistency. Characteristic of this late style are the Love Letter, in the Rijksmuseum, and the Allegory of Catholic Faith, in The Metropolitan Museum of Art.

32 Portrait of a Young Woman

THE HEAD AND bust of a young woman are portrayed against a dark background. With her head turned to a three-quarters position over her left shoulder, she gazes directly at the viewer. A cool, silvery light falls on her from an unseen source at the upper left. She is painted in delicate flesh tones with faint traces of pink in her cheeks and lips. Her dark brown hair is drawn back from her high forehead and gathered at the crown of her head, from which a pale yellow cloth falls down her back. Her wide-set hazel eyes complement the color of the ice blue ample garment drawn around her shoulders and over her arm. A glimpse of what seems to be the back of her hand is visible at the bottom of the picture. At her throat is the border of a white collar or blouse. A large pearl hangs from her left earlobe.

The background is painted a warm, dark brown,

1. *Detail: signature*

slightly lighter in tone than her hair. There is a narrow band of darker paint along the left edge of the picture.

The upper left-hand corner of the painting is signed in light gray paint: *I Meer* (Fig. 1).

PROVENANCE: The picture may have been one of the twenty-one Vermeers sold at an anonymous auction in Amsterdam on May 16, 1696 (Gerard Hoet and Pieter Terwesten, eds., *Catalogus of Naamlyst van Schilderyen*, Amsterdam, 1752, I, p. 36). The sale included three portrait heads:

Lot 38. Een Tronie in Antique Klederen, ongemeen Konstig. 36–0 [A face in antique costume, uncommonly artistic. 36 florins].

Lot 39. Nog een dito Vermeer. 17–0 [Another by the same Vermeer. 17 florins].

Lot 40. Een werga van denzelven. 17–0 [A pendant of the same. 17 florins].

Although the brevity of these catalogue descriptions does not allow a positive identification of the paintings involved, there is a strong possibility that the Wrightsman portrait is lot 38, the "face in antique costume, uncommonly artistic." By "antique" the catalogue compiler could have meant exotic, old-fashioned, or, most probably, classic in the sense of Greek or Roman antiquity. If the last is meant here, none of the other extant Ver-

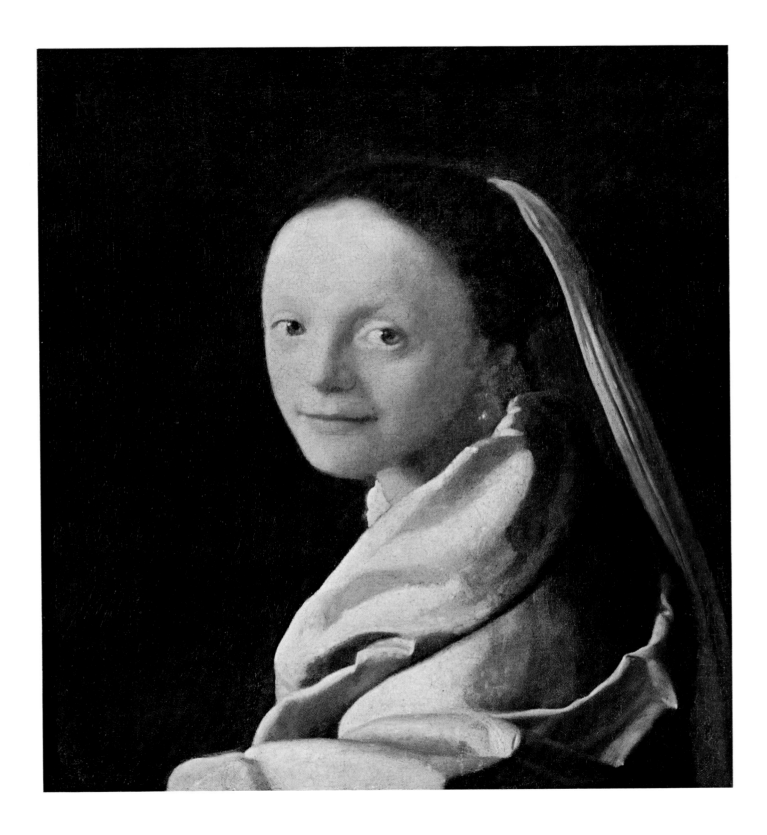

meers would qualify, since they depict girls or young women wearing either fanciful costumes or typical seventeenth-century dress. The pale blue cloak around the shoulders of the young woman in the Wrightsman portrait is much closer to what generally is associated with antique or classic clothing.

One hundred and twenty years after the Amsterdam sale, the picture appears to have been sold in an auction held in Rotterdam (*Catalogue d'une belle collection de tableaux, recuillie avec soin depuis plusieurs années par un Amateur à Rotterdam*, April 20–22, 1816, p. 26; according to Frits Lugt, *Répertoire des catalogues de ventes publiques 1600–1825*, The Hague, 1938, I, no. 8868, the anonymous "Amateur" was a certain Dr. Luchtmans). Lot 92 of this sale was listed as a painting by "J. van der Meer de Delft; Haut 17 pouces, large 15 pouces; Toile. Le Portrait d'une jeune personne." These measurements correspond almost exactly to those of the Wrightsman Vermeer.

The painting was acquired by Prince Auguste d'Arenberg sometime before 1829, when it was published for the first time (Anonymous, *Lithographies d'après les principaux tableaux de la collection de S.A.S. Monseigneur le prince Auguste d'Arenberg, avec le catalogue déscriptif*, Brussels, 1829, p. 10, no. 53). It remained in the possession of the Arenberg family until the early 1950s. During World War I the picture was transferred from the Arenberg residence in Brussels to Schloss Meppen, Germany (Vanzype, 1921, p. 71, pl. XXXIII). Since it was not accessible to scholars after the war, some writers mistakenly reported that it had been lost. It was acquired by Mr. and Mrs. Wrightsman in New York in 1955.

THIS EXQUISITE portrait is a rather unusual work for Vermeer. Although many of his genre paintings contain portraits, the people represented are shown on a small scale in interior settings. By contrast the Wrightsman Vermeer is an almost life-size portrait of a beguiling individual isolated against a neutral background. It is a pure portrait, restricted to the head and bust, unencumbered by the domestic furnishings seen in so many of Vermeer's works. It is remarkable for its simplicity, the extraordinary beauty of its coloring, the subtle turn of the head, and the wistful, hesitant smile.

Within Vermeer's oeuvre there are only three other portraits to compare with the Wrightsman picture: a pair of tiny portraits in the National Gallery of Art, Washington, D.C. (Figs. 2, 3) and a nearly life-size painting in the Mauritshuis, The Hague (Fig. 4). Like the Wrightsman painting, each of these pictures is a bust-length portrait of a single female sitter. However, the paintings in Washington are less closely related to the Wrightsman portrait than is the painting at The Hague. The Washington pictures, for example, are on small wood panels rather than canvas. Since the two Washington portraits have nearly identical dimensions, they probably were painted as a pair: the light falls from the same direction, and they have similar furnishings—the familiar Vermeer lion-back chairs and tapestries. The rich handling of paint in them also differs from the even finish of the Wrightsman portrait. In the Washington pictures the paint is applied with heavy globules of saturated pigment, with abrupt contrasts of light and shadow. The Portrait of a Girl at The Hague (Fig. 4), on the other hand, is more closely related to the Wrightsman painting. It is on canvas and has nearly the same size and format. Portrayed against a plain dark background, the girl is painted with the same even modeling and subdued coloring as the Wrightsman portrait. Moreover, both The Hague and Wrightsman portraits bear the same peculiar abbreviation of Vermeer's signature: the monogram of his initials "IVM" and the letters "eer."

Thoré-Bürger (1866, p. 545), the French critic who rediscovered Vermeer over a century ago, compared the Wrightsman portrait to "la prestigieuse *Joconde*, de Léonard." Though Vermeer, of course, never saw the Mona Lisa, his portrait does possess something of the mysterious effect of Leonardo's masterpiece. He has captured the same

2. *Johannes Vermeer, Girl with a Red Hat. Oil on wood, 23.0 by 18.0 cm. Washington,* D. C., *National Gallery of Art, Mellon Collection*

OPPOSITE:
4. *Johannes Vermeer, Portrait of a Girl. Oil on canvas, 46.5 by 40.0 cm. The Hague, Mauritshuis. Photo: A. Dingjan*

3. *Johannes Vermeer, Girl with a Flute. Oil on wood, 20.0 by 18.0 cm. Washington,* D. C., *National Gallery of Art, Widener Collection*

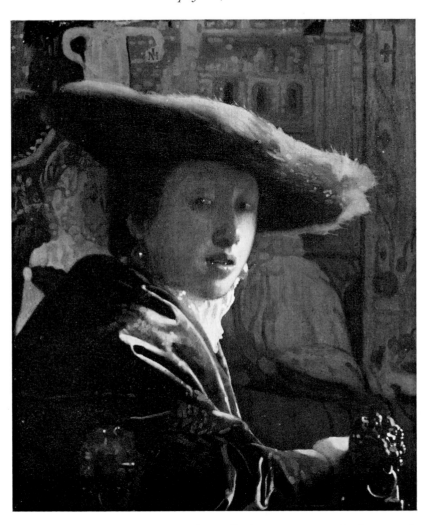

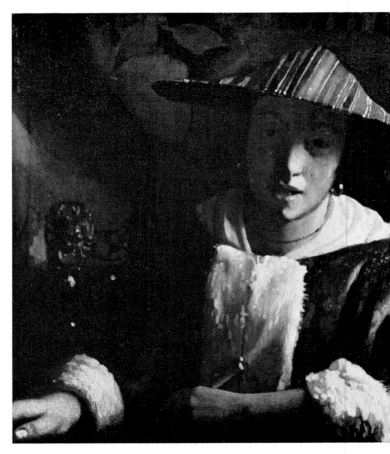

curious quality of light passing into shadows with almost imperceptible transitions. It is a mild and diffuse light, forming glowing accents on the pearl earring and the highlights of the dress, enhancing the cool mother-of-pearl tonality of the colors. It is as if the head were caught in a ray of moonlight.

Leonardo is also suggested by the gentle expres-

sion of the eyes. They penetrate the spectator with almost hypnotic insistence. The more one looks at the painting the deeper one's impression grows of the subtle and intimate spiritual qualities of the young woman Vermeer has painted so sympathetically.

The fragile quality of the woman's head in the Wrightsman painting is emphasized by the muted

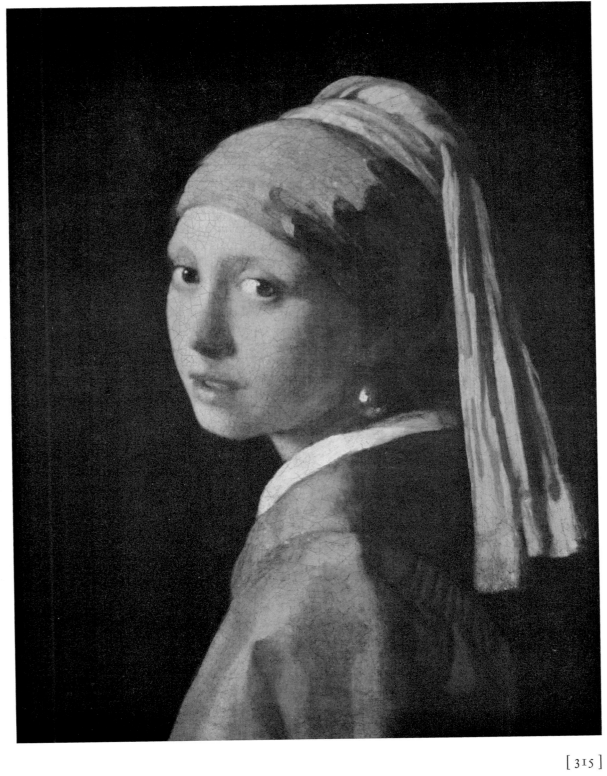

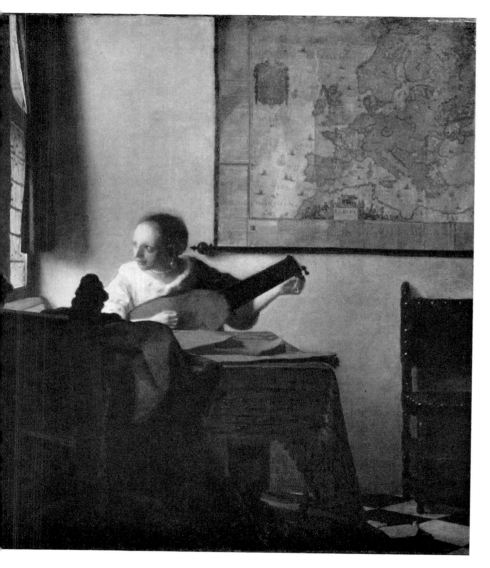

5. *Johannes Vermeer, Lute Player. Oil on canvas, 51.5 by 45.7 cm. New York, The Metropolitan Museum of Art, bequest of Collis P. Huntington, 25.110.24*

The design of the Wrightsman portrait has a kind of classical stability, recalling the relaxed composure of Raphael's Portrait of Baldassare Castiglione, in the Louvre. Vermeer has masterfully centered the pearl-shaped head of his sitter, framing it with the cloth falling from the head and the crumpled garment gathered around the shoulders and back. These folds of cloth, arranged in gentle diagonal patterns, create an almost architectural stability for the head, like the setting for a jewel.

Because of the muted tonality of its colors and the balanced structure of its design, the portrait can be dated toward the end of the 1660s. The single dated picture of this period, the Astronomer (1668) in the Rothschild Collection, Paris, displays the same classical style. Although it represents a small figure in an interior setting, all the elements of the composition are arranged to give the maximum impression of geometric order and clarity. The paint surface is delicate, thin, and evenly balanced. The colors, though necessarily more varied than those in the Wrightsman portrait, possess a similar muted character.

Recognizing the late date of the picture, several writers have suggested that perhaps the sitter was one of Vermeer's eleven children. Vermeer married in 1653 and stopped painting about nineteen years later, three years before he died. It would be difficult to assign a precise age to the sitter in the Wrightsman portrait, but it is conceivable that she could be in her late teens. She appears to be the same person Vermeer portrayed in the Lute Player (Fig. 5), in The Metropolitan Museum of Art. Although the latter is a very small figure, her features are similar. The same girl also seems to be represented in Vermeer's painting of A Lady Writing (Fig. 6), in the National Gallery of Art, Washington, D.C. (inv. no. 1664).

The Wrightsman portrait is unusual not only for Vermeer but also for seventeenth-century Dutch painting in general. Its radiant light and utter simplicity have no parallel in the work of any of Vermeer's contemporaries. In a generic

colors Vermeer used, the pervading bluish tone combined with soft yellow and grays. The colors, moreover, are thinly applied. In contrast to the richly painted works of Vermeer's early career, the Wrightsman portrait displays great delicacy and restraint, even in the handling of paint.

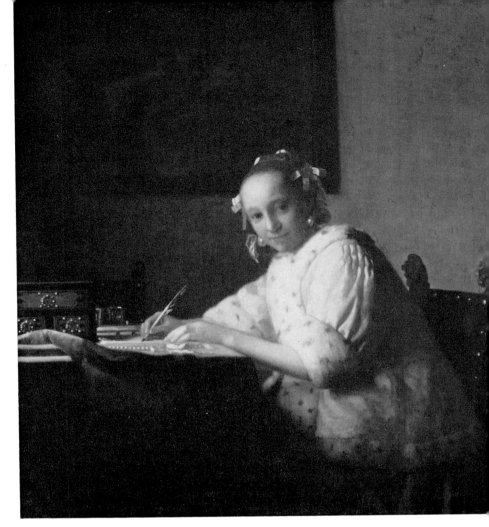

6. *Johannes Vermeer, Lady Writing. Oil on canvas, 46.0 by 36.0 cm. Washington, D. C., National Gallery of Art, gift of William Waldron Havemeyer and Horace Havemeyer, Jr., in memory of their father, Horace Havemeyer*

sense, however, it relates to fancy dress pictures, a type of painting popularized in Holland by Rembrandt and his circle. Fancy dress pictures portray the sitter in exotic costumes that appealed to the romantic imagination of the artist's contemporaries. Typical of this type of picture are Rembrandt's portrait of a man in Oriental costume, known as the Noble Slav, in The Metropolitan Museum of Art, and Govaert Flinck's Portrait of Saskia as a Shepherdess, in the Herzog Anton Ulrich Museum, Brunswick. Vermeer's portrait in the Wrightsman Collection belongs to this tradition, in that the sitter does not wear the contemporary seventeenth-century Dutch costume one would expect to see in a straightforward portrait. The classical draperies around her shoulders set her apart from the everyday world depicted in so many of Vermeer's genre scenes.

The Wrightsman Vermeer brings to mind the portraits of the Flemish painter Michael Sweerts (1624–1664). Sweerts had studied in Rome for about a decade, and under the influence of the Dutch *bamboccianti* and the Italian baroque masters he evolved a portrait type that seems to anticipate the style and format of the Wrightsman Vermeer. The relationship may not be entirely fortuitous, since Sweerts worked briefly in Holland about 1660–1661, roughly six or seven years before the probable date of the Wrightsman portrait. Sweerts's Portrait of a Boy (Fig. 7) in the Wadsworth Atheneum, Hartford, Connecticut, possesses much of the luminous quality of the Wrightsman portrait. Its clear colors, transitory pose, and wistful expression might well have appealed to the great Delft master.

7. *Michael Sweerts, Portrait of a Boy. Oil on canvas, 36.9 by 29.2 cm. Hartford, Connecticut, Wadsworth Atheneum, Ella Gallup Sumner and Mary Catlin Sumner Collection*

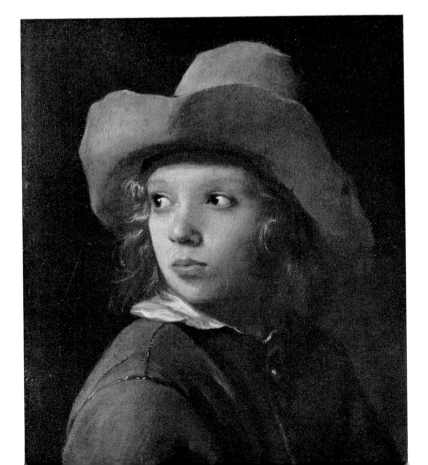

VERSIONS: A poor copy of the Wrightsman portrait appeared on the German art market in 1964. Its present whereabouts is unknown. It may be the same picture recorded by De Vries (1939, p. 84) as a mediocre modern variant of the Wrightsman portrait.

EXHIBITED: Düsseldorf, *Kunsthistorische Ausstellung*, 1904, catalogue no. 398; The Metropolitan Museum of Art, New York, June—November 1955, April—October 1957, May —October 1967; National Gallery of Art, Washington, D.C., May—November 1956; Mauritshuis, The Hague, *In Het Licht van Vermeer*, June—September 1966, catalogue no. VI (illustrated); Orangerie des Tuileries, Paris, *Cinq Siècles de peinture: Dans la lumière de Vermeer*, September—November 1966, catalogue no. VII (illustrated).

REFERENCES: Anonymous, *Lithographies d'après les principauz tableaux de la collection de S.A.S. Monseigneur le prince Auguste d'Arenberg, avec le catalogue descriptif*, Brussels, 1829, p. 10, catalogue no. 53 (briefly describes the painting and lists its height as 17 pouces, its width as 14 pouces) // Étienne Joseph Théophile Thoré (alias William Bürger), *Galerie d'Arenberg à Bruxelles avec le catalogue complet de la collection*, Paris—Brussels—Leipzig, 1859, pp. 31, 34–36, 140, catalogue no. 35 (identifies six works by Vermeer, one of them the painting now in the Wrightsman Collection, which he compares with certain paintings by Rembrandt and Correggio) // Gustave Friedrich Waagen, *Handbook of Painting: The German, Flemish, and Dutch Schools*, London, 1860, II, p. 352 (and again in the French edition *Manuel de l'histoire de la peinture: écoles allemande, flamande et hollandaise*, M. Hymans and J. Petit, trans., Brussels—Leipzig—Ghent, 1864, III, p. 28) (observes that the portrait is life-size and that it is admirable for its *sfumato* effect) // Charles Blanc, *Histoire des peintres de toutes les écoles: école hollandaise*, Paris, 1861, II, p. 4 (lists it as one of ten known works by Vermeer) // Étienne Joseph Théophile Thoré (alias William Bürger), "Les Cabinets d'amateurs à Paris—Galerie de MM. Pereire," in *Gazette des Beaux-Arts*, XVI, April 1864, pp. 313–314 (alludes to the Arenberg portrait as one of six paintings by Vermeer he discovered; he calls it an example of the perfection of the artist's style) // Étienne Joseph Théophile Thoré (alias William Bürger), "Van der Meer de Delft," in *Gazette des Beaux-Arts*, XXI, October 1866, p. 299; XXI, December 1866, pp. 543, 545 (compares it to Leonardo's Mona Lisa; suggests that it might have been no. 38 in the Amsterdam sale of 1696 and that it may have been in the Rotterdam sale of 1816) // Lord Ronald Gower, *The Figure Painters of Holland*, London, 1880, pp. 67, 111 (calls the painting "worthy of Rembrandt") // Henry Havard, *Van der Meer de Delft*, Paris [1888], p. 35, catalogue no. 2 (lists it as an autograph work and states that the girl's hair is worn "à la chi-

noise") // Cornelis Hofstede de Groot, "Johannes Vermeer," in *Die Graphischen Künste*, XVIII, 1895, pp. 20, 22–24 (suggests that it may be of approximately the same date as Vermeer's Portrait of a Girl in the Mauritshuis, because of the similar subject matter and the simplicity of the style) // Theodor v. Frimmel, *Blätter für Gemäldekunde*, Vienna, 1906, II, p. 185 (calls it a mature work dating from between 1660 and 1675) // Cornelis Hofstede de Groot, *Beschreibendes und kritisches Verzeichnis der Werke der hervorragendsten holländischen Maler des XVII Jahrhunderts*, Esslingen, 1907, I, p. 605, catalogue no. 42 (identifies it with no. 39 in the Amsterdam sale of 1696 and states it may have been in Dr. Luchtmans's sale, Rotterdam, 1816, lot 92) // Gustave Vanzype, *Vermeer de Delft*, Brussels, 1908, pp. 10, 41, 42, 52, 67, 96–97, illustrated opp. p. 96 (praises the painting for its realism and proposes that it and The Hague painting may portray two of Vermeer's daughters) // Wilhelm von Bode, *Great Masters of Dutch and Flemish Painting*, Margaret L. Clarke, trans., London, 1909, p. 57 (and again in *Die Meister der holländischen und vlämischen Malerschulen*, Leipzig, 1917, p. 74; Leipzig, 1951 [Eduard Plietzsch, ed.], p. 98; Leipzig, 1958 [Eduard Plietzsch, ed.], p. 98) (dates it, along with The Hague Portrait of a Girl, shortly after 1655, and observes that both show the artist's developed style) // Cornelis Hofstede de Groot, *Jan Vermeer of Delft and Carel Fabritius*, Ada E. H. Wyche, trans., Amsterdam, 1909, pp. 22–23, 30, pl. 29 (places the picture, along with the Portrait of a Girl in the Mauritshuis and the Portrait of a Woman at Budapest, between the early compositions with life-size figures and the later small figure paintings; he finds the sitter less attractive and the composition less impressive than those of the Hague painting) // Alfred von Wurzbach, *Niederländisches Künstler-Lexikon*, Vienna, 1910, II, p. 776 (lists it in a catalogue of works by Vermeer) // Eduard Plietzsch, *Vermeer van Delft*, Leipzig, 1911, pp. 57–58, 115, pl. XV (calls it an early work, painted shortly before the Portrait of a Girl at The Hague, and finds the face abstracted and the lighting a little theatrical) // Baron N. N. Wrangel, "Jan Vermeer of Delft" [in Russian], in *Apollon*, 1911, p. 8, illustrated opp. p. 10 (describes the painting and comments on the life-like rendering of the features, especially the lips) // Georges Dreyfous, *L'Oeuvre de Jan Vermeer de Delft*, Paris, 1912, p. 29 (lists the painting under portraits in his catalogue of Vermeer's works) // Philip L. Hale, *Jan Vermeer of Delft*, Boston, 1913, pp. 240, 242, 333–334, 358, 371, 372, illustrated opp. p. 232 (alludes several times to the painting, remarking upon the subtlety of its modeling; dates it and the painting at The Hague quite late because of their technical accomplishment and the probability that they depict Vermeer's daughters) // Georg Jacob Wolf, "Jan Vermeer van Delft," in *Westermanns Monatshefte*, CXIX, Part 1, September 1915, pp. 65–75, illustrated p. 70 (links the Wrightsman and Mauritshuis portraits with Ver-

meer's early works) // Max Eisler, "Der Raum bei Jan Vermeer," in *Jahrbuch der Kunsthistorischen Sammlungen des Allerhöchsten Kaiserhauses*, XXXIII, 1916, pp. 240–241 (compares the pose and treatment of space in the Wrightsman picture to that in Vermeer's Portrait of a Girl in the Mauritshuis and the Mistress and Maid in the Frick Collection, acc. no. 19.1.126) // A. E. Gallatin, *Vermeer of Delft* [privately printed], 1917, unpaginated (gives incorrect dimensions for the painting and states that it is less fine in quality than The Hague picture) // P. Johansen, "Jan Vermeer de Delft, à propos de l'ordre chronologique de ses tableaux," in *Oud-Holland*, XXXVIII, 1920, pp. 195, 197, 198 (considers it to be a pendant to The Hague Portrait of a Girl and dates them both about 1665–1667) // Gustave Vanzype, *Jan Vermeer de Delft*, Brussels, 1921, pp. 7, 31, 67, 69, 71, pl. XXXIII (rejects the proposal that it was in the Amsterdam sale of 1696, but does agree that it was in the Luchtmans sale of 1816) // Edward Verrall Lucas, *Vermeer of Delft*, London, 1922, pp. 26, 31, 43 (states that if the Wrightsman painting represents one of Vermeer's daughters it must have been painted in 1670 or later; mentions having seen it in a bad state of preservation "so cruelly treated by time . . . a mass of cracks") // Benno Reiffenberg and Wilhelm Hausenstein, "Vermeer van Delft," in *Das Bild Atlanten zur Kunst*, X, 1924, pp. 24, 27, pl. 23 (date it about 1668 and suggest that it is later than The Hague painting) // Wilhelm von Bode, "Kunsthistorische Ausbeute aus dem deutschen Kunsthandel von Heute: Jan Vermeer van Delft," in *Repertorium für Kunstwissenschaft*, XLVII, 1926, p. 251 (compares it in type to the Smiling Girl [now in the National Gallery of Art, Washington, D. C., inv. no. 55]) // Jean Chantavoine, *Ver Meer de Delft*, Paris, 1926, pp. 36, 44, 47, 59, 103 (places it, along with Vermeer's other portraits, about 1660 or a little later; suggests that the Wrightsman painting was a study for a small genre painting such as the Lute Player in The Metropolitan Museum of Art) // Edward Verrall Lucas, *Vermeer the Magical*, London, 1929, p. 45 (proposes that, if it represents Vermeer's third daughter, it then must date from the last years of his life) // Wilhelm R. Valentiner, "Zum 300. Geburtstag Jan Vermeers, Oktober 1932, Vermeer und die Meister der holländischen Genremalerei," in *Pantheon*, X, October 1932, pp. 323, 324 (associates it with the style of the Girl with a Wine Glass, in the Gemäldegalerie, Brunswick, and dates it a little after 1658) // Arsène Alexandre, "Vermeer et l'école de Delft. Nouveaux aperçus sur Vermeer," in *L'Art et les Artistes*, no. 134, February 1933, p. 164 (believes that it represents one of Vermeer's daughters because of the physical resemblance to figures he feels are the wife, and because of the affection with which it was painted) // Philip L. Hale, *Vermeer*, Boston—New York, 1937, pp. 51, 106, 134, 135, 182, 227, pl. 41 (remarks that it has an "intensity of expression that is almost mystical"; suggests that its pendant may be the Smiling Girl

in the National Gallery of Art, Washington, D.C., inv. no. 55; reports that "its modeling lacks firmness and the paint quality is unattractive") // Frithjof Willem Sophi van Thienen, *Vermeer*, Amsterdam, 1939, illustrated p. 26 // Ary Bob de Vries, *Jan Vermeer van Delft*, Amsterdam, 1939, pp. 9, 42–43, 84, catalogue no. 18, pl. 44 (and in the revised English edition, Robert Allen, trans., New York, 1948, pp. 13, 38, 86, pl. 15; and the French edition, Paris, 1948, p. 40, and p. x of the catalogue, pl. 15) (dates it about 1660; calls it "lacking in charm and refinement" but considers the treatment of light to be "very effective"; notes that the painting has not been seen by any professional connoisseur since 1914; mentions that "a mediocre modern version was at one time on the market") // Eduard Plietzsch, *Vermeer van Delft*, Munich, 1939, pp. 28, 33, 62, 64, catalogue no. 35, fig. 27 (places it after 1665 and considers it to be later than The Hague picture; describes the sitter's expression as "fast ein wenig lasziv") // Thomas Bodkin and Ludwig Goldscheider, *The Paintings of Jan Vermeer*, New York, 1940, pp. 12, 13, pl. 29 (include it in a catalogue of Vermeer's works) // Anonymous, *National Gallery of Art: Preliminary Catalogue of Paintings and Sculpture*, Washington, D.C., 1941, p. 209 (alludes to it in the catalogue entry for the Smiling Girl [a picture of doubtful authenticity catalogued as an original]) // M. Mir, *Jan Vermeer de Delft*, Buenos Aires, 1942, pl. 36 // André Blum, *Vermeer et Thoré-Bürger*, Geneva, 1945, pp. 26, 30, 63, 120, 140, 158, no. 2, 198, catalogue no. 19, illustrated on page preceding p. 65 (suggests that it reflects the influence of Rembrandt and dates it about 1660) // P. T. A. Swillens, *Johannes Vermeer: Painter of Delft 1632–1675*, C. M. Breuning-Williamson, trans., New York, 1950, pp. 62, 105–106, 154, catalogue no. 29, pl. 29 (lists the painting under "doubtful attributions" because he had not seen it for many years and believed it to be "in such a bad state, that it precludes any well-based opinion"; discounts the possibility that it portrays one of Vermeer's daughters and doubts that it was in the Amsterdam sale of 1696) // André Malraux, ed., *Vermeer de Delft*, Paris, 1952, pp. 119, 120, illustrated p. 119 (considers the painting to have disappeared and mistakenly writes that it was no longer in the Arenberg Collection) // Lawrence Gowing, *Vermeer*, London, 1952, pp. 77, 78, 134, 138, catalogue no. XVII, pl. 41 (notes that it and The Hague picture are "possibly among nos. 38, 39 and 40" in the 1696 sale; dates it 1664 along with A Young Lady with a Necklace, in the Kaiser Friedrich Museum, Berlin; observes that the "deep and narrow concave folds [of the drapery in the picture] are one of the very few deliberately rythmical passages of drawing in the painter's work as we know it") // Paul Fierens, *Jan Vermeer de Delft*, Paris, 1952, pl. 36 (dates it about 1660) // Vitale Bloch, *Tutta la pittura di Vermeer di Delft*, Milan, 1954, p. 33, pl. 46 (and in the English translation by Michael Kitson, *All the Paintings of Jan Vermeer*, New York, 1963,

[319]

pp. 33–34, pl. 46) (places it between 1660 and 1665) // Erik Larsen, "News and Views of Art in America," in *Apollo*, LXII, August 1955, p. 56 (states that the Wrightsmans had recently acquired the painting and that it was currently on exhibition at the Metropolitan Museum) // Erik Larsen, "The d'Arenberg Vermeer Redivivus," in *Apollo*, LXII, October, 1955, pp. 102–104, illustrated p. 102 (calls it "an uncontested technical masterpiece . . . in marvelous shape"; proposes that Indonesian art may have influenced Vermeer in the serenity and aloof withdrawal of the painting) // Anonymous, "No Biz like Art Biz," in *Time Magazine*, LXVI, December 5, 1955, p. 88, illustrated p. 91 (mentions the price the Wrightsmans reputedly paid for the picture) // Helen Comstock, "The Connoisseur in America," in *The Connoisseur* (American edition), CXXXVI, January 1956, pp. 307–308, illustrated p. 308 (reports that it had not been exhibited for fifty years; says it is "preserved in excellent condition" and calls it the most luminous of Vermeer's works, observing that "the head and shoulders project forward sharply, as though from a window") // Cyril Connolly, "Style Rococo," in *Art News Annual*, XXVI, 1957, p. 122, illustrated p. 122 hanging on a wall in the Wrightsmans' house in Palm Beach (dates it about 1660) // Ludwig Goldscheider, *Jan Vermeer: The Paintings*, London, 1958, pp. 37, 39, 141–142, catalogue no. 33, pl. 76 (states that it is among three paintings by Vermeer with a dark background; considers it to be a very late work of about 1671, and asserts that it was in neither the 1696 sale nor the 1816 sale of Dr. Luchtmans) // Alfred Frankfurter, "Midas on Parnassus," in *Art News Annual*, XXVIII, 1959, p. 42, illustrated p. 42 (mentions the price the Wrightsmans paid for the painting when it was purchased in 1955) // Edith Greindl, *Jan Vermeer*, Milan, 1961, pl. 26 // Germain Seligman, *Merchants of Art: 1880–1960, Eighty Years of Professional Collecting*, New York, 1961, pp. 240–245 (outlines the history of the picture, describes its sale to the Wrightsmans, and reports that it was given "a light cleaning" in Mr. Seligman's gallery in New York under his personal supervision) // Lawrence Gowing, *Johannes Vermeer*, London, 1961, p. 33, catalogue no. 83, illustrated p. 83 (and in the American edition, New York, 1962, p. 84, illustrated p. 64) (catalogues it as being in the Wrightsman Collection) // Charles Seymour, Jr., "Dark Chamber and Light-filled Room: Vermeer and the Camera Obscura," in *The Art Bulletin*, XLVI, September 1964, p. 329 (proposes that it was no. 38 in the 1696 sale and that nos. 39 and 40 were the Girl with the Red Hat and the Girl with a Flute in the National Gallery of Art, Washington, D.C., inv. nos. 53 and 694; suggests that all three paintings are "slightly disguised costume pieces," among his first experiments with the *cubiculum*, dating as early as 1660) // Pierre Descargues, *Vermeer*, James Emmons, trans., Geneva, 1966, p. 132 (includes it in a chronologically arranged cata-

logue of Vermeer's works, placing it immediately after the Portrait of a Girl at The Hague, which he explicitly dates about 1665) // Ary Bob de Vries, *Cinq Siècles de peinture: Dans la lumière de Vermeer*, exhibition catalogue, Paris, 1966, no. VII, illustrated opp. catalogue entry (remarks that Vermeer is more a portraitist in this painting than in any other, and dates it about 1663–1665) // Benedict Nicolson, "Vermeer and the Future of Exhibitions," in *The Burlington Magazine*, CVIII, August, 1966, p. 397 (alludes to it as a rarely seen Vermeer and describes it as "damaged, disagreeable, but authentic") // Ary Bob de Vries, *Vermeer*, New York—Toronto, 1967, pp. 22–23, color pl. 22 (places it about 1667–1668 and notes the model's physical resemblance to the Young Lady Writing, National Gallery of Art, Washington, D.C., inv. no. 1664) // Horst Gerson, "Vermeer," in *Encyclopedia of World Art*, New York, 1967, XIV, col. 743 (mentions the Wrightsman and Mauritshuis portraits together and says that in both "there is no clear delimitation of space; the colors are incredibly pure and the soft skin is unbelievably delicate; the eyes of the two girls catch the light, as do the pearl earrings they wear") // Piero Bianconi, *The Complete Paintings of Vermeer*, New York, 1969, p. 92, catalogue no. 23, color pl. XXXIV (dates it about 1660–1665 and says that it "has been spoiled by cleaning") // Denys Sutton, "Pleasure for the Aesthete," in *Apollo*, XC, September 1969, p. 230, illustrated p. 230 (calls it a "masterpiece of enigmatic understatement") // Lawrence Gowing, *Vermeer*, 2nd ed., London, 1970, pp. 77, 78, 134, 138, pl. 41 (amends the 1952 edition of his monograph with the comment that both this portrait and the Concert in the Gardner Museum, Boston, "were previously dated too early") // Daniel A. Fink, "Vermeer's Use of the Camera Obscura—A Comparative Study," in *The Art Bulletin*, LIII, December 1971, pp. 493, 498, 502 (observes that the highlights in the eyes and pearl are similar to those in the Girl with a Flute and the Girl with a Red Hat, in the National Gallery of Art, Washington, D. C., inv. nos. 53 and 694, and that in all three pictures the camera obscura was focused on a plane immediately behind the girl's head).

Oil on canvas, H. 17½ (44.5); W. 15¾ (40.0).

The picture was cleaned and treated in New York in 1952 by Alain Boissonnas. Contrary to the assertions of Lucas (1922, p. 31), Nicolson (1966, p. 397), Bianconi (1969, p. 92), and others, it was found to be reasonably well preserved. It underwent extensive technical examinations in the laboratory of the Metropolitan Museum in 1955, when an X-ray (Fig. 8) was made, and again in 1970. The X-ray reveals not only that there are very few paint losses but also that the paint surface was built up with the same solid technique as other autograph Vermeers (compare for example the X-ray of the Portrait of a Girl in the Mauritshuis, reproduced by

Gowing, 1952, text fig. 31). The picture has suffered, however, from surface abrasion. Microscopic examinations show that the best-preserved parts of the picture are the darker areas of the mantle, which still retains much of its final coats of blue glazing.

Because of its age, the paint has developed a rather pronounced craquelure covering the entire surface of the picture. This pattern of fine cracks is clearly visible in photographs of the picture before restoration, for example those reproduced by Vanzype (1921, pl. XXXIII) and Gowing (1952, pl. 41).

There is a narrow band of dark paint along the left border of the painting. Microscopic examination of the pigment in this area suggests that it is discolored, perhaps because it was once covered by a frame along this side. At first glance, however, the discolored left border might be construed as a *trompe l'oeil* shadow of the frame. Such a device has been a common trick with portrait painters since the time of Corneille de Lyon (about 1520–about 1564), and it does appear in certain paintings by Rembrandt's followers. But in the Wrightsman Vermeer this effect is definitely unintentional.

8. *X-ray of the painting*

ANTOINE VESTIER (1740–1824) was active in Paris during the last quarter of the eighteenth century as a miniaturist and portrait painter. He was born in Avallon, Bourgogne, the son of a local merchant. By 1760 he had moved to Paris, where he was employed by a *maître émailleur* named Révérand. He married Révérand's daughter in 1764 and was registered the same year as being "Élève de l'Académie Royale de Paris." Among his earliest known works are a pair of miniatures, dated 1766, of himself and his wife (now in the Louvre). Executed in a rather tight and dry manner, they reflect the influence of Vestier's early training in enamel decoration. Stylistically they are also related to the miniatures of the Swedish artist Peter Adolf Hall (1739–1793).

In 1776 Vestier traveled to England and visited William Peters (1742-1814), the English miniaturist. The trip acquainted him with the work of the leading English portrait painters of the period. About this time, Vestier became a student of Jean-Baptiste-Marie Pierre (1713–1789), the important French artist who was then *premier peintre du Roi* and *directeur* of the Académie. Pierre specialized in large mythological and historical subjects, which seem to have had little influence on Vestier, who devoted himself exclusively to portrait painting.

During the late 1770s, Vestier evolved a style close to those of Joseph Siffred Duplessis (1725–1802) and Jean-Baptiste Greuze (1725–1805). He used a cool palette dominated by white, black, and grays, evenly applied in a slick, enamel-like surface. He exhibited in the Salon de la Correspondance from 1782 until 1785, when he was presented by Duplessis as a candidate for the Académie Royale de Peinture et de Sculpture. He was accepted as a member in September 1786, with portraits of the academicians Doyen and Brenet, now in the Louvre.

Like many French portrait artists during the reign of Louis XVI, Vestier displayed great virtuosity in painting different textures, particularly silks, satins, laces, and thin veils. While his portraits are perhaps more direct and honest than Nattier's flattering portraits of the court of Louis XV, they are never very profound character studies. He avoided any deep psychological study of his sitters, preferring to record only their outward appearance.

With the advent of the Revolution and the overwhelming popularity of Jacques Louis David (1748–1825), Vestier's style underwent a marked change. His compositions became simpler and his handling of paint much looser. He placed less emphasis on the rendering of sumptuous garments and more on the character of the sitter. Two of his finest portraits were painted at this time, those of Jean Theurel, in the Musée des Beaux-Arts, Tours, and of Jean Henri Latude, in the Musée Carnavalet, Paris, both dated 1789.

Throughout his life Vestier painted portraits of the members of his family, often exhibiting them at the Salon. In 1795 he painted Mme Nicolas Vestier and Her Child in an engaging manner reminiscent of Marie Louise Élisabeth Vigée-Lebrun (1755–1842).

His popularity declined after 1790, and he was paid very little for the few commissions he received. He continued, however, to exhibit both oil portraits and miniatures in most of the Salons through 1806.

Due, apparently, to failing eyesight and his total eclipse by the younger generation of portrait painters, he was virtually inactive during the last eighteen years of his life.

33 Portrait of Eugène Joseph Stanislas Foulon d'Écotier

IN AN OVAL format a young man is portrayed to the waist. He faces the viewer and rests his left elbow and forearm on a wooden table or shelf. His right arm falls to his side. He wears a heavily powdered wig with curls over each ear and at the nape of the neck. Contrasting with his pale complexion are his dark brown eyes and black eyebrows.

His greatcoat and waistcoat are made of a shiny black satin material trimmed with matching round black satin buttons. He wears a white stock with a short white lace ruff and a double white lace cuff at his left wrist. A light film of powder has fallen from his wig onto the shoulder of his greatcoat.

Behind the sitter is a plain gray wall and a brown wooden bookcase with two shelves visible. The lower shelf holds what appears to be a brass bell and a brass inkwell with a white quill pen (Fig. 4). Behind the inkwell is a book with a brown leather binding. The red band on the binding is inscribed in gold lettering: ORDON [NANCES] / DE LA / MARIN[E]. To the left of the book is a white pamphlet entitled MEMOIR[E]. It bears many lines of illegible, dark gray printing and a decorative cartouche at the top. In back of the book and pamphlet stands a large box with the letters ME printed on the lid. Lying on top of it are some sheets of white paper, one bearing illegible script and a red wax seal at its lower edge. On the upper shelf several more papers are piled.

The sitter holds in his left hand a partially rolled white map (Fig. 2) inscribed in dark gray lettering: CARTE REDUITE DES ISLE . . . / LA GUADELOUPE / MARIE GALANTE ET LES SAINT . . . / DRESSÉ AU DEPON DES PL . . . / POUR LE SERVICE DE . . . / PAR ORDER DE M. BEH. . . .

The map is signed and dated in a small cartouche: *vestier* / *pinxit—* / *1785*.

PROVENANCE: The painting was formerly in a private collection in Paris. It subsequently belonged to an unidentified London art dealer, who offered it for sale in an auction at Sotheby's on March 24, 1965, lot 84 (as a portrait by Vestier of Monsieur Foulon d'Écotier, Governor of Guadeloupe). It was acquired by Mr. and Mrs. Wrightsman at this sale.

IN 1785, the year Vestier became a candidate for membership in the Académie Royale de Peinture et de Sculpture, he signed and dated the present portrait. Two years later, he exhibited it in the Salon of the Académie. The painting is listed under no. 148 in the 1787 Salon catalogue as a portrait of "M.xxx en habit de satin noir, tenant en sa main la carte des Isles de la Guadeloupe." It was not heard of again until 1965, when it was offered for sale in an auction as a portrait of M. Foulon d'Écotier, "Governor of Guadeloupe."

In the *Almanach Royal* (Laurent d'Houry, ed., Paris, 1786, pp. 176–177) only two Frenchmen are listed in 1785 as holding posts in Guadeloupe. M. le Baron de Clugny, the Governor, and M. Foulon d'Écotier, the Maître des Requêtes, Intendant. Extensive documentation concerning both men can be found in the Archives Nationales, Paris.

Baron Nicolas Gabriel de Clugny (A. N. folio:

Marine C⁷ 69 [177 pieces]) was born about 1725–1727 and died in 1792. He was appointed Governor of Guadeloupe in July 1783, and arrived in the islands in May of the following year. In his correspondence he complains of having been in Guadeloupe without returning to France from the summer of 1784 until the spring of 1786. This makes it most unlikely that he is the person portrayed in the Vestier portrait, which was painted in Paris in 1785. In addition, the sitter in the portrait is a young man, much younger than Baron Clugny, who would have been nearly sixty years old when the portrait was made.

Eugène Joseph Stanislas Foulon d'Écotier (1753-1821), on the other hand, was named Intendant de la Guadeloupe in June 1785. He left France to assume this post in November 1785. He thus could have sat for Vestier in the summer or early fall. As a young man of thirty-two, he may have wanted to commemorate his new appointment with a portrait. In the 1965 Sotheby sale catalogue, Écotier is called Governor of Guadeloupe, whereas in fact he was only Intendant. The Intendant's position was secondary to the Governor's; he administered taxes and other aspects of the islands' economy. The discrepancy in the sale catalogue may be due to the relative obscurity of the sitter and the wish of his descendants to make him more important than he actually was.

In some ways, Écotier's life paralleled that of the artist who painted his portrait. Both men were modestly successful before the Revolution, and though both tried to adjust to the ideals of the new regime, they soon were superseded by younger men. Plagued with financial problems, they lived on through the first two decades of the nineteenth century.

Écotier was the son of the Intendant Général des Finances of France (A.N. folio: Colonies EE 950 [539 pieces]). He began his career in 1772, serving as Conseiller au Châtelet in Paris. After receiving the position of Conseiller à la cour des aides de Paris in 1775, he was made Maître des Requêtes for Parlement in 1776. Finally, in June 1785, the Maréchal de Castries appointed him Intendant de la Guadeloupe. At this time the islands in the French Antilles were under the jurisdiction of the Ministère de la Marine. Their administrators were directly responsible to the Maréchal de Castries, the Ministère de la Marine under Louis XVI.

Écotier served as Intendant in Guadeloupe continuously from 1785 to 1791, except for a short period in 1786 when he was made interim Intendant in Martinique. In 1789 there was a small revolution in Guadeloupe in reaction to the one taking place in France. Écotier, joining the patriots rather than the landowners, was eventually forced to give up his post. He returned to France in 1791 and requested that his post be renewed in service to the Republic. Although liberated by the Tribunal Révolutionnaire in 1793, he spent eighteen months in jail during the Terreur. Under Napoleon he renewed his request for a post in the French Antilles, this time declaring his loyalty to the Empire, but he was again refused. Finally, in 1815 he wrote to Louis XVIII and the Duchesse d'Angoulême requesting his old post and at long last, in 1816, returned to Guadeloupe as Intendant. He was recalled, however, in September 1817, because of misappropriation of tax funds. Returning to France, he declared himself bankrupt. He pleaded with the Ministère de la Marine for retirement pay and was awarded a pension by order of the king in July 1820. He was posthumously awarded the Cross of St. Louis in January 1822.

The portrait, painted before this troubled career began, contains references to Écotier's new appointment. The book on the shelf (Fig. 4), for instance, is one he would need in his work. Entitled ORDON[NANCES] DE LA MARIN[E], it contains regulations for administering French colonies. Next to the book is a report entitled MEMOIR[E]. It might possibly be the important *mémoire* given to Baron Clugny by the Maréchal de Castries when he was named governor. Dated March 20, 1784, it contained instructions concerning all the branches of the administration of Guadeloupe and its dependent islands (Auguste Lacour, *Histoire de la*

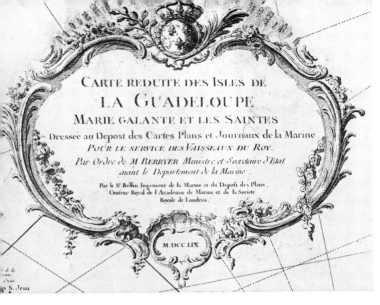

1. *Detail of Figure 3: cartouche on map of Guadeloupe*

RIGHT:
2. *Detail: map of Guadeloupe, signature, and date*

3. *Map of Guadeloupe, Paris, chez Bellin, 1759. Engraving, hand-colored, 58.5 by 86.5 cm. New York Public Library, Ford Collection, Map Division*

Guadeloupe 1635–1789, Basse-Terre [Guadeloupe], 1855, I, p. 361). The most obvious allusion to Écotier's new assignment is the map he holds (Fig. 2). It covers the territory under his jurisdiction: the large island of Guadeloupe, the smaller island of Marie Galante, and the cluster of tiny islands called Les Isles des Saintes. The actual map Vestier has shown (Fig. 3) was published by Bellin in Paris in 1759. Vestier faithfully copied the cartouche of this map (Fig. 1), reproducing every detail except the Roman numerals of the date, for which he substituted his own name and the date of the portrait.

The books and map thus inform us about the

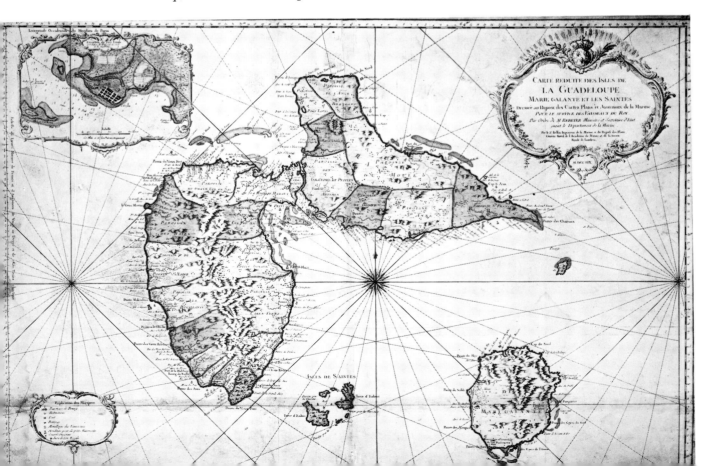

4. *Detail: still life in the background*

sitter's occupation. Vestier often included such objects in his portraits. When he painted Jean Henri Riesener, *ébéniste ordinaire du Roi*, he depicted him seated beside one of the tables for which he was famous, with his elbow resting on some of his designs for gilt-bronze mounts (Fig. 5). The portrait of Riesener was executed the same year as the one of Écotier, and it is remarkable how closely related they are. The handling of the lace cuffs and powdered wigs are especially similar. The poses of the sitters, with one arm resting on a horizontal surface, are also comparable.

Vestier's clients were occasionally painted as pairs, and it is possible that he painted Écotier's wife. There is a portrait of a woman by Vestier with the same oval format and the same dimensions as Écotier's portrait (Fig. 6). It was sold at the Hôtel Drouot, Paris, on May 21, 1947 (lot 21, pl. III), and its present whereabouts is unknown. The pose of the woman, shown to the waist, holding a rose with her right elbow resting on a table as she faces the viewer, echoes Écotier's pose in reverse. Although it is signed and dated 1787, two years after the date of Écotier's portrait, there is no reason why they could not have been painted as pendants. Not all his paired portraits bear the same dates. Vestier's matching portraits of M. and Mme Bernard de Sarrette, in the Phoenix Art Museum, Phoenix, Arizona, for example, are dated 1788 and 1781, respectively.

EXHIBITED: Académie Royale de Peinture et de Sculpture, Paris, Louvre, Salon, 1787, catalogue no. 148; The Metropolitan Museum of Art, New York, October 1966—October 1971.

REFERENCES: Comte de la Billarderie d'Angiviller, *Explication des peintures, sculptures et gravures, de messieurs de l'Académie Royale*, exhibition catalogue, Paris, 1787, p. 27, catalogue no. 148 [in *Collection des livrets des anciennes expositions*, Paris, 1870] (lists the portrait as "M.xxx en habit de satin noir, tenant en sa main la carte des Isles de la Guadeloupe") // Lanlaire, *Au Salon académique de peinture*, Paris, 1787, pp. 28, 31 (referring to catalogue numbers 141–152 in the Salon, observes "Différens portraits qui font grand honneur à M. Vestier") // Jules Guiffrey, "Table des portraits exposés aux Salons du dix-huitième siècle jusqu'en 1800," in *Nouvelles*

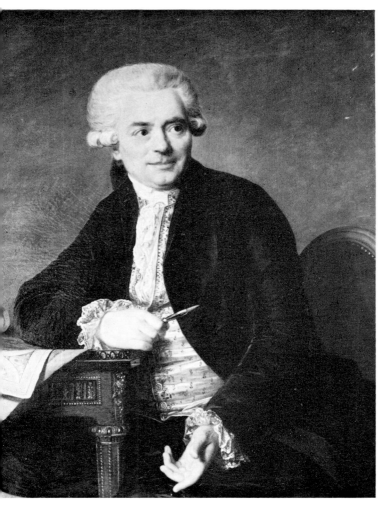

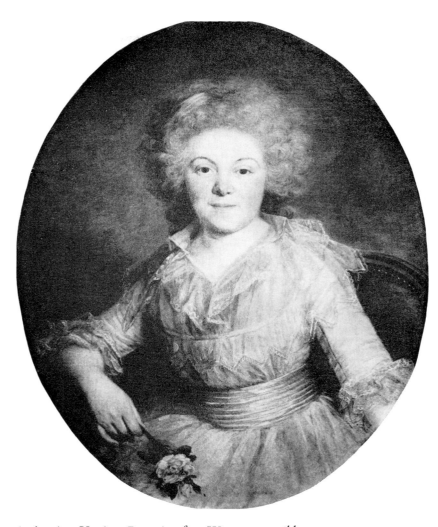

5. *Antoine Vestier, Portrait of Jean Henri Riesener. Oil on canvas, 95.0 by 76.0 cm. Versailles, Musée. Photo: Bulloz*

6. *Antoine Vestier, Portrait of a Woman, possibly Mme Écotier. Oil on canvas, 79.0 by 64.0 cm. Present whereabouts unknown. From sale catalogue, Hôtel Drouot, May 21, 1947*

Archives de l'Art Français, V, 1889, p. 35 (includes the Wrightsman painting in a list of anonymous male portraits exhibited in the Salon of 1787) // Denys Sutton, "Pleasure for the Aesthete," in *Apollo*, XC, September 1969, p. 238, no. 6, illustrated p. 238 (mentions that the map in the portrait is of Marie Galante et Les Saintes in the Guadeloupe Islands and that the 1965 Sotheby sales catalogue identified the sitter while the 1787 Salon catalogue did not).

Oil on canvas, H. 31⅝ (80.3); W. 25⅛ (63.8).

DRAWINGS

CARMONTELLE (Louis Carrogis, 1717–1806) was born and died in Paris. A courtier, poet, and minor artist, he was employed to make sketches of French military officers during the Seven Years War. In 1763 he entered the service of the Duc de Chartres, later Duc d'Orléans, Philippe-Égalité. Until the Revolution he served as the duke's official *lecteur*. He wrote plays and made portrait drawings of many of his aristocratic contemporaries. An organizer of fêtes and musical entertainments, he laid out the gardens of the Parc Monceau, Paris. A prolific draftsman, he often made replicas of his own drawings. He was a charming and not highly inventive draftsman, who habitually inclined to show his subjects in full-length and in profile. The largest collection of his work (encompassing 484 sheets including 561 portraits) belongs to the Musée Condé at Chantilly. They were published in detail by F. A. Gruyer, *Chantilly: Les Portraits de Carmontelle*, Paris, 1902.

34 Portrait of Ange Laurent de La Live de Jully

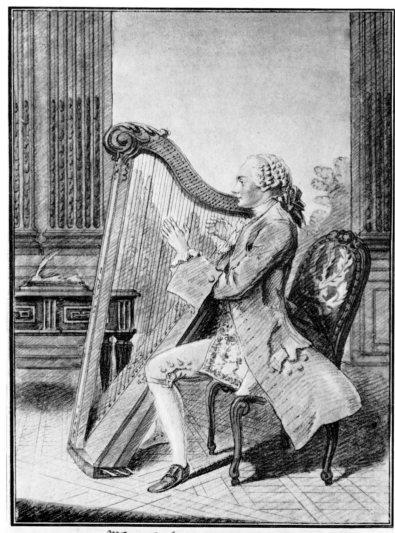

RED, WHITE, and black chalk with pale blue, pink, green, gold, brown, and gray washes on paper: H. 11 15⁄16 (30.4); W. 8⅜ (21.3). Mounted on another sheet of paper: H. 13⅞ (35.2); W. 9⅞ (25.0). Inscribed in black ink on the mount: *Mr. de La Live, introducteur des Ambassadeurs.*

PROVENANCE: Réne Fribourg Collection, New York (sale, Sotheby's, London, October 16, 1963, lot 519). It was acquired by Mr. and Mrs. Wrightsman at this sale.

LA LIVE de Jully (1725–1775) was a diplomat, celebrated collector of paintings, and an amateur musician. A portrait of him by Jean-Baptiste Greuze (1725–1805), exhibited in the Salon of 1759, now is in the Kress Collection of the National Gallery of Art, Washington, D.C. Like Carmontelle's drawing, it shows him seated at a harp. Visible in the background of the painting is

[333]

Mr. de La Live, introducteur des Ambassadeurs.

a famous bureau designed by Philippe Caffieri (see Svend Eriksen, "Lalive de Jully's Furniture 'à la grecque,'" in *The Burlington Magazine*, CIII, August 1961, pp. 340–347, figs. 6, 7). It is much more ornate than the table depicted in the drawing.

An exact replica of the Wrightsman drawing is in the Musée Condé (Gruyer, 1902, p. 247, catalogue no. 349). Gruyer placed the sitter's age about thirty-five, which would date the drawing around 1760.

35 Portrait of Béatrix de Choiseul-Stainville, Duchesse de Gramont, with Mme de Stainville and le Comte de Biron

RED, WHITE, and black chalk with blue, yellow, rose, green, gray, lavender, and terracotta washes on paper: H. 13⅝ (33.8); W. 9⅜ (23.6). Mounted on another sheet of paper: H. 15¹¹⁄₁₆ (38.3); W. 10⅜ (26.4). Inscribed in brown ink on the mount: *La Duchesse de Grammont* [sic], *Mme. de Stainville, Mr. Le Comte de Biron.*

PROVENANCE: René Fribourg Collection, New York (sale, Sotheby's, London, October 16, 1963, lot 520). It was acquired by Mr. and Mrs. Wrightsman at this sale.

MME DE Stainville (later Duchesse de Choiseul) became the niece-in-law of the Duchesse de Gramont (1730–1794) in 1761, and the drawing may be dated a year or two later on the evidence of the costumes. The Comte de Biron (1747–1793) later became the Duc de Lauzun.

There exist two close replicas of this drawing. One is in the Musée Condé (F. A. Gruyer, *Chantilly: Les Portraits de Carmontelle*, Paris, 1902, pp. 193–194, catalogue no. 269). The other, which once belonged to Edmond and Jules de Goncourt, was last recorded in a private collection in Paris (Seymour de Ricci, *Dessins du dix–huitième siècle: Collection Albert Meyer*, Paris, 1935, catalogue no. 18, illustrated).

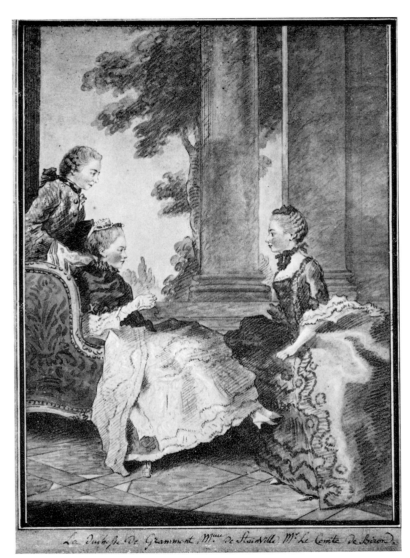

36 Portrait of Charlotte de Manneville, Duchesse de Mortemart

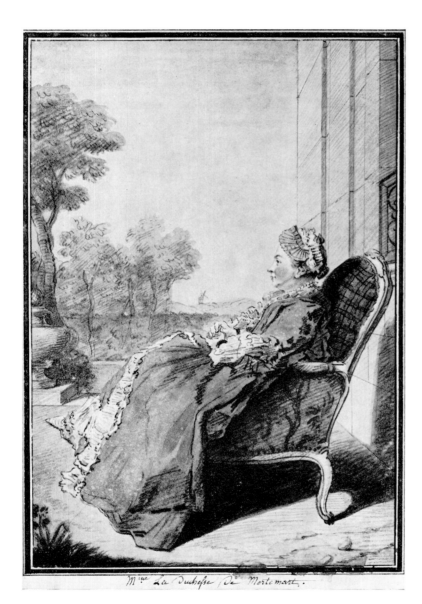

RED, WHITE, and black chalk with blue, red, green, and terracotta washes on paper: H. 12⅜ (31.5); W. 8³⁄₁₆ (20.7). Mounted on another sheet of paper: H. 14⅝ (37.2); W. 9¹¹⁄₁₆ (24.7). Inscribed in brown ink on the mount: *Mme. La Duchesse de Mortemart.*

PROVENANCE: Mr. and Mrs. Wrightsman acquired it in New York in 1957.

CHARLOTTE de Manneville (born 1728) was the third wife of the Duc de Mortemart, whom she married on May 1, 1751. A close replica of this drawing is in the Musée Condé (F. A. Gruyer, *Chantilly: Les Portraits de Carmontelle*, Paris, 1902, p. 217, catalogue no. 305). Gruyer dates it about 1770.

JEAN HONORÉ FRAGONARD (1732–1806) was, like Shakespeare, the son of a glovemaker. Born in Grasse, he spent his youth in Provence and studied in Paris briefly with Jean Siméon Chardin (1699–1779) and for several years with François Boucher (1703–1770). He won a Prix de Rome and worked at the French Academy in Rome from 1756 until 1761. His large history painting, the High Priest Corseus Sacrificing Himself to Save Callirrhoë, was bought in 1765 by Louis XV and the artist was named *peintre du Roi*. In the same year he was elected a member *agréé* of the Academy, but he never became a member in full standing. He found amorous and light-hearted subjects more congenial than the history painting preferred by the academicians. His oeuvre thus consists of delicate landscapes inspired by seventeenth-century Dutch masters, scintillating portraits, and splendid decorative panels, such as the Progress of Love, commissioned in 1771 by Mme du Barry and now in the Frick Collection, New York. As a draftsman, Fragonard was more versatile than Watteau (*q.v.*), who worked consistently with colored chalks. Fragonard varied his technique, often combining different media—pen and ink, crayon, bistre washes—through which he achieved shimmering atmospheric effects suitable to the highly poetic subject matter of his drawings.

37 The Education of a Dog

BROWN WASH over hard charcoal underdrawing on paper: H. 9½ (24.0); W. 14 (35.5). Inscribed in brown wash (different in hue from that of the drawing) on the bench in the lower left-hand corner: *Fragonard* (Fig. 1). A collector's mark, the initials M.P., is stamped in the lower right-hand corner.

1. *Signature*

PROVENANCE: According to Alexandre Ananoff (*L'Oeuvre dessiné de Jean Honoré Fragonard [1732–1806]: Catalogue raisonné*, Paris, 1963, II, p. 25, catalogue no. 589, fig. 184), this drawing belonged to the eighteenth-century collector M. le Chevalier de Clesne. Ananoff identified it with lot 116 in the auction of de Clesne's collection, which took place on December 4, 1786. In the sale catalogue it is described as "Deux jeunes femmes et plusieurs enfants s'amusent à faire danser un chien. Cette scène agréable est représentée sur la terrasse d'un jardin. Ce dessin vigoureux de touche est lavé au bistre sur papier blanc. H. 9 p—L. 13 ½." This description matches the subject and dimensions of the Wrightsman sheet, but there is no way to establish that it is the drawing de Clesne owned because at least three replicas of the drawing exist (Ananoff, 1963, catalogue nos. 590–592).

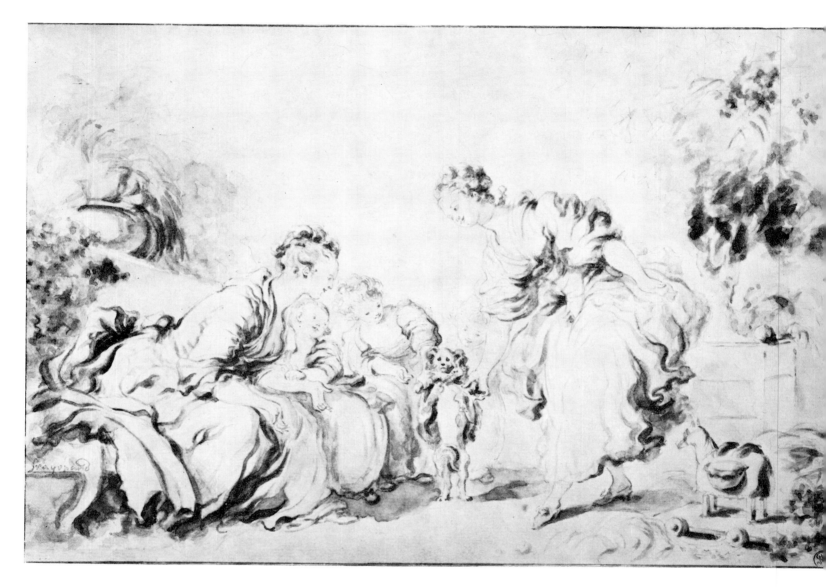

Ananoff also asserts that the Wrightsman draw-
ing belonged to M. Delaunay, *graveur du Roi*,
whose collection was auctioned on May 7, 1792.
Lot 22 in his sale consisted of two drawings by
Fragonard, one corresponding in subject to the
Wrightsman drawing: "Un intérieur de jardin
où l'on voit deux femmes faisant jouer des enfants
avec un chien." But, contradicting himself, Ana-
noff (1963, catalogue no. 590), assigns the same
provenance to one of the replicas of the Wrights-
man composition. Until more is known about the
past histories of the different replicas, it will be
impossible to determine which of them belonged
to de Clesne and which to Delaunay.

The modern history of the drawing begins with
Marius Paulme (born 1863), a collector and dealer
of old master drawings. The drawing is stamped
with his mark (Frits Lugt, *Les Marques de collections
de dessins & d'estampes*, Amsterdam, 1921, p. 350,
catalogue no. 1910). It is next recorded in a private

collection at Amboise (presumably that of Alexandre Ananoff, the Fragonard drawing specialist). It subsequently belonged to Georges Wildenstein (1892–1963), New York. Mr. and Mrs. Wrightsman acquired it in New York in 1959.

THIS DRAWING was intended as a finished work of art rather than as a study or preparatory sketch. It is the type of elaborate wash drawing that the artist made for contemporary art collectors and connoisseurs. Its popularity is witnessed by the number of close variants. Ananoff, who catalogued the Wrightsman sheet as the primary version, lists three other autograph repetitions.

Fragonard did a small genre painting that has a similar theme. Entitled Education Does All, it belongs to the Museu de Arte, São Paulo, Brazil (Georges Wildenstein, *The Paintings of Fragonard: Complete Edition*, London, 1960, p. 304, catalogue no. 472, pl. 105). The design of the painting and the drawing are quite different, but they both show young women training dogs to stand on their hind legs, to the enormous delight of the children looking on.

GABRIEL JACQUES de SAINT-AUBIN (1724–1780) was born and spent all of his life in Paris. The son of an embroiderer, he studied first with Jean-Baptiste Sarrazin (active about 1740—after 1793). In 1747 he became a student at the Académie, where he worked under the influence of Étienne Jeaurat (1699–1789), a painter of Parisian street scenes, and François Boucher (1703–1770). Between 1752 and 1754 he competed three times for the Prix de Rome, but his history paintings were not well received and he gave up hopes of ever becoming an academician. Instead, he joined the Académie de Saint-Luc, where he worked as a teacher. His paintings are not numerous, but he was a prolific draftsman and printmaker. He specialized in delicately drawn views of Paris and contemporary life. Among his most characteristic works are the marginal illustrations he made in various *livrets de salon*, auction sale catalogues, and the eight volumes of the 1742 edition of the *Description de Paris* by Piganiol de la Force.

38 Placets de l'officier Desbans (petitions to Queen Marie Antoinette and Louis XVI)

A QUARTO volume of twenty-two pages, bound in red morocco leather with the arms of Marie Antoinette on the cover. H. 14¾ (36.5); W. 9⅜ (23.7). Beginning with page 5, each illustrated page has a border of five narrow lines—colored in sepia, bright red, yellow, and bluish green. There are fifteen pictorial decorations by Saint-Aubin— one oval, four roundels, and ten rectangles—as well as decorative head- or tailpieces. Most of the pages with illustrations are divided into three parts: title, illustration, and explication. The text was lettered by the artist with elaborately decorative penmanship in a variety of colors. Many of the drawings are signed and dated 1775.

PROVENANCE: The booklet was presented to Marie Antoinette (1755–1793), whose coat of arms is embossed on the binding. According to Roger Portalis (*Les Dessinateurs d'illustrations au dix-huitième siècle*, Paris, 1877, II, p. 570), it belonged in 1877 to Baron Jérôme Pichon (1812–1897). It was in the collection of Baron Maurice de Rothschild (1881–1957) by 1909, when it was mentioned by A. Vuaflart and H. Bourin (*Iconographie de Marie-Antoinette*, Paris, 1909, II, pp. 90–91). It eventually passed to Baron Philippe de Rothschild (born 1902). Mr. and Mrs. Wrightsman acquired it in New York in 1963.

THIS BOOKLET consists of two *placets*, or petitions, addressed to Marie Antoinette and Louis XVI by an army officer called Desbans. The booklet requests his promotion to a lieutenant-colonelcy, which he believed himself to have been promised by Louis XV in 1770. In order to ensure that his request would attract the attention of the king and queen, Desbans commissioned Saint-Aubin to decorate his petition with drawings celebrating the royal couple.

Although the *placets* were published in some detail by Émile Dacier (*Gabriel de Saint-Aubin: peintre, dessinateur et graveur [1724–1780]*, II, *Catalogue raisonné*, Paris—Brussels, 1931, p. 187, catalogue no. 1025), Desbans's first names and the details of his career have remained unknown. It is now possible, however, to suggest that he was

Edme Louis Desbans (whose life was compiled by É. Franceschini in the *Dictionnaire de biographie française*, eds. Roman d'Amat and R. Limouzin-Lamothe, Paris, 1965, X, col. 1199). Born in 1728, Desbans began his military career in 1743 as a musketeer, and eventually he served as a volunteer to the Dauphiné and as an *aide de camp* to the Maréchal de Maillebois. On May 10, 1778, he became the *commandant* of the Garnison de Bassigny. His long-sought-for lieutenant-colonelcy was finally awarded him on January 22, 1779. He retired from the military at this rank in 1788. Three years later he was granted an honorary promotion to *maréchal de camp*.

In the following description of the booklet, the blank pages are omitted:

1. A brief preliminary inscription.
2. The queen's initials are intertwined over a cartouche with different inscriptions, one stating that the project of illustrating the booklet lasted from January 13, 1775, until June 26, 1775. Above, a putto carrying a pennant covered with fleurs de lis hovers over a crown of flaming hearts.
3. In an oval medallion the officer Desbans presents his petition to Marie Antoinette. The medallion rises from the smoke of an urn placed on a circular plinth inscribed: *A la reine*. It is surrounded by a pale blue trellis of rose garlands, with birds and butterflies fluttering above. The medallion, executed in black ink and gray washes, measures 9.5 by 7.5 cm. (Fig. 1).
5. Inscriptions.
7. Dedication to the queen.
10. Notes by the artist on the subjects of his drawings.
11 (numbered 1 by the artist). A roundel showing Justice and Truth presenting Desbans to the queen. Initialed on the folding stool next to the queen: *G d S A*. The roundel, executed in black ink and gray washes, has a diameter of 11.5 cm. It was cut out and pasted onto the page.
13 (numbered 2 by the artist). A rectangular drawing entitled *Bienfaisance de la reine*. The pedestal beneath the queen is inscribed: *la reigne decend de son trône pour faire du bien*. The ground below the kneeling peasant on the right is inscribed: *G d S A / Gabriel . . . ft 1775*. Executed in black ink and gray washes, the drawing measures 11.5 by 16.1 cm. It was cut out and pasted onto the page.
15 (numbered 3 by the artist). A roundel showing the queen

1. *Desbans presenting his petition to Marie Antoinette (page 3)*

presenting the petition to the king. Executed in black ink and gray washes, it has a diameter of 10.5 cm. and was pasted onto the page.
17 (numbered 4 by the artist). A rectangular drawing entitled *Goût de la reine pour les arts*. The small painting on

ABOVE:
2. *Celebration in honor of Marie Antoinette* (*page 25*)

3. *Marie Antoinette receiving an ovation at the Opéra*
(*page 27*)

4. *Coronation of Louis XVI in Rheims Cathedral* (*page 30*)

the easel, inscribed *1773 G de S . . .*, is copied from a gouache by the artist (see Dacier, 1931, p. 104, catalogue no. 595). The base of the queen's throne is dated: *1775*. Émile Dacier ("Gabriel de Saint-Aubin peintre," in *La Revue de l'art ancien et moderne*, CLIX, February 1912, pp. 124, 131, illustrated) misread it as 1776. This page of the *placets* was first reproduced and discussed by Vuaflart and Bourin, 1909, p. 90, pl. XXIX. The drawing, which was pasted onto the page, measures 11.4 by 16.2 cm.

19 (numbered 5 by the artist). A roundel showing the officer's daughter copying a portrait of the queen. The music on the piano is inscribed: *GLUK*. The roundel, executed in black ink and gray washes, has a diameter of 10.5 cm.

21 (numbered 6 by the artist). A rectangular drawing entitled *Amour de la Reine pour la France*. In the shadows of the cloud it is inscribed: *Gabriel*. It is 11.1 by 16.0 cm.

23 (numbered 7 by the artist). A roundel dated *1775*, show-

ing the officer and his daughter watching as her copy of the queen's portrait is presented to the queen. Executed in black ink and gray washes, the roundel has a diameter of 10.6 cm.

24. Inscriptions.

25 (numbered 8 by the artist). A rectangular drawing entitled *Fête en l'honneur de la Reine*. It shows a group of people out of doors dancing about a bust of the queen. There are seated spectators and an orchestra in the background. Cut out and pasted onto the page, it measures 11.5 by 16.0 cm. (Fig. 2).

27 (numbered 9 by the artist). A rectangular drawing entitled *Amour des françois pour la reine. 13 Janvier 1775*. A view of a performance of Gluck's *Iphigénie* at the Opéra at which Marie Antoinette received a standing ovation. Above the highest balcony it is inscribed: *13 Janvier 1775*. On the right beneath the first balcony it is signed: *par gabriel d. S . . . | 18 juin 1775*. Executed in a very elaborate technique with black ink, gray washes, and white highlights, it measures 12.3 by 18.5 cm. (Fig. 3).

28. Inscriptions and a drawing of an eagle and a cock.

29 (numbered 10 by the artist). In a large green fleur de lis decorated with pink and yellow flowers, the title *Placet au Roi*, surrounded by medallions with profile portraits of the king and queen and the *princes généreux* (the Comte de Provence and the Comte d'Artois) and an infant (inscribed *Spes prævia gallis*). Executed in watercolors, the overall dimensions of this design are 28.2 by 7.1 cm.

30. A rectangular drawing entitled *Couronnement de sa Majesté a Rheims le 12 Juin 1775*. Executed in black ink and gray washes with heavy white highlighting, it measures 12.1 by 17.0 cm. (Fig. 4).

31 (numbered 11 by the artist). The text of Desbans's petition.

32. Inscriptions.

33 (numbered 12 by the artist). Inscriptions.

35 (numbered 13 by the artist). Inscriptions.

36. Rectangular drawing entitled *Le Roi Louis XVI En son Conseil D'Etat*. The male figure on the left holds a book inscribed: . . . *du Louis XVI*. Below the book are the initials: *S A*. The drawing, which is pasted onto the page, measures 11.2 by 16.3 cm.

37 (numbered 14 by the artist). Rectangular drawing entitled *Prière Pour le Roi*. It shows a man kneeling with his arms outstretched before a cross set in a landscape with a view of a vast palace in the distance, presumably Versailles. The drawing was executed on a piece of paper 10.7 by 15.8 cm. It was then pasted onto the page and extended on the left and at the bottom, making its overall dimensions 11.7 by 16.6 cm.

40. A rectangular drawing entitled *Retour de Sa Majesté de Son Sacre à Rheims*. Dated on the left: *1775*. Cut out and pasted onto the page, it measures 6.5 by 16.0 cm. (A preparatory study for this illustration belongs to the Rijksmuseum, Amsterdam; see Denys Sutton, *France in the Eighteenth Century*, exhibition catalogue, London, 1968, p. 118, catalogue no. 639.)

41 (numbered 15 by the artist). Rectangular drawing entitled *Conclusion Générale*. In the hall of mirrors at Versailles the king's two brothers tell Desbans that his request will be granted. Inscribed along the bottom: *221 pied de long 32 pied de large 37 du haut*. The drawing was cut out and pasted onto the page. It measures 6.5 by 15.9 cm.

39 Illustrated catalogue of an anonymous auction held on December 13, 1773

THE BOOKLET is entitled *Catalogue des tableaux originaux de bons maîtres des ecoles d'Italie, des Pays-Bas & de France, qui composent le Cabinet d'un Artiste. Cette Vente se fera le Lundi, 13 Décembre 1773 trois heures de relevée & jours suivants aussi de relevée dans une des salles des Révérends Peres Augustins du grand Couvent . . .*, Paris, 1773. H. 6⅝ (16.1); W. 4 (10.2). It has marbled boards and a green spine, entitled *Catalogue Lebrun 1773*. There are thirty-four numbered pages (Fig. 1) interleaved with blank pages on which the artist noted the prices and the names of the buyers (or the words *non vendu*). The text is illustrated with 186 black chalk drawings by

1. *Black chalk drawings (page 14). List of buyers and prices on right-hand page*

Détail du N.º 109.

Dubois. / 1. allégorie sur la peinture		12.
Jd. Les 3. Graces		3.3
Lafausse. / 1. Tabl. gout du Titien		3.1
Mr. 1 Paisage et. 1. Portrait		8.1
Mr. 1. paisage avec archit		38.6
Le Brun / 1 Descente de Croix		5.19
Dubois. 1. Tete de franck		6.1
Lebrun. 1. Tabl. ovale		8.19
Serrico. Renaud et Armide		1.1
Remi. 1 Lion et 1 Chien		5.
Fourcville. 1 Tabl. gout du Caravage		4.1
Richard. 1. portr. et 1. buste		3.6
Jd. la Nativité d'après le Correge		13.5
Boismenu. Vue americaine		3.10
Caillet. Venus et l'amour sans bord		180.
Mr. Enlevement des Sabines		17.
Boismenu, gout de Lairesse		28.10

4.54.3

Lu & approuvé le 15 Novembre 1773.
MARIN.

Vu l'approbation, permis d'imprimer, ce 16 Novembre 1773. DE SARTINE

De l'Imprimerie de DIDOT, rue Payée, 1773.

2. List of paintings not included in the printed catalogue. Black chalk drawings of these paintings on right-hand page

[346]

Saint-Aubin, the smallest measuring about 2.3 by 1.8 cm., the largest 5.0 by 8.5 cm. The sale consisted of 209 lots, the last one described as *Plusieurs Tableaux qu'on détaillera*, which comprised an additional seventeen pictures listed by hand on a page added at the end (Fig. 2).

PROVENANCE: The catalogue was sold by an anonymous owner at Christie's, London, April 7, 1970, lot 109. Mr. and Mrs. Wrightsman acquired it at this sale.

BOTH THIS sale catalogue and the following one (Catalogue No. 40) are examples of the booklets Saint-Aubin illustrated with diminutive sketches in the margins. Dacier (*Gabriel de Saint-Aubin: peintre, dessinateur et graveur*, Paris—Brussels, 1931,

II, catalogue nos. 1031–1066) lists thirty-six sale catalogues that the artist illustrated between 1767 and 1780, the year of his death. Neither of the catalogues in the Wrightsman Collection, both of considerable importance as documents of art history as well as for their own aesthetic merit, has been published. It is hoped that it may be possible to do so separately, at some future date. Frits Lugt (*Répertoire des catalogues de ventes publiques*, The Hague, 1938, I, no. 2212) suggested that the collection belonged to a certain Martin, an artist (possibly Guillaume Martin, 1737–1800). In the catalogue for the sale at Christie's when the booklet was sold in 1970, it is tentatively suggested that the collector could also have been the painter Jean-Baptiste Le Brun. In the Christie's catalogue there is an incomplete list of the pictures in the sale that Saint-Aubin copied.

40 Illustrated catalogue of an anonymous auction held on April 1, 1776

THE BOOKLET is entitled *Catalogue de tableaux, des trois écoles; desseins; estampes d'un très beau choix . . . du Cabinet de M. M. *** par Pierre Remy. La Vente se sera le Lundi premier Avril 1776 . . . et jours suivants, rue S. Honoré, a l'Hôtel d'Aligre*, Paris, 1776. H. 6¾ (17.2); W. 4½ (10.5). It has marbled boards and a brown spine with a red label stamped in gold: *Cabinet de MM *** 1776*. There are 39 numbered pages listing a total of 226 lots. The margins of the text are illustrated with twenty-five drawings of pictures in the sale. In addition, there are several drawings (Fig. 1) of works by Fragonard, Delaporte, and Watteau, described as "ne seront pas vendus." On the reverse of the title page is a sketch (Fig. 2) in black chalk and brown wash of an exhibition at the Colisée, Paris, initialed by Saint-Aubin and dated *Colisée 1776*. At the end of the booklet is a view of the gardens of the Tuileries, initialed and dated *Tuileries 1776* (Fig. 3).

PROVENANCE: The catalogue was sold by an anonymous owner at Christie's, London, April 18, 1967, lot 45. It was acquired at this sale by Mr. and Mrs. Wrightsman.

ACCORDING to Frits Lugt (*Répertoire des catalogues de ventes publiques*, The Hague, 1938, I, no. 2522), this catalogue was for the sale of the collection formed by the surgeon Sorbet. See the comments under Catalogue No. 39.

1. *Page illustrated with black chalk drawings*

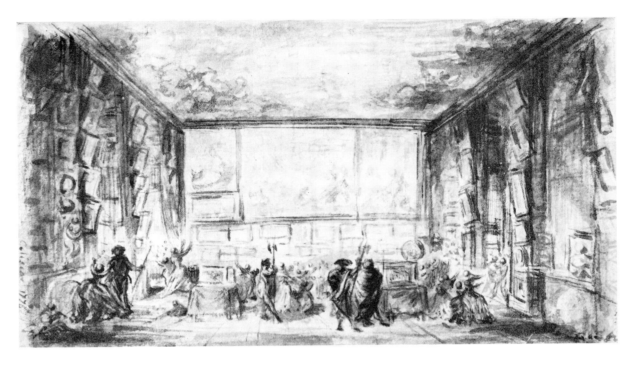

2. *An exhibition at the Colisée. Black chalk and brown wash, 9.7 by 16.7 cm.*

3. *The Tuileries. Black chalk and brown wash, 7.0 by 11.4 cm.*

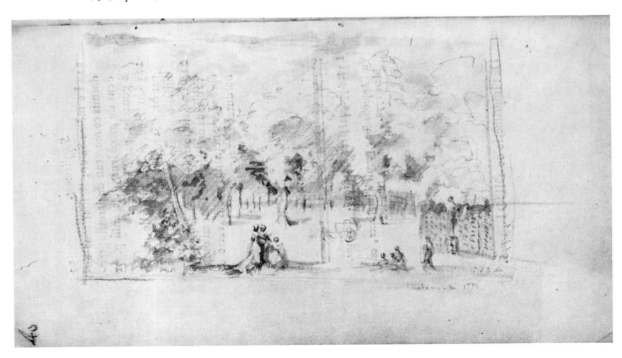

ANTOINE WATTEAU (1684–1721) was born at Valenciennes, a Flemish town that was ceded to France six years before Watteau was born. As a result the artist was regarded by his contemporaries and later eighteenth-century writers as a *peintre flamand*. Flemish art, particularly the work of Rubens (*q.v.*) and the genre painter David Teniers the Younger (1610–1690) had a deep influence upon his style. He was trained at Valenciennes by an obscure religious painter before moving to Paris about 1702. There he entered the studio of Claude Gillot (1673–1722), a designer of theatrical scenes and painter of subjects from the Italian Commedia dell'Arte. About 1707 he joined Claude Audran III (1658–1734), a decorative painter, who, as concierge of the Palais du Luxembourg, gave Watteau free access to Rubens's great canvases of the Marie de Médicis cycle. In 1712 he was nominated *agréé à l'Académie Royale*, but it was not until 1717 that he presented his *morceau de réception*, or diploma picture. This was the celebrated Embarkation for the Island of Cythera, now in the Louvre (a later version, painted for the collector Jean de Jullienne, is in Berlin). Because of its wistful mood and distinctive subject, Watteau was the first artist to be elected to the Académie as a *peintre des fêtes galantes*, a genre he perfected in numerous scenes of aristocrats enjoying the fleeting pleasures of the countryside. In 1719 he went to London to seek medical advice, and returned to Paris in failing health sometime before September 1720. It was then that he painted a shop sign known as the Enseigne de Gersaint, now in Berlin. Most of Watteau's pictures were composed from drawings, which he kept by the hundreds. Executed in red, black, and white crayon, they are generally studies of figures, heads, hands, and draperies, which he could re-use in different compositions.

41 Study of a Woman's Head and Hands

RED AND black chalk, retouched in graphite, on paper: H. 7³⁄₁₆ (18.2); W. 4⅝ (11.7). (The paper is attached to a larger sheet, 19 by 12.5 cm.)

PROVENANCE: The earliest known owner of this drawing was Julien Léopold Boilly (1796–1874), a minor artist who was the son of the better-known genre painter Louis Léopold Boilly (1761–1845). According to an inscription in Boilly's hand on the back of the drawing's mount (Fig. 1),

he gave it to a friend called Bouchardy. The inscription reads:

> donné a mon ami Bouchardy
> le mercredi des cendres 1816
> Bhy [?] Julien Leopold Boilly

Bouchardy probably was Étienne Bouchardy (1797–1849), a miniaturist who studied with Boilly under Baron Gros. There was a posthumous auction of Bouchardy's collection in Paris on

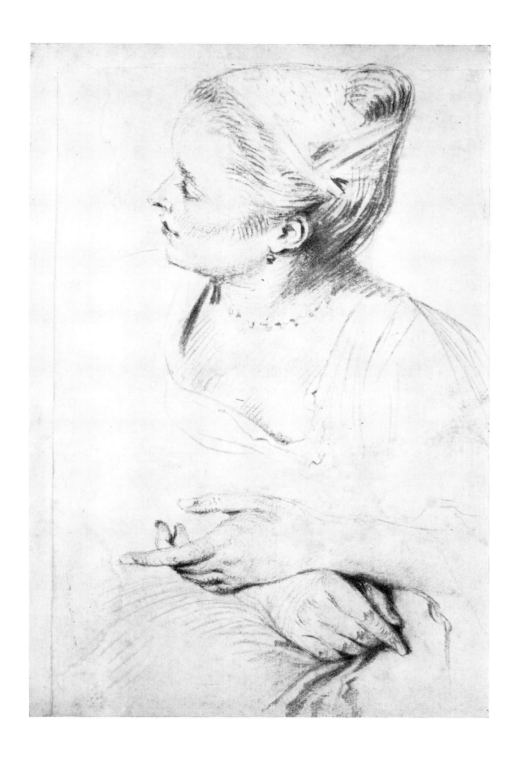

1. Label on the back of the drawing

May 14–15, 1850, but no drawings by Watteau are described in the summary sale catalogue. According to the catalogue of the exhibition in which the drawing was shown at the Royal Academy, London, the next recorded owner was a certain Georges Deligand (listed in E. Renart, *Supplément aux répertoires des collectionneurs et aux listes d'amateurs étrangers*, Paris, 1912, p. 33, no. 5385). By 1954, when it was lent to the Royal Academy, it belonged to Jacques Mathey of Paris, the Watteau specialist. Mr. and Mrs. Wrightsman acquired it in New York in 1958.

THIS SHEET is characteristic of the preparatory studies Watteau made for his paintings. His working procedure was to make drawings from life and then to incorporate various details of them in larger compositions painted in his studio. On a given page of his sketchbook, the artist would often record more than one pose, or, as in the present example, draw the head and hands separately. The head and shoulders of the woman are observed from a slightly different angle than the hands; the head is viewed from above, whereas the hands are seen almost at eye level. The hands also give the impression of being slightly larger in scale than the woman's head.

It has not been possible to identify the painting for which these studies were made. The pose and shape of the woman's head, however, are similar to those of a woman seen in two closely related canvases in the Wallace Collection, London (Les Champs Elysées, P389; Fête in a Park, P391).

Seven years after Watteau's death, an engraving of this drawing was published by Jean Audran (1667–1756) in a two-volume collection of prints after Watteau's work (*Figures de différents charactéres de paysages et d'études déssinés d'après nature par Antoine Watteau*, Paris, 1728, II, pl. 182). In the engraving the hands are omitted.

The drawing is listed in Edmond de Goncourt's *Catalogue raisonné de l'oeuvre peint, dessiné et gravé d'Antoine Watteau*, Paris, 1875, p. 280, no. 559. It is recorded as no. 578 in K. T. Parker and J. Mathey's *Antoine Watteau: catalogue complet de son oeuvre dessiné*, Paris, 1957, II, p. 312. A reproduction of it appears in Philippe Jaccottet's *Le dessin français au XVIIIe siècle*, Lausanne, 1952, pl. 20.

EXHIBITED: Galerie Cailleux, Paris, *Le Dessin français de Watteau à Prud'hon*, April 1951, catalogue no. 156; Royal Academy of Arts, London, *European Masters of the Eighteenth Century*, November 27, 1954–February 27, 1955, catalogue no. 291; M. Knoedler & Co., London, *Old Master, Impressionist, and Contemporary Drawings*, June 12–July 9, 1958, catalogue no. 3.

SCULPTURE

INTRODUCTION

It is a commonplace that few of the great collectors of French decorative art have concerned themselves with sculpture. The reason why they have not done so needs no emphasis. French furniture combines harmoniously with paintings of every kind, with Gerard David and Poussin and Vermeer, but it does not willingly coexist with sculpture. We have only to imagine reliefs by Donatello or Michelangelo or a bust by Bernini standing beside furniture by Weisweiler and Joubert to realize how inappropriate, indeed improper, the juxtaposition would seem.

The sculpture in the Wrightsman Collection falls into two broad groups, the first consisting of sculpture produced at the same period as the furniture that it accompanies, and the second composed of sculptures made at an earlier time. When one considers the mounting literature on French eighteenth-century furniture and painting, it is a little surprising that French decorative sculptures have been so inadequately studied and so little understood. Superficially, Clodion may appear a predictable, rather repetitious artist, but as soon as we allow our eyes and mind to engage with one of his small terracotta groups, it becomes evident that he was a sculptor of a controlled vitality and an inventiveness which should properly have earned him a far higher reputation than he enjoys today. It it were ever possible to organize a Clodion exhibition (one of the impediments to doing so is, of course, the extreme fragility of Clodion's work), it would transpire that he was a choreographer of a very high order indeed, and that the quality of formal thinking behind his deceptively carefree terracotta groups was exceptionally fine. Both points are illustrated to perfection in the Bacchic Group (No. 52) in the present catalogue, where the ambivalent posture of the satyr, interrupted at one side by the satyr child and on the other lifting the bacchante from the ground, is of extreme sophistication and subtlety. In the work of few sculptors is the command of transient movement so complete.

We do not know precisely how these small groups were produced. Internal evidence suggests that in practically every case they must have been preceded by rough models on a smaller scale, but if this is so, the models have almost without exception been destroyed. In relief, however, a few bona fide Clodion models are known, and one of them is the Triumph of the Infant Bacchus (No. 54) in this catalogue. It belongs to a class of composition that was popularized in the seventeenth century by Duquesnoy, copies of whose classical reliefs of putti circulated throughout Europe, but it is at the same time a highly individual work, both in the nervous modeling and in the types, which are faithful to the eighteenth-century conception of the child as an aspirant adult.

Joseph-Charles Marin, the only one of Clodion's imitators to emerge as an artist in his own right, was a more placid personality. Whereas the style of Clodion runs the whole gamut from high rococo to neoclassicism, Marin was by temperament a neoclassicist. Incapable of Clodion's abandon, he gravitated toward static groups, in which the joy of the participants, and therefore the pleasure they communicate, though real, is less intense. The two groups in this collection (Nos. 55 A and B), based on the common principle of a reclining female figure with raised arm, supported by the vertical of a standing child behind, are charming and typical examples of Marin's work.

People who take small bronzes seriously often refer to eighteenth-century French statuettes rather condescendingly as "furnishing bronzes." It is indeed true that relatively few bronzes produced in France can measure up to the incredibly high standard set by Giovanni Bologna and his predecessors, but just occasionally comparison is not invidious, and this is the case with the superb versions of the Coysevox Fame and Mercury in the Wrightsman Collection (Nos. 46 A and B). Versions of these bronzes seem to have been extremely popular, but in no examples known to me is the finish so fine or the handling so free. The models belong to the seventeenth century, not the eighteenth—they descend from the rearing horses that were produced in the following of Giovanni Bologna, probably by Pietro Tacca, were exported to Germany by Caspar Gras, and were established in England by Fanelli. Did we not know that their immediate source was the two monumental groups made by Coysevox for Marly, we should never guess that they did not, like the comparable Tacca bronzes, originate as statuettes. Both in balance and movement these bronzes are much superior to the heavy adaptations of the statues that entered the collection of Augustus the Strong at Dresden before 1715.

There are certain decorative French sculptures that have no great merit in themselves but are enchantingly apposite in the context for which they were designed. Among these are the little marble figures by or after Falconet. Though they are unsigned, the Boucher-like groups of Venus and Cupid in this collection (Nos. 48 A and B) were certainly made from Falconet's models and were possibly carved by Falconet as well. As a marble sculptor Falconet was competent rather than inspired, and appears so the more decisively if his work is juxtaposed with that of Houdon, the greatest marble sculptor of the eighteenth century. To find an equivalent for the hypersensitive surfaces of Houdon's marble busts we have to go back three hundred years to the busts carved by Desiderio da Settignano in Florence. No intervening sculptor was capable of the sensitive nuances of form and the psychological differentiation that characterize his portraits and that are fully apparent in the Wrightsman bust of Diderot (No. 50). The most obviously appealing of Houdon's male portrait busts are works like the Miromesnil in the Frick Collection, where the sitter's profession is established by a robe carved with the same concentration and delicacy as the face; but still finer are those portraits like the Diderot, which show only the head and sufficient of the neck and chest to establish the posture of the body beneath, and where Houdon confronts, more boldly than any other sculptor before or since, the enigma of human identity.

Of the remaining sculptures two in particular merit individual mention. The first is the bronze

[356]

(No. 44) cast from a preliminary model for Puget's elaborate group of the Rape of Helen at Genoa. Beside the great Italian baroque sculptors, Puget was, in marble, a rather coarse executant. What is remarkable about his works is the animating impulse, which was translated with singular success from the model into the finished work, and it is this that is recorded in this eloquent bronze. The second sculpture is the little statuette of the Spinario by Antico (No. 42), where the relatively loosely modeled classical original is condensed and schematized. Of the many adaptations of the Spinario, this little figure, with its gilded hair, is one of the most romantic and most beautiful, and though it is the only Renaissance sculpture in the collection, it reminds us that the act of discrimination on which this, like all major collections, rests, is the outcome of humanist taste.

JOHN POPE-HENNESSY

42 Boy Pulling a Thorn from His Foot (the "Spinario")

H. 7¾ (19.7); w. of base 2¹⁵⁄₁₆ (7.4).

OF BRONZE with a very dark brown patina, partially gilded on the hair. The eyes are inlaid with silver.

A youth, seated on a tree stump in the form of a rough truncated cone, has his left leg crossed over his right knee. He clasps his left ankle with his left hand and leans over to examine the foot from which he is pulling a thorn with his right hand. His shoulder-length hair is brilliantly gilded a pale, whitish gold.

By Pier Jacopo Alari-Bonacolsi, known as Antico (about 1460–1528).

REFERENCE: F. J. B. Watson, "From Antico to Houdon," in *Apollo*, XC, September 1969, pp. 214–215, fig. 1.

Formerly in the collection of the Duc d'Arenberg, Brussels.

After the famous classical statue generally known as the "Spinario," dating from the third century B.C., the most familiar example of which is the bronze in the Capitoline Museum, Rome (Fig. 1). (A version in Florence is illustrated in Salomon Reinach, *Répertoire de la statuaire grecque et romaine* [Rome, 1965], II, p. 143, no. 6).

Antico, a Mantuan court artist patronized by Gianfrancesco and Lodovico Gonzaga as well as by Isabella d'Este, earned his nickname because he was sent to Rome in 1497 by Lodovico Gonzaga to model bronze reductions of classical marble statues. By far the fullest and most able account of his activities is given by Julius Hermann ("Pier Jacopo Alari-Bonacolsi, genannt Antico," in *Jahrbuch der Kunsthistorischen Sammlungen des Allerhöchsten Kaiserhauses*, XXVIII [Vienna—Leipzig, 1909–1910], pp. 201–288). In this (p. 209) the author quotes from a document in the Mantuan archives that refers to a "puttino del spino" in the collection of Lodovico Gonzaga. He also quotes

the following (pp. 215, 216) from an inventory of 1542 of the property of the art-loving Isabella d'Este, including a list of objects found in a cupboard in the castle at Mantua "nelle Grotta di Madama in Corte vecchia":

> E più nudo dalla spina col suo
> basamento adorato.

This cannot, however, be No. 42, for there is no trace of gilding on the tree stump, nor of a gilded plinth having been removed.

Other reduced versions of the Spinario attributed to Antico in patinated bronze but without the gilding are known, notably an example in the Trivulzio Collection in Milan (illustrated in Hermann, *op. cit.*, p. 262, fig. 36; and in Wilhelm von Bode, *The Italian Bronze Statuettes of the Renaissance* [London, 1907–1912], I, pls. LXXXVII–XC).

Antico was a court artist, and it is characteristic of his manner that he should have given to the somewhat rough surface of the Greek bronze he copied the refined surface finish and even patination of a piece of Hellenistic sculpture. The use of parcel gilding on the hair, too, is another instance of his subtle refinement of his original models. A number of bronze statuettes by Antico similarly finished by parcel gilding are known, and the reference to Isabella d'Este's version of No. 42 quoted above is itself evidence of the practice. In the majority of them the eyes are inlaid with silver as here. The most famous is perhaps the Venus Victrix in the Kunsthistorisches Museum, Vienna (illustrated in Hermann, *op. cit.*, pl. XXXVIII), in which the hair and the drapery of the lower part are both gilded, while the circular plinth is inset with gilded coins. Other instances of similarly treated bronzes by Antico are the Paris in the Metropolitan Museum (acc. no. 55.93), the Meleager in the Victoria and Albert Museum (illustrated in *Meesters van het Brons der Italiaanse*

Renaissance [exhibition catalogue, Rijksmuseum, Amsterdam, 1961–1962], catalogue no. 29, fig. 24) and the reduction of the Apollo Belvedere now in the Ca' d'Oro in Venice (illustrated in Hermann, *op. cit.*, p. 234, fig. 11), both of which are identifiable in Mantuan inventories.

The treatment of the hair and the sweetening of the expression (for in the original the figure is of a common street boy) are, like the surface treatment and the gilding, very characteristic of Antico's refined court manner. So is the modification of the roughly cut-off branches of the tree stump to a series of smooth protrusions. This feature is to be paralleled in the treatment of the fragment of wood on which Venus rests her foot in the bronze statuette by Antico in the Kunsthistorisches Museum, Vienna, and in the club held by Antico's

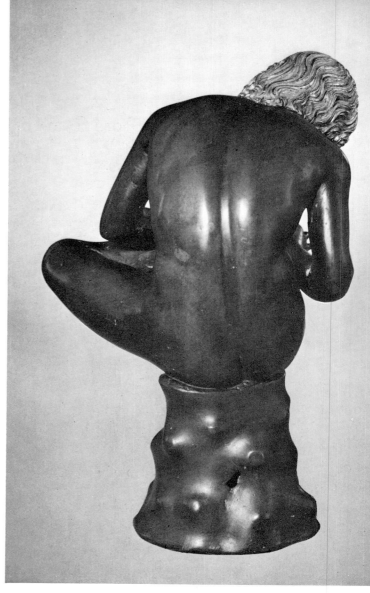

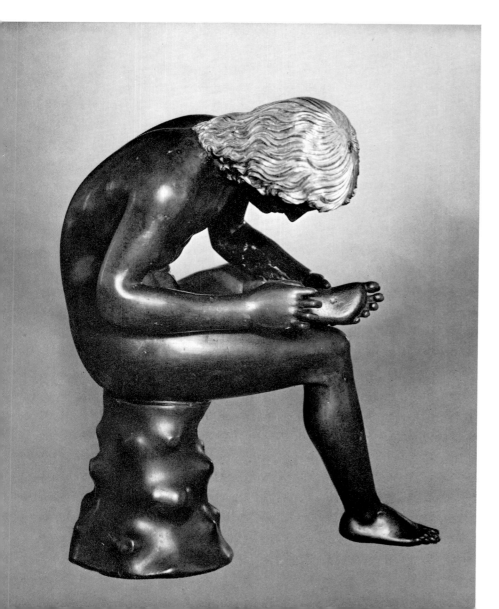

Mercury in the same museum (illustrated in Hermann, *op. cit.*, pl. XXXIX).

Pier Jacopo Alari-Bonacolsi, known as Antico, was an Italian sculptor working principally in bronze but also in marble, who, as his nickname suggests, specialized in the imitation of classical sculpture. He attracted the attention of the court of Mantua and in 1497 was sent to Rome by Bishop Lodovico Gonzaga to model small reductions of antique marbles. Various works by him are identifiable through references in the Gonzaga inventories. He worked for Isabella d'Este, and a bronze Hercules and Antaeus in Vienna is inscribed below the base D[omina] ISABELLA M[antiva] E

[360]

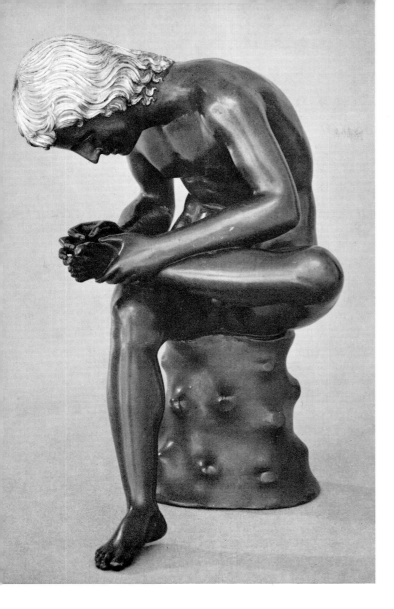

MAR[chionessa] and is referred to also in the inventory taken after her death. His work is marked by a refined, smooth, and somewhat cold finish; details were sometimes heightened by parcel gilding as on No. 42.

The celebrated Martelli mirror in the Victoria and Albert Museum, long attributed to Donatello (about 1386–1455), is probably by a pupil or follower of Antico, perhaps Giovanni Francesco Ruberti. It is a synthesis of motifs taken from classical gems and is an allegory of the powers of fertility. The treatment of the bronze has the same refined and frigid finish as Antico's own work.

BIBLIOGRAPHY: Julius Hermann, "Pier Jacopo Alari-Bonacolsi, genannt Antico," in *Jahrbuch der Kunsthistorischen Sammlungen des Allerhöchsten Kaiserhauses*, XXVIII (Vienna—Leipzig, 1909–1910), pp. 201–288.

1. *Spinario. Bronze. Rome, Capitoline Museum. Photo: Alinari-Art Reference Bureau*

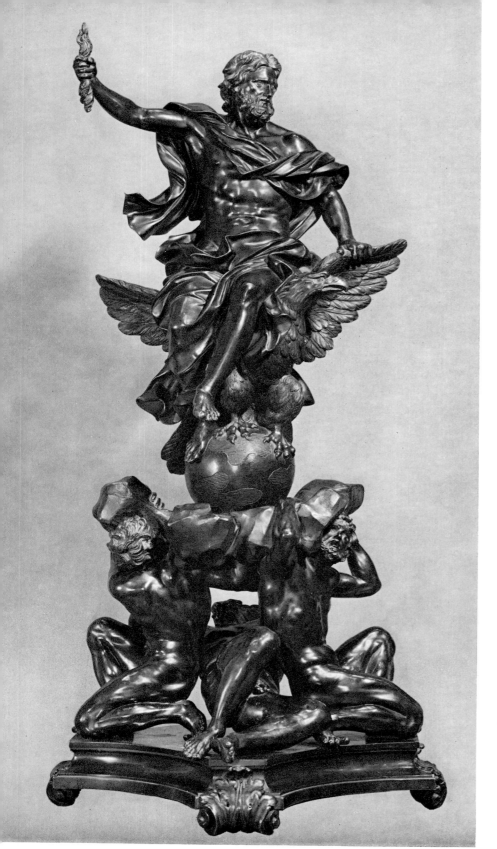

43 A, B Jupiter and Juno

Jupiter: H. 45½ (115.6); W. of base 22 (55.9).
Juno: H. 44¼ (112.4); W. of base 22¼ (56.5).

OF BLACK patinated bronze.

No. 43 A is a group representing Jupiter Victorious over the Titans. Jupiter, wielding a thunderbolt in his right hand and seated on an eagle poised on a terrestrial globe, is supported on rockwork resting on the shoulders of three seated Titans. On No. 43 B the group represents Juno Controlling the Winds. Juno, accompanied by a peacock and similarly standing on a globe, is supported on rockwork resting on the shoulders of three seated Winds. Both groups stand on square molded bases with concave sides set diagonally to the groups and clasped at each corner by an acanthus scroll.

After Alessandro Algardi (1598–1654) and probably cast at the Manufacture des Gobelins as firedogs for use in one of the French royal palaces.

REFERENCES: John Goldsmith Phillips, "Sculpture: Sacred and Profane," in *The Metropolitan Museum of Art Bulletin*, March 1962, p. 216, fig. 5 (Jupiter); *The Wrightsman Collection* (New York, 1966), II, pp. 364–367, nos. 185 A and B, to which some slight corrections and additions are made here.

Formerly in the collections of Prince Nicolas Demidoff (sold Paris, March 24, 1870, lot 252, for 41,000 francs); Baron Gustave de Rothschild; Baron Lambert, Brussels.

Bellori, in his life of Algardi (*Le vite de pittori, scultori, et architetti moderni* [Rome, 1672], p. 399), mentions, among works executed for Philip IV, King of Spain, wax models for firedogs:

> . . . li capifocolari furono quattro, e rappresentano li
> quattro elementi. In uno vi è Giove à sedere sù
> l'aquila, & avventa il fulmine premendo i giganti, li
> quali inalzano sassi, e monti contro il cielo. Nell'altro
> figurò Giunone à sedere sopra il pavone, volgendosi

dietro li Venti, che soffiano; e si muovono frà scogli, & antri.

The same writer goes on to explain that these represent the elements Fire and Air; the other two elements, Water and Earth, were symbolized by groups surmounted by Neptune and Cybele, respectively. Passeri (*Vite de' pittori, scultori ed architetti* [Rome, 1772, but written a century earlier], p. 214) also describes them. He asserts that they were made in the last year of Algardi's life, 1654, and that in fact the artist lived to complete only the Juno and Jupiter himself; the other two were finished by his pupils Ercole Ferrata (1610–1686) and Domenico Guidi (1628–1701). The original casts were lost in a shipwreck on the way to Spain, but terracotta models remained in Rome, and from these further casts seem to have been made, probably by Domenico Guidi.

An interesting reference to the Algardi firedogs appears in one of the rare surviving letters of the painter Velázquez, dated from Madrid, March 28, 1654, and addressed to Camillo Massimi:

Illmo. y Rmo. Sr.
La carta de V. S. Illma. de 13 deste me la dio un Religioso de la Santissima Trinidad ayer 27. Luego di quenta a S. M. Dios le guarde de quanto V. S. Illma. en ella me dize de los morillos con que salio S. M. del cuidado con que estava jusgando que hubiesen llegado a España.

Most Illustrious and Reverend Sir.
The letter from your Excellency of the 13th of this month was given to me by a religious of the Most Holy Trinity yesterday the 27th. I immediately reported to His Majesty, God keep him, what your Excellency tells me in it about the firedogs, whereupon His Majesty was freed from the anxiety which he felt judging that they had reached Spain.

The reference (from Enriqueta Harris, "A Letter from Velázquez to Camillo Massimi," in *The Burlington Magazine*, CII, April 1960, p. 166) is no doubt to the shipwreck mentioned above.

In fact, when the second castings eventually arrived in Spain they do not appear to have been used as firedogs at all. According to the *Mercure Galant* for July 1714 (quoted by Yves Bottineau,

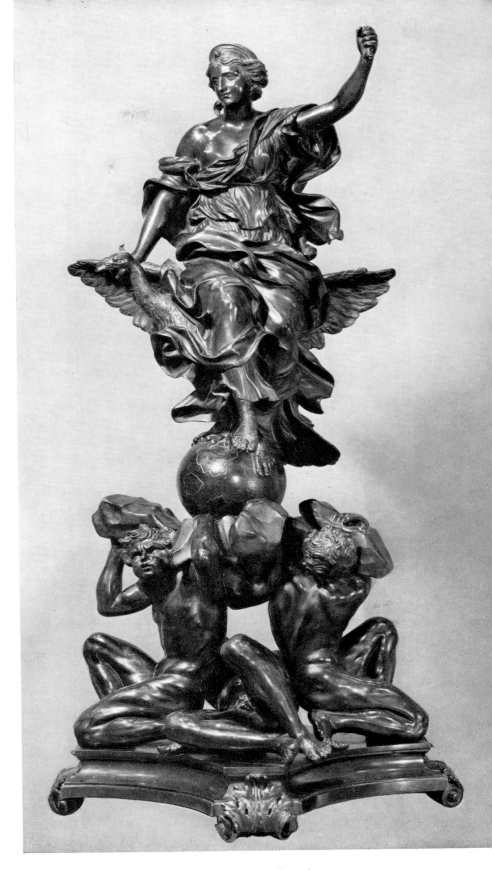

L'Art de cour dans l'Espagne de Philippe V, 1700–1746 [Bordeaux, 1961], p. 217, note 73) they were given by Philip IV to the Duque de Terra Nueva and were adapted as decorations of a fountain in the Jardin de la Isla at Aranjuez (Figs. 1, 2). (On their history and relation to the general development of Algardi's style, see Jacob Hess, "Ein Spätwerk des Bildhauers Alessandro Algardi," in *Münchner Jahrbuch der Bildenden Kunst,* VIII [1931], pp. 292 ff.)

It does not appear to be known how models of the groups representing Fire and Air came to France, but several sets of firedogs following the design of the groups at Aranjuez, though on a considerably reduced scale, seem to have been cast there before the end of the seventeenth century. The earliest cast was perhaps of slightly different form and of silver. The *Inventaire général du mobilier de la couronne sous Louis XIV (1663–1715),* ed. Guiffrey (Paris, 1885–1886), drawn up for Louis XIV by du Metz mentions, under the heading *Argent Blanc* (I, pp. 37, 40):

> 24–25—Une grosse paire de chenets cizelez de deux figures, l'une représentant Jupiter et l'autre Junon, posées chacune sur un pied d'estal cizelé de godrons, le tout porté sur un pied cizelé dans le milieu d'un mufle de lion, au dessus duquel sont les armes du Roy dans un cartouche, et aux costez deux consoles sur chacune desquelles est assis un enfant, pesant ensemble . . . 158m1o

A further pair in silver is recorded in the same inventory under no. 27. A variant version mentioned in the same section of the inventory was:

> 57—Un devant de gril d'argent, cizelé de godrons, dans le milieu d'un grand masque au dessus duquel est un Phenix, et aux deux bouts deux pieds d'estaux en forme de tombeau, sur l'un desquels est Jupiter avec son Aigle, et sur l'autre Junon avec son paon, pesant ensemble . . . 48mooog

According to Émile Molinier (*La Collection Wallace: Meubles et objets d'art français des XVIIe et XVIIIe siècles* [Paris—London, 1902], II, pl. 3), bronze firedogs such as Nos. 43 A and B are probably repetitions of a pair in silver that stood in Louis XIV's bedchamber at Versailles. He possibly had in mind one or another of the pairs mentioned above. But bronze versions were already sufficiently valued in 1682 for Louis XIV to display a pair referred to as *chenêts d'Algarde* in niches in the Salon Ovale at Versailles among specially precious pictures, gems, etc., from his art collection. Verlet suggests (*Versailles* [Paris, 1961], p. 265) that these were the examples now in the Wallace Collection mentioned below. In that case they may well be the original models from which all subsequent French versions were derived. During a visit to the Palais Mazarin in 1687, the younger N. Tessin, the Swedish architect, noted: "In der Alcove oben stehen 2 sehn schöne genetten [chenets] von bronz, so da seijndt dess Cav. Algardi Juppiter undt Junon mit den riessen unter" (Osvald Sirén, ed., *Nicodemus Tessin D. Y. Studieriesor* [Stockholm, 1914], p. 96).

In the *Inventaire des diamants de la couronne* prepared for the Assemblée Nationale in 1791, the examples in bronze now in the Wallace Collection (*Wallace Collection Catalogues: Sculpture* [London, 1931], nos. 161, 162), which bear the incised numbers 297 and 298 of this inventory, are ascribed to Michel Anguier (1604–1669), but the evidence for this is anything but strong, and all earlier references mention only Algardi. It seems safer to assume merely that they were made (as the silver ones must almost certainly have been) in the Gobelins factory.

Such firedogs are mentioned several times in the *Inventaire du mobilier de la couronne,* notably in 1706, in 1722 (*Inventaire des sculptures du Roi* drawn up by Michel Masson), and again in 1785 when a pair (probably those in the Wallace Collection mentioned above) was removed from Marly for the queen's use at Versailles. These were then valued at 15,000 livres (something on the order of $30,000 in modern purchasing power), an extraordinarily high price for such bronzes.

Several others of bronze are known, both singly and in pairs. A pair similar to Nos. 43 A and B, for instance, was until recently in the collection of

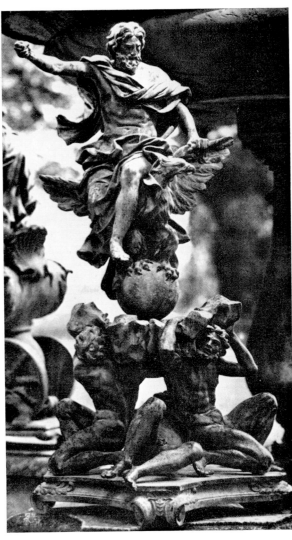

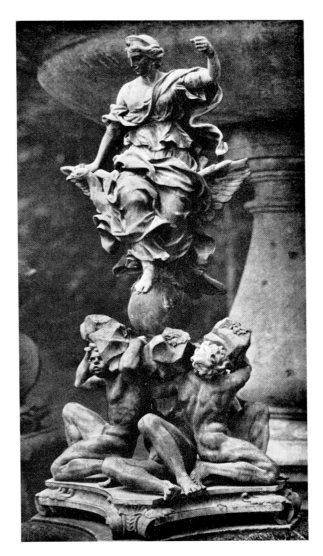

1, 2. *Alessandro Algardi, Jupiter and Juno. Bronze. Aranjuez, Jardin de la Isla*

Francis Stonor, London (from the collection of the Duke of Westminster [sold Sotheby's, London, July 10, 1959, lot 139, for £400]). Another pair, or perhaps one of the above, was in the Pontchartrain sale, Paris, December 1747, lot 96 (Lugt, *Catalogues de ventes publiques* [The Hague, 1938], I, no. 678), sold for 520 livres. These were of the same sizes as Nos. 43 A and B and stood on Boulle pedestals. A single firedog with Jupiter is in the Louvre (*Catalogue des bronzes et cuivres* [Paris, 1904], no. 209, partially gilded); another with Juno alone but ungilded is in the Palace of Pavlovsk.

A variant pair, entirely gilded and probably dating from the Louis XVI period, with elaborate bases enriched with Boulle marquetry but lacking the supporting Winds, was lot 360 in the sale of the Duc d'Aumont's possessions, Paris, Decem-

ber 12, 1782, and was bought for 581 livres by his son the Duc de Villequier.

In addition to the pair now in the Wallace Collection, the fourth Marquess of Hertford possessed a second version of the Jupiter cast in Paris in the nineteenth century by the *fondeur* Charles Crozatier (1795–1855).

Alessandro Algardi had only one rival as a sculptor in baroque Rome in the second quarter of the seventeenth century: Bernini, the dominating figure of the period. Born at Bologna, where he frequented the academy of the aged Lodovico Carracci, Algardi received his training there as a sculptor under the mediocre G. C. Conventi and came to Rome in 1625 with a recommendation from the Duke of Mantua, in whose principality he had been working. Algardi was employed only on relatively minor work—restoration of antique statues, busts, etc.—until 1635, when he received his first major commission, the tomb of Leo XI for St. Peter's. This was followed in 1640 by an order for an over-life-size statue of St. Philip Neri for Santa Maria in Vallicella. Under Innocent X, commissions showered on Algardi and included the memorial statue of the Pope himself in the Palazzo dei Conservatori (1645). His greatest legacy to posterity was the huge bas-relief of the Meeting of Pope Leo and Attila of 1646–1650 in St. Peter's, which inspired a whole series of similar baroque works. He also executed a considerable number of portrait busts.

Although Bernini was his rival, Algardi was deeply influenced by him. Nevertheless, his style is far more classical than that of the great Roman baroque master. He tended to use white statuary marble rather than Bernini's elaborate combinations of colored marbles and complex surface patterns; Algardi also eschewed Bernini's picturesque presentation of his works.

BIBLIOGRAPHY: There is no monograph on Algardi. The early lives by G. P. Bellori, *La vite de pittori, scultori, et architetti moderni* (Rome, 1672) and G. B. Passeri, *Vite de' pittori, scultori, ed architetti* (Rome, 1772) are the most valuable. A more or less complete bibliography down to 1962 is to be found in the catalogue of the exhibition *L'Ideale classico del seicento in Italia e la pittura di Paesaggio* (Bologna, 1962), pp. 354–355.

44 The Rape of Helen

H. 38 3/16 (97.1); W. 15 (38.1); D. 13 5/8 (34.6).

OF BRONZE with a clear brownish-black patina produced by the use of a black varnish over an interpatination of reddish-brown color that shows through in places.

A low, square plinth supports, slightly askew, a short flight of steps against which the stern of the boat is moored, while small waves lap around it. On the two topmost steps one of the companions of Paris, semi-naked, clasps the partially clad Helen supported upon his left shoulder. At the back, the lower part of her body rests on the outspread wings of Cupid standing on the lower step. She gesticulates wildly with her right arm. Her left hand is clasped by Paris, who is standing on the gunwale of the boat into which he begins to lower her. Paris is bearded and wears classical armor and a helmet; behind him, his octagonal shield, chased in relief with a head of Zeus with a thunderbolt, rests against the steps.

The stern of the boat, chased with playing tritons and decorated above the rudder with a figurehead in the form of the mask of a boar, is tethered to the steps by a pendent rope. Its prow curves around the foot of the steps to the back, where it is again tethered by a rope passed through a ring.

There are a few damages. Paris's sword, one arm of Cupid, and the tip of his arrow are missing, while a panel some 7½ inches long has been inserted into the right side of the plinth. This seems to be a normal repair, but was possibly originally intended to bear an inscription.

After a model for a life-sized marble group by Pierre Puget (1620–1694).

REFERENCES: Léon Lagrange, *Pierre Puget*, 2nd ed. (Paris, 1868), pp. 206, 385, catalogue no. 115; Guy Walton, " 'The French Bronze' at Knoedler's," in *The Burlington Magazine*, CXI, March 1969, p. 169; F. J. B. Watson, "From Antico to Houdon," in *Apollo*, XC, September 1969, p. 215, fig. 2; Klaus Herding, *Pierre Puget: Das bildnerische Werk* (Berlin, 1970), pp. 84, note 464, 108 ff., 183, catalogue no. 46a, figs. 221, 225, 229.

EXHIBITED: Royal Academy, London, *France in the Eighteenth Century*, 1968, catalogue no. 818, fig. 362; Knoedler's, New York, *The French Bronze 1500 to 1800*, 1968, catalogue no. 24 (illustrated).

Said to have been formerly in the collection of the Earls of Warwick at Warwick Castle, sold privately in the 1920s.

When Colbert, who had never been very sympathetically disposed toward Puget, died in 1683, he was replaced as *surintendant des Bâtiments* by Louvois. The new *surintendant* was a great admirer of the sculptor's Milo of Crotona (now in the Louvre; *Catalogue des sculptures*, Part II, *Temps modernes* [Paris, 1922], no. 1466), which had been delivered at Versailles in the spring of 1683 (not in August 1682 as is sometimes asserted) and was banished for a time to a remote corner of the garden. Soon after his appointment Louvois declared "Je prendray tres volontiers pour les bastiments du Roy tout ce que fera ledit Sr Puget pourvu qu'il soit de la force du Milon." (quoted by Léon Lagrange, *op. cit.*, p. 195, and by most other writers on Puget). On September 16, 1683, he wrote personally to the sculptor: "Le Roy m'ayant fait l'honneur de me donner la charge de surintendant des bastiments, je vous prie de me mander si vous n'avez point des ordres de faire des statues pour le Roy, et, en cas que vous en ayez, de me mander en quel état elles sont."

In a long and somewhat truculent reply, dated October 20, 1683, Puget mentioned: "je fis à Genes le modèle du ravissement d'Hélene, qui étant exécuté en marbre, seroit quelque chose

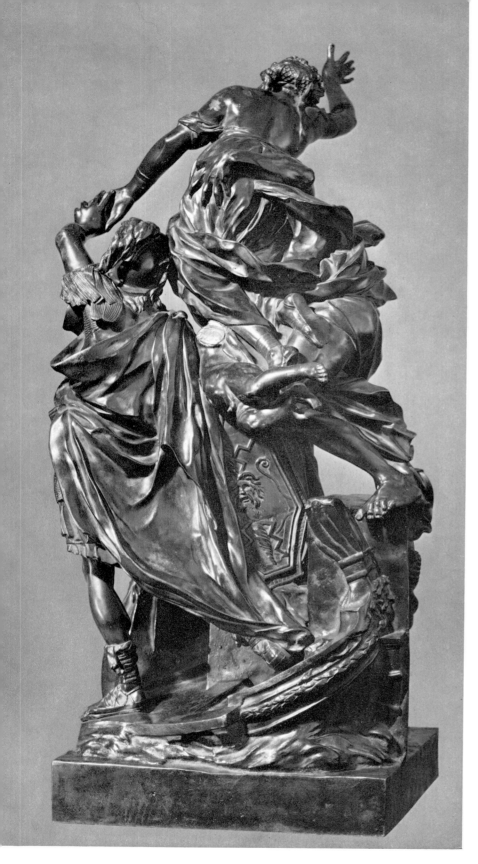

d'extraordinaire. . . ." (quoted by Herding, *op. cit.*, pp. 223–224).

In any event the marble never went to France, for the death of Louvois in 1694 put an end to the minister's artistic policies. The Rape of Helen was, however, completed for the Spinola family of Genoa, and Ratti (Raffaele Soprani and Carlo Giuseppe Ratti, *Delle vite de' pittori, scultori, ed architetti genovesi* . . . [Genoa, 1769], II, p. 325) refers to it in discussing Puget's work for Genoese patrons: ". . . L'altra è il gruppo esprimente la fuga di Elena, il quale si conserva da' Signori Spinola nel loro palazzo. . . ." The group was, in fact, placed on the terrace of the Spinola Palace, now the Palazzo Gambaro in the Via Garibaldi. About the middle of the nineteenth century it was removed and entirely lost sight of for a time, but it reappeared in the Palazzo Doria in 1885 (Herding, *op. cit.*, p. 182, catalogue no. 46, figs. 219, 220). At some time before 1908 it was moved to the villa at Sturla of Marchese Oberto Gentile, a descendant and heir of the Spinola family (see Mario Labò, "Pierre Puget à Gênes," in *Actes du Congrès d'Histoire de l'Art* [Paris, 1924], II, pp. 541–553, item 6 of the *catalogue raisonné*, p. 547).

In 1950 an attempt to export it from Italy as a work by pupils of Puget met with refusal of a license on the ground that it was certainly Puget's own work, and the marble group was acquired by the state for 500,000 lire (*Bollettino d'Arte*, XXXV [1950], illustrated p. 379). It is now in the care of the Soprintendenza alle Gallerie della Liguria.

No. 44 corresponds, on a much-reduced scale, to the marble group in all but quite minor particulars, e.g., the position of the arms of Cupid, some details of the boat, and the treatment of the waves. It was evidently cast from the model, probably of terracotta, referred to by Puget in his letter of October 20, 1683, to Louvois quoted above. Paola Rotondi ("Sculpture inconnues à Genes attribuées à Pierre Puget," in *Gazette des Beaux-Arts*, LI, March 1958, pp. 146–148) suggests a date of 1680–1681 for the model. But in a letter addressed to Louvois on October 20, 1683, cited by

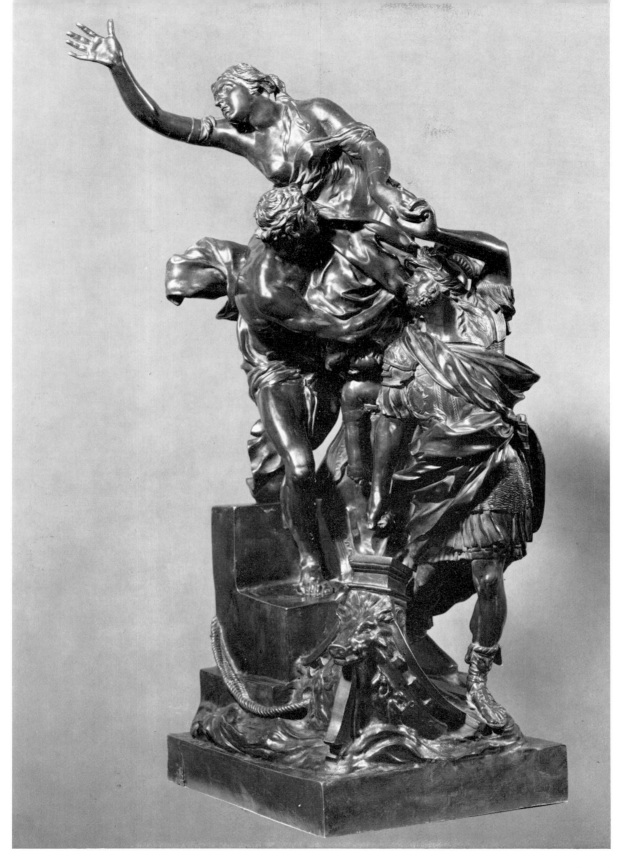

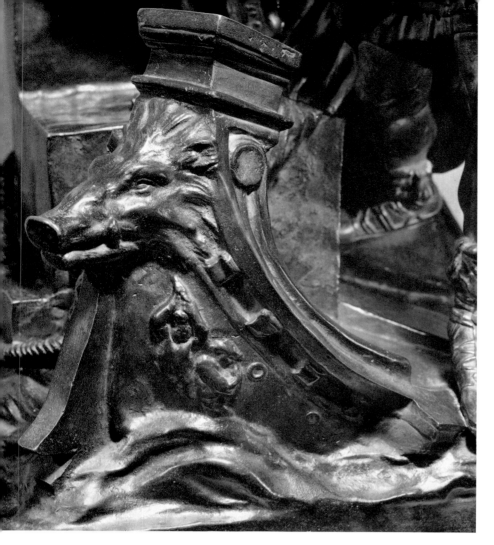

Herding (*op. cit.*, pp. 223–224; the original is lost), Puget wrote "Que s'il faut réduire à quelques ouvrages de moindre dépense, je fis à Genes le modèle du ravissement d'Hélene, qui étant exécuté en marbre, seroit quelque chose d'extraordinaire; j'en enverrai le dessein." This suggests a rather later date. The model was perhaps the terracotta belonging to La Live de Jully, whose fine collection of terracottas was renowned (see p. 379). In his *Dictionnaire pittoresque et historique* ... (Paris, 1766), I, p. 125, Hébert mentions, in the course of a description of the *Cabinet de M. de la Live de Jully*, among the *Sculptures de la première pièce sur le jardin:*

L'Enlévément d'Helène en terre cuite; par
 Pierre Puget.

This reappears in the sale of La Live's collection (Paris, March 1770; Lugt, *Catalogues de ventes publiques* [The Hague, 1938], I, no. 1805), as lot 168:

Pierre Puget. L'enlevement d'Helene, groupe composé de trois grandes figures & d'un enfant: il porte 3 pieds de hauteur. La force du génie de ce grand Artiste, s'annonce dans ce morceau.

It was sold for 150 livres, 2 sous. According to Stanislas Lami (*Dictionnaire des sculpteurs de l'école française sous le règne de Louis XIV* [Paris, 1906], p. 421), this terracotta was later (1807) in the Bastide Collection at Marseille; since then it has disappeared. Curiously, Santo Varni (*Ricordi di alcuni fonditori in bronzo*, Genoa, 1879, p. 52), writing about Algardi, mentions "Alquanti modelli dell'Algardi vidi pure in Carrara; ed uno potei acquistare, rappresentante il Ratto di Elena." Algardi is not known to have made such a model, and it seems possible that it may have been one of Puget's early models, which was to be seen at Carrara.

It seems highly likely therefore that the bronze was cast in France (probably soon after 1683), as indeed its technical and stylistic characteristics suggest. The terracotta may perhaps have been sent to Louvois for his approval of its execution in marble for the gardens at Versailles. The group has very much the character of the garden statues of the well-known Rapes by François Girardon and others to be seen there, but is markedly more baroque in character. Its composition is clearly influenced by the famous painting in the Capitoline Museum, Rome, of the Rape of the Sabines by Pietro da Cortona (1596–1669) with whom Puget worked in Rome. Only one other complete cast of the group is known (Figs. 1, 2). It is in the possession of M. Petit-Hory at Le Vallois-Perret (Herding, *op. cit.*, catalogue no. 46b, fig. 222). It differs from No. 44 in a number of minor particulars: the position of the figures in relation to one another is slightly different; there is a rock beneath the left foot of the companion of Paris; the sword of Paris survives; and there are differ-

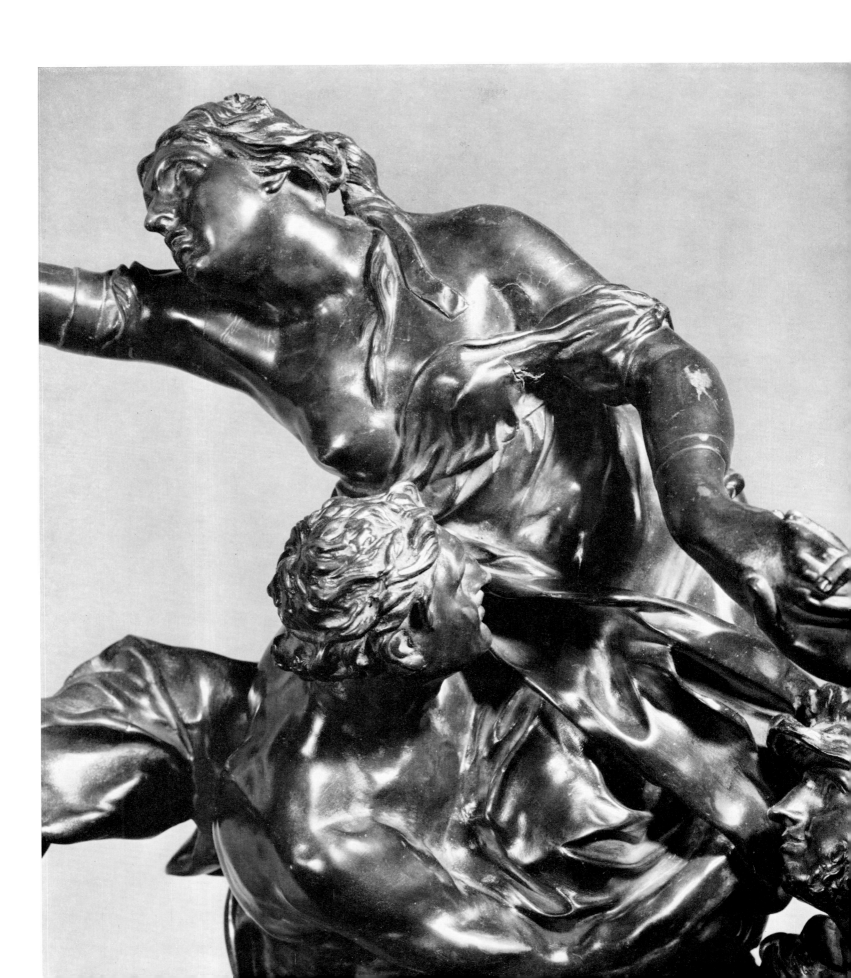

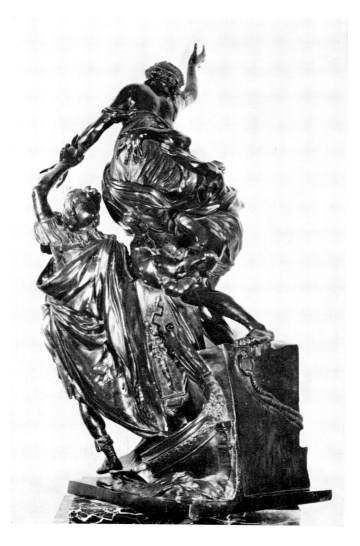

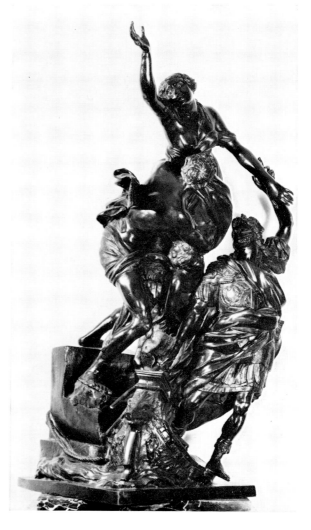

1, 2. *Pierre Puget, Rape of Helen. Bronze. Le Vallois-Perret, collection of Jacques Petit-Hory. Photos: Agraci*

ences in the surface chasing. In addition, the right arm of the Cupid, which is cut off at the shoulder on No. 44, is more complete and extends to the elbow. It is cast with metal bands binding it, as though the arm of the original terracotta had been badly damaged.

This is possibly a slightly earlier cast from which the *fondeur* worked up the more finished version of the group, No. 44. The differing arm of the Cupid suggests this. A further smaller bronze comprising the figures of Helen, the companion, and the unsupported body of Cupid only, resting on a thin circular base, is in the Musée des Arts Décoratifs, Paris (inv. 27.140; Herding, *op. cit.*, p. 183, catalogue no. 46c, fig. 226. See Fig. 3). In spite of the character of the base, it seems likely that it was cast at about the same period as No. 44 and the Petit-Hory bronze.

Among the accounts submitted by the *marchand-*

bijoutier Simon Philippe Poirier to the Comtesse du Barry, the following appears:

1770 Juin 23
Un très fort groupe de bronze de couleur antique, composé de quatre figures représentant l'Enlevement d'Helene par Paris, le tout sur un pied de bronze doré d'or moulu. 1440 l.

At the same time a smaller bronze group of five infants playing with a goat, after Jacques Sarazin (1588–1660), was supplied to the same client for the price of 816 livres (see Georges Wildenstein, "Simon-Philippe Poirier, fournisseur de Madame du Barry," in *Gazette des Beaux-Arts*, LX, September 1962, p. 373). Both groups were placed in the salon of the comtesse's apartments at Versailles and were described by several visitors, who record that the Rape of Helen stood on a commode of *ancien laque*, while the Sarazin group stood on a commode inlaid with porcelain plaques, also supplied by Poirier (see Émile Molinier, *Histoire générale des arts appliqués à l'industrie*, III, *Le Mobilier au XVII^e et au XVIII^e siècle* [Paris, 1898], pp. 173, 174).

This group of the Rape of Helen may possibly have been No. 44 or the version of it in the Petit-Hory Collection mentioned above, although neither shows any trace of gilding today. The subject is rare among French bronzes of the eighteenth century, although a much smaller bronze group of the Louis XIV period described as "L'Enlèvement de Rhéa Sylvia par Mars" (Louvre, *Catalogue des bronzes et cuivres* [Paris, 1904], no. 236) clearly depends on No. 44 in some way (Fig. 4). The figure of Helen is similarly posed, and the boat with a boar's head on the prow is of a similar character, but the figure of Paris and his female companion as well as the accompanying Cupid are totally different. The entire group is much more closely knit and less baroque than No. 44. It rests on an octagonal gilded bronze base cast

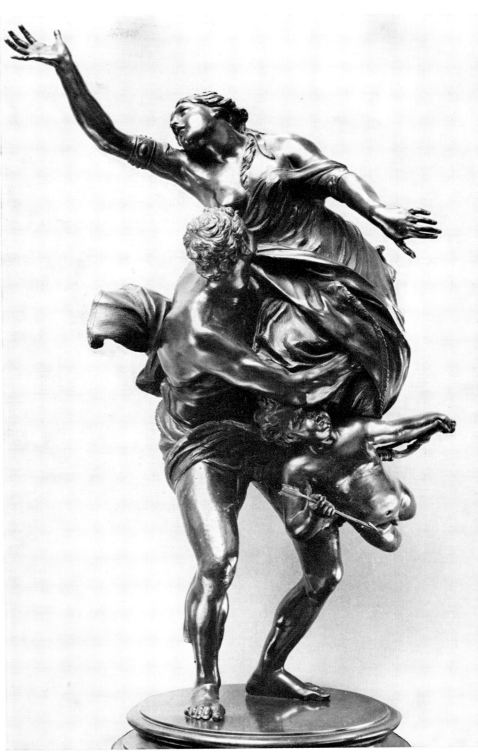

3. *Pierre Puget, Rape of Helen. Bronze. Paris, Musée des Arts Décoratifs*

integrally with the group. In spite of its present title the Louvre group appears to have been intended as an Enlèvement d'Hélène. This has sometimes been identified as a cast from the *morceau de réception* of Philippe Bertrand (about 1661/64–1724), the maquette for which was shown at the Salon of 1699 and passed to the Académie (see André Fontaine, *Les Collections de l'Académie Royale de Peinture et de Sculpture* [Paris, 1910], p. 167, no. 231), but this maquette has since disappeared. The contemporary description of it, however, corresponds much more closely with a bronze Rape of Helen in the Hermitage, which is there attributed to Bertrand (illustrated in Z. Zaretskaïa and N. Kossaréva, *La Sculpture de l'Europe occidentale à l'Ermitage* [Leningrad, 1970], pl. 97). This may be the bronze version that was lot 138 in the Lebrun Lerouge sale (Paris, January 19, 1778; Lugt, *op. cit.*, I, no. 2772), although there are discrepancies in the sizes. In any case the composition of the Hermitage bronze clearly derives from No. 44.

Pierre Puget was the most baroque of French sculptors. He was also a painter and an architect. Born at Marseille, he had his full share of the southern temperament and a highly original personality. Coming from a family of master masons, his earliest training was under a woodcarver named Jean Roman, but in 1640 he made his own way to Florence and Rome where he learned the fundamentals of art under the leading painter of the day, Pietro da Cortona. On his return to Marseille in 1644 he began his career as a painter, but also worked for a time carving the wooden prows of galleys in the Arsenal at Toulon. A feeling for stone was, however, in his blood, and when, in 1656, he obtained the commission to decorate the portal of the town hall at Toulon, his future was settled. The two Michelangelesque caryatid figures supporting a balcony with which he framed the door brought more than local fame, and he was commissioned by the Marquis de Girardin to execute two statues for the gardens of his Château de Vaudreuil in Normandy. This led to a commission from Fouquet for a Hercule Gaulois for Vaux-le-Vicomte (later at Sceaux and now in the Louvre).

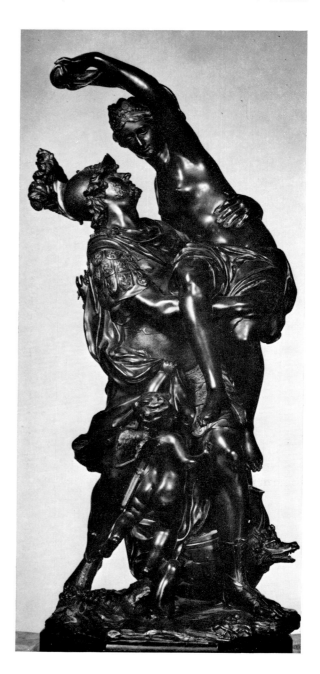

4. *Enlèvement de Rhéa Sylvia par Mars. Bronze. Paris, Musée du Louvre. Photo: Musées Nationaux*

At the moment of Fouquet's fall, in 1661, Puget was at Genoa, or possibly at Rome obtaining marble for this work. He remained in Genoa for the next seven years, working with considerable success for local patrons. A group of monumental figures of saints in the full baroque style for the church of Santa Maria in Carignano was his outstanding achievement in these years. On his return from Genoa to France he was made master sculptor in the Arsenal at Toulon and designed a number of vessels for construction there, executing their carved decoration himself.

His undisciplined temperament and the extremely anti-classical tendencies of his work, however, lost him this post and did not recommend him to Le Brun and Colbert, whose vision of the Louis XIV style was of a far more restrained baroque than Puget's. It was with great difficulty that Puget obtained the acceptance of the now famous Milo of Crotona for the gardens at Versailles, a work that arrived there in 1683, on the eve of Colbert's death. It was perhaps Colbert's opposition to Puget as much as the artist's own abilities that recommended him to Louvois, Colbert's successor, who immediately ordered him to complete his relief of Alexander and Diogenes and the Perseus Delivering Andromeda (both now in the Louvre). It was on this occasion that Puget wrote to the minister the remarkable description of his own attitude to sculpture: "Je me suis nourri aux grands ouvrages, je nage quand j'y travaille; et le marbre tremble devant moi, pour grosse que soit la pièce." (Herding, *op. cit.*, p. 224). His last work, a bas-relief of San Carlo Borromeo Praying for the Relief of Milan from the Plague, was executed for his native city, in which he died.

BIBLIOGRAPHY: Klaus Herding, *Pierre Puget: Das bildnerische Werk* (Berlin, 1970), is richly documented and illustrated. It contains a complete catalogue of Puget's works, a full bibliography, and displaces Léon Lagrange, *Pierre Puget* (Paris, 1868), the only previous book on the artist of any great significance, which, however, is still of some interest for citing letters of some of Puget's correspondents.

Detail of the Wrightsman bronze

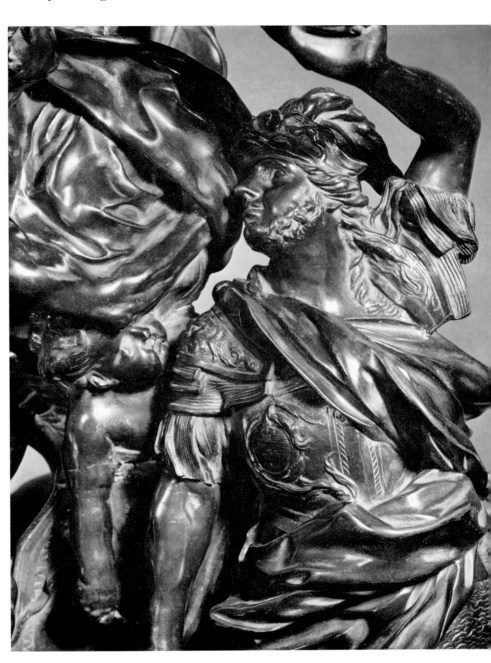

45 A, B Pair of Figures after Michelangelo's Dawn and Night

Dawn: H. 15½ (39.4); W. 28 (71.1); D. 11 (28.0).
Night: H. 14 (35.5); W. 30 (76.2); D. 11 (28.0).

OF LIGHT, buff-colored terracotta, covered with a light gray wash. The bases are probably of lime-wood, veneered with ebonized pine; additional drapery at the back of the figures is of pine, painted gray.

The two reclining figures are reduced versions of Michelangelo's most celebrated sculptures. No.

45 A is a variation of Michelangelo's unfinished figure of Dawn, executed between 1521 and 1527 for the tomb of Giuliano de' Medici in the Medici memorial chapel in the church of San Lorenzo in Florence. No. 45 B is likewise based on the figure of Night (or Dusk) on the tomb of Lorenzo de' Medici in the same chapel. The drapery at the

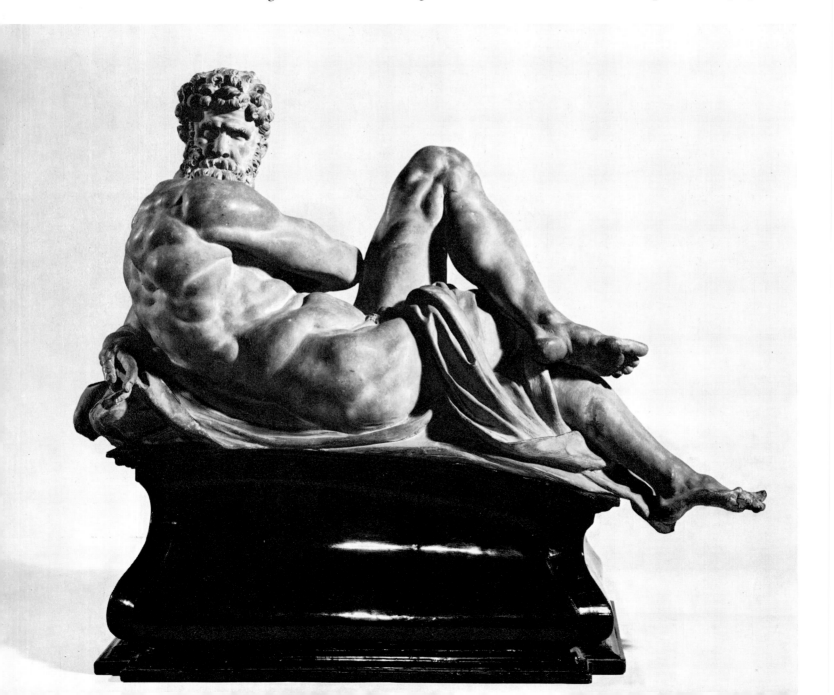

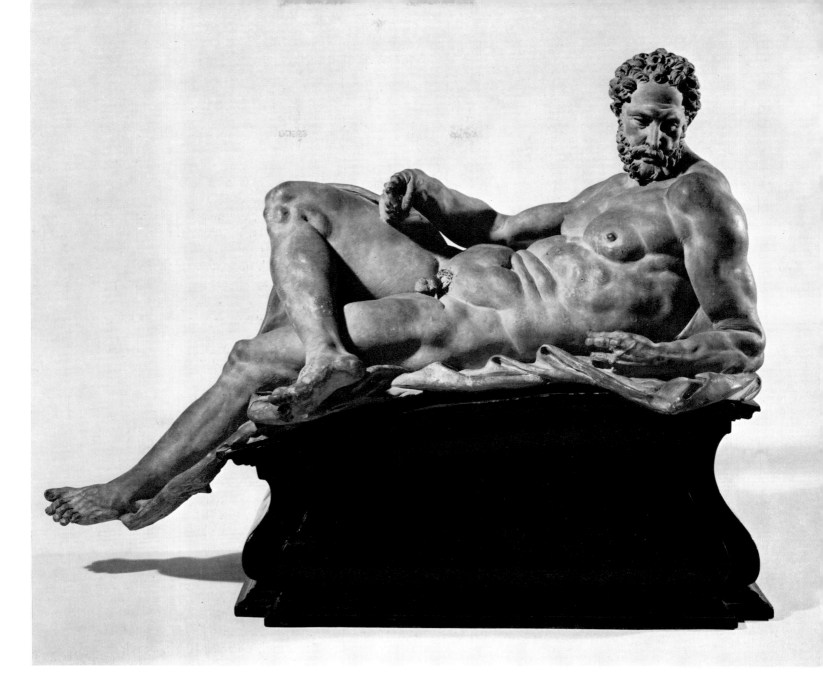

back of each is carved from wood and forms a support for the terracotta figure.

Certain numbers, much defaced and difficult to read, are painted on the backs. They may be nineteenth-century inventory numbers or possibly dealers' stock marks. They appear to read, on No. 45 A, 99 [?] 17//, and on No. 45 B, 84 [?] 7, with another totally illegible group of figures.

After Michelangelo Buonarroti (1475–1564),

probably by a northern (possibly Dutch) sculptor, dating from the early eighteenth century.

The fame of Michelangelo's Medici tomb figures caused them to be copied and imitated in various media from soon after their creation. Small reductions were produced for collectors and travelers (a number of eighteenth-century examples purchased by Englishmen on the Grand Tour are recorded), and no doubt terracotta was

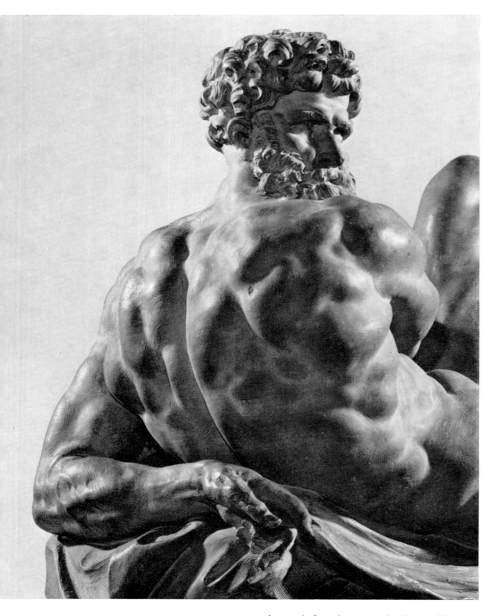

terracottas by Tribolo of 1535 (Umberto Rossi, "Il Museo Nazionale di Firenze nel Triennio 1889–1891," in *Archivio storico dell' arte* [Rome, 1893], VI, p. 13); a terracotta of the Night in the Museum of Fine Arts at Houston (formerly in the Ruland Collection, Weimar; later in that of Percy Strauss, New York, illustrated in Ernst Steinmann, *Das Geheimnis der Medicigraeber Michel Angelos* [Leipzig, 1907], p. 85, fig. 18); three terracottas in the Victoria and Albert Museum (see Pope-Hennessy, *op. cit.*, nos. 446, 447, 448; the Dawn from the Gherardini Collection and the Dawn and Night formerly in that of Paul von Praun); a wax model in Oxford, Ashmolean Museum (J. C. Robinson, *Drawings by Michel Angelo and Raffaello in the University Galleries* [Oxford, 1870], no. 89); plasters made by Vincenzo Danti in 1573 at the Accademia di Belle Arti in Perugia ("I gessi michelangioleschi. . . ," in *Rassegna d'Arte Umbra*, I [1909], pp. 26–27).

Lost sixteenth-century replicas include plasters by Daniele da Volterra (1557), generally assumed to have been used by Tintoretto for several drawings now in Oxford, Florence, Paris, and New York, and bronzes by Pietro da Barga (inventory of Cardinal Ferdinand de' Medici, 1571–1588) and by Pietro Tacca (Baldinucci, *Notizie dei professori del disegno* [Florence, 1845–1847], IV, p. 87). A bronze after the Night appears on one of the plates of *La Galerie de Girardon*, engraved about 1710 by Charpentier and Chevallier (illustrated in Pierre Francastel, *Girardon* [Paris, 1921], fig. 92), and a replica of the Night is shown on a table in a picture gallery in a painting by Frans Francken II at Wilton, in the collection of the Earls of Pembroke (illustrated in *A Catalogue of the Paintings & Drawings in the Collection at Wilton House* [London—New York, 1968], no. 148, pl. 49).

Attributions of terracottas are notoriously difficult. The material takes no patina enabling it to be dated. Only purely stylistic criteria can therefore be applied. Nos. 45 A and B differ considerably from Michelangelo's originals. Both are more completely finished with smooth, carefully worked surfaces. The torsos are rather more

sometimes adopted for these with the deliberate intention of suggesting that they were the sculptor's original *bozzetti*, which, if they ever existed, do not appear to have survived (for a discussion of these points, see John Pope-Hennessy, *Catalogue of Italian Sculpture in the Victoria and Albert Museum* [London, 1964], II, pp. 424–426).

A number of examples dating from the sixteenth century survive. Among these are three

slender than the originals, and the anatomy is treated in an analytical fashion. The handling is formalized and slightly mannered with the silhouettes somewhat emphasized, although the modeling, particularly of the extremities, is vigorous and nervous. In contrast to the interplay of powerful masses of Michelangelo's originals, the emphasis is on linear and expressive qualities, and the faces in particular are given a quite different and almost supercilious character, quite absent from the meditative, inward-looking originals.

Various proposals as to authorship have been put forward. The style of Pietro Francavilla (1548[?]–1615) was tentatively suggested by Miss Olga Raggio, but no certain autograph terracotta from his hand is known to survive. Others have seen a connection with the studio of Giovanni Bologna (1529–1608), based on a comparison with various versions of two River Gods in terracotta in the Berlin Museum, the Museo Nazionale in Florence, the Accademia di San Luca in Rome, The Metropolitan Museum of Art, New York (acc. nos. 17.190.2090, 2091), and elsewhere, all of which are generally considered to be replicas from Giovanni Bologna's studio.

The style and handling of the terracottas appear, however, to be of eighteenth-century date rather than seventeenth-century. In the absence of any documentary evidence Sir John Pope-Hennessy's suggestion that the terracottas are of northern and possibly Dutch origin carries considerable conviction.

There was a marked taste for terracotta models in the eighteenth century, especially in France. La Live de Jully, whose collection of such terracottas was outstanding, wrote in the introduction to the catalogue of his own collection (*Catalogue historique du cabinet de peinture et sculpture françoise* [Paris, 1764]):

> Pour remplir à peu près le même objet,★
> j'ai rassemblé un modèle de terre cuite
> de chaque Sculpteur, & ces modèles ont
> souvent plus d'avantages que les marbres,
> parce que l'on y trouve bien mieux le feu &
> le véritable talent de l'Artiste.

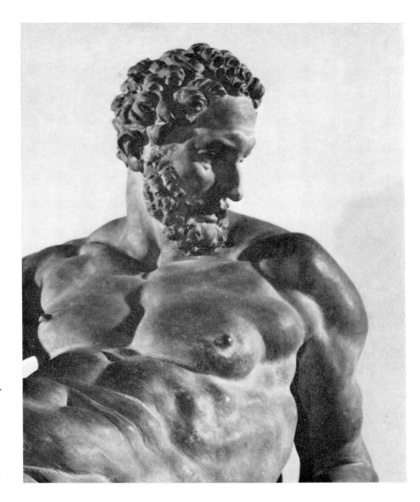

Such a taste may well account for the creation of such pseudo-models as Nos. 45 A and B during the eighteenth century.

In 1971 Nos. 45 A and B were donated by Mr. and Mrs. Wrightsman to The Metropolitan Museum of Art (acc. nos. 1971.206. 35. 36).

BIBLIOGRAPHY: For a discussion of the whole question of Michelangelo's wax and other models, and other models after Michelangelo, see John Pope-Hennessy, "The Gherardini Collection of Italian Sculpture," in *Victoria and Albert Museum Yearbook*, no. 2, 1970, pp. 7–26).

★La Live is referring here to his scheme to assemble a representative collection of French painting and sculpture but remarks that the difficulties of assembling marbles are too great.

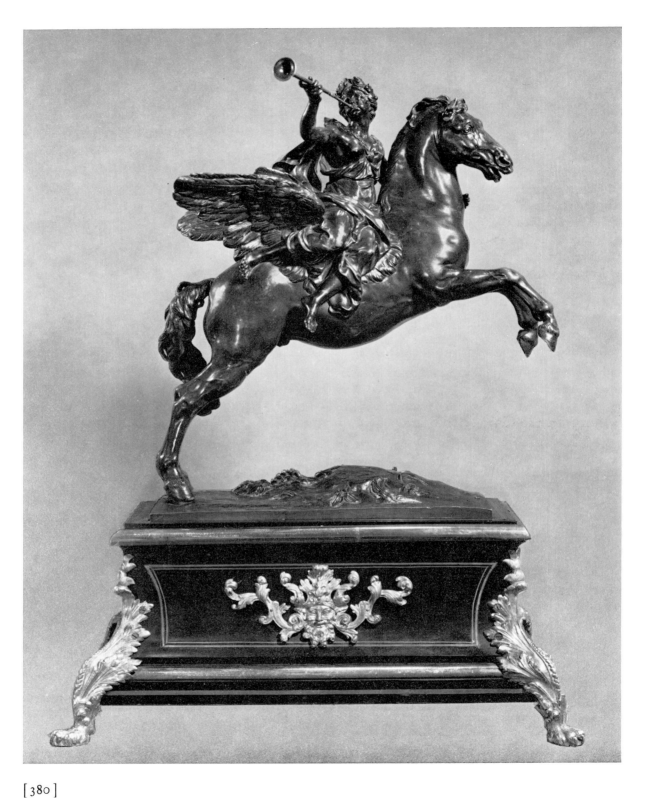

46 A, B Fame and Mercury (Les Chevaux de Marly)

Fame: H. 23¼ (59.0); W. of base 17 (43.2); D. of base 7⅝ (19.3).
Mercury: H. 24⁵⁄₁₆ (61.7); W. of base 16¾ (42.6); D. of base 7⅝ (19.3).
Socles: H. 10¾ (27.2); W. 25½ (64.8); D. 16½ (41.9).

OF BRONZE with a translucent orange varnish that has become brownish black in most areas. Where the varnish has been rubbed, a mottled greenish yellow patination of the bronze is revealed beneath.

Nos. 46 A and B are reductions of the over-life-sized marble equestrian groups by Antoine Coysevox installed in November 1702 at the end of the Abreuvoir at the Château de Marly. They were moved to Paris on January 7, 1719, and set up at the entrance to the Tuileries gardens facing the Place Louis XV (now the Place de la Concorde), where they still stand (Figs. 1, 2). They were replaced at Marly by a pair of horses being restrained by nude men, the work of Guillaume I Coustou (1677–1746); these in turn were moved in 1794 to the opposite end of the Place de la Concorde.

The figures are each seated side-saddle on a winged horse rearing at an angle of about thirty degrees from the horizontal. Fame, a female figure wearing classical draperies, faces slightly backward. She holds a long trumpet to her lips with her right arm. Mercury, wearing the petasus, or winged hat (here surmounted by a crouching dog), and glancing downward, brandishes his caduceus above the horse's head with his right hand and clasps the reins (missing) in his left. As messenger of the gods he wears winged sandals, and a piece of drapery flies in the wind from his right shoulder. Each figure is seated on a saddlecloth of fur. The tail of Fame's horse is pendent; that of Mercury blows in the breeze. Each horse's rear legs rest on a thin rectangular base, cast and chased with a hummock of earth, foliage, etc.

The socles are each of ebonized wood inlaid with narrow fillets of brass following the shape of the concave panels of the sides. At each corner they are mounted with acanthus leaves of gilt bronze terminating in a foot in the form of a lion's paw that elevates the socle off the ground. The center of each panel in front is mounted with the mask of a bearded man flanked by meandering acanthus scrolls.

After Antoine Coysevox (1640–1720), perhaps cast in his workshop about 1700–1702.

REFERENCES: F. J. B. Watson, "From Antico to Houdon," in *Apollo*, XC, September 1969, pp. 215–216, figs. 3, 4. The literature on the original marbles is extensive. See Georges Keller-Dorian, *Antoine Coysevox (1640–1720)* (Paris, 1920), II, pp. 33–40.

EXHIBITED: Knoedler's, New York, *The French Bronze 1500–1800*, 1968, catalogue no. 41 (illustrated).

Formerly in the collection of Baron Louis de Rothschild, Vienna; possibly once in the collection of Bonnier de La Mosson (1702–1744).

Reduced bronze casts of the Chevaux de Marly are not uncommon. A pair, for instance, was sent to Augustus the Strong in 1715 by Baron Le Plat, who was buying sculpture for him in Paris and Italy (Walter Holzhausen, "Die bronzen Augusts des Starken in Dresden," in *Jahrbuch der Preuszischen Kunstsammlungen*, LX [1939], pp. 157–186). These are still to be found in the Grünes Gewölbe in Dresden (J. G. Th. Graesse, *A Descriptive Catalogue of the Grüne Gewölbe* [Dresden, 1880], p. 11, nos. 68, 86). Several other versions are recorded in French sale catalogues during the eighteenth century (e.g., Pontchartrain, Paris, 1747, p. 17, lot 99, Lugt, *Catalogues de ventes publiques* [The Hague, 1938], I, no. 678; de Selle,

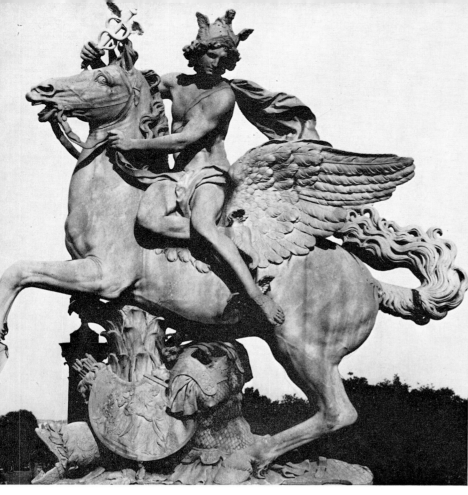

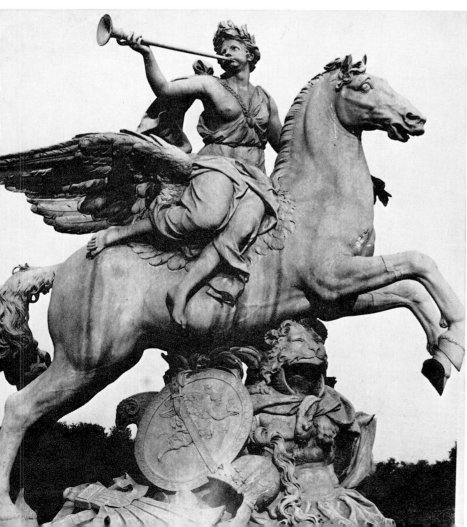

Paris, February 19–28, 1761, p. 34, lot 75, Lugt no. 1137; Nicolai, Paris, May 25, 1797, p. 11, Lugt no. 5603).

An entry in the sale catalogue of Bonnier de La Mosson (Lugt no. 614; March 8 ff., 1745) is of particular interest:

> No. 895 Deux Renommées de bronze à cheval, de vingt-trois pouces de haut, sur terrasses aussi de bronze, montées sur des pieds de bois noirci, avec ornemens de bronze. . . .

There is a small discrepancy in the measurement of the height, but this is not unusual in eighteenth-century sale catalogues, while the striking similarity of the socles suggests the possibility that the bronzes may actually have been Nos. 46 A and B. Bonnier de La Mosson was a wealthy art collecting son of the former trésorier de Languedoc.

A number of examples survive today as do reductions of the Coustou groups that replaced Coysevox's sculptures at Marly in 1719. However, only three other casts (and a single, gilded Fame) on anything like this scale are known. One pair was in the Eugène Kraemer sale, Galerie Georges Petit, Paris, April 28–29, 1913, lot 121 (illustrated), inscribed and dated 1702; a second is in the Hermitage Museum, Leningrad (illustrated in Z. Zaretskaïa and N. Kossaréva, *La Sculpture française des XVII—XX siècles au Musée de l'Ermitage* [Leningrad, 1963], pls. 6, 7) and apparently came from the Yousoupoff Collection (illustrated in *Les Trésors d'art en Russie* [St. Petersburg, 1905], V, no. 3, pls. XIII, XIV); and a third pair belongs to Baron Élie de Rothschild, Paris (illustrated in *Great Private Collections*, ed. Douglas Cooper [New York, 1963], one on p. 170, the other on the dust jacket). The horses of the Hermitage and the Kraemer pair are supported beneath the belly by a military trophy and palm fronds as are the original marbles. This also appears on an exceptionally large gilded bronze of Fame in the possession of Messrs. Heim, London, in 1970. The trophies are absent from the Rothschild pair, in

1, 2. *Antoine Coysevox, Mercury and Fame. Marble. Paris, Jardins des Tuileries*

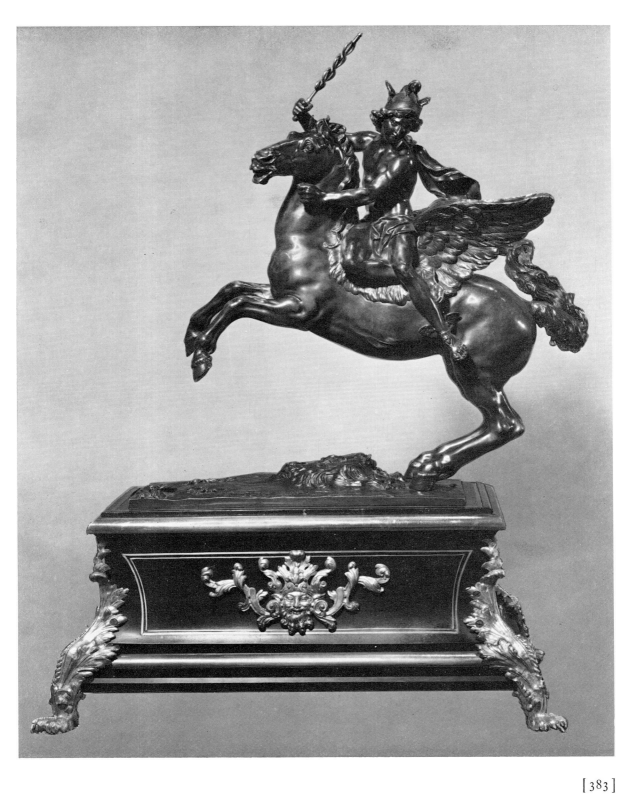

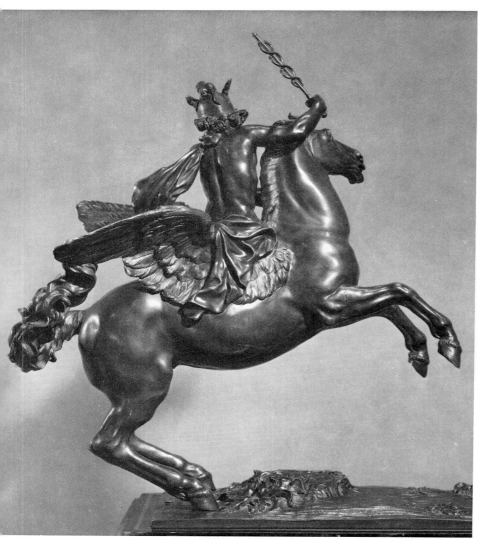

Rear view of Mercury

rearing mounted horses around the axis of the rear legs, each group has a long strut cast integrally with the base and set at an angle of about fifteen degrees below it. This strut passes diagonally from side to side right across the interior of the contemporary socles and is securely bolted to the inner structure of the woodwork at the end opposite to the horses' rear legs. This unusual feature enables the visually satisfactory but physically unwieldy groups to stand in stable equilibrium. This feature is missing on all other examples examined by the compiler. It suggests that Nos. 46 A and B must have been cast at a quite early stage in the creation of the groups, before the need for the supporting trophies had been fully thought out. The terracotta or plaster models from which they may, perhaps, have been cast, being constructed of relatively light material, probably with a simple metal armature, would not have presented the same difficulties of equilibrium.

When first examined by the compiler, the component parts of the bronzes were attached by old screws and bolts, presumably the originals. These have now been replaced by modern bolts and screws, probably for security during the transportation of the pieces from Europe.

In 1971 Nos. 46 A and B were donated by Mr. and Mrs. Wrightsman to The Metropolitan Museum of Art (acc. nos. 1971.206.37, 38).

Antoine Coysevox was born in Lyon, the son of a sculptor, possibly of Spanish extraction. After preliminary training under his father he quitted his native city in 1657 for Paris, where he studied under Louis II Lerambert (1620–1670), whose niece he married in 1666. Thereafter Coysevox rapidly achieved a leading position as a sculptor at the court of Louis XIV and was extensively employed to embellish the royal palaces of Marly, Trianon, Saint-Cloud, and especially Versailles. For the gardens of the latter he executed, in collaboration with Jean–Baptiste I Tuby (about 1630/35–1700), elaborate fountain groups, the Char de la France Triomphante and the Empire Vaincu (1683), as well as the Vase de la Guerre (1684) and other important works. Coysevox was elected to the Acad-

which both horses have been canted up an additional thirty degrees as compared with the other versions mentioned in order that they should remain in a stable position on their relatively short rectangular bases.

On Nos. 46 A and B, however, the horses are prancing freely at approximately the same angle as that of the original marbles. In order that such weighty casts should remain stable in this position, in spite of the immense torque exercised by the

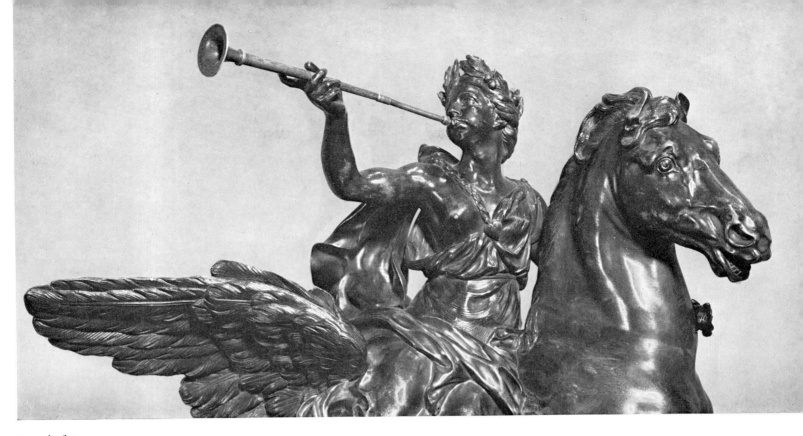

Detail of Fame

Rear view of Fame

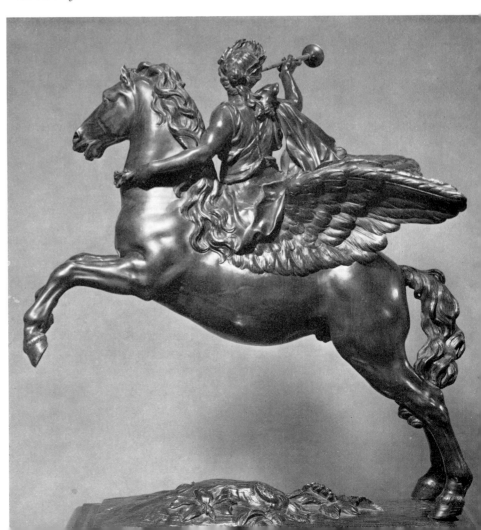

émie in 1676, his *morceau de réception* being a bust of its president, the great designer and decorative painter Charles Le Brun. In 1716 he was appointed its chancellor.

In addition, Coysevox was an outstanding portrait sculptor, executing, for instance, the statue of Louis XIV for the Paris Hôtel de Ville (1689; now destroyed) and bust of the Grand Condé for Chantilly (1686), as well as tombs and portraits of many of the most famous figures of the period.

Coysevox was perhaps the ablest exponent in sculpture of the modified baroque of the Louis XIV style, although his portrait busts were certainly influenced by Bernini's portrait of Louis XIV. His nephews Nicolas (1658–1733) and Guillaume Coustou (1677–1746) were trained under him and became outstanding sculptors of the next generation. Guillaume was responsible for creating the second pair of the Chevaux de Marly, which took the place of his uncle's horses when these were moved to Paris.

BIBLIOGRAPHY: Georges Keller-Dorian, *Antoine Coysevox (1640–1720)* (Paris, 1920), is the best monograph on the artist. Luc Benoist, *Coysevox* (Paris, 1930), adds little or nothing to it and is less well illustrated.

47 A, B Pair of Groups of Infants and Sea Monsters

47 A: H. (without plinth) 11¼ (28.6); W. 17⅜ (44.1); D. 10⅜ (26.3).
47 B: H. (without plinth) 10¼ (26.0); W. 17⅜ (44.1); D. 10⁷⁄₁₆ (26.6).

OF BRONZE, partly gilded and partly patinated an even black tone. The painted wood plinths are modern.

Each deals with a marine theme and consists of a group of two infants and a sea monster of patinated bronze supported on a reticulated oval base of gilt bronze representing waves. Each rests on a low oval plinth of wood painted to simulate red griotte marble with a gilded molding around its upper and lower edges.

On No. 47 A a hippogriff with a spirally twisting fishtail rears neighing from the waves, while an infant triton and a young mermaid with double fishtails play among the waves on each side. On No. 47 B a large dolphin, its tail in the air, swims through the waves while two infants ride astride its back and head.

The two groups are cast somewhat differently. The gilt-bronze waves supporting No. 47 A are cast in three pieces, and the lower part of the body of the hippogriff actually passes through a hole in them. On No. 47 B this base is cast whole, and the patinated bronze group rests in a recess on its surface. The bodies of the hippogriff and the dolphin as well as the fishtails of the triton and mermaid are chased with delicate scales.

Attributed to an anonymous follower of Edme Bouchardon (1698–1762).

REFERENCE: F. J. B. Watson, "From Antico to Houdon," in *Apollo*, XC, September 1969, pp. 216–217, figs. 5, 6.

These two groups have been associated with Edme Bouchardon's monumental groups of infants astride dragons in the Bassin de Neptune at Versailles (Fig. 1). The models for these were begun in 1736 or 1737, and they were finally put in position in 1741, for on August 14 of that year Louis XV inspected the finished fountain for the first time. Several works of a cognate character by Bouchardon are recorded in the eighteenth century. Thus in the Salon of 1738 the sculptor exhibited an "Autre [enfant sur un dauphin] modéle en terre cuite." This was later in the Mariette Collection and appeared at his sale on November 15, 1775, as lot 55, where we are told that it stood "sur des pieds de bois de marqueterie de 12 pouces de proportion." In the same Salon he showed

> Un Modéle en terre cuite pour une Fontaine;
> l'on y voit un Triton & une Nereïde couchés
> aux côtés d'un Hippopotame . . .

which he presented to the Comte de Caylus. Later it appeared at the Vassal de Saint-Hubert sale in 1774 as lot 149:

> Deux syrenes, un dauphin, &c modele d'une
> fontaine par *Edme Bouchardon*, qu'il a
> exécutée à Versailles

which sold for 241 livres.

Probably Nos. 47 A and B were inspired by such works as these and date from around 1740, but they are likely to be the work of a lesser hand than Bouchardon's, possibly that of one of his assistants.

A very similar group of white statuary marble representing a single infant triton playing with a dolphin is in the Dartmouth Collection, London. It likewise is anonymous.

Edme Bouchardon was an early precursor of neoclassicism in France. He was a pupil first of his father, and later of Guillaume I Coustou (1677–1746). Although his early works are a mere continuation of the baroque style of the seventeenth century, the permanent classical bias of his art was settled once and for all in Rome, where he was living from 1723 to 1733. His copy of the Barberini Sleeping Faun, made while a student there, created a sensation.

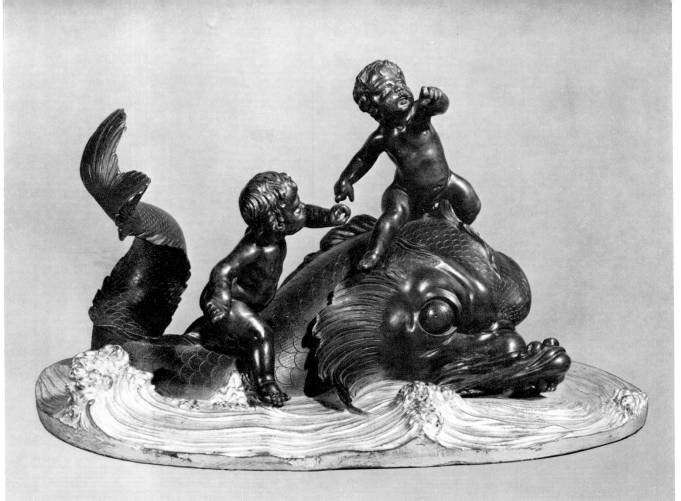

1. *Edme Bouchardon, group from the Bassin de Neptune. Versailles. Photo: Musées Nationaux*

On his return to Paris he was less successful than Lambert Sigisbert Adam (1700–1759), who had been his exact contemporary at Rome and whose style was markedly rococo. The two, however, collaborated on the Bassin de Neptune at Versailles, though Bouchardon worked only in an inferior capacity. In 1739 the city of Paris commissioned him to execute a monumental fountain in the Rue de Grenelle, a work that when completed in 1745 anticipated to a remarkable degree the fully developed Louis XVI style of three decades later. These classicizing tendencies recommended him to the Comte de Caylus, the chief propagandist at this date of the reaction against the rococo style. Mariette, too, was a great supporter of Bouchardon, as was Charles Nicolas Cochin, the influential secretary of the Académie who has left valuable biographical notes on the sculptor. Cochin, likewise, was a firm opponent of the rococo. As a consequence of support in these quarters, Bouchardon received from the Bâtiments the commission for the statue of Amour Taillant son Arc dans la Massue d'Hercule. This much-discussed work took ten years to complete, but achieved little success when exhibited at Versailles in 1750, being still in advance of the taste of the day. Before this, however, in 1748, he had received from the city of Paris the commission for the equestrian statue of Louis XV to stand at the center of Ange Jacques Gabriel's Place Louis XV (now the Place de la Concorde) in Paris. This work, for which he drew hundreds of carefully observed studies in red chalk, especially of the horse, occupied him for the rest of his life. Only the horse and rider were cast by the time of Bouchardon's death. The execution of the figures supporting the pedestal was left to J. B. Pigalle (1714–1785). The statue itself was destroyed during the Revolution, but numerous drawings and engravings, as well as a few reduced models in bronze, survive to testify to its monumental classicism.

BIBLIOGRAPHY: The most recent study of Bouchardon is Alphonse Roserot, *Edme Bouchardon* (Paris, 1910). It includes a bibliography, but several important articles have been published since the book was issued.

48 A, B Pair of Groups of Venus and Cupid

48 A: H. 12¹⁵/₁₆ (32.9); Diam. of base 5½ (14.0).
48 B: H. 12⅞ (32.8); Diam. of base 5½ (14.0).
Pedestals: H. 5 (12.6); w. 8 (20.2).

OF WHITE statuary marble. The pedestals are of the same marble, mounted with gilt bronze.

On No. 48 A Venus, naked with roses entwined in her hair, is seated on drapery arranged on a tree stump. She looks down toward Cupid, whom she clasps against her side with her left arm, while she drapes a swag of roses around him. Cupid raises his left arm upward toward her chin. Her right arm is extended full-length across her body; her left foot projects slightly beyond the rockwork. On No. 48 B Venus is again seated on a tree stump, over which drapery is hanging. She turns toward Cupid, who stands at her right side, his hands grasping her thigh. In her left hand Venus clasps a dove against her right thigh, while with her extended right arm she touches one of Cupid's wings. Her right foot extends slightly beyond the rockwork base.

Each group rests on a low, columnar pedestal of white marble fluted and fitted with gilt-bronze *chandelles*. A gilt-bronze beading runs around the top and above the foot of the column, which, in its turn, rests on a low, square plinth of gilt bronze with chamfered and coved corners, decorated with panels chased with vertical ribbing.

Attributed to Étienne Maurice Falconet (1716–1791) or one of his assistants.

Falconet produced a considerable quantity of small sculptures of this type. Among these, groups of Venus and Cupid and of Bathing Nymphs predominate. None were exhibited at the Salons, so that only those which bear Falconet's authentic signature can be regarded as absolutely from his own hand. The production of these small decorative groups was undoubtedly considerable. The same composition is often repeated. It seems likely that some, at least, of the repetitions must be the work of studio assistants or imitators. In the second category, the brothers Joseph and Ignace Broche (working about 1757—after 1779) are known to have produced small sculptures of this character, several of which were in the Duc de Chabot sale, July 21, 1777 (Lugt, *Catalogues de ventes publiques* [The Hague, 1938], I, no. 2724). Others may be copies or pastiches produced during the nineteenth century, some of which can be remarkably deceptive.

Versions of Nos. 48 A and B were in the Pierpont Morgan Collection and later in the collection of Judge Elbert Henry Gary (illustrated in Louis Réau, *Étienne-Maurice Falconet* [Paris, 1922], I, pl. XIX). They both rest on simple, fluted bases without gilt-bronze enrichments and were attributed by Réau (p. 238) to Falconet himself. No signed or dated version of either statuette is recorded.

The dated examples of sculpture from this group all fall into the decade 1754 to 1763 (a list of them is printed in Réau, p. 237, which may be supplemented by others mentioned in the *Wallace Collection Catalogues: Sculpture* [London, 1931], pp. 11, 12, no. S 28). They seem to be associated with his work at Sèvres, where he was appointed *chef de l'atelier de sculpture* in 1757, although he had produced small-scale sculpture for the Vincennes factory as early as 1754. After 1766, when he left for Russia, he probably ceased to produce them.

Étienne Maurice Falconet, the son of a *compagnon menuisier*, was a pupil of Jean-Baptiste Lemoyne (1704–1778), although he learned the groundings of his art from his maternal uncle Nicolas Guillaume. In 1744 while still in Lemoyne's studio he modeled a Milo of Crotona with such success that he was *agréé*

at the Académie on the strength of it. Ten years later he became a full academician, his *morceau de réception* being a marble version of the Milo. Later he became professor and *adjoint au recteur*.

In 1757 he was appointed head of the sculpture department of the Sèvres factory and produced numerous models for reproduction in *biscuit* porcelain. These, in which a somewhat cold feeling for the antique is softened by a certain rococo grace, were immensely popular and continue to be so to this day. He undoubtedly found it irksome to have to concentrate on these minor works rather than on monumental sculpture. Nevertheless, although he produced a number of large statues they never attained the popular success of his small groups. These and his work at Sèvres brought him, however, the patronage of Mme de Pompadour, for whose gardens and houses at Choisy and Bellevue he produced several statues.

In 1766 he received an invitation from Catherine II of Russia to execute an equestrian memorial statue to Peter the Great at St. Petersburg. He jumped at the offer, resigned from Sèvres where he was replaced by Bachelier, and proceeded to Russia, where, with the help of his daughter-in-law and pupil Marie Anne

Collot (1748–1821), he produced the famous monumental Bronze Horseman (Peter the Great) that looks out across the Neva from its huge granite plinth on the Decembrists' Square. It was probably the opportunity to produce a work on this scale, even more than the exceptionally high fee offered by the empress, that induced Falconet to quit Paris. The statue of Peter the Great took twelve years to complete. He remained at St. Petersburg until 1778 but was eventually soured by the difficulties he encountered there and quitted the country before the monument was inaugurated. Falconet arrived in Paris in 1781 after a stay at The Hague in Holland of nearly three years. He was planning to embark on a visit to Italy, where he had never been, when he was struck down by death in 1791.

In later life he published a book on neoclassical theory and engaged in polemics on the subject with Diderot, but, in fact, his masterpiece, the equestrian statue of the czar at St. Petersburg, looks forward to the romantic sculpture of the early nineteenth century rather than back to antiquity.

BIBLIOGRAPHY: Louis Réau, *Étienne-Maurice Falconet* (Paris, 1922), with full bibliography down to that date. Little of significance has been written since.

49 Bust of Claude Adrien Helvétius

H. 18⅜ (46.6); W. 16 (40.7); D. 10¾ (27.3); H. of base 6⅛ (15.6).

OF A WARM, yellowish, buff-colored terracotta. A thin coat of gesso solution has apparently been used to paint the bust, as was often done in the eighteenth century, but it has worn off in places. The base is of *brèche violette* marble.

The head and shoulders of the *fermier-général* and philosopher are shown, the body being rounded below the sloping shoulders in the manner of a Roman republican portrait bust. His head is half-turned to the left, and he wears a short tie-wig with a large ribbon bow at the back of his neck. The sitter's throat and the upper part of his chest are exposed by a light undershirt worn loosely open at the neck. Over this is cast what appears to be part of a collarless coat or cloak.

The bust rests on a circular marble podium with incurving sides.

Incised on a flattened area of the terracotta at

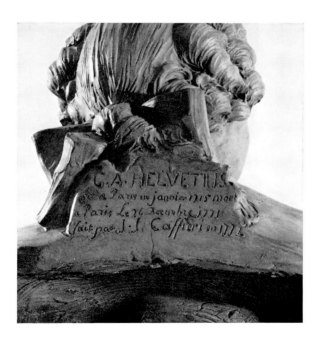

the back of the neck: *C. A. HELVETIUS/ ne a Paris en janvier 1715 mort/ a Paris Le 26 Decembre 1771/ fait par J. J Caffieri en 1772*

By Jean Jacques Caffiéri (1725–1792).

The precise history of the bust is not easy to reconstruct, but it probably remained in the artist's possession for some years after 1772 (see below).

Five other busts of Helvétius are known, all related to No. 49. The definitive version was a marble exhibited at the Salon of 1773, where it appears in the catalogue, under Caffiéri's name as:

No. 204. Portrait du feu M. Helvetius.
 Buste en Marbre.

This bust is now in the Louvre (*Catalogue des sculptures*, Part II, *Temps modernes* [Paris, 1922], p. 16, no. 985) and bears Caffiéri's signature and the date 1772 (Fig. 2). It was executed for Mme Helvétius and remained in the possession of the sitter's descendants until it was sold by the Marquis de Balleroy in 1910 and passed to the Louvre by bequest in 1912. It differs from No. 49 in several respects. It is not rounded in the lower part like the terracotta; rather the upper part of the sitter's body is swathed in an ample, deeply folded drapery, rolled around the lower edge. In addition, it shows minor differences in the position of the face, in the set of the wig, in the tying of the bow, which is placed considerably lower, as well as in the disposition and folds of the undershirt. The actual appearance of the countenance is distinctly different also (see below).

A second version of the Louvre marble, resting on a different plinth but otherwise following it exactly, is illustrated in *Versailles; Revue de Société Suisse des Amis de Versailles*, no. 7, January 1961, p. 22. It was then to be found at the Château de

Voré, formerly the country seat of Helvétius and his wife, and still in the possession of his descendants. It is not made clear, however, whether this is a contemporary repetition or a copy made to replace the marble now in the Louvre when it was sold by the family, and the compiler has not seen it.

The history of the third bust, which is of plaster (Fig. 1), is as follows. In 1784 Caffiéri presented a series of busts of sixteen distinguished French men of letters to the Académie Française, where they were placed on cupboards in the hall of assembly (L. V. Thiéry, *Guide des amateurs et des étrangers voyageurs à Paris* [Paris, 1787], I, p. 342). Not all of these were the work of the donor himself, but on the list of them drawn up by Caffiéri (but not in his own handwriting), it appears as:

Adrien Helvétius, que j'ay exécuté en
marbre pour Madame Helvétius
(Jules Guiffrey, *Les Caffiéri* [Paris, 1887], p. 360)

During the Revolution the plaster was removed with many of the other possessions of the Académie to the Musée des Monuments Français (*Inventaire général des richesses d'art de la France; Archives du Musée des Monuments Français* [Paris, 1897], III, p. 200), from which it was taken after the Restoration on August 21, 1824, by "M. Rolle pour la Préfecture de la Seine" (*Inventaire*, pp. 301, 302). Some time after this and before 1839, when it appears in the catalogue (*Notice historique des peintures et des sculptures du Palais de Versailles* [Paris, 1839]) for the first time (under no. 562, p. 312), it passed into the then recently established Musée de Versailles. It remained there forgotten and neglected until attention was drawn to it by J. J. Marquet de Vasselot, who published it in 1901 ("Trois oeuvres inconnues de S. Mazière, J.-J. Caffiéri et C.-A. Bridan au Musée de Versailles," in *Revue de l'Histoire de Versailles et de Seine-et-Oise*, pp. 202–208), who stressed its relationship to the Louvre marble.

This plaster differs little from the terracotta No. 49 and has evidently been cast from it. There are slight changes in the position of the bow of the tie-wig, which, presumably, would have been cast separately, and the bust rests on a square, tapering, and hollow-sided plinth instead of a circular one. It bears at the back an inscription almost identical to that on No. 49, though the last line is apparently a separate sentence, and is transcribed by Marquet de Vasselot as *Fait par I. I. Caffieri en 1772* (Marquet de Vasselot, *op. cit.*, p. 202).

A fourth version, agreeing closely with No. 49 and the Versailles plaster in size and appearance but of patinated bronze is in the Forsyth Wickes bequest in the Boston Museum of Fine Arts (acc. no. 65.2229). This is somewhat coarse and blunt in its detail and is unlikely to have been cast from the terracotta model. It rests on a square, waisted plinth similar to that supporting the Versailles plaster, and the bust may well have been cast from this at the period when it entered the Musée de Versailles. At that time Louis-Philippe was collecting portrait sculptures of as many notable Frenchmen as possible for the museum, and many repetitions of these were made (see Amédée Boinet, "Catalogue des oeuvres d'art de la Bibliothèque Sainte-Geneviève," in *Société de l'Histoire de Paris et de l'Ile-de-France, Mémoires*, XLVII, 1924, pp. 87–172).

Marquet de Vasselot tells us (*op. cit.*, p. 203) that "Caffieri avait l'habitude de tirer ainsi plusieurs exemplaires de chaque buste qu'il exécutait; et les amateurs recherchent ces plâtres patinés, qui ont le grand mérite de faire connaître l'oeuvre telle qu'elle était sortie des mains de l'artiste." He quotes a number of examples of such casts of other busts by Caffiéri. The only plaster cast taken from No. 49 whose whereabouts is known today is the Versailles version.

In the Frick Art Reference Library, New York, however, there is a photograph dating from before 1932 of a version of the Louvre bust described on the reverse of the print as being of "painted terracotta." It is more likely, however, to be of plaster painted to resemble terracotta. The back bears the same inscription as that on No. 49, but the first names of Helvétius are given in full and not by

[393]

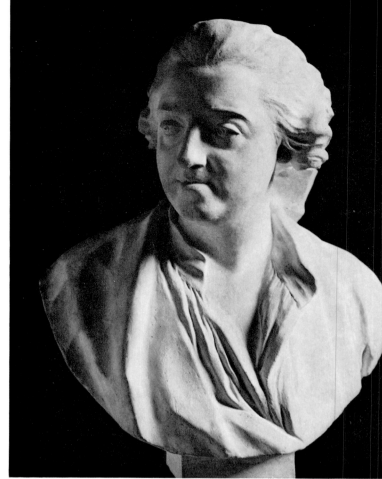

1. *Bust of Helvétius. Plaster cast. Versailles, Musée.*
Photo: Musées Nationaux

2. *Jean Jacques Caffiéri, bust of Helvétius. Marble.*
Paris, Musée du Louvre. Photo: Giraudon

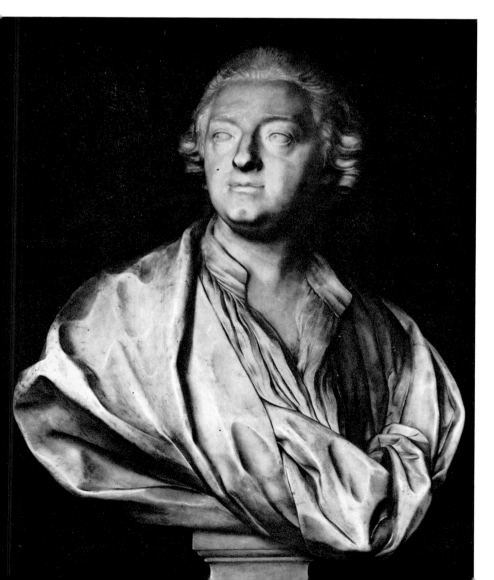

initials only. The height is given as 29½ inches, and the bust is stated to be in the collection of Jacques de Saint-Pierre, Paris (information kindly supplied by Mr. Peter Fusco).

The inscription incised on No. 49, which must have been executed while the terracotta was still unbaked, makes it clear that this bust was executed posthumously, perhaps being based either on another made during a sitting from the life, and now untraceable, or possibly on a painted portrait of the recently deceased philosopher. No portrait of Helvétius known to the compiler, however, can be identified as such a source. No. 49 may have been retained by Caffiéri in his own possession at any rate until after the execution of the marble in 1772. In a list of the *État des portraits des hommes illustres que possède M. Caffiéri, sculpteur du Roy, en 1778* there is included a bust of "Charles Helvétius, fait par J. J. Caffiéri" (Guiffrey, *Les Caffiéri*, p. 453). The list was not drawn up by Caffiéri,

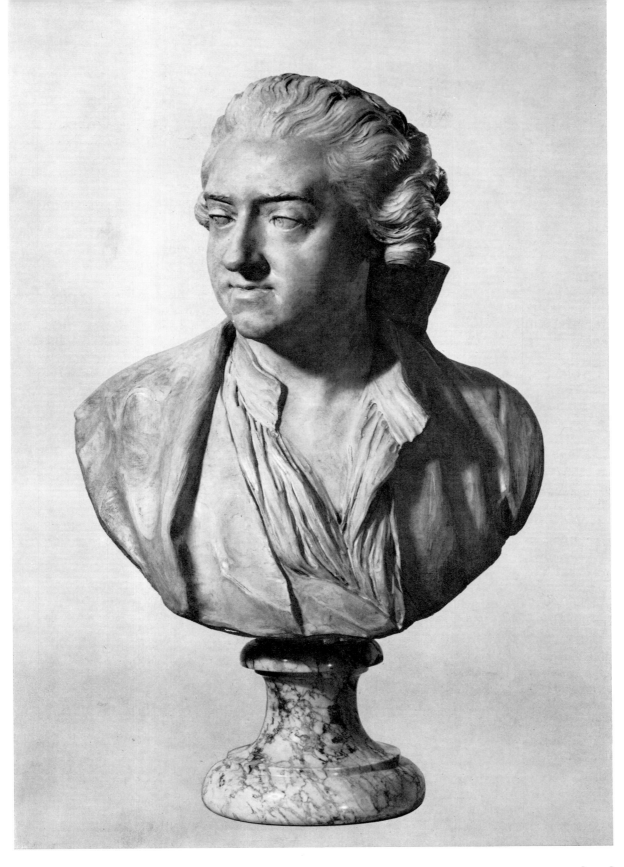

and presumably the reference to "Charles" rather than "Claude" is a mistake. If, as seems possible, the series of plaster busts presented to the Académie Française was cast shortly before the gift was made in 1784, this may well refer to the terracotta, for the marble was already in the possession of Mme Helvétius by 1778. Its subsequent history until it was acquired in 1969 in New York is unknown.

Helvétius died in 1771, and the marble, dated 1772, must also have been executed posthumously. It seems likely that when Caffiéri came to carve the marble he deliberately introduced the differences of physiognomy noted above. Bachaumont, writing in the *Mémoires secrets* . . . (London, 1780), XIII, p. 139, September 21, 1773, about the Salon of that year, comments on the bust: "Il est fâcheux qu'à travers la bonté, dont les traits brillent sur cette belle figure en marbre, on y trouve mêlé un air de dédain, vrai caractere de la philosophie des *Encyclopédistes*, mais qui n'étoit point celle de l'auteur du livre *de l'Esprit*." It has been suggested that those remarks were directed rather against the *encyclopédistes* themselves, rather than Helvétius personally. Nevertheless, there certainly is a somewhat sneering turn of the lips of the marble that is not to be found in the terracotta. It seems evident that Caffiéri attempted to idealize the somewhat puffy face of the aging philosopher as he appears in the terracotta to make him look more youthful, and this probably produced the effect referred to by Bachaumont.

The rather unusual placing of the long inscription appears to be characteristic of Caffiéri. It appears on several of his busts, for example on a terracotta bust of Georges de Lafaye that was in the possession of Messrs. Heim, London, in 1968 (illustrated in *French Paintings & Sculptures of the 18th Century*, exhibition catalogue [London, 1968], no. 57).

Jean Jacques Caffiéri, portrait and monumental sculptor, was born in Paris in 1725, the son of the celebrated *fondeur-ciseleur* and sculptor Jacques Caffiéri (1678–1755; for a biography, see Volume II of this catalogue, pp. 563–564). Jean Jacques received his early training in his father's workshop and later entered the studio of Jean-Baptiste II Lemoyne (1704–1778), the outstanding portrait sculptor of his day. In 1748 he carried off the first prize for sculpture at the Académie's school and proceeded to Rome as a *pensionnaire* at the Académie de France in the following year. He remained in Italy until 1754, when he returned to Paris. Three years later he was *agréé* at the Académie and in 1759 was elected a full member, becoming *professeur adjoint* in 1765 and full *professeur* in 1773.

Caffiéri seems to have been a vain and jealous man, constantly bombarding the Directeur général des Bâtiments with memoranda seeking pensions, commissions, and honors. Nevertheless, he was made a *sculpteur du roi* and given a studio in the Louvre in 1765, from which he was moved to better apartments in 1783. This was no doubt in recognition of his position as one of the most successful sculptors of the Louis XVI, or neoclassic period. Nevertheless, right down to his death in 1792 he remained a somewhat *retardataire* figure and never entirely eradicated from his style traces of the rococo, of which his father had been one of the ablest exponents. As a portrait sculptor he produced busts of many of the most famous men and women of his period and worked for the Crown, for Mme du Barry, and for private individuals. He died shortly after having been put in charge of the art collections of the Académie Royale.

BIBLIOGRAPHY: The principal source for our knowledge of all the Caffiéri family is Jules Guiffrey, *Les Caffiéri* (Paris, 1887), but it is almost unillustrated. Large numbers of works by Jean Jacques Caffiéri have been published in articles and catalogues, but there has been no major study of his work since Guiffrey's book appeared.

Claude Adrien Helvétius was born in 1715 in Paris, the son of a well-known Dutch physician. While still only twenty-three he obtained, through the influence of Queen Marie Leszczynska, a lucrative position as a tax farmer, thus making him at once a man of exceptional wealth. In 1758, however, he threw up this post and settled down as a writer and philosopher, allying himself with the *encyclopédistes*. A man of somewhat narrow and superficial views, he earned considerable notoriety when his work *De l'Esprit* was burned by

the Paris *parlement* after having received the approval of the censorship. *De l'Esprit* put forward, in effect, a philosophy closely related to the later Utilitarianism of Bentham, basing morality on the interest of the greatest number and asserting that individuals are motivated exclusively by egoistic impulses. Bentham indeed acknowledged his debt to the author of *De l'Esprit* as one of the sources of his own philosophical ideas. Nevertheless, the philosopher's contemporary Desessarts describes Helvétius as a warm-hearted, generous, and charitable man, who "a aimé la gloire avec passion," adding "c'est la seule passion qu'il ait éprouvée" (*Biographie Universelle*, ed. Hoefer [Paris, 1858], XXIII, col. 884).

Side views of the Wrightsman bust of Helvétius

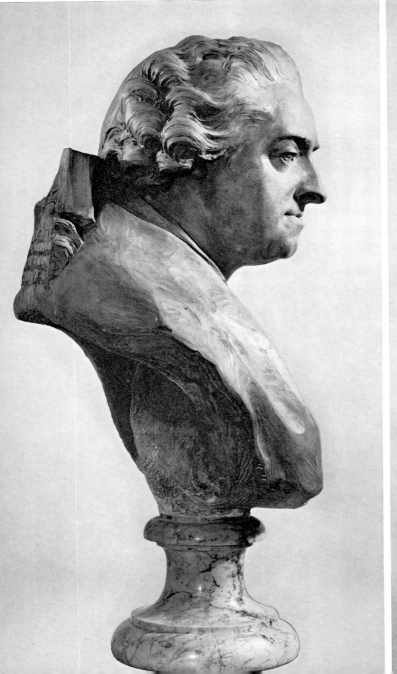
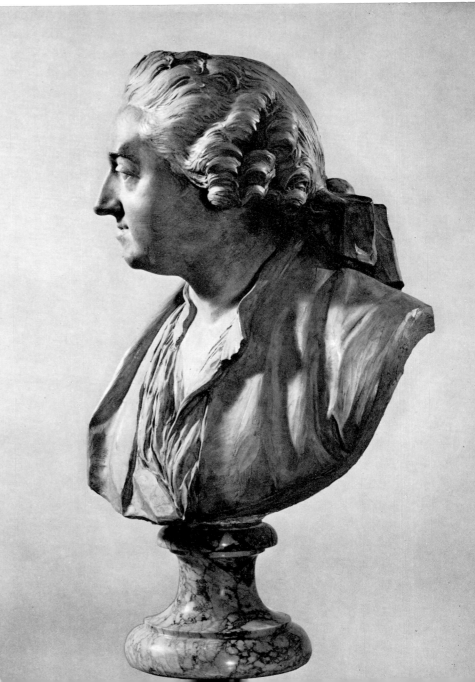

H. 15¾ (40.0); W. 9¾ (24.8); D. 8¾ (22.2); H. of base 4¹¹⁄₁₆ (11.8).

OF WHITE statuary marble, with one or two faint flecks of black.

The head of the philosopher, writer, and art critic, very naturalistically treated, is half turned to the left. He is shown without a wig, his hair carelessly disarranged, the eyes wide open and piercing, giving a great effect of vitality and immediacy to the portrait. A small amount of the shoulders is represented, rounded to a semi-circular shape and undraped.

The bust is supported on a circular, flared, and molded base of Sicilian marble, white with gray and black striations, resting on a square plinth of the same marble.

Incised along the edge of the shoulders at the back to the left of center: *Mʳ Diderot, fait en 1773 par houdon.*

Incised along the front of the plinth (the inscription is filled with black wax): *il eut de grands Amis et, quelques bas jaloux/le Soleil plait à l'aigle, et blesse les hiboux.*

By Jean Antoine Houdon (1741–1828).

REFERENCES: Строгановский дворец-музей; краткий путеводитель (*The Stroganoff Palace-Museum; a Brief Guide*) (Leningrad, 1922), p. 7; Louis Réau, "L'Art français du XVIIIᵉ siècle dans la collection Stroganov," in *Bulletin de la Société l'Histoire de l'Art Français*, 1931, p. 65; Louis Réau, *Houdon; Sa Vie et son oeuvre* (Paris, 1964), I, p. 353, II, p. 30, catalogue no. 115; F. J. B. Watson, "From Antico to Houdon," in *Apollo*, XC, September 1969, pp. 218–221, fig. 10.

EXHIBITIONS: London, Royal Academy and Victoria and Albert Museum, *The Age of Neo-Classicism*, September 9–November 19, 1972, catalogue no. 381, pl. 59.

Formerly in the Stroganoff Collection, St. Petersburg (sold by the Soviet Government in Berlin, Rudolph Lepke, May 12–13, 1931, lot 225 [illustrated] for 45,000 D M). No copy of the catalogue with the names of purchasers seems to have survived the Second World War. The bust was later in the collection of a member of the Thomas Fortune Ryan family.

Three years after his return from Rome in 1768,

1. *Houdon's bust of Diderot as it appeared in the library of the Hermitage. From sale catalogue of Lepke's, May 12–13, 1931*

Houdon exhibited at the Salon of 1771 (catalogue no. 281) the head of Denis Diderot, the famous man of letters and editor of the *Encyclopédie*, on which No. 50 is based. Although the catalogue does not specify whether the exhibited bust was in plaster or terracotta, it seems likely that it was the terracotta bequeathed to the Louvre by Walferdin in 1880 (*Catalogue des sculptures*, Part II, *Temps modernes* [Paris, 1922], no. 1355; see Fig. 2). The sitter seems to have been satisfied by it, for in his copy of the *livret* for the Salon Diderot noted laconically: "Très-ressemblant" (*Diderot Salons*, ed. Jean Seznec [Oxford, 1967], IV, p. 226).

A number of marbles were executed from this exhibited model. The earliest two are certainly No. 50 and that made for the sitter's great admirer and patron, Catherine II of Russia, which is now in the Hermitage Museum, Leningrad. It bears the inscription *M. Diderot. Fait en 1773 par Houdon*,

and the plinth has the same inscription as does No. 50.

The first of these must be the bust of which Diderot writes in a letter to his sister dated March 23, 1770, "Le prince de Gallitzin fait faire mon buste" (*Denis Diderot: Correspondance*, ed. Georges Roth [Paris, 1955–1970], X, p. 40). Or, at that date, he may have been referring to the model, for it was exhibited in 1771 as the first stage in the creation of the bust. There were several princes Gallitzin in Paris during the eighteenth century, but the reference here must be to Prince Dimitri Alexeivitch Gallitizine, who was minister plenipotentiary from St. Petersburg to the court of Versailles at that date. Before mid-1774, when Baron Grimm, the editor with Diderot and Jacques Henri Meister of the *Correspondance littéraire*, became the empress's principal agent in Paris for the acquisition of works of art, Gallitzine would have been the obvious person for Catherine to employ in her negotiations with French artists. He was, moreover, known to Diderot and greatly admired by him. A few years later, writing of Gallitizine to a Dr. Clerc, Diderot

declared: "C'est un des hommes les plus honnêtes et les plus aimables, non pas de la Russie seulement, mais du monde entier" (*Correspondance*, XIII, p. 217; letter dated April 8, 1774). He may even have selected Houdon as the most suitable sculptor to make a likeness of the philosopher so much admired by his sovereign.

Count Alexander Sergeivitch Stroganoff, for whom the second and almost identical marble bust No. 50 was executed, was also a friend of Diderot who wrote of him in a letter addressed to Falconet and his daughter-in-law Marie Anne Collot on May 30, 1773: "Je suis lié très étroitement à Mr. et Madᵉ de Strogonoff" (*Correspondance*, XII, p. 229). The immensely wealthy Russian resided in Paris for two lengthy periods, from 1752 to 1754 and again from 1770 to 1779. There he moved in artistic circles and became a great Maecenas, forming an important collection of French art of the period. On his return to St. Petersburg at the end of 1779 Catherine wrote to Grimm: "Stroganof n'a garde d'oublier Paris; il n'a que cela à la bouche" (letter of December 7, 1779; Louis Réau, "Correspondance artistique de Grimm avec Catherine II," in *Archives de l'Art Français*, XVII [1931–1932], p. 71).

Stroganoff must have commissioned No. 50 almost concurrently with the execution of the marble for Catherine II now in the Hermitage. The Russian had already established himself as a patron of Houdon, for he had quite recently commissioned an unusually large bust of Catherine II herself from him, and this was exhibited at the Salon in 1773 (catalogue no. 231). As Houdon had never visited Russia, it is believed that he based his likeness on a miniature of the empress by J. C. de Mailly. According to Réau the bust of the empress is now in the Hermitage (*Houdon*, II, p. 28, catalogue no. 97).

It is possible that Pidansat de Mairobert is referring to No. 50 in his discussion of the sculpture exhibited at the Salon of 1773 (*Mémoires secrets*, XIII, p. 144–145). Into his text he inserts this curious passage, apparently referring to the busts of Diderot, although there is no suggestion in the *livret* that either was exhibited on that occasion:

> L'Auteur du buste de M. *Diderot*, en nous le reproduisant une seconde fois, veut peut-être nous dédommager de l'absence de ce savant & ne pas nous laisser refroidir sur son compte.

It seems probable that he had seen the Stroganoff bust, which was to remain in Paris for some time after the first marble had been dispatched to Russia. In the second part of this passage the author is, of course, referring to the fact that Diderot had left Paris for St. Petersburg in mid-1773 to visit the Empress Catherine and was to remain in Russia until the autumn of 1774.

In the brief guide to the Stroganoff Palace Museum issued by the Soviets in 1922 (cited above, p. 6), No. 50 is described as standing in the Hubert Robert room (so called because of the large number of works by that artist, now mostly in the Hermitage, hanging there). But in the photographs of the interior of the palace published in the Berlin sale catalogue (Fig. 1) at the time the bust was sold by the Russian government, it can be seen standing on a fluted half column apparently of white marble in the small, domed library (Lepke sale catalogue cited above, unnumbered page in the introduction), where it formed a pendant to a bust of Voltaire also by Houdon (Lepke sale catalogue, no. 224, illustrated). This is inscribed, according to the sale catalogue, *Houdon 1775*. The transcription is, however, an error, for Voltaire was not sculpted by Houdon until 1778, when he sat for the portrait bust commissioned, like the other version of No. 50, by Catherine II and now in the Hermitage. The Stroganoff Voltaire is now in the possession of The Metropolitan Museum of Art, acc. no. 1972.61, and is clearly dated 1778. No doubt it, too, was commissioned from Houdon from similar motives to the commission for the second bust of Diderot.

There are a number of other versions of No. 50 in a variety of materials. In marble there is a version in the Musée de Versailles inscribed *A M.*

Robineau de Bougon. Houdon sculpsit 1775. (Réau, *Houdon*, II, pl. LV, no. 115c). This was given by a descendant of Robineau to Louis Philippe in 1838 for the museum he was forming at Versailles. Another, coming from the Vandeul family (i.e., descending from Diderot's daughter), is in the Louvre (*Catalogue des sculptures*, Part II, *Temps modernes*, no. 1356). From the same source came a plaster with a bronze patina now in a private collection in Switzerland. Two or three other original plaster casts are known in Germany (notably one in the Bayerisches Nationalmuseum, Munich, patinated black and bearing the seal of the Houdon atelier), and elsewhere, including one belonging to Mr. and Mrs. Charles Seymour, Jr., of New Haven, Connecticut, which was exhibited in *Sculpture by Houdon, a Loan Exhibition* (Worcester [Massachusetts] Art Museum, 1964, pp. 26–29, illustrated). A bronze, cast about 1780, is in the Hôtel de Ville, Langres, Diderot's birthplace (illustrated in Georges Giacometti, *La Vie et l'oeuvre de Houdon* [Paris, 1929], II, opp. p. 38). This last example was presented by the writer himself in April 1781 in response to a resolution by the Conseil Municipal on August 23, 1780, to ask Diderot for his portrait. It is of remarkably fine quality, but shows small variations from No. 50 and may have been made from a fresh model by the artist. Houdon exhibited another marble head of Diderot, smaller in size and varying slightly from No. 50, in the Salon of 1789 (catalogue no. 249). Its present whereabouts is unknown. Giacometti (*op. cit.*, II, p. 38) mentions that the sculptor made several reductions of the bust of Diderot. Only two are traceable today. One in plaster, formerly in the Henri Piazza and Jules Strauss collections, is signed and dated 1780 (Giacometti, *op. cit.*, I, p. 163). The other (described as of terracotta) appeared in an auction sale in Paris (Hôtel Drouot, March 6, 1972, lot 119, illustrated on the cover of the catalogue).

Diderot is said, like Voltaire, to have been a difficult and restless sitter. Writing of No. 50 when it was exhibited in the Salon of 1771 in the *Mém-*

The Wrightsman bust of Diderot

2. *Jean Antoine Houdon, bust of Diderot. Terracotta. Paris, Musée du Louvre. Photo: Giraudon*

oires secrets . . . (London, 1780, XIII, p. 101), Bach-aumont declared: " . . . on doit louer le feu, l'expression que M. *Houdon* a su mettre dans son ouvrage, & l'enthousiasme du brûlant auteur des *Bijoux indiscrets* semble avoir gagné l'artiste, dont les autres ouvrages n'annoncent pas un caractere chaud & ardent." Today, in spite of the liveliness of the representation, it is perhaps its neoclassic qualities, the "tête à médaille" of which the same writer also speaks, that we see in this bust. Its form, with the abbreviated shoulders, is based on the typical Roman imperial portrait bust of the first century A.D. This seems particularly appropriate, for Diderot liked to think of himself as having "la tête tout à fait du caractère d'un ancien ora-teur" (*Diderot Salons*, ed. Jean Seznec and Jean Adhémar [Oxford, 1963], III, p. 67).

An engraving is said by Réau, *Houdon*, p. 30, to have been made by Tardieu after this bust or the Langres example referred to above. It is, how-ever, not recorded elsewhere, and all attempts to trace it through the Biblothèque Nationale and other informed sources have failed.

Jean Antoine Houdon, the greatest French sculptor of the neoclassic period and perhaps the greatest of the eighteenth century, was the son of the concierge of the École des Élèves Protégés. It was there that he received his first training while still a boy. In his youth he was advised by Jean-Baptiste Lemoyne and René Michel Slodtz, although he was not strictly a pupil of either. At the age of sixteen he obtained a prize at the Académie Royale, which was followed by an official stay at the École des Élèves Protégés, from which he won a scholarship to the Académie de France at Rome in 1764. Here he obtained a great success with his famous Écorché and the statue of St. Bruno for Santa Maria degli Angeli, a remarkable example of realism for its period. Returning to Paris with a great reputa-tion, he was *agréé* at the Académie Royale on July 23, 1769, offering a figure of Morpheus as his *morceau de réception*. He became a full academician in 1777.

After his return to Paris, he embarked on the series of busts of royalty, noblemen, and women, lawyers, philosophers, and literary figures on which his fame

rests. Politicians of the pre-Revolutionary period were less drawn to him, although he made busts of Turgot and Miromesnil. Foreign courts eagerly sought his services, Gotha and Saxony in 1771, Russia shortly afterward; and after two visits to Germany in 1771 and 1773 he enjoyed the patronage of Prince Henry of Prussia as well as of the Duke of Saxe-Gotha. It was through the intermediaries of Grimm and Diderot that Catherine II sought to persuade him to visit St. Petersburg, but, although he refused to go to Russia, he executed an outstanding series of works for Cath-erine's court, many of which are now in the Hermitage Museum. They included a bust of the empress herself and two mausoleums for the Gallitzine family. In 1781 he exhibited at the Académie his statue of Voltaire seated, a work intended for the Académie Française but which was placed almost at once in the foyer of the Comédie Française, where it still stands and is one of his masterworks. He also executed a number of heads of Voltaire in marble.

In spite of his success Houdon was not wealthy, and it was the financial opportunity offered that persuaded him to accept in 1785 the commission from the Vir-ginia legislature (conveyed through Franklin) to visit America to make a statue of George Washington. Returning to Paris in the following year, he married and, at the Salon of 1789, exhibited the bust of his daughter Sabine, one of the earliest of a particularly appealing series of portraits of children.

He continued to work, little troubled by politics, during the Revolutionary period, when a number of political figures, among them Mirabeau, Barnave, and Dumouriez, sat to him as did Napoleon, Joseph-ine, and one or two of the emperor's marshals under the Empire. But he was out of sympathy with the ethos of post-Revolutionary society, and his style grew increasingly cold and dryly neoclassic in these later years. After 1814 he did little work until his death in 1828.

Houdon was the first eighteenth-century French sculptor to free himself entirely from the baroque, but he is to be regarded as a realist rather than as a pure neoclassic artist, except in his latest works. He was not, perhaps, a very subtle psychologist, but his incompa-rable series of portrait busts attain an effect of penetrat-ing insight into character by an intense and direct observation of nature combined with great technical

skill. This enabled him to impart an almost living quality to white statuary marble, so that the intractable material takes on the very quality of the human epidermis.

BIBLIOGRAPHY: Louis Réau, *Houdon; Sa Vie et son oeuvre* (Paris, 1964), with bibliographies. This work was left incomplete at the author's death, but contains the most comprehensive catalogue of Houdon's work in print, besides publishing numerous documents and early references to Houdon's work. It is not, however, entirely free from errors of fact and is less satisfactory as an aesthetic commentary than Georges Giacometti, *La Vie et l'oeuvre de Houdon* (Paris, 1929). Valuable information about the artist is also contained in H. H. Arnason, *Sculpture by Houdon*, a loan exhibition held at the Worcester (Massachusetts) Art Museum in 1964.

Denis Diderot, philosopher and man of letters, was born at Langres in 1713, the son of a master cutler. Destined at first for the church and later for the law, he abandoned both these careers after a brilliant scholastic beginning under Jesuit teachers, first in Langres and later in Paris at the Collège Louis-le-Grand. For a time he lived in great poverty in Paris, frequenting the cafés Procope and La Régence, the haunts of free-thinking writers and talkers, before eventually finding his vocation as one of the most brilliant of them himself.

Diderot's early writings, notably a translation of Shaftesbury, and his pamphlets *Suffisance de la religion naturelle*, *La Promenade d'un sceptique*, and the *Lettre sur les aveugles* quickly revealed him as a deist and brought him into collision with the ecclesiastical authorities as an anti-Christian writer. As a result, in 1749, he was imprisoned in the Bastille, where some humiliating recantations obtained for him the privilege of working in the governor's library.

Here he was able to continue to write and, more important, to plan the *Encyclopédie* that was to become his greatest monument. The scheme for this great project arose in his mind when, in the winter of 1746, he was approached to undertake a translation of the English *Chambers' Encyclopaedia*. Diderot and his chosen co-editor d'Alembert (who later relinquished his task for fear of imprisonment) developed the original scheme so that it eventually resulted in a plan to create an entirely new encyclopedia of the arts, trades, sciences, and philosophy that would sum up the best of contemporary thought. The enormous labors of bringing out the twenty-one volumes of this huge work, in the face of the fiercest opposition on account of its anti-Christian tone, occupied him for more than a quarter of a century and stamped him as one of the great minds of the age. The publication of the *Encyclopédie* was a truly epoch-making achievement and, in a sense, marked the end of the *ancien régime* quite as clearly as the outbreak of the French Revolution, for which it provided a fertile source of propaganda material.

Editing the *Encyclopédie* did not occupy all of Diderot's time, however, and in the intervals of working on it he wrote novels like *La Religieuse* and *Jacques le fataliste*, witty pamphlets like *Le Neveu de Rameau*, plays, and philosophical works, as well as innumerable letters, the best of which are addressed to his middle-aged mistress Sophie Volland. In addition, the commentaries of the Salons from 1759 to 1781 that he wrote for his friend Grimm's *Correspondance littéraire* may be considered the foundation stones of modern journalistic art criticism. His brilliant conversational powers and his warmth of heart brought Diderot into the social circle of bluestockings like Mmes Geoffrin and d'Épinay in whose salons writers and aristocrats met on equal terms and where many of the ideas embodied in the *Encyclopédie* were first discussed.

His European fame brought him an invitation from Catherine II to visit Russia and produce the *Encyclopédie* there free from ecclesiastical censorship. In 1767 she relieved his indigence by purchasing his library for 15,000 livres, while leaving him the usufruct of the books. Eventually, in 1773, he acceded to the empress's pressing wishes and visited St. Petersburg, spending the winter there in daily converse with Catherine herself.

This journey proved a severe test of his health and strength, but the last decade of his life, his Herculean labors on the *Encyclopédie* completed, was passed in comparative tranquility in Paris, where he died suddenly in 1784 in apartments that the empress of Russia had taken for him in the Hôtel de Bezons.

H. 9⁷⁄₁₆ (24.0); W. 7⅜ (18.7); H. of opening 6⅜ (16.2).

OF BRONZE chased and gilded, and porphyry.

The frame is of neoclassic Louis XVI design, rectangular with square, projecting corners. Motifs of flowers, berries, and leaves fill the spandrels at the corners around the oval picture opening. A molding of repeating leaves in high relief surrounds this opening and also runs within the border of the frame itself. A ring for hanging is attached in the center of the upper edge of the frame.

Against a background of porphyry, which fills the oval, is a silhouette bust in relief of a warrior of gilt bronze. He is in armor, facing left with the ribbon of an order crossing his breast, his hair worn long, tied by a ribbon at the back of the neck, and curled over the ears. His identity is unknown.

Signed along the underside of the drapery in which the bust terminates: *F. C. THIERARD / 1777*

No sculptor by the name of F. C. Thierard is known, but there was a Jean-Baptiste Thiérard who exhibited two figures, La Musique and La Poésie, at the Salon de la Correspondance in 1779. F. C. Thierard may have belonged to the same family.

[406]

52 Bacchic Group

H. 23 (58.4); w. of base 10¾ (27.3); D. of base 9 (22.8).

OF BROWNISH terracotta.

On a low, circular base a bearded satyr is rising
from a tree stump on which he has been seated,
his left hoof, slightly raised, resting on an over-
turned wine jar from which wine is flowing.
With his left arm around her waist, he clasps a
naked bacchante to his side. She turns away, her
right leg outstretched in an attitude of flight, and
casts a backward glance toward the spectator. Her
left arm is stretched across the satyr's chest to his
right shoulder. He clasps it lightly by the wrist. In
her right hand she holds a thyrsus, a roughly cut
stick entwined with flowers. Beside them at the
left an infant satyr raises his right arm to attract the
attention of the satyr, who glances downward
toward him.

On the base Panpipes and a tambourine from
which grapes are spilling are piled against the
rockwork on the right.

Incised at the base of a root of the tree stump
at the back: *CLODION.*

By Claude Michel, known as Clodion (1738–
1814).

REFERENCE: F. J. B. Watson, "From Antico to
Houdon," in *Apollo,* XC, September 1969, p. 217,
fig. 7.

Formerly in the collection of Baron Gustave de
Rothschild, Paris.

In an anonymous sale in Paris on May 14, 1855

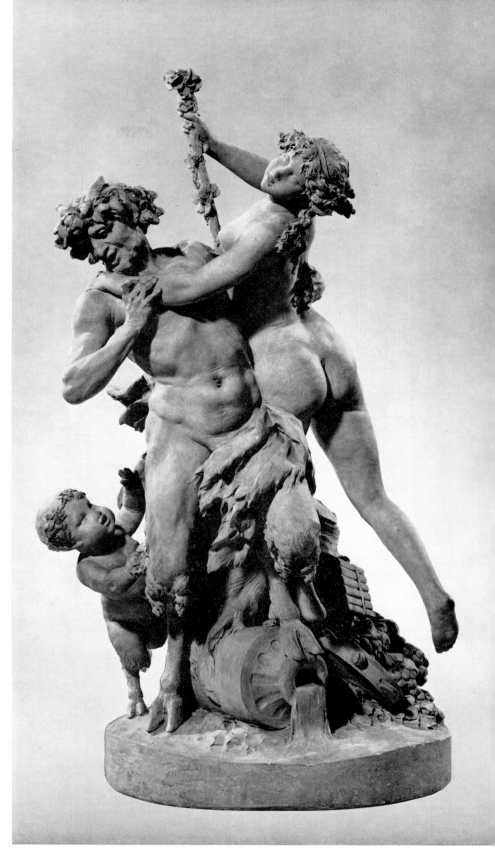

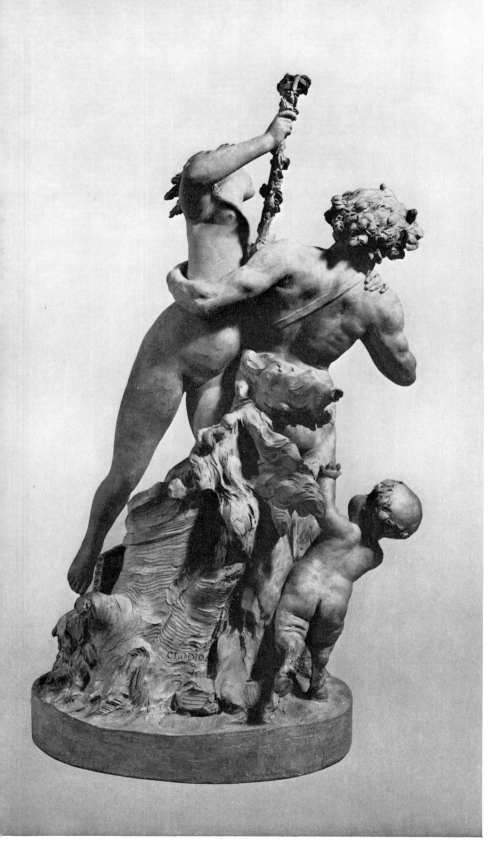

(not in Lugt, *Catalogues de ventes publiques*, and apparently untraceable today, but quoted by Henri Thirion, *Les Adam et Clodion* [Paris, 1885], p. 404), the following two items appear among a number of works by Clodion:

> 28–29.-4° Deux groupes, Satyres portant une Bacchante et jouant avec des enfants (partie et contre-partie).—Hauteur, O m, 58.

one of which may possibly have corresponded to No. 52.

These later passed into the collection of Paul Roux, where they are stated by Stanislas Lami (*Dictionnaire des sculpteurs de l'école française au dix-huitième siècle* [Paris, 1911], II, p. 147) to have been both signed and one of them to have been dated 1778. No. 52 may conceivably have been the signed but undated example. The catalogue of the Paul Roux Collection (Paris, Galerie Jean Charpentier, December 14, 1936) gives no mention of a date under lot 91, and the description of this single possible group is insufficiently precise to permit an identification with No. 52.

For a biography of Clodion, see under No. 54.

53 Bacchic Group

H. 18¼ (46.4); Diam. of base 8¼ (21.0).

Of PINK-tinted terracotta.

A youthful bacchant and bacchante stand in an embrace before a tree stump, while he holds up a cluster of grapes above her head. An infant, clutching a bunch of grapes to his breast, stands between them in front. The group rests on a circular base modeled with flattened stones.

The youth, at the right, wears a lion's pelt cast around his loins, supported by a ribbon over his left shoulder. It flutters against the tree stump behind. His hair is entwined with vine leaves. With his right arm he clasps the bacchante around the waist, while she, nude save for a drapery caught between them and falling over her left thigh, embraces her companion with both arms and gazes up at the bunch of grapes held above his head in his right hand. Her hair is bound with a ribbon. The infant wears vine leaves in his hair and has a garland hung over his right shoulder and across his body.

A Panpipes is suspended by a ribbon at the back of the tree stump, while a tambourine filled with grapes, lying across a thyrsus, is supported against the foot of the tree.

Incised at the foot of the tree stump at the back:
CLODION.

By Claude Michel, known as Clodion (1738–1814).

Although no other version of this group is known, it is almost certainly one of the repetitions

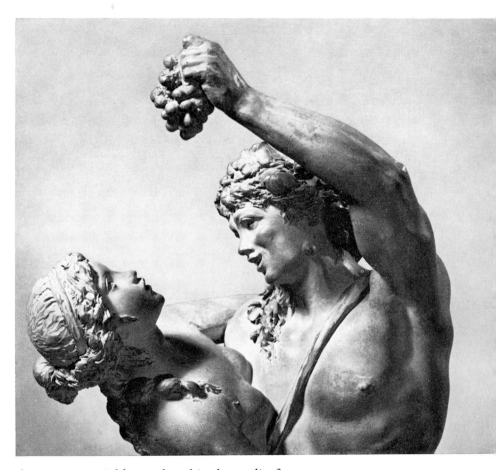

that were invariably produced in the studio from Clodion's original models, which must be regarded of equal authenticity to the artist's prime terracotta model. The secondary character can be inferred here from such features as the lack of tooling of, for example, the youth's forefoot.

It may be safely assumed that Clodion's small terracottas were always produced in several versions (with, at the most, only minor variations). Many of them survive today in more than one example. Discussing the artist's sculptural panels for the decoration of architecture, Guiffrey com-

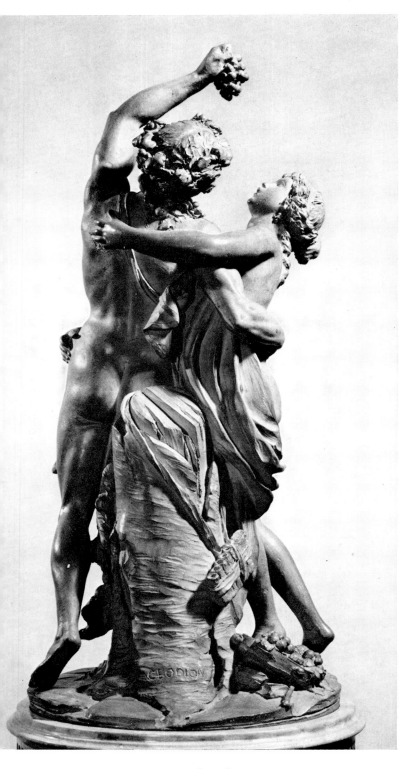
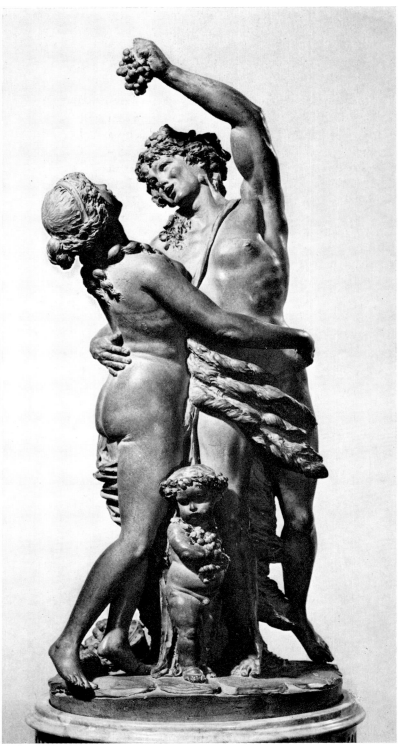

mented " . . . pour répondre aux multiples de-mandes de ses clients, [il] avait installé un atelier de reproduction industrielle de ses oeuvres" ("Le Sculpteur Claude Michel dit Clodion," Part II, in *Gazette des Beaux-Arts*, IX, February 1893, p. 171). It must have been somewhat the same with his small sculptures. The same author records the contempt the artist earned from his colleagues in the Académie for exploiting his works commercially by reproduction "comme un simple maître de la corporation de Saint-Luc" ("Le Sculpteur Claude Michel dit Clodion," Part III, *Gazette des Beaux-Arts*, IX, May 1893, p. 399). He formed a company in partnership with the picture dealer Verrier and the bronze caster Dubois. When this business was dissolved in 1783 a large number of terracotta models by Clodion were dispersed.

Exactly how these repetitions of terracottas were produced is uncertain. Having regard to the extraordinary virtuosity of the bronze casters of the period, such as, for example, Gouthière, it is difficult to suppose that repetitions in terracotta could not have been produced by casting from molds followed by the working of details in the unbaked material by hand. Indeed, Clodion's association with the *fondeur-doreur* Dubois strongly suggests that this method was sometimes followed. On the whole, however, it seems more probable that the artist's prime original was directly copied in the studio and then worked over and the details inserted with a stylus either by the master or one of his assistants.

Clodion had a number of these. They included his three older brothers, Sigisbert, Michel, and Pierre, as well as Joseph Charles Marin (see under No. 55). But there must have been a number of others, for we hear of complaints by neighbors of the assistants singing and making other noises in the workshop in the Rue Chaussée d'Antin.

For a biography of Clodion, see under No. 54.

54 Triumph of the Infant Bacchus

H. 6⅕₆ (16.0); w. 9⅞ (25.0).

OF PINKISH-brown terracotta set in a gilded wood frame of Louis XVI design.

The rectangular panel is modeled in low relief in a somewhat rough and unfinished technique with an infant riding a goat facing to the right. Two further infants push at the goat's hindquarters, while three more attempt to drag it by means of reins. A sixth has fallen beneath the goat's hind legs.

The gilded wood frame is carved with a band of entwined circles, alternately large and small, and with a square fleuron at each corner. This is surrounded by a narrow border of oak leaves within a plain molding, while a large ribbon bow is carved above the upper edge of the frame.

Incised at the lower left-hand corner of the plaque: *1779*.

Attributed to Claude Michel, known as Clodion (1738–1814).

Formerly in the collection of Jacques Doucet (sold Paris, Galerie Georges Petit, June 6, 1912, lot 104 [illustrated in catalogue], for 4,000 francs [bought by Böhler]).

In the catalogue of the Doucet sale it was pointed out that at the Salon of 1779 Clodion exhibited (catalogue no. 243):

> Trois bas-reliefs en terre cuite, sous
> le même numéro.

The subjects are not given. It seems likely, however, that works to be exhibited at the Salon would have been more highly finished (and probably larger) than No. 54, but this might well be a preliminary sketch for one of the exhibited bas-reliefs.

The subject derives from Hellenistic art, perhaps through the medium of one of Duquesnoy's pastiches, and was used by Boucher and other French eighteenth-century artists (see Fig. 1). The treatment of the subject, though very similar, is not sufficiently close to suggest that Clodion actually used Huquier's engraving after Boucher.

1. *Gabriel Huquier after François Boucher, Fête de Bacchus. Engraving. New York, The Metropolitan Museum of Art, Harris Brisbane Dick Fund, 53.600.1084*

Claude Michel, known as Clodion, a native of Nancy, was born with sculpture strongly in his blood. He was a nephew and pupil of the sculptor Lambert Sigisbert Adam (1700–1759) and was related to Augustin Pajou (1730–1809). In addition to working with his uncle, he studied for a short while with J. B. Pigalle (1714–1785). In 1759 he won the Grand Prix de Sculpture and went to Rome in 1762. There he enjoyed considerable success and obtained the patronage of Catherine

[412]

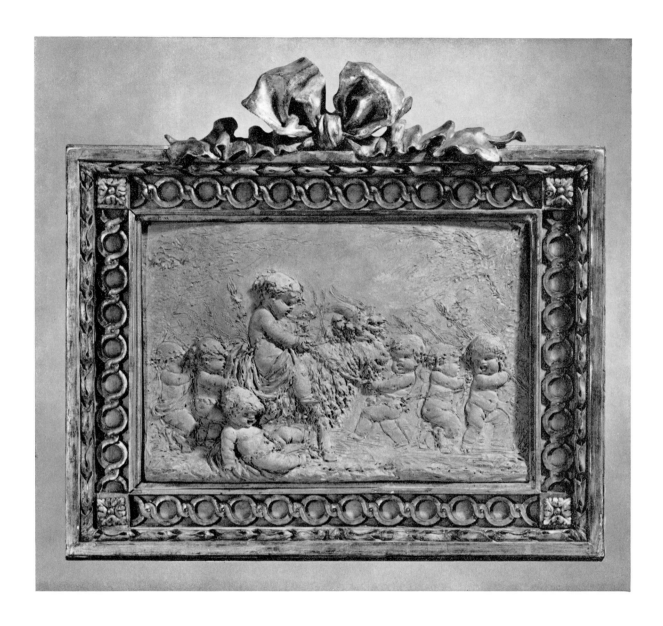

II of Russia, among others, remaining on in the city until 1771 after his period of study ended in 1767. In 1773 he was *agréé* at the Académie, but he never proceeded to become a full academician (perhaps on account of the opposition within the Académie to his methods, mentioned above under No. 53) and only rarely exhibited at the Salons.

He executed a number of commissions for monumental sculpture, notably a St. Cecilia (1775–1777) for the screen of Rouen Cathedral and the statue of Montesquieu for the series of Grands Hommes de France ordered by the Bâtiments in 1783, but his true métier was for small work of a decorative character. He modeled an enormous number of small figures, groups, and bas-reliefs of bacchantes, nymphs, satyrs, etc., mostly in terracotta. In these, neoclassicism is given a remarkable warmth and freshness. He had the gift of imparting an extraordinary sensuousness and

charm to figures that other neoclassic sculptors such as Falconet (see under No. 48) treated with a colder orthodoxy. Clodion also made small models for *biscuit* figures for the Niderviller factory.

Clodion's terracottas were in great demand among collectors in the eighteenth century, and many exist in duplicates, triplicates, or even greater numbers of copies. There can be no doubt that several versions of these terracottas were often produced in his studio either by assistants or with his personal intervention (see under No. 53). It is not always easy to distinguish these from later *surmoulages* except by very careful measurement and the direct confrontation of a known original and an example cast from it. But it seems reasonable to treat all the versions made in the studio under Clodion's own supervision as original works of the master. The existence of both authentic repetitions and casts has, however, made modern collectors chary of buying even signed terracottas by Clodion when other apparently genuine examples of the subject are known. Large numbers of pastiches of his works were also made in the nineteenth century, most successfully by his pupil Marin (see under No. 55), and many bronzes were cast from his terracottas during the same period. These, too, have affected the attitude of collectors toward Clodion's small sculptures.

BIBLIOGRAPHY: There is no adequate modern study of Clodion. Henri Thirion, *Les Adam et Clodion* (Paris, 1885), is still the standard critical biography.

55 A, B Pair of Bacchic Groups

55 A: H. 8¾ (22.2); W. 10⅜ (26.3); D. 7½ (18.4).
55 B: H. 7⁵⁄₁₆ (18.6); W. 10½ (26.7); D. 6⅝ (16.8).
Plinths: H. 4⅞ (12.3); W. 12¼ (31.2); D. 9⅞ (25.1).

OF PALE, pinkish-brown terracotta. The carved wooden plinths are partly gilded and partly painted.

On No. 55 A a naked, reclining bacchante, facing right, holds in her left hand a wine cup above her head and out of reach of an infant standing behind her who attempts to seize it with his upstretched hands. Within her right arm she embraces two additional infants who are fighting for a bunch of grapes. A lion's pelt is lightly draped over her right thigh and falls over a tambourine lying on the rockwork in front of her crossed legs.

Incised on the base at the back below the rock on which the bacchante reclines: *MARIN*.

On No. 55 B a naked, reclining bacchante, facing left, with vine leaves in her hair, holds a bunch of grapes in her outstretched right arm. An infant stands behind her crossed legs. In the crook of her left arm she clasps another infant seated on a rock; below this rock a third infant lies face downward on a tambourine and is eagerly devouring grapes.

Incised at the back on the rock against which the bacchante reclines: *MARIN*.

The plinths, in the Louis XVI style, are of walnut painted to resemble porphyry. Each is carved around the side with four recessed panels painted dark greenish blue and carved with gilded swags of roses. The panels are separated by heavy inverted consoles carved with an acanthus leaf. These are marbleized in tones of gray with streaks of gold. Gilding is also found on the acanthus leaf and on the pearled beading around the top of each plinth. The panel at the front of each is overlaid by a circular medallion painted *en camaïeu* in ivory on a dark blue ground with a profile head of Louis XVI facing left on No. 55 A and with a Cupid stringing his bow on No. 55 B. Above the former is a label inscribed CHERI DE TOUS in gilding. The label above the Cupid is blank. The plinths are probably later in date than the terracottas.

Various labels are stuck on the recessed top of the plinth (and repeated under the plinth) of No. 55 A, and on No. 55 B, on the top of the plinth only, as follows: a circular paper label inscribed in ink 210/9; a rectangular paper label printed MADE IN FRANCE; a circular paper label printed DOUANE EXPOSITION PARIS. On No. 55 A there is also a typewritten label C 12695/35/2; and written in pencil are D2 3K850 and an indecipherable word. On No. 55 B there is also a paper label inscribed P 570; and written in pencil are No. 1 D 4K230 and an indecipherable word. On the underside is written in ink DW/851/1. These appear to be variously sale room numbers, loan exhibition labels, and perhaps dealers' stock marks.

By Joseph Charles Marin (1759–1834).

REFERENCE: F. J. B. Watson, "From Antico to Houdon," in *Apollo*, XC, September 1969, pp. 217–218, figs. 8, 9.

Formerly in the collections of the Marquis de Bailleul; the Comtesse de la Potterie, his daughter, at the Château de Rouville, Seine-Inférieure. Sold in London, Sotheby's, July 3, 1959 (Property of a Gentleman), lot 65 (illustrated in catalogue, pl. IX), for 4,400 guineas (bought by Rosenberg).

These two groups follow very closely the manner of Clodion (1738–1814), an artist who provided inspiration for Marin's work throughout his life. Right down to his death in 1834 he was continuing to produce pastiches of this sculptor's works. For this reason it is far from easy to date them. Bacchantes playing with infants proliferate in his work (see the *catalogue sommaire* appended to Maurice Quinquenet, *Un Élève de Clodion, Joseph-Charles Marin, 1759–1834* [Paris, 1948], pp. 53–72). It may perhaps be noted that Marin exhibited at the Salon of 1793:

> Une Bacchante couchée, grouppée avec des Enfans.
> En terre, forme ovale, 15 pouces de large.

and at the Salon of 1795:

> Bacchante couchée et groupée avec des Enfans.
> Modèle en terre.

But the descriptions are far too generalized to permit of any certain identification. The group exhibited in 1793 might equally well (or better) apply to a terracotta in the Victoria and Albert Museum, London (No. A421954), which is dated in that year.

According to Quinquenet (p. 70), there is an old photograph in the library of the Musée des Arts Décoratifs, Paris, of a "Bacchante au raisin étendue, entourée de trois enfants," but he gives no further particulars, and the photograph is untraceable today.

Joseph Charles Marin was a pupil of Clodion (see under No. 54). He studied at the Académie and com-

[416]

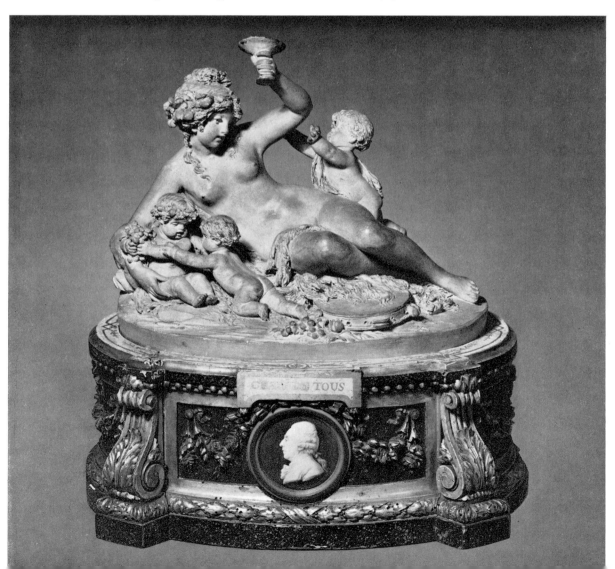

peted six times for the Grand Prix de Sculpture without success, for he was not by nature an academic type of artist. During the rest of his life he worked with real pleasure only in the manner of his master, chiefly producing small-scale terracottas of nymphs, satyrs, bacchantes, and the like, together with a few busts mostly modeled during the Revolutionary period, when he reached the height of such success as he was to enjoy.

He accompanied the commission that followed Napoleon's armies in Italy to select works of art to be taken as loot to the Louvre, and was in Rome in 1798. On his return to Paris he won a prize for a *tête d'expression* in 1800 and in the following year, at the unusually advanced age of forty-two, at last won the Grand Prix with a neoclassic work, Caius Gracchus quittant sa femme pour aller rejoindre ses partisans, and was sent to Rome. There he enjoyed considerable success, staying on after his scholarship ended in 1806 and obtaining the patronage of Lucien Bonaparte, Murat, and Châteaubriand.

He returned to Paris in 1810, and in 1813 replaced Chinard as professor at the École des Beaux-Arts at Lyon. At the Restoration he rallied to the monarchy and received a number of commissions, notably one in 1816 for a colossal marble statue of Admiral Tourville for the Pont Louis XV at Paris. But monumental sculpture was not his true métier, and the figure was completed only in 1827 after strong official protests at Marin's tardiness. His last years were spent in great financial want, and the sculptor Bonnassieux describes him as pitifully modeling quantities of small terracotta figures in the now outmoded style of Clodion and selling them for a few sous each. Thereafter he was virtually forgotten, his works confused with those of Clodion, until 1908 when a bust of a young girl suddenly attained the price of 2,600 guineas at auction in London.

BIBLIOGRAPHY: Maurice Quinquenet, *Un Élève de Clodion, Joseph-Charles Marin, 1759–1834* (Paris, 1948), with a *catalogue sommaire* of his works.

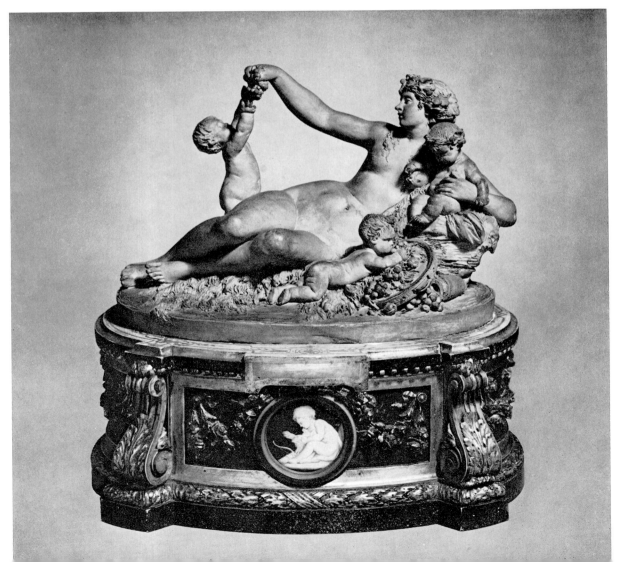

INDEX

A

exhibitions

F

M

N

O

P

U

V

W

Photography by Taylor & Dull. Designed by Peter Oldenburg and Anne Preuss. Composed in English Monotype Bembo and printed on Warren's Lustro Dull by the Press of A. Colish; color and monochrome plates by Publicity Engravers, Inc.; endleaves printed by The Meriden Gravure Company; binding by Publishers Book Bindery.

First printing, 1973: 4000 copies

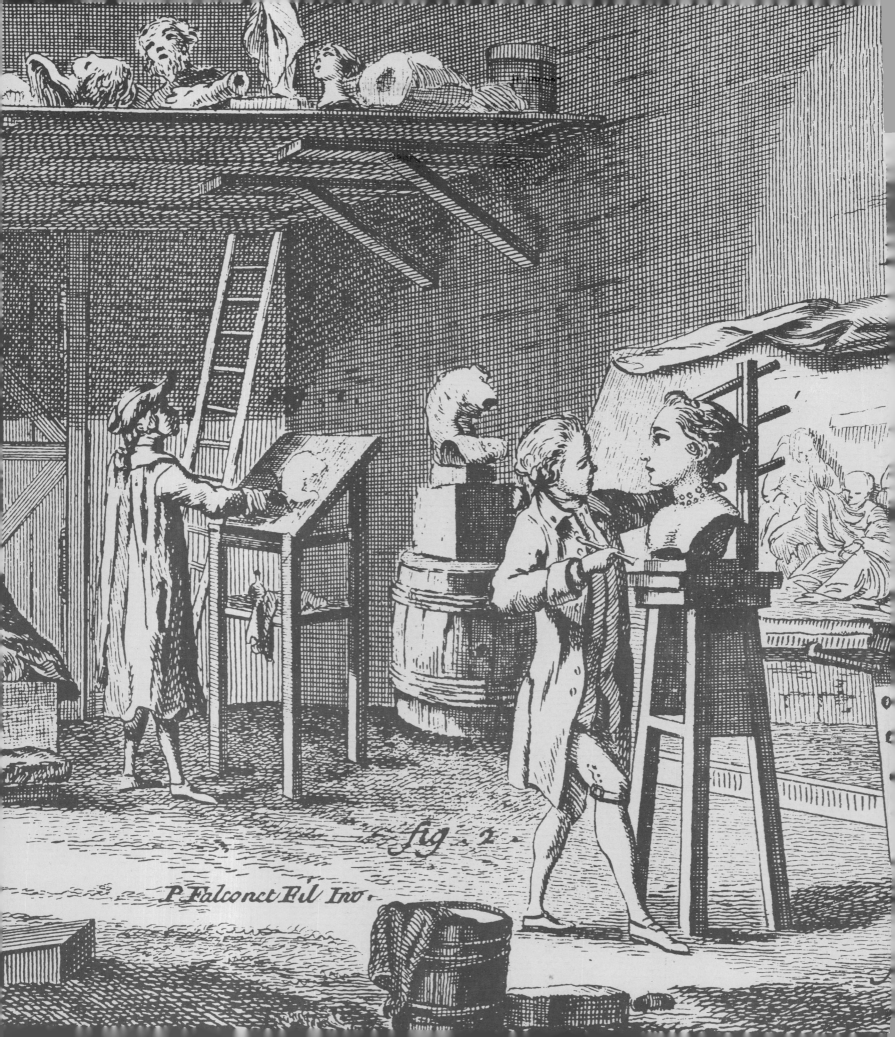

fig. 2.

P. Falconet Fil Inv.

OVERLEAF: View of a sculptor's workshop, taken from Diderot and d'Alembert's *Encyclopédie*, volume VIII of plates, 1770. Plates engraved by P. Falconet *fils*.

The Metropolitan Museum of Art, Harris Brisbane Dick Fund, 33.23

Fig. 1 Sculptor copying a model in the round in bas relief.

Fig. 2 Sculptor modeling a head in the round.

Fig. 3 Bas relief.

Fig. 4 Small, portable stands that can be stood on a table or bench and on which reliefs can be modeled. Behind is a revolving stand for modeling in the round.

Fig. 6 Sculptor modeling in plaster by hand.

Fig. 7 Workshop assistant beating or tempering plaster.